MASKS OF THE SPIRIT

MASKS OF THE SPIRIT

Image and Metaphor in Mesoamerica

Peter T. Markman
Roberta H. Markman

With an Introduction by
Joseph Campbell

UNIVERSITY OF CALIFORNIA PRESS
Berkeley Los Angeles London

University of California Press
Berkeley and Los Angeles, California

University of California Press, Ltd.
London, England

Copyright © 1989 by
The Regents of the University of California

First Paperback Printing 1994

Library of Congress Cataloging-in-Publication Data

Markman, Peter T.
 Masks of the spirit: image and metaphor in Meso-
america / Peter T. Markman, Roberta H. Markman:
with an introduction by Joseph Campbell.
 p. cm.
 Includes bibliographical references:
 ISBN 0–520–08654–6
 1. Indians of Mexico—Masks. 2. Indians of
Mexico—Religion and mythology. I. Markman,
Roberta H. II. Title.
F1219.3.M4M36 1989
299'.74—dc20 89-20160
 CIP

Printed in the United States of America

1 2 3 4 5 6 7 8 9

For Joseph Campbell (1904–1987),
"companion on the way,"
whose life and work and encouragement
have marked that way

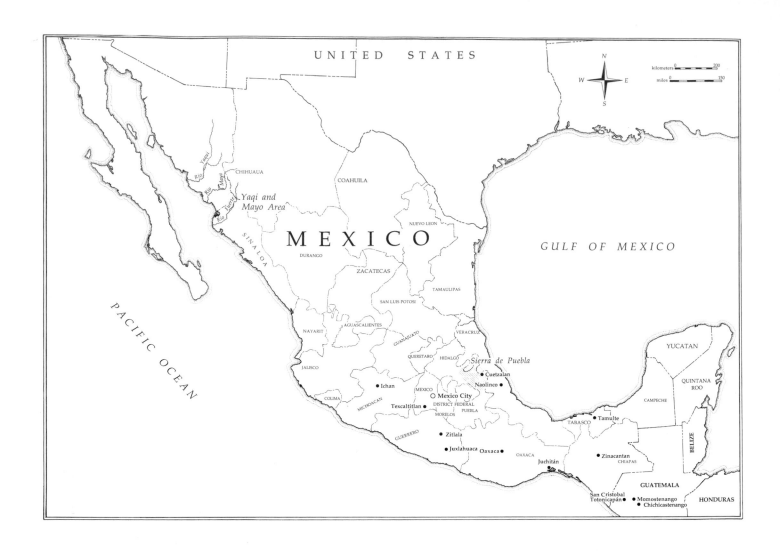

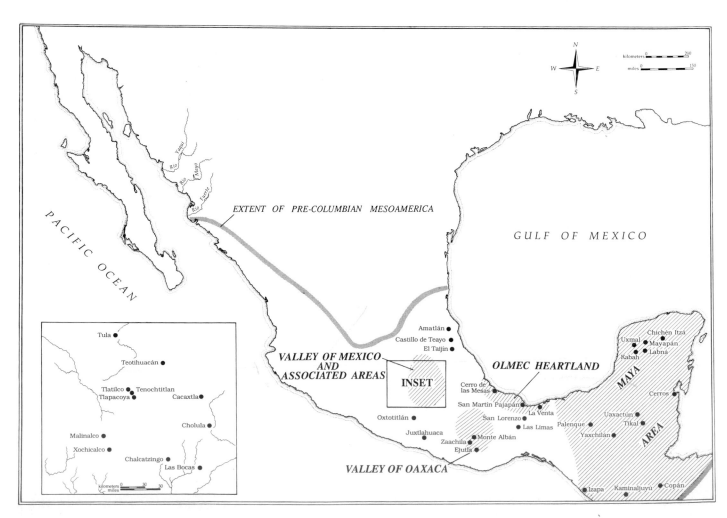

Contents

List of Illustrations

Abbreviations:

AMNH American Museum of Natural
 History, New York
MAX Museo de Antropología de Xalapa
MNA Museo Nacional de Antropología,
 México
PMLV Parque Museo de La Venta

Unless otherwise indicated, all photographs are by Peter and Roberta Markman. Figures 1–5 were prepared by Tim Seymour.

Figures

Black and White Plates

Color Plates

Acknowledgments

In addition to Joseph Campbell, to whom this work is dedicated in recognition of our profound appreciation of all he taught us, both personally and through his works, there were others who were of great assistance. Without the Fosados—Victor, Sr., Victor, Jr., Pilar, and Ramon and Irene—we might never have understood the fascination of the masks of Mexico, and without Silvan Simone, Bob Curry, and Jack Wheelhouse we might never have seen the beauty of the rich and varied artistic tradition of which those masks are a part. Without the advice, help and influence of Armando Colina and Victor Acuna our trips to and activities in Mexico, as well as our understanding of modern Mexican art, would have been much less enjoyable, enriching, and productive. And without all of our other friends in Mexico—especially Felipe Siegel and Miguel Angel Fernández, but also Jaled Muyaes, Estela Ogazon, and Jorge Antonio Hidalgo—many experiences that richly enhanced our understanding would not have been. Especially helpful were the thoughtful director and staff of the magnificent new Museo de Antropología de Xalapa, particularly Antonio Rumayor Mendez, Crescencia Celis Sanchez, Miguel Osario Aguilar, Brigido Lara Lara, Arqlgo. Hector Cuevas Fernandez, and Mark Antonio Reyes. And we must particularly thank Jamake Highwater for his ideas, his encouragement, and his thoughtful criticism and Bill Ruder for his helpful concern.

Without the constant encouragement and the generous funding provided by California State University, Long Beach, especially through the Office of University Research and its dedicated staff and faculty advisory committees, the road would have been far more difficult; and we must also acknowledge with gratitude the support provided by both the National Endowment for the Humanities and Fullerton College. Many of our colleagues have been of great assistance, among whom are Dr. Marianne Woods, Provost John Beljan and Dean Karl Anatol of California State University, Long Beach, and Dean Janet Portolan and Lois Powers of Fullerton College. In connection with the illustrations in the text, we would also like to thank Terry O'Brien, Jacques Montluçon, Galerie LeLoup, Paris, and the helpful staff of the Museum of Mankind, London.

Most important, there was Scott Mahler who believed in us and the book at some very crucial points, encouraged and helped us more than even he knows and, from our very first contact with him, has been the kind of editor very few authors have the privilege of working with but all dream of having. We are indeed blessed.

Period and Date	Central Mexico	Gulf Coast	Oaxaca	Maya Area
PRECLASSIC PERIOD — Early: 1500, 1300, 1100	Tlatilco Chalcatzingo Oxtotitlán Juxtlahuaca	*OLMEC* — San Lorenzo; La Venta		Kaminaljuyú
Middle: 900, 700, 500, 300				Izapa
Late: 100 B.C., 100 A.D.	*TEOTIHUACAN*		*MONTE ALBAN*	Cerros
CLASSIC PERIOD: 300, 500, 700, 900	Cacaxtla Xochicalco Cholula	*EL TAJÍN* — Huastec Sites		**Classic Period Sites** { Uaxactún, Tikal, Yaxchilán, Copán, Palenque; **Yucatec Sites** { Uxmal, Kabah, Labná, Sayil
POSTCLASSIC PERIOD: 1100, 1300, 1500	Tula (Toltec); Tenochtitlan (Aztec)		Mixtec States	Chichén Itzá Mayapán

Chronological Table.

Introduction

The engaging title of this study leads one to expect that it would reward the careful reader with an understanding of the metaphorical dimension of the use of the ritual mask by the peoples who created and developed the mythological tradition of Mesoamerica. And while it surely provides that reward in full measure, remarkably, it provides still more as the constellating theme of the mask as metaphor is developed and extended to represent, finally, the whole ritualistically controlled civilization of Mesoamerica as metaphorical of the spirit. Moreover, the clarity of its exposition, through the vehicle of the mask, of a consistent weltanschauung informing the whole spectacle of that civilization from the Olmec period, ca. 1200 B.C., to the folkways of the present enables this work to penetrate the veil that has so long obscured the mythological thought of that monumental flowering of civilization that took place in the middle zone of the Americas.

Developing as their thesis the idea that "for Mesoamerica all of reality—inner and outer, microcosmic and macrocosmic, natural and supernatural, earthly, subterranean, and celestial—formed one system whose existence betrayed itself in the order that could be discerned behind the apparent chaos of the natural world," the authors show in fascinating detail how that system, represented by the mask as a central metaphor, could bring into a unity the myriad details of the world of appearances confronting the Mesoamerican consciousness. They differentiate clearly between the ethnic ideas necessarily derived from that local experience and the elementary ideas they enclose, that is, between metaphor and connotation. And the wealth of detail they present enables them to demonstrate again and again how nature has been transformed by the shaping mind of the artist and seer into the mythic images, rites, and festivals through which life within the cultural monad is defined and controlled metaphorically in the way of art. For it is ultimately the artist, as the Markmans often remind us, whose transforming consciousness brings the images of this and every mythology to realization.

They understand and have used the complex historical factors that shaped Mesoamerican culture to penetrate ancient America's "mythogenetic zone," a zone I have defined elsewhere as any geographic area in which a language of mythic symbols and related rites can be shown to have sprung into being, from which diffused many of the forms with which we are familiar in the myths and tales of the native peoples of North America. We are introduced to the initiating metaphysical insights and an understanding of the connotations of the most important metaphoric customs of that civilization, and we are enabled to see the essential pattern of the development of those early insights into the elaborate mythological system existing in Mesoamerica at the time of the Conquest. Thus, because the imagery of a mythology is metaphorical of the reality of the people to whom it belongs, we are exposed, by means of the fortuitous choice of the mask, to the marvelously rich and highly complex mythological tradition of archaic Mesoamerica.

Their choice of the mask was indeed a fortuitous one. The mask has always been used as a ritual agent of transformation, and since a fundamental premise in Mesoamerican spiritual thought is that of the interchangeability through transformation of the inanimate, the lower animals, the human, and the divine, it is through the mask, which touches and exhilarates centers of life beyond the reach of the knowable, that the unknowable can be revealed. The mask, as the authors indicate, served both "as a symbolic covering of a spiritu-

ally important substance and . . . as a method of transforming the accidental to the essential, the ordinary to the extraordinary, the natural to the supernatural." Furthermore, it may be noted that the authors' insightful realization that "the most essential form of transformation does not require abandoning one state for another but allows them all to exist simultaneously" enables them to explain the "unfolding" of the god identities and to consider each of the individual gods as a set of symbols that constitutes a mask that specifies the particular aspect of the life-force being considered and not as a member of a group of fixed individual deities such as those of the Greek or Roman pantheon, a misconception that has dogged the study of Mesoamerican myth and religion and hindered its understanding and appreciation. If we are to seek a model in other civilizations, this study makes clear that it would more likely be found in Hindu than in Greek thought. Because the god identities were not always transformed in a diachronic process but rather exhibited a synchronic totality, they can furthermore be seen to exist simultaneously in more than one state.

For this reason, the discussion of transformation as the operational mode of the entire Mesoamerican cosmological system, to my mind the most significant single portion of the study, enables the Markmans to bring together all the areas of their earlier consideration: the shamanic underpinnings of the culture; the temporal order as manifested in the solar cycles revealing the macrocosmic order and the cycles of generation, death, and regeneration which revealed the corresponding microcosmic order and "provided proof to the Mesoamerican mind that there is no death in the world, only transformation, and there is no end to life, only changing forms, changing masks placed on the eternal and unchanging essence of life"; the spatial order that provided the impetus to reproduce the divine "shape" of space and time in architecture, thus marking the points of transformation from the earthly plane to the realms of the spirit; and the highly sophisticated, astronomically and numerologically derived calendars of Mesoamerica which "embodied in abstract form the whole process of transformation" and provided here, as they did in all of the archaic high civilizations, a glimpse into the essence of the eternal order as revealed through the celestial lights of the macrocosmic order.

The first task of any systematic study of the myths and religions of mankind should be the identification of the underlying universal ingredients, what Adolph Bastian termed the elementary ideas, and as far as possible, their interpretation; and the second task should be to recognize and interpret the various locally and historically conditioned transformations of those elementary ideas, Bastian's ethnic ideas, through which these universals have been rendered. But it must be remembered that in the final analysis, the religious experience is psychological and in the deepest sense spontaneous and universal. Thus, there surely can be no absolute or final system for the interpretation of the mythic images upon which religious experience is built and through which it is communicated. Since myths reply only to the questions put to them in the course of the study of any local mythology, what they disclose will be great or trivial according to the questions asked, and only those who are themselves alive to the fascination of the inexhaustible symbols of myth, always fresh and alive to the seeking, open mind, can ask the right questions. Those whose sole aim is to systematize and classify can understand neither the vitality nor the deep meaning of such symbols. Putting the right questions to the images constitutive of the Mesoamerican mythology which remain for our perusal enables the Markmans to gain replies that not only illuminate the structure of the ethnic ideas of that culture but reveal clearly the underlying elementary ideas that continue to fascinate. By doing that, this study enables one to relate these sometimes strange images and rites to those of the other cultures mankind has developed, cultures that must necessarily express the elementary ideas derived from our common psychological structure and basic life experiences, but each in images drawn from its particular, locally based experiences of the world so that for each reader the mythic thought of this now irretrievably destroyed civilization can come once more to life through the mythic image.

What we have here is an illuminated exposition of the spiritual content of a profoundly inspired, major religious system centered not in the worship of any single god but in the recognition, as in Hinduism, of a transcendent, yet immanent, informing ground of all being, an exposition whose argument is so clear that one hardly realizes to what complicated symbolic systems and profound mystical insights he is being introduced. After announcing their thesis in the prologue and then demonstrating that a mask may reveal rather than conceal as it bridges the gap between nature and spirit, the authors show one how to "read" the visual myth presented in the mask by presenting first the case of the Aztec god, Huitzilopochtli, to make clear that "the Mesoamerican visual statement uses specific items—features, masks, attire—combined in a plastic rather than narrative fashion" to specify the identity and function of the god.

Following that is a lengthy section devoted to an amazingly thorough investigation of the rain god in each aspect of its manifestation from the Olmec were-jaguar to the time of the Conquest three thousand years later. Demonstrating that the figure identified by the rain god mask not only involved the provision of life-sustaining rain but was also concerned with divinely ordained rulership

and other fundamental themes of Mesoamerican spirituality, the authors suggest that these mythic forms point past local ethnic idiosyncrasies to mysteries of universal import, as mythic images are wont to do. Thus, it is no surprise that while it is in his seemingly infinitely varied metamorphoses that the fascination of this god resides, each of those metamorphic manifestations points directly to the underlying elementary idea linking fertility and rulership to the eternal cycle of life existing both microcosmically and macrocosmically. The analysis of the individual features that occur in these varied manifestations of the symbolic mask of the rain god enables the Markmans to explore the fusion of Olmec spiritual thought with the art styles and belief structures of the coexisting village cultures, and that exploration allows them to present a convincing explanation of the method by which those elementary ideas, crystallized first in Olmec culture, diffused to all of the high cultures of that zone, forming, by that process, one great mythological tradition. It is remarkable that all of this can be read so clearly in the features of the masks of the rain god in its various incarnations, and it is even more remarkable that this exploration of those symbolic features is able both to uncover the ethnic ideas of each of those cultures and the elementary ideas of which they are metaphoric.

This first part of the study concludes with a discussion of the mask as it was used in ritual, becoming therein a veritable apparition of the mythical being represented—even though everyone knew that a man made the mask and that a man wore it. As the authors show, that ritual wearer, so often depicted in the images of this mythic art, does not merely represent the god; he *is* the god. He manifests the life-force. Through that ritual transformation joining the worlds of spirit and nature, man and god fuse in what the Markmans, using Arnold van Gennep's conception as modified by Victor Turner, describe as a zone of liminality, a zone of mysterious transition marked in Mesoamerican myth, as elsewhere, by the mask that is itself metaphoric of that stage. This consideration of the ritual mask ends with a thorough investigation of the architectural masks that were used on ritual structures to signify and control the presence of the sacred and, ultimately, with a discussion of that final mask, the funerary mask by which the peoples of Mesoamerica attempted to comprehend the mystery of the return of the life-force to its source.

Following that detailed consideration of particular masks the study opens out into a consideration of the cosmological view underlying and gaining expression through those specific masks and presents with great clarity the shamanic assumptions forming the core of Mesoamerican spiritual thought, elements to be seen as early as the El Riego phase of the Tehuacán valley (ca. 8000–5800 B.C.) with the evidence of burial ceremonialism

discovered by Richard MacNeish. Shamans were the first finders and exposers of those inner realities that are recognized today as of the psyche, and the myths and rites of which they were the masters served not only the outward (supposed) function of influencing nature, causing game to appear, illness to abate, foes to fall, and friends to flourish, but also the inward (actual) work of touching and awakening the deep strata and springs of the human imagination. So primitive man, from the first we know of him, here and elsewhere, through his myths and rites turned every aspect of his work and life into a festival celebratory of the wellsprings of his being, and these festivals, in Mesoamerica, made extensive use of the mask, which was itself metaphoric of the inner reality celebrated.

But as we know, man early turned to the heavens to further explore the mystery of being, and the order apparent there, most clearly in the sun, but most magnificently in all the orderly complexity of the glittering lights of the night sky, led him to a conception of cyclic time as a manifestation of the cosmic mystery. Thus, it is proper that the Markmans move from a consideration of the shaman's inner journey to Mesoamerica's "outward journey" into the heavens, through astronomy, to an understanding of the cycles through which time could be seen to move, cycles charted in the sophisticated calendrical systems by which the mysteries of the cosmos could be unlocked to reveal the underlying spiritual order that exists behind the mask. This complex calendrical system existing, so far as we know, only in the metaphoric god images of the sacred and solar calendars represents the Mesoamerican realization of a cosmos mathematically ordered, a realization that it is in the magic of number that the mystery of being ultimately resides, a realization directly parallel to that original realization of the Sumerians in the Tigris-Euphrates valleys ca. 3500 B.C.

But in the Mesoamerican experience, as this study clearly reveals, the revelation arising from the inner world of the shaman could be made compatible with that of the outer world reckoned by the skyward-looking priest in the temple through the solar cycle's metaphoric unification of the macrocosmic annual cycle of that burning orb with man's microcosmic cycle of birth, death, and regeneration. And, fascinating to behold, all of this was then fused with the spatial order through the identification of the path of the sun with the four world quarters. Thus is revealed a metaphorically conceived all-encompassing cosmic system reflective of the essential order of the cosmos and expressive of the divine essence, which is none other than the life-force itself. Quite obvious, then, is the fundamental importance of the concept of transformation to this cosmological view, for it is through transformation that the essence of life informs the

myriad manifestations of life in the world of nature. And it is the mask that is the transforming agent par excellence. Once again it is apparent that the generative conception, from which this study springs, of the mask as metaphor is a fortunate opening, giving unity and clarity to the whole.

As I have remarked above, transformation seems to me to provide the core of this study since that conception unites all of its elements. It is through the transformation of creation that god becomes man; and it is through the transformation of sacrifice that man "feeds" god just as it is through the transformation of the seasonal changes of the earth that god provides food for man. But it is also through the transformation wrought by the artist that the commonplace materials of life become images expressive of the power of the mysterious force of life. For the peoples of Mesoamerica, as the evidence here adduced so eloquently testifies, as for all the peoples of this earth, it was the artist who was able to render the message of the spirit through his heritage of symbols, images, myth motives, and hero deeds. And so this concluding consideration of transformation brings us full circle to the metaphorical implications of the mask as that which covers the animating spirit of the wearer corresponding in that way to the world of nature which "covers" the animating hidden spiritual world that must come from beyond "meaning" on all levels at once, most important, through the images of the artist, if man is to survive.

The final section of the text carries us beyond the time of the great Conquest by Cortés to the present day through the violent transformation of conditions represented by the introduction of Christianity and illuminates the fate of the mask in those crucial four hundred fifty years. The study here of the syncretic processes that occurred through the fusion of the Christian and pagan religious beliefs is a marvelous analysis of every significant aspect of that uneasy merging of two of the world's great mythological traditions, and it is followed by a study of the uses of two exemplary mask forms in the rites which represent the terms of the relationship between those two traditions: the masks of the *Tigre* through which the symbolic features of the pre-Columbian rain god continue in existence and the masks of the *Pascola* of northwest Mexico in which the syncretic compromise of the two traditions is evident. Used in ritual still today, the mask remains a manifestation of the living myth bringing together the worlds of spirit and matter. Providing a fitting conclusion to this last section, the final chapter looks at another type of mask being carved today and voices what may well be a prophetic concern with the loss of meaning in the use of festival masks, which no longer serve to carry the human spirit forward because the signal code is losing its force as the conditions from which it sprang undergo alteration, the new conditions no longer permitting the group to experience the mystery of existence in the old way. For when the metaphoric implications of the mythic image become too far removed from the immediate experience of the group, myth and rite lose their power.

But the Markmans find hope where others might despair. They allow us to see that even as the traditional mask with its age-old symbolic features seems to be losing its metaphoric power, the mask has found new life as a symbol in modern Mexican art, and at least two important artists, both born Indians, have used the mask as a means of drawing from the indigenous past a metaphor capable of revealing the spiritual mystery at the heart of things and allowing the yea-saying made possible through the transformation of art. Like the shamans, priests, seers, and artists of the past, such modern artists have mastered metaphorical language and continue to serve, as the artist always has, as mankind's wakener to recollection: a summoner of the outward-turning mind to an awareness of inner reality and then to conscious contact with the universe without in the way of the spirit. For art is the mirror at the interface where the worlds without and within must meet. Like ritual and myth, art thus reestablishes within each of us our own deep truth and allows us to know that our own truth is at one with that of all being. Once known through the way of art, that truth allows communication across the void of space and time from one center of consciousness to another, precisely the communication that in earlier systems was the function of myth and rite.

When Marija Gimbutas said of Vinca art that "it is almost unbelievable that during the thirty or more years in which essays treating Vinca art have appeared, there has been no sustained reference to the mask, its most captivating element," * she might well have been writing of the neglected treatment of the essential metaphoric role of the mask in Mesoamerican ritual and mythic thought. This neglect is surprising, especially so when we realize that the first monumental civilization of the New World appears to have been created by the Olmecs ca. 1200 B.C. at roughly the same time that the Late Shang dynastic capital was built in China at Anyang (Honan), ca. 1384–1025 B.C.; the same time as the legendary fall of Troy to the Achaeans, ca. 1184 B.C., marking the end of the Mycenaean period and the beginning of Hellenic civilization ca. 1100 B.C.; the same time that the Colossi of Rameses II were built in Egypt, ca. 1290–1225 B.C.; and the time of Moses, ca. 1250–1200 B.C. We have had the opportunity to understand the root metaphors of the Chinese, Egyptian, Hebrew, and Hel-

* Marija Gimbutas, *The Goddesses and Gods of Old Europe* (Berkeley, Los Angeles, London: University of California Press, 1982), 60.

lenic worlds through the many perceptive studies of the mythologies of those civilizations readily available to us. But this has not been true of the metaphorical form at the center of the Mesoamerican mythological tradition until the publication of this study, which I believe will stand for many years as the most coherent and comprehensive as well as eminently readable exposition yet composed of the Mesoamerican experience, an experience whose fragmentary remains still give us the sense of a majesty and spiritual force yet to be fully recognized.

It should perhaps have been expected that a work of this nature would have been written by comparativists conversant, by training and inclination, with the methods and scholarship of history, including the history of art and of religions, anthropology, including (presently) archaeology and ethnology, literary and art criticism, and the comparative study of mythology. The spiritual development of Mesoamerican culture, like that of any culture, must be studied through the images that comprise its mythology, and these images require what is today known as an interdisciplinary approach if they are to yield their insights, since no single modern discipline is capable of encompassing the references or understanding the language of the images of the great mythologies. For that reason, perhaps, the great mythical and cosmological thought of Mesoamerica has too long been hidden in specialists' monographs that are necessarily technical, scattered, fragmentary, and very difficult to coordinate.

Presented without jargon, the scholarship here is formidable yet unaggressive, and conflicting opinions of major scholars in the field are constructively interpreted, reconciled, and coordinated as the result of the Markmans' ability to penetrate beneath the surface of these symbolic images to the underlying structure, deriving from that structure the interpretation of the symbol. This, as any reader of specialist publications in comparable fields must realize, is an unusual ability. Particularly impressive in this regard is their treatment of the controversy over the nature of the connection between the god images of the Olmec and those of the Aztecs millennia later, a controversy generated by Michael Coe's and Peter Joralemon's assertion that the prototypes of particular Aztec gods may be identified in Olmec art. This claim provoked heated opposition of several types, but as is here argued, that opposition, as well as the original assertion, was the result of too great a concentration on specific images to the neglect of the underlying structure generative of those images and alone supportive of their meaning. When viewed in the light of this structure, the controversy surrounding these images fades and their true relationship appears.

Similarly reconciled are the differing interpretations of the metaphoric images found in the mu-ral art of Teotihuacán. George Kubler argues that those images may not be read in terms of the meanings attached to similar images in the centuries-later Toltec and Aztec art of that region, while Esther Pasztory argues that those later meanings may be used, and Laurette Séjourné, taking a different tack and condemned for it by both Kubler and Pasztory, among many others, attempts to read essentially Platonic meanings in these images. The Markmans not only reconcile these opposed interpretations, seemingly so fundamentally at odds, but demonstrate that each interpretation is essentially correct in its treatment of the piece of the puzzle it chooses to solve. However, the puzzle is larger—and deeper—than those who would solve it realize, and only the realization of its most fundamental level of meaning, what Bastian terms the elementary idea, makes possible the recognition that interpretations on other levels are to be seen as applications of the elementary idea. The reconciliation of such seemingly divergent views on the basis of detailed analyses of the matter at hand is scholarship at its best. I know of no other work in the field of Mesoamerican studies that analyzes such images so insightfully or that interprets every aspect of the grandiose symbolic development from Olmec to contemporary times as thoroughly and thoughtfully as the present study.

Perhaps the most exciting aspect of the work, however, is that it offers not only a series of insights into the local mythology of Mesoamerica but also a truly significant insight into the nature of mythology per se. Its constant return to the theme of the mask as the agent of transformation from inner to outer makes the symbolic mask not only a metaphor for the understanding of Mesoamerican myth but a metaphor for myth. For myths, by their very nature, function to reveal the inner in terms of the outer. Novalis's saying captures the essential idea: "The seat of the soul is there, where the outer and inner worlds meet." To that magic, germinating point of myth, the senses bring images from the world to be transformed through contact with accordant insights awakened as imagination from the inner world of the body. For the Buddhist, these are Buddha Realms, orders of consciousness to be brought to mind through meditations on appropriately mythologized forms. For Plato, these are universal ideas, lost from memory at birth, to be recalled only through philosophy. And these, of course, are Bastian's elementary ideas and Jung's archetypes of the collective unconscious. And for the seers of ancient Mesoamerica, these are levels of inner reality to be brought to consciousness in the guise of the mask, that seemingly perfect metaphor for the inner made outer. Finishing this fascinating study, we are left to ponder the connection between these masks of the spirit and our own inner reaches.

1987 Joseph Campbell

Prologue
The Mask as Metaphor

Everywhere and always, human beings have struggled to understand and express their relationship to the infinite, their place in the grand spiritual design they perceive in the cosmos. While that attempt to understand is universal, the ways of understanding are myriad since a great deal depends on the assumptions from which each perception of design grows. One is reminded of Thomas Mann's novel *The Confessions of Felix Krull* when the title character, during a period of "interior activity" very early in his life, confronts this crucial problem. "I would ask myself: which is better, to see the world small or to see it big?" It was an important question for Felix because the answer would determine his view of the nature of the reality in which he was to function and would provide the basis for his most important responses to life. And indeed, once he decided "to see it big," to see it as "a great and infinitely enticing phenomenon offering priceless satisfactions,"[1] a whole repertoire of secondary assumptions necessarily and naturally followed.

As Mann realized, first principles regarding the nature of reality do determine one's perception of the world and circumscribe the area within which he functions, a truth that clearly applies to man in the aggregate as well as man, the individual. Just as we must be aware of Felix's decision in order to make sense of the events of his life in the novel, we must discover and understand a culture's basic assumptions regarding man's relationship to the underlying source of life and order in the universe in order to be sensitive to the full repertoire of that culture's responses to the world in which it functions. Only with this understanding can we appreciate the implications of a culture's cosmic vision in both the everyday reality of its practical life and the more highly charged reality of its ritual life.

Our study of the metaphor of the mask in Meso-american myth and ritual, and thus in the cosmological and cosmogonical thought embedded in those myths and acted out in that ritual, has led us to the conclusion that the Mesoamerican answer to Felix's question is to see the world as big, that is, to see the various aspects of nature as integral parts of a single cosmic system, "a great and infinitely enticing phenomenon" in which human beings were capable of interacting not only with the things of the world they saw and touched but with the realities of the invisible world of the spirit. The thinkers of Mesoamerica did not envision a creation separate from its creator or a world lacking the order ultimately derived from a supernatural source. Theirs was a tantalizing vision of ultimate and complete unity, a vision that we will describe in some detail in the second section of this study, "Metaphoric Reflections of the Cosmic Order." For them, the worlds of nature and spirit, of man and the gods were one; all of reality—inner and outer, microcosmic and macrocosmic, natural and supernatural, earthly, subterranean, and celestial—formed one system, a system whose existence betrayed itself in the order that could be discerned behind the apparent chaos of the natural world. From that fertile first assumption, all the manifestations of Mesoamerican spirituality necessarily follow, and because there is no doubt that art reflects belief, the adoption of the mask as a central metaphor, as a basic repository of this world view, seems in retrospect almost inevitable.

Whenever and wherever it is used, the ritual mask symbolizes not only particular gods, demons, animal companions, or spiritual states but a particular relationship between matter and spirit, the natural and the supernatural, the visible and the invisible. The mask and its wearer exist in a series of relationships analogous to those larger relationships. On the one hand, the mask is a lifeless,

material thing animated by the wearer, exactly, of course, the relationship between human beings and the gods: human beings are created from lifeless matter by the animating force of the divine, and life exists only as long as it is supported by that divine force. Thus, the wearer of the ritual mask almost literally becomes the god; he is, for the ritual moment, the animating force within the otherwise lifeless mask. But at the same time, the mask expresses outwardly—visually—the inner, spiritual identity of the wearer, that is, the life-force within the microcosm, and is thus a truer reflection of the wearer's spiritual essence than his so-called real, or natural, face. Paradoxically, then, the mask simultaneously conceals and reveals the innermost spiritual force of life itself. Precisely this fundamental opposition of the two ways in which the mask symbolizes the essential relationship between matter and spirit informs Mesoamerican spiritual thought. The mask delineates the oppositional relationship between matter and spirit but in the very process of that delineation allows man simultaneously to be both, to unite his obviously material being with the spiritual reality he senses deep within him and through that union to express his profound identification with the cosmic structure of which his dual nature is the microcosm. All of this was contained in the metaphor of the mask which Mesoamerica placed at the center of its spiritual thought.

Recognizing a central metaphor through which the most basic beliefs of a culture are expressed is an invaluable aid to understanding the implications of those beliefs. As Thorkild Jacobsen points out in his study of Mesopotamian religion,

> in its choice of central metaphor a culture or cultural period necessarily reveals more clearly than anywhere else what it considers essential in the numinous experience and wants to recapture and transmit, the primary meaning on which it builds, which underlies and determines the total character of its response, the total character of its religion.

Furthermore, one must see the metaphoric nature of the mythic narrative or image since the "purpose of the metaphor is a leap from that [literal] level, and a religious metaphor is not truly understood until it is experienced as a means of suggesting the Numinous."[2] It must be seen, in Joseph Campbell's terms, as "transparent to transcendence," for works of mythic art are always "of the two worlds at once: temporal in the human appeal of their pictured denotations, while by connotation opening to eternity."[3] But the "leap" Jacobsen describes, especially in Mesoamerican studies with its dearth of written records, can only take place after a painstaking examination of the remaining evidence of spiritual thought, evidence contained in the archaeological record, the few written sources that survived the Conquest, Colo-

nial documentation of indigenous practices, and early and contemporary ethnographic studies.

Nor is it enough to compile that evidence in yet another exhaustive list of the "exotic" art and "bizarre" practices of ancient Mesoamerica; to be understood, as Jacobsen clearly indicates, it must be placed in the perspective of the unique way in which the various cultures that made up pre-Columbian Mesoamerican civilization experienced and recreated the numinous.[4] Examining that evidence with an intuitive sensitivity to the numinous and an intellectual openness to its spiritual implications clearly reveals "the primary meaning" of reality throughout the centuries-long development of Mesoamerican religion. From its shamanic beginnings to the height of its development in the intricacy, complexity, and subtlety of Aztec religion, and to its syncretic merging with Christianity and its present status as a folk religion, that primary meaning remains constant and is consistently expressed through the central metaphor of the mask. As Octavio Paz realized, art "serves to open doors to the other side of reality,"[5] and the mask through its dynamic linking of external reality to that other side of reality, the inner world of the numinous, consistently "opened the door" from the literal to the spiritual for the peoples of Mesoamerica.

Our study attempts to use the fragmentary evidence left us by the pre-Columbian peoples of Mesoamerica to understand what those now-lifeless works of art must have meant to the men and women who breathed the life of their unique spiritual vision into them so many centuries ago. Those people, human beings like ourselves, were dealing with the mystery that confronts us all, trying to render that mystery comprehensible in the only way it can be rendered—through metaphor. Now we must learn to see through their eyes to make those metaphors once more "transparent to transcendence," and through careful and sensitive study of the material unearthed by archaeology, ethnology, and history, we believe that we and others of our time can come to an understanding of the human legacy left us by those forebears. Gaining that understanding is an important enterprise, for we cannot fully appreciate the future without understanding all of the dimensions of our human past. As Tennyson put it in a poem celebrating, and using, another ancient mythological tradition, "all experience is an arch wherethrough gleams that untravelled world."[6] Or to change the metaphor, we can appreciate that gleam anew, from a different perspective, by donning the mask of Mesoamerican civilization, for a moment, and seeing through those eyes. Through them we will see a dimension of our own future which we could see in no other way.[7]

That ancient vision is expressed nowhere more clearly than in the metaphor of the mask. We will

focus our attention specifically on the spiritual implications of the mask since that spiritual dimension was, we believe, primary for the peoples of Mesoamerica. But the interests of the ancient peoples of Mesoamerica were varied, as are the interests of modern scholars who study Mesoamerica, and as we will indicate throughout our discussion, the mask served the ancient thinkers and seers as a multivalent symbol. In addition to, and as a result of, its use as a way of understanding the mystery of the underlying spiritual reality, the mask was used metaphorically to delineate the ultimately sacred nature of worldly power and in that connection to sanctify current rulers, to deify rulers of the past, and to define as sacred the seats of power they occupied. In fact, the divinely ordained ruler was himself a "mask," worn by the gods to make visible their spiritual essence in the world of nature. The gods spoke through that "mask," providing for man a social order grounded in the world of the spirit.

Our study begins with a detailed consideration of exemplary forms of mask use in pre-Columbian Mesoamerica: first, the masks of the rain gods throughout the development of the Mesoamerican mythological tradition, which demonstrates the use of the mask as a metaphor for the god, and second, the ritual use of masks, which illustrates the nature of the interaction of human beings with those gods. We will then consider the fundamental assumptions underlying that mask use in the following part, "Metaphoric Reflections of the Cosmic Order," a discussion that will make clear the variety of ways in which the force at the very heart of the cosmic structure, the unitary life-force, immanent and eternal, was understood to have created, shaped, and ordered all of perceived reality. It was the animating force underlying the natural world and thus analogous to the ritual performer who gives life to the ritual mask. Paradoxically, however, just as in the case of the ritual mask, the features of that vital force could be found in the natural world it created and maintained. Evidence of the shaping force of that animating spirit can be seen in the shamanic beginnings of Mesoamerican spiritual thought as well as in the varied facets of its complex development; in its basic conception of the underlying temporal order as manifested in the solar cycles and the parallel cycles of generation, death, and regeneration; in the manner in which its architecture replicated the "form" of the cosmic spiritual structure; in its fascination with the abstractions of that underlying order which it could use to construct elaborate directional and mathematical systems; and finally in its supremely metaphorical creation of a complex system of

"gods" majestically "unfolding" from the very life force itself. Ultimately, the composite that is Mesoamerican religion becomes coherent; the thread running through every manifestation of that religion is the symbolic relationship between the underlying life-force and the natural world it forms and sustains. And for all of this, of course, the mask is the metaphor. It is no wonder then that, as Alberto Ruz Lhuillier informs us, the mask is "one of the most widespread elements of Mesoamerican culture, . . . found in all chronological horizons, from the Olmec to the Aztec, and in all geographic areas."[8]

Those masks, as we shall see, are symbolic. Terence Grieder points out that "discourse at its highest levels, when it aims to unify experience into one composite multivalent symbol, is myth, ritual or monument."[9] That is, the central metaphor finds expression in specific artistic forms and activities. Our study will make clear the variety of ways the mask functioned metaphorically to provide a way of proceeding from the known to the unknown and to effect the "instantaneous fusion of two separated realms of experience into one illuminating, iconic, encapsulating image."[10] According to Paul Westheim, that metaphorical fusion, achieved by the symbolic mask in this case, simultaneously creates and destroys a "representation of reality in order to penetrate to the meaning: this is the goal and magic force of the symbol. Thanks to the symbol, the imagination becomes productive and capable of conceiving the inconceivable, the divine." The symbolic creations typical of pre-Columbian Mesoamerican art

give plastic expression to the divine concept insofar as it is humanly possible; therefore it arrives at pure, spiritualized form, an expression not of nature but of natural law, that natural law revealed by heaven, in which it sees the eternal and in which its theogonic system is anchored. Thus it attains stylization, an overcoming of materiality through its impregnation with form and spirit.[11]

In short, each creation and use of a mask in Mesoamerican art created anew the central metaphorical relationship between man and the numinous. In each case, the mask, a symbol of transformation and thus a means of overcoming materiality, metaphorically united the realms of matter and spirit and expressed the basic Mesoamerican belief that the natural world is but a covering or mask of the supernatural. Through the symbolic mask, the divine order of the spirit can break through the barrier dividing the two realms and transform the accidental to the essential, the ordinary to the extraordinary, the natural to the supernatural.

Part I

THE METAPHOR OF THE MASK
IN PRE-COLUMBIAN MESOAMERICA

1 The Mask as the God

God is day and night, winter and summer, war and peace, satiety and want. But he undergoes transformations, just as [a neutral base], when it is mixed with a fragrance, is named according to the particular savor [introduced].

—Heraclitus[1]

God, for Heraclitus, was the name for the spiritual force undergirding reality and disclosing itself in the wide variety of earthly states that were nothing more than its fleeting manifestations. The peoples of Mesoamerica held a similar view; for them, the vitality of the natural world had its source in the world of the spirit, the domain of the mysterious life-force. This force was the ground of being, the animating and ordering principle that explained every aspect of earthly life. Originating in the shamanistic heritage of Mesoamerican religion, this basic belief led to a consistent emphasis on inner/outer, spirit/matter dichotomies as a means of explaining the order apparent in nature, and for that reason, Mesoamerican spiritual thought betrays a fascination with "inner" things: the heart of man symbolized the life-force within him and was sacrificially offered to the gods, the "heart" of the earth reached through caves and through the temples that were artificial caves, and the "heart" of the heavens reached by ascending mountains or man-made pyramids. This fundamental inner/outer paradigm, then, placed "god," or the creative life-force, at the core of the cosmos and saw the natural world as its "mask."

But in the most profound sense, the mask reveals rather than disguises; through "reading" the symbolic features of the "mask" of nature, man could perceive the relationship of those features to the creative life-force at the heart of the cosmos. And nowhere was this metaphorical function of the mask more significant than in the construction of the multiplicity of symbolic supernatural entities, each carefully identified by a characteristic mask and costume, which the conquering Spaniards called gods. These were not, however, independent deities as the Spaniards thought but rather the symbolic "names" for momentary manifestations of that underlying spiritual force showing itself in terms of a particular life process, and they existed in the same way as the forces and states they represented. Rain, for example, exists eternally only in the sense that it is a recurring part of the process through which life continues; in another sense, however, rain does not exist when it is not raining. Thus, the "gods'" moments of existence would recur periodically as the eternal spiritual force regularly "unfolded" itself into the contingent world of nature according to the laws of the cycles that had their source in the mysterious order of the creative life-force. Metaphorically, then, the life-force functioned by putting on and taking off the various "masks" through which it worked in the world of nature. The "gods" were direct expressions of the spiritual force clothed in finery drawn from the world of nature and thus could be seen as mediating between the worlds of spirit and matter.

Edmund Leach has designed a structural model, which he does not apply to Mesoamerica, that explains such mediation:

Religious belief is everywhere tied in with the discrimination between living and dead. Logically, life *is simply the binary antithesis of* death; *the two concepts are the opposite sides of the same penny; we cannot have either without the other. But religion always tries to separate the two. To do this it creates a hypothetical "other world" which is the antithesis of "this world." In this world life and death are inseparable; in the other world they are separate. This*

world is inhabited by imperfect mortal men; the other world is inhabited by immortal non-men (gods). The category god is thus constructed as the binary antithesis of man. But this is inconvenient. A remote god in another world may be logically sensible, but it is emotionally unsatisfying. To be useful, gods must be near at hand, so religion sets about reconstructing a continuum between this world and the other world. But note how it is done. The gap between the two logically distinct categories, this world/other world, is filled in with tabooed ambiguity. The gap is bridged by supernatural beings of a highly ambiguous kind—incarnate deities, virgin mothers, supernatural monsters which are half man/half beast. These marginal, ambiguous creatures are specifically credited with the power of mediating between gods and men. They are the objects of the most intense taboos, more sacred than the gods themselves. In an objective sense, as distinct from theoretical theology, it is the Virgin Mary, human mother of God, who is the principal object of devotion in the Catholic church.[2]

Suggesting all of the elements contained so economically in the metaphor of the mask, this model describes the Mesoamerican method of mediation marvelously, especially since it focuses on the binary discrimination between life and death, an opposition at the heart of Mesoamerican spiritual thought. For Mesoamerica, the world of the spirit, mysterious and inaccessible, was synonymous with the life-force, while the world of nature was inextricably involved with death. Permanence was found in the other world; this world offered only change culminating in death, which permitted entrance to the other, an entrance characterized as deification in the case of great leaders and culture heroes. This fundamental distinction between life and death, spirit and matter, permanence and flux threads its way through Mesoamerican thought from the earliest times to the time of the Conquest: at the beginning of the development of Mesoamerican spirituality, that distinction was basic to shamanism with the shaman as the mediator between the worlds, and in the last phase of autonomous indigenous thought, that same distinction was at the heart of a religious and philosophical genre of Aztec poetry. One Aztec poet addressing this theme wrote,

Let us consider things as lent to us, O friends;
only in passing are we here on earth;
tomorrow or the day after,
as Your heart desires, Giver of Life,
we shall go, my friends, to His home.

The conclusion was inescapable that "beyond is the place where one lives."[3] Permanence was to be found in the world of the spirit; this world offered flux ending in death.

But as Leach points out, the gap between the two worlds must be bridged to explain the existence of life and spirit, even though transitory, in this one and to enable man to participate in a ritual relationship with the source of the spirit that animates him. These two points of contact are made in theological thought and in ritual; in both cases, the mode of contact between the two in Mesoamerica is aptly characterized in Leach's analysis, and in both cases, the mask was of central importance to this mediation. Theologically, Mesoamerican thought posited a creator god devoid of characteristics except that of creativity itself located in the "center" of that other, spiritual world. This god, Ometeotl among the Aztecs and Hunab Ku among the Maya, for example, was "a remote god in another world," rarely represented in figural form and playing little part in ritual.

The characteristic Mesoamerican metaphor of "unfolding" through which the creative force put on a variety of "masks" denoting the specific roles it played in the world resulted in the elaborate system of "gods" who could mediate between the creativity of an Ometeotl or Hunab Ku and the created world of man. That transformational unfolding allowed the original creative force to produce "gods" in sets of four, each associated with a particular relationship between nature and spirit, and each of these often further unfolded into a series of aspects. In the terms of Aztec religion, the variant of Mesoamerican religious thought about which we have the most specific information, those four gods, each an aspect of the quadripartite Tezcatlipoca, were the red Tezcatlipoca who was Xipe or Camaxtli-Mixcóatl, the black Tezcatlipoca commonly known simply as Tezcatlipoca, the blue Tezcatlipoca who was identified as Huitzilopochtli, and Quetzalcóatl who was probably a white Tezcatlipoca. Each was characterized by facial painting and costume that served as a "mask" covering and giving a specific identity to the underlying creative force of Ometeotl. Because Xipe and the Tezcatlipoca/Quetzalcóatl duality are far too complex to consider here, we will use Huitzilopochtli and his related manifestations to illustrate briefly the use of the "mask" of costume to define spiritual entities in the process of reconstructing "a continuum between this world and the other world."

Huitzilopochtli (literally, Hummingbird on the Left) is an especially good symbol of mediation since he had particularly strong ties to each of these two worlds. Both as one of the four Tezcatlipocas and as the one associated with the blue sky of the day and thus with the sun, which throughout Mesoamerican history was consistently seen as the source of and metaphor for life, he had a strong link to the creative power of Ometeotl. However, he was very much involved in earthly affairs. As the tutelary god of the Aztecs, he led them on the

mythical journey from their humble beginnings in Aztlán to the heights of imperial splendor at Tenochtitlán. Like the other gods, Huitzilopochtli was always depicted in the codices (pl. 1) and described in the chronicles in terms of his "mask," his characteristic facial painting, costume, and accoutrements. These identifying items were not selected arbitrarily; they symbolized his roles in Aztec myth, thought, and society by pointing clearly to his links with Ometeotl, on the one hand, and the Aztec state, on the other.

The most obvious features of his costume are those that identified him with his namesake the hummingbird, such as, in the codices, a device worn on his back or, according to Diego Durán,

> a rich headdress in the shape of a bird's beak. . . . The beak which supported the headdress of the god was of brilliant gold wrought in imitation of the [hummingbird]. . . . The feathers of the headdress came from green birds. [The idol] wore a green mantle and over this mantle, hanging from the neck, an apron or covering made of rich green feathers, adorned with gold.[4]

Durán relates these visual references to rebirth and the seasonal cycle paralleling the emphasis in the mythic account of Huitzilopochtli's birth and defense of his mother, Coatlicue, from the assault of Coyolxauhqui and her followers, which also suggested the cyclical nature of the sun's daily rebirth, its creating the "life" of day after the "death" of night. This emphasis on rebirth fit well with the Mexican belief, recorded by Bernardino de Sahagún, that the hummingbird, Huitzilopochtli's *nahualli*, the animal into which he could transform himself and who shared his identity, "died in the dry season, attached itself by its bill to the bark of a tree, where it hung until the beginning of the rainy season when it came to life once more."[5]

The concept of rebirth, of course, relates directly to the creativity of Ometeotl, and the association with Ometeotl represented in myth by Huitzilopochtli's unfolding from the creator god as one of the four Tezcatlipocas was suggested visually by facial painting; the ultimate unity of the four Tezcatlipocas can be seen in the fact that the face of each of them is striped with horizontal bands. In the case of Huitzilopochtli, the bands are alternately blue and yellow, representing the daytime sky and the light of the sun, thereby suggesting again the creativity of Ometeotl. According to the sixteenth-century *Relación de Texcoco*, this facial painting was represented in sculpture, none of which survives, by precious turquoise and gold mosaic, after the fashion, no doubt, of the extant mosaic masks. This sky/sun association was also suggested by his blue sandals and gold bracelets as well as by his being "seated in a blue bower or adorned with blue cotinga-feather earplugs."[6]

But these links to Ometeotl and the creative

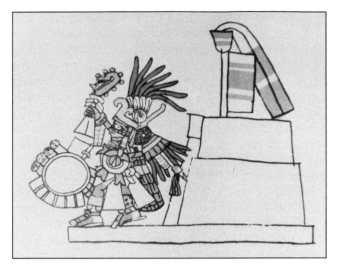

Pl. 1. Huitzilopochtli, from the Codex Borbonicus (reproduced with the permission of Siglo Veintiuno Editores, S.A., México).

power of the life-force relate only to one side of the dichotomy bridged by Huitzilopochtli. His blue staff was central to the imagery delineating his symbolic function as war god and leader of the Aztec state, for that staff represented the fire serpent, *xiuhcóatl*, with which he "pierced Coyolxauhqui, and then quickly struck off her head" in the myth of his birth. "His shield [named] *teueuelli*, and his darts, and his dart thrower, all blue, named *xiuatlatl*,"[7] derived from the same myth and suggested again his association with war. His shield was adorned with a quincunx composed of five tufts of eagle feathers. From it "hung yellow feathers as a sort of border; from the top of the shield, a golden banner. Extending from the handle were four arrows. These were the insignia sent from heaven to the Mexicas, and it was through these symbols that these valorous people won great victories in their ancient wars."[8] Thus the items he carried suggested his function as deified leader of the Aztec state, his "preeminently warlike associations [that] were conveyed by such metaphors as 'the eagle' or 'the bird of darts.'"

And these associations, in turn, are related to his identity as the hummingbird through which he is linked to various other birds, "the blue Heron bird, the lucid Macaw, and the precious Heron"[9] but primarily the high-flying, powerful eagle, the bird most closely related to the sun and to warriors, Huitzilopochtli's dual role in the myth of his birth. And his identification as an eagle also suggested the other myth in which he figured prominently, the myth of the birth of the Aztec state. That myth recorded his telling the wandering Aztecs,

> In truth I will lead thee to the place to which thou art to go; I will appear in the guise of a white eagle . . . go then, watching me only, and when I arrive there, I will alight . . . so presently make my temple, my home, my bed of

grass, there where I was lifted up to fly, and there the people shall make their home.[10]

The myth was of great importance in symbolically characterizing the Aztec state. In following the eagle, the Aztecs were following the sun, which gave their history the aura of a divine mission; they were not only the people who followed the eagle but the People of the Sun. In their wandering movement from north to south, they were not invading new territory to which they had no claim but returning to Huitzilopochtli's home, where he "was lifted up to fly." He was, after all, Hummingbird on the Left, and Left meant South to a people who determined directions by facing in the direction of the path of the sun. Thus, they were returning to the birthplace of Huitzilopochtli in something akin both to a seasonal (and thus cyclical) migration and a return to their ancestral lands. In following the sun, they were following the eagle, and the eagle symbolized the warrior aspect of Huitzilopochtli shown in his fearlessly routing his sister and her followers in their assault on Coatlicue, their mother. As the myth leads one to suspect, there is some evidence that Huitzilopochtli was not only linked to the eagle and the sun but was intimately connected with an early or legendary leader of the Aztecs, a leader deified at his death in the time-honored Mesoamerican fashion. Such a leader might well have been associated with Huitzilopochtli since, as Sahagún suggests, the souls of dead warriors are "metamorphosed into various kinds of birds of rich plumage and brilliant color which go about drawing the sweet from the flowers of the sky, as do the hummingbirds upon earth."[11] For all these reasons, expressed in myth but functioning to support the practices of the Aztec state, Huitzilopochtli was "the divine embodiment of the ideal Mexica warrior-leader: young, valiant, all-triumphant,"[12] an "embodiment" symbolized by his "mask" of facial painting, costume, and accoutrements.

Thus, for Aztec Mexico, Huitzilopochtli simultaneously symbolized the creative power of the world of the spirit and the imperial power of the Aztec state. For that reason, he was seen as a manifestation of Ometeotl, as "the greatest divinity of all, . . . the only one called Lord of Created Things and The Almighty."[13] That exalted status, celebrated by the details of his costume signifying the link between the creative life-force and the Aztec state, was also revealed by the sacrificial ritual performed periodically in the temple of Huitzilopochtli atop the pyramid of the Templo Mayor in the Aztec capital. In mythic terms, such a sacrifice of the hearts and blood of men was necessary to provide the nourishment necessary to ensure the daily rebirth of the sun. The mythic equation suggested that the sun's creating life for man must be reciprocated by man's providing life for the sun. "Human sacrifice was an alchemy by which life

was made out of death,"[14] and as the People of the Sun, the Aztecs had a divinely imposed responsibility to perform that alchemy. As modern scholars have pointed out, however, that duty coincided nicely with the militaristic nature of the Aztec state; warfare could be seen as providing captives for the divinely required sacrifices while it also extended the dominions under Aztec sway and reinforced Aztec power. Human sacrifice took on its all-important role in Aztec society precisely because it met both mythic and political needs. That Huitzilopochtli was the primary focus of this sacrificial ritual demonstrates his importance to the Aztecs in the symbolic mediation between the worlds of spirit and matter; he was for them a particular way of understanding natural facts in spiritual terms and is thus a good example for us of the specific way in which Mesoamerican spiritual thought bridged the gap between spirit and nature.

Huitzilopochtli demonstrates, just as Leach suggests, that "the gap between the two logically distinct categories, this world/other world," is bridged by beings who have, so to speak, one foot in each of the worlds. In their Mesoamerican incarnations they are composite beings who, on examination, generally turn out to be human beings wearing masks and costumes comprised of the features of a variety of natural beings combined in unnatural, that is, "monstrous," ways. Thus are created the "supernatural monsters" to which Leach refers. This disguise or "mask" is the visual representation of the logical construct by which the particular continuum between the two worlds, which is what each god becomes, is reconstructed. Significantly, this "reconstruction" takes elements of living beings from the created world of nature and uses those elements in a mythic process of creation that imitates the original work of the creator god. These elements are combined to form the mask, costume, and ornamentation of the god, then placed on a human being who thus represents the life-force underlying and expressing itself in the set of specific items that form its identity. The god is always identified by a mask or characteristic facial painting, a specific costume, and the objects he carries. The visual image created by combining these things is essentially a myth.

Just as what is commonly called a myth—a narrative recounting the symbolic actions of a god—is made up of specific items—actions and events—arranged in a particular order and meant to be understood symbolically as an expression of the identity and function of the god, so the Mesoamerican visual statement uses specific items—features, masks, attire—combined in a plastic rather than narrative fashion to similarly specify that identity and function. Seen in this light, those particular items function in the same way as the natural items appearing in mythic narratives. As Claude Lévi-Strauss says of the use of characteristics of

particular birds in the myths of the Iban of South Borneo,

It is obvious that the same characteristics could have been given a different meaning and that different characteristics of the same birds could have been chosen instead. . . . Arbitrary as it seems when only its individual terms are considered, the system becomes coherent when it is seen as a whole set. . . . When one takes account of the wealth and diversity of the raw material, only a few of the innumerable possible elements of which are made use of in the system, there can be no doubt that a considerable number of other systems of the same type would have been equally coherent and that no one of them is predestined to be chosen by all societies and all civilizations. The terms never have any intrinsic significance. Their meaning is one of "position"—a function of the history and cultural context on the one hand and of the structural system in which they are called upon to appear on the other.[15]

By "reading" the visual myth that each god's appearance represents historically and structurally, we can understand the nature and function both of that particular god and of the creative process underlying the creation of all of the gods making up the Mesoamerican mythic system, for it is surely true, as Fray Durán commented, that "each of these ornaments had its significance and connection with pagan beliefs."[16]

Thus, Huitzilopochtli, as represented in Aztec art, must be seen as a visual myth designed to be "read" so that his image might communicate specific information about the world of the spirit to those who understood it and impress with its grandeur those who did not understand the more sophisticated levels of metaphoric meaning. It was designed to mediate for those "readers" between their world and the otherwise inaccessible world of the spirit. The figure of Huitzilopochtli is, in that sense, a typical product of the dialectical process by which Mesoamerican man created the continuum whereby he could transcend mundane reality and commune with the gods.

But it is important to emphasize that the set of symbols used to designate a particular god was not fixed; a good deal of variation was possible. Huitzilopochtli could "wear" his hummingbird nahualli as a headdress, as a back device, or not at all. His shield could be decorated with a quincunx of feathers or remain plain.[17] These are but two of the many possible variations of the basic symbols suggesting the fluidity of the concept of the god. Rather than being a fixed, static entity in the minds of those who manipulated the symbol system, each god was clearly a set of traits, each to be "used" as it was needed. This use of various traits

is illustrated by the characteristic manipulation of a deity's image during the feast of Izcalli. Twice

they took out of the temple an image of the deity to whom it was consecrated: once adorned with a turquoise mask and with quetzal feathers, and once with a mask of red coral and black obsidian, and with macaw feathers. . . . Seler explains that this double adornment "symbolized the sprouting and maturing of the maize."[18]

Furthermore, the gods were also fluid in the sense that their identities often merged, overlapped, and folded into one another. As we saw above, the facial painting of each of the aspects of the quadripartite Tezcatlipoca indicated both their unity, in that they shared the same design, and their individual identities, in that each wore the design in colors appropriate to his particular function. While linked in this way to the other Tezcatlipocas, Huitzilopochtli was also linked to a series of gods who seemed to unfold from him and who shared his particular symbols. Paynal, for example, wore "the hummingbird disguise"[19] and represented Huitzilopochtli in ritual. Tlacahuepan and Teicauhtzin, among others, "seem merely to express aspects of his supernatural personality."[20] And as Alfonso Caso points out, Huitzilopochtli was also "an incarnation of the sun" and in that sense an aspect of Tonatiuh, the sun god, but his important symbolic use of the fire serpent, xiuhcóatl, suggested a relationship with Xiuhtecuhtli, god of fire.[21]

In addition to these mythic connections with other gods, there is the connection with Tlaloc, the old god of rain and lightning, suggested by their placement side by side in the twin temples atop the Templo Mayor in Tenochtitlán, the symbolic center of the universe "from which the heavenly or upper plane and the plane of the Underworld begin and the four directions of the universe originate."[22] This placement suggests the dialectical method by which the Aztecs symbolically dealt with natural and spiritual forces. In one sense, Tlaloc was an agricultural force while Huitzilopochtli was concerned with the human forces of war. However, both rain (Tlaloc) and sun (Huitzilopochtli) were necessary for the growth of the crops and the maintenance of life. Similarly, Tlaloc as the old god who had existed from time immemorial in the Valley of Mexico could be seen as opposed to Huitzilopochtli, the young god who came to the Valley of Mexico with the Aztecs. But their placement together would suggest that they both served as patron gods of the Aztecs, comprising a unity transcending the opposed realities for which they stood individually. That larger unity, according to Pasztory, defined the Aztec self-image:

The migration manuscripts emphasize that the Aztecs were outsiders of humble origin who

*prevailed because of their god, their persever-
ance, and their military powers. . . . These
manuscripts answer the question "who are
we," with "we are the descendants of nomads
led by Huitzilopochtli." The sculptures and
architecture in Teotihuacán and Toltec style
represent the Aztecs as upholders of ancient
traditions. They answer the question "who are
we" by saying "we are the legitimate succes-
sors of the Toltecs and their god Tlaloc."*[23]

Significantly, a similar set of relationships of op-
position and concurrence could be worked out
with all of the other major gods of the Aztecs.

From all of this we must conclude that the
Mesoamerican system of "gods" is to be seen as a
totality. Each of the individual gods is, in essence,
a set of symbols, and these individual symbol sets
merge to form what is typically, if misleadingly, re-
ferred to as a "pantheon." The term is misleading
because it suggests a group of fixed individual dei-
ties, such as those of the Greeks or Romans from
whom the concept is derived, each with an exis-
tence independent of the pantheon. The nature of
the Aztec gods specifically and those of Mesoamer-
ica generally, however, is different. They exist only
as part of the relatively fluid set of relationships of
spiritual "facts" which results from the Mesoamer-
ican process of creation, which we have character-
ized as "unfolding," through which the life-force
radiates outward from its source in the world of
the spirit. The symbols that make up each of the
"gods" is, in that very specific sense, a mask that
specifies the particular aspect of the life-force, the
particular "line of radiation," being addressed.

Although he does not apply his insight to Meso-
america, Lévi-Strauss suggests the essence of the
process involved in the construction and elabora-
tion of this system of mediating entities through-
out the long history of Mesoamerican spiritual
thought. Speaking of the natural source of the im-
ages man combines to make the supernatural mean-
ingful and accessible, he says, "even when raised
to that human level which alone can make them
intelligible, man's relations with his natural envi-
ronment remain objects of thought: man never per-
ceives them passively; having reduced them to
concepts, he compounds them in order to arrive
at a system." In other words, man analyzes his
environment, isolates its component parts, and
rearranges them in logical, but nonnatural, com-
binations. Thus, it is a mistake "to think that nat-
ural phenomena are *what* myths seek to explain
when they are rather the *medium through which*
myths try to explain facts which are themselves
not of a natural but logical order."[24] If myth is
defined to include "images, rites, ceremonies, and
symbols" that demonstrate "the inner meaning
of the universe and of human life,"[25] the "su-
pernatural monsters" of Mesoamerican spiritual
thought reveal themselves as logically constructed

compounds of natural facts; each masked "god" is
actually a "system" designed to explain a "fact" of
the world of spirit.

Taken together, these masked and costumed
figures comprise a complete system of mediation,
logically constructed and ordered, that renders the
essential reality of the world of the spirit com-
prehensible in the terms of the contingent real-
ity man experiences in the world of nature. An-
other insight of Lévi-Strauss clarifies the process of
construction.

*The dialectic of superstructure, like that of
language, consists in setting up constitutive
units (which, for this purpose, have to be de-
fined unequivocally, that is, by contrasting
them in pairs) so as to be able by means of
them to elaborate a system which plays the
part of a synthesizing operator between ideas
and facts, thereby turning the latter into signs.
The mind thus passes from empirical diversity
to conceptual simplicity and then from con-
ceptual simplicity to meaningful synthesis.*[26]

Each of the mask and costume elements must be
seen as a constitutive unit in this sense, becoming
a sign of something else in the simplification of na-
ture's diversity by the order-making mind of man
through the construction of a new, nonnatural or-
der revealing the supernatural order at the heart of
the world of nature. Thus, while each of the ele-
ments comprising the mask is a constitutive unit,
one can also see each masked figure as a unit in the
whole of the system that mediates between nature
and spirit.

As our analysis of Huitzilopochtli makes clear,
an understanding of the nature of any of the myriad
Mesoamerican "gods" must come from a reading of
the visual myth each presents. Each "constitutive
unit" of the myth must be related to its sources in
Mesoamerican spiritual thought, and the resulting
combination of spiritual ideas will then "define"
the god in question. Such a reading of the visual
myth of Huitzilopochtli is relatively easy because
the items that make up the "mask" he wears were
provided by the Aztecs about whose thought we
are relatively well informed. While the interpretive
process becomes somewhat more difficult when
we turn to those "gods" whose existence can be
traced at least to the Preclassic, the method re-
mains the same because the process of the "gods'"
creation was demonstrably the same. To under-
stand any of the Mesoamerican gods, we must read
the constitutive units of which they are comprised;
in this sense, the gods are the masks, and the
masks are the gods.

THE MASK AS METAPHOR
The Olmec Were-Jaguar

From the standpoint of Aztec civilization, Huit-
zilopochtli is of major importance, but from a

broader perspective encompassing all of Mesoamerica and adding the temporal dimension that allows a view ranging back as far as archaeology permits us to see, Huitzilopochtli pales into insignificance; he was only a god of the Aztecs. But the figure with whom he shared the Templo Mayor in Tenochtitlán suffers no such fate. Tlaloc, the god of rain, associated always with storms and lightning, has his roots deep in the Mesoamerican past. To understand the complex of symbols comprising his characteristic mask is to understand something fundamental about Mesoamerican spiritual thought, because that mask has its readily identifiable counterpart in every civilization that played a role in Mesoamerican culture and because, like Tlaloc, the figure identified by the rain god mask is in every case involved not only with the provision of the life-sustaining rain but also with divinely ordained rulership and several other equally fundamental themes of Mesoamerican spirituality. Thus, the mask of the rain god provides a particularly good example of the way Mesoamerica as a whole constructed metaphorical masks to delineate its gods.

Tlaloc, the Aztec incarnation of the complex of symbols associated with rain, is the rain god we know most about because, as with Huitzilopochtli, we have the evidence of the codices and the chronicles to supplement and clarify the information we can glean from the remains of art and architecture. The earlier civilizations of the Classic and Preclassic periods left us no such explanatory material. But although there has been some dispute about whether it is possible to use the information regarding Aztec culture to explain symbolic visual images from earlier cultures,[27] our analysis of rain god imagery that follows suggests that this particular complex of images can be traced from its origins in the relatively dim past to the time of the Conquest. It is undeniable[28] that certain symbolic visual traits occur in combinations consistently connected with rain. At times, it is possible to "read" the meanings of particular symbols even from very early times, and when it is possible, these meanings coincide remarkably well with those suggested by working backward from later times. Mesoamerica, after all, was one culture, however complex, with one mythological tradition. The complexity of cultural development over a large geographic area and a time span of three thousand years will necessarily cause difficulties for our full comprehension of its fundamental unifying themes, but the unity is always tantalizingly present; we must attempt to find it amid the artifacts archaeology provides for us.

What is easiest to demonstrate about the continuity of Mesoamerican spirituality from the earliest times is that the characteristic Mesoamerican way of constructing "gods," or masks, by combining a variety of natural items, that is, constitu-

tive units, in unnatural ways begins very early and that certain combinations recur from those early times until the Conquest. The mask associated with the complex process of the provision of water by the gods, a process involving caves, underground springs, and cenotes as well as rain with its accompanying thunder and lightning is a case in point; the remarkable similarities in imagery in the features of the masks of the rain gods, a term we will use to denote this whole complex of associated meanings, created by each of the cultures of the Classic period in Mesoamerica certainly suggest the existence of a shared prototype in earlier, Preclassic times.[29]

That prototype can be found in the first high civilization in Mesoamerica—that of the Olmecs. This argument was made clearly and forcefully as early as 1946 by Miguel Covarrubias, who constructed a chart (pl. 2) showing "the 'Olmec' influence in the evolution of the jaguar mask into the various rain gods—the Maya Chaac, the Tajín of Veracruz, the Tlaloc of the Mexican Plateau, and the Cosijo of Oaxaca."[30] But the tremendous number of archaeological discoveries and the equally large body of scholarly thought devoted to the Mesoamerican material since Covarrubias advanced this idea have revealed levels of complexity neither he nor anyone else imagined at that time. It is therefore doubly remarkable and a tribute to his deep intuitive understanding of the spiritual art of Mesoamerica that the Covarrubias hypothesis has held up quite well. That hypothesis, however, must now be understood in the light of more recent developments, which necessitates an explanation of recent thought regarding Olmec spirituality in general which, however, has clear implications concerning the fundamental nature of Mesoamerican spiritual art of all periods. That done, we can return more meaningfully to the features of the Olmec mask associated with rain.

Covarrubias, in addition to seeing the jaguar as involved with rain, believed that the jaguar "dominated" the art of the Olmecs and that "this jaguar fixation must have had a religious motivation."[31] As his chart suggests, however, it is not the jaguar himself who dominates Olmec art but rather the composite being who has come to be known as the were-jaguar, a creature combining human and jaguar traits. As Ignacio Bernal notes, "when one attempts to classify human Olmec figures, without realizing it one passes to jaguar figures. Human countenances gradually acquire feline features. Then they become half and half, and finally they turn into jaguars. . . . What is important is the intimate connection between the man and the animal."[32]

The contentions of both Covarrubias and Bernal must be further qualified by acknowledging the hypothesis of Coe and Joralemon regarding the Olmec gods, a hypothesis based on a recently dis-

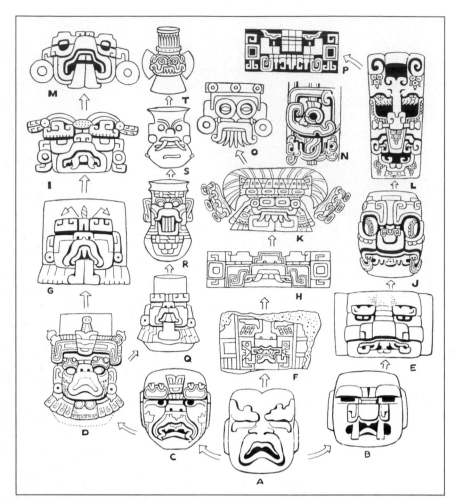

Pl. 2. Covarrubias' graphic representation of the evolution of the mask of the Rain God from an Olmec source, which we designate Rain God C, through the Oaxacan Cocijo, in the left-hand column, the Tlaloc of central Mexico in the next column, followed by the Gulf coast rain gods and finally, those of the Maya in the right-hand column.

covered Olmec sculpture, the Lord of Las Limas (pl. 3). As Coe noted, the knees and shoulders of the seated figure are incised with "line drawings," in typical Olmec style, of masked faces. Joralemon later discovered another mask incised on the figure's face which, with the mask "worn" by the infant, brought the total of distinctly different masked faces to six. After a great deal of analysis of the corpus of Olmec art by Joralemon, he and Coe have argued "that the Las Limas figure depicts the Olmec prototypes of gods worshiped in Post-classic Mexico" and that "Olmec religion was principally based on the worship of the six gods whose images are carved on the Las Limas Figure." Furthermore, Joralemon concluded that

> the primary concern of Olmec religious art is the representation of creatures that are biologically impossible. Such mythological beings exist in the mind of man, not in the world of nature. Natural creatures were used as sources of characteristics that could be disassociated from their biological contexts and recombined into non-natural, composite forms. A survey of iconographic compositions indicates that Olmec religious symbolism is derived from a wide variety of animal species.[33]

Thus, Coe and Joralemon would probably not agree with Covarrubias's contention that the jaguar dominated Olmec religious art, but they continue to believe, as Covarrubias did, that there is a demonstrable continuity linking Olmec and Aztec gods.

Predictably, their theory caused tremendous controversy. Some objected to the argument from the analogy with Aztec and even more recent spiritual traditions; Beatriz de la Fuente, for example, objected to Coe's identifications on the grounds that they were

> based on a comparison of the Aztec with the Olmec, the cultures having between them a span of some 2000 to 2500 years. They seek explanations for ancient forms in activities or beliefs of present-day peoples, whose societies have, furthermore, suffered the inevitable effects that result from the clash of native and western cultures.[34]

Another form of objection concerned the equation of certain traits with certain fixed and specifically defined gods. Contending that Joralemon had artificially isolated and emphasized certain visual features at the expense of others and neglected to pay sufficient attention to the complexity and fluidity of the combinations of features, Anatole Po-

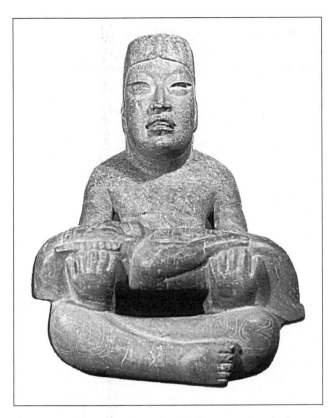

Pl. 3. The "Lord of Las Limas," Olmec sculpture from Las Limas, Veracruz; dimly discernible in this photograph are the masked faces incised on the figure's face, shoulders, and knees; the face of the child held by the figure is an excellent example of our Rain God CJ (Museo de Antropología de Xalapa).

horilenko maintained that "there are no Olmec compositions which consistently depict recurring combinations of the same referential signs. . . . For instance, a four-pointed flaming eyebrow is not exclusively and consistently used with a jaguar mouth showing slit fangs and an egg-tooth."[35] Thus, both de la Fuente and Pohorilenko suggest, in rather different ways, that the Coe-Joralemon hypothesis is too rigid, too specific in its identification of the gods of the Olmecs.

Accepting these objections, however, neither invalidates nor trivializes the fundamental insight at the heart of the argument advanced by Coe and Joralemon: Olmec religious art, rather than betraying a fixation on the jaguar, presents a variety of composite beings, each delineated in a characteristic mask and each a symbolic construct derived from a variety of natural creatures. Furthermore, these varied figures must be seen as the component parts of an all-inclusive system that mediated between man and the powerful forces originating in the world of the spirit. While it is possible to feel that the identification of specific Olmec figures with specific Aztec gods is unwarranted, it seems unarguable that, as Coe and Joralemon have allowed us to see, the Olmecs created a mediating system of gods to establish a relationship between

man and the world of the spirit in precisely the same manner as did the Aztecs, their distant Mesoamerican heirs. There is, then, a demonstrable continuity linking Olmec and Aztec spiritual thought. In fact, the Olmecs are the likely originators of this characteristic Mesoamerican practice of creating a spiritual system composed of a large number of interrelated "gods," each of which is represented by a mask and costume made up of symbolic features. The seemingly endless parade of Mesoamerican gods tricked out in their fantastic regalia probably begins at La Venta.

These gods can be seen in Olmec religious art, but when one looks closely at the way they are depicted, the identification of particular clusters of features as specific, recurring deities does not seem as simple as the Coe-Joralemon hypothesis suggests. Two sorts of complexity must be reckoned with. First, three distinct categories of figures exist in Olmec art despite the fact that some figures straddle the boundary between two categories. Only one of these categories is made up of figures that stand as metaphors for the supernatural, that is, the Olmec "gods." Second, even within that category, there are, as Pohorilenko points out, a very large number of combinations of the basic repertory of symbolic features.

The first of these levels of complexity is easiest to deal with. Although all Olmec art is essentially religious,[36] that religiosity expresses itself in three different ways, sharing only a fascination with natural forms, especially the form of the human body. The first category glories in the presentation of the human form and countenance in all its ideal beauty. Perhaps the best example of this is the sculpture from San Antonio Plaza, Veracruz, which is often called The Wrestler. Its sensitively realized dynamic pose and clearly but delicately delineated physical features reveal the Olmec artist's desire and ability to idealize the human body as a purely natural form of beauty almost spiritual in its compelling vitality. And that elusive spirituality is also hinted at by the slightly downturned mouth suggestive, of course, of the symbolic werejaguar. The well-known colossal heads and the characteristic jade and jadeite masks, both realistic enough to suggest portraits,[37] often evoke the ideal beauty of the human countenance and similarly hint at man's basically spiritual nature.

Opposed to these realistic depictions of human features, a second category of Olmec art depicts fantastic composite beings whose faces are masks comprised of natural features combined in strikingly nonnatural ways, denizens of the world of the spirit rather than the world of nature. Though the human body provides the basic form for the sculptures, they are clearly not human. San Lorenzo Monument 52 (pl. 4), which is analyzed in detail below, serves as an excellent example of the type. Everything about it—its combination of fa-

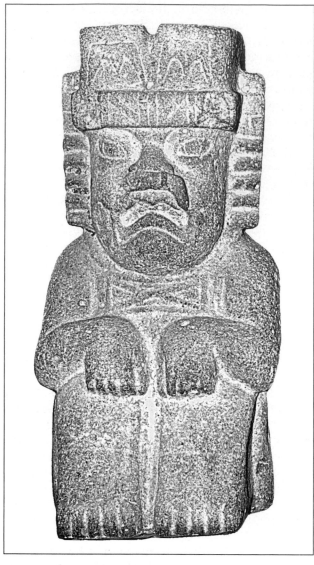

Pl. 4. Monument 52, San Lorenzo, our "Rain God CJ" (Museo Nacional de Antropología, México).

cial features, its human body with nonhuman hands and feet, and its stylized form and unnatural proportions—proclaims it a mythological creature rather than a natural one. As anyone even slightly familiar with Olmec art is aware, such composite beings, once thought to be primarily were-jaguars, are so frequently depicted as to be practically characteristic of that art. These composite beings are, collectively, the Olmec metaphor for the domain of the spirit, a domain that could be conceptualized only by departing from the order inherent in the natural world. No doubt the Olmecs, like their Mesoamerican heirs, saw a creator god, their prototype of an Ometeotl, in this spiritual realm, a creator who was not depicted, a force so essentially spiritual that it could not be encompassed and ordered by human thought. The mythological creatures who populate Olmec art are the "unfoldings" of this spiritual essence.[38]

Significantly, there is a third category of Olmec artistic representation that mediates between the first two diametrically opposed categories. It depicts realistic human beings, as does the first type of Olmec art, but they are masked and costumed to resemble the mythological creatures of the second type. Mural I of Oxtotitlán, Guerrero (pl. 5), provides the clearest representation of such a figure. The seated man is depicted x-ray fashion, as the Maya were to do later,[39] disclosing the realistically rendered human being within the fantastic birdlike disguise. These are ritual figures, and we will explore their symbolic dimensions in the later discussion of the mask in ritual.

These three categories of Olmec figural representation—human, mythological, and ritual—reveal an Olmec conception of the universe basically the same as, and thus the logical prototype of those of, the later cultures of Mesoamerica delineated in the second part of this study. For the Olmecs, the world of nature, symbolized in art by the realistically rendered human figure, was imagined as the binary opposite of the world of the spirit, symbolized by the composite beings. The masked ritual figures show man's way of mediating between those two opposed realms. Though her analysis of Olmec art is quite different from ours, de la Fuente grasps the essential nature of that art: "The human figure, the gravitational center of almost all the forms of Olmec art, appears in this art with different metaphysical definitions which, at their extreme, seem to repeat ... the entire order of the universe."[40] Thus, this symbolic art allowed the Olmecs to represent their conception of the cosmic

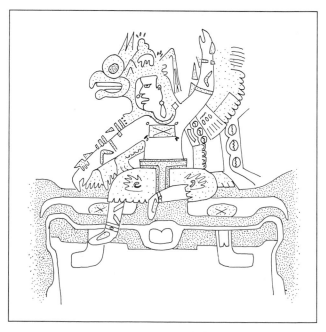

Pl. 5. Mural I, Oxtotitlán, Guerrero displaying the x-ray convention which allows the simultaneous depiction of the features of the wearer of the ritual mask and of the features of the mask itself (drawing by David Grove, reproduced by permission).

structure in visual form by symbolically reordering the materials of nature.

Distinguishing carefully between the three different categories of the art through which the Olmecs represented the tripartite cosmic structure allows our discussion of the gods to focus on those works of art representing the fantastic composite beings who symbolized the forces of the world of the spirit. But there is another form of complexity that must also be acknowledged: as Pohorilenko pointed out, the features of these composite beings are not characterized by a limited number of combinations of the same symbolic features. On the contrary, though the total number of features is not great, they are combined in what often seems to the would-be iconographer an endless series of combinations. In view of the limited state of our present knowledge of Olmec spiritual thought—Jacques Soustelle says, "We are overawed by the immense depths of our ignorance"[41]—we believe it would be impossible to determine which of those combinations, if any, the Olmec priesthood identified as named deities. When we think of how little we know of Olmec thought in comparison to the relative wealth of information we have about Aztec spirituality and then realize that even with the knowledge of Aztec spiritual thought provided by the codices and chronicles, there is still a great deal of uncertainty involved in the identification of many Aztec gods represented in art,[42] our difficulties become clear. Fortunately, what we do know of Aztec art can help us to understand their distant forebears.

Our brief analysis of Huitzilopochtli revealed that not all of the symbols associated with him by the Aztec priesthood need be present in any particular depiction of him and, furthermore, that it was possible within the Aztec symbol system to create figures combining the features usually associated with particular gods. We term these combinations "secondary masks" and will discuss them in the conclusion to our consideration of the mask as metaphor for the gods. The Aztec system was an extremely complex one built up—like the calendrical systems of Mesoamerica—through the permutation of a limited set of symbolic features through the range of their possible combinations. If the Olmec system was similarly constructed, and the evidence suggests overwhelmingly that it was, it seems unlikely that, lacking codices and chronicles or other explanatory material, we will ever be able to reconstruct the system as it would have been understood by the Olmec priest.

This is not to say, however, that we cannot "read" particular symbolic features and understand the general ritual or mythological function they probably served. This then enables us to understand the more complex meaning that a cluster of individual symbolic features could carry, but the more complex the configuration, the more general

our understanding is likely to be. Thus, a number of such clusters can be shown to refer generally to rain and lightning, vegetation and fertility, and divinely ordained leadership. It is no doubt true that each of the configurations conveyed a particular shade of meaning to the Olmec priest, and it is certainly possible that each of them was a particular "god." It is equally possible, however, that many of them were aspects of one basic spiritual essence, particular manifestations of a single "god." And it is also possible that none of them was thought of as a god at all but rather as a collection of spiritual "facts" joined together temporarily to make a mythological or ritual statement. It is therefore difficult to talk about the gods of the Olmec but not nearly so difficult to discuss the ways the Olmecs symbolized the forces they identified with the world of the spirit. Through an analysis of the individual features that occur on the symbolic masks, we can begin to understand at least this much about Olmec spiritual thought.

Thus, to return finally to our discussion of the mask representing the rain god, we can concur with Covarrubias, Bernal, and Coe and Joralemon that a mask combining particular features drawn from nature was associated by the Olmecs with the provision of the life-maintaining rain from the world of the spirit. We, and most other scholars who have studied Olmec art, would further agree that the particular "god" associated with rain is a were-jaguar,[43] that is, a mask dominated by the characteristically feline mouth with downturned corners beneath a pug nose. But this general agreement comes to an end when specific masks are discussed. The particular were-jaguar depicted at the bottom of Covarrubias's chart as the archetypical rain god, a stone mask or face panel now in the American Museum of Natural History in New York (pl. 6), differs in several symbolic features from the were-jaguar identified as the Rain God by Coe and Joralemon, a composite figure typified by the were-jaguar child held by the Las Limas figure (pl. 3) and seen clearly on San Lorenzo Monument 52 (pl. 4). Those differences account for Joralemon's seeing the Covarrubias mask (which we will call Rain God C) as representing his God I,[44] "the Olmec Dragon," rather than the Rain God he and Coe have designated as God IV (which we will call Rain God CJ).

These differences should not, however, obscure some fundamental similarities. Both Rain God C and Rain God CJ have generally rectangular faces with cleft heads, pug noses, heavy upper lips, and downturned mouths showing toothless gums. They differ in their ears or ear coverings—C's are long, narrow, and plain while CJ's are long, narrow, and wavy; in their eyebrows—C's are the so-called flame eyebrows while CJ's are nonexistent, replaced by a headband with markings which is part of a headdress; and in their eyes—C's are trough

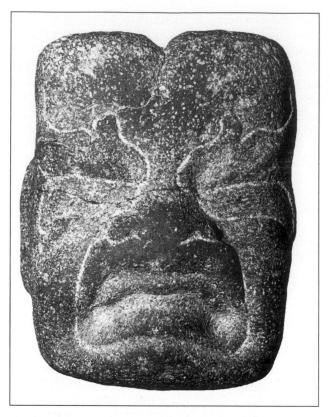

Pl. 6. Olmec stone mask, probably architectural, our "Rain God C" (American Museum of Natural History, New York).

shaped and turned downward at the sides while CJ's are almond shaped and turned upward; CJ wears the typical Olmec St. Andrew's cross as a pectoral while C, being only a mask, of course has no pectoral. Perhaps significantly, the tops of the heads of the two are similar as are the bottoms, that is, the mouth areas. The differences occur in the middle zone of the faces. And it seems even more significant that, to a casual glance, the similarities are far more apparent than the differences; the two faces seem clearly to be variations on a single theme, perhaps the variations that would identify the aspects of a quadripartite god. We believe that an analysis of their symbolic features will demonstrate that a casual glance does in fact reveal an essential truth and that the symbolic features all refer to fertility connected with rain.

Beginning at the top, the first symbol is the cleft head, which Coe and Joralemon evidently do not see as diagnostic since each of their six gods is sometimes depicted with a cleft head and sometimes without. The presence or absence of the cleft, in the light of our earlier analysis of the four Tezcatlipocas whose faces are fundamentally similar with minor variations to indicate their distinct identities, is a tantalizing suggestion that these symbolic faces might also be manifestations of a quadripartite god. Whether this is true or not, however, when one examines the occurrence of the cleft head in Olmec art,[45] several significant facts emerge. First, cleft heads seem to occur only on masks that contain other clearly symbolic features and not on the relatively naturalistic masks and sculpture. This, incidentally, is not true of the symbolic were-jaguar mouth. Second, the cleft appears in two opposed forms, either empty or with vegetation appearing to emerge or grow from it. Third, the empty cleft seems to be found in certain contexts, the vegetal cleft in others. Votive axes were often carved with their upper halves as were-jaguars with cleft heads, but the clefts are always empty.[46] Celts, however, are often decorated with incised masks; when those masks are cleft-headed, the clefts are vegetal. Thus, the appearance of the cleft seems to follow a pattern. These facts would indicate that the presence or absence of the cleft and the form it takes have sufficient symbolic importance to be governed by rules and that it makes a significant contribution to the overall meaning of the symbolic cluster in which it appears.

That the cleft has symbolic importance is further suggested by the fact that it appears only on masks containing other clearly symbolic features and not on the more naturalistic ones. But to understand its function, we must first decipher its symbolic meaning.[47] The fact that the cleft is often depicted with vegetation, probably corn, sprouting from it suggests fertility, and the associations of the other symbolic features on the masks on which it is found with water surely support that connection. As the source of the growing corn plant, it suggests the "opening" in the earth from which life emerges, the symbolic point at which the corn, the plant from which man was originally formed and which was given by the gods as the proper food for man and thus a symbol of life and fertility, can emerge from the world of the spirit to sustain mankind on the earthly plane.

That symbolic connection is reinforced by the fact that the V-shaped cleft, or inverted triangle, has been since paleolithic times a specifically female symbol representing, in human terms, the point of origin of life. Peter Furst discusses the occurrence of this motif in the much later Mixtec codices as a means of identifying these Olmec clefts with "a kind of cosmic vaginal passage through which plants or ancestors emerge from the underworld" and laments the "enormous span of time dividing them" as possibly calling into question the validity of reading Olmec symbols with this Mixtec "language."[48] However, Carlo Gay's discussion of the highly symbolic designs found in pictographic form in shallow caves associated with the Olmec fertility shrine at Chalcatzingo would seem to lay that objection to rest, if indeed these pictographs are contemporary with the Olmec art found at that site.[49] He records the occurrence of "triangle and slit signs [that] are among the most graphic of vulval representations"

among the many sexually related symbols in those pictographs found at a site obviously dedicated to fertility,[50] signs that are identical in shape to the cleft in the were-jaguar head.

That a sexual symbol would occur on the head of a composite being generally seen as remarkably childlike or sexless is perhaps not so strange. The spiritual thought of Mesoamerica is, in a sense, fundamentally sexual in nature. Its ideas regarding the transformative nature of creation through unfolding, which we will delineate in our consideration of the entrance of the life-force into the world of nature (Part II), surely parallel the natural, sexual process of regeneration. Its persistent emphasis on duality—opposites coming together to form a unity—has one of its most obvious examples in the sexual act. Its emphasis on caves as places of origin must surely be connected with the emergence of the child from the womb as the final result of the sexual act.[51] And its common conception of the fertile earth as female clearly has a sexual origin. But the conventions governing Mesoamerican spiritual art did not allow direct expression of this sexual metaphor. Generally speaking, though there are notable exceptions, throughout the development of Mesoamerican art and thought any depiction of sexual organs or the sexual act was taboo. Under these circumstances, it is not surprising that sexual symbols should appear in disguised ways. Although not overtly sexual, the cleft head carries the sexual meaning: it symbolizes creation, especially as that creation takes the form of agricultural fertility, but by extension it can refer to any related instance of life entering the world in the cycle of life and death. Perhaps the vegetal cleft refers directly to agricultural fertility and the empty cleft to the concept of birth and rebirth in a more general sense, especially as it relates to such state-related matters as rulership and sacrifice.

The fertility theme is also the focus of the other symbol the two rain god masks share, the characteristic were-jaguar mouth. The mouth is, of course, far more striking than the cleft, so striking that it has come to be seen as characteristic of Olmec art generally. But before discussing the complex set of symbolic associations it makes, it might be well to clarify what it is since there have been numerous suggestions that it is not a jaguar mouth or even feline. Peter Furst and Alison Kennedy claim that what is represented is the toothless mouth of a toad, the fitting representative of the earth. Terry Stucker and others and David Grove see the mouth as sometimes crocodilian, and Karl Luckert, who sees the facial configuration as that of a serpent, goes even further by claiming that not only is this mouth not that of a jaguar but, aside from three figures, there are no jaguar representations at all in Olmec art.[52] In our view, however, and that of most other Mesoamericanists, the typical were-jaguar mouth is just that, the mouth

of a jaguar with some features exaggerated for symbolic reasons and some modified to fit the human facial configuration. The heavy pug nose that is an integral part of the configuration and the general frontal flatness of the mouth segment are typically feline and not at all serpentlike. Furthermore, when the body of the figure on which the mouth is generally found is taken into account, both the posture and numerous anatomical details suggest the jaguar. In addition, the jaguar is indisputably represented with reasonable frequency in Olmec art,[53] and it is an important symbolic creature in every Mesoamerican culture that succeeded the Olmecs and was used by each of them as a source of attributes for its gods. And there are several Olmec sculptures that clearly combine the features of the feline with those of man and that depict the characteristic mask.

But it is important to recognize that while the jaguar is the most likely source of the nose/mouth configuration, that facial feature is a highly multivocal symbol that has meanings other than those related to the creature from whom it was taken. Two of those other meanings can be seen in Monument I (pl. 7) from the Olmec fertility shrine of Chalcatzingo which depicts a figure holding a ceremonial bar signifying rulership seated within a stylized cave mouth that lies under three stylized clouds from which raindrops are falling. The clouds themselves bear a striking resemblance to the heavy upper lip of the were-jaguar mouth, and the cave is that very mouth represented in profile, as is made clear by the appearance above it of an eye bearing the Olmec St. Andrew's cross on its eye-

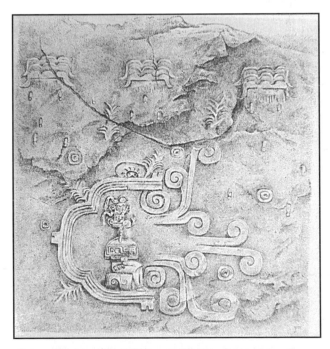

Pl. 7. Monument I, "El Rey," Chalcatzingo, Morelos (drawing by Frances Pratt, reproduced by permission of Akademische Druck- u. Verlagsanstalt, Graz, Austria).

ball, the same cross found on the pectoral of Rain God CJ and occasionally found on one or both eyes of were-jaguar masks. A further indication that this cave is to be seen as a mouth are the "speech scrolls" issuing from it in typical Mesoamerican fashion.

The identification of the cavity as a mouth is strengthened by another bit of evidence external to the relief itself. A freestanding monument found at Chalcatzingo, Monument 9 (pl. 8), is a frontal view of the were-jaguar mouth/cave represented in profile in Monument I. It has the same eyes and the same ridged mouth with vegetation sprouting from its "clefts" in a fashion reminiscent of the cleft heads, and further suggesting the close relationship between the two symbolic works is the apparent use of Monument 9. According to Grove, the carved slab, when erected for ritual use on the most important platform mound at Chalcatzingo, was designed to be entered: "The interior of the mouth is an actual cruciform opening which passes completely through the rock slab. Interestingly, the base of this opening is slightly worn down, as if people or objects had passed through the mouth as parts of rituals associated with the monument."[54] It replicated the natural cave and allowed the ritual "cave" to be entered through the mouth of the composite being representing the world of the spirit, which the ritual enabled man to contact. The seated figure depicted in Monument I has entered that same liminal zone from which issues the "speech" of the supernatural. Thus, the relief designated Monument I relates the cave to the rain cloud by visually associating both of them with the were-jaguar mouth.

Such an association of caves and clouds seems as strange to us as it did to Evon Vogt when he encountered it in his work with the present-day Maya of Zinacantan. But he learned that in the context of the Mesoamerican environment, it is not so strange.

I have had a number of interesting conversations in which I have attempted to convince Zinacantecos that lightning does not come out of caves and go up into the sky and that clouds form in the air. One of these arguments took place in Paste⌣ as I stood on the rim with an informant, and we watched the clouds and lightning in a storm in the lowlands some thousands of feet below us. I finally had to concede that, given the empirical evidence available to Zinacantecos living in their highland Chiapas terrain, their explanation does make sense. For, as the clouds formed rapidly in the air and then poured up and over the highland ridges . . . they did give the appearance of coming up from caves on the slopes of the Chiapas highlands. Furthermore, since we were standing some thousands of feet above a tropical storm that developed in the late after-

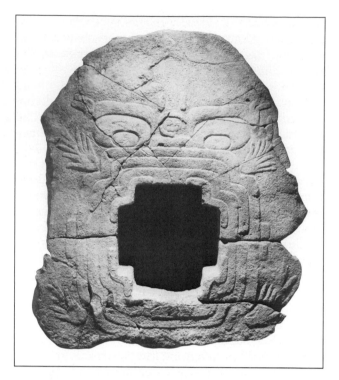

Pl. 8. Monument 9, Chalcatzingo, Morelos (Munson-Williams-Proctor Institute, Utica, New York; photograph courtesy of that institution).

noon, I had to concede that it was difficult to tell whether the lightning was triggered off in the air and then struck downward to the ground, or was coming from the ground and going up into the air as the Zinacantecos believe.[55]

The Olmec connection between caves and clouds apparent on Monument I indicates that today's Zinacantecos have a belief system rooted deep in the past. And that Olmec connection between caves and clouds and the were-jaguar mouth clearly worked in reverse as well; the shape of the mouth called to the Olmec mind caves and rain clouds as well as jaguars.

The connection at Chalcatzingo between these elements is supported by the existence there of numerous miniature, artificial "cavities" linked by a system of miniature carved drain channels[56] evidently designed for the symbolic movement of water in the ritual reenactment at this fertility shrine of the provision of water by the gods. There is also a curious relief carving, Monument 4, that depicts a feline creature, perhaps devouring a man, associated with a branched design that might represent "the pattern of watercourses of the valley north of Chalcatzingo"[57] which would thus flow symbolically from the mouth of the "jaguar." This concern with systems through which water flows is not an isolated phenomenon; the Olmec cave-shrine at Juxtlahuaca, Guerrero, exhibits a comparable, though different, system. These symbolic structures, and others no doubt yet to be found in

the caves of Guerrero, were perhaps the first instances of the jaguar mouth/cave/drain combination that finds its most celebrated example in the carved drain running the length of the cave under the Pyramid of the Sun at Teotihuacán.

Even more significant for our discussion of the Olmec rain god is the fact that the symbolic use of a system of drains also occurs at all four of the major sites in the Olmec heartland on the Gulf coast, though not in association, so far as we know, with caves. "The complex of artificial lagoons or water tanks on the plateau top and the drain systems associated with them form one of the most unusual aspects of San Lorenzo architecture," according to Richard Diehl, and from an archaeological point of view

> the association of Monuments 9 and 52, both
> of which depict water-related symbolism, with
> the drain system, the geometric shapes of some
> of the lagoons, and the fact that the scarce and
> expensive basalt was used for the drain system
> instead of wood, all suggest that the system
> had more than a strictly utilitarian meaning to
> the Olmec.[58]

All of this, of course, suggests ritual use in the reenactment of the gods' provision of water. Although there are no caves associated with this man-made system of drains and lagoons at San Lorenzo, the fact that the drain channels were carefully covered and that they emptied into the lagoons suggests they may have been used symbolically to recreate the emergence of water from the "heart" of the earth in the fashion of an underground spring feeding a pool of water. One thinks in this connection of the cenotes held sacred by the Maya of the Yucatán.

It is quite significant that the were-jaguar mouth is also linked to this symbol of the gods' provision of water since Monument 52 (pl. 4), one of the primary images bearing the mask of Rain God CJ, "was discovered at the head of the principal drainage system."[59] Further suggesting its relationship to the drain system, the back of the sculpture is fashioned in exactly the same U-shaped form as the basalt stones of which the drain system was constructed. Symbolically, both the drain and the god are "conduits" for the movement of water, the fluid needed to maintain life, from the world of the spirit to the world of man. Whether as the cave mouth or the point at which an underground spring bubbled to the surface, the were-jaguar mouth was surely seen by the Olmecs as the liminal point of mediation between the source of spiritual nourishment located within the essentially female earth and the world of man that existed on the earth's surface. And that mouth was a primary feature of many of the symbolic masks constructed by the Olmecs, masks that, in what was to become the time-honored Mesoamerican fashion, designated the point of contact between the world of nature and the world of spirit, the interface between man and the gods.

But why connect the jaguar with rain? The connection might seem an unlikely one to the modern scholar who probably has never encountered a jaguar outside a book, movie, or zoo and surely hopes never to do so. Similarly, the scholar has been sheltered to some extent by the conveniences of modern urban life from the terrible reality of brutal storms and floods, on the one hand, and drought, on the other. In this respect, the inhabitants of the jungles and forests of Preclassic Mesoamerica knew far more than we do about both jaguars and rain from personal experience as well as from the shared experiences of their group, knowledge that no doubt suggested numerous possible connections between the two. They would have known that the jaguar truly was the lord of the Mesoamerican jungle: it is the largest cat in the western hemisphere, weighing as much as 300 pounds and measuring up to 9 feet in length and almost 3 feet in height at the shoulder[60] and because of its size and power, has no natural enemies. Two other creatures used symbolically by the Olmecs, the crocodilian and the snake, might kill young jaguars, "but adult jaguars regularly hunt full-grown caimans as food" and hunt and eat the giant anaconda.[61] The Olmecs might have had an even stronger reason to respect the jaguar than the fact that it preyed on the most powerful creatures in its habitat. According to a modern guide to game animals,

> the jaguar is the only cat in the Western
> Hemisphere that may turn into an habitual
> man-eater. There are two reasons for this.
> One is the jaguar's large size and superior
> strength. . . . The second reason is that most
> jaguars live in areas where the natives do not
> possess firearms. Although the jaguar often has
> been killed with spears and bows and arrows,
> it takes an expert hunter to do it.[62]

The formidable power of the jaguar, then, was impressive enough to have served as the basis of a symbolism that continued to exist until the Conquest and to some extent continues even today. As Eduard Seler points out, "the jaguar was to the Mexicans first of all the strong, the brave beast, the companion of the eagle; quauhtli-océlotl 'eagle and jaguar' is the conventional designation for the brave warriors."[63]

The jaguar must also have seemed almost supernatural in its typically feline ability to move almost noiselessly despite its great size and in its surprising ability to move equally well on land, in water, and in the air.

> The jaguar is the most arboreal of the larger
> cats. It climbs easily and well. . . . At those
> times of the year when its jungle home turns
> into a huge flooded land, the jaguar takes to
> the trees and may actually travel long dis-

tances hunting for food without descending. Water holds no fear for the jaguar, and it swims well and fast, frequently crossing very wide rivers. On the ground, jaguars walk, trot, bound and leap. Their speed is great for a short, dashing attack.[64]

These qualities explain why, as Covarrubias discovered, "even today the Indians regard the jaguar with superstitious awe; subconsciously they refer to it as The Jaguar, not as one of a species, but as a sort of supernatural, fearsome spirit."[65]

The storms that lash the Gulf coast—the *nortes* during the winter months which can bring winds up to 150 kilometers per hour, making coastal navigation impossible, and the hurricanes of late summer and fall with wind velocities over 180 kilometers per hour and tremendous amounts of rain producing destructive floods[66]—make it possible to appreciate the range of possible connections between rain and the jaguar. Rain for the Olmecs was not April showers. In the Veracruz heartland it fell throughout the year and was often accompanied by tremendously destructive storms. Even without the storms, the quantity of rainfall could cause disastrous flooding.[67] In the central highlands, the other area in which a substantial amount of symbolic Olmec art depicting the were-jaguar is found, the more common Mexican rainfall pattern prevails; there are distinct dry and rainy seasons. In that area, a lack of rain at the right time can cause the death of the corn by which man survives. The destruction caused by drought, though different from that wrought by a hurricane and flooding, is just as devastating. The problem for man in these environments is not to "bring rain" as many people think. Rather, man must attempt to bring the elemental forces represented by rain and storm under human control, reduce them to an order that will make the orderly life of culture possible. This, for early man, could only be accomplished through ritual that would enable him to interact with the source of all order, the underlying, otherwise unreachable realm of the spirit.

The ritual control of the rain-related forces probably involved the jaguar because it was the animal equivalent of the storm, equally powerful, equally sudden in its attack, equally destructive of human life and order. Furthermore, the jaguar was at home both in water and in the trees from which it was able to fall, like the storm, on its prey. Like the storm, it was a force that revealed itself in the natural world outside man's control, a force that could be seen as symbolically at the apex of the "unordered," wild forces of nature. By creating the were-jaguar mask, the Olmecs combined the creature who epitomized the forces of nature with man, the epitome of the force of culture. In typical Lévi-Straussian fashion, they created the were-jaguar mask as the dialectical resolution of the binary opposition between the untamed forces of nature and the controlled force of man. While the jaguar hunts with natural weapons (teeth and claws), lives entirely from hunting, and eats his prey raw, man hunts with artificial weapons for food that is a supplement to his staple diet derived from cultivation and eats his food cooked. The jaguar, though generally remaining in the same area, seldom has a den, "usually curling up to sleep in some dense tangle or blowdown,"[68] while man constructs a dwelling and returns to it each night. The jaguar acts instinctively while man can act rationally. In a sense, then, man and jaguar are equal opposites, and the were-jaguar by virtue of combining the force of man with the forces of nature brings together both aspects of the life-force in a being who can thus mediate between man and the origin of that force. By donning the mask in ritual to become that being, man could bring the otherwise destructive elemental forces under control so that they might aid in the maintenance of life by providing the rain in moderation so that the corn would grow and his own life would be maintained.

Thus, the were-jaguar mouth makes symbolic sense, but a glance at that mouth on Rain Gods C (pl. 6) and CJ (pl. 4) reveals a remarkable difference between image and reality; these were-jaguar mouths are toothless. The significance of this is made more apparent by the fact that although there are a great number of fanged were-jaguar mouths in Olmec art, Covarrubias and Coe and Joralemon have selected toothless images to represent the rain god. That this selection is correct is suggested, at least in the case of Rain God CJ, by the water associations of Monument 52. The lack of fangs might suggest visually the association with caves that would be somewhat more difficult to see were the mouths fanged, but the toothless mouth also carries other connotations linked in Mesoamerican thought to rain. The were-jaguar mask is often called a baby-faced mask, the reason for which can be seen in the more naturalistic faces that bear the same toothless were-jaguar mouth that we see here. In the context of the puffy cheeks and chubby facial configuration of those faces, the mouth looks like that of a pouting infant. When the face is found on a body with infantile features, as it often is, the designation seems even more apt. The child held by the Lord of Las Limas (pl. 3) is just such a figure and is, significantly, another primary image of Rain God CJ.

The association of infant and were-jaguar mouth inevitably brings to mind the ritual sacrifice of children to the rain god by both the Postclassic Maya and the peoples of central Mexico, a characteristic form of sacrifice that may well have a prototype in Olmec thought and ritual, as the seemingly lifeless body of the infant held by the Las Limas figure suggests. Most commentators explain this form of sacrifice in the terms suggested by Sahagún, as a form of sympathetic magic where-

by the tears of the children cause the rain, that is, "tears" of the gods, to fall.[69] And Thompson suggests that the rain gods "liked all things small";[70] their "helpers," the *tlaloques* or *chacs*, like today's *chaneques*, were thought of as dwarfs, though not children.[71] In addition to these connections between small children and rain, however, one might also see in this ritual the return of a child to the womb of the earth from which he has only recently emerged. Such an interpretation would accord with one of the means of sacrificial death—drowning in such a manner that the bodies never again rose to the surface—as well as the burial rather than cremation of the bodies of victims sacrificed in other ways to Tlaloc. The common Mesoamerican conception of the sacrificial victim as the bearer of a message to the gods would seem to support this interpretation, as would the symbolic identification of caves as both the womb of the earth and the source of rain and lightning. The lifeless body of the were-jaguar child held by the Las Limas figure whose infantile features are often found on Olmec figures would thus symbolically unite these diverse ideas.

These symbolic connections between the were-jaguar mouth and caves and infants help to explain the difficulty scholars have had in identifying the natural origin of the mouth. Though we feel certain that it is feline in origin, the natural form has been modified to suggest its symbolic multivocality by making visual reference to other rain-related symbols. The complexity of the symbolic structure lying behind the outward form is typical of the Mesoamerican way of constructing complex symbols by combining a number of symbolic details drawn from nature in a metaphoric, emphatically nonnatural structure. As we will explain in detail below, the life-force enters the world of man through transformation, and the construction of the mythic symbol illustrates that transformative process. The source of the water that nourishes natural life on the earthly plane is to be found in the world of the spirit, but the essence of spirit cannot be visualized. Hence the intermediary stage represented by the combination of natural features in a nonnatural, "spiritual" form. Through the mediation of that form—the symbolic were-jaguar mouth in this case—energy, in the form of rain, can flow from the world of the spirit to the world of man. Thus, the appearance of the toothless variant of the were-jaguar mouth on an Olmec mask, especially in conjunction with the cleft head, would connote fertility generally and rain specifically. It is especially interesting, then, that Coe and Joralemon and Covarrubias selected such masks as images of the Olmec rain god. Although neither explain in detail their reasons for associating the toothless mouth with rain, their remarkable familiarity with Mesoamerican religious symbols probably led them to do so intuitively. As we

have shown, they had good reason to make that connection.

Although the similarities between these two faces indicate without a doubt that they are both concerned with the symbolic representation of forces associated with rain and fertility, there are important differences that indicate that Olmec symbolic art was not made up of a small number of static combinations of symbols endlessly repeated; it exhibits a large range of symbolic figures created by combining in different ways details drawn from the basic inventory of symbols. Thus, when viewing any collection of Olmec art, we are always involved in the fascination of theme and variation. Far removed in time and culture from the creators of this body of art, it is impossible for us to say with any precision what shades of meaning were conveyed to the Olmec cognoscenti by these variations, but we can say with certainty that such a body of symbolic art has the capacity to communicate sophisticated and complex spiritual ideas with precision. Such an art begins the heritage that came to fruition, for example, in the monumental Aztec Coatlicue (pl. 9) and on the lid of Pacal's sarcophagus at Palenque (pl. 10), both of which, as we will demonstrate, are complex symbolic structures that must be "read," item by item, if they are to reveal their profound meanings.

When we look again at the masks of the rain god, this time seeking variation, the variations we find form a fascinating pattern that holds constant the symbolic motifs of the toothless were-jaguar mouth at the bottom of the face and the cleft at the

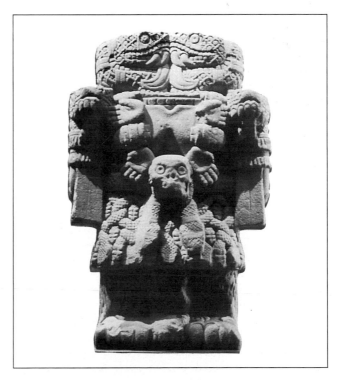

Pl. 9. Coatlicue, Tenochtitlán (Museo Nacional de Antropología, México).

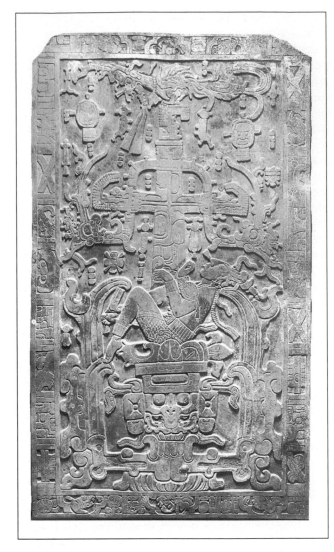

Pl. 10. Relief carving on the cover of the sarcophagus of Pacal, Temple of Inscriptions, Palenque (Photograph by Merle Greene Robertson and Lee Hocker, reproduced by permission).

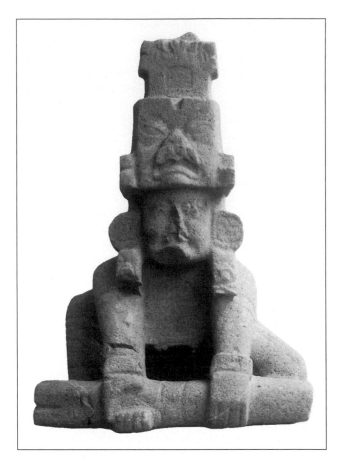

Pl. 11. Olmec Kneeling Figure, San Martín Pajapán, Veracruz (Museo de Antropología de Xalapa).

top while varying the treatment of the area between them. Taking care to deal only with masks representing mythological creatures—which can be distinguished from human representations with symbolic mouths by their frontal flatness, rectangular rather than ovoid shape, and symbolic cleft—we can see that the variation involves a progression from simple to complex and is accomplished by adding features to the basic mask. An excellent example of that basic mask can be seen in the headdress of a figure found at the summit of the volcano at San Martín Pajapán (pl. 11), one of the Tuxtla Mountains held sacred by the Olmecs. Its mountaintop placement, like that of rain god figures throughout Mesoamerican history, suggests clearly its function. The mask's almost square, flat shape, its pronounced cleft and symbolic mouth, and its almond-shaped eyes set at an angle to the horizontal line of the mask all contrast markedly with the human face below it and indicate clearly its sym-

bolic nature. This is the symbol of the rain god—as identified by Coe and Joralemon, Covarrubias, and our own analysis—reduced to its essentials. The same mask also appears at La Venta in Monument 44, a head that is all that remains of a figure that must have been almost identical to that of San Martín Pajapán,[72] and on a small greenstone object from Ejido Ojoshal, Tabasco.[73]

The simplest variation on the basic theme involves the addition of eyebrows and changes in the shape of the eyes. The eyebrows are all the so-called flame eyebrows, and the mask Covarrubias identifies as the rain god, our Rain God C, displays them in one of their several variant forms. Masks displaying these eyebrows are commonly found on celts and votive axes carved to represent the figure of the rain god, but the same mask can also perhaps be seen on a sarcophagus found at La Venta.[74] The mask on the sarcophagus might have had a dangling, bifid tongue, a development of the rain god we will see clearly in all of the later rain gods of the Classic period, which would suggest a connection with the serpent. Such a connection may also be suggested by the eyebrows since, as several scholars have felt, these are probably better interpreted as feathers or plumes than as flames. If they are so interpreted, the composite mask reveals avian connotations and would suggest an Olmec

version—perhaps the original version—of the jaguar/bird/serpent symbolism associated with the lightning, wind, and rain of the storms through which water was provided by the gods for man. Just as there are variants of the flame eyebrows, there are also variants of eye shape in the masks with plume eyebrows. Some continue to display the almond-shaped eye of the basic mask, but others have rectangular, trough-shaped eyes, some of which are turned down in an L-shaped fashion at the outer edge. It is quite likely that the particular combination of eye and eyebrow—and all possible combinations seem to exist—meant something specific, now forever lost, to the Olmec priest.

At the succeeding levels of complexity, other items are added to the mask. The first of these is a headband with symbolic markings which covers whatever eyebrows the figure might be imagined to have. Perhaps attached to this headband are elaborate wavy ear coverings, which are long and narrow and similar to those often depicted in Aztec art, the design of which might well suggest water. Such a combination of headband and ear coverings is worn by the child held by the Las Limas figure (pl. 3), a primary image of Rain God CJ, as well as by an iconographically equivalent standing figure holding a child now in the Brooklyn Museum and can also be seen on several carved celts from the Olmec heartland. The final addition to the basic concept is that illustrated by Monument 52 from San Lorenzo (pl. 4), another primary image of Rain God CJ. In addition to the headband with ear coverings, this figure wears a headdress with a pair of presumably symbolic markings prominently displayed. Like the design on the ear coverings, these markings might also suggest water.[75] Since this image of Rain God CJ was found at the head of the system of ritual water channels at San Lorenzo, the symbols it carries likely relate to the gods' provision of water not by rain but directly from the earth in the manner of the cenotes and of underground springs bubbling to the surface.

Interestingly, however, a stone object from Tlacotepec, Guerrero, an area with caves but no cenotes, displays, in very different form, the same combination of mask and headdress. This suggests that the symbolic reference must be wider than one resting on an interpretation of the San Lorenzo figure. But whatever the precise meaning of each of the symbolic details of the many variants of the mask, it is clear that while all of the combinations refer to rain, each particular image has a different inflection symbolized by the individual combination of features drawn from the basic inventory. Perhaps each figure deals symbolically with a different part of what is, after all, quite a complex process, or perhaps one of the features—the mouth, for example—is significant enough to embody the basic meaning of any figure on which it appears.

But as we suggested at the outset of this lengthy discussion of the mask we call the Olmec rain god, that particular point of contact with the world of the spirit symbolized more than the provision of the life-maintaining rain. For the Olmecs, as for all the peoples of Mesoamerica who were to follow them, the mask that symbolically identified the rain god was simultaneously involved with the metaphorical delineation of the essentially sacred nature of what we would call profane power and thus demonstrated the intimate relationship between spiritual and worldly leadership which has always intrigued and puzzled students of the pre-Columbian Mesoamerican civilizations.[76] Although we will not attempt at this point to define precisely that relationship, it seems clear that the Olmecs believed, as did the Aztecs and all the civilizations between the two, that their rulers were provided by the gods and returned at death to the realm of the gods, the world of the spirit. In the exercise of profane power, these rulers spoke for the gods and provided an essentially spiritual order for the world of nature in which humanity was embedded. That spiritual function was symbolized in Olmec art by the were-jaguar mask, which also symbolized rain.

The origin of this fascinating three-way connection between rain, rulers, and jaguars cannot be discovered for us by archaeology, but it seems reasonable to suppose that that enduring link was forged in the Preceramic phase of the development of Mesoamerican culture, probably in the period of transition from the nomadic existence of hunting-gathering groups to the settled life associated with the beginnings of agriculture. It was at this time, perhaps, that the jaguar, the hunter's greatest adversary, became involved in Mesoamerican man's symbolization of the twin requirements for maintaining the communal life both based on and necessary for raising crops—a settled society and regularly timed rainfall. As we have demonstrated above, the were-jaguar mask metaphorically resolved the binary opposition between "wild" nature and the control necessary for the development of human culture. By uniting the equal opposites of the jaguar, the epitome of nature, and man, the epitome of culture, the were-jaguar mask provided the focal point for the ritual through which the gods' provision of rain could be harmonized with the needs of the crops that were to sustain human life and provide the basis for the existence of human culture.

Similarly, social harmony could be achieved through the rulership of a particular man sent by the gods to "take over the burden, . . . devote thyself to the great bundle, the great carrying frame, the governed."[77] In that sense, at least, the ruler is the equivalent of the rain. Both are sent by the gods, both are necessary parts of the framework within which the common man can sustain his life, and thus both are prerequisites for the life of

culture. The Quiché Maya creation myth embodied in the *Popol Vuh* is both fascinating and instructive in this regard since even though it is a post-Conquest document recording Postclassic beliefs, it clearly relates rain and rulers, sustenance and governance in its delineation of the creation of humanity, which is, of course, essentially a definition of what it means to be human. In the myth, man is finally created after three previous failures, two of which depict the newly created would-be man as incapable of attaining human status and relegate him to the status of "wild" animal. The meaning of these two failures is clear: true humanity can exist only in the context of culture, defined in the myth as the binary opposite of nature.

The second of those two cases—the wooden men who ultimately become monkeys—is especially intriguing since the myth takes care to differentiate between the forces of nature and those of culture. The wooden men are destroyed as humans and thus relegated to animal status by the forces of untamed nature—"The black rainstorm began, rain all day and all night. Into their houses came the animals, small and great"—and, separately, by the forces of culture—"Their faces were crushed by things of wood and stone. Everything spoke: their water jars, their tortilla griddles, their plates, their cooking pots, their dogs, their grinding stones, each and every thing crushed their faces."[78] The opposed forces of nature and culture act in destructive harmony on this occasion, but the myth makes clear that it is the task of human society, through ritual and the efforts of the ruler, to harmonize those forces, as Olmec art much earlier similarly harmonized the faces of jaguar and man in the metaphorical were-jaguar mask. This harmony, now constructive rather than destructive, is precisely the theme of the gods' fourth and final attempt to create man.

[They] sought and discovered what was needed for human flesh. It was only a short while before the sun, moon, and stars were to appear above the Makers and Modelers. Broken Place, Bitter Water Place is the name: the yellow corn, white corn came from there.

And these are the names of the animals who brought the food: fox, coyote, parrot, crow. There were four animals who brought the news of the ears of yellow corn and white corn. They were coming from over there at Broken Place, they showed the way to the break.

And this was when they found the staple foods.

And these were the ingredients for the flesh of the human work, of the human design, and the water was for the blood. It became human blood and corn was also used by the Bearer, Begetter.

And so they were happy over the provisions of the good mountain, filled with sweet things, thick with yellow corn, white corn, and thick

with pataxte and cacao, countless zapotes, anonas, jocotes, nances, matasanos, sweets— the rich foods filling up the citadel named Broken Place, Bitter Water Place. All the edible fruits were there; small staples, great staples, small plants, great plants. The way was shown by the animals.

And then the yellow corn and white corn were ground, and Xmucane did the grinding nine times. Corn was used, along with the water she rinsed her hands with, for the creation of grease; it became human fat when it was worked by the Bearer, Begetter, Sovereign Plumed Serpent, as they are called.

After that they put it into words:
the making, the modeling of our first
 mother-father,
with yellow corn, white corn alone for the
 flesh,
food alone for the human legs and arms,
for our first fathers, the four human works.[79]

The creation of man is intimately connected here with the origins of agriculture, that is, with the "discovery" of corn at Broken Place. Broken Place, translated by Munro Edmonson as Cleft,[80] is symbolically the point at which man's sustenance, the corn, emerges from the world of the spirit into the natural world. This place-name in the *Popol Vuh* is thus the equivalent of the visual clefts found in the Postclassic Mixtec codices, and both symbols are related, as we have demonstrated above, to the symbolic cleft on the Olmec were-jaguar masks from which, of course, corn is often depicted emerging. But corn, as Mesoamerica well knew, is a cultivated plant, not a wild one, and the import of the myth in this regard is clear. Man exists in culture, not as a wild animal; the animals find the corn, but man is formed from it. Only within the context of culture can man make use of plants and water, his symbolic flesh and blood, to sustain his individual life and the life of the community without which truly human life would be impossible. And communities implied rulers to the Mesoamerican mind. The *Popol Vuh* makes this quite clear.

These are the names of the first people who were made and modeled.
This is the first person: Jaguar Quitze.
And now the second: Jaguar Night.
And now the third: Mahucutah.
And the fourth: True Jaguar.
And these are the names of our first mother-fathers.
. .
And then their wives and women came into being.
. .
Celebrated Seahouse is the name of the wife of Jaguar Quitze.

Prawn House is the name of the wife of
Jaguar Night.
Hummingbird House is the name of the
wife of Mahucutah.
Macaw House is the name of the wife of
True Jaguar.
So these are the names of their wives, who
became ladies of rank, giving birth to the
people of the tribes, small and great.
And this is our root, we who are the Quiché
people.[81]

The mythical ancestors, the mother-fathers, the
Lords of the Quiché, are the root of the Quiché
people, their means of attachment to the source of
their sustenance in the world of the spirit. These
mythical beings are symbolically both male and
female, matter and spirit, temporal and eternal,
human and divine, and thus unite, precisely in the
manner of the were-jaguar mask, the whole series
of opposed categories that define god and man,
categories that metaphorically find their meeting
place in these "first people." These are the first rul-
ers, the progenitors of and the models for all the
Lords of the Quiché who are to follow them.
Through their wives, they unite metaphorically
the two aspects of the enveloping world of the
spirit with the earthly plane on which man lives
and on which they rule: Sea and Prawn suggest the
watery underworld, equivalent in Maya thought to
the cave, while Macaw and Hummingbird suggest
the airy upper world. And all of them are married
to and thus complement the Jaguar—three of the
four Lords' names—the creature of the earth in this
set of symbolic oppositions. The primary function
of the ruler, then, is here defined through the
metaphor of the three-layered cosmos fundamental
to shamanistic thought as the uniting of matter
and spirit.

Clifford Geertz explores this symbolic function
in "Centers, Kings, and Charisma: Reflections on
the Symbolics of Power":

> At the political center of any complexly or-
> ganized society . . . there is both a governing
> elite and a set of symbolic forms expressing
> the fact that it is in truth governing. . . . [Such
> elites] justify their existence and order their
> actions in terms of a collection of stories, cere-
> monies, insignia, formalities, and appurte-
> nances that they have either inherited or, in
> more revolutionary situations, invented. It is
> these—crowns and coronations, limousines
> and conferences—that mark the center as
> center and give what goes on there its aura of
> being not merely important but in some odd
> fashion connected with the way the world is
> built. The gravity of high politics and the sol-
> emnity of high worship spring from liker im-
> pulses than might first appear.[82]

When we discuss Olmec society, of course, crowns
become headdresses and we must do without lim-

ousines, but the principle remains operative; here
too, as early as 1200 B.C., we see carved in stone
by Olmec sculptors the evidence of an elite at the
center of things defining its position and function
through "a set of symbolic forms" that thoroughly
interweave "the gravity of high politics and the so-
lemnity of high worship."

Strange as it might seem, the clearest expression
of this fundamental theme of Olmec art appears
not in the Olmec heartland on the Gulf coast but
hundreds of miles away in the central highlands at
Chalcatzingo, Morelos. Perhaps Grove is correct
in contending that the art created on the Olmec
"frontier," as he calls it, made graphically clear the
ideas that "are abstracted in Gulf coast monu-
ments" in order to instruct a populace not con-
versant with those concepts,[83] but whatever the
reason, the thematic interweaving of high politics
and high worship, of the rain god and the ruler, is
nowhere more apparent than in Monument I at
Chalcatzingo (pl. 7), a relief carving fittingly called
El Rey by today's villagers. As we indicated above,
Monument I depicts a figure holding a ceremonial
bar seated within a stylized cave/jaguar mouth
from which issue speech scrolls. On the one hand,
the seated figure is clearly associated with the rain
god by the stylized raindrops, identical to those
falling from the clouds, decorating his costume and
headdress and by his location within the mouth of
the cave/jaguar, but, on the other hand, he is iden-
tified as a ruler by the ceremonial bar he holds and,
perhaps, by the headdress he wears.

What might seem to be two conflicting thematic
motifs in this relief can be resolved into one: we
see here the Olmec identification of ruler and rain
god. Monument I, according to Grove and Gilles-
pie, "depicts a person seated within a cave, source
of both water and supernatural power." That per-
son, they believe, "was a revered ancestor rather
than merely a generalized 'rain god.'" But the loca-
tion of the relief "above the site on the main rain-
water channel," which would cause "the torrent of
water rushing down the mountain" to appear "to
come directly from this revered ancestor,"[84] and
the evidence of the symbols on the relief suggest
overwhelmingly that the "revered ancestor" or,
perhaps, current ruler is to be equated metaphori-
cally with the rain. The speech symbolized by the
scrolls emanating from the cave mouth would
seem to be either his speech or speech concerning
him, and that speech is symbolically equated with
the issue of the mouthlike rain clouds—the rain-
drops—with which his costume and headdress are
also decorated. The ruler depicted here is symboli-
cally equivalent to the rain, as is the "speech"—his
rule—that issues from him, and thus from the
gods. That speech sustains the life of the ruled as
does the rain that gives life to the corn that nour-
ishes man. While the relief was no doubt intended
by its creators to commemorate a particular ruler

or to indicate their reverence for the supernatural power that provided the rain or, perhaps, to do both, its primary significance for us is to indicate the identification in the Olmec mind of those two motifs.

Another sculpture at Chalcatzingo, a fragment of a freestanding relief or stela, depicts a strikingly similar motif but in a form that relates it directly to the sculptures of the Olmec heartland we have discussed and helps, in the process, to clarify their meaning. This sculpture, Monument 13, depicts a seated or kneeling figure, remarkably similar in posture to the San Martín Pajapán figure (pl. 11), within a stylized cave/jaguar mouth identical to the empty cave/mouth of Monument 9 (pl. 8). The figure within this mouth suggests that the empty mouth of Monument 9 was occupied by a living figure, probably that of the ruler, in a ritual that legitimized his rule by relating it to the provision of rain. Both the rain and the ruler would thus be seen metaphorically as emanations of the world of the spirit. Furthermore, both Monuments 9 and 13 are frontal views of the mouth depicted in profile in Monument I, the mouth in which the seated figure fittingly designated *El Rey* is found, suggesting the importance of this theme in the art of Chalcatzingo.

But that theme is not restricted to Chalcatzingo and the Olmec frontier. It occurs with equal frequency, though somewhat more subtly, in the art of the Gulf coast Olmec heartland, as the striking similarity between the figure depicted in relief on Chalcatzingo's Monument 13 and the sculpted figure found atop the volcano of San Martín Pajapán indicates. Both are depicted in the same posture, a posture clearly indicated by the continuous curve described by the back, shoulders, and arms; both wear a headdress bent back and cleft; both have a mouth suggesting the were-jaguar configuration, but neither is an extreme version of that mouth; and both have their hands resting on a barlike object in front of them, an object that is probably a ceremonial bar and thus a symbolic indication of rulership. Furthermore, both are associated with a clearly symbolic version of the were-jaguar mouth: Monument 13's figure is seated within it and the San Martín Pajapán figure carries it in his headdress. Were Monument 13 not a fragment, we might see an even greater similarity because we would then know what the front of the seated figure's headdress looked like. But even without that knowledge, we can say the existing similarities are so striking as to demonstrate that the carver of the Chalcatzingo relief was depicting the same thematic motif, and that motif clearly relates rulership to rain.

That relationship can also be seen in the complex of symbols depicted in several variant forms on the monumental sculptures called altars, but which more likely served as thrones, found throughout the heartland and at Chalcatzingo and depicted in a painting on the cliff face above a cave-shrine at Oxtotitlán, Guerrero. These "altars" are massive rectangular tablelike forms with tops extending beyond large pedestal bases. Altar 4 from La Venta (pl. 12), the most fascinating of them from our point of view in this discussion, depicts on the face of its pedestal, below the protruding ledge of its top, a figure in high relief wearing a headdress, cape, and pectoral ornament. He is seated cross-legged within the stylized mouth of a were-jaguar, a mouth remarkably similar to the mouths on the Chalcatzingo reliefs. Above the mouth on the face of the ledge appears the upper jaw, fanged and decorated with the St. Andrew's cross, and the eyes, with a cleft between them, of the were-jaguar. Interestingly, though the body of the emerging figure is quite realistically human, the face, though now mutilated, seems also to suggest the were-jaguar. Bent forward slightly, the figure grasps a rope that runs along the base of the altar and is tied to realistically depicted human figures on either side. Those familiar with later Maya symbolism would be inclined to see the figures on the sides as captives suggesting the dominance of the lord seated in the niche.[85] But the figures on the sides are not bound, as captives typically are in Maya art, and may symbolize kinship ties resulting in alliances with the domains of other lords[86] or the common Maya theme of accession. In any case, it seems clear that the symbolic meaning of the rope is related in some way to earthly rulership and equally clear from the altar as a whole that rulership is to be thought of as fundamentally connected with the rain suggested by the were-jaguar/cave mouth motif. That this complex of ideas was also present at the Olmec site of San Lorenzo is indicated by Monument 14, an altar that is now heavily mutilated but which seems to have been virtually identical to La Venta Altar 4.

Other Gulf coast altars, La Venta Altars 2 and 5 and San Lorenzo Monument 20, express the same symbolic meaning in a different way by depicting a seated figure in a cave/mouth niche holding a seemingly lifeless infant. The infant is probably always the were-jaguar figure we have called Rain God CJ[87] so that the symbolic motif is identical to that of the Lord of Las Limas (pl. 3). Altar 5 of La Venta is the least mutilated of this group, and it, like Altar 4, bears figures on the sides (pl. 13); each of the figures wears an elaborate headdress and holds a were-jaguar infant or dwarf, but one who is very much alive in contrast to the lifeless infant held by the central figure. That contrast might very well suggest that the central infant represents a sacrifice, an offering to the rain god, while the four infants or dwarves on the sides represent the quadripartite helpers of the rain god—the Olmec prototype of the later chacs of the Maya or tlaloques of central Mexico. The elaborate headdresses of the

THE METAPHOR OF THE MASK IN PRE-COLUMBIAN MESOAMERICA

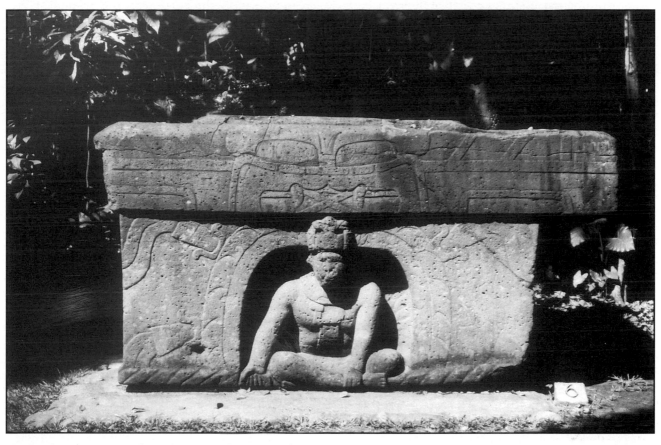

Pl. 12. Altar 4, La Venta (Parque Museo de La Venta).

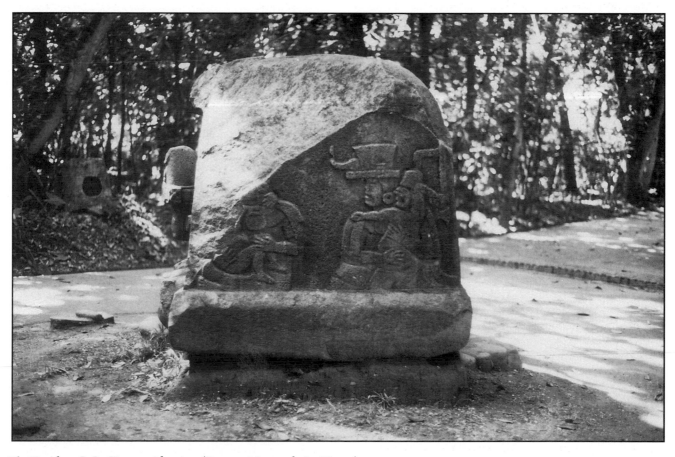

Pl. 13. Altar 5, La Venta, side view (Parque Museo de La Venta).

figures holding the infants as well as their realistic features, in contrast with the were-jaguar features of the infants or dwarfs, suggest that they are depictions of past or present rulers, thus tying rain and rulership together in still another fashion. And just as the rope on Altar 4 may represent kinship ties, the infant on Altar 5 may also suggest "the basic concept of royal descent and lineage."[88] The Olmec altars, then, symbolically link Olmec rulers to the provision of rain from the realm of the spirit, the entrance to which is represented by the niche in the altar symbolizing simultaneously the were-jaguar mouth and the cave. Thus, in an almost literal sense, the altars were "masks" placed on the earth to allow the ritual entrance into the world of the spirit from which the power wielded by the temporal ruler must ultimately flow. That power was legitimized by virtue of its emergence, through the mask, from the world of the spirit.

For the Olmecs, then, the were-jaguar mask of what we have been calling the rain god served to delineate the mode of entrance into this world of the force that ultimately sustained human life. All of the images of that mask which we have discussed, taken together, demonstrate the fluid and flexible nature of the mask as a symbol for the Olmecs and the sophisticated way in which they manipulated that symbol. As our analysis makes clear, the mask provided the iconographic core of the symbolism of bodily form and regalia through which the Olmecs, like all the peoples of Mesoamerica who were to follow them, communicated spiritual facts. The range of mask types, of which the toothless or fanged, cleft-headed were-jaguar is but a small part, revealed by the body of Olmec art as well as the variety of ritual uses of those masks makes clear that this communication was capable of handling a broad range of connections between man and the life-force and also suggests that the Olmecs, like all of their Mesoamerican successors, conceived of their gods as quadripartite beings. Were this the case, the subtler variations between masks with the same cleft head and toothless mouth might well represent individual units of a four-part structure. The pervasive use of the St. Andrew's cross in Olmec art, a use seen often in the symbolic markings on headband, pectoral, and headdress of these figures, and even in the fanged mouth of Altar 4, probably indicates that very quadriplicity. That cross is, after all, a variation of the quincunx, a four-part figure reminiscent of those used throughout Mesoamerican history to represent the "shapes" of time, space, and the gods. Perhaps, then, we should be considering the masks, rather than the mask, of the rain god in Olmec art.

Whether one or four, however, what is abundantly clear is that the Olmecs used the metaphor of the mask, in this case the cleft-headed, toothless were-jaguar mask, as a means of understanding the way in which the life-force—the ground of their being and all being—provided both the water that caused the corn to grow and the rulers who established an order of the spirit in the world of nature. The mask provided for them a symbolic means of constructing a mediating system of gods that allowed that life-force to "unfold" into man's world.

THE MASK AS METAPHOR
Cocijo

Though the particular mask that the Olmecs used to designate that point of contact with the world of the spirit disappeared with the death of Olmec culture, it lived on in altered form within the religious art of each of the major cultures of the Classic period as an integral part of a system delineated through a variety of similarly constructed masks through which each of those cultures mediated between the worlds of nature and the spirit. As Covarrubias's chart (pl. 2) demonstrates, those cultures used the features of the Olmec mask, modified in their own ways, to symbolize the provision of the life-sustaining rain and divinely ordained rulership from the world of the spirit. Those modifications that distinguish each of the major Classic period rain gods—Cocijo, Tlaloc, and Chac—resulted from the particular means by which the Olmec culture was transmitted to its Classic period heirs.

That this transmission did, in fact, take place is now generally accepted by Mesoamerican scholars; as Covarrubias suggested in 1957, the Olmec was the "mother culture" that gave birth to the great Classic period cultures of Mesoamerica.[89] Or to put it more precisely, Olmec influence operating on the village cultures of various areas of Mesoamerica "played the role of a catalyst. It led to decisive steps forward, or quickened the pace of progress . . . [by implanting] religious ideas and rough ideas of social structures that germinated, flowered, and bore fruit in the classic era."[90] But this general agreement among scholars does not extend to a unanimity of opinion as to the means of cultural transmission. Covarrubias seems to have imagined an Olmec empire, "a form of incipient theocracy by which they dominated a large population of peasant serfs, the peoples of the Preclassic cultures, a system that later prevailed all over Middle America and replaced the simple communalistic system of small autonomous peasant villages."[91] Others, no doubt thinking of the clearly religious art that betrays the Olmec presence, believed that Olmec warriors "paved the way for missionaries who spread the cult of the Olmec jaguar god."[92]

But the intensive research effort in the last twenty years directed toward understanding the development of the Preclassic cultures of the highlands of Mexico suggests that trade rather than

colonizing or proselytizing was the primary motivating force,[93] especially that trade through which the Olmecs acquired the goods necessary for religious art and ritual—such things as "obsidian, jade, turquoise, iron pigments, iron ores, mica, mollusk shell, turtle shell, fish and stingray spines, and shark teeth."[94] At site after site outside the Olmec heartland on the Gulf coast, there seems to have been a relatively small number of Olmecs living with a large group of local people, presumably to direct the acquisition of the needed goods. Grove concludes that even Chalcatzingo, the highlands site with the most extensive evidence of an Olmec presence, was not an Olmec city but merely served as a "gateway city" through which the Olmec funneled "the supply of status goods" acquired from the village cultures.[95] Archaeological data regarding numerous other Preclassic sites also suggests either an Olmec presence or significant Olmec contact related to precisely this sort of trade.[96]

The archaeological evidence also suggests that the extensive contact with or even the permanent presence in these early villages of representatives of a significantly more sophisticated culture had a predictable effect. Symbolic forms in art and ritual, the maintenance of which were the fundamental reason for the Olmec presence, flowed from the more sophisticated group to the less sophisticated one, a movement encouraged by the fact that both cultures were rooted in and grew from the same shamanic base whose fundamental assumptions we will describe at length below. Thus, the Olmec culture in the heartland became the model to be emulated by the village cultures. There is evidence of this sort of relationship on both sides. Philip Drucker argues convincingly that a number of Gulf coast monuments depict contact with outsiders, presumably leaders from one or another of these villages. "These foreign visitors," he goes on to say,

may well have been honored by being shown the splendors of La Venta—the ceremonials and the monuments—[and] . . . may have been impressed enough to want to emulate their hosts, and were lent (or given?) Olmec sculptors to do some carving for them; or they arranged for some of their personnel to be trained by Olmec sculptors.[97]

As for the other side of the relationship, Robert Drennan concludes that in the Valley of Oaxaca from 1150–850 B.C., Olmec symbolism was intimately involved with "ritual activity accompanying the emergence of larger-scale, ranked society." These Olmec symbols were derived from "a network of interregional contacts through which were transmitted several kinds of ritual objects and materials together with symbols of probable religious meaning."[98] Thus, Drennan would seem to be describing the effect on the receiving group of precisely the contact described by Drucker. Although Drennan's dates would make this particular example of that connection impossible since the scenes Drucker describes are to be found on monuments carved several hundred years later, the general principle nevertheless seems valid: Olmec symbolism derived from Olmec contact was used pervasively, not only in Oaxaca but in village cultures in a number of Mesoamerican areas, both to make clear and to support the status of rulers and religious functionaries in those village cultures. The masks of the gods of the village cultures came to have Olmec features.

But it is equally clear that this influence operated during a limited period and that it did not change completely the art style or belief structure of the local group. Thus, Olmec symbolism was superimposed on preexisting local cultures with indigenous beliefs, ritual, and artistic style. Concerning the central Mexican highlands, for example, Grove notes that Chalcatzingo "was not an Olmec colony. The vast majority of the site's artifacts show that in basic cultural details it was central Mexican and non-Olmec."[99] Similarly, according to Louise Paradis, "Olmec-related artifacts have now been found in an archaeological context in Guerrero . . . imbedded in a local cultural tradition that has nothing to do with the one commonly labeled Olmec."[100] And according to Coe in his study of the material from such sites as Tlatilco, Las Bocas, and Tlapacoya, "there are manifestly two distinct artistic traditions during the Middle Preclassic in the highlands—one Olmec and the other indigenous."[101] These Olmec artifacts constitute the evidence that remains of the use by the leaders of these cultures of Olmec symbols, beliefs, and, probably, connections to consolidate their status, and this was also true in the Valley of Oaxaca. Most objects carrying Olmec symbols discovered in Oaxaca were for ritual use and "functioned to connect those who were entitled to use them to the ultimate sacred propositions of Olmec religion"; in other words, these individuals were marked as the descendants of the gods, indicating that "a major reason for the diffusion of the Olmec art style throughout Mesoamerica was the increased need for mechanisms of sanctification in various regions owing to internal social evolution."[102] The "mechanisms" used were Olmec because the Olmecs had developed them for precisely the same purpose from precisely the same set of underlying assumptions about man, the gods, and the relationship between them.

As the Olmec art style and the underlying belief system it expressed diffused throughout Mesoamerica in this way, a similar phenomenon occurred in each of the areas to which it spread. Rather than supplanting the indigenous style and belief system, the Olmec system first coexisted but ultimately fused with the local system. This fusion of religious ideas and symbols can be seen generally in the development of mask symbolism and

specifically in the evolution of the mask of the rain god which we can trace from the Olmecs, through the village cultures, and into the Classic cultures that grew from those village cultures as a result of the Olmec "catalyst." Of the three clear-cut routes of this complex development, we will consider first the Valley of Oaxaca and its development in the Classic period of the great civilization centered on Monte Albán, for which its version of the were-jaguar mask continued to symbolize both rain and rulership as it had for the Olmecs. Next we will explore the central Mexican highlands and the development of that mask, primarily as a symbol of rain, in the Classic period culture of Teotihuacán and in the Postclassic Toltec, Aztec, and Mixtec cultures. Finally, we will trace the development of the rain god by the Maya, primarily as a symbol of rulership, first at Izapa and Kaminaljuyú, then in the lowland culture of the Classic period, and finally in the Yucatán.

We have chosen to look at Oaxaca first both because its rain god, Cocijo, was the first post-Olmec rain god to appear and because the rain god of no culture shows clearer evidence of its Olmec heritage than that Cocijo of the Zapotec culture of the Valley of Oaxaca, which constructed the mountaintop urban center of Monte Albán at about 550 B.C. and from that remarkable site "dominated the Valley of Oaxaca for more than 1000 years."[103] The similarities between Cocijo and his Olmec ancestor are both visual and conceptual. The visual similarities can be seen at a glance: both have symbolic headdresses, exaggerated eyebrows, distinctive ear ornamentation, and, most important, a were-jaguar mouth. The conceptual similarities are equally clear though they cannot be seen. Both Cocijo and the Olmec rain god are actually a range of symbolic variations of a basic mask with each of the variant forms being a particular combination of symbolic features designed to convey a particular aspect of the supernatural force, in this case, rain and rulership, that we are calling a god. In addition, in both cases, the rain god exists as an integral part of a system of such gods, each a similarly constructed but differently detailed mask, by which their creators symbolized the systematic totality of the world of the spirit. Thus, the Zapotec system in general and the features of Cocijo in particular were rooted firmly in the Olmec past.

As Covarrubias's chart (pl. 2) makes clear, however, the most immediately apparent similarity of the mask of Cocijo to its Olmec ancestors is the were-jaguar mouth. This mouth is commonly depicted in Zapotec art, often but not always in the Cocijo mask, but nowhere can it be seen more clearly and its development traced more easily than on the so-called funerary urns characteristic of the culture of Monte Albán. Present in all the phases of development of that culture, these ceramic urns are generally found in tombs, but they "occur as offerings in temples and caches as well."[104] What, if anything, the urns originally held is unknown, but that is perhaps unimportant since their primary function seems to have been to support a representation of the face or entire body of a human being or a god with either the person or the god wearing a variety of clearly symbolic items such as masks, headdresses, pectorals, ear flares, and clothing.

As is the case with much symbolic Mesoamerican art, the identity of these figures and the meaning of their symbolic regalia have proven very difficult for scholars to interpret. One of the problems of interpretation is general: those who have viewed Mesoamerican art from a European perspective—from the Spaniards of the sixteenth century to the scholars of the present—have had great difficulty distinguishing between gods and human beings, and the tendency from the beginning has been to see almost all figures as gods even though the art makes clear distinctions between creatures of myth and those of the natural world, distinctions that we have seen in Olmec art and that we will discuss at length in our discussion of the mask in ritual. In the case of Oaxaca, this difficulty is compounded by the fact that little is known about Zapotec religion before the Conquest. No codices survive, and the basic sources of the little information we have are the reports of the Spanish friars of the sixteenth and seventeenth centuries, among which are to be found lists of what the friars took to be gods. Unfortunately, it now appears that the friars confused two very different spiritual categories. On the one hand, there were the composite beings, such as the rain god, symbolizing forces originating in the world of the spirit. These composite beings were involved in myth and ritual throughout the area, as the widespread representations of Cocijo, for example, suggest. On the other hand, each local area had deified the ancestors of local leaders, and there were, of course, a multiplicity of such "deities" in the valley at any given time.

Using one of the lists of the friars as a guide and creating new categories, that is, new "gods," when they needed them, Caso and Bernal in their monumental 1952 classification of the urns, *Urnas de Oaxaca*, attempted to identify the figures on the urns, figures they assumed were gods. The result was a large number of so-called gods, many of them no doubt actually deified ancestors, a number that has grown larger as more urns are studied. In his 1966 study that categorizes urns not recorded by Caso and Bernal, Frank Boos says that by that time "the figures . . . appear to fall into 44 primary categories [most of them gods], which at once subdivide into 138 subcategories."[105] Truly a bewildering variety of gods. But taking into account the results of recent scholarship makes it clear that we must distinguish, as we did with Olmec sculpture,

between those urns that depict composite masks made up of features taken from a variety of natural creatures, that is, masks representing creatures of myth, and the urns that depict human beings either unadorned or wearing elaborate symbolic regalia.[106] In our discussion of the symbolic masks that are the gods of Monte Albán, we will concentrate on the urns, and related art, that depict the composite masks—the fantastic creatures of Mesoamerican myth.

And on such urns no god was depicted more often than Cocijo. The earliest depictions of his characteristic mask, in the period from 500 to 200 B.C., designated Monte Albán I, establish the basic characteristics that remain constant to his representations in the last phase of Zapotec development before the Conquest. The urns of Monte Albán I indicate clearly the Olmec influence, but research has shown that this influence was the result of a conscious revival of a style adopted by the earlier village cultures rather than the result of a continuing tradition. The period of Olmec contact was roughly from 1150 to 850 B.C., and after that time, the use of Olmec symbolism in the art and ritual of the Valley of Oaxaca waned for several hundred years[107] until, by the beginning of Monte Albán I in 500 B.C., Olmec symbols are no longer found. However, such symbolic Olmec forms as were-jaguar mouths and flame eyebrows reappear late in that period at about 300 B.C. "in what must have been a conscious revival" that interpreted these symbols in ways indigenous to the Valley of Oaxaca on ceramic objects completely uncharacteristic of Olmec forms. As John Paddock puts it in discussing three such pieces, "somebody in the Valley of Oaxaca had a total understanding of Olmec style in a cultural setting that was no longer Olmec."[108] The transition from the Olmec were-jaguar rain god to Cocijo had been made. And this transition marks an important point in any study of the development of the rain god in Mesoamerica; we now have, for the first time, a name for that supernatural concept.

An examination of one of the earliest Cocijo urns (pl. 14), a marvelously simple, beautiful realization of the essential form, shows clearly the Oaxacan reinterpretation of the Olmec heritage.[109] The general appearance of these early Cocijo is very similar, for example, to San Lorenzo Monument 52 (pl. 4), our Rain God CJ. Both are easily distinguished from representations of human beings by their pudgy, relatively rectangular, and frontally flat faces surmounted by similarly shaped headdresses with incised symbolic markings. In both, the ears, eyes, and mouth are emphasized by their symbolic treatment, but the most immediately apparent similarity is the mouth; Cocijo's protruding upper lip surmounted by a pug nose graphically indicates his were-jaguar origins. But this feline

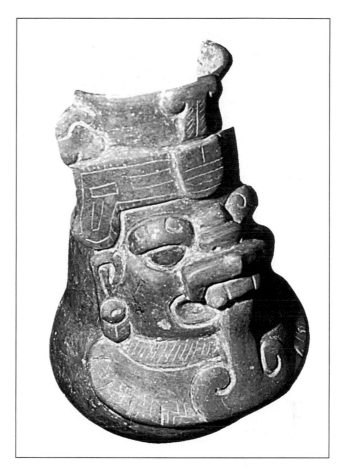

Pl. 14. Cocijo, funerary urn, Monte Albán I (Museo Nacional de Antropología, México).

mouth is different in two respects. First, it has teeth, but not the fangs often seen in Olmec representations. These protrude, in the manner of human buckteeth, directly under the extended lip. A far more striking difference, however, is the exaggerated bifid tongue that emerges from just under those teeth. This is the tongue of a serpent and marks the beginning of the association of the serpent with the jaguar in a mask symbolizing rain.[110]

And there are other differences as well. Even this early Cocijo has notably non-Olmec eyebrows, which in the course of the development of Cocijo's mask through the centuries, evolve into a Tlaloc-like "goggle" form, perhaps due to the influence of Teotihuacán. These early eyebrows are rather crescent shaped and puffy and carry an incised design suggesting the bifurcation of the tongue. The headdress, too, is distinctly non-Olmec in shape and in the designs incised on it. The central design is a rudimentary glyph C, a common feature of Cocijo headdresses and a widely used symbol in Zapotec art. Although neither the meaning nor the referent of the glyph to the Zapotecs is at all clear, in its earliest form, the form suggested here, it seems to depict a vase "seen in cross section and having a

horizontal band . . . often decorated with undulations that represent water"[111] and suggest the serpent. This would seem a fitting design for a rain god, and the fact that Caso and Bernal, at least, see that design as evolving into a stylized jaguar mouth[112] makes it all the more fitting. Seemingly rising from the glyph is another repetition of the bifurcated tongue element, this time with the implied cleft in the tongue at the same spot as the cleft in the headdress of the Olmec Monument 52 and all the other cleft-headed were-jaguars. While the facial configuration and the mouth of the Olmec were-jaguar remain, the tongue of the serpent has now appeared on the mask of the rain god, creating a link between the jaguar and the serpent which was to endure.

But why connect the serpent to rain? Some of the reasons are obvious. As Seler points out, the serpent's "peculiar form and mode of locomotion" suggest water and lightning,[113] as is made clear by the use of an undulating line to represent both water and the serpent in Mesoamerica generally and in the Valley of Oaxaca specifically and by such concepts as the fire serpent carried by the Tlaloc of the highland Mexican cultures which represents lightning.[114] Lightning is no doubt suggested by the way the serpent strikes its prey, but it is also traditionally connected with the flickering tongue of the serpent, and it is, of course, precisely that tongue that is the symbolic detail used in the mask of Cocijo. Beyond these fairly obvious connections, however, another stands out clearly. As we will demonstrate in Part II, the logic underlying blood sacrifice involves reciprocation, in this case the provision of mankind's most precious fluid, blood, to the gods in ritual reciprocation for the provision of their most precious fluid, water, to humanity. Just as water sustains life, blood symbolizes life. And as the blood in the form of snakes rising from the necks of both the massive decapitated Aztec Coatlicue (pl. 9) and the decapitated ball players depicted on the Lapida de Aparicio and on the reliefs of the ball court at Chichén Itzá, for example, reveal, the snake symbolized the blood of life to the Mesoamerican mind. Thus, the serpent represents sacrificial blood, the mythic equivalent of the rains.

But there is still another, quite different, way in which the serpent's shape contributed to its symbolic connection with rain. In Mesoamerica, as elsewhere in the world, the serpent is vitally linked to the earth's fertility, and that fertility, of course, depends upon rain. The serpent's phallic shape and its entrance into the female earth both suggest the human sexual metaphor through which agricultural fertility was symbolically rendered, and that phallic suggestion is made even stronger by the use of the tongue, another common symbol for the phallus, as the symbolic reference to the snake on

the Cocijo mask. And more fascinating is the fact that this is a bifid, or cleft, tongue, a detail commonly exaggerated on the Cocijo masks which coincides nicely with the female sexual connotations of the cleft in earlier Olmec art. Thus, the cleft tongue in itself brings together fundamentally male and female sexual symbols in a mask symbolically related to fertility, and that tongue reinforces, then, the symbolic connection of the serpent to sexual, and thus agricultural, fertility. Just as the "opposed" male and female principles are united on the symbolic tongue, a union that in nature creates new life, so the Cocijo mask unites the "opposed" worlds of spirit and matter to provide the sustenance for that life.

Very closely related to the sexual metaphor with its emphasis on the creation of life is the serpent's shedding its skin to be "born anew," a rebirth mythically analogous to the seed's sprouting to renew the earth's vegetation with the coming of the rains. In the serpent, Mesoamerican man could see the endless cycle of existence: first death, but then rebirth as the orderly cosmic processes sustained his individual life through the annual renewal of his sustenance, the corn, which was symbolically man's flesh, the mythic equivalent of life itself. What Heinrich Zimmer says of Indian spiritual thought is equally true of Mesoamerica: "the serpent is life-force in the sphere of life-matter. The snake is supposed to be of tenacious vitality; it rejuvenates itself by sloughing off its skin."[115] That Mesoamerican mythic thought was aware of this symbolic dimension of the serpent is apparent in the Aztec hymn to Xipe Tótec which uses the snake metaphor in exactly this way. The hymn says that "the fire serpent hath been made a quetzal serpent."[116] As Pasztory points out,

the fire serpent, Xiuhcóatl, signified the dry season, and this mythical beast was believed to carry the hot, daytime sun across the sky; the quetzal serpent, Quetzalcóatl, is a metaphoric reference to the earth covered by a green mantle of vegetation in the rainy season. Xiuhcóatl and Quetzalcóatl were gods rather than mythical creatures, two visual metaphors that illustrated the alternating seasons in time and the transformations of the earth's surface.[117]

And both, of course, were linked to the snake, *cóatl*, and to the ultimately spiritual process that guaranteed fertility. It is no doubt also significant that this line occurs in the hymn to Xipe Tótec, Our Lord the Flayed One, in whose ritual priests donned the flayed skins of sacrificial victims to become the metaphorical equivalent, as is the snake, of the dead seed that carries new life within it (see below).

The metaphorical use of the snake to suggest rebirth was not limited to the Valley of Mex-

ico. Merle Robertson's study of the Maya art of Palenque reveals a similar metaphor at work. At Palenque,

> red seems to have represented the living world, the world of humans and the environment in which they lived. Certain parts of serpents were assigned the color red—scales, teeth, tongue and sometimes beards. This may have been because these were considered the "humanlike" living parts of serpents that die or are shed, and then are renewed (reborn) by the growing of new parts.[118]

Perhaps not coincidentally, red is fundamentally related both to Xipe who was for the Aztecs the red aspect of the quadripartite Tezcatlipoca and to death, as the red pigment, often cinnabar, lavishly spread over burials throughout Mesoamerican history attests. And as if to underscore the connection between the serpent and the rebirth that follows death in the endless cycle of life, the ceramic tube connecting the womb-shaped tomb of Pacal in the Temple of Inscriptions at Palenque to the temple above is "both an umbilical cord proclaiming the lineage rites and a serpent."[119]

It is important to remember that all of these symbolic uses of the serpent to suggest renewal through a series of metaphors related to the emergence of life from within the womb, the seed, or the dead skin exist within a mythological tradition that uses the mask as a metaphorical means of emphasizing inner/outer, spirit/matter oppositions at every turn. Within such a tradition, it is no surprise to find the snake playing a vital symbolic role. Turner speaks of snake symbolism elsewhere in the world as one means of representing "logically antithetical processes of death and growth" which he characterizes as "liminal: that which is neither this nor that, and yet is both."[120] And a fascinating hint that Mesoamerican snake symbolism relates precisely to the liminal point at which life and death, inner and outer, spirit and matter come together is the fact that the part of the snake chosen to represent the creature as a whole is the tongue, exactly the part that emerges from within the body and the part that functions, in human terms, most significantly in the speech that allows the communication of inner realities to the external world. In Mesoamerican art, tongues and speech scrolls frequently emerge from mouths; they are the inner made outer in the same symbolic way that the mask makes inner reality visible by placing the inner, true face over the outer, physical face.

The liminal role of the snake in Mesoamerican symbolism is no doubt partially the result of its being an anomalous creature, one that is difficult to fit into the categories into which human beings divide the living creatures of the world. For this reason, among others, it has universally provoked the awe that allows it to function as a sacred symbol.[121] For Christians, of course, it is the epitome of evil, and in its ability to penetrate into the earth, it suggests Satan and the nether regions. In pre-Columbian Mesoamerica, however, its anomalous character suggested the whole of the spiritual realm, both the netherworld and its complementary opposite, the heavens, as Quetzalcóatl, for example, indicates. Nowhere is the snake's symbolic role in linking the earth's surface to the enveloping spiritual realm made clearer than in the great serpents that flank the stairways of pyramids at Teotihuacán's Ciudadela and Tenochtitlán's Templo Mayor and in those serpents that flank the doorways of temples at Chichén Itzá and presumably did so at Tula. Just as the pyramid stairway joins earth to heaven and the temple doorway links the surface to the heart of the earth, so the serpent symbolizes man's ability, through mythic art and ritual, to move from the surface of the earth to these spiritual realms, the ultimate source of his life on earth.

For all these reasons, the snake is the fitting companion to the jaguar in the mask of the rain god. For the peoples of the highlands, the rattlesnake, in particular, can be seen as the equivalent of the jaguar in the lowlands. Each represented in its environment that aspect of nature beyond man's power to control by normal means, the reason, no doubt, for the Zapotec's seeing the snake as a particularly disastrous omen.[122] As Ruz points out, "the deification of the serpent is easy to understand in regions where this animal abounds; the fear inspired by the deadliness of its poison, and in spite of its fragile aspect, the silence and quickness of its movements, all suggest a supernatural power."[123] Thus, the snake, like the jaguar and ultimately the rains, represents a disruptive force that man cannot control through normal means, a force that can only be brought into harmony with man's life in culture through myth and ritual. That fusion, as we have shown above in the case of the jaguar, is accomplished symbolically by constructing a mask made up of the features of man and serpent which unites those opposed forces in a representation of the harmony ultimately found only in the world of the spirit. Through the mask man can transcend nature and participate in the force that alone can control snake, jaguar, and rain.

We can now return to our consideration of the urns representing Cocijo with an understanding of the significance of the serpent's tongue emerging from the mouth of the mask, but while that symbolic tongue remains a constant part of Cocijo's features, other symbolic details are transformed to create a number of variations on the basic theme enunciated by the mouth. The headdress, for example, exists in a number of forms, the most common of which displays the glyph C. At times, the glyph has what might be interpreted as two streams of water flowing from the top of the vaselike form in what is probably a visual reference to the pan-

Mesoamerican notion that the rain is stored in great urns from which it is spilled onto the earth, a reference repeated in varying forms in connection with the rain gods of all the Classic period cultures. These streams are often superimposed on a background of plumes (pl. 15) that, especially in the light of a similar use of plumes in connection with a serpent face during the same period of time at Teotihuacán, are a tantalizing suggestion of the plumed serpent that is directly related in the Valley of Mexico to the storm's winds that sweep the roads clear for the coming of the rains and thus to fertility. Other Cocijos wear a simple, hatlike headdress also found on many other figures represented on the urns. It is often incised with striations and sometimes bears a glyph. Still others have headdresses bearing corncobs and, perhaps, stylized representations of parts of the corn plant which rather obviously refer to a particular aspect of Cocijo's function.

The treatment of the eyes also varies somewhat but not as significantly as the headdress. Most Cocijo masks have eyes bracketed by U-shaped elements underneath and similar elements, raised in the center to form a stepped fret, as eyebrows. The eyebrows may well be a stylization of the bifurcated tongue design on the puffy eyebrows of the early urn we examined above and thus a continuing reference to the serpent qualities of Cocijo. It is also quite possible that the bracketing of the eyes on the Cocijo mask is related to the so-called goggle eyes of Tlaloc, a motif also related to the serpent. But a similar treatment of the eyes of relatively realistic jaguars from the Valley of Oaxaca suggests the alternative possibility of were-jaguar symbolism in this element. There are slight variations of the basic theme: occasionally, the outer edges of the lower brackets are hook-shaped, a motif found on other urn figures as well. In fact, virtually all the masks of the figures representing the gods on the urns of the Valley of Oaxaca have one variation or another of the basic bracket pattern, and the symbolic significance of this is made clear by the consistent occurrence of a particular variation with a particular type of mask. In this case, the stepped fret of the top element occurs generally on Cocijo masks and not on others.

Thus, the existence of the basic mouth in connection with a limited number of variations in eyes and headdress, as well as in pectorals and costume, reveals the fundamental debt of the peoples of the Valley of Oaxaca to their spiritual ancestors on the Gulf Coast. Following the Olmec lead, they developed a system for symbolizing their gods, that is, the forces emanating from the world of the spirit, by combining a relatively small number of symbolic traits as facial features in a mask that delineates the spiritual forces underlying and sustaining the natural world. Varying those features through the range of their possible combinations

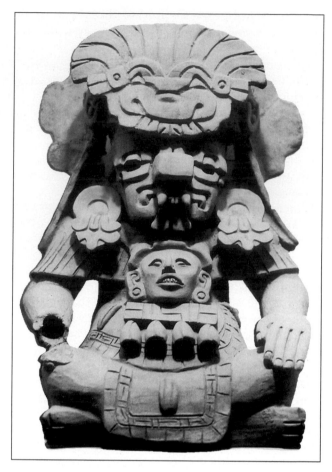

Pl. 15. Cocijo wearing a Glyph C headdress, funerary urn, Monte Albán III (American Museum of Natural History, New York).

made it possible to specify the particular aspect of the spiritual force in question—in this case, the provision of water to sustain man's crops and his life—and thus to communicate with a great deal of precision information about man's relationship to the gods. The Cocijo urns thus comprise a system with "a set of attributes (e.g., water, corn, lightning) that define the supernatural force or set of forces depicted."[124]

It is clear that this system was fully developed quite early in the history of the Zapotec culture of Monte Albán since its basic symbolic features changed very little over the thousand-year development of that culture despite the fact that the style of the urns changed dramatically, reflecting the changing society; as the society became larger and more stratified, religious symbolism became more conventional and more ornate.[125] As Covarrubias puts it, the simple vases of Monte Albán I (pl. 14) became "increasingly more elaborate in period II, majestic and imposing in size and design; becoming more and more ornate and formalized in period III; reaching a frankly baroque flamboyancy that sinks suddenly into complete decadence in period IV."[126] It is no doubt more than coincidental that the point of most abrupt change which occurred

between periods II and III was also the time of Monte Albán's most significant contact with Teotihuacán.[127] But even though that influence may well have affected the style of the urns, the fundamentally Zapotec symbolism embodied in the mask of Cocijo changed very little.

Although there is no question that that symbolism was fundamentally related to rain, it is evidently true that Cocijo was a god of the lightning that the Zapotecs saw as the operative force in splitting the clouds to release the needed rain.[128] That concept of an operative force, with its clear implications of creative power, may explain the close relationship between Cocijo and the earthly rulers of the Zapotec people. The power these rulers wielded was derived from the gods, and upon their death, they "became gods" through whose mediation mortal men could approach the essence of divinity.[129] Such a conception of rulership no doubt accounts for the great number of urns depicting human beings wearing headdresses displaying the mask of Cocijo, a way of displaying a mask in ritual regalia which we saw earlier with the Olmecs and one which we will explore at length in our consideration of ritual mask use, and for the incorporation of the name of the rain and lightning god in the names of some of the rulers.

Cocijo's power and significance is also demonstrated in his close relationship to the calendar that charted the motion of time, a motion directly revelatory of the essence of divinity to the Mesoamerican mind. In the Valley of Oaxaca, both the 365-day solar calendar and the 260-day sacred calendar were divided into units designated with Cocijo's name. The solar "year could be divided several ways, the most common being a contrast between a dry season, *cocijobàa*, and a rainy season, *cocijoquije*." In this case, the reason for the designation *cocijo* seems clear since the distinction between the seasons relates to rain, but "the term *cocijo* was also used for units of the *pije* [the 260-day calendar], but in this case the division was into 4 *cocijo* of 65 days each."[130] This division seems to have no obvious basis in Cocijo's function as a rain god, and for that very reason it reveals clearly the power attributed to him: just as he was the operative force in providing the rain, he was also the force that moved the calendar, that is, time, through its endless cycles, a fundamental relationship to time shared, as we shall see, by Tlaloc. And Cocijo, like all of the rain gods of the Classic and Postclassic cultures of Mesoamerica, was quadripartite—mysteriously one and four simultaneously. Interestingly, this concept is given symbolic form in ceramic pieces with Cocijo attached to four or five linked vessels that suggest visually his quadriplicity with the fifth vessel, when present, marking the center position of the quincunx.[131] As the calendar divisions suggest, he was the force of time and its periods as well; he was

the essence of life and its existence in time and space; he was the one and the many. A number of qualities of the Olmec rain god suggested precisely this quadriplicity, and it is significant that the first descendant of that Olmec ancestor manifests it so fully and strongly.

Thus, the mask of Cocijo symbolically unites diverse elements from the world of nature to suggest the attributes of one of the fundamental supernatural powers through which that natural world exists. The significance of that supernatural force to the Zapotecs is clearly indicated both by the tremendous number of Cocijo representations created by them in their long history and by the fact that the basic symbolic form stayed virtually the same over that time span while both the form of the society and the style of its religious art changed tremendously.

THE MASK AS METAPHOR
The Teotihuacán Tlaloc

When we turn from the Valley of Oaxaca to the Valley of Mexico, we move from the realm of Cocijo to the territory of Tlaloc, his younger but far better known "brother." While representations of Cocijo are found as early as Monte Albán I (500–300 B.C.), no full image of the mask of Tlaloc has been found before the Tzacualli phase at Teotihuacán (A.D. 1–150). Significantly, that first, almost sketchlike image appears on an effigy urn,[132] numerous examples of which are found in the archaeological record throughout the history of the Valley of Mexico. Often associated with burials, these urns no doubt had a ritual function since they are similar to those frequently depicted in the hands of painted and sculpted images of Tlaloc; in these depictions, the urns are the containers from which the waters are dispensed by the god, an obvious visual reference to the pan-Mesoamerican mythic attribution of the rains to the urns of the rain god. It is a measure of the fundamental importance of the concept being represented that this early "sketch" reveals, except for its lack of fangs, the mask's essential symbolic configuration, which was to remain the same, in form as well as meaning, through violent social upheavals for 1,500 years until the Conquest and which, we suggest in the final section of this volume, continues to exist in somewhat modified form even today. Thus, that mask of the rain god we call Tlaloc, its Aztec name, "clearly constitutes one of the most generally accepted cases of long-term iconographic continuity in pre-Hispanic Mesoamerica. Nearly every student appears to regard the earlier images [i.e., those of Teotihuacán] as directly ancestral to the historic Tlaloc" identified by the Spaniards at the time of the Conquest.[133]

As with Cocijo at Monte Albán, the essential

features of Tlaloc coalesced to form that composite mask during the transition from the Preclassic to the Classic period, a stage marked

> in central highland Mexico . . . by the coming of age of the largest city of pre-Columbian America, Teotihuacán. It was the dominant political and religious center in the Basin of Mexico for more than five centuries, during which time it exerted far reaching influences that radiated in various directions over ancient trade routes as far as the Maya area.[134]

The development of that city and its far-flung relations with other areas of Mesoamerica is fundamentally bound up with the symbolic elaboration of the mask of the rain god which moved over those trade routes to appear throughout Mesoamerica[135] as the symbol of Teotihuacán, which was "emphatically the city of Tlaloc."[136] Like Cocijo, Tlaloc was essentially related to lightning and through lightning to both power and the orderly passage of time, as the central image of the god we will discuss demonstrates. Holding a flowing urn displaying the mask of Tlaloc topped by the year sign in one hand and a lightning symbol in the other, he effectively relates sustenance, time, and power in a single compelling image. Through the mask of that god, the massive material entity that was the city thus acknowledged its indebtedness to the world of the spirit, which provided both the order and the sustenance through which its life was maintained.

That Tlaloc can be seen to have been symbolically and conceptually, although not visually, identical to Cocijo strongly suggests their common derivation from an Olmec model, and there are other strong suggestions of Olmec influence at Teotihuacán. "One cannot avoid the impression that in many respects, particularly the abundance of shells and other coastal symbols, the entire Teotihuacán complex was in a sense what might be termed 'Gulf oriented'" as a result of the Olmec "inspiration,"[137] but the precise way in which that inspiration manifested itself in the transition from the Olmec were-jaguar through the village cultures to the Tlaloc of Teotihuacán, often associated symbolically with those "shells and other coastal symbols," is not completely clear. As we have shown, the Olmecs, through relations based fundamentally on trade, exerted a profound influence on those village cultures, an influence that in Oaxaca resulted in the fusion of Olmec with indigenous beliefs and iconography in general and in the development of the Cocijo mask in particular.

There is some evidence of similar developments in the art of the village cultures presumably responsible for the development of the urban center of Teotihuacán:[138] a number of images suggest the Olmec were-jaguar and prefigure the Tlaloc mask. A late Preclassic "proto-Tlaloc effigy" urn from Tlapacoya,[139] for example, displays a distinctly Ol-

mec mouth, a result of the Olmec influence in the middle Preclassic.[140] And, as Grove points out,

> a Middle Preclassic goggle-eyed Tlaloc face exists among the paintings at Oxtotitlán cave. A more tenuous example occurs at the extreme top of the Cerro de la Cantera, Chalcatzingo, while several other Tlaloc paintings, also possibly Middle Preclassic, exist at the same site, . . . suggesting that the goggle-eyed Tlaloc visage is part of the indigenous altiplano belief system which in the Middle Preclassic had fused with the [Olmec] belief system penetrating into the altiplano from the Gulf coast.[141]

The coexistence of such Tlaloc-related images with clearly Olmec art at each of these sites marks a point of fusion of the Olmec were-jaguar with the indigenous god-mask since none of the Tlalocs are full representations of the later mask[142] and since the Olmec were-jaguar does not exist in highland art after this period. The bulbous or "goggle" eyes, probably a symbolic feature indigenous to the Valley of Mexico or the result of Zapotec influence, which Grove sees as characteristic of Tlaloc's mask, are also found on the composite masks of other gods at Teotihuacán, indicating that they do not identify Tlaloc unless they are present on a mask with Tlaloc's mouth, a mouth clearly derived from the Olmec were-jaguar.[143] Thus, the Tlaloc mask exemplifies the fusion of indigenous and Olmec motifs, but it also illustrates the complexity of the iconographic systems involved.

And there is another form of complexity that makes understanding the development of the mask of the rain god in the Valley of Mexico difficult. While the art of Teotihuacán with its constant visual references to water surely indicates that "the cult of the rain god was supreme,"[144] not all of the masked figures associated with water and fertility in that art are clearly Tlaloc, although some have features more closely related to the Tlaloc mask than others. The situation has provoked the predictable controversy among Mesoamericanists. Many scholars, especially those in Mexico, hold to the view that all iconographic motifs related to water are also related to Tlaloc. This includes such seemingly diverse elements as "the jaguar, serpent, owl, quetzal, butterfly, bifurcated tongue, water lily, triple-shell symbol, spider, eye-of-the-reptile symbol, cross, and the year sign."[145] Kubler, despite his unwillingness to identify these traits by the Aztec name Tlaloc of over a thousand years later, holds a similar view. At Teotihuacán, he says, "the rain-god cluster is most common, with five or six variants in the representation of the deity, under reptile, jaguar, starfish, flower, and warrior aspects."[146] Pasztory, however, has suggested that such all-inclusive categories "are cumbersome in their breadth."[147] As she demonstrates in her study and as we will demonstrate in a somewhat different way below, it is possible to be more precise:

there is a particular mask with a particular combination of features which can be identified as the essential Tlaloc.

But it is not a simple matter of agreeing with Pasztory and disagreeing with Kubler and the Mexican scholars. The complexity arises from the fact that both are correct. In the case of the rain god, for example, a particular image fusing symbolic references to all of the facets of the world of the spirit for which his mask stands as the metaphor can be identified as central to the grouping of images of Tlaloc to be found in the art of Teotihuacán, but, significantly, there are many variants of this essential Tlaloc mask, all of which were no doubt seen at Teotihuacán as aspects of the god. These aspects of the unitary Tlaloc as well as the aspects of the other gods of Teotihuacán were depicted in stone carvings, ceramics, and paintings, but nowhere were they more beautifully detailed and colorfully rendered than in the murals decorating the inner and outer walls of the city which delineated the full spectrum of the supernatural as it existed for the Teotihuacanos. Of course, relatively little of that spiritual art has been preserved; we must try to imagine its magnificence from the fragments remaining.

For the citizen of Teotihuacán, that spectrum filled his every waking moment, and no doubt his dreams as well, since the city in which he lived was literally covered with painted murals and relief carvings depicting the masks of the gods and symbolically arrayed priests enacting rituals dedicated to those gods, paintings that adorned the inner walls of the apartment compounds and temples as well as the facades of buildings and pyramids. The most magnificent lined Teotihuacán's *Via Sacra*, the north-south Avenue of the Dead lies in front of the Pyramid of the Sun and connects the Ciudadela at the heart of the city with the Pyramid of the Moon and the Quetzalpapálotl Palace. Along this mural-lined, sacred avenue, which, as we will explain, expressed in its orientation the relationship between man and god by symbolically becoming the vertical axis that joined the world of man to the enveloping world of the spirit, the ritual processions of masked performers, symbolically costumed priests, and musicians with flutes, horns, and drums often made their way. The fragments of the murals that remain allow us to imagine the spectacular beauty and profound significance of those processions in that sacred space. At the height of its magnificence and power, Teotihuacán must truly have seemed the city of the gods that the Aztecs, its distant heirs, thought it had been. And Tlaloc, depicted in those murals in all his varying aspects, was chief among the gods of that painted city.

All that remains of that beauty and significance are the fragmentary murals,[148] but even in their present state they suggest the vitality of the spiritual thought embodied in them by their creators and their function as the "channel of communication" of that thought from the priests to the populace.[149] "Every wall is, as it were, a page out of a unique and splendid codex," which, were it intact, would "hold the key to the spiritual structure of Mesoamerica," according to Séjourné.[150] But unfortunately that "mural codex," as we might call it, is not intact. And even if it were, we would have great difficulty reading its images since they lack even the glyphic notations that accompany the images of the Maya. Lacking such explanatory glosses, we must try to understand the system underlying these images, their organizing principle, which alone can enable us to understand the relationship between them as the Teotihuacano would have, even though we can never hope to understand them in all the intricate detail meaningful only to the initiate. Interestingly, Kubler approaches the Teotihuacán mural codex in exactly this way.

> Within each mural composition, a principal theme or figure is evident, enriched by associated figures and by meaningful frames suggesting a recital of the powers of the deity, together with petitions to be granted by the god. We can assume that the images of Teotihuacán designate complex liturgical comparisons, where powers, forces, and presences are evoked in metaphors and images.[151]

He suggests that these metaphors and images be grouped thematically to reveal their full significance, a principle that, when coupled with Pasztory's identification of specific images as central to the symbolization of particular gods, provides something like the key Séjourné mentions and indicates the extent to which the mask did function as the central metaphor in the thought of Teotihuacán. Thus, we can identify a particular mask that expresses symbolically the full range of "powers" associated with a specific god as the central image of the god and use it to understand the numerous variant forms that address particular aspects of that full range of power.

Each of the "gods" of Teotihuacán is thus really an elaborate system of god-masks in which each particular mask delineates an aspect of the supernatural continuum identified by the name of that god. The system that is each god is embodied visually in the series of variations of the central mask achieved through the permutation of several symbolic features through the range of their possible combinations, the archetypical Mesoamerican method of systematizing spiritual reality seen in its clearest form in the calendrical systems. Together, all of these variant forms must have been combined in the Teotihuacán imagination to form one mask, the true mask of the god, its essential form that could exist only in the mind—the embodiment within each human being of the world of

the spirit. Just as the multiplicity of being in the world of nature had its source in a spiritual unity and could only be fully understood in terms of that unity mysteriously existing in and through the multiplicity of the created world, so the mask of the god was imagined as a unity but depicted in all its variant forms in an attempt to capture in paint, stone, and ceramic the fullness of that elusive spiritual conception. The mask embodying the "central image" of the god was the closest actual image to the conception, which by its very nature could exist only in the minds of the seers of Teotihuacán.[152]

The first task facing anyone who would understand the Teotihuacán conception of Tlaloc, then, is the identification of a central image of the god in the art of that city. As we suggested above, Pasztory has identified that central mask by working backward from the masks we know were Tlaloc, those Aztec representations identified as such by the Spanish at the time of the Conquest. Following Hermann Beyer,[153] she selects as representative of the god those images of Tlaloc on page 27 of the Aztec-era Codex Borgia (colorplate 1), figures that have "goggled eyes and curving upper lips with fangs, who from one hand pour water from effigy vessels representing themselves and in the other hold an adze and a serpent representing lightning."[154] The images on this page of the codex serve nicely to identify the essential Tlaloc since they relate the god both to water and to the cyclical movement of time, a connection always fundamental to the rain god of the Valley of Mexico. There are five differently costumed Tlalocs, one in each corner and one in the center, which illustrate the Mesoamerican identification of time and space since, seen as a spatial image, they depict each of the four directions and the center. But seen as a temporal image, they depict each of the four points in the daily cycle of the sun and the center around which the sun symbolically moves (see p. 121). The temporal interpretation is further strengthened by the function of this page within the codex which, according to Seler, is to represent the quadripartite divisions of the 260-day sacred calendar and of the 52-year cycle[155] and thus to establish an order for the ritual life of the society. These images, then, in bringing together rain and the orderly passage of time, illustrate the Mesoamerican view of the essential order of the universe through which man's life was maintained and on which man's ritual life must be patterned. These are certainly among the most significant images of Tlaloc in Mesoamerican spiritual art, and we will return to them below in our discussion of the Aztec concept of the god.[156] It is therefore a remarkable, almost incredible, indication of the great significance of this particular image of the god that there are iconographically equivalent figures in the Teotihuacán murals painted a thousand years earlier and equally re-markable that actual effigy vessels, such as the vase we mentioned above from the Tzacualli phase, similar to those held by the Tlalocs of the murals and codices, appear continuously in the archeological record of the Valley of Mexico from the time of Teotihuacán to the Conquest.

If, at the height of Teotihuacán's glory a thousand years before Aztec priests were using the Codex Borgia's esoteric lore for divination and prophecy, we were to have wandered into the apartment compound of Tetitla not very far from the center of the city, we would have found that same image of the masked figure of Tlaloc painted on the lower register of an inner wall near the ceremonial patio of the complex containing the small pyramidal altar, or *adoratorio*. The image is still there today (colorplate 2a) although the painter, priests, and worshipers are gone, as are the beliefs that bound them together in their ritual activities in that sacred space. Séjourné, who directed the excavation of Tetitla, calls that image a Lightning Tlaloc[157] because it holds in its right hand an undulating spear prefiguring the lightning serpent of later times held by the Codex Borgia Tlalocs. Its left hand clutches an effigy urn with a mask identical to that of the figure holding it, an urn like those from which water pours in other Teotihuacán images. Though the masks are the same, the headdress surmounting the mask on the urn differs from that of the figure holding it in being "a stylized year sign" made up of "a rectangular panel topped by a triangle between two volutes."[158] This clearly connects this Tlaloc symbolically with the orderly movement of time and, again, with the Codex Borgia Tlalocs as well as with other Aztec Tlalocs who often wear a similar headdress. The headdress worn by the figure holding the effigy vase is mostly gone now, but what remains suggests the plumed headdress with a rectangular headband often seen on Teotihuacán figures related to fertility.

All of these features, however, find their true significance in the mask-face they frame, and the most striking feature of that mask is the mouth with its curving, pronounced upper lip reminiscent in its prominence and stylization of the Olmec were-jaguar. Under the lip, the gum protrudes and from it come five fangs, the two outer ones long and curving back, the three center ones shorter; that these are the fangs of the jaguar is made clear in the numerous depictions of jaguars with similar fangs in the mural art of Teotihuacán. From beneath the fangs, in place of a tongue, emerges a stylized water lily with a flower bud on either side, a symbolic motif common in the art of the Maya and one that, by its trilobed form, suggests the bifurcated tongue of Cocijo, a tongue that is, in fact, found on other Teotihuacán images of Tlaloc which lack the water lily. While that tongue is clearly the tongue of the serpent, it is also depicted

THE METAPHOR OF THE MASK IN PRE-COLUMBIAN MESOAMERICA

in the art of Teotihuacán on the figures of jaguars, thereby suggesting again the symbolic relationship between those two creatures. Thus, the water lily and tongue motifs relate Tlaloc to the Olmec rain god in their jaguar connotations but also to his Maya and Zapotec analogs through the Maya water lily and Cocijo's serpent tongue.[159] On either side of and slightly above the mouth are the exaggerated ear flares composed of two concentric circles which are depicted on long, narrow ear coverings attached to the headdress, ear coverings similar to those worn by San Lorenzo Monument 52 (pl. 4), the Olmec Rain God CJ. Still higher than the ear flares and directly above the mouth are the typical goggle eyes of Tlaloc, with what is perhaps the suggestion of an actual eye within them. The "goggles" are also concentric circles and echo visually the ear flares as well as the eyes of the Cocijo mask.

This, then, is the central image of Tlaloc, identifiable by its symbolic reference to the essential powers of the god and to the rain gods of the other cultures to which it is related. It is significant that this particular mask, like many of the other Tlaloc masks in the art of Teotihuacán, has been stylized to the point of depicting only mouth, ears, and eyes—a stylization with enormous symbolic overtones regarding the interaction of the gods with the world of man and nature. Since each of the forms of which it is composed are found separately in the art of Teotihuacán, each of them must be seen as individually symbolic, and their combination in a single mask results in a symbolic statement that is, at least in one sense, the "sum" of those individual meanings. If one feature were changed, as we will show, the statement would be different. Significantly, each of those separate forms making up the mask represents one of the sensory organs through which human beings relate the external reality of nature to their own inner being and, conversely, in speech and through the expressions of mouth and eyes, communicate their own inner realities to the external world. These organs and the signs that represent them in the symbolic art of Teotihuacán refer directly, then, to that liminal point at which inner and outer, matter and spirit merge, a constant symbolic preoccupation of Mesoamerican art for which the mask is the primary metaphor and one often associated, as we have shown, with the rain god. In its stylization, then, the Tetitla Tlaloc serves also as a central image of the god by emphasizing the symbolic features of his mask. It is as close as human creativity can come to rendering "the thing itself," the true image of the god, the precise delineation of that particular meeting place of spirit and matter.

Thus, the centrality of this image of Tlaloc, like that of the Codex Borgia images, results from its bringing together symbolically all of the essential qualities of Tlaloc as we know them from the tradition in which he exists: his role as rain in the provision of sustenance, his role as lightning with its implications of the power of rulership, and his role as the driving force behind the orderly movement of time. But there are countless other images of Tlaloc in the art of Teotihuacán, and those other images are variants of this central one, each, no doubt, with its own precise meaning to the priesthood.[160]

A number of those other Tlaloc images are very closely related to the Tetitla Tlaloc. One of them (colorplate 2b) is crucially and centrally placed in the border between the upper and lower parts of the Tepantitla mural (colorplate 3), which we will discuss at length, and is virtually identical to the Tetitla Tlaloc, with one important difference: instead of holding an effigy urn in one hand and a lightning-spear in the other, this Tlaloc holds in both hands effigy urns from which water flows. This iconographic shift surely suggests a change of emphasis; the Tepantitla Tlaloc is concerned primarily with the provision of rain, an emphasis borne out by the mural as a whole, which is perhaps the most extensive and intricate treatment in Mesoamerican art of a ritual involving the provision of water by the world of the spirit to maintain human life on the terrestrial plane. In addition, a profile view of the same Tlaloc, this time a full standing figure, can be seen on a mural fragment now in a private collection.[161] Since the figure is facing left, the painting emphasizes the effigy urn held facing the viewer in its right hand, and in this painting, it is quite clear that the urn is meant to symbolize a container of rain since we see streams of water pouring from it. Still other images of this Tlaloc exist with varying headdresses and holding various symbolic items in mural fragments at Tetitla[162] and at Zacuala, one of them holding a corn plant in a configuration to be repeated until the time of the Aztecs.[163] Similar Tlalocs are found on ceramic figures and figurines,[164] on painted and molded vessels,[165] and on actual effigy vessels found with burials at Teotihuacán.[166]

While all of these Tlaloc masks have a mouth whose upper lip turns under the two elongated outer fangs to join the lower lip, there is another distinctive Tlaloc mouth treatment that seems visually to be derived from merging those two outer fangs with the upper lip, resulting in a lip that looks rather like a handlebar mustache and is not connected to the lower lip, a common feature of post-Teotihuacán Tlalocs and, in fact, much more like that on the Codex Borgia Tlalocs than is the lip of the Tetitla Tlaloc we and Pasztory see as the central image of Tlaloc at Teotihuacán.[167] From beneath that upper lip extends a row of three or four teeth or fangs, usually straight and of the same length. In some depictions of that mouth, an elongated bifurcated tongue, the tongue of the serpent, emerges beneath the fangs. The serpentine tongue in these images replaces the water lily extending from the mouth of the Tetitla Tlaloc, a substitu-

tion that is no doubt symbolically significant since we know of no Tlaloc image with both a tongue and a water lily. While the water lily seems clearly to relate to the god's provision of water since it is generally found in the context of symbolic allusions to rain, the meaning of the bifurcated tongue is more complex. Pasztory sees it as connected "with water and warfare and [sees] a possible relationship with a sacrificial warrior cult,"[168] primarily because it occurs in the border of a mural at the apartment compound of Atetelco containing warriors and a number of allusions to sacrifice, one of which is a jaguar with a bifurcated tongue, a speech scroll, and what is thought to be a representation of a bleeding human heart just outside its mouth. That this is related to sacrifice seems clear, even though the precise significance of the union of jaguar, serpent, and human heart is elusive.

The connection between the Tlaloc with the bifurcated tongue and sacrifice occurs in other contexts as well, though these contexts are not connected with warfare. That Tlaloc is clearly depicted, for example, on a tripod vessel found in Burial 2 at Zacuala[169] alternating with representations of Xipe, a figure also related fundamentally to human sacrifice, in this case, however, as it is related to fertility. The same mask is depicted on a fragment of another tripod vessel[170] alternating with temples on platforms depicted so as to emphasize the stairway and temple entrance, thereby suggesting the sacrificial ritual that in later times would have taken place in precisely that sacred context. Thus, it seems reasonable to relate the tongue to sacrifice on the basis of these examples since, as we have demonstrated above in our discussion of the mask of Cocijo, the serpent is symbolically related to sacrificial blood in later Mesoamerican art, as the massive Aztec Coatlicue created by the heirs of the spiritual thought of Teotihuacán so impressively demonstrates.[171] It seems likely, then, that the serpent-tongued Tlaloc mask is to be found in contexts associated with sacrificial fertility ritual, and as we have shown, this symbolic connection with sacrifice is but one of many connections between the snake and fertility which are ample reason for providing the god of rain with a serpent's tongue.

That alternation between the serpent's tongue and the water lily is symbolically significant, but even a casual glance at the metaphoric cluster of Tlaloc masks that define the god in the art of Teotihuacán will suggest that that is not the only symbolic variation of the configuration of the mouth of that mask. An interesting example of those variations and their possible meaning can be seen in a series of four different depictions of Tlaloc on *almenas*, or merlons, found in varying locations at Teotihuacán. Designed to line the edges of flat roofs in the manner of battlements, such merlons would have seemed to look down on the ritual ac-

tivity taking place in the patios and plazas beneath them, seemingly an ideal placement for images of the rain god.

The most abstract of the four (pl. 16) is a stylized depiction of only the upper lip, fangs, and tongue of the mask, indicating clearly that that combination, in itself, had a significant symbolic meaning surely related to the mouth's function in expressing the "inner" reality of people and gods. This variant of the mouth has the "handlebar mustache" upper lip with four long fangs, all of them straight, projecting beneath it. A second version (pl. 17), which is somewhat more realistic but still quite stylized, depicts the face of Tlaloc within a starfish, one of many uses of marine life in conjunction with Tlaloc at Teotihuacán to suggest water. Though this mask also has the handlebar mustache upper lip and an exaggerated bifid tongue, the fangs differ from those on the first example; this Tlaloc has the two long, backward-curving outer fangs enclosing three shorter ones of the Tetitla Tlaloc. But it is interesting and perhaps significant that in an almost identical depiction of this same combination of starfish and Tlaloc in the border of a mural in the Palace of Jaguars,[172] the mask, in every other respect identical to this one, has the turned-under upper lip of the Tetitla Tlaloc.

And the mouth with the handlebar mustache upper lip also exists without the tongue, as can be seen on the other two merlons, perhaps the most

Pl. 16. Stylized Tlaloc mouth, relief on a merlon, Teotihuacán (Museo Nacional de Antropología, México).

Pl. 17. The face of Tlaloc within a starfish, symbolic of water, relief on a merlon, Quetzalpapálotl Palace, Teotihuacán (Museo Nacional de Antropología, México).

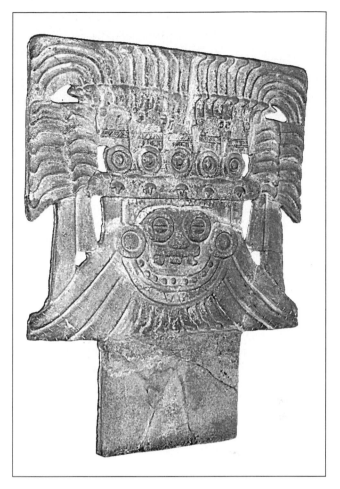

Pl. 18. Tlaloc, relief on a merlon, Teotihuacán (Museo Nacional de Antropología, México).

fascinating of which is the one now in the Teotihuacán museum (colorplate 4) which suggests the face of Tlaloc by displaying "goggles," ear flares, nose, and mouth on a flat surface. The handlebar mustache upper lip in this case has three long, tapering fangs reminiscent of those common in depictions of the rain god in the art of Veracruz. The lower border of the merlon might be meant to suggest a bifurcated tongue, but in place of the tongue is an unusual design suggesting vegetation, perhaps the cornstalk often associated with Tlaloc. Also depicted are the hands of the god, and from these hands drops of water fall to the world of man below, suggesting that this mask's combination of features refers to rain and fertility.

A fourth version of the mouth, somewhat more realistic still, is found on a merlon similarly displaying a headdress, goggle eyes, ear flares, and a beaded necklace (pl. 18). Though the mouth of this mask seems different from that of the preceding Tlaloc at first glance, it is essentially similar. In this version, the upper lip has become a bar, slightly raised at either end to suggest the upturned ends of the more elaborate upper lips, from which descend three short, stubby fangs, the central one

straight, the outer two curved slightly back in what might be seen as a further stylization of the Tlaloc mouth. And the mouth of this Tlaloc has no suggestion of a tongue or vegetation symbol at all. That this extreme stylization of the upper lip is a significant one is suggested by the fact that it is found on both the Tepantitla and Ciudadela masks which we will examine below.

These four Tlaloc masks carved on merlons, then, illustrate clearly the possibilities of variation in one of the features—the mouth—of the Tlaloc mask. The shape of the upper lip can be either turned under or curved up; the fangs, which can vary in number from three to seven, can be straight and of the same length or the two outer ones can be curved back and longer than the inner ones; and there can be a tongue or a water lily or nothing at all protruding from the mouth. A series of Tlaloc masks constructed through the permutation of the variations in each of these three features—lip, fangs, and tongue—through all their possible combinations would be very large, and when one adds the possible variations of eye and ear form, headdresses, costume, and paraphernalia, the number of possible variations of the Tlaloc mask becomes truly mind boggling. Of course, not all of these po-

tential Tlaloc masks exist in the fragmentary body of Teotihuacán art that now remains, but a significant number do, and certainly many more did exist. There are, then, many more masks of Tlaloc in the art of Teotihuacán than we can discuss here. But such a discussion, while interesting, is not necessary since the variation exemplified by the masks we have discussed, all of them clear examples of Tlaloc as almost all scholars would agree, reveals the underlying principle governing the construction and functioning of the mask and costume as vehicles of metaphorical communication in the art of Teotihuacán. Each of these potential masks formed by the permutation of symbolic features of Tlaloc is to be seen as an aspect of the unitary Tlaloc mask that could exist only in the spiritual imagination of the seers of Teotihuacán, an aspect created by combining particular features of the god to make a precise symbolic statement. Thus, it seems clear that if we are to come to an understanding of the spiritual thought of Teotihuacán, we must understand this fundamental principle by which that thought was formulated and communicated.

Such an understanding also enables us to establish the identity of a number of images that, while containing some of the features of the central Tlaloc mask, also contain others so unusual that scholars have not been able to agree as to the identity of the god being represented. The importance of establishing that identity can be seen in the fact that two of those masks are very significant symbolic aspects of the two most important and celebrated works of painting and sculpture at Teotihuacán: the Tlalocan patio mural at the apartment compound of Tepantitla and the frieze decorating the Temple of Quetzalcóatl in the Ciudadela. If we are to understand the complex symbolic meaning expressed by the interrelationship of a number of symbols in works such as these, we must understand first the masks and other symbols of which they are composed and then the symbolic meaning resulting from their combination. The individual masks, like themes in a symphony or characters in a novel, can be understood fully only in the context of the work as a whole. Perhaps because these particular masks were meant to function within such complex works, they are almost unique and therefore occupy a place at the outer limit of the continuum of masks created by varying the symbolic features of Tlaloc and have been difficult to interpret precisely for that reason.

As we have said, the key to resolving the difficulty lies in understanding the underlying principle by which the masks and the figures wearing them are constructed, and that principle is an extension of the method of varying individual symbolic features which accounts for the range of Tlaloc masks. The god we call Tlaloc was actually a series of variations of a central mask, a metaphoric cluster of god-masks, and there were, of course, other clusters of masks constructed in the same way to represent other gods. Just as each of the gods of Teotihuacán is actually a continuum of masks, so the complete system comprised of the totality of these god-masks is also a continuum as one god shades into another, creating the "secondary" masks we discuss below. This shading is accomplished in a variety of ways in the religious art of Mesoamerica, all of them involving the varying of symbolic details of mask and costume, and the two works of art we are now considering exemplify two of those ways.

The most complex of the two is the mural at Tepantitla. Found on the right half of the east wall of the "Tlalocan" patio, "the most sumptuously painted patio in all of Teotihuacán,"[173] this mural is really two related paintings, one above the other, framed and separated from each other by a highly symbolic decorative border. Restored and reconstructed by Villagra, whose copy of the reconstruction can be seen in the Museum of Anthropology in Mexico City (colorplate 3), it is now the most complete one of six such formally similar but probably thematically different pairs that originally decorated the walls of the patio. When one looks at this pair of paintings, it is readily apparent that although the upper and lower paintings are quite different from one another, they are symbolically and visually unified by the images that form a central vertical axis for the composition as a whole.

But a casual glance would find more difference than similarity in them. The upper painting has a large central figure, either a god or an impersonator, wearing a mask and a headdress that displays a bird mask probably representing a quetzal. The figure is depicted frontally either atop or partially obscured by a base or temple platform containing a "mouth" from which streams of water are flowing. From behind the figure, seeming almost to grow from its headdress, rises a treelike form made up of entwined vines or streams of liquid. This central figure is flanked by two priests shown in profile who wear headdresses identical to that worn by the god and from whose hands flow streams of water. Behind the priests, plants, perhaps corn, grow from the streams of water flowing from the mouth in the base in front of or beneath the god. Visually, the "tree," the god, and the base, taken together, dominate the painting so completely that the overall impression is almost that of a painting of a single figure. The lower painting, however, has no such central figure but depicts a large number of small figures seemingly scattered at random over its surface. Although there is a central hill or mountain at the base of the painting containing a symbolic cave or mouth from which two streams of water flow, this painting does not concentrate the viewer's attention but rather diffuses it over the entire painted surface.

Different as the overall effect of the upper and

lower paintings is, a careful look reveals an important visual link between them as the mountain of the lower painting occurs directly underneath the central figure of the upper painting and repeats that figure's triangular form. Although the form of the god is visually more complex than that of the mountain, connecting the small triangle above the eyes of the god's headdress with the edges of the base allows one to realize the figure's essential triangularity. In addition, both the mountain and the god are a bluish gray, and both are depicted on an identical maroon ground. Furthermore, both contain a mouth or cave-shaped form from which flow waters that divide into two streams to form the baselines of their respective paintings. Thus, the repetition of the figure of the god by the upward-thrusting mountain of the lower painting provides a vertical emphasis counteracting the horizontal band created by the frame and bottom line of the upper painting which separates the two.

Strangely enough, however, the band that separates them provides visually the strongest evidence of their thematic connection, for in it, directly between the god of the upper painting and the mountain of the lower, is an image of Tlaloc (colorplate 2b) holding two vases from which flow the streams of water that make up the painting's frame. Virtually identical to the Tctitla Tlaloc, which we have identified as the central image of the god in the art of Teotihuacán, this Tlaloc functions almost as a title indicating the thematic significance of the mural, a theme repeated in the streams of liquid that make up the "tree" and symbolically flow from the hands of the priests in the upper painting and from the cave/mouths of both paintings; in the drops of water falling from the hands of the god and from the branches of the "tree"; and in the fact that the lower painting depicts the paradise of the rain god, the spiritual realm called Tlalocan by the Aztecs.[174]

Taking our cue from that centrally placed Tlaloc mask, when we look again at the vertical axis of the paintings, we see a virtual pillar of masks and mask parts, all of them variations on the theme announced by that central mask. Above the "tree" of the upper painting are two of the many profile views of the central Tlaloc mask which occur in the border framing the pictures.[175] Immediately below the "tree" is the goggle-eyed bird mask displayed in the headdress of the god, and immediately below that is the mask of the god represented by the central figure, a mask quite similar, except for the eyes, to the conventional Tlaloc mask. It is no doubt significant that while the bird mask in the headdress has the goggle eyes generally associated with Tlaloc, the mask of the god does not; or to put it another way, the two masks, taken together, display all of the individual characteristics of the mask of Tlaloc. Below the mask of the god, the mouth in the base in front of or below the

god is depicted as an upper lip quite similar to the handlebar mustache upper lip characteristic of some Tlaloc masks, though not the masks of this painting. Directly beneath that mouth is the central image of Tlaloc in the frame, and this image holds two effigy vases that carry identical Tlaloc masks. Below that Tlaloc at the base of the painting is the cave/mouth of the mountain. If we include the two mouths as partial masks, there are nine symbolic masks in the vertical axis of the painting, all of them related in one way or another to the mask of Tlaloc. It is reasonable to conclude from this plethora of masks that Tlaloc provides the theme of the symbolic painting and that the variations on that theme enunciated by the variant masks serve to modify the thematic statement in order to communicate a specific spiritual reality related to the powers generally symbolized by the mask of Tlaloc.

In the light of that obvious thematic centrality of Tlaloc to the mural, it seems strange that the most dominant figure in the mural, the central depiction of the god in the upper painting, is not clearly an image of Tlaloc[176] although possessing some of that god's attributes. The mask worn by the god, like the Tlaloc mask below it but unlike the bird mask in its headdress, has a fanged mouth, ear flares, and eyes in the standard Tlaloc configuration. The Tlaloc theme is also suggested by the bifurcated tonguelike form representing streams of water which descends from the mouth—Tlaloc's serpentine tongue modified to harmonize with the numerous other representations of flowing water in the mural. These streams, like the ones below them in this painting and in the frame, contain starfish forms that, along with other representations of marine life, are linked elsewhere in the art of Teotihuacán to Tlaloc. The shape of the mouth of this mask is also related to other Tlaloc masks, but unlike the Tlaloc in the frame below whose mouth has an upper lip turned under the outer fangs, this mask has a variant of the handlebar mustache upper lip, a stylized version almost identical in shape to that worn by the Tlaloc on the last of the merlons we discussed above (pl. 18), but quite different from the mouth below it in the base. Slightly above the mouth on either side of the mask are the typical Tlaloc ear flares, each composed of two concentric circles.

But with the ear flares, the symbolic features that constitute the Tlaloc theme end. Slightly above these ear flares and directly over the mouth are a pair of eyes quite different from the goggle eyes of the typical Tlaloc mask. Somewhat smaller than Tlaloc's, these have circles representing the eyes framed by "concentric" diamonds on a horizontal band interspersed with vertical lines, giving the effect of a bar across the upper portion of the face rather than the twin circle image associated with Tlaloc. While this eye band is not at all typi-

cal of the Tlaloc mask, it is, as Séjourné points out, commonly seen as the decorative band on the braziers carried on the heads of images of the old fire god (pl. 19), known among the Aztecs as Huehuetéotl or Xiuhtecuhtli. Transplanted to the mask of Tlaloc, its purpose is clearly to link the attributes of that god to Tlaloc, a linkage supported by a number of other references to fire in the mural. The god wears what seems to be a "large yellow (fire-colored) wig"[177] and above that wig a headdress displaying a goggle-eyed bird mask also probably related to fire since an almost identical mask in four representations adorns an incensario found at La Ventilla which was no doubt used, as such incensarios typically were, to burn copal or other incense as an offering to the gods. And this bird mask is quite similar to the masks depicted both frontally and in profile on the columns of the Quetzalpapálotl Palace[178] whose relationship to the butterfly suggests a fundamental symbolic connection with fire. Thus, the masks in the upper painting seem to have as their primary purpose the connection of Tlaloc to Huehuetéotl and the unification of the seemingly opposed forces of fire and water.

That symbolic connection in the upper painting is particularly intriguing because the lower painting makes the same symbolic connection in an entirely different way. As we will demonstrate in our discussion in Part II of the relationship between the Mesoamerican perception of spatial order and the central metaphor of the mask, the cave/mountain image of the lower painting refers specifically to the cave underneath the nearby Pyramid of the Sun, a cave of enormous symbolic significance and almost certainly the scene of ritual reenactments of the coming of the rains. According to René Millon, "offerings of iridescent shell surrounded by an enormous quantity of tiny fish bones" were found in fire pits near the center of the cave, and the fires in which the fish and shell were burned as offerings were, "together with water made to flow artificially, the most essential part of" the cave's ritual, suggesting in several ways a symbolic "union of fire and water,"[179] precisely, of course, the union achieved in the mask of the upper painting. The common purpose of the two paintings thus is to depict the union of these opposed forces and to refer directly to the ritual through which man celebrated that unity. While the upper painting depicts a stylized ritual scene similar to those depicted in the later codices, many of which show priests wearing symbolic headdresses containing masks alongside a single masked god or god impersonator symbolizing the focal point of the ritual, the lower painting refers directly to the ritual use of the cave lying under the Pyramid of the Sun. It is fascinating to realize that the upper scene may well depict, relatively realistically, the ritual preceding the

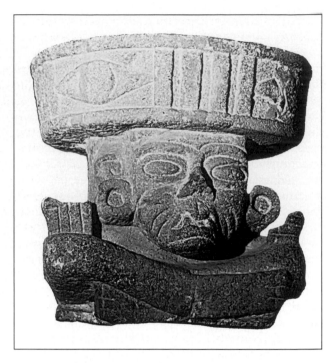

Pl. 19. Huehuetéotl, stone brazier, Teotihuacán (Museo Nacional de Antropología, México).

coming of the rains actually enacted at the mouth of that cave so long ago.

It seems clear, then, that both paintings refer to the symbolic and ritual union of fire and water depicted metaphorically in the mask of the central figure of the upper painting. Séjourné suggests its meaning:

The dynamics of the union of two opposites is at the basis of all creation, spiritual as well as material. The body "buds and flowers" only when the spirit has been through the fire of sacrifice; in the same way the Earth gives fruit only when it is penetrated by solar heat, transmuted by rain. That is to say, the creative element is not either heat or water alone, but a balance between the two.[180]

And this union is also suggested by the lightning serpent often held by images of Tlaloc. In later Aztec mythic thought, that serpent was known as Xiuhcóatl and was intimately related to Xiuhtecuhtli, the god of fire. And Xiuhtecuhtli, of course, was the Aztec manifestation of the Teotihuacán fire god on whose brazier the diamond-shaped eyes of the god of the Tepantitla mural are found. Significantly, however, Xiuhtecuhtli was also associated with the calendar. He was "lord of the year" and "the god of the center position in relation to the four cardinal points of the compass,"[181] a position with important calendrical implications as we have suggested above in connection with the Codex Borgia Tlalocs. Thus, the relationship of fire and water in the mask at Tepantitla has metaphoric implications regarding both fertility and

time, and a moment's thought suggests the relationship of those two concepts in the ritual ensuring the regular coming of the rains.

A related symbolic suggestion can be seen in the presence of great numbers of butterflies in both the upper border and the lower painting. In the art of Teotihuacán, "this brilliant insect *is* fire,"[182] and throughout Mesoamerica fire was the symbol par excellence of transformation. It is therefore no surprise to find symbolic references to butterflies on the incensarios of Teotihuacán or to see butterflies related to Tlaloc, since for the peoples of Mesoamerica it was through the process of transformation that the world of the spirit entered into the contingent world of man, creating and sustaining life as we know it. Metaphorically, Tlaloc became rain, exemplifying the manner in which the gods transformed spirit, that is, *themselves,* into matter, and fire allowed man to reciprocate by transforming matter into spirit. The fire "dematerialized" the substance of the offering and allowed its essence to return to the realm of spirit from which it came, a process that reversed and thus completed the provision of sustenance for the world of man by the world of the spirit. This ritual burning sent clouds of smoke into the air, reenacting the coming of the rain clouds which would initiate another cycle of the endless process in which life was constantly poised between creation and destruction.

That the relationship between these two concepts is metaphorically expressed most precisely and economically in the construction of the mask of the central figure makes clear the reason for the departure from the conventional mask of Tlaloc by the creators of this mural. The principle underlying the construction of the mask is basically the same as the principle by which the individual masks of Tlaloc are constructed, but in this case, it is used to create a continuum of gods by combining their symbolic features. This mask illustrates the fact that the gods were not seen as precisely defined individual entities but shaded into one another as they reached the "limits" of the particular areas of spiritual concern for which they stood as symbols.

Another significant and quite unusual Tlaloc mask exemplifying the same underlying structural principle indicates that the Tepantitla mural is typical rather than a unique case. This Tlaloc is found on the decorative frieze of the pyramidal Temple of Quetzalcóatl in the centrally located compound the Spanish called the Ciudadela. The frieze (pl. 20), which originally covered the pyramid's surface, is described by Nicholson as "one of the greatest *tours de force* of monumental stone sculpture in world history." He sees in its "powerful, massive" carving "the essential qualities of the classic Teotihuacán sculptural style."[183] Those superlatives suggest the significance of the frieze, as does the striking thematic unity of its symbolic reliefs, which are divided into six bands, one on each of the pyramid's six levels. Each of these bands has two registers, the lower one on a sloping talud and the upper one on a vertical tablero. Unlike the talud and tablero of the Tepantitla mural, however, these two registers are fundamentally similar as both of them depict the undulating bodies of rattlesnakes. While the talud displays only the snake, on the tablero's undulating serpent are superimposed alternating full-round composite masks of plumed serpents and, strangely in the midst of all of these serpents, Tlalocs. Not only do the composite masks of Tlaloc seem out of place in this serpentine context but their abstract, geometric, "flat" appearance seems designed to call attention to their difference from the naturalistic masks of the plumed serpent which project from the frieze. And, as if to call further attention to the Tlaloc theme, depicted within the sinuous undulations of the serpents' bodies are seashells realistic enough "to permit precise zoological identification."[184]

Although these Tlaloc masks were obviously designed to bring that god immediately to mind, they are quite different from the central image of Tlaloc at Teotihuacán. Viewed frontally, they look like Tlaloc because they present exactly the configuration of shapes found on other masks of the rain god. The upper portion of the mask contains two pairs of concentric circles arranged in the same format as Tlaloc's goggle eyes and ear flares. Below those circles is a projecting horizontal bar, somewhat reminiscent of the highly stylized handlebar mustache upper lip, with two fangs projecting downward from its outer edges. And underneath this projection, on the same plane as the concentric circles, another upper lip appears also in the form of a horizontal bar from which project four curving fangs in a clear variant of the Tlaloc mouth. Obvious as the reference to Tlaloc is, however, the differences between this mask and the typical Tlaloc are equally striking. A second glance reveals, for example, that the "goggle eyes" are not eyes at all. The concentric circles in the position normally assigned to the ear flares are actually the eyes of the mask, and the circles above them which would normally be eyes are merely decorative embellishments placed over the skin of the forehead, the unusual texture of which can be seen within them. The mouth, too, is strange as it is actually two mouths, one superimposed on the other in the manner of a buccal mask. As in the case of the Tepantitla mask, then, we have a Tlaloc modified thematically to contribute to the symbolic statement of a complex work of art.

The point of the modifications is quite clear from a profile view of the Tlaloc mask and even clearer when one includes in that view a profile of the plumed serpent mask next to it (pl. 20) which reveals the striking fact that the eyes and eyebrows of the two masks are quite unusual and virtually identical. Both have an identically shaped round

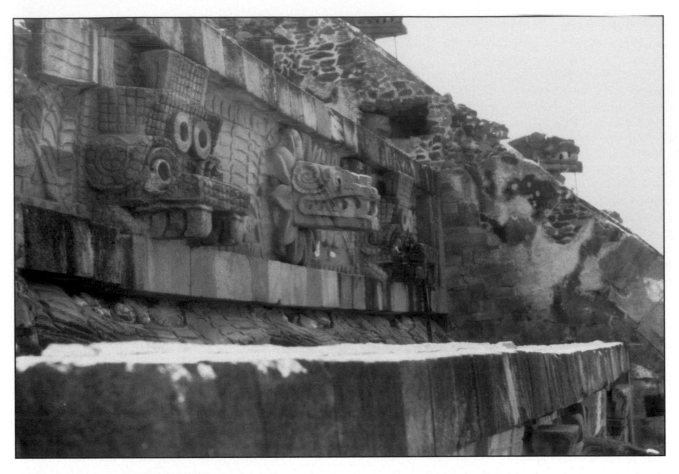

Pl. 20. Profile views of Tlaloc and Plumed Serpent heads on the frieze of the facade of the Ciudadela, Teotihuacán and Plumed Serpent heads lining the stairway.

"goggle" around each eye surmounted by a large, seemingly scaly eyebrow that drops down on the outside of the eye and then sweeps back along the side of the mask to form a spiral. The similarity in the eye treatment allows one to see a similarity in the shapes of the projecting mouths although they are far from identical. In profile, then, these two masks, which seem completely different from one another when viewed from the front, are actually two versions of the same thing,[185] making clear the reason for the change in position of this Tlaloc's eyes. Through the sophisticated manipulation of frontal and profile views, the creator of the frieze was able to connect Tlaloc with the plumed serpent, known in later times as Quetzalcóatl, in order to make a complex symbolic statement that unites those two god-masks to present a larger spiritual reality; the seemingly separate gods must be seen as parts of a continuum, precisely as we saw the gods of the Tepantitla mural, although the symbolic depictions of the relationship are achieved in somewhat different ways in the two works of art. But here Tlaloc's position vis-à-vis the other god is reversed. Despite the obvious importance of Tlaloc at Teotihuacán, the serpent symbolism of the frieze as well as the plumed serpent heads that line the stairway ramps suggest

that the rain god here is subordinate to the theme announced by the plumed serpent.

And what is that theme? The most obvious answer is fertility. The undulating serpent bodies, the seashells, and the masks themselves all combine to suggest that the crops that sustain man's life are themselves nourished by the water provided by the gods. In addition to the fundamental fertility associations of Quetzalcóatl and Tlaloc, vegetation is suggested both by the unusual texture of the Tlaloc mask which may well suggest corn, perhaps the reason for H. B. Nicholson's suggestion that it "may be a Teotihuacán version of a Monte Albán maize deity,"[186] and the peculiarly leaflike plumes of the serpent. In addition, a frontal view of the plumed serpent masks emphasizes the fertility-related bifurcated tongue and the jaguarlike pug nose that is depicted as an inversion of the form of the tongue. Emphasized by being framed between these two potent symbols and the front fangs on either side is the circular hole of the mouth. Such a strange emphasis on the mouth opening may well be related to the later Ehécatl, an aspect of the feathered serpent, Quetzalcóatl, who blew the winds that cleared the roads for the coming of the rain through his buccal birdmask. Mythically, Tlaloc and Ehécatl working in tandem provided man's

sustenance, and it is therefore tempting to relate this plumed serpent to that later aspect of Quetzalcóatl. From that point of view, we could see the frieze as symbolically relating two opposed forces, as did the Tepantitla mural, from the union of which comes fertility and human life. Such an interpretation is tempting precisely because it reflects the paradigmatic Mesoamerican conception of the cycle of life.

But there is another symbolic suggestion here as well, for the serpent is also the quintessential Mesoamerican symbol for sacrificial blood, and these two quite different serpent-related masks superimposed on the serpent bodies may well symbolize another unity born of the merging of opposites. Tlaloc as metaphor for the rain and the plumed serpent as metaphor here for sacrificial blood suggest the cyclical process through which life is maintained: in return for the provision of the life-giving rain by the gods, man must provide the sacrificial blood that metaphorically nourishes the gods. It is significant in this regard that atop the pyramid, "a layer of human bones beneath a layer of seashells was discovered,"[187] and "shells and numerous vessels representing the water deity," the urns in which the Tlaloc of myth stored the rain, were found in burials at the base of the stairway.[188] Such an interpretation would make sense of the numerous references to fertility in the frieze and to the obvious "double meaning" of the serpents' undulating bodies.

To return for a moment to the mural at Tepantitla, not very far from the Ciudadela, it is interesting to note that despite its utterly different appearance from the Ciudadela frieze, there are remarkable and perhaps significant similarities between them. Séjourné's description of the "frame" of the mural suggests one of them. "This charming image of creation," she says, "is enclosed in a rectangle formed by two serpents intertwined and covered with signs of water and heads of Tlaloc."[189] The intertwined serpents are distinguished from each other by being different colors and thus, for Séjourné, represent different elemental forces. Similarly, the two streams that make up the "tree" rising behind the central figure of the upper painting are different colors and intertwined in such a way as to make obvious the intention to depict a union of opposites. Thus, the mural, in a manner remarkably similar to that of the frieze, depicts fertility flowing from the symbolic merging of opposed elemental forces, and the red color of one of the streams of the tree may well be a reference to the sacrificial blood by which man reciprocates for the gift of the gods.

Such an interpretation of the two works of art would place them both at the liminal meeting point of the realms of spirit and matter, that point in ritual and art where man touches god. In ritual and through art, man is able to function momentarily on the level of god and thus to bring into his world the spiritual essence of life. Significantly, both the placement of the Temple of Quetzalcóatl within the compound of the Ciudadela and the decoration of the pyramid further develop that symbolism of the meeting place of spirit and matter. Situated facing the courtyard of the Ciudadela, the positive upward thrust of the pyramid balances the negative "sunken" space of the court, a balancing repeated in the configuration of the Pyramid of the Moon and its plaza and surely the symbolic equivalent of the combination of cave and pyramid at the nearby Pyramid of the Sun. In each of these cases, the emphasis on the penetration into the upper and lower realms of the spirit defines man's position in the world of nature. As if to emphasize that theme, the stairway that led to the temple divides the face of the pyramid fronting the courtyard. The ramps on either side of that stairway are lined with plumed serpent heads like those on the frieze indicating the dedication of the temple to Quetzalcóatl and prefiguring the symbolic use of serpents to flank temple doorways and pyramid stairways elsewhere at Teotihuacán as well as by the later cultures of the Valley of Mexico. This use of the serpent to define the liminal meeting place of spirit and matter coincides with the serpent symbolism associated with blood sacrifice since it was up these pyramid stairways, after all, that the sacrificial victim made his way to the temple where his spirit was freed by the act of sacrifice to return to its home and his body, now merely matter, released to tumble back down that same stairway to be reunited with the earth.

This symbolic concern with the meeting point of spirit and matter is further indicated by the location of the Temple of Quetzalcóatl within the compound of the Ciudadela, a compound that, as we will show in our discussion of the Mesoamerican perception of the sacred spatial order, stands at the central point of the grid system according to which Teotihuacán was laid out, at the intersection of the main east-west avenue and the Avenue of the Dead, which runs north and south. The Ciudadela thus marks the ultimate union of opposites by defining the center point of the quincunx formed by these two avenues, a quincunx that by its replication of the four-part figure symbolizing the sacred "shape" of space and time defines the ultimately sacred nature of the city. The central point of this quincunx would have been seen as the symbolic center of the universe, the point at which the vertical axis of the world of the spirit, symbolized here by the *Via Sacra* of the Avenue of the Dead, met the horizontal axis of the natural world, the east-west avenue in this case. That central point naturally would have been, as Millon believes the Ciudadela was, the "sacred setting" for the city's political center, which was, in fact and in the minds of its rulers, the center from which the influence of Teotihuacán radiated to every corner

of the known world. And for the same reason it was "the setting for the celebration of elaborate calendrical rituals" probably led by rulers seen as "the embodiment of the religion of Teotihuacán" since "the Teotihuacán polity was undoubtedly sacralized."[190] The Ciudadela was symbolically the very center, both spiritually and physically, of Teotihuacán.

We must conclude, then, that fertility was not the only issue of this symbolic meeting of man with god. As we might expect from the intimate relationship between the god of rain and the symbolism of rulership in the art of the Olmec "mother culture" as well as in the roughly contemporary Zapotec art of Monte Albán, the Tlaloc masks in this central place suggest the provision by the gods of divinely ordained rulers as well as man's sustenance. It is significant in this regard that the composite masks of Quetzalcóatl as well as those of Tlaloc both have jaguar characteristics as the symbolism of the jaguar was intimately related to rulership by both the Olmecs and the Zapotecs. But both of these masks have serpent characteristics as well, and the serpent, especially the plumed serpent, has strong connections in later Mesoamerican symbolism with rulership, a symbolism often expressed in the metaphoric connection of the serpent and lightning. We saw precisely this relationship in the art of the Zapotecs, and the Tetitla Tlaloc with his lightning spear shaped as an undulating serpent indicates that the same connection was perceived at Teotihuacán. By the time of the Toltecs, in fact, the plumed serpent is thought to have supplanted the jaguar as the symbol of kingship, and Quetzalcóatl's fertility symbolism had been relegated to Ehécatl.

But at Teotihuacán, Tlaloc was still the divine force from which the earthly ruler drew his mandate. Wigberto Jiménez Moreno characterizes what we would also see as the legitimizing role of the Teotihuacán Tlaloc nicely. He sees the ruler's authority as

> deriving from the fact that he personified the god of lightning and rain, Tlaloc-Quetzalcóatl. Indeed, one source tells us that Tlaloc was a lord of the quinametin, the "giants" whom I have identified (1945) with the Teotihuacanos. This could be understood to mean that the most venerated god in the Teotihuacán culture was personified by the ruler-priest, who would appear as Tlaloc's living image.[191]

Given the Ciudadela's symbolic identity as the center of the universe and its actual role as the locus of sacralized political power at Teotihuacán, it is to be expected that the art of that compound would symbolize the divine basis of what we today call secular power. And the burials with seashells were probably related to the ritual involving the accession of a new human wielder of that essentially divine power, a man within whom the later Aztecs

would say the god would "hide himself." It would be hard to imagine a better metaphor for that relationship than the shells, which had the virtue of suggesting fertility as well.

Ultimately, then, the masks of the frieze of the Temple of Quetzalcóatl symbolize the relationship between the realm of the spirit and the world of man and suggest that life is made possible in this world through the continuous intervention of that other realm. In the final analysis, what is provided is order, the order of civilized life made possible by agricultural fertility and symbolized by and inherent in the ruler; the spatial order derived from the central point "of ontological transition between the supernatural world and the world of men," a point symbolized at Teotihuacán by "the Temple of Quetzalcóatl [which] probably functioned not only as the opening toward the supernatural world of the vertical, but also as the pivot of the horizontal sociopolitical cosmos";[192] and the temporal order symbolized by the compound of the Ciudadela itself. According to Kubler, "the three groups of four secondary platforms surrounding the main pyramid in the principal court recall the calendrical division of the Middle American cycle of fifty-two years into four parts of thirteen years each,"[193] a division that, according to Seler, is one of the primary concerns of the page on which the Codex Borgia Tlalocs are depicted.[194] In addition, within the boundary marked by these platforms, the courtyard facing the pyramid "was probably used for rituals of a calendrical nature."[195] The calendrical significance of the pyramid itself is suggested by the widely held view that it originally displayed from 360 to 366 composite masks, numbers of clear calendrical significance and a fact that would link it to the Pyramid of the Niches at El Tajín as a calendrically symbolic structure. It is quite significant from our point of view that all of these connections between the Ciudadela and the temporal order find their primary symbol in the composite mask of Tlaloc. As Roman Piña-Chan points out, "this deity can be considered the Lord of Time, of the annual cycle which nourishes vegetation and life, on the basis of the interwoven triangle and rectangle, the symbol of the year, in his headdress."[196]

Thus, it all comes together in the mask. The composite masks of Tlaloc and Quetzalcóatl on the frieze carry in their symbolism all of the meanings elaborated by the other symbols on the frieze and by the compound's structures, ritual use, design, and siting. What Henri Stierlin says of the masks of Tlaloc here can surely be extended to encompass the metaphoric construction of all the masks of the gods by the "learned clerics" of Teotihuacán:

> The abstract nature of the representational modes resulted in what can only be called graphic symbols that are replete with significance for those who beheld them. In this sense it was the expression of a sacerdotal body, the

reflection of a caste of learned clerics con-
cerned with elaborating the concepts of a
pantheon in which the forces of the universe
are personified.[197]

These graphic symbols recorded the speculative thought of that sacerdotal body, "a well-integrated cosmic vision" that Jiménez Moreno has likened in its sophistication to the *Summa* of Saint Thomas, expressing "a religious doctrine and a very coherent and harmonious philosophy [capable of] fostering the architectural, sculptural, and pictorial creations."[198] And as we have seen, the mask, especially the mask of the rain god we call Tlaloc, served as the central symbol in the elaboration and expression of that profound body of spiritual thought.

We do not know the name of Teotihuacán's Saint Thomas or, more appropriately, Aristotle or Plato, nor even the language he spoke, but the evidence compels us to acknowledge the existence of such seminal thinkers there and allows us to savor the subtlety and originality of the small portion of their thought we are able to know. The evidence we have examined here, the complex multivocality of the symbolic mask of Tlaloc, is clearly but a small part of the profound body of thought characteristic of that highly developed society, which

was unquestionably the preeminent ritual center of its time in Mesoamerica. It seems to have been the most important center of trade and to have had the most important market-place. It was the largest and most highly differentiated craft center. In size, numbers, and density, it was the greatest urban center and perhaps the most complexly stratified society of its time in Mesoamerica. It was the seat of an increasingly powerful state that appears to have extended its domination over wider and wider areas. . . . Indeed, it appears to have been the most highly urbanized center of its time in the New World.[199]

THE MASK AS METAPHOR
Tlaloc from the Fall of Teotihuacán
to Tenochtitlán

What happened to the speculative thought of Teotihuacán during the decline and after the fall in A.D. 750? Evidence of philosophical activity is difficult to detect archaeologically under the best of circumstances, and the widespread social, political, and military chaos that must have resulted has left little record for the archaeologists. Consequently, our understanding of that period is as murky as our understanding of the reasons for the fall of such a mighty society. But in the limited area of our concern with the development of the mask of the rain god, one thing is absolutely clear: Tlaloc survived, essentially unchanged, the fall of

the culture that conceived him. Whether that survival was owing to the survival of the priestly tradition of Teotihuacán among those who found refuge elsewhere or to the use of Teotihuacán's symbols by newcomers on the scene eager to legitimize their own power by association with the fallen grandeur of Teotihuacán is uncertain. But whatever the historical process that brought it about, the development of the rain god of the Valley of Mexico followed precisely the same course as the parallel development of Cocijo in the Valley of Oaxaca, although the cataclysmic social changes of the Valley of Mexico have no real parallel in Oaxaca. Fixed in form and meaning early in the Classic period, the symbol system of Tlaloc, like that of Cocijo, remained essentially unchanged.

That stability is remarkable in view of the developments in the Valley of Mexico which brought influences from all over Mesoamerica to bear on the area. According to Diehl, the vacuum created by the fall of Teotihuacán "was soon filled by at least two, and possibly four, centers" in and on the periphery of the valley. Tula and Cholula were most involved, with Tula ultimately gaining the ascendancy, but Xochicalco and El Tajín, as well as Cacaxtla, "reached their highest developments at this time" and played a role in the politics of the region which is not yet clearly understood.[200] That it was a time of ferment is indicated archaeologically by the fact that "these centers . . . seem to combine architectural and artistic forms drawn from both highland and lowland Mesoamerica."[201]

At Xochicalco, for example, the pottery recovered archaeologically suggests that it was "the northwestern frontier outpost for a Maya cultural tradition"[202] while "the sculptural style . . . is clearly linked to Teotihuacán, on the one hand, and to Monte Albán, on the other. It also is obviously connected with the 'Ñuiñc' tradition of northern Oaxaca-southern Puebla"[203] associated with the Mixtecs. This sculptural tradition is best represented in two examples from the site. Perhaps best known and certainly the most impressive is the decorative frieze on the Pyramid of the Feathered Serpent, a frieze depicting undulating feathered serpents within whose coils are interspersed seashells and seated priests wearing feathered serpent headdresses. Although in appearance it is quite different from the frieze on the Temple of Quetzalcóatl at Teotihuacán, the iconographic similarities are unmistakable. It is significant, however, that here the feathered serpent does not share the frieze with Tlaloc.

But Tlaloc does appear in the other well-known example of Xochicalco art. In 1961, three stelae that had been ritually broken and interred under the floor of a temple were discovered. Covered on all four surfaces by symbolic motifs and glyphs, each of them has a central face on the front surface. Two of the three depict a face emerging from the

mouth of a jaguar or serpent mask, a mask that, with its bifurcated tongue and that same motif inverted to form nostrils, looks very much like the frontal view of the feathered serpent masks on the Temple of Quetzalcóatl at Teotihuacán. These faces have been widely interpreted as Quetzalcóatl, but the four short teeth with outcurving fangs on either side in the mouth of the mask above the emerging face are those of Tlaloc, as is proven by the other stela, Stela 2 (pl. 21), which displays the mask of Tlaloc, with the same teeth, in its center. This Tlaloc is remarkably similar to the central image of Tlaloc at Teotihuacán in its mouth and teeth, its goggle eyes, and the water lily dangling from its mouth. Like the Tlaloc mask found on urns at Teotihuacán, this mask wears a year-sign headdress, a motif repeated twice on the rear of the stela, and in the only significant difference from the Teotihuacán images, has a pendant dangling from the center of each circular ear flare. To carry the similarity to Teotihuacán a step further, immediately beneath this Tlaloc mask on the lower third of the stela is a representation of the Tlaloc mouth virtually identical to that on the first of the Teotihuacán merlons discussed above (pl. 16). Though this stela, like the other two, "bears columns of glyphs pertaining to names, places, motions, and dates, reminiscent both of Classic Maya and Monte Albán inscriptions,"[204] the Tlaloc it displays as its raison d'être is the Tlaloc of Teotihuacán.[205]

Tlaloc appears in a similar way at the most recently recognized late Classic period site in the region, the fortified, mountaintop center of Cacaxtla celebrated for its two groups of mural paintings discovered in 1975 which are a striking mixture of the styles of Xochicalco, Teotihuacán, Veracruz, and the Maya.[206] One of these two groups is composed of the four murals found in Structure A, each a large painting of a single human figure wearing an animal or bird costume, and in each case the head of the human figure emerges from the open mouth of the animal or bird, a motif we will explore at length in the discussion of the ritual use of the mask. Of particular interest to us at this point is the painting on the north door jamb (pl. 22) of a figure iconographically similar to the Teotihuacán Tlaloc. The man depicted either wears a jaguar costume or is emerging from the open mouth of a jaguar, an ambiguity that results from the fact that the hands and feet of the figure are the paws of a jaguar rather than the human hands and feet customarily depicted when human beings wear costumes in Mesoamerican art. The jaguar head from which the human head emerges itself wears a headdress composed of the upper jaw and head of a saurian creature iconographically similar to the headdress worn by the Sowing Priests at Teotihuacán (pl. 38). The most striking connection with Teotihuacán, however, is that the figure holds a stylized serpent in one hand and clutches a Tla-

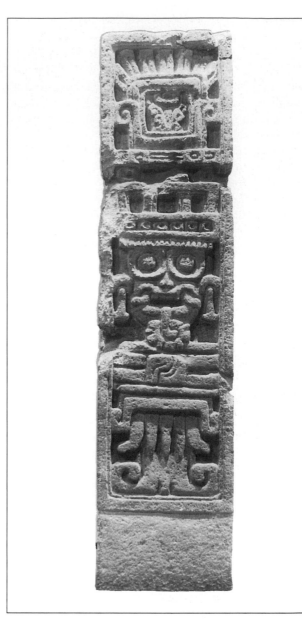

Pl. 21. Stela 2, Xochicalco (Museo Nacional de Antropología, México).

loc effigy urn from which water flows under the other arm—exactly the accoutrements of the earlier Lightning Tlaloc at Teotihuacán (colorplate 2a) and of the later Codex Borgia Tlalocs (colorplate 1). But the figure could hardly appear less similar to those figures. Stylistically, it is Maya, strongly recalling the figures of Bonampak in its realistic features, graceful pose, and curvilinear style.[207] And its most striking symbolic feature, clearly related to fertility, has no counterpart at Teotihuacán; this is what seems to be a flowering vine springing from the abdomen of the figure rendered in a style reminiscent of the interlocking scrollwork characteristic of El Tajín. Whether this standing figure with all its fertility symbolism is meant to represent Tlaloc or to connect the representation of a ruler with the legitimizing symbols of that god as Pasztory and Donald McVicker argue,[208] the fact re-

THE METAPHOR OF THE MASK IN PRE-COLUMBIAN MESOAMERICA

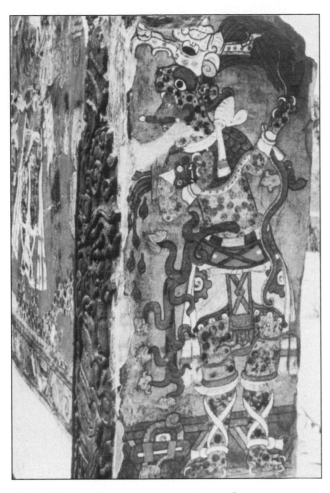

Pl. 22. "Tlaloc," mural painting, Cacaxtla.

and rulership, Mary Elizabeth Smith's comments on the Mixtec codex known as the Vienna obverse are significant:

The deity motif that occurs most frequently in the names of persons who are historical and neither priests nor mythological personages is the rain deity known in Nahuatl as Tlaloc *and in Mixtec as* Dzavui. *This deity is part of the names of 56 different rulers in the Mixtec genealogies. The prevalence of the rain deity motif in Mixtec names is not surprising because the Mixtec people call themselves in their own language* ñuu dzavui, *or "the people of the rain deity."[213]*

Her comment makes clear the reason for the abundance of similar images of the rain god in Mixtec art—in the other codices, on small greenstone figurines known as *peñates* (pl. 23), and on ceramic incense burners and *xantiles*.[214] In fact, the rain god is so fundamental to the art of the Mixtecs that Covarrubias sees the motif of the mouth and goggle eye in profile as a basic ideographic and decorative element.[215] Although "the most challenging problem connected with Mixteca-Puebla is still that of the precise time and place of its emergence as a clearly recognizable stylistic-iconographic tradition,"[216] it seems likely that Cholula was directly involved and was responsible for the movement of Teotihuacán's Tlaloc to Oaxaca under the name of Zavui.

Important as Xochicalco, Cacaxtla, and Cholula are to the later development of Tlaloc, the artists

mains that the Teotihuacán Tlaloc depicted on the typical urn continues its symbolic existence at Cacaxtla.

The case for the continuity of Tlaloc at Cholula is different since no major painting or sculpture depicting the god has yet been discovered there. It is generally felt, however, that the distinctive art style of the Postclassic period known as the Mixteca-Puebla either originated at or developed in conjunction with Cholula,[209] and most of the art of Postclassic central Mexico falls within what H. B. Nicholson, in discussing Aztec sculpture, calls "a broadly conceived Mixteca-Puebla stylistic universe,"[210] a style particularly associated with the art in which the Postclassic Mixtecs recorded their spiritual thought. In terms of our concern with Tlaloc, it is significant that although the Mixtecs were primarily located in Oaxaca, their rain god was not the Cocijo of the Zapotecs but was called "*Zaaguy* or *Zavui* (literally, 'rain')"[211] and depicted in images identical to Tlaloc. Although Mixtec scholars insist that there are significant differences between Mixtec spiritual thought and that of the Valley of Mexico,[212] the images through which that thought is expressed are virtually the same as are at least some of the meanings.

In the light of the connection between Tlaloc

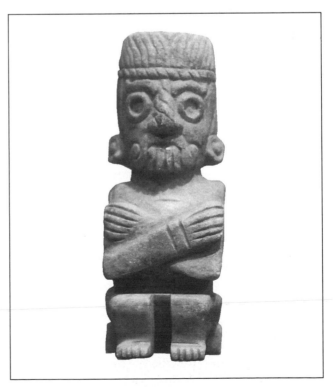

Pl. 23. Tlaloc, Mixtec peñate (Museo Nacional de Antropología, México).

and thinkers most directly responsible for the transmission of the Teotihuacán Tlaloc to the Aztec culture that dominated the Valley of Mexico at the time of the Conquest were the Toltecs of Tula. The chain of events that led to their assumption of the mantle of Teotihuacán in the Valley of Mexico is not clearly understood but probably involves the migration to Tula of groups carrying the culture of Teotihuacán.

> They are referred to as wisemen, leaders, priests, merchants, and craftsmen; in other words, bearers of the Mesoamerican elite tradition. The sources indicate that they spoke Náhuatl, Popolaca, Mixtec, Mazatec, and Maya. This linguistic diversity suggests that they were not a single ethnic group but rather "civilized people" who migrated to Tula . . . when their home communities declined in power and importance. . . . The prosperity they helped to create attracted more migrants and Tula soon became the New Teotihuacán.[217]

And as Diehl's summary of developments suggests, the symbolism of this New Teotihuacán was the one associated with the original Teotihuacán. While much has been made of the dominant symbolic role at Tula of Quetzalcóatl,[218] scant attention has been paid to the numerous images of the mask of Tlaloc there. This is strange since Tlaloc was of major importance at Teotihuacán, the source of the Toltec heritage, and, as Pasztory points out, "the god most frequently represented in Aztec art,"[219] the ultimate beneficiary of that heritage. And as we would expect, the evidence of Toltec art shows that the mask of Tlaloc was important at Tula. The recent excavations at that site directed by Diehl, for example, unearthed a small temple whose associated artifacts indicate that it was "devoted to the Tlaloc cult." Located near a large temple mound in the residential Canal Locality, the small Tlaloc temple would seem to have little relevance to Tlaloc's fertility associations, but Diehl suggests that the residential area may have been inhabited by priests who served the large temple and that the smaller Tlaloc temple may have been "a personal shrine for worship of their own tutelary god."[220] If so, Tlaloc survived at Tula in a privileged position and continued to demonstrate the connections with the priesthood he had at Teotihuacán due to his role in the provision of the order necessary for the maintenance of civilized life.

This supposition might suggest a reexamination of one of the better-known symbolic artworks at Tula. The frieze on the pyramid called the Temple of Tlahuizcalpantecuhtli, the aspect of Quetzalcóatl related to Venus as morning star, contains among other relief carvings a number of depictions of a face emerging from the open jaws of what appears to be a jaguar with a plumed headdress, the teeth of Tlaloc, and a bifurcated tongue (pl. 24).

The emerging face consists only of goggle eyes, circular ear flares, and a large nose from which hangs a decorative pendant covering the mouth. The eyes and ears are those of the Teotihuacán Tlaloc, and the pendant is identical to those commonly seen in the art of Teotihuacán, especially on braziers, which are generally identified as butterflies. If this mask were found at Teotihuacán, it would be identified immediately as Tlaloc wearing a butterfly nose pendant. Strangely, however, at Tula it is seen as "Quetzalcóatl in the guise of Venus the Morning Star"[221] or, even more strangely, as "Quetzalcóatl in the guise of Tlaloc emerging from the jaws of a plumed serpent."[222] One suspects that such identifications are the result of the importance Quetzalcóatl is presumed to have had at Tula rather than an examination of the details of the relief. A similar Tlaloc can be seen in the headdress of a warrior depicted on a stela now in the Tula museum, and this one is surely Tlaloc since he wears no pendant covering his mouth, the mouth of Tlaloc. And should there be any doubt about the importance of Tlaloc, the numerous effigy urns, braziers, and figurines bearing his mask at Tula, the New Teotihuacán, would surely lay that doubt to rest.

Thus, even a brief consideration of the images of the mask of Tlaloc created outside of Teotihuacán during the decline and after the fall of that great city demonstrates that that god continued to be of fundamental symbolic importance in the area. In speaking of the relative importance at this time of Tlaloc vis-à-vis Quetzalcóatl, Davies says,

> one should not exaggerate the degree to which Tlaloc suffered a decline. He still figures quite prominently in Xochicalco and even in Chichén Itzá; moreover it is Tlaloc rather than Quetzalcóatl who prevails in the designs of Plumbate pottery, the great trade ware of the Early Postclassic era.[223]

This type of pottery is generally associated with elites and ritual. The manifestations of Tlaloc in the lengthy period between the decline and fall of Teotihuacán and the rise to preeminence in the Valley of Mexico of Aztec Tenochtitlán are often associated with the art of the ruling class as well as with that of the farmers whose crops depended on the fertility associated with Tlaloc. The simple figurines, urns, and braziers were no doubt used in fertility ritual, but the stela at Xochicalco, the mural at Cacaxtla, the relief at Tula, and the plumbate pottery throughout the region served a different function. And that function of the mask of Tlaloc continued with even greater importance at Tenochtitlán, for in the Aztec capital Tlaloc shared the temple atop the Templo Mayor, the central temple of the ceremonial center of the city, with Huitzilopochtli, the tutelary god of the Aztecs.

Although the documentary sources dating to the

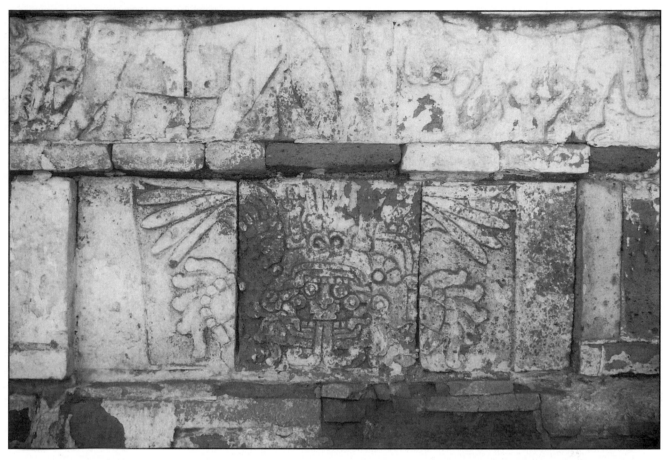

Pl. 24. The face of Tlaloc emerging from a jaguar's mouth wearing a butterfly nose pendant, relief on Pyramid B, Tula.

time of the Conquest stress the importance of Huitzilopochtli, the recent excavations at the Templo Mayor tell a different story.

> A quick review of the materials found in the Templo Mayor offerings forces us to see the importance of the god Tlaloc, present in stone masks, stone figurines, and pottery . . . [and symbolically alluded to by] a great quantity and variety of biological remains such as snails, shells, coral, fish, birds, turtles coming from both coasts. Moreover, there are symbols associated with the god, such as the presence of canoes and stone serpents. One can affirm without doubt that the vast majority of the material found was associated with Tlaloc.[224]

The essential reason for the importance of Tlaloc at the Templo Mayor, which was for the Aztecs "the fundamental center where all sacred power is concentrated,"[225] was the attempt by the Aztec ruling elite to identify themselves with and carry forward in time the sacralized political tradition of the Valley of Mexico which had its origin at Teotihuacán and a subsequent period of development among the Toltecs at Tula. For the Aztecs,

> the "Toltec" past was crystallized around the figure of the god Tlaloc who shared the twin pyramid with Huitzilopochtli. . . . A striking aspect of the Aztec attitude to Tlaloc, as re-

> vealed by the Templo Mayor excavations, is how much of the offerings buried in the temple were dedicated to Tlaloc and how many representations of him exist in stone and clay. Tlaloc, as deity of the earth, also occurs on the underside of important sculptures, such as the Coatlicue, where he was not visible to anyone. The concern with the power of Tlaloc was therefore not merely a theatrical display for the sake of politics but also a demonstration of what the elite believed to be a historical and religious truth. Tlaloc was the personification of the past in the present.

While the Temple of Huitzilopochtli atop the Templo Mayor suggests that the Aztecs thought of themselves as "the descendants of nomads led by Huitzilopochtli," Tlaloc's temple reveals an opposed self-image that was equally true: "we are the legitimate successors of the Toltecs and their god Tlaloc."[226] And while the Aztecs as the nomadic followers of Huitzilopochtli formed a warrior state that maintained its power through the sacrifice of countless victims on the sacrificial stone still in place in the Temple of Huitzilopochtli, those same Aztecs, as the "successors of the Toltecs," were more inclined to philosophical speculation and artistic expression. Sahagún reveals the Aztec view of that heritage:

These Toltecs were very religious men,
great lovers of the truth,

. .

These Toltecs were very wise;
it was their custom to converse with their own
 hearts.
They began the year count,
the counting of days and destinies.

In the Aztec expression of those truths of the heart,
"the true artist . . . works like a Toltec." He "draws
out all from his heart" and "works with delight;
makes things with calm, with sagacity."[227] Thus,
the Aztecs saw themselves as the carriers of the
tradition that began at Teotihuacán and that they
identified as Toltec. H. B. Nicholson describes their
system of philosophical speculation and artistic ex-
pression precisely in that way as

> a final precipitate of the ceaseless flow of
> iconographic development and change stretch-
> ing over a period of more than two millennia
> from the Early Preclassic to the Conquest. No
> system, therefore, probably better epitomizes
> the whole intricate fabric of Mesoamerican
> symbolism, the tangible graphic expression of
> the religious ideologies that played such a per-
> vasive role in Mesoamerican civilization.[228]

It therefore follows that the meanings associated
with the mask of Tlaloc in that system are the re-
sult of the centuries-long development of that sym-
bolic mask which we have traced in this study.
And in that sense at least, the mask of Tlaloc sym-
bolizes the system as a whole.

Significantly, among "the most spectacular" of
the ceramic finds at the Templo Mayor, "a center
dedicated to the major gods of the Aztec state
cult," is a pair of almost identical Tlaloc effigy urns
(pl. 25) similar in design to those carried by the
Tlalocs of the Teotihuacán and Cacaxtla murals
and to those found in burials and offerings from the
Preclassic period on. These two were found sepa-
rately in Offerings 21 and 56, but each contained
three oyster shells,[229] aquatic symbols related to
Tlaloc. An iconographically similar ceramic urn
was found in Offering 31,[230] and a sculpted stone
version was found in Offering 17.[231] These urns
surely indicate the persistence of the view that the
rain, Tlaloc's water, was stored in great urns that
were thus the source of fertility, and the symbols
composing the masks on them suggest their roots
in the preceding cultures.

The goggle eyes of the masks on the urns are
those of the Teotihuacán Tlaloc; however, in all
four of the masks, those eyes are surmounted by
eyebrows that cntwine to form the nose, a famil-
iar motif in Aztec images of Tlaloc which, as a
number of those images makes clear, represents
serpents. According to Seler, a sculpture now in
Berlin has a face "made up of the twinings of two
serpents," and he concluded that Tlaloc's typical

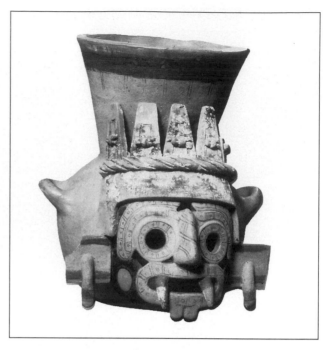

Pl. 25. Tlaloc urn, Templo Mayor, Tenochtitlán. (Mu-
seo del Templo Mayor, México).

goggle eyes and upper lip were derived from that
original conception.[232] But as we have seen, those
features were already part of the earliest Tlaloc
images, long before entwined serpents made their
appearance on the mask. Furthermore, as these
urns demonstrate, the serpents form the eyebrows
and nose; the goggle eyes remain under those eye-
brows. It seems likely that the Aztecs devised this
eyebrow/nose configuration as another means of
suggesting the serpent symbolism manifested in
the bifurcated tongue associated with Tlaloc from
the earliest times. And like the eyebrows, the ear
flares on these masks also differ from those found
on the Teotihuacán Tlaloc; they are a rectangular
variant of those circular ones and have pendants
similar to the pendants on the mask on Xochicalco
Stela 2 (pl. 21) hanging from their centers. But the
all-important symbolic mouths are those of Teo-
tihuacán. The masks on the three ceramic urns
have their upper and lower lips joined to form an
oval mouth from which two outer fangs, with no
teeth between them, protrude; below the mouth is
the suggestion of a bifurcated tongue. The mask
on the stone urn, in contrast, displays the more
typical Tlaloc handlebar mustache upper lip from
beneath which protrude four curving fangs; this
mask has no tongue.[233] Thus, the two mouth treat-
ments found at Teotihuacán continue to occur at
Tenochtitlán.

The more common of the two, by far, is the
"handlebar mustache" type. It is generally found
on the numerous stone figurines of the god carved
by the Aztecs and is the mouth seen on the god in
the codices, where the mask is almost always de-
picted in profile. As it is quite similar to the mask

depicted on the Mixtec peñates (pl. 23) and as it is found in the codices of Mixtec origin, it may have traveled from Teotihuacán to the Mixtecs and from that culture to the Aztecs.[234] These urns, then, display masks that have features associated with all of the cultures and art styles derived from Teotihuacán. The Aztecs, in achieving a Teotihuacán-like hegemony over the peoples of the Valley of Mexico and related areas, seem also to have re-united, symbolically, the features of the mask of Tlaloc.

And the reverse is also true. The Tlaloc whose images we find at Tenochtitlán can be found throughout the Valley of Mexico and in politically related areas such as Veracruz, Puebla, Oaxaca, and Guerrero during the Aztec period. In Veracruz, for example, where Tlaloc images are practically non-existent in the Classic period, stone and ceramic figures with the mask of the Aztec Tlaloc have been found at a number of Postclassic sites. Castillo de Teayo provides an apt example since a number of stone sculptures bearing Tlaloc masks have been found there. One of them, a relief carving of the god on a tall, narrow slab, has a mask virtually identical to that found on the stone urn of the Templo Mayor. The figure wears a headdress displaying the year sign, indicating the continuity of that aspect of the Teotihuacán Tlaloc as well.

But fertility continues to be Tlaloc's primary symbolic concern, as another relief carving from the same site (pl. 26) indicates. It depicts, very much in the style of the codices, Tlaloc holding a corn-stalk and facing another fertility-related figure. These representations of the mask of the god all display the handlebar mustache mouth, but a large, striking ceramic incensario from central Veracruz now in the Museum of Anthropology in Mexico City illustrates the existence in Veracruz of the oval-mouthed Tlaloc mask as well.

And in Puebla and Oaxaca, the Mixtec images of Tlaloc originating in the late Classic period continued to be produced during the time of the Aztecs. The iconography of those images finds its most complex statement in the pre-Conquest codices in the Mixteca-Puebla style probably associated with that area, and it is in one of these codices, in fact, that Pasztory finds the central image of the Postclassic Tlaloc. The images of the god in his characteristic mask on page 27 of the Codex Borgia (colorplate 1) make clear his great significance in the philosophical speculation involved with calendrical studies by the priesthood. Seler describes and then analyzes these images.

We see, one in each of the four corners of the picture, four images of Tlaloc which designate the four cardinal points. The fifth image in the

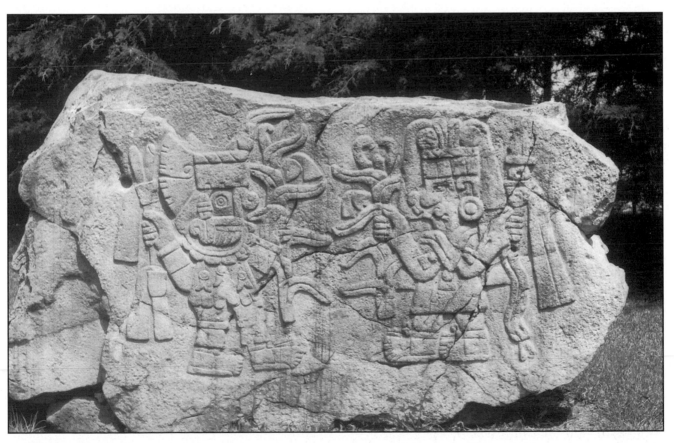

Pl. 26. Tlaloc holding a corn stalk and facing another fertility-related figure, relief carving, Castillo de Teayo, Veracruz (Museo de Antropología de Xalapa).

center naturally corresponds to the fifth region of the world, the center or the vertical axis. . . . It is likely that images of Tlaloc were chosen to represent the cardinal points because the god of rain rules over all. Because of this relationship between the god of rain and the four cardinal points, the Zapotec calendar designates the initial days of the four quarters of the tonalámatl *by the names of Cocijo, god of rain, or* pitao, *"the great" or "the god." We may surmise that it was extremely important in the picture we are discussing to connect man's well-being to the significance of the four periods and the years characterized by the four distinct signs corresponding to the cardinal points.*

But a further suggestion of Seler's indicates just how important these images in particular were.

To the ancient seers it must have seemed marvelous that of the twenty day-signs, only four fell on the initial days of the years, but we can imagine that they considered as a veritable mystery the division of the 52 year cycle . . . into four quarters, each of which had as its initial day a day numbered 1 which had one of those same four day-signs in the proper sequence. Thus the 52 year cycle was automatically ordered in accord with the four cardinal points in the same way that the tonalámatl *. . . organized itself into four sections similarly corresponding to the four directions. And this division of the 52 year cycle in accord with the four cardinal points is what is represented on page 27 of our manuscript.*[235]

On this page is recorded, then, the central mystery of the division of the essential unity of the cosmos into the quadripartite form of the world of man. The images here reproduce what we will describe below as the essential "shape" of the space-time continuum as perceived by the sages of Mesoamerica. The significance of Tlaloc serving as the vehicle for the expression of this mystery is enormous, but another aspect of the page suggests that his image is even more significant. While the four images of Tlaloc representing the cardinal points, that is, the world of nature, each wears a mask helmet representing another symbolic identity, the Tlaloc of the center who represents the all-important vertical axis of the spirit wears no such mask. He is the essential Tlaloc, the "thing itself," as close as man can come to depicting the essential reality of the world of the spirit.

And these images of Tlaloc are virtually identical to those of Tenochtitlán, as are those from Veracruz, so it seems reasonable to conclude that the Tlaloc mask we find of such importance at Tenochtitlán's Templo Mayor was of equal importance throughout the area influenced by the power that ruled there. What H. B. Nicholson says generally of that Aztec influence applies remarkably well to

the mask of Tlaloc. The Aztecs, he says, "clearly shared the majority of their fundamental ideological and socio-political patterns with most of their neighbors, both those subject to their greater military power and those who had successfully withstood it."[236]

That the masks depicted on the urns of the Templo Mayor and reproduced so widely actually were conceived as masks is made clear by the form of their appearance on another type of ceramic sculpture—the large ceremonial incensarios that "stood at the top of the balustrades of pyramid stairways"[237] to house the burning copal which symbolized the transformation of matter to spirit and created the clouds of smoke that would call forth the rain clouds, which would in turn transform spirit into the nourishing reality of corn. Several of these large incensarios display a human figure wearing a Tlaloc mask in such a way that the man's face is clearly visible beneath the mask (pl. 27), a form of great symbolic importance in Mesoamerican art which will be discussed in our consideration of the ritual use of the mask. In the case of these incensarios, the visibility of both face and mask would suggest the same matter-spirit dichotomy as the fire that burned within the image of the man-god.

These incensarios symbolically link fire and water in their concern with the provision of man's sustenance, a linkage we saw earlier at Teotihuacán in the Tlalocan mural (colorplate 3). That this is not a coincidental connection is suggested by the discovery of another figure at the Templo Mayor which makes that same connection in the context of a clear reference to the art of Teotihuacán. It is a sculpture that "copies stone braziers from the Classic Teotihuacán period . . . in the form of an old god carrying a vessel on its head,"[238] but in this case, the Aztec sculptor partially covers the old god's face with the goggles and buccal mask of Tlaloc to create precisely the same symbolic linkage of fire and water differently symbolized by the mask of the central figure of the Tlalocan mural at Teotihuacán. This reference to Teotihuacán is reinforced by the reference of the form; this image of the old god of fire, Huehuetéotl, is unusual in Aztec art but was quite common at Teotihuacán (pl. 19). After creating this archaic form in what must have been a conscious allusion, the sculptor made clear with the addition of the mask of Tlaloc in a peculiarly Aztec version that his intention was not to copy the past but to interpret it for his own time. The goggles and the mouth of this mask are rectangular rather than circular and oval, and the other details of the sculpture complement these "Aztec" touches, touches that can also be seen on an Aztec Chac Mool, which similarly copies a Toltec form. While the sides of the brazier carry the diamond-eye and bar design found at Teotihuacán and used in the Tlalocan mural to symbolize fire, the top is

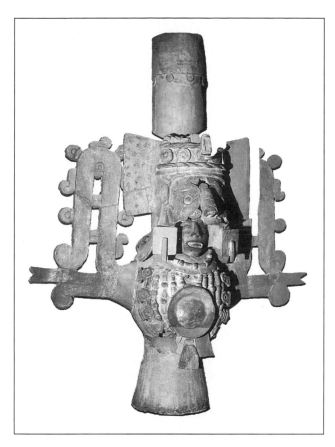

Pl. 27. Ritual figure wearing a mask of Tlaloc, Aztec incensario, Azcapotzalco (Museo Nacional de Antropología, México).

sealed and decorated with "snails, whirlpools, and water motifs," thereby uniting fire with water by placing aquatic symbols precisely where the mind expects fire. And the elbows and knees of the figure are uncharacteristically decorated with Tlaloc-like masks of the "handlebar mustache" variety.[239] This figure, like the Tlalocan mural figure, is a virtual hymn to creativity in its linkage of an aspect of the creator god to the god who assures the creativity of the earth and in its uniting of the fire that "spiritualizes" matter with the water that "materializes" spirit. If this figure originally found its place in a temple dedicated to Tlaloc, as seems likely, it would have stressed the breadth of the symbolic range of that god in the thought of Aztec Tenochtitlán.[240]

The recently uncovered second temple of the Templo Mayor also provides us with another "mask" of Tlaloc, this one in the most abstract possible form but also reminiscent of Teotihuacán. Behind the Chac Mool on the narrow walls flanking the entrance to the interior of the small temple are mural paintings of a seemingly abstract design (colorplate 5a). Although there are traces of blue paint above suggesting a portion of the mural now lost, what remains is a band of white concentric circles set on a black ground immediately above a blue band containing black circles, both of which

are above a solid red band. These horizontal bands surmount a row of alternating black and white vertical stripes. The location of this painting suggests that the Aztec artist has "deconstructed" the Tlaloc mask and then constructed an abstract representation of its symbolic elements—Tlaloc's goggle eyes and fangs—to flank the "mouth" of the temple of the god. Interestingly, a similar composition of these elements is to be found in a mural on Teotihuacán's sacred Avenue of the Dead (colorplate 5b) painted almost a millennium earlier. In that earlier version, the vertical lines are wavy, probably suggesting water in this city overwhelmingly concerned with Tlaloc, and superimposed on the mural is the figure of a jaguar, the creature associated with the god of rain from the beginning of Mesoamerican thought.

The serpent symbolism evident in the mask of Tlaloc has led to the suggestion that "the Aztec Tlaloc is no longer feline; fundamentally his nahual is the serpent. The jaguar of the hot lowlands does not represent Tlaloc in the highlands,"[241] so that by the time of the Aztecs, the jaguar was fundamentally associated with the earth god and with Tezcatlipoca rather than with Tlaloc. While it is certainly true that the jaguar was of great symbolic importance and that its symbolism did encompass the caves of the earth god and the mysterious darkness of the night associated with Tezcatlipoca, it is equally true that the jaguar maintains its fundamental relationship to Tlaloc at Tenochtitlán. Although the eyes of the Aztec Tlaloc are symbolically associated with the serpent, the mouth and fangs of Tlaloc are those of the jaguar, as we have demonstrated in our discussion of the Teotihuacán Tlaloc. And the recent excavations at the Templo Mayor have added further evidence of the symbolic relationship between the jaguar and Tlaloc, for "among the offerings are numerous jaguar skulls, some of which carry egg-sized jade stones (a symbol of life and regeneration) in their mouths; even a complete skeleton of a jaguar was found placed on top of other offerings dedicated to Tlaloc."[242] The remains of that jaguar testify to the direct line of continuity linking the Olmec were-jaguar mask to the Aztec Tlaloc presiding over the imperial state conquered by Cortés.

THE MASK AS METAPHOR
Chac

A consideration of the Maya use of the mask as a metaphor for the rain god is somewhat more difficult. That there are masks of the rain god is clear: any visitor to the archaeological sites of the Yucatán finds masks of Chac forming the doorways, lining the stairways, marking the corners, and embellishing the facades of ancient pyramids and temples. But lowland Yucatán is only one part of Maya

territory, and most of the masks we see are from relatively late in the development of Maya civilization. It is somewhat more difficult to isolate a mask of the rain god in the Classic period, especially in the highlands, and yet the antecedents of the Chac masks of the late Classic and Postclassic Yucatán seem to be found in Preclassic developments in those distant highlands and on the Pacific slope. And a difficulty of another sort arises from the fact that the rain god of the codices, presumably of Postclassic Yucatec origin, is a man, or four men, with exaggerated and distorted facial features but not a mask. These difficulties are compounded by the paucity of knowledge of Maya religion available to modern scholars. Nevertheless, we feel that a case can be made for the existence among the Maya of a metaphorical mask of the rain god, a mask that, like those of Oaxaca and central Mexico, carries with it connotations of fertility and divinely ordained rulership, and that, like those other metaphorical masks, was derived from an Olmec original.

The case for an Olmec source of Chac was made early. Covarrubias's chart (pl. 2) traces Chac's descent from the Olmec were-jaguar, and J. E. S. Thompson, who saw serpent rather than jaguar associations, believed that the Maya rain cult, "with world color and directional features and with quadripartite deities deriving from or fused with snakes, had developed in all its essentials in the Formative period, probably as an Olmec creation."[243] Not until recently, however, did scholars begin to understand the precise means of transmission of the were-jaguar mask to the Maya. While still not as clear as it might be, it now seems that

> Classic Maya civilization's Olmec ancestry is traceable through the Izapan culture, which spread through the Intermediate Zone and much of the Maya Highlands in the late Preclassic period. Olmec art preshadows Izapan art in subject matter, in style, and even in specific iconographic elements. . . . In a very real sense, Maya symbol systems began with Izapan culture, which in turn has an obvious Olmec ancestry.[244]

While Olmec influence can also be seen in the lowlands of the Petén and Belize (Olmec-related objects from as early as 1000 B.C. appear at Seibal, Xoc, and Cuello),[245] Izapan art, characteristic of sites on the Pacific slope and in the highlands, seems to be the link between the Olmec were-jaguar and Chac.

Among other human and composite beings depicted in the relief carvings of Izapa "is what may be called the 'Long-lipped God.' This being has an immensely extended upper lip and flaring nostril and is surely a development of the old Olmec were-jaguar, the god of rain and lightning." This god "becomes transformed into the Maya rain god Chac."[246] And Izapan art displays other symbols associated

with later rain gods as well—fangs protruding from the corners of the mouth à la Tlaloc and Chac and bifurcated tongues like those of Cocijo—though not in the context of the long-lipped mask. In profile, that mask (pl. 28) shows obvious similarities to the Olmec were-jaguar mask because in both cases symbolic attention is focused on the exaggerated upper lip. While the exaggeration of the Izapan upper lip is greater than that found on most Olmec were-jaguar masks, a number of stone masks have an upper, "jaguar" lip elongated so as to protrude well beyond the plane of the face.[247]

There are other signs of continuity between Olmec and Izapan art directly related to the mask of the rain god. Significantly, the long-lipped god of Izapan art is found primarily on stelae presumably associated with rulership. The Olmecs began the

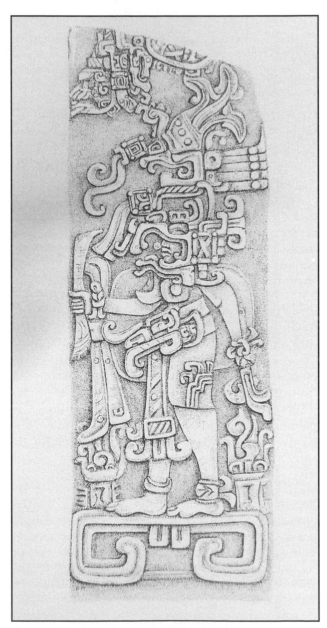

Pl. 28. Stela 11, Kaminaljuyú depicting a masked ritual figure whose face is visible within the mask (after Gay 1971, fig. 14; reproduced by permission).

long Mesoamerican tradition of carving and setting up stone stelae, a tradition that was to reach its apex among the Classic Maya. From its Olmec inception, that tradition was dedicated to the portrayal of rulers, and the Olmecs often indicated the ruler's status on the stelae in the same way they symbolized it on the throne/altars: a number of the earliest stelae depict a figure or figures associated with rulership within the open mouth of a jaguar. The Olmec Stelae A and D from Tres Zapotes depict this motif most clearly; both frame scenes involving what seem to be rulers and warriors within the jaw of a jaguar.[248]

La Venta Stela 2 (pl. 29), discussed below, lacks the jaguar mouth "frame" but also relates the jaguar mask to rulership. This stela depicts a standing figure holding a ceremonial bar and wearing an elaborate headdress displaying prominently a common Olmec abstract motif that Joralemon calls the "four dots and bar symbol" representing a mask.[249] The headdress is depicted with a curving lower edge that seems to disappear behind the figure, creating a clear visual reference to the cave/niches of the altars and uniting this stela with those monuments that legitimize the ruler by associating him with the were-jaguar mouth. For the Olmecs, then, the stelae, like the altars, provided a means of defining, through the symbolic use of the mask, the spiritual nature of temporal power. And that use of the stela passed to Izapa and ultimately became one of the primary features of the cult of the divine ruler among the Maya.

The Izapan-style Stela 11 (pl. 28) from the highlands site of Kaminaljuyú brings together the mask of the long-lipped god and the stela tradition by depicting a man, presumably a ruler, wearing what Coe describes as "a series of grotesque masks of Izapan long-lipped gods"[250] to indicate his exalted status. There are four masks in this "series." One of them covers his face, and another is in his headdress. Above his head "floats" a third, downward-peering mask prefiguring the Classic Maya convention of representing the ancestor of the current ruler, and a fourth mask with a long bifurcated tongue marked with what may well be water symbols hangs from his belt. Somewhat different from each other, these four masks share the emphasis on the exaggerated upper lip derived from the Olmec tradition, and there are other, equally clear references to that mask tradition. The ruler's x-ray style depiction within the mask is similar to that of the ruler atop the throne/altar in the Olmec painting at Oxtotitlán (pl. 5) and represents a symbolically important convention in the depiction of masked figures which we will discuss in the context of masked ritual below. In another similarity to that painting, this figure stands atop a stylized jaguar mouth, the symbolic equivalent of the mouth on the Olmec throne/altars and stelae from which rulers symbolically emerge from the world of the

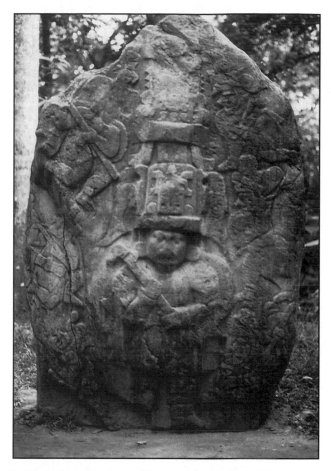

Pl. 29. Stela 2, La Venta (Parque Museo de La Venta).

spirit to provide a sacred order for the world of man.

This stela is but one indication of the exaltation of the ruler at Kaminaljuyú; another can be seen in the elaborate burials uncovered there. These burials were located within pyramidal temple platforms, anticipating the later Maya practice, and in one of them,

> the corpse was wrapped in finery and covered from head to toe with cinnabar pigment, then laid on a wooden litter and lowered into the tomb. Both sacrificed adults and children accompanied the illustrious dead, together with offerings of astonishing richness and profusion. . . . Among the finery recovered were the remains of a mask or headdress of jade plaques perhaps once fixed to a background of wood.[251]

Also in that tomb was a soapstone urn similar to the Tlaloc urns displaying a face with an Olmec-like were-jaguar mouth. In life, as depicted on the stela, and in death, the mask symbolized the divine status of the ruler in Preclassic Kaminaljuyú as it did earlier for the Olmecs and would soon do for the Maya. That aspect of the symbolism of the were-jaguar mask would be the dominant one in Maya art, although its association with rain and fertility was always just beneath the surface.

We do not know the name of the deity symbolized by that mask of the long-lipped god of Izapa, but we do know that the Classic-period god in whose mask Maya rulers often displayed themselves was one of the quadripartite Chacs, Chac Xib Chac by name. In a fascinating symbolic shift, the elongated lip of the Izapan god at times becomes an elongated nose or both lip and nose are elongated.[252] Throughout the Classic period, that long-lipped or long-nosed mask and the accoutrements of Chac Xib Chac are worn by living Maya rulers and accompany them in death. On Tikal's Stela 31 (pl. 30), for example, which depicts the accession rites in A.D. 445 of the ruler Maya scholars have named Stormy Sky, a downward-peering "floating image" like that above the figure on Ka-

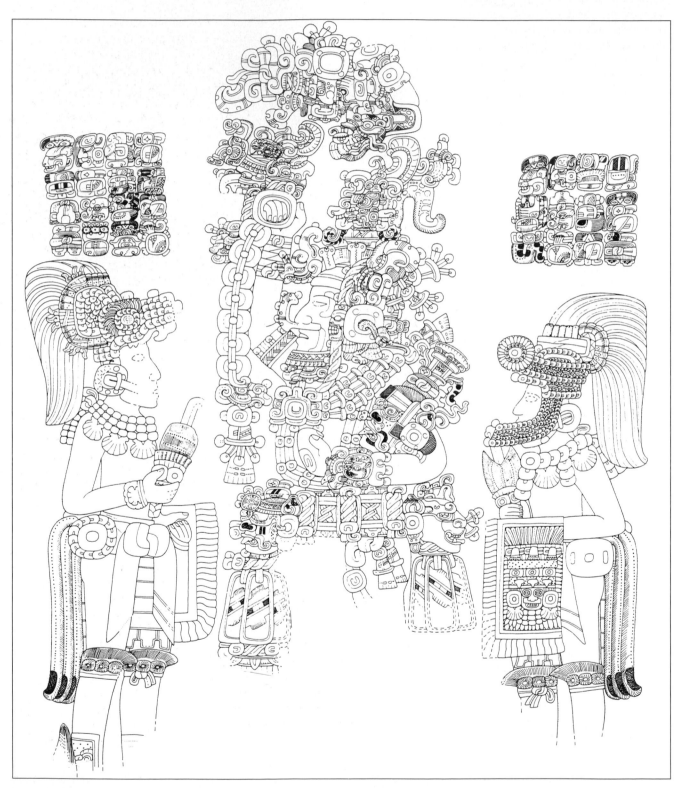

Pl. 30. Stela 31, Tikal, front and sides (drawing by William R. Coe, reproduced by permission of The University Museum, University of Pennsylvania).

minaljuyú Stela 11 appears over Stormy Sky's head. It is a manifestation of his dead father, the previous king, called Curl Snout[253] because his upper lip is elongated like the Izapan lips but turned upward in this case. Above and below his disembodied head, however, are long-nosed masks, "one of the earliest known examples of the Maya rain deity much later known as Chac."[254] And Stormy Sky himself wears a buccal mask with a long upturned lip like that worn by Curl Snout and also displays masks with exaggerated noses in his headdress and on his belt. Both the headdress and belt masks, like those of Curl Snout above, display a backward-curving spiral at the corner of the mouth very similar to the fangs protruding from the corners of the mouths of the later Chacs. Similar images of Chac Xib Chac were worn on pectorals and suspended from symbolic ceremonial belts worn by kings throughout the Classic period.[255]

This symbolic identification of the ruler with Chac through the use of the mask continues later in the Classic period. A late Classic figurine illustrated by Linda Schele and Mary Ellen Miller wears a costume of Chac Xib Chac which is "standard for Maya rulers" and "identical to costumes worn by rulers on Dos Pilas Stelae 1 and 17."[256] And one of the better-known rulers of the late Classic, Yaxchilán's Bird Jaguar, is depicted on Stela 11 from that site (pl. 31) in an X-ray image discussed in the following section. Portrayed in ritual "directly preparatory" to his accession, he manifests himself as Chac Xib Chac[257] in a mask with an elongated nose, the suggestion of an elongated upper lip, and a spiral device at the corner of the mouth.

These images of living rulers have their counterparts in the tombs of dead rulers. The early Classic period Kendal Tomb in northern Belize, for example, has yielded jade artifacts—a pectoral, an ear flare, and an ax—that "reveal that the ruler . . . went to his grave dressed in the costume of the god Chac Xib Chac."[258] And the association of Chac with burials can also be seen in the stuccoed wooden figures of the god found in a Classic period tomb at Tikal[259] which display enormously elongated upper lips and noses that have merged in a single projecting form. This association of the mask of Chac with death reveals the Maya belief in regeneration. The king died to the world of nature only to "become a god," to merge with the life-force of which he was the representative and for which he was the conduit in his stay on earth. This belief is captured in the image on a carved limestone panel from Palenque which depicts Kan Xul, dead king of that city, dancing "out of Xibalbá wearing the costume of Chac Xib Chac." The text on this

apotheosis tablet . . . begins by recalling the ritual, on February 8, A.D. 657, in which Kan Xul was named as the kexol, *the "replacement," of a dead ancestor of the same name*

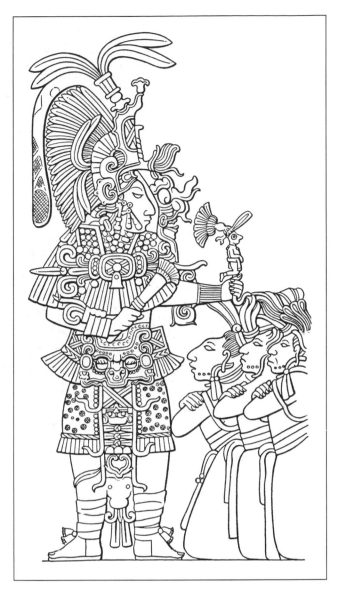

Pl. 31. Stela 11, Yaxchilán, rear face (from *The Rise and Fall of Maya Civilization*, by J. Eric S. Thompson. Copyright 1954, 1966 by the University of Oklahoma Press).

who had died on February 10, A.D. 565, ninety-two years earlier. It ends with the rebirth of Kan Xul on November 24, A.D. 722 after his sacrificial death at Tonina.[260]

Death has been defeated, and the cycle of life through which the life-force manifests itself continues its eternal movement. The mask of Chac and the dance of Kan Xul are marvelously symbolic of this victory and of the continuity demonstrated in the person of the ruler who is "replacing" his predecessor as a new manifestation of the eternal god whose mask they wear and are.

This belief is also expressed through the mask and figure of Chac on the painted ceramics characteristically associated with late Classic burials in the southern lowlands and north along the Caribbean coast into the Yucatán. These ceramics are closely allied stylistically and iconographically to

the somewhat later codices that are presumably also of Yucatán origin. A remarkable example of that ceramic tradition is an "extraordinary plate [that] presents a conceptual cosmological model of the Maya universe that is without previous precedent in the ceramic medium" (colorplate 6) in the form of "the resurrection of a personage (if not Venus) . . . linked to a visual observation of the first appearance of Venus as the Evening Star (a Water Lily Jaguar) on the night of October 24, A.D. 775."[261] In the center of the plate appears Chac Xib Chac rising from Xibalbá through the waters that separate that realm of the spirit from the world of nature.

His face is the god's distinctive mask with its exaggerated nose, elongated upper lip, curving fangs, and distinctive eye and ear treatment reminiscent of Cocijo and Tlaloc. This is the Chac of the later codices and the mask that decorates the contemporaneous architecture of the northern lowlands. Growing from the top of his head is the World Tree, the branches of which "are transformed into the bloody body of the Vision Serpent." Above and below the god, painted on the angled walls of the plate, can be seen the enveloping world of the spirit; "in the lower border, the skeletal Maw of the Underworld encloses bloody water; in the upper half of the border, the Celestial Monster arches around the rim of the plate forming the dome of heaven."

> *This single image encompasses the entire Maya cosmos and synthesizes all of the imagery that was integral to the lives and functions of kings. It explains the rationale behind accession, the role of bloodletting, the nature of the vision produced, the necessity of sacrifice, the inevitability of death and the possibility of renewal. . . . To the Maya, this plate held a symbolic depiction of the fundamental causal forces of the universe, exactly as the equation $e = mc^2$ symbolically represents our understanding of the physical forces that structure our universe.*[262]

The symbolism of this plate offers eloquent testimony to the central role played by the mask of the god in delineating metaphorically the relationship between man and the world of the spirit for the Maya. Its central image refers simultaneously to Venus emerging from "death" as the Evening Star, Chac in his association with the cyclical rebirth of vegetation, and the unknown ruling "personage" who had, like Kan Xul, vanquished death to merge with the life-force.

Not only does this image of Chac tell us a great deal about Maya thought but in an almost unbelievable way it also suggests the extent to which that thought shared its fundamental assumptions with the spiritual thought of the other great Classic period civilizations. Although the image on this plate is completely different visually from the scene depicted on the upper half of the Tlalocan mural at Teotihuacán (colorplate 3), the iconographic parallels are striking. In both cases, an image of the rain god is central and water flows beneath him. And in both cases, this water separates him from the world of the spirit. In both images, a stylized tree from which liquid flows seems to emerge from his head, and in both cases, liquid flows from his hands. These similarities in detail reveal the essential similarity: in both, the figure of the rain god with his characteristic mask is central to a composition that symbolically depicts the gods, impersonated in ritual by priests or kings (or priest-kings), as the conduits through which the life-sustaining forces of the world of the spirit enter the world of man. Similarly, the reciprocal sacrifice required of man is noted in both. While the Maya plate, unlike the mural, refers centrally to Venus and astronomical cycles, in typically Maya fashion, and the Teotihuacán mural's central reference to the union of fire and water has no counterpart on the plate, the imagery of both of these important pictorial statements connects the mask of the god of rain to the eternal elemental processes manifested in the cycle of life driven by the life-force.

Significantly, the image of Chac on the Maya plate is Chac Xib Chac, "the name that is used for God B in the Dresden Codex and documented in colonial sources. In Postclassic cosmology, there were four Chacs assigned to the four directions. The chief among them was Chac Xib Chac, the Red Chac of the east."[263] That eastern aspect of the quadripartite Chac is naturally associated with regeneration since the eastern horizon is the location of the sun's daily rebirth, and red, as we have seen, is associated with the sacrificial blood that man must shed to ensure the continuation of the cycle of generation and regeneration. But in addition to that, the Chac of the plate is the "chief" Chac, the essential Chac, the god who, like the Tlaloc and Tezcatlipoca of central Mexico, unfolds into aspects, each of which are still the god. Tezcatlipoca, as we have seen, was both the unitary god and one of the aspects. The same situation seems to exist here. It is particularly interesting that "the other three Chacs have not yet been identified with specific Classic period images";[264] perhaps they, like the other three aspects of Tezcatlipoca, have other identities. Whatever the case, it is significant that the unfolding of Chac parallels that of the gods of central Mexico just as the mask of Chac parallels that of his central Mexican "brother."

Those parallels are firmly rooted in Maya history as well as in their common Olmec origin. The mask of Tlaloc and other indicators of a central Mexican presence appeared in the Classic period when "from a base at Kaminaljuyú, Teotihuacanos developed economic ties with a few centers in the southern lowlands."[265] One of these centers was Tikal, and Stela 31 from that site (pl. 30) which, as

we have seen, presents "one of the earliest known examples" of Chac worn in the headdresses of the ruler, Stormy Sky, and his father, Curl Snout, shows that ruler "flanked by two men dressed in the manner of Highland Mexicans" carrying shields decorated with Tlaloc-like masks.[266] As Clemency Coggins demonstrates, the Tlaloc mask was symbolic of Mexican influence in the spiritually significant areas of calendrical thought and ritual,[267] but "Tlaloc imagery was soon Mayanized to conflate with the Maya long-nosed rain and storm personification later known as Chac."[268] And Tikal was not the only example of this use of Tlaloc; there are similar allusions to Tlaloc in depictions of Bird Jaguar at Yaxchilán, another ruler also connected with Chac.[269] The striking similarities between the Chac of the late Classic plate and the Tlaloc of the Teotihuacán mural are clearly not coincidental.

The late Classic period also saw the development of the architecture of the regional societies of the northern lowlands, an architecture that used the mask to an unprecedented degree. Large public buildings in the Río Bec, Chenes, and Puuc regions were similarly embellished with mosaic masks of Chac, masks that "most closely resemble the long-nosed 'Chacs' of the Maya Postclassic manuscripts or codices."[270] Made up, mosaic style, of separately carved elements, these masks decorated the facades of the buildings, marked their corners, and delineated the liminal importance of the temple doorways and the pyramid stairways. The large mosaic mask that surmounts a doorway in the east facade of the palace at the Puuc site of Labná (color-plate 7) provides an excellent example of the type. Clearly identifiable as Chac by its elongated, upturned nose (on which is inscribed a Maya date equivalent to A.D. 862), it contains features characteristic of that god as well as reminiscent of the other Classic period rain gods. Immediately below that characteristic nose is a mustachelike element representing the two curving or spiral fangs that typically protrude from the corners of Chac's mouth, but in this case, the similarity to Tlaloc's "handlebar mustache" upper lip is striking. The mouth, with its teeth flanked by outturned fangs, is also similar to the Tlaloc mouth, although the lower teeth are characteristic of Chac. The roughly rectangular eyes are also typical of the Chac mask, though they are similar to Cocijo's eyes, but the ear flares are again somewhat reminiscent of Tlaloc. Such a mask as this, then, illustrates clearly the iconographic interconnectedness of the masks of the rain god in the Classic period, due in great part to their common Olmec ancestry.

The symbolic use of such masks will be discussed in our consideration of architectural masks, but it is important to note here Rosemary Sharp's contention that the quadriplicity of the Chacs was used as "a cosmological model" by the peoples of the Yucatán on which to base their political system and that "the conflation of sacred and secular systems was manifested in an artistic form which combined particularly potent natural symbols with a quadripartite plan for the limitation of power." Whether or not she is correct in her contention that rulers were "rotated" on the basis of this cosmological model, the multiplicity of Chac masks on public buildings surely supports her contention that "like Oaxacan Cocijos," and, we might add, the Olmec were-jaguar, "Chacs imply a great deal more than rain."[271] They connote the inherent orderliness of life and are intimately related to rulership.

These late Classic period mosaic Chac masks as well as the Chac depicted on the painted ceramic funerary plate and others on ceramic vessels are no doubt similar to those that must have been depicted in codices at the time. Unfortunately, none of those codices has survived; we have only four Postclassic works, all of them Yucatec, that contain Chacs whose masklike faces are clearly derived from the earlier models. In the Codex Dresden, the most complete of the four, representations of Chac vastly outnumber those of other gods. They are depicted with masklike faces characterized by long noses and fangs curving backward from the corners of their mouths. These Chacs appear most frequently in sections devoted to "problems of farmers—the weather and the crops."[272] This clearly indicates that despite its intimate connections with rulers, the mask of Chac retained its primary association with rain and fertility without losing its ability to delineate symbolically the essential nature of reality.

> One group of Chacs enthroned on their directional trees are followed by a fifth Chac seated in a sort of cave or underground chamber with the glyphic label yolcab, "in the heart of the earth" (Codex Dresden, 29a–30a). Directional trees are of this world, so the center is a spot below the center of the world.[273]

These five Chacs (pl. 32), like the five Tlalocs on page 27 of the Codex Borgia, reproduce the sacred shape of space and time and in doing so reveal their use by the Maya sages as a means of understanding and expressing metaphorically the most profound of mysteries. In this, they are essentially similar to the masks of Tlaloc and Cocijo.

But while Chac seems to have continued his existence undisturbed in the Postclassic codices, developments in the Yucatán forced his mask to coexist with that of Tlaloc on the facades of temples and elsewhere. Although its extent, dating, and precise nature are uncertain, there was an intrusion into the northern lowlands, particularly evident in the architecture of Chichén Itzá, of the artistic forms and presumably the belief system and political organization of the dominant power in central Mexico, Toltec Tula. And with their ar-

Pl. 32. Chacs, Dresden Codex (from Thompson 1972, 29A and 30A, reproduced by permission of The American Philosophical Society).

chitectural style, the Toltecs brought their gods. Best known of the "new" gods in the Yucatán was Kukulcán, the Yucatec variant of Quetzalcóatl, but masks of Tlaloc also appear. At Uxmal, for example, "on the north range of the Monjas quadrangle . . . a pile of Chac masks is surmounted by a Tlaloc," and in the Balankanche Cave near Chichén Itzá, a large shrine surrounded by Tlaloc effigy vessels testifies to the presence of the Mexican rain god.[274]

But Chac survived this challenge by Tlaloc as he survived the smaller but comparable intrusion of the alien god-mask during the Classic period in the southern lowlands. His survival can be seen clearly in the plethora of long-nosed fanged faces on the ceramic urns, figurines, and incensarios produced late in the Postclassic at Mayapán. Although such ceramics are often associated with Tlaloc, these depict Chac. One of the similar effigy urns found in the Balankanche Cave (pl. 33) demonstrates the means of that survival. The face on the urn has many of the features of Tlaloc; we see clearly the goggle eyes, the circular ear flares, and the handlebar-mustache upper lip from which protrude Tlaloc's typical fangs. But the nose on the urn is the nose of Chac, and extending from the sides of that nose is the same spiral design that appeared under the nose of the Labná mosaic mask, a stylized version of the fangs of Chac. Significantly, the urn is painted half blue—the color of Tlaloc's urns—and half red—the color of Chac Xib Chac. After centuries of separate development from its Olmec beginning, the features of the rain god are reunited in this urn, which was fittingly found

"deep in the cave"[275] from which could emerge the life-sustaining water from the realm of the spirit. Thus, the essential unity of the masks of the rain god of pre-Columbian Mesoamerica can be seen in this simple but striking urn that metaphorically holds both the rain god's waters and a key to our understanding of his mask.

Pl. 33. Chac/Tlaloc, painted ceramic urn, Balankanche Cave, Yucatan (Museo Nacional de Antropología, México).

THE STRUCTURE OF THE MASK

The key that that simple Maya pot so effortlessly holds is the very structure by which the gods—or masks—of pre-Columbian Mesoamerica were constructed. Built on the armature of the human face, these god-masks were created by replacing the human features, often through the use of partial masks, with features drawn from a number of other natural creatures. In this way were created Leach's "supernatural monsters" (see above) capable of mediating between man and the otherwise inaccessible world of the spirit. As the rain god has shown us, the features replaced were few, and the number of features in the repertoire used to replace them really quite limited. The human forehead could be cleft, the eyes could be "ringed" or "bracketed" in several possible ways, the nose could be elongated and turned up or down, the ears could be decorated with flares of various shapes, the flesh of the face could be colored and patterned, and the features of the mouth could be varied.

The variations involving the mouth were the most important. They are the most striking visually and consequently seem to be the most significant iconographically. Tlaloc is most easily identified by his "handlebar mustache" and fangs, Cocijo by his upper lip and bifurcated tongue, Chac by his elongated upper lip or nose and curving fangs, and their common ancestor, the Olmec were-jaguar, by his jaguar-derived mouth from which all these later features came. This careful attention to the symbolism of the mouth is typical of Mesoamerican god-mask construction and no doubt reflects an awareness of the importance of the mouth in expressing inner—and therefore metaphorically spiritual—realities. For the mask is a metaphor. It converts the human face, itself a primary symbol of identity, into a visual symbol of inner reality. In making the inner outwardly visible, the mask exemplifies the inner/outer duality at the heart of Mesoamerican spiritual thought and reveals the most fundamental purpose of life in pre-Columbian Mesoamerica: to convert the material of this world into spirit or, as we shall see in our consideration of transformation, to create, as the Aztecs put it, a face expressive of the "deified heart" within.

The primary purpose of our lengthy consideration of the mask of the god of rain was not, however, the enumeration of its symbolic features. Beneath those features, as we have shown, is the system according to which they are selected and combined, a system that generates masks as metaphors for spiritual realities. The mask of the rain god is the perfect vehicle for an exploration of that system since it provides the most easily seen continuity from the earliest times to the Conquest and because the symbolic dimensions of that mask in each of its Mesoamerican incarnations are relatively clear. Directly related to the provision of rain by the gods, the mask is also associated with fertility, rulership, and the structure of time. Thus, it played a fundamental role in Mesoamerican spiritual thought, which accounts for the relative ease with which its development can be traced. Its fundamental nature is underscored by the fact that in all of the cultures for which there is evidence, the mask of the rain god is quadripartite *in itself*, that is, Cocijo, Tlaloc, and Chac unfold into four Cocijos, Tlalocs, and Chacs with directional, temporal, calendrical, and color associations. This is not true in the same way of any other god-mask. Tezcatlipoca, for the Aztecs, is quadripartite, of course, but his "unfoldings" are different; they are other gods with other names and functions. Because it symbolized the most fundamental order, or "shape," of reality, the development of the mask of the rain god, as we have seen, is intimately related to the development of urban civilization and speculative thought during the Classic period.

The fact that the rain god's mask was a fundamental vehicle of Mesoamerican spiritual thought also assures that conclusions drawn from an analysis of its systematic construction will be applicable to all the other metaphorical god-masks constructed during the course of the development of the profound and complex spiritual thought of Mesoamerica. And there were many others. So many that scholarship has had tremendous difficulty in identifying them and understanding their meanings. That difficulty has its primary source, we feel, in the failure to understand a fundamental fact about the system within which those god-masks exist. As we will show clearly in the second section of this study, the essence of the world of the spirit, the life-force, manifests itself in this world through a process of unfolding through which certain primary manifestations of the spirit become accessible to man through ritual. On the basis of what we have learned from the rain god, it is apparent that these manifestations have a relatively fixed and permanent identity and are generally well understood by modern scholarship. In Aztec terms, the four Tezcatlipocas—Tezcatlipoca, Xipe Tótec, Huitzilopochtli, and Quetzalcóatl—and the quadripartite Tlaloc are good examples of such primary manifestations, and each of them is readily identified by a characteristic "mask" made up of an actual mask or distinctive face painting and articles of costume.

We can call such masks as these primary masks since they identify the primary manifestations of the spirit, and our study of the mask of Tlaloc, probably the best example of such a primary mask, enables us to identify several of their fundamental characteristics. First, they demonstrate continuity in time. Although each of the constituent cultures of the Mesoamerican tradition has its own version of the mask, those versions are visually and conceptually closely related. Second, they are multi-

vocal. They unite in one symbolic image a cluster of related mythic themes; the mask of the rain god, for example, symbolizes rain and lightning, fertility, divinely ordained rulership, and the driving force of time in a single image. Third, they unite microcosmic and macrocosmic manifestations of the spirit; the rain god's mask, for example, ties the macrocosmic rain to the microcosmic blood, the macrocosmic spiritual order of the gods to the microcosmic social order of the ruler. These primary god-masks are as close as the Mesoamerican spiritual tradition comes to the creation of "gods," that is, fixed and therefore stable combinations of spiritual qualities.

We have delineated the rain god mask's symbolic features and the spiritual concepts for which it was the metaphor. Other primary masks can be identified, and detailed studies of their development would make a better understanding of their metaphorical range and meaning possible. Such a mask as the bird-billed Aztec Ehécatl, for example, has analogs in other cultures, and it is clearly multivocal. Directly related to the wind that "clears the roads for the coming of the rains," it symbolizes, by extension, both fertility and the human breath, symbol of human life. In its combination of the creature of the air, the bird, with the creature of the earth, the serpent, it relates fertility to sacrifice, life to death. Thus, it is no surprise that its aspects, the Mexican Quetzalcóatl and the Maya Kukulcán, symbolize the creative principle and relate that macrocosmic principle to its microcosmic manifestation in rulership. The mask combining bird and serpent, then, has all the characteristics of a primary mask.

There are a number of other primary god-masks depicted in the spiritual art of Mesoamerica. The hook-beaked bird so important in the art of Teotihuacán appears frequently as a mask element in the art of other cultures and may well be part of another primary mask. And there are other possibilities. The stripe through the eye characteristic of the Aztec Xipe Tótec and present in Mesoamerican art from the time of the Olmecs may constitute the major element of another primary mask, as Coe and Joralemon claim,[276] but understanding Xipe Tótec requires dealing with the ritual mask made of flayed human skin and, perhaps, differentiating that mask from the symbolic mask of the god—a difficult task. Similarly, the old, wrinkled face that in Aztec thought was the "mask" of Huehuetéotl, who is intimately related to Xiuhtecuhtli, fire, can be traced through Mesoamerican art and is often associated with the masklike "diamond-eye" motif encountered at Teotihuacán. And another, even more intriguing symbolic form is the "smoking mirror" associated in the Valley of Mexico with Tezcatlipoca who wears it as a pectoral and in the Maya codices with the similar God K in whose forehead it can be seen. Not a mask but a reflection

of the face, or "mask," of the viewer, such mirrors are found archaeologically from the time of the Olmecs to the Conquest in ritual contexts. The central role of the face in all of these symbolic constructs indicates again the metaphorical significance of the mask and suggests the variety of ways that metaphor can be applied.

But not all of the god-masks encountered in Mesoamerican spiritual art are primary masks, in the sense that we are using the term, and unfortunately the other type of god-mask, which we will call secondary, has not been so well understood. Unlike the primary masks, these masks do not have fixed, recurring features. Rather, they are particular, often unique, combinations of features designed to make a particular mythic or ritual statement and have no continuing existence apart from that. The mask of the central figure in the Tlalocan mural at the apartment compound of Tepantitla at Teotihuacán (colorplate 3) provides an excellent example. By combining the diamond eyes of the old god of fire with the mouth of Tlaloc, that mask unites the opposed forces of fire and water as a metaphorical statement of the necessity of sacrifice and death, that is, the "spiritualization" of matter symbolized by fire, for the continuation of life, that is, the "materialization" of spirit symbolized by water. As the mural makes clear, this metaphorical statement provided the focal point for a particular ritual presided over by this mask, and its combination of features existed at Teotihuacán only in and for that ritual. In it, we can see the characteristics of the secondary masks. First, they are composed of features taken from two or more primary masks and are created to link the fundamental areas of spiritual concern designated by those primary masks. Second, they are unique or infrequently seen combinations of features. These secondary masks, we feel, are better regarded as ritual statements than as gods since they have no existence beyond the particular myth or ritual in which they function.

These secondary masks provide one of the greatest sources of confusion in the discussion of Mesoamerican spiritual thought as their status is not generally understood. The key to understanding them, as we have shown, lies in an understanding of the nature of the system of spiritual thought by which they are generated and in which they exist. Perhaps this has been difficult for modern scholars because our materialistic assumptions and scientific procedure are too distant from the assumptions and procedure of those who developed the system. We insist that each mask, each "god," have a fixed, permanent identity, that it be a "thing" in a world of comparable "things" so that it can be defined and classified by our science and stored neatly away in the proper bin. Unfortunately, such an approach is not consistent with the basic assumptions underlying Mesoamerican

thought. As we will show, that system was one based on the idea that ultimate reality was to be found in the world of the spirit. The material reality of this world, the reality seen as fundamental by modern man, was for that system an ephemeral, kaleidoscopic projection of a mysterious spiritual reality that man could comprehend only partially and express only through metaphor, most fundamentally in the system of masks we have described. While the primary masks provide a few fixed reference points, the secondary masks that fill Mesoamerican art reveal the fluidity of that world of the spirit as they attempt to capture the momentary, visionary connections between the fundamental truths expressed by the primary masks. Their basic quality is their evanescence, and we will not understand them until we accept that evanescence.

In the final analysis, a full understanding of both primary and secondary masks can come only from an understanding of the system that generates the masks of the gods and within which they function; the individual god-masks cannot be understood in isolation through an enumeration of their features or characteristics. Our consideration of the mask of the rain god clarifies the basic tenets of that system and the demonstrable consistency in the development of that mask of the rain god proves beyond any reasonable doubt the existence of that essential system. Jacobsen, in his exemplary work on Mesopotamian religion, suggests that in the study of such material as this,

> ultimately, the coherence of our data must be our guide. True meanings illuminate their contexts and these contexts support each other effortlessly. False meanings jar, stop, and lead no further. It is by attention to such arrests, by not forcing, but by being open to and seeking other possibilities, that one may eventually understand—recreate, as it were—the world of the ancients. For the world of the ancients was, as all cultures, an autonomous system of delicately interrelated meanings in which every part was dependent on every other part and ultimately meaningful only in the total context of meaning of the system to which it belonged. Understanding it is not unlike entering the world of poetry, [where, as E. M. Forster puts it,] . . . "we have entered a universe that only answers to its own laws, supports itself, internally coheres, and has a new standard of truth."[277]

It was on the basis of those laws that the sages and visionary artists of pre-Columbian Mesoamerica constructed the metaphorical masks we have examined as part of their "attempt to convert the body into a hieroglyph for the mystic formula"[278] that would reveal to them the mysteries of the gods. We look ever so carefully *at* those masks in our attempt to understand them, but, ironically, the creators of the masks looked *through* them. As Joseph Campbell points out in a discussion of Christian mythology, "the first step to mystical realization is the leaving of such a defined god for an experience of transcendence, disengaging the ethnic from the elementary idea, *for any god who is not transparent to transcendence is an idol, and its worship is idolatry.*"[279] The sages and artists of pre-Columbian Mesoamerica were not idolators, and we must endeavor to avoid that sin as well.

2 The Mask in Ritual
Metaphor in Motion

As we have seen, the masks of the gods provided Mesoamerica a metaphorical means of visualizing the transcendent, of defining the powers and differentiating between the various aspects of the world of the spirit. Used for those purposes, the masks of the gods gradually became more and more involved in priestly speculation as a means of recording the results of that increasingly abstract and sophisticated thought and as a means of communicating it on a variety of metaphoric levels to the laity. In that sense at least, through the course of the development of Mesoamerican spiritual thought, the mask was involved in and is illustrative of the growing intellectualization of the relationship between man and the gods, an intellectualization resulting naturally from the growth of a priestly class whose function was to mediate between man and god.

But important as the mask's role was in the progressively more abstract speculations of the priesthoods of Mesoamerica, it was also central to another, seemingly opposed tendency. When donned in ritual, the mask allowed men to become gods, to experience the numinous in all its immediacy and urgency, rather than to think about the godhead with the detachment and distance of the philosopher. In Mesoamerican masked ritual, the world of the spirit and the world of daily existence met, and the dynamic tension between those two opposed worlds catapulted the masked impersonators of the gods, and, vicariously, those who participated by watching, out of the familiar routine of their daily existence into "a no-time and no-place that resists classification," which Turner has called the "liminal experience."[1] It is, he says,

in liminality and also in those phases of ritual that abut on liminality that one finds profuse symbolic reference to beasts, birds, and vegetation. . . . Structural custom, once broken,

reveals two human traits. One is liberated intellect, whose liminal product is myth and protophilosophical speculation; the other is bodily energy, represented by animal disguises and gestures. The two may then be recombined in various ways.[2]

Although Turner does not apply this insight to the speculative thought and masked ritual of pre-Columbian Mesoamerica, it would be difficult to imagine a more applicable statement. As we have seen, it was precisely through "profuse symbolic reference to beasts, birds, and vegetation" that priestly speculation liberated itself from the constraints of the mundane material world to explore the world of spirit. And as we will demonstrate in this chapter, the "bodily energy" of masked ritual provided an alternative means of liberation.

Kent Flannery's characterization of very early Mesoamerican religious practice based on his discovery at sites in Oaxaca of numerous masked figurines and pottery masks similar to those found at such sites in the Valley of Mexico as Tlatilco, Tlapacoya, and Las Bocas indicates just how fundamental those "disguises and gestures" were.

Religion was another phenomenon that linked Mesoamerica, region by region, into one giant sphere of interaction. Indeed, it often seems that, for Early Formative Mesoamerica, there was only one religion. . . . It was a religion in which dancers, summoned by conch shell trumpets and accompanied by turtle shell drums, dressed in macaw plumes and equipped with gourd and armadillo shell rattles, performed in the disguises of mythical half-human, half-animal creatures. All this is suggested archaeologically; what eludes us is the underlying structure.[3]

It is unlikely that we will ever have the intuitive or even the intellectual understanding of the mys-

teries underlying that early ritual possessed by those masked dancers, who were probably members of "dance societies or sodalities" participating in "annually recurring rituals,"[4] but Turner's discussion of liminality does allow a tantalizing glimpse of the "underlying structure." In departing from "structural custom" to enter the "liminal experience," they acted on the assumption that the world of the spirit must be joined to man's world to ensure the continuation of life on the earthly plane.

It is significant in this respect that the source of Turner's concept of liminality is van Gennep's seminal work on initiatory rites, a concept that Turner extended to apply more generally to ritual. For van Gennep, "liminal (or threshold) rites" occurred during the transitional stage of initiation rites between the "preliminal rites" separating the initiate from the world he knew and the "postliminal rites" incorporating him into the new world of the initiated adult.[5] Turner characterizes that transitional stage as ambiguous since the initiate is "neither here nor there. . . . He passes through a symbolic domain that has few or none of the attributes of his past or coming state."[6] The ambiguity of that transitional stage is characteristic not only of initiation, however, but more generally of masked ritual. As Turner explains, "people have a real need . . . to doff the masks, cloaks, apparel, and insignia of status from time to time even if only to don the liberating masks of liminal masquerade" within which they can "contemplate for a while the mysteries that confront all men."[7] Thus, the liminal zone in which they find themselves is neither the day-to-day world that confers their public status on them nor the mysterious spiritual realm; it is "betwixt and between" in that "no-place and no-time" in which intellect and bodily energy can be "liberated" from "structural custom" to confront the mysteries of the spirit.

A contemporary example of a pair of opposed attempts to achieve such liberation is instructive. In Peter Shaffer's play *Equus*, the psychiatrist, Martin Dysart, a man of science, ponders his own intellectual attempts to understand spiritual reality in the context of the actions of his youthful patient, Alan Strang, actions through which the boy attempts to use his "bodily energy" to become a "mythical half-human, half-animal creature":

*Such wild returns I make to the womb of
civilization. Three weeks a year in the
Peloponnese, every bed booked in advance,
every meal paid for by vouchers, cautious
jaunts in hired Fiats, suitcases crammed with
Kao-Pectate! Such a fantastic surrender to the
primitive. And I use that word endlessly:
"primitive." "Oh, the primitive world," I say.
"What instinctual truths were lost with it!"
And while I sit there, . . . that freaky boy tries
to conjure the reality! I sit looking at pages of*

*centaurs trampling the soil of Argos—and out-
side my window he is trying to become one, in
a Hampshire field.*[8]

Alan's ritualistic approach to the spiritual is more personal, more immediate, and, at least from Dysart's point of view, more real and fulfilling than his own vicarious, detached, speculative experience. Shaffer, of course, feels that modern scientific, analytical man, through his intellectual progress "beyond" ritual, has lost the capacity to feel the spiritual and is thus left, on the one hand, with only his relatively sterile intellectualizations or, on the other, with desperate, futile attempts like Alan's to create a personal spiritual reality. But the engaging point here is that body and mind must be united in "conjuring the reality" of the world of the spirit.

An observation of Joseph Campbell's indicates the root of the modern problem. Speaking of "the function of the priest to represent . . . the art of living in the knowledge of transcendence without dissolving into it in a rapture of self-indulgence" and quoting Jung's statement that "the function of religion is to protect us from an experience of God," Campbell describes the characters in the mythic tales of Ovid's *Metamorphosis* as

*ill-prepared, . . . unfavorably transformed by
encounters with divinities, the full blast of
whose light they were unready to absorb. The
priest's practical maxims and metaphorical
rites moderate transcendent light to secular
conditions, intending harmony and enrich-
ment, not disquietude and dissolution. In con-
trast, the mystic deliberately offers himself to
the blast and may go to pieces.*[9]

In his own way, Alan Strang quite "deliberately offers himself to the blast," and he does "go to pieces"; Dysart, however, has so totally insulated himself from the experience of the blast that he feels nothing. Shaffer's Alan and Campbell's mystic are illustrative of what seems to be a universal human desire—to throw off the trappings of this mundane world and *become* the god. But it is important to realize that the true alternative to their destruction is not the equally destructive sterility of Dysart but, as Campbell points out, the way of ritual through which man can become god yet remain in the world. Only through ritual can the transcendent light of timelessness illuminate man's life without eclipsing totally his secular existence.

Geertz suggests, in a rather different way, that same view of ritual as a means of merging the mundane and the transcendent:

*It is in ritual—i.e., consecrated behavior—that
this conviction that religious conceptions are
veridical and that religious directives are
sound is somehow generated. It is in some
sort of ceremonial form—even if that form be
hardly more than the recitation of a myth, the*

consultation of an oracle, or the decoration of a grave—that the moods and motivations which sacred symbols induce in men and the general conceptions of the order of existence which they formulate for men meet and reinforce one another. In a ritual, the world as lived and the world as imagined, fused under the agency of a single set of symbolic forms, turn out to be the same world.[10]

For pre-Columbian Mesoamerica, the "single set of symbolic forms" through which the worlds of spirit and nature were fused was derived from the central metaphor of the mask, and the "metaphorical rites" through which those forms achieved their power developed the intrinsic logic of mask use, a logic expressed in the basic symbolic equation underlying masked ritual which we developed at the outset: just as the fantastically composed natural features of the mask, lifeless in itself, represent a specific, definable manifestation of the all-encompassing, mysterious ground of being or life-force, so that same mask worn by the human being in ritual and art is animated by the living person behind it who, by wearing the regalia, brings it to life and in so doing symbolically becomes the life-force itself. This symbolic identification of the life-force with the human wearer of the mask demonstrates the typically Mesoamerican attitude that human life is the closest of all forms to the divine and is charged with a special ritual duty to cooperate in the transformative movement of that life-force into the world of nature. In this sense, Mesoamerican spiritual art shows man at the center of the cosmos, mediating through the use of the mask between the opposed worlds of nature and spirit. And, paradoxically, the mask reveals man's central position not, as one might immediately think, by disguising the wearer but rather by expressing his true nature. By revealing the visage of the god, it is a truer reflection of the wearer's spiritual essence than his natural face. The ritual mask thus simultaneously reveals and conceals the innermost spiritual force of life itself. That force was the essence of the divine.

Those who wore the masks, the impersonators in ritual of the gods themselves, thus entered a liminal realm in which the reality of the temporal, mundane world was simultaneously juxtaposed to and fused with the timeless world of the spirit. In Mesoamerica, that liminal realm was delimited by the mask, and in that realm, the masked ritualist could "conjure the reality" of the world of the spirit protected by the mask from succumbing to "the blast" of transcendence. While we do not, of course, have the testimony of any of the masked dancers of early Mesoamerica referred to by Flannery to help us see that reality, we do have something very close to it. As we will show below, an examination of a similar use of masks in the kachina dances of the Hopi in the American South-

west, one probably derived from Mesoamerican ritual practice in the time of the Toltecs, suggests precisely the paradoxical nature of the liminal experience of the god-impersonator. Speaking of his own experience of the initiation into the kachina cult, Sam Gill tells us that

the event occurs as a part of the Bean Dance which concludes the annual celebration of Powamu, a late winter ceremonial to prepare for the agricultural cycle. The newly initiated children are escorted into a kiva, an underground ceremonial chamber, there to await the entrance of the kachinas, the masked dancers they have come to know as Hopi gods. Prior to this time, the already initiated go to great efforts to keep the children from discovering that kachinas are masked male members of their own village. Announcing that they are kachinas, the dancers enter the kiva where the children are eagerly awaiting them. But they appear for the first time to the new initiates without their masks. The children immediately recognize the identity of the dancing figures. Their response is shock, disappointment, and bitterness.[11]

Emory Sekaquaptewa, himself a Hopi, explains the result of that disillusioning experience.

When it is revealed to him that the kachina is just an impersonation, an impersonation which possesses a spiritual essence, the child's security is not destroyed. Instead the experience strengthens the individual in another phase of his life in the community. . . . For the kachina ceremonies require that a person project oneself into the spirit world, into the world of fantasy, or the world of make-believe. Unless one can do this, spiritual experience cannot be achieved. I am certain that the use of the mask in the kachina ceremony has more than just an esthetic purpose. I feel that what happens to a man when he is a performer is that if he understands the essence of the kachina, when he dons the mask he loses his identity and actually becomes what he is representing. . . . He is able to do so behind the mask because he has lost his personal identity.[12]

In other words, Sekaquaptewa has learned to see the mask as the means of entering the liminal realm defined by Turner. Knowing that, we can appreciate Gill's interpretation of the experience.

It is important that we take seriously what the initiated Hopi says. We must recognize that he actually means what he says, that in putting on the kachina mask he really becomes a god. . . . The children are told that the kachinas are gods who come to the village from their homes far away to overlook and direct the affairs of the Hopi people. They are taught that they too will become kachinas when they die.

But once initiated into the kachina cult, religious events can never again be viewed naively. Unforgettably clear to the children is the realization that some things are not what they appear to be. This realization precedes the appreciation of the full nature of reality. . . . The initiated children are made aware of the "essence" or sacrality of things they had until then seen only as "matter." Thus the initiation serves to bring the children to the threshold of religious awareness. . . .

This brings us back to the question of truth regarding the Hopi statement that when one dons the kachina mask he becomes a kachina. Given the appreciation by the initiated Hopi of the full nature of reality in both its material and essential aspects, the truth of the statement can be more clearly understood. By donning the kachina mask, a Hopi gives life and action to the mask, thus making the kachina essence present in material form. Mircea Eliade illuminates this point in his book The Sacred and the Profane: *"by manifesting the sacred, any object becomes something else, yet it continues to remain itself." The anomaly we observe in the Hopi statement that he becomes a kachina is but an expression of the paradox of sacredness; but, in this case, the sacred object is the Hopi himself. By wearing the kachina mask, the Hopi manifests the sacred. He becomes the sacred kachina, yet continues to be himself. We, as uninitiated outsiders, observe only the material form. The spirit, or essence, of the kachina is present as well, but that can be perceived only by the initiated. The material presence without the spiritual is but mere impersonation—a dramatic performance, a work of art. The spiritual without the material remains unmanifest; it leaves no object for thought or speech or action. The spiritual must reside in some manifest form to be held in common by the community. The view, often taken, that the kachinas are "merely impersonations" fails to recognize the full religious nature of the kachina performance. It also fails to take into account the truth of the statement. If the kachinas are not present in both material and essential form, the events could scarcely be called religious.*

Both Navajo and Hopi religions evidence an appreciation for the power of symbolization. Only through symbolization is the sacred manifest; the subtleties are many. On the one hand, the mundane materials which comprise religious symbols must never be taken as being more than the simple ordinary earthy elements they are. This fact is driven home in the disenchantment with the material appearance of the kachinas experienced by the children undergoing initiation. . . . On the other hand, the ordinary materials *when presented in the proper form* manifest the sacred.[13]

The Hopi experience, then, provides a precise definition for us of the liminal experience: "by wearing the kachina mask, the Hopi manifests the sacred. He becomes the sacred kachina, yet continues to be himself." And it delineates clearly the role of the mask as metaphor and extends the dimensions of its significance far beyond the specific ritual event. The initiated Hopi, unlike Shaffer's Alan Strang or Ovid's "ill-prepared" characters, can *become* the god he impersonates without "going to pieces" because the ritual moment of that impersonation is so structured that it can, as Campbell puts it, "moderate transcendent light to secular conditions, intending harmony and enrichment, not disquietude and dissolution." It is in this complex and profound sense that Sekaquaptewa's simple statement, "in Hopi practice the kachina is represented as a real being,"[14] is meant and must be understood. And that statement provides a marvelous example of Turner's definition of metaphor "as a means of effecting instantaneous fusion of two separated realms of experience into one illuminating, iconic, encapsulating image."[15]

At the same time, it makes clear that the liminal experience is indeed the experience of metaphor, the experience in which oppositions are "much less sharply polar than they appear in day-to-day living."[16] For the Hopi, it is the spiritual vision rather than that of day-to-day living that is true; only that vision captures the "full nature of reality in both its material and essential aspects." And throughout Mesoamerica, as in the American Southwest, it was through the agency of the mask that man entered the liminal zone of "no-time and no-place" where that essential truth could be experienced by allowing the essence of the god "to become present in material form." Through that liminal masquerade, he played his part in "the transformational drama" through which the material world was infused with spirit and life was enabled to continue. The ritual mask, then, was simultaneously the instrument of the liminal and the metaphor for the liminal fusion of spirit and matter.

For that reason, the examination of mask use in ritual is, in a sense, the most important part of this study since the ritual moment brings together at one highly charged point in time and space every aspect of the metaphorical meaning of the mask. Telescoped into that liminal experience are all of the fundamental qualities of Mesoamerican spirituality which we will delineate in Part II. In masked ritual, we can see the persistence of the essentially shamanistic belief in a magical transformation by which man can enter the realm of the spirit; we can see the fundamental belief in an order underlying material reality which can be approached through calendrically determined ritual

in sacred spaces oriented according to a sacred spatial order; we can see clearly that the mask, as a multivocal symbol at the point of liminality, served as the metaphor for that pervasive transformational process through which the divine essence could create and sustain the life of man and his world; and we can see that the gods, defined by the features of the mask, were "brought to life" through the animating force of the ritual performer within the mask. In a metaphorical sense, then, life emerges through the mask as the performer merges his individual identity into the all-encompassing world of the spirit symbolically represented by that mask.

EMERGING FROM THE RITUAL MASK

No image in Mesoamerican spiritual art more clearly illustrates all that is contained in the metaphor of the ritual mask than that of the ruler of Yaxchilán, Bird Jaguar by name, carved on the rear face of Stela 11 (pl. 31) at that site. Though the image is essentially a frontal view of the splendidly arrayed figure of the ruler, his face is shown in profile, and depicted in front of his face is a mask that is an integral part of and extends downward from his elaborate symbolic headdress. It is important to realize that this image, for all the realism of its depiction of the facial features of Bird Jaguar and the figures kneeling in front of him, is the result not of an attempt by the carver to portray natural reality but rather the result of his application to the stone of an elaborate set of artistic conventions designed to permit the symbolic communication of spiritual reality. The frontal view of the body allows the viewer to see—and "read"—the symbolic details of the ruler's costume, while the profile view of the head is surely designed to afford the viewer precisely the same experience as that of Hopi children seeing the unmasked kachinas for the first time. What has been called an X-ray view of the face within the mask allows the simultaneous depiction of the masked face of the costumed ruler which was presented to his subjects on the ritual occasion and the human face of the man within the mask.

We can paraphrase Gill's interpretation of the Hopi children's initiatory experience as an explanation of the effect of such an image. The viewer of the stela would be forced to realize that Bird Jaguar, in symbolically becoming the god depicted by the mask, has actually entered the liminal realm in which he can be human and divine simultaneously. He is, at this precise point in time and space, "manifesting the sacred,"[17] demonstrating that "only through symbolization is the sacred manifest." Thus, the man within the mask "becomes *something else*" yet remains himself. And

as the viewer must surely have known, the *something else* he now seemed to be was what he had essentially been all the time. The apparent contradiction between these two identities is the "paradox of sacredness"; Bird Jaguar is the animating force within the mask of the divine at the same time that the essence of that divine spirit is the life-force within him. The convention by which this image on the stela is constructed *in itself* makes this truth apparent.

In the image of Bird Jaguar, we see a graphic portrayal of precisely the same relationship between ruler and god delineated in the ritual entreaty made by the newly installed Aztec ruler which we will analyze in our discussion of transformation. Speaking to Tezcatlipoca, the "lord of the near, of the nigh," of the succession of rulers of which he is now the latest, he says, "Thou wilt have them replace thee, thou wilt have them substitute for thee, thou wilt hide thyself in them; from within them thou wilt speak; they will pronounce for thee."[18] Bird Jaguar, also at the point of accession to rulership,[19] wears his entreaty to the god. That god "hidden within" Bird Jaguar is manifested by the mask, and Bird Jaguar speaks the commands of the god through the mask just as the god speaks through Bird Jaguar. In the timeless moment of ritual, the identities of Bird Jaguar and the god merge to reveal a truth more fundamental than those of the natural world.

What Schele and Miller say about Maya ritual—"These scenes do not appear to represent play-acting but, rather, a true transformation into a divine being"[20]—is exactly what Gill said of the kachina—"The spiritual must reside in some manifest form to be held in common by the community. The view, often taken, that the kachinas are 'merely impersonations' fails to recognize the full religious nature of the kachina performance." In this sense, "Maya ritual was more than a symbolic act. It . . . transformed spiritual beings into corporeal existence in the human realm and allowed people and objects to become the sacred beings they represented."[21] Such transformation was not limited to the Hopi and the Maya; it took place in rituals throughout pre-Columbian Mesoamerica. Thus, for the Maya, as for all the other cultures of Mesoamerica, masks and other costume parts were "the instruments in which sacred power accrued,"[22] and through their ritual use, that power, the life-force, could enter man's world.

Yaxchilán's Stela 11 and other uses of the X-ray convention in the art of the Maya[23] and their counterparts in the other Classic period cultures of Mesoamerica would seem to suggest a prototypical X-ray technique in the art of the Olmec, and a particularly striking example of the Olmec use of this convention fortunately survives in the large polychrome mural found on the face of a cliff above a cave at Oxtotitlán, Guerrero (pl. 5). Despite the

fact that it was painted between 1,500 and 2,000 years before the carving of Yaxchilán Stela 11, it depicts its subject according to precisely the same representational conventions. Its central figure, also a ruler, is depicted frontally so as to display the symbolic regalia in which he is dressed, and his face, precisely as Bird Jaguar's, is depicted in profile within a cutaway mask. The conventions governing Maya art allow Bird Jaguar's status as a ruler to be indicated by the glyphs on the stela and by the figures kneeling before him, and the placement of the Olmec figure atop the upper jaw of a jaguar that forms the niche on a throne/altar similar to those found in the Olmec heartland is a similarly conventional way of indicating his status to the viewer. It is probably true as well that in both cases the rulers are particularly identified. That such a detailed similarity would exist at such widely separated points in time, space, and culture is an amazing testimony to the importance of these conventions, especially since only the conventions are the same; the particular masks and costumes are quite different from one another.

Such differences no doubt reflect the passage of time. While there is the suggestion of a connection with fertility in the mask of Bird Jaguar, that connection has been subordinated almost entirely to his status as the ruler of a relatively complex, sophisticated, and aggressive city-state, a status that is particularly indicated here by his symbolic connections with warfare. There is no such subordination at Oxtotitlán where the symbols of fertility are predominant. According to Grove, "it is probable that Oxtotitlán functioned as a shrine to water and fertility," and even in recent years, water is reputed to have cascaded out of the cave into the land below suggesting that Oxtotitlán continues to be seen as a "mystical source of water." The grottoes of the cave are themselves decorated with fertility-related paintings, and the mural above the entrances to the cave "must have presented an impressive sight," proclaiming the cave's significance to those arriving.[24]

For the symbolic regalia worn by the figure in the mural announces the fertility theme. Soustelle and Grove identify several water motifs,[25] and, as we have shown in our discussion of the rain god, there is a fundamental relationship between the cave/mouth form of the niche on the throne/altar and fertility. More important from our point of view, however, is the fertility symbolism of the mask itself. The face on the mask is clearly that of a bird, and significantly a hook-beaked, goggle-eyed bird remarkably similar to the bird mask depicted in the headdresses of the god impersonator and the attendant priests on the Tlalocan mural at Teotihuacán's Tepantitla apartment compound (colorplate 3) which we examined in our discussion on Tlaloc.[26] The X-ray technique is obviously used here to identify the particular ruler with the forces

of fertility; like those forces, he is an expression of the gods, and his personal identity is to be understood as coexistent with his divine status. The fact that this mural is remarkably similar iconographically and in placement to the relief carving at Chalcatzingo, which is referred to as El Rey (pl. 7), suggests that these conventions were widespread among the Olmecs.

The use of the X-ray convention in the art of the Olmec and the Maya captured in stone and paint the moment of liminality achieved by the ruler in ritual, and that moment is also suggested in related ways in other depictions of impersonators. Ceramic figurines of masked impersonators, for example, are found at Classic period Maya sites, especially at Jaina, which indicate that a man is wearing the mask by making the mask and headdress removable. A typical figurine wears a headdress containing "the Mosaic Monster whose huge mouth gapes open to emit an animal skull with an articulated lower jaw. This skull is a mask that fits over the face of the king. Thus, the king becomes the apotheosis of this god when he goes to war,"[27] and yet when the headdress with the mask is removed, a gentle human face is revealed. The scene on Lintel 26 from Structure 23 at Yaxchilán which depicts a ruler identified as Shield-Jaguar receiving a jaguar mask from his ritually attired wife similarly manifests, in a somewhat different way, the coexistence of the faces of the man and the god as the viewer of the scene knows full well that that mask will soon cover the face of the ruler. In all these images, we see the Maya equivalent of the unmasked kachina.

Still another way of revealing the human face beneath the mask is illustrated by a large ceramic figure of an impersonator wearing a helmet mask covering his head and shoulders found in a Zapotec tomb at Monte Albán (pl. 34). If one looks at the proper angle through the slightly opened jaws of the mask,[28] the fully modeled head of the man inside the opossum mask can be seen. While this figure achieves the effect of the X-ray technique, it also indicates the relationship between that technique and another, even more important, convention used to represent the relationship between man and god, a convention that another Zapotec figure (pl. 35), now in the Brooklyn Museum, illustrates. That figure similarly portrays a human head inside the mask/head of an animal whose spiked back suggests its crocodilian nature. The crawling figure carries a bowl on its back, but the significant symbolic feature, from our point of view, is that the jaws of the animal are open wide so that the human head is fully visible.[29] Thus the opossum-masked, standing figure is midway between the god impersonator whose face is fully hidden (though made visible through the X-ray convention) and the fully visible human face emerging from the jaws of the crawling crocodilian figure.

Pl. 35. Crawling figure with human face emerging from open mouth, Zapotec (Brooklyn Museum).

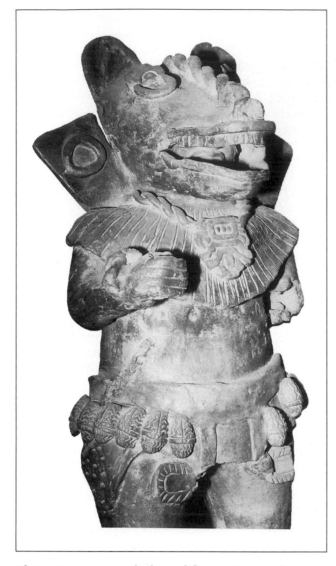

Pl. 34. Opossum-masked ritual figure, Monte Albán. The face of the wearer of the ritual mask is visible through the open mouth (Museo Nacional de Antropología, México).

This progression from hidden to visible human faces suggests that the widespread Mesoamerican technique of representing a face, and even a whole figure at times, emerging from the jaws of a mask was conceived as an expression of a particular stage of the liminal ritual moment. This suggests, in turn, that the liminal state was imagined not as monolithic but as a series of stages, a continuum joining man to god which must be seen as a visual counterpart to the process of "unfolding" by which the life-force enters the world.

In fact, a careful examination of representations of ritual in pre-Columbian spiritual art reveals that the specific form of the masks which allowed ritual performers to exist, for the ritual moment, "betwixt and between" the world of spirit and the world of nature allowed the precise designation of that series of stages of liminality by progressively removing the human face from beneath the mask. Closest to the world of the spirit and farthest from

man's secular world, god impersonators, like the Hopi kachina dancers, wore masks that completely covered the face. Hidden within the masks, they "became" the gods whose masks they wore and thus manifested in the natural world the spiritual qualities inherent in those gods.[30] The X-ray technique thus provided a way of portraying in art, but not in ritual, the fully masked impersonator while simultaneously revealing his human identity. He is a man *become* a god in the ritual moment; his inner spiritual identity has been made visible.

While the fully masked impersonator most clearly "becomes" the god, the most dramatic portrayal of the liminal position of man in relationship to the world of the spirit shows the head or even the entire upper body of a human being emerging from the jaws of the mask of the god as in the Zapotec crawling figure. Among the most fascinating of such representations is one of the earliest, and, significantly, it is clearly related to ritual. La Venta's Monument 19 (pl. 36) depicts a priest, identifiable as such by the valiselike bag he carries in his extended right hand, seated within the womblike enveloping body of a powerful, protective serpent. The relationship between priest and serpent is suggested by the fact that the priest's head is depicted within the open jaws of a mask/ headdress identical to the serpent's head. Thus, it is doubly clear that the human figure emerges from and is an expression, in ritual, of the composite serpent figure. As Elizabeth Easby and John Scott point out, the serpent's "stylized head, repeated in the mask helmet of the human figure, combines features of serpent, jaguar, and bird of prey."[31] That combination, especially in connection with the crest or plume above the serpent's head, leads us, along with many other scholars, to conclude this is a prototypical plumed serpent, perhaps the first of those that would later become the Mexican Quetzalcóatl and the Maya Kukulcán.[32]

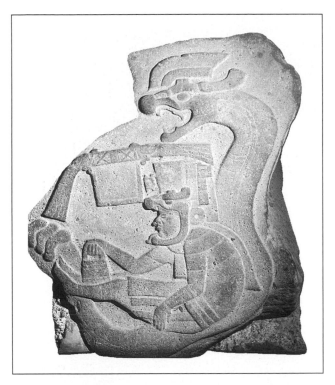

Pl. 36. Monument 19, La Venta (Museo Nacional de Antropología, México).

Pl. 37. Plumbate effigy jar lid covered with mother-of-pearl mosaic, found near El Corral temple, Tula (Museo Nacional de Antropología, México).

More significantly, however, this bas-relief epitomizes the depiction of liminality in Mesoamerican ritual art. In the jaws of the serpent mask, the priest is metaphorically midway between earthly reality and the world of the spirit; emerging from the "womb" formed by the serpent, in much the same way that the serpent emerges from the sheltering, fertile earth, the masked priest, whose "curved back . . . echoes the line of the cape and the snake's body,"[33] is perilously close to the world of the spirit—whose danger is here indicated by the fact that this particular serpent is a rattlesnake— and yet is protected by ritual from the danger, from "succumbing to the blast and going to pieces." This, then, is a magnificent visual expression of the mystery of the liminal experience that can only occur in a place "betwixt and between" in a time that is no longer in time.

Mesoamerican spiritual art contains literally countless examples of faces and figures similarly emerging from the jaws of animal or composite masks. Perhaps the most celebrated later example of this motif is the exquisite small Toltec plumbate sculpture covered with mother-of-pearl mosaic (pl. 37) which has been described as a face-painted warrior emerging from the mouth of a coyote or as the bearded face of Quetzalcóatl emerging from the jaws of the Feathered Serpent.[34] As we have seen (pls. 21, 22, 24), the same theme is found elsewhere in the Valley of Mexico in the early Postclassic, and it culminates in Aztec stone sculpture, relief carving, and codex illustration.[35]

While numerous examples of open-jawed helmet masks on ritual figures can also be seen in the earlier art of the Classic period, perhaps the most interesting example in the Valley of Mexico depicts priests wearing headdresses containing only the upper jaw of what would be a helmet mask were the lower jaw present. This sort of headdress no doubt developed from the full mask, but in terms of liminality, it is a step removed as the dramatic sense of emergence from the world of the spirit has departed with that missing lower jaw, leaving behind only the symbolic indication of that emergence. These particular priests appear in ritual procession in a mural (pl. 38) in the Tlalocan complex at Teotihuacán's Tepantitla apartment compound, and they have come to be known as the Sowing Priests because the streams of water flowing from their hands are filled with seedlike objects which they could be imagined as sowing. Identified as priests by their ritual bags, like that carried by the figure on La Venta's Monument 19, these men are depicted in a ritual context, and the priests' ritual regalia, the "seeded" streams decorated with rows of flowers falling from their hands, the facial paint, the necklaces of shells, the two scrolls similar to speech scrolls rising from their hands, and, most important, the feathered serpent headdresses, all combine to leave no doubt that the focus of their ritual is fertility.[36]

It is thus significant that the open-jawed serpent of the headdress is virtually identical to the plumed serpents projecting from the frieze of the Temple of Quetzalcóatl at Teotihuacán (pl. 20) because as we have seen in the preceding section, those serpents are directly related to fertility ritual.

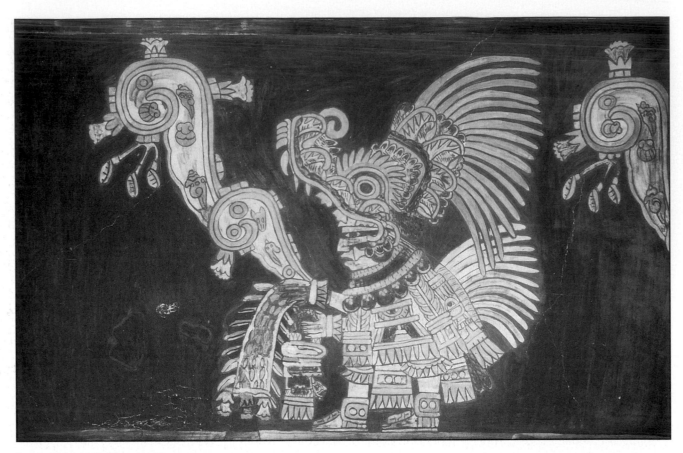

Pl. 38. Sowing Priests mural, Tepantitla, Teotihuacán, detail (reproduction in the Museo Nacional de Antropología, México).

The priests' faces, painted with red bands at eye and nose level, emerge beneath the raised upper jaws of the feathered serpents whose eyes, like the eyes of the priests, are depicted frontally, while the rest of each figure is characteristically depicted in profile. Thus these priests, like the Olmec priest of La Venta's Monument 19, are identified with and function as the conduit for the movement of the spiritual power represented by the Plumed Serpent into the world. It seems likely, then, that at Teotihuacán as well as in the later history of the Valley of Mexico and perhaps earlier among the Olmecs "Quetzalcóatl is more than just a symbol of water and fertility; he is also the patron of the priesthood which carried out vital ritual actions,"[37] and that function is indicated by the mask/headdress his priests wear.

There are a number of other depictions at Teotihuacán of helmet masks, both with and without lower jaws, from the mouths of which emerge human faces, and this motif was not limited to the Valley of Mexico. A great number of the funerary urns found in tombs at Monte Albán depict similar masks and headdresses. In fact, one of the most magnificent urns from the period Monte Albán II (pl. 39) during which, according to Covarrubias, the finest urns, "majestic and imposing in size and design,"[38] were produced, was found in Tomb 77 and depicts "a powerful middle-aged portrait face within the helmet" framed beautifully within

"concave and convex planes" made up of "overlapping ochre and green plates of clay."[39] The headdress or upper part of the helmet represents a broad-billed bird[40] while beneath the portrait face, a wide circular band almost abstractly suggests a lower jaw, providing a beautiful foil for the facial features of the portrait. While our information concerning the meanings of the symbols of Monte Albán art is so limited as to make it impossible to identify the particular aspect of the supernatural represented by this imposing helmet/mask, it is clear that its creator is suggesting the emergence of this very particular person from that aspect of the spiritual realm symbolized by the mask. And it is fascinating to realize that this urn was created to be placed in a tomb, perhaps designed to accompany the person portrayed in his return to the world of the spirit. This urn, in that sense, is composed of two masks—the mask of the sacred bird and the death mask of the man. The complex interplay suggested by one's emerging from the other just as life emerges from the spirit suggests metaphorically both the complexity and profundity of the liminal state within which this interplay takes place, a complexity even greater in view of the fact that the meaning of this urn is involved not with the emergence of birth but with the return of death. As one would expect, a number of other urns have been found at Monte Albán which display similar headdresses and helmet masks, one type of which

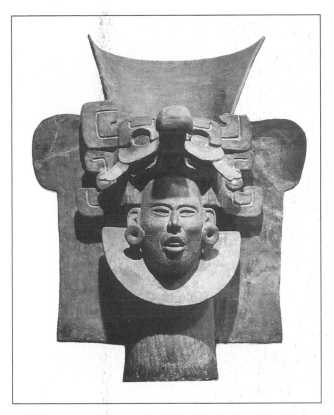

Pl. 39. Funerary urn, Tomb 77, Monte Albán II (Museo Nacional de Antropología, México).

has a headdress representing the upper jaw of a serpent[41] which looks remarkably like the headdresses worn by the Sowing Priests of Teotihuacán.

Figures emerging from the mouths of animal and composite masks are characteristic of Classic period Maya art as well. They are found on stelae and architectural carving in such profusion that it would be impossible for us even to list here the seemingly endless variations on the theme played by Maya sculptors. Tatiana Proskouriakoff describes the type as it is found on stelae:

The design of the headdress most commonly worn by the principal figure on Maya stelae consists of a central mask with attached plumes and other ornaments. It is possible that originally the head of the figure was enclosed in the gaping jaws of the mask, for what looks like a lower jaw beneath the face is seen on one of the Cycle 8 monuments at Uaxactún and recurs later as a decorative element. In most designs only the upper jaw of the mask is shown, the lower is entirely omitted.[42]

According to Schele and Miller, that central mask most often represented a god whose identity "depended on the ritual context," and that ritual, as we indicated above, "transformed spiritual beings into corporeal existence in the human realm and allowed people and objects to become the sacred beings they represented."[43] A particularly striking, though highly stylized example of this motif in late Classic or early Postclassic Maya art is a carved stone sculpture (pl. 40) that once decorated the

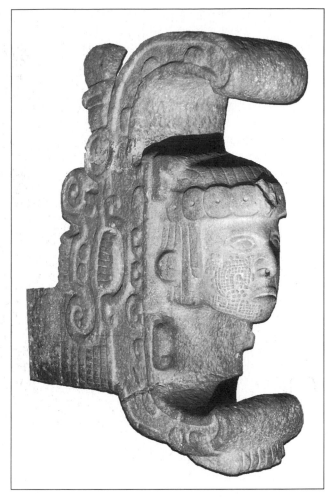

Pl. 40. Architectural sculpture, El Advino, Uxmal (Museo Nacional de Antropología, México).

upper temple of the Pyramid of the Magician at Uxmal. It depicts a head with a heavily scarified face and a crownlike headband made up of circular forms emerging from the stylized open jaws of a serpent. Ruz describes the portrait as displaying "the sullen frown and disdainful mouth of a priest,"[44] and Stierlin suggests that he is a priest of Quetzalcóatl, the Plumed Serpent who was to become the "much-venerated Kukulcán" in the Postclassic Yucatán.[45] Thus, this sculpture may be related to the architectural carvings at Chichén Itzá which manifest the same theme, and it is surely a Yucatec Maya version of the relief carvings of the Classic period characterized by Proskouriakoff.

Schele and Miller also believe, for a different reason, that such a Maya depiction of a figure emerging from the open jaws of a serpent is a visual image of what we have been calling the liminal experience. They contend that the ritual bloodletting often depicted in Maya art was designed to induce hallucinatory visions, "symbolized visually by a rearing snake . . . [with] the persona contacted through the vision . . . shown emerging from [the snake's] gaping mouth," and that "through

such visions, the Maya came directly into contact with their gods and ancestors."[46] In our terms, then, that bloodletting, like the ingestion of hallucinogens, allowed the ritual performer to transcend the limits of the world of nature, entering a liminal "no-place and no-time" in which he would encounter the gods and his ancestors who had "become gods" on their death. These same ritual performers, often rulers, are precisely the figures commonly depicted wearing the helmet masks and masked headdresses from which their faces emerge, suggesting in still another way the fundamental relationship between their position and power and the liminal state through which it was achieved and legitimized. The masks, in this sense, are visual metaphors of their psychological immersion in the world of the spirit.

This symbolic theme of emergence, as we suggested earlier, appears everywhere in the spiritual art of Mesoamerica, and one of its most beautiful manifestations comes from a tradition separate from, though intimately related to, those of central Mexico, Oaxaca, and the Maya. It is the profoundly simple, life-sized Huastec figure of a ritually dressed standing man from Amatlán, Veracruz (pl. 41). The man's face emerges from under the upper jaw of a mask of a seemingly human face with just the suggestion of the mask's lower jaw beneath the man's face. The eyes of the mask are almost closed, and on either side of it, in the place of earrings, hang limp human hands. The face and mask are set against a semicircular plane forming a headdress which is repeated in inverted, U-shaped form beneath the face in the garment covering the chest of the man, a shape that is also repeated in the earrings he wears. In the middle of that U-shaped form is a hole in the chest of the figure which would probably have held a piece of jade representing the heart. Above the upper semicircle and below the U-shaped plane extend rectangular planar forms, giving the sculpture the appearance of an abstract composition of planes, an appearance obviously meant to contrast sharply with the lifelike demeanor of the face and the vigorous positions of the arms. In addition to the use of geometrical forms as counterpoints to living forms, life, here, is juxtaposed to death in the contrast between the face and the mask, between the dead hands and the living ones, and between a skeletal face carved on the back of the semicircular plane of the headdress and the frontal living face. The location of the heart in this composition suggests its centrality to this theme of life emerging from and returning to death as the heart was, after all, the primary symbol of life for Mesoamerica, and its sacrifice marked the ultimate movement from the life of man into, and beyond, the liminal state in which man, through ritual, became god.

Two typical stelae also from Veracruz, one reput-

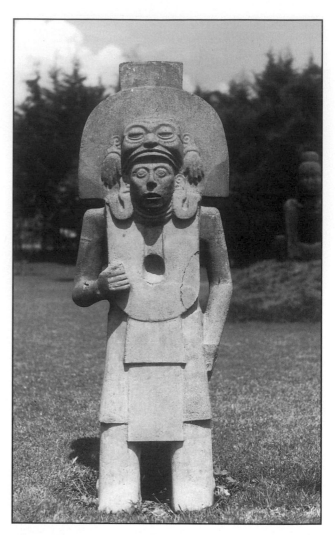

Pl. 41. Huastec standing figure, Amatlán, Veracruz. Behind the figure's face, on the rear of the sculpture, a skeletal face appears (reproduction at Museo de Antropología de Xalapa).

edly from San Miguel Chapultepec and the other from Cerro de las Mesas (pls. 42 and 43) provide a fitting conclusion to this discussion. The figures depicted, probably rulers, are dressed in identical regalia, and that regalia, especially the complex headdress, is a virtual symphony of masks. Each wears a buccal mask over the lower portion of his face, and each face emerges from the open jaws of an enormous, stylized serpent mask that is surmounted by a second open-jawed serpent mask. Still another open-jawed serpent mask is attached to the rear of the headdress, and a small jaguar head or mask is attached to each man's knee. This open-jawed serpent mask is found elsewhere in the art of Veracruz and is important enough symbolically to be depicted alone as the central element on a stela from Castillo de Teayo. These five formidable masks, three of them open-jawed serpents, when "read" together no doubt symbolically identified the divine source of the ruler's power and placed his ritual action depicted here in that liminal zone in which he "became" the power symbolized by

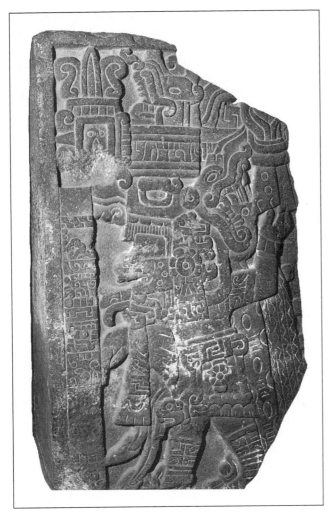

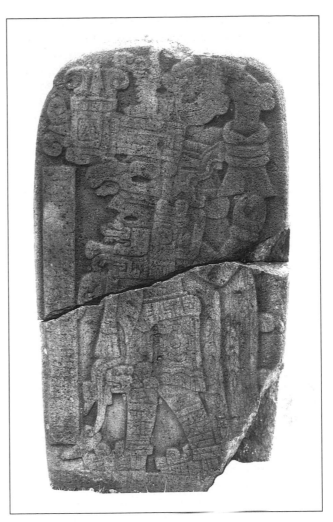

Pl. 42. Stela, San Miguel Chapultepec, Veracruz (Museo Nacional de Antropología, México).

Pl. 43. Stela 5, Cerro de las Mesas, Veracruz (Museo de Antropología de Xalapa).

the masks. In this connection, it is interesting that the buccal mask, symbolic of the god's features merging with his own, is not that of the open-jawed serpent from which he emerges and which he also wears as an emblem on the front and back of his headdress. As was the case with the imper-sonator in the Tepantitla mural (colorplate 3), a distinction is made here between the more general aspect of the realm of the spirit symbolized by the serpent and the ruler's particular ritual contact with that realm symbolized by the merging of his human face with the buccal mask. Thus, we have on these stelae several aspects of liminality dis-played in a single image. The ruler emerges from the realm of the spirit and wears the mask sym-bolic of that emergence as an emblem while at the same time his human identity is merged with a spiritual identity. Viewing that image, his subjects would have had no doubt about the power and legitimacy of his rule.

Step by step, then, through the convention of de-picting the faces of ritual performers within the jaws of composite masks, Mesoamerican spiritual art depicts those human beings from the state of being totally immersed in the world of the spirit

and barely visible through the slightly opened mouth of the mask to the point of having emerged from that immersion wearing the upper jaw of the mask as a headdress symbolic of their state. This conventional manipulation of the degree and man-ner of exposure of the human face allows the delineation of the precise relationship of the hu-man being with the world of the spirit just as the features of the mask allow a precise definition of a particular facet of the spiritual realm. But what-ever the degree of immersion and the identity of the spiritual force, the metaphor underlying all of these representations is the emergence of life from the spirit, the manifestation of the life-force in a particular living being, for as Gill points out, "only through symbolization is the sacred manifest."

MERGING WITH THE RITUAL MASK

The buccal masks on those two stelae from Vera-cruz are particularly significant for us since they suggest another way in which the spiritual art of Mesoamerica used the mask to "measure" the de-gree of contact with the world of the spirit of a

priest or ruler engaged in ritual, to depict what seem to be stages along the continuum that joins the worlds of man and the gods. If the costume of the impersonator is considered as an extension of the mask, a fully masked figure would be one showing no vestige of the human figure within, presenting to the viewer a figure visually indistinguishable from the god—a man become a god. Such figures exist in Mesoamerican art, but far more common are those, like the Zapotec opossum-masked impersonator (pl. 34), with fantastic animal or composite heads on human bodies. Many of the figures in the Postclassic codices, for example, are of this type, and the metaphoric import of such figures is to suggest that in some sense the ritual performer retains his humanity as he merges with the god in the liminal state.

Still further removed from total identification with the gods are those figures, like the rulers on the Veracruz stelae, who wear masks covering only a portion—often the mouth—of the human face. Since the face is of such fundamental symbolic importance in Mesoamerican spiritual art and thought, such partial masking clearly delineates a merging of man and god in a truly liminal moment, the moment of transition from one state of being to another. Finally, a number of gods are represented, especially in the artistic tradition of the Valley of Mexico, by fully human figures with faces that are unmasked but painted in specific ways, revealing even more fully than does the partial mask the human face of the "god." Thus, the degree to which the mask of the god covers the human wearer indicated metaphorically the stage of liminality experienced by the wearer, and in this way as well, as through the emergence of the face from the mask, Mesoamerican art portrays the liminal ground between man and the gods as a continuum, a progression from the realm of the spirit to the world of nature.

The use of such partial masks in Mesoamerican art and ritual goes back to the earliest times. Among the Olmec, in fact, there are far more buccal masks than full masks, a result, perhaps, of the Olmec emphasis on the were-jaguar mouth, the primary symbol of the rain god, but other buccal masks are depicted as well. Probably the best single example of the range of such masks in Olmec art can be seen in the six masked faces inscribed on the figure called the Lord of Las Limas (pl. 3) which Coe and Joralemon see as representing the six most important Olmec gods. Each of these faces is essentially human with a striking masklike treatment of the mouth area, and each of those treatments is represented elsewhere in Olmec art by a buccal mask. One of the clearest examples of such a representation can be seen in a small painting, designated Painting 7, in the grotto of the Oxtotitlán cave, the location of the X-ray representation (pl. 5) described above. This painting depicts the face of a human being whose mouth is covered by a fanged serpent mask. Both his jaw and upper face are fully exposed except for the scroll eyebrow he wears covering his own. His face is shown in profile, accentuating the outline and position of the mask, and the mouth is further emphasized by a small scroll element appearing before it which may be "the earliest known example of a speech glyph" indicating the man's ritual speech.[47] Numerous other examples of buccal masks exist in Olmec art on masks, celts, carved figures, and in paintings, suggesting the importance Olmec thought assigned to this graphic representation of liminality.

Contemporary with the Olmecs, villagers in the Valley of Mexico were making and using the small pottery masks (pl. 44) through which they created "the mythical half-human, half-animal" disguises referred to by Flannery in his characterization of early Mesoamerican religion. While these certainly do not look like buccal masks—they are always full human faces—the figurines that show them in place on dancing figures often show them covering only the lower part of the face and thus serving precisely the same metaphorical function as the buccal mask.

Given the early importance of the buccal mask in Mesoamerican spiritual art, we would expect to find it well represented in the art of the Classic period, and that expectation is fulfilled, although less fully in the art of the Maya than elsewhere. In Oaxaca, for example, a figure commonly depicted throughout the development of Monte Albán wears the buccal mask of a serpent (pl. 45) which Caso and Bernal see as related to Quetzal-cóatl of the Valley of Mexico,[48] although one might

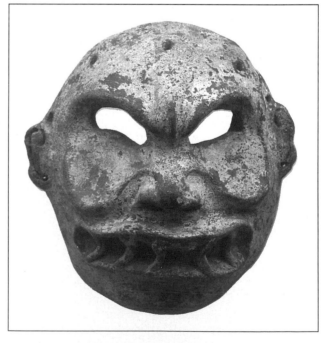

Pl. 44. Ceramic mask of an old man, Tlatilco (Museo Nacional de Antropología, México).

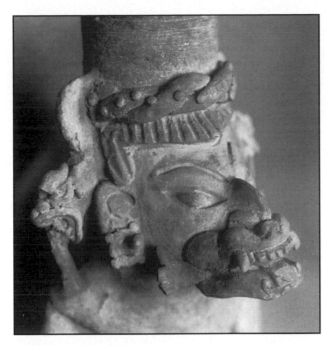

Pl. 45. Ritual figure wearing buccal mask of a serpent, funerary urn, Monte Albán (Museo Diego Rivera, México).

Pl. 46. Ehécatl, Aztec Atlantean sculpture, Tenochtitlán (Museo Nacional de Antropología, México).

also see a strong visual resemblance to the buccal portion of the Cocijo mask (pls. 14, 15), particularly since the serpent is very closely related to both sacrifice and lightning, the two major themes expressed by the mask of Cocijo in its delineation of the great supernatural forces related to fertility and rulership. And buccal masks appear also in the art of Teotihuacán, illustrated most clearly in the so-called Jade Tlaloc mural at the apartment compound of Tetitla. The name is misleading because the priests pictured here do not serve Tlaloc but the god represented by the hook-beaked bird whose mask they wear as an emblem in their headdresses. Their buccal masks are related to that mask, but in what is clearly a significant similarity, both the masks in the headdress and the buccal masks are virtually identical to those worn by the central figure in the Tepantitla mural (colorplate 3). This similarity would suggest that the ritual focus of these figures was also fertility but a fertility that, as Séjourné indicates, may well be associated with creation in a more general sense.[49]

That symbolic meaning continues to be conveyed by the buccal mask in the Valley of Mexico during the Postclassic period where it is most clearly associated with Ehécatl (pl. 46), the aspect of Quetzalcóatl whose natural manifestation is the wind that "clears the roads" for the coming of the rains. That wind, blown through his buccal bird mask, is an obvious symbolic reference to the breath, or essence, of life, especially since man's creation was mythically attributed to Quetzalcóatl. And just as Ehécatl worked in tandem with Tlaloc to provide life for man's crops, so Quetzal-

cóatl symbolized the breath that along with blood symbolized the essence of life. Significantly, then, Ehécatl's buccal bird mask was the instrument through which that breath was provided by the god since by merging the faces of god and man, the buccal mask provided a metaphor for the movement of the essence of life from the world of the spirit to the world of nature.

Face painting and scarification provide the natural end to the progression from the full mask to the partial mask by revealing fully the human face while "marking" it with the symbols of the world of the spirit. Like the other forms of masking, face painting and the scarification that can be seen as a method of making that painting permanent have their roots early in Mesoamerican spiritual history. In the village cultures of the Valleys of Oaxaca and Mexico, faces, and whole bodies, were decorated with paint by the roller stamps commonly found in the remains of those cultures alongside figurines displaying the decorations. And among the Olmecs, the incised lines and designs commonly found on the faces of sculptured figures (pl. 3) and on masks surely represent the face painting and scarification worn by priests and other ritual performers. These practices in the cultures of the Pre-

classic prefigured even more elaborate forms of facial decoration in the Classic period. There is, for example, a good deal of evidence of face and body painting as well as scarification on the urns of Monte Albán,[50] and similar evidence exists in the ceramic and stone sculpture of the Maya, such as the Yucatec priest emerging from the jaws of a serpent found at Uxmal (pl. 40) and in the vase paintings of the Classic period.[51]

Such forms of facial decoration reached their apogee among the Classic and Postclassic period cultures of the Valley of Mexico. Faces of priests in the murals of Teotihuacán were often painted in designs signifying their functions, and stone and ceramic masks were decorated with mosaics or paint in similar designs (colorplate 8). These latter are funerary masks (discussed below), which are used in ritual at that most liminal of moments evidently requiring the identification of the physically dead man with the living god whom he was about to "become." Face painting served this function by allowing the death mask of the man, in idealized rather than portrait form at Teotihuacán, to be visible under the symbolic mask of the god. He remained himself—the human ancestor who could be contacted through ritual—while becoming a god.

The importance of face painting at Teotihuacán no doubt provided the impetus for its even greater development in the Postclassic in the Valley of Mexico. In our detailed consideration of the symbols that identified Huitzilopochtli, we delineated the method by which the Aztecs symbolized their gods. "Not many deities were regularly depicted wearing masks," Nicholson points out, but "facial painting was particularly diagnostic."[52] And even beyond the use of conventional designs to define particular gods, face and body painting were used in the codices and presumably on ceramic and stone sculpture to create symbolic combinations of gods in the same way that the mural art of Teotihuacán combined the features of masks to create unique "gods," as we have shown in our discussions of the Codex Borgia Tlalocs (colorplate 1) and the Tepantitla mural (colorplate 3). For the Aztecs, then, and no doubt for the cultures that preceded them, such face painting was the equivalent of a mask, as Sahagún's informants make clear in speaking of Huitzilopochtli: "His face is painted with stripes, it is his mask."[53] Such facial painting, as a mask, allows the simultaneous perception by the viewer of the human and divine identity of the wearer and forces the realization, exemplified by the Hopi children confronting the unmasked kachina, that the world of man and the world of the spirit are essentially one, a unity realized in the liminal state of ritual. Everything in Mesoamerican spiritual art combines to communicate that meaning, and the ritual mask is its single most important metaphor.

The Aztec god Xipe Tótec, Our Lord the Flayed One, provides what is probably the most compelling example both of the importance of face painting and scarification and of the liminal state of the wearer of the ritual mask. For the Aztecs, Xipe Tótec was the red Tezcatlipoca, and his face was painted red with horizontal yellow stripes, the Tezcatlipoca design with red substituted for black, as a visual indication of his identity. He was, however, often depicted with vertical lines through his eyes as well, which may represent a diagnostic detail by which prototypical Xipes can be identified very early in Mesoamerican art. Indeed, Coe identifies one of the masked faces inscribed on the Lord of Las Limas (pl. 3) as the Olmec prototype of Xipe Tótec for this reason,[54] and Caso and Bernal use those same lines to identify early representations of Xipe at Monte Albán in which the lines seem often to represent scarification.[55] Nicholson urges caution as such lines through the eyes are also found on the images of other gods among the Aztecs,[56] but our analysis of the system underlying the construction of symbolic masks suggests that those "other gods" may well be secondary masks symbolizing a merging of the qualities of Xipe with other primary god-masks.

These facial details are not, however, the clearest and most common visual indication that we are in the presence of Xipe Tótec. Rather, that indicator is the unique "mask" worn by his priests and votaries in ritual and often depicted in art (pl. 47), a mask that is the skin of the face and body flayed from a sacrificial victim impersonating the god, donned in the final segment of a complex ritual, and worn for a period of time afterward by beggars before being buried in the temple of the god. In most representations of Xipe, all that is discernible in what seems to be a human face are the slit, buttonhole-shaped eyeholes, the openings of the nose, and the almost circular opening of the mouth through which the lips of the wearer can be seen. All else is hidden by the tightly stretched, flayed skin that has become the most macabre and most metaphoric of masks. The victim's hands hang limp at the wearer's wrists, and on many representations in the round, the lacing in the rear that holds the skin together is elaborately rendered.

Although there are various theories concerning the meaning of this ritual wearing of the victim's skin, the metaphor underlying the ritual is clearly the same as the central metaphor provided by the idea of the mask for Mesoamerican spirituality. The ritual and the art depicting it require us to consider separately the external covering and the essence of a living being. Most literally, the god is the essence; he is "the flayed one" who is revealed by the stripping away of his covering or mask according to the consistent logic of Mesoamerican sacrifice which always, at the sacrificial moment, opens or removes the outer to reveal the inner that is metaphorically the essence of life itself—

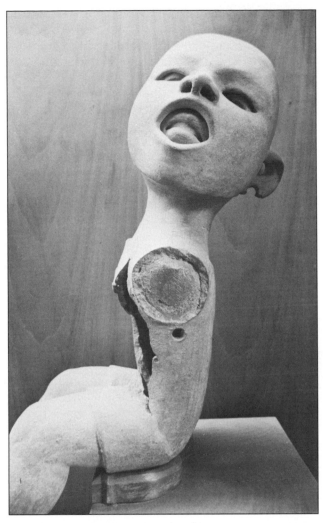

Pl. 47. Xipe Tótec, Palma Cuata, Veracruz (Museo Nacional de Antropología, México).

the god. When that now-removed covering or mask was donned by another in ritual, the wearer almost literally found himself within the skin of the god. And after the skin had been flayed from the sacrificed body of the impersonator, the flesh was cooked and eaten in a form of communion that reversed the metaphor by placing the god's essence within the ritual participant.

Seler's interpretation of this ritual as a metaphor for the living seed bursting forth from within its dead covering, resulting in the "new skin" of vegetation placed on the earth by the coming of the rainy season,[57] has been generally accepted since it seems to explain the timing of the calendrical ritual dedicated to Xipe and the reference in the mysterious and beautiful "Song of Xipe" to the god's donning of his "golden garment." As Seler suggests, the metaphor and the ritual refer both to sowing, as we have seen, and to the harvest where the skin becomes the metaphor for the husk of the corn. In thus embodying the agricultural cycle, Xipe reveals himself as an earth god whose concern is fertility and man's sustenance. Nicholson objects to this interpretation on the grounds

that we have no native informant's testimony to support it, although he does agree "that fertility promotion was the central purpose" of the ritual. He seems more comfortable with a more general interpretation.

> By donning such a terrible garment the ritual performer thereby becomes the deity into which the victim had earlier been transformed, literally crawls into his skin, so to speak—or, at least more directly partakes of his divine essence than by merely attiring himself with the god's insignia.[58]

Such an interpretation of the ritual accords with our idea of the mask as metaphor, and it is important to note that it does not conflict with Seler's interpretation; they approach the ritual on different levels. This seems a perfect example of the multivocality of what we have termed primary god-masks, and Séjourné provides still another level of interpretation that, we would argue, conflicts with neither of these. Calling Xipe "the most hermetic of all Nahuatl divinities," she sees the symbolism of his ritual as one in which the victim

> is relieved (by flaying) of his earthly clothing and is freed forever from his body (an act represented by the dismembering of the corpse). The mystical significance of these rites is emphasized by the behaviour of the owner of the sacrificed prisoner. Not only does he dance, miming the various stages of the [ritual] combat and death; he also behaves towards the corpse as if it were his own body. This identification suggests that the slave represents the master's body offered to the god, the former being merely a symbol for the latter. The drama thus unfolds on two planes: that of the invisible reality, and that of finite matter, a mere projection of the former.[59]

Such an interpretation fits perfectly the most fundamental assumptions of Mesoamerican spiritual thought as we will outline them in Part II. And while it is probably true that the ordinary citizen observing this ritual was most aware of its gruesome fertility implications, it is just as probable that the priest saw in its series of oppositional relationships between inner and outer and living and nonliving the acting out of the most profound mystery recognized by Mesoamerican seers, that mysterious entry of the spiritual essence of life into the world of nature for which the mask stood in art and ritual as metaphor.

Sahagún indicates clearly the validity of such an interpretation of the ritual in his delineation of the relationship between the prisoner of war who was to become the sacrificial victim and his captor. The captor did not himself kill the captive but offered him "as tribute," the actual sacrifice being consummated by the priests. Furthermore, "the captor might not eat the flesh of his captive. He said: 'Shall I, then, eat my own flesh?' For when he took

the captive, he had said: 'He is as my beloved son.'" That identity between captor and captive is made explicit in still another way:

> They named the captor the sun, white earth, the feather, because he was as one whitened with chalk and decked with feathers.
>
> The pasting on of feathers was done to the captor because he had not died there in the war, but was yet to die, and would pay his debt in war or by sacrifice. Hence his blood relations greeted him with tears and encouraged him.[60]

Thus the captive is simultaneously the god whom he impersonates and the alter ego of the all-too-human captor; in the captive, the human and divine identities of the human being merge, and it becomes agonizingly clear that the human skin is but a mask hiding the divine essence that is revealed in the most literal and striking manner possible in the course of the ritual.

In this ritual, called Tlacaxipeualiztli, which means the flaying of men, the mask is no longer an instrument of ritual; here it becomes the very subject, a subject no longer metaphorical but now intensely, almost overwhelmingly, real. The impersonator of the god is stripped of his human covering to reveal the essence of life, which is then consumed so that it—literally—can sustain human life. Such a ritual unmasking as this makes the Hopi children's realization pale by comparison.

But in the final analysis, even this masked ritual is metaphoric. Like the Maya incised conch shell described by Octavio Paz, itself a potent symbol of the inner-outer dichotomy that fascinated Mesoamerican artists, Xipe Tótec in ritual

> not only offers us the crystallization of an idea in a material object, but is also the fusion of the two into a true metaphor, not verbal but emotional. This kind of fusion of literal and symbolic, matter and idea, natural and supernatural reality, is a constant factor not only in Maya art but in that of all the Mesoamerican cultures.[61]

Such fusion is characteristic both of metaphor and liminality, for in both cases, at the moment of the juxtaposition of the two normally separated realms of experience, a recombination and transformation takes place through which a new reality is formed. In that moment, all previous definitions of reality are questioned and the new image created by the transformation enables man to transcend his mundane existence and, like Melville's Ahab, "strike through the mask" of nature to engage the very essence of life while protected by ritual from "going to pieces" in that encounter.

Two facts emerge from this relatively brief and partial survey of the vast subject of Mesoamerican masked ritual. First, throughout their long history, the cultures that made up Mesoamerican civilization explored every possible dimension of the metaphor of the mask. That metaphor was twisted and turned, looked at this way and that, and made to express every nuance of Mesoamerican spiritual thought. Second, in each of those expressions, the emphasis was always on the link between man and god, on the creation in ritual of a liminal space in which that linkage could be made. For this reason, perhaps, the emphasis in Mesoamerican masking seems overwhelmingly on the mouth—mouths open to reveal faces emerging, mouths composed of the features of a variety of natural creatures dominate masked faces, mouth masks partially cover human faces—announcing the fundamental Mesoamerican idea that man is an expression of the gods, that natural reality is a manifestation of spiritual reality.

THE ARCHITECTURAL MASK
Defining Sacred Space

As if to indicate in tangible form the ability of ritual to create that liminal space where man could meet god, the very structures that housed that ritual were themselves embellished with masks. Whether those masks created doorways between the mundane and the sacred, emblazoned the facades of buildings with a symbol of the sacred activity housed within, or marked the sacred pathway up the steps of the pyramid leading to the temple, they served always to signify the presence of the sacred. Just as the ritual mask manifested the sacred inner reality of the performer, so the architectural mask made apparent the sanctity of the place where that ritual mask was worn. But beyond that significant function, the architectural masks found throughout pre-Columbian Mesoamerica symbolize the underlying cosmological purpose of the structures on which they appear, structures that served "to dramatize the cosmogony by constructing on earth a reduced version of the cosmos."[62] The structures themselves were metaphors, and Octavio Paz describes the creation of such works of art when he speaks of the "Maya's transformation of literal realism in objects that are metaphors, palpable symbols. . . . A marriage of the real and the symbolic is expressed in a single object." He extends this observation to all of Mesoamerican civilization, which is, "like its art, a complex of forms animated by a strange but coherent logic: the logic of correspondences and analogies,"[63] a logic seen nowhere more clearly than in the "masked" architecture of Mesoamerica. The masks announce that the very real stone doorways also open into the world of the spirit, that the stone stairways lead both to the tops of the pyramids and to the heavens, that the stone walls of the buildings contain within them the transcendent.

As our discussion of the spatial order will show, Mesoamerican architecture exemplifies this "logic

of correspondences and analogies" in other ways as well. The design of Teotihuacán, and many later cities, for example, replicates the quincunx, the sacred cosmic figure that merges space and time in a single "shape," and the buildings within the ceremonial centers of these cities were similarly laid out. The Maya Temple 11 at Copán was "designed as a diagram of the cosmos."

> The north facade represents the arc of heaven held up by the Pauahtuns at the four world directions; it functioned as a place of audience and ceremony. . . . The south facade is defined as the Underworld and a place of sacrificial death. . . . The Middleworld is the interior of the temple itself, sandwiched between the roof, which represents the Heavens, and the south court, or Underworld. The king's accession is recorded in the interior. Yax-Pac conducted the rituals that preserved world order at the four doors of the Temple.[64]

Thus, both the cities and the sacred buildings within their ceremonial centers were "reduced versions of the cosmos"; at the center of the quadripartite city was what Millon has termed the "sacralized political center,"[65] and at the center of the temple was the king—"the manifestation of the divine in human space."[66] Those "centers" were designated as sacred by the presence of architectural masks. Millon refers to Teotihuacán's Ciudadela, and as we have seen, its all-important Temple of Quetzalcóatl (pl. 20) was literally covered with masks. At Copán, the critical north entry of Temple 11 which gave ritual access to the "center" was probably "rendered as the mouth of a monster"[67] in typical Maya fashion, and the figure of the ruler, Yax-Pac, ensconced in the center was surely bedecked with masks as Maya rulers always were.

This center of the four-part figure replicating the cosmos was marked by masks because it was the symbolic center of the universe, the navel of the world. Eliade explains that

> in cultures that have the conception of three cosmic regions—those of Heaven, Earth, and Hell—the "centre" constitutes the point of intersection of those regions. It is here that the breakthrough on to another plane is possible and, at the same time, communication between the three regions.[68]

The center allows passage from one mode of being to another, precisely, of course, the function of the ritual mask. For that reason, no doubt, the caves and temples, the mountains and pyramids that throughout the development of Mesoamerican spiritual thought were seen as symbolic centers of the universe were marked by masks symbolizing the point of passage.

As we have seen in other contexts, the importance of the cave in Mesoamerican mythology is due to its role as a point of passage "to another plane." Like the mountaintop, it is a "center" where "the sacred manifests itself in its totality"[69] and is thus linked symbolically to the creation of life, that is, the manifestation of the sacred life-force in the world of nature. Throughout Mesoamerica, "the cave was, and still is, highly revered as the womb of the earth."[70] This symbolic belief can be seen early in the development of Mesoamerican spiritual thought—in the infants held by the figures emerging from the cave/jaguar mouth niches of the Olmec altar/thrones (pl. 12), for example. And that belief lasted to the time of the Conquest; one of the Aztec origin myths records their emergence from Chicomoztoc, Seven Caves, pictures of which look remarkably similar to the modifications made by the Teotihuacanos to the inner sanctum of the cave under the Pyramid of the Sun, suggesting again the antiquity of this belief.[71]

Just as life emerged from the world of the spirit through the cave, it was through the cave that it returned. At Dainzú, near Monte Albán, for example, the jaguar mouth surmounting the entrance to a tomb marks that doorway as an artificial cave and as the final doorway through which the occupant of that tomb would pass in this world. Priests and rulers were often buried in natural caves or in tombs, as at Dainzú, that replicated the cave, and even the sun was thought to enter the underworld at sunset through the mouth of a cave and to emerge from another at sunrise.[72] Fittingly, rites of passage often took place in caves,[73] as did rites of accession because the sanctity of the cave confirmed the divine right of secular rulers.[74] For the same reason, ceremonial centers were often located near the mouths of caves because, as Mendoza puts it, the cave mouth was seen as the "'shaman's doorway' to the acquisition of esoteric knowledge."[75]

It is not surprising, then, that the earliest examples of architectural masks transformed the entrances of caves into the mouths of jaguars, demonstrating clearly Paz's "logic of correspondences and analogies." As we have seen, Monument 1 from the Olmec fertility shrine of Chalcatzingo (pl. 7) shows in profile a figure, El Rey, seated within a stylized were-jaguar mouth, thereby revealing the meaning and function of another relief carving at that site. That carving, the freestanding Monument 9 (pl. 8), is a frontal view of the mouth of Monument 1 meant either to be placed in front of an actual cave mouth to demonstrate its symbolic meaning and to provide ritual access to the world of the spirit or, as Grove believes, to be erected on a ceremonial platform to symbolize the cave.[76] In either case, it allowed entrance to the ritual "cave" through the mouth of the mask of a composite being representing the world of the

spirit. While the mouth of the ritual mask opens to allow man to emerge, the mouth of the cave mask opens to allow him to enter.

The mask is similarly used in later Maya art to identify the cave as the entrance to the underworld, Xibalbá.[77] In a dramatic scene incised on a Maya vase, the Cauac Monster is shown as

> an independent, architectonic symbol of the door between the natural and supernatural worlds. . . . He is both the cave and the architectural opening into the interior of the temple. . . . Temple doors were articulated as the mouth of the Cauac Monster to identify them as a sacred locus. The entry doors of Structures 11 and 22 at Copán were both surrounded by huge architectural sculptures that transformed the doors into the mouths of monsters. . . . These two buildings at Copán, as well as monster doors used in Chenes and Puuc buildings, were architectural manifestations of the stepped portal on this pot. In this image, the stepped form indicates that the supernatural gate is architectural.[78]

This association of the mask, cave, and temple doorway, widespread in Mesoamerica, was particularly evident among the late Classic Maya. As we have seen, the doorways of temples throughout the Yucatec regions of Río Bec, Chenes, and the Puuc and at Copán are consistently constructed as the mouths of giant masks "so that entering the building, one is swallowed by the monster"[79] to experience the "inner" reality of the sanctuary. Such temples were artificial caves, symbolically the body of the god whose mask they "wore." When the priest entered the building and proceeded toward the shrine, he metaphorically entered the earth and moved toward its center, the axis of the universe, and simultaneously entered the god with whom he would symbolically merge. The metaphor of the architectural mask could not be clearer: through ritual enacted on sacred ground, man became god.

But the "shaman's doorway" opened upward as well as downward. In the shamanistic cosmological thought of Mesoamerica, the realm of spirit enveloped the earth so that whether one penetrated into the earth below or the heavens above, he encountered the transcendent. The ascent into the heavens took place on the stairways of the pyramids, the artificial mountains constructed, seemingly obsessively, throughout Mesoamerica. The importance of these symbolic penetrations into the world of the spirit is indicated by the symbol of the mask which designates their function as the route to absolute reality and can be gauged by the incredible number of man-hours spent in their construction. As Sacred Mountains, the pyramids are, like the cave, a space excised and set apart from mundane reality, in Eliade's terms a center, the meeting point of heaven, earth, and hell.

> The mountain, because it is the meeting place of heaven and earth, is situated at the centre of the world . . . and impregnated with sacred forces. Everything nearer to the sky shares, with varying intensity, in its transcendence. Every ascent is a breakthrough, as far as the different levels of existence are concerned, a passing to what is beyond, an escape from profane space and human status.[80]

Completely separated from profane space, such centers can only be reached through an arduous passage.

> The road leading to the center is a "difficult road." . . . The road is arduous, fraught with perils because it is, in fact, a rite of the passage from the profane to the sacred, from the ephemeral and illusory to reality and eternity, from death to life, from man to the divinity . . . or, to speak cosmologically, from chaos to cosmos.[81]

Walking through the mouth of the mask into the architectural "cave"[82] or climbing between the masks lining the steep stairway up the architectural "mountain" to reach the sacred temple at its apex thus symbolizes the passage through what we have called the liminal zone, the zone that exists *between* chaos and cosmos.

The symbolic nature of the passage is particularly clear in the case of the pyramid's stairway. Eliade contends that "the act of climbing or ascending symbolizes *the way towards the absolute reality*, and to the profane consciousness, the approach towards that reality arouses an ambivalent feeling, of fear and of joy, of attraction and repulsion."[83] That ambivalence must have found its most extreme manifestation in the feelings of the sacrificial victim as he made his way up those steps to his death. On the one hand, he must have felt a dread almost beyond our ability to comprehend, but, on the other, he surely felt a compelling attraction to the moment of his apotheosis. As Eliade says and as that victim must surely have known in his own far more personal terms, "death is the supreme case of a rupture of the planes. That is why it is symbolized by a climbing of the steps,"[84] and that is why those steps in Mesoamerica were so often lined with masks.

Such architectural masks occur throughout Mesoamerica from the earliest times to the Conquest. The earliest examples are found among the Maya: the Preclassic Structure 5C-54 was built at Tikal "with four stairways flanked by huge masks,"[85] Structure E-VII-sub at Uaxactún was also provided with four mask-flanked stairways, and Structure 5C-2nd was constructed at Cerros with great masks on friezes flanking the stairway. Similar mask-lined staircases are found in the Classic period throughout the Maya lowlands and in central Mexico, as we have seen in the remarkable pyramid of the Temple of Quetzalcóatl at Teoti-

huacán (pl. 20). In no Classic period structure, however, is the concept more profoundly embodied than on the west face of the pyramid at Uxmal known as El Advino (pl. 48). "Uxmal is by far the largest Puuc site, and one of the triumphs of Maya civilization,"[86] and El Advino is one of its major structures. The pyramid we see today is the result of successive reconstructions from the sixth century to the tenth,[87] each of which superimposed a new pyramid over the existing one so that "we can count five temples on top of each other,"[88] but the lateral rather than square design of the pyramid allows some of the earlier temples to remain exposed. Thus, the "breathtakingly steep" steps[89] that ascend the west facade lead directly to a massive Chac mask forming the doorway to the fourth temple while the remainder of the fifth reconstruction and Temple V rise behind it. The dramatic doorway and staircase form a single visual unit set against the backdrop of the striking elliptical pyramid. That drama and unity are both emphasized by the Chac masks that line the staircase (pl. 49), in time-honored Maya fashion, as if to emphasize the "arduous passage" those steps represent. To complete the dramatic picture and indicate its ritual function, just before the masked doorway of the temple, a smaller mask forms a platform probably used in the sacrificial ritual that climaxed and completed the arduous passage up

the stairway. Nowhere in Mesoamerican architecture is the symbolic role of the mask on temple and pyramid clearer, and nowhere is the metaphor more strikingly presented.

A similar construction on a smaller scale demonstrates both that this use of the mask was not limited to the Maya and that it continued to the time of the Conquest. The late Aztec site of Malinalco has as its principal structure a temple carved into the living rock of the hillside and entered through the mouth of a giant mask (pl. 50). That entrance is reached only after a truly arduous climb up the hillside followed by an ascent of a stairway of thirteen steps, symbolic of the thirteen levels of the upper world of the spirit,[90] leading to the platform in front of the temple. At the head of the stairway on the floor of the ceremonial platform extends the bifurcated tongue of the mask whose open mouth forms the doorway to the temple. That mask has been identified both as a "serpent-like visage"[91] and as Tlaltecuhtli, the earth monster,[92] an identification consistent with the symbolism of the cave, but it displays many of the characteristics of Tlaloc in its fangs, bifurcated tongue, and eyes. And Tlaloc, like Tlaltecuhtli with whom he often merges symbolically in secondary masks, is also associated with the cave.

Whatever the identity of the mask, its function is clear: it marks the entrance to a symbolic ar-

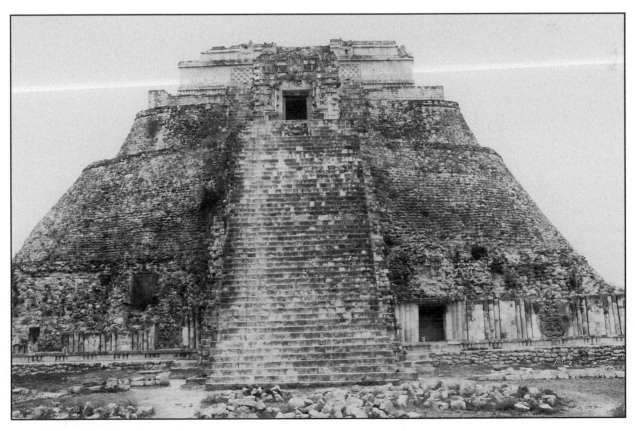

Pl. 48. El Advino, Uxmal.

Pl. 49. Chac masks lining the stairway, El Advino, Uxmal.

chitectural "cave," which in this case served, according to Richard Townsend, as "a component of a larger ceremonial landscape where the ritual integration [between the social and the natural orders] was established" and acted "as a place of transition between levels of the universe—the surface, and the world below." Thus, like the Maya temples, it provided a symbolic setting in which "the transference of power from one monarch to the next was sanctified and made legal."[93] According to Stierlin, however, the ritual use of the cave/temple was probably initiatory since the eagles and jaguar carved as seats on the benches within "represent respectively the diurnal and nocturnal course of the sun" and the cave is where "the sun disappears on its subterranean journey."[94] Pasztory's suggestion that the round form of the temple, in addition to referring to natural caves, "may also have a female connotation as the womb of the earth"[95] would lend further support to the initiatory interpretation. What is abundantly clear, however, is that the architectural mask continued to be used up to the time of the Conquest as a symbolic means of marking the passage from the world of nature to the world of the spirit.

Masks not only form the doorways and line the staircases of pre-Columbian Mesoamerican structures but they often decorate the facades to signify the sacred function of the building. This architec-

Pl. 50. Mask doorway, Malinalco.

THE METAPHOR OF THE MASK IN PRE-COLUMBIAN MESOAMERICA

tural use of the mask also began early. Structure 29B at Cerros, built in the Preclassic about the time of Christ, "has masks on 3 separate platforms on its summit," and as we have seen, Structure 5C-2nd has similar masks decorating panels on the successive stages of the pyramid.[96] That this practice continued among the Maya is made overwhelmingly clear by the almost obsessive use of masks to form, rather than merely embellish, the facades of late Classic temples in the Yucatán. The most extreme example of this use can be seen in the mask-covered facade of the building known as the Codz Pop (pl. 51) at the Puuc site of Kabah. The frieze that, except for five doorways, entirely covers the facade is composed of two horizontal panels, each containing three rows of long-nosed Chac masks. A seventh row appears beneath the doorway's thresholds with the long, upturned noses of the appropriate masks serving as steps permitting entrance through the doorways. Norman Hammond calls the facade "mind-dazzling,"[97] and Stierlin suggests its possible symbolism:

> Although calculations are difficult because the upper part of the palace is badly damaged and not yet restored (the pieces of the puzzle lie at its feet), we may estimate that this proliferation of eyes, upturned hook noses, ears, and eyebrows originally added up to some 260 masks—the same . . . as the number of days in the sacred year.[98]

If those calculations are correct, the Codz Pop would take its place beside a number of other important structures in Mesoamerica which display calendrically significant symbolism, generally in the form of masks. Nearby Uxmal's Palace of the Governors is decorated with a frieze containing 260 masks, as Stierlin also notes, and we have already seen that the number of masks on the frieze on the Temple of Quetzalcóatl in the Ciudadela at Teotihuacán is related to the solar year as is the number of niches in the Pyramid of the Niches at El Tajín. Such structures as these render the cosmos in miniature, true to "the logic of correspondences and analogies" observed by Paz. That logic, reflected in their calendrical symbolism, no doubt enabled these masks, and their counterparts on the facades of buildings throughout Mesoamerica, to provide a backdrop for the ritual enacted before them and to symbolize the meanings of that ritual and of the activities carried out on the sacred inner side of the masked facade. Thus, whether serving as the doorways, embellishing the facades, or lining the steps to the temple, architectural masks provided access from the mundane to the sacred and marked the liminal path to another level of existence.

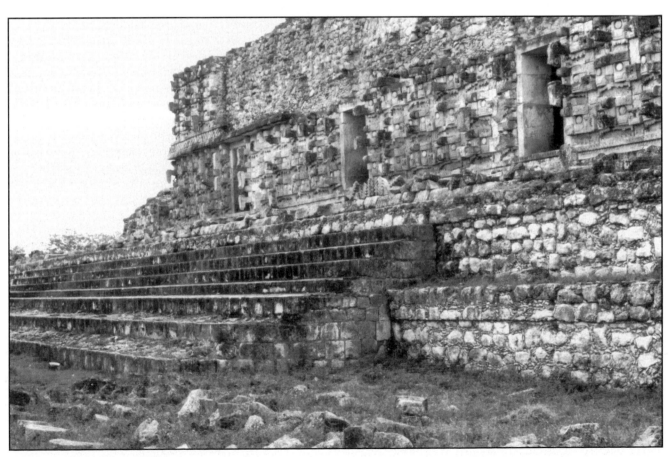

Pl. 51. Facade, Codz Pop, Kabah.

THE FUNERARY MASK
Metaphor of Transformation

Just as life for the pre-Columbian inhabitants of Mesoamerica culminated in the funerary ritual that marked the beginning of the passage back to the realm of the spirit from whence the individual's life came—often a difficult passage, according to Mesoamerican mythology—so our study of the masks of pre-Columbian Mesoamerica comes to its conclusion with a consideration of the funerary mask that brings together in its final image all of the cosmological conceptions for which the mask stood as the metaphor throughout the long development of Mesoamerican spiritual thought and art. Death, for the peoples of Mesoamerica as for all peoples, was the great mystery. The Aztec account of the metaphoric journey to Mictlan after the body's physical death suggests that except in the case of divine rulers, death was seen as a gradual fading of the individual identity of the person into the anonymity of the life-force.[99] Like the monumental Aztec image of Coatlicue (pl. 9), it was both the womb and the tomb, generating and receiving back all the individual lives in the natural world.

> Meditate upon it, O princes of Huexotzinco;
> although it be jade, although it be gold,
> it too must go to the place of the fleshless.
> It too must go to the region of mystery;
> we all perish, no one will remain![100]

The gradual movement from individual life to dissolution in the life-force, metaphorically a journey fraught with danger and difficulty in all Mesoamerican myths, begins with separation and detachment from human society, continues through the intervening liminal state, and ends in the mysterious and hitherto inaccessible world of the spirit. Through that metaphor of the journey, as well as the metaphorical funerary mask, the cultures of Mesoamerica attempted to comprehend the mystery of death, to convert what would seem the finality of the end of life into a passage to the essence of life. In this sense, the imagery associated with death in both Mesoamerican myth and art—all the skulls, bones, and skeletal figures—are not emblematic so much of death as of the essence and regeneration of life.[101] "The place of the fleshless, the region of mystery" is, after all, the home of the eternal life-force. And in that realm, "in one way or another" according to the poet, life mysteriously continues.[102]

Life's continuation was the message conveyed by all of the cycles of death and regeneration making up the natural world in which man existed. These cycles found their clearest example in the daily and yearly movement of the sun which provided the basic framework for much of Mesoamerican cosmology and served as the ideal metaphor for the dualistic, cyclical order of the cosmos, particularly for the complementary opposites of matter and spirit, life and death. Just as the sun made the inevitable passage from the life of day to the underworld, followed by a return to life, so man's spirit would repeat the endless pattern and return to life again. Symbolically, then, life existed within death and death within life. The funerary mask symbolized that unity.

Just as the ritual mask allows the wearers' identity to merge with that of the being the mask represents, the funerary mask, as C. Kerényi indicates, allows a fusion of life and death.

> *The mask . . . is an instrument of unifying transformation: negatively, in that it annuls the dividing lines, e.g., between the dead and the living, causing something to be manifested; positively in that through this liberation of the hidden, forgotten or disregarded, the wearer of the mask becomes identified with it.*[103]

Kerényi's observation is consistent with the fundamental Mesoamerican cosmological principle that there is no death in the world, only transformation; there is no end to life, only changing forms, changing masks placed on the eternal and unchanging essence of life.

But unlike man's first, biological birth, "the beginning of a new spiritual existence," as Eliade reminds us, does not happen naturally; "it is not 'given' but must be ritually created,"[104] and this, in Mesoamerica, was the task of funerary ritual and particularly of the funerary mask. Since death was seen as transformation rather than an end, it seems natural that cremation was widely practiced in Mesoamerica. Fire, the great transformational agent, could transform the material into the spiritual and thus free the spirit from the body. The Aztec funerary ritual associated with the cremation of rulers suggests precisely this view: before cremation, the ruler's body was elaborately arrayed, and masked, in the costume of a god,[105] and as the fire consumed his body, his spirit started on the journey that would end in his becoming the god in whose attire he had been arrayed. When the body was not cremated, the funerary mask—whether placed over the face of the deceased, buried in the tomb, or placed on the funerary bundle—served exactly the same symbolic purpose as the crematory fire; it was both catalyst and metaphor for the transformation of the material reality into the spiritual essence.

Thus, funerary masks functioned like other ritual masks to express visually the inner, spiritual identity of the wearer which survives the death of the body. Portrait masks recreating the physical face of the deceased, common among the Maya, reflected the belief that through the course of his life, the person had "created" a face that expressed his deified heart, while masks like those of Teo-

tihuacán, which created an abstract and impersonal "ideal" face, suggested the essential unity of the spirit animating all of humanity. Painting the face of the deceased in the symbolic pattern of a god, or the common practice of representing that face painting on a mosaic mask, combined the attributes of the portrait and idealized funerary masks since it allowed the death mask of the man, his actual face or an idealized mask, to be fully visible under the symbolic mask of the god. The important person, often a ruler, wearing such a mask remained himself—the human ancestor who could be contacted through ritual—while becoming a god. Thus, the funerary mask moves a symbolic step beyond the ritual mask worn by the god impersonator in recording the final and complete transformation: the man has *become* a god. Seen in this way, the funerary mask serves to create another being different from the person who was alive and is now dead. This is "a recreation close to procreation when, in the Mask, two images are combined to make a new single being. . . . [Thus] the Mask often claims a triumph of life over death,"[106] exactly the "fusion" noted by Kerényi.

Of whatever type, the funerary mask is the metaphor par excellence of liminality as it bears witness to man's ultimate movement between the worlds of spirit and matter. And from the earliest times, those masks and their accompanying ritual were a part of Mesoamerican life and death. Burials as early as the El Riego phase in the Tehuacán valley (ca. 6000 B.C.) "not only have abundant burial goods but suggest elaborate burial rites," which led MacNeish to speculate that "the rich ceremonialism of later Mesoamerican culture is only the culmination of a long tradition."[107] While these burials do not indicate funerary mask use, another early burial does. At about 2000 B.C., a woman was buried in a shallow grave at Cuello wearing a necklace of roughly chipped shell beads with a pottery bowl over her face and another at her feet.[108] This was clearly a ritual burial, and just as clearly there was a concern to protect and preserve the face of the dead woman, precisely the impetus behind the funerary mask. Interestingly, that pot placed over the dead woman's head recalls a much earlier burial. Speaking of a skeleton he considers post-Pleistocene but Preceramic, Aveleyra Arroyo de Anda says, "the human skeleton was found, according to the farmers who uncovered it, . . . with one of the large flat stones over the skull, a situation which suggests a ritual interment"[109] and which, we contend, places the impetus for the development of the funerary mask with the earliest evidence of ritual activity. It is interesting that in most late Classic period burials at Jaina, the head of the deceased was protected by a pottery bowl.[110] This demonstration of concern for the preservation of the face has a long history in Mesoamerica.

Actual funerary masks begin to appear in the Preclassic, and as with the other types of masks we have discussed, they appear first, and in a very sophisticated form, among the Olmecs. Perhaps the most sophisticated are the group of about thirty-five jade and jadeite masks found at Arroyo Pesquero, Veracruz. Strikingly realistic, they were obviously designed to capture the identities of the dead nobles and rulers with whom they were buried.[111] Probably of La Venta origin (ca. 900–800 B.C.), the masks were presumably solely funerary in function as they seem too heavy to have been worn, although a few do have eye and nose holes as well as perforations that could have been used to tie them to the faces of their wearers. According to Alfonso Medellín Zenil, "the hollowed interior" of one of the masks "fits the face of a normal person, indicating the functional purpose of the mask."[112] Most, however, lack the characteristics of the ritual mask.

The eyes were probably inlaid with shell and obsidian or a black metallic stone to simulate the living organs. . . . Hourglass-shaped perforations along the edge of the Arroyo Pesquero masks indicate former attachment to funerary bundles that were probably cremated. Indeed, some of the masks have fracture lines caused by extreme heat, while fire changed the original color, and occasionally transmuted even the stone itself, of others.[113]

These masks, and others like them, thus suggest that the ritual use of the funerary mask began early in Mesoamerican history, as the characteristics of these masks accord perfectly with the practices of later times. They also indicate the conceptual relationship between ritual and funerary masks which clearly derived from the idea that the deceased was involved in the *ritual* movement from one state to another in a way comparable to the movement of the shamanistic ritual performer.

This conflation of the funerary and ritual mask is seen even more clearly in the burial practices of the village cultures in the Valleys of Oaxaca and Mexico contemporary with the Olmecs. The small pottery masks of these cultures (pls. 44, 52), exemplified by those found at Tlatilco, Las Bocas, and Tlapacoya in the Valley of Mexico, were found in burials, though not over the faces of the dead. As we have seen, these were "pierced for suspension" and actually used in ritual, being worn in the manner shown on the pottery figurines accompanying them in these burials.[114] That they also have a particularly funerary purpose, however, is indicated by one type of mask, the characteristics of which can be seen in an example from Tlatilco depicting a face half-skeletal and half-living (pl. 52), a conception that can only represent the liminal state of the deceased in his movement from life to absorption in the spirit, "the land of the fleshless" as the Aztec poet calls it. This striking

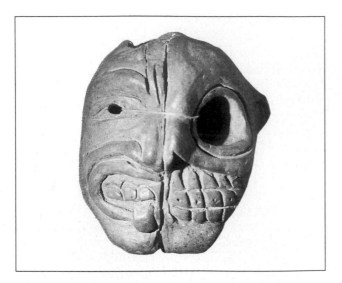

Pl. 52. Ceramic mask, half-fleshed, half-skeletal, Tlatilco (Museo Nacional de Antropología, México).

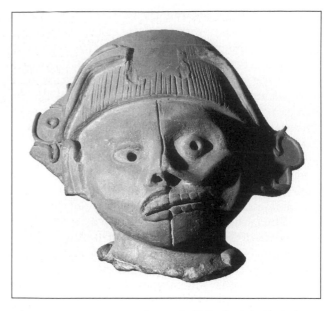

Pl. 53. Mixtec ceramic figure, half-fleshed, half-skeletal, Soyaltepec, Oaxaca (Museo Nacional de Antropología, México).

manifestation of the dualism at the heart of Mesoamerican thought can also be seen in a Classic period Mixtec funerary figure from Soyaltepec, Oaxaca (pl. 53) exhibiting the identical motif centuries later.

As we have seen, the village cultures demonstrating this funerary mask use were those that transmitted Olmec religious concepts, ritual, and artistic forms to the Classic period cultures of Monte Albán and Teotihuacán. For the Maya, the Izapan culture performed the same function. It is significant, therefore, that we see at Kaminaljuyú the same funerary mask use—although the masks are quite different—as in the Valley of Mexico. The richly furnished Preclassic burials at that site, which we discussed in our consideration of the development of the mask of Chac, are typified by Tomb II in Mound E-III-3, the tomb of a ruler whose body had been placed on a litter, covered with red cinnabar, and wrapped in a burial cloth. A mosaic mask of greenstone placed over his face completed his preparation for the journey to the world of the spirit, a journey on which he was believed to be accompanied by the sacrificial victims whose bodies were interred with him.[115] In Tomb B-II nearby, what appear to be the remains of an actual ritual mask were found,[116] suggesting a conceptual identification of ritual and funerary masks similar to that of the Valley of Mexico. That these tombs were within pyramidal platforms and had been covered by floors that were used for ceremonial activities suggests the belief manifested by later cultures, especially the Maya, that the ancestral dead existed as gods and could be called on, through ritual, by the divinely ordained current ruler. A different kind of ritual interment was found in another pre-Maya burial, this one not Izapan. In the Preclassic Burial 10 at San Isidro, Chiapas, the deceased, an adult, was positioned

facing east, sitting with his right leg inside of the left and his arms crossed over his chest. His face was masked by a large, flat, pink-hued seashell perforated for attachment.[117] The careful masking, with the mask tied to the face as in ritual, and the symbolic implications of the seashell relate this funerary mask to ritual as well.

These early examples of the funerary mask led to its widespread and sophisticated use among the Classic period Maya, a practice with clear ties to the Maya view of death expressed in the mythic narrative of the *Popol Vuh*. In the account of the adventures of the Hero Twins in the underworld, Xibalbá or "the place of fright," we have what Coe calls "the most complete description and explanation of the ideology behind the funerary cult that we have or ever will have from anywhere in the world." Fittingly, as he has shown, this narrative account of the defeat of the Lords of Death and the attainment of rebirth is also depicted on the painted ceramic vessels created solely to be buried with "the honored dead." Symbolically, these vessels "comprise one great mythic cycle, along with explanatory chant, to prepare the defunct for the dread journey into the Underworld, much as the Egyptian Book of the Dead or its Tibetan counterpart do."[118]

And that function of those beautiful and profound works of art was also served by the striking jade mosaic masks created by the Maya to cover the faces of the honored dead. Found in tombs at Palenque and Tikal, these masks, unlike the composite masks of Maya ritual, recreated the face of the deceased in order, no doubt, to preserve his identity by preserving his face.[119] This, of course, is one of the primary symbolic purposes of the funerary mask, one clearly related to the belief that the

dead ancestor somehow retains his identity while "becoming a god" who can be called on by his successors. The most famous of these masks, the death mask of Pacal, ruler of Palenque (colorplate 9), illustrates the connection between the mask and that particular set of beliefs. Pacal's tomb, in its shape, in the reliefs decorating it, in its color, and in its placement, is one vast metaphor of regeneration, and the serpentine "psychoduct" connecting that tomb to the temple above indicates the precise nature of the resurrection it symbolizes. Pacal became a god, yet retained his earthly identity; he died, yet lives.

Pacal's mask is one of the most expressive and beautiful works of Mesoamerican art of any period, perhaps because it reflects this fundamental belief. It represents handsomely the powerful face of the ruler over which it was placed and in so doing, compels even our belief that his face reflected his inner strength and beauty. Ruz describes the mask as he found it during the excavation of the Temple of Inscriptions tomb in 1952:

It is composed of some 200 jade fragments of different shades but principally an intense green, at times very dark and shiny, with the eyeball made of conch shell and the iris of obsidian. In the center of the iris a point on the reverse side of the obsidian is painted black to represent the pupil. The personage must have been interred with the mask in place, but during the interment it slipped to the left side of the face where the majority of the fragments were found, a number of them in a position which permitted us to deduce their original location. Under the fragments of jade we discovered, partially conserved, a layer of fine stucco that had been applied directly over the face of the dead man and that served to attach the mosaic fragments of the mask. The nose was sufficiently complete to allow us to see the anatomical form, but the fragments which had composed the right ear and the right side of the mask were found displaced among the bones of the face, over the nose and the upper teeth. It is likely that the mask was originally composed on a model of the head, perhaps on one of the stucco heads left as offerings under the sepulcher. At the moment of preparing the corpse for interment, a thin coat of stucco was applied over the face and the fragments of the mask were immediately moved from the model to the corresponding place in the stucco.[120]

Because it has been very difficult to ascertain whether masks found in and around tombs were actually funerary, Ruz realized that his discovery was a crucial one: "The discovery of the crypt at Palenque confirmed our supposition about the funerary use of masks and to date is the only known case of a jade mosaic mask discovered . . . still in place . . . over the face of the corpse."[121] The

reconstruction of the mask indicated to Ruz that it "must have reproduced the features of the personage more or less faithfully."[122] The obvious care with which the mosaic mask was transferred from the model to the just-dead face of the ruler surely indicates the concern to preserve that royal identity. If a memorial had been all that were intended, the stucco head that served as a model for the mask would surely have been sufficient, but more was needed. His actual face—with all that the face symbolized in Mesoamerican thought—had to be preserved for all time.

That face still conveys to us the strength and wisdom of its "wearer" and the fundamental spiritual belief that prompted its construction, but alone it cannot convey the intricate structure of belief carved metaphorically into the lid of the sarcophagus containing Pacal's body and his death mask. The lid's image

depicts the instant of Pacal's death and his fall into the Underworld. . . . The cosmic event that forms the context for Pacal's passage into death is the movement of the sun from east to west. . . . The sun, poised at the horizon, is ready for its plunge into the Underworld. It will carry the dead king with it [and] . . . he anticipates the defeat of death. [But] a bone attached to his nose signifies that even in death he carries the seed of rebirth. . . . [That bone] is the seed of Pacal's resurrection.[123]

The image thus reflects the Maya belief that "a king dies, but a god is born. . . . Here a ruler is shown suspended in time, about to enter the Underworld from which he will be reborn a god."[124] The mask was placed over the face of Pacal to assist in that process. Thus, all the complex symbolism of the image on the sarcophagus lid is contained within the simple features of that jade mask.

This profound use of the funerary mask was not limited to Palenque; at Tikal, important figures were also buried with jade or greenstone masks or cremated in bundles to which masks were tied.[125] In the late Preclassic Burial 85 located on the axis of the North Acropolis,[126] a ruler's "jade mask, with eyes and teeth of inlaid mother-of-pearl, had originally been attached to a mortuary bust, the individual having been interred, after decapitation and mutilation of the legs, seated and wrapped in a shroud. In this case the mask had been substituted for the head."[127] Thus, both at Palenque and at Tikal the funerary mask served the same purpose in slightly different ways, and were our information more complete, it is certain that we would find similar evidence at other major Classic period sites.

That these Classic period burial practices continued in the later stages of the development of Maya civilization is confirmed by Diego de Landa's account of burial practices in the Yucatán at the

time of the Conquest, an account that incidentally suggests what may have happened to the missing head of the ruler interred in Tikal's Burial 85.

> Among the ancient lords of the house of the Cocoms [the ruling house of Mayapán] they cut off the heads after death, boiled them so as to remove the flesh; then they sawed away the back part of the skull, leaving the front with the cheeks and teeth, supplying in these half sections of the head the removed flesh by a sort of bitumen, and gave them almost the perfection of what they had been in life. . . . These people have always believed in the immortality of the soul, in greater degree than many other nations.[128]

At Palenque, the deceased ruler's head was covered with a realistic mask that preserved his features; at Tikal, the head was replaced with a similarly realistic mask; and, later, in the Yucatán, the head *became* the mask. Step by step the face became the mask; by the time of the Conquest, the artfully reconstructed living face had become a mask covering the ruler's lifeless skull. The viewers of that mask, aware as they must have been of the ruler's past and present states, would have "seen" the living mask and the dead skull simultaneously and thus would have had the same sensation as the viewer of the half-fleshed, half-fleshless masks and heads from Tlatilco and Monte Albán which we discussed earlier. With the Maya we have come one step closer to the gods; the mask is no longer a separate entity in a sacred-human relationship as it was in the case of the ritual masks with the X-ray view; it *is* the sacred being man has become.

The Maya tradition had its counterpart in central Mexico. The pottery masks found in Tlatilco burials (pls. 44, 52) were the precursors of funerary masks used throughout the Classic and Postclassic periods up to the time of the Conquest. Perhaps the best known are the ceramic and stone masks of Classic Teotihuacán. Although none have been found in situ, in part because no tombs of any importance have yet been discovered at Teotihuacán, it is clear that their use was funerary. Séjourné believes that ceramic masks found at the apartment compounds of Tetitla and Yayahuala were affixed to the funerary bundles of the deceased before cremation,[129] a practice illustrated on a number of ceramic incense burners that display funerary bundles carrying such masks.[130] As Covarrubias points out, such a use would account for a number of the physical features of the masks, especially those of stone. The bundles, in addition to bearing masks, are

> provided with a great feather headdress and massive earplug flares and beads of jade. Possibly the life-size stone masks were attached to such dead bundles, which would explain why the masks are cut off horizontally across the forehead for the headdress to rest on,

> and would justify the many perforations: on the ears to attach the earplug flares, under the lower jaw to hang the necklaces, and on the temples and forehead to secure the headdresses.[131]

Moreover, both the ceramic and stone masks often have marginal perforations that might well have been used to attach them to such funerary bundles.

The stone masks (colorplate 8)—often of greenstone, serpentine, onyx, or obsidian and meant to be covered with mosaic designs—are particularly reminiscent of Olmec stone masks, also presumably funerary, in the way they are carved and the manner in which their backs are finished,[132] and both manifest a similar "predilection for hard, lovingly polished stone, the same concise vocabulary, the same consummate craftsmanship."[133] But there are differences. While the Olmec stone masks are strikingly realistic, the masks of Teotihuacán present idealized, expressionless faces. Westheim suggests that this idealization can be seen in two tendencies: first, the widening of the head so that the height and width are approximately equal, thus eliminating the natural verticality of the face, and second, the flattening of the naturally rounded mass of the head, "giving it an almost bidimensional effect."[134] The relatively flat, horizontal shape that results is emphasized by the projecting flanges of the ears and the unbroken ridge of the eyebrows sweeping across the mask above the horizontal slits of the eyes and, as Kubler points out, by the "chin and forehead boundaries [being] treated as flat, parallel planes." Kubler goes on to suggest that "this geometric conception of the human face is dictated by the technique of working the stone. The eyes, the nose, and the mouth are defined by six fundamental saw-cuts. One horizontal cut marks the parted lips. Two more horizontal cuts mark out each of the eyes."[135]

But Westheim sees something more profound than the dictates of technique at work in the stylization of those masks. For him, they are conceptualizations of the essential spirituality of humanity, consciously designed to avoid realistic portraiture. By reducing the face to the essential— perhaps even the symbolic—the artist "spiritualizes" the natural form. Thus, for Westheim, it is not a matter of "stylization." Instead, the masks are "the plastic expression of a conception of the world governed by dualism," and they capture the basic concept underlying all Mesoamerican art in their combining of reality and irreality so as to reflect "the cosmic," "the meaning of things."[136] These symbolic qualities can also be seen in the designs painted on the ceramic masks and worked in mosaic and inlay on the stone masks, designs seen elsewhere in the art of Teotihuacán which no doubt designated the status of the deceased in life and the particular aspect of the realm of the spirit to which his spiritual essence became assimilated

after his death. It is that spiritual essence, rather than the physical face as with the Maya, that these masks depict and perpetuate, and it is that which is captured in the idealized features of these masks, in their "nobility, serenity, timelessness, and impassivity."[137]

The funerary mask was similarly important in Oaxaca, both among the Classic period Zapotecs and in the Postclassic among the Mixtecs. In our discussions of the metaphoric mask of the rain god and of the use of the mask in ritual, we considered at some length the Zapotec funerary urns of Monte Albán and suggested that their frequent combination of a relatively realistic human face wearing or emerging from a composite mask brought together the death mask of an important person with the mask of the god symbolic of his spiritual essence (pl. 39). In addition to these urns, actual masks have also been found in the tombs of Monte Albán. One of the most striking of all Mesoamerican masks, in fact, comes from Burial XIV-10 (pl. 54). Probably representing the features of a bat, the mask is composed of twenty-five carved and polished pieces of dark green jade with eyes made of shell. Caso calls it "one of the most beautiful jades discovered in Mesoamerica,"[138] and Covarrubias says, "this extraordinary mask is a masterpiece of the lapidary art and shows an uncommon sophistication in concept and design."[139] Whether designed for the buried personage with whom it was found or, as Covarrubias believes, imported from the "'Olmec' zone,"[140] those who placed it with the remains of the deceased surely saw in it a metaphor for the spirit of that dead leader. And if it did represent a bat, the metaphor would be clear. The bat flies, that is, "lives," at night and returns at daybreak to the cave where it rests. As we have seen, the cave was always viewed in Mesoamerica as the entrance to the world of the spirit, so the bat symbolically reversed man's life. The bat's "day" was man's night, and its "night," man's day. Metaphorically, this reversal could thus be used to suggest the continuation of life after death and to indicate that the man interred with the mask had not died but had "flown" to the life of the spirit. In that sense, the bat mask can be seen to illustrate in a particular way the general conception underlying all funerary mask usage.

The existence of that and other funerary masks at Monte Albán is complemented by another indication of the importance of the funerary mask there. An offering made up of ceramic figures discovered in the patio of the house built over Tomb 103 (pl. 55) appears to depict a funeral and strongly suggests both the importance of funerary ritual and the central role the mask played in it. The deceased is represented by a mask set atop a step-shaped funerary bundle behind which five priests wearing masks and headdresses form a semicircle. Off to the side of the scene is a seated figure quite similar

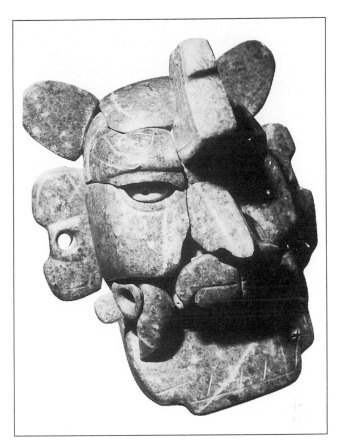

Pl. 54. Jade mosaic mask, probably funerary, Adoratorio near Mound H, Monte Albán II (Museo Nacional de Antropología, México).

to representations of the old god of fire found at Teotihuacán, and in front of this assemblage of figures is a small (both in size and numbers) band of musicians, there, no doubt, to provide music to accompany the ritual.[141] The funerary ritual depicted is complex: as the headdresses and masks of the priests indicate, they are of two related varieties and probably served two different symbolic functions. The hook-billed bird in the headdresses of the two priests holding large circular plates or mirrors is worn as a mask by the other three priests, who wear different headdresses. The representation of the old god of fire adds yet another symbolic dimension to the ritual.

In addition to this level of complexity, the scene also suggests a complex series of interactions with other areas of Mesoamerica. The hook-billed bird mask and the old god of fire are reminiscent of Teotihuacán and, in fact, are united in the Tepantitla mural (colorplate 3). That mural symbolizes the union of spirit and matter in the context of fertility, while this scene may well symbolize that same union at the moment at which one might think spirit and matter had reached the point of separation. The purpose of the ritual, however, is to indicate the continued union of the two, a continuity most economically symbolized by the large, centrally placed mask, also visually related to those of Teotihuacán. The mask stands as a meta-

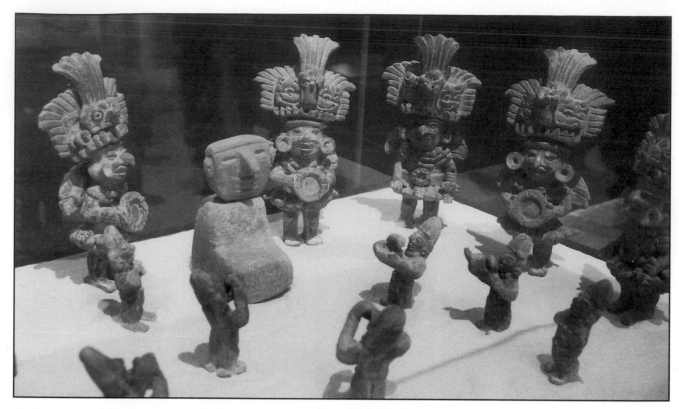

Pl. 55. Funerary offering composed of ceramic figures arranged to form a ritual scene, Tomb 103, Monte Albán III (Museo Nacional de Antropología, México).

phor for the continued existence of the man, probably a ruler, who had just become a venerated intermediary between the human community and the great supernatural forces on which their individual and communal lives depended.[142] That this recreation of the funerary ritual of the dead ruler was found buried in the patio of the house constructed *above* his tomb suggests exactly the same relationship between living and dead rulers we have seen among the Maya—most clearly, at Palenque. But the symbolic figures that make up the scene are related to Teotihuacán, not to the Maya. Thus, this scene reflects both the complexity of the interaction of influences within Classic period Mesoamerica and the fundamental similarities of all of those traditions, similarities that permit the assimilation of influences in symbolic scenes such as this.

The later Mixtec burials in Oaxaca yield additional, though somewhat different, evidence of the importance of the funerary mask and are themselves related to funerary practices among the Maya and in the Valley of Mexico. A common feature in the elaborate tombs and burials of Mixtec rulers and important citizens is turquoise mosaic masks such as those associated with the two principal burials in Tomb 1 at Zaachila which Caso has identified, on the basis of the Mixtec Codex Nuttall, as the final resting place of one of the lords of Yanhuitlan.[143] Similar masks have been found at Monte Albán in association with Mixtec burials,

and recently the remains of other masks were found in the exploration of a large, heavily looted Mixtec cave with at least forty-five tombs or cells at Ejutla. Christopher Moser, a member of the exploring team, believes that some of the cells had served as tombs, and that those tombs

> provide evidence of the profound Mixtec belief in an afterlife and demonstrate that the concept of survival of the spirit—which retained its personal status—was central to the funerary ritual which included the killing of servants who would then attend their fallen master in the land of the dead as well as the offering of ornaments and personal riches, the sacrifice of birds, self-sacrifice, and the burning of incense and amatl.[144]

The remains of two wooden masks encrusted with turquoise mosaic left by the looters are probably a small indication of the number and importance of such funerary masks in that cave, but

> these mosaic artifacts are of particular interest because of their similarity to the masks illustrated by Saville (1922, fig. 6) which now form part of the collection of the Museum of the American Indian in New York. Saville says that the seventeen examples in this collection came from "a cave in the mountains of the Mixtec region of Puebla" (1922, 48). Dockstader, director of the museum, could not distinguish between a photograph of the mask from the cave at Ejutla and the fragments

of masks in the collection of the museum he directs.[145]

Those masks now in New York may thus very well be the ones that originally accompanied the deceased Mixtec luminaries buried in the cave at Ejutla, "a burial site for nobles and their retainers from one of the Cuicatec (or Mixtec?) *cacicazgos* in the Cañada below." The deceased nobles "were wrapped in textiles, given a turquoise mosaic funerary mask, and sealed up in stone masonry cells. This procedure would fit the ethnohistoric descriptions of Mixtec and Cuicatec funerary rites as well as portrayals in the Postclassic codices."[146] The Mixtec burial cave at Ejutla, then, once more symbolically brings together burials, caves, and masks to mark the liminal point of passage from the world of nature and human life to the world of the spirit.

That funerary masks were as important to the Aztecs as to their Mixtec contemporaries is certain. Cecilia Klein points out that

the corpses of deceased Aztec rulers were, we know, dressed and masked for cremation, and the secondary funerary images set up in their honor in the Tlacochcalco were dressed in several superimposed costumes, each of which represented the garb of a different deity. . . . Fray Gerónimo de Mendieta says that their masks referred to either the patron deity of their home town or that of the temple in which their ashes were to be buried.[147]

Westheim describes the Aztec mortuary bundle as made of cloth and shaped like a seated person, which, interestingly, is precisely the shape of the bundle on which the mask rests in the offering scene we described from Monte Albán. This bundle was then covered with the attire of the deceased, and a mask was attached in the position of the head. In cases where the body was not prepared in this way for cremation, but was to be buried, the mask was placed directly over the face of the deceased.[148]

Townsend's discussion of the Aztec conception of death suggests the symbolic function of the funerary mask:

The ancestral dead were considered to be assimilated to the cosmos. . . . "To all their dead they gave the name téotl *so-and-so, which means 'god so and so' or 'saint so and so,'" writes Motolinía. . . . [Thus] the use of* teixiptlas *[ceremonially attired cult effigies] in funerary contexts spelled out the continuing connections of community leaders with the cosmic forces.*

Funerary masks were often associated with these teixiptlas; in the case of the ruler Axayacatl, for example, an effigy was constructed with five layers of attire, each representing a different god, and atop that layered figure was placed a bird-billed jaguar mask, a fascinating example of what we

have earlier called a secondary mask. Then, "in the conclusion of the ritual, this composite bundle was placed together with the body of the deceased emperor upon a pyre in front of the Huitzilopochtli idol, and both were burned."[149] The mask was clearly a means of preserving the transcendental affinity of the deceased with the cosmic forces he expressed as the living ruler. Once again, then, we have an example of a funerary mask related to the inner, spiritual identity of the deceased rather than his physical identity, a conception succinctly expressed in the last lines of a Nahuatl poem:

For this reason the ancient one said,
he who has died, he becomes a god.
They said: "He became a god there,"
which means that he died.[150]

The Aztec funerary mask use explained by these fundamental conceptions seems to unite the practices of the Postclassic Mixtecs with those of Classic period Teotihuacán as two distinctly different types of masks were probably associated with funerary practices by the Aztecs. On the one hand, there are a number of stone masks (pl. 56) that may well have had a funerary function. Although she does not connect them specifically with such a function, Pasztory describes them as related to deities, often Xipe Tótec, but obviously not meant to be worn in ritual since they have no eyeholes. Furthermore, "these masks represent the Aztec facial ideal: a long head, wide mouth, straight nose, and eyebrows set close to the eyes."[151] Though they do not look like the stone funerary masks of Teotihuacán (colorplate 8), Pasztory's description suggests that they expressed the Aztec spiritual ideal in exactly the same way that those earlier masks expressed the ideal conception of Teotihuacán and thus contain all the elements associated

Pl. 56. Aztec stone mask (The British Museum).

with the funerary masks.[152] Interestingly, Pasztory illustrates a carved wooden, gilded mask[153] that is remarkably similar to the stone masks. The existence of this mask suggests that the stone masks may well have been luxurious versions used by royalty of the more common wood masks used by illustrious Aztecs of somewhat lower status. These wooden masks, of course, would have perished in the flames of the funeral pyre or rotted in the earth after burial.

In addition to these stone and wood masks that seem to continue the tradition begun by the Olmecs and brought to the Valley of Mexico at Teotihuacán, turquoise mosaic masks in the Mixtec style (see pl. 58) were also used by the Aztecs. According to Pasztory, they probably had multiple functions. Some were used on effigy figures, others were worn in ritual, while still others "were placed on the bundles containing deceased rulers who were dressed in the regalia of the gods for the funeral in which they were finally cremated."[154] Whether these masks were created by Mixtec craftsmen in Tenochtitlán, as many believe, or were the work of Aztec craftsmen, perhaps in imitation of Mixtec work,[155] or were sent as tribute to the Aztec capital[156] is not fully understood. But their remarkable formal similarity to the Mixtec funerary masks clearly suggests a similar function.

While these mosaic masks are relatively realistic representations of the human face built on wooden frames, what is perhaps the most striking Aztec mosaic mask, and one clearly related to funerary ritual, is different. The mosaic in this case rests on the front half of a human skull lined with leather so that it could be worn as a mask (pl. 57). The alternating bands of blue turquoise and black lignite which compose the face recall the patterned mosaics of the stone masks of Teotihuacán (colorplate 8) and suggest the facial painting of Tezcatlipoca whom the mask may well represent,[157] but the idea of preserving and decorating the skull of an important person is reminiscent of the Maya practice noted above. A number of similarly decorated skulls in both Aztec and Mixtec offerings[158] indicates that this skull-mask is not an isolated phenomenon. Rather, it is yet another way of suggesting the link between life and death, a link represented metaphorically by the conception of the funerary mask.

As this mask so clearly illustrates, life and death were not separate states for the peoples of Mesoamerica. The life-force was eternal, and one's brief "life" on earth was a moment in that eternity. Assimilation into that eternal force was not death; on the contrary, it was a movement into the essential nature of life. The funerary mask was the most fundamental metaphor created by the peoples of Mesoamerica for that conception. All of the varied masks found in Mesoamerican graves and designed for Mesoamerican cremations are variations on that single metaphorical theme.

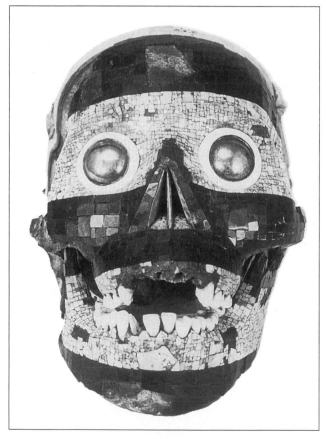

Pl. 57. Aztec mosaic-covered skull (The British Museum; photograph courtesy of The British Museum, reproduced by permission).

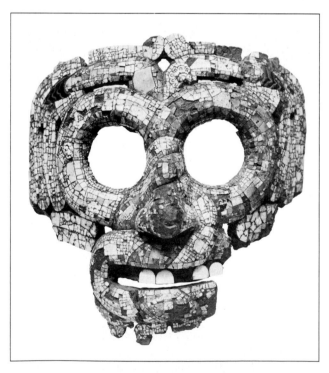

Pl. 58. Aztec mosaic mask, perhaps one of the masks presented to Cortés by Moctezuma (The British Museum; photograph by The British Museum, reproduced by permission).

3 Coda I: The Mask as Metaphor

The mask served pre-Columbian Mesoamerica in death and in life as a metaphor for the ultimate nature of reality. Mankind and all of the aspects of the natural world were finally to be seen as features of the mask worn by the eternal life-force. The gods were but varied manifestations of the essence of life which "unfolded" as masks into man's world, and man himself, through ritual, could emerge from the spirit and merge with it again, with death providing the final assimilation. It is no wonder then that Mesoamerica used the mask as the central metaphor for its spiritual vision.

It is thus amazingly fitting that the mask played a prominent symbolic part in the final collapse of the tradition to which it was central. As Cortés and his troops rested on their ships before their march from the coast of Veracruz toward Tenochtitlán, Moctezuma, believing on the basis of a series of omens that those men were destructive apparitions from the world of the spirit, had to decide how to deal with them and protect his people. He made what must have seemed to Cortés a strange decision but one that we can understand as the only proper one from his point of view. He sent with his emissaries the regalia that would enable these apparitions to manifest themselves in their true form, a form in which they would become comprehensible in Mesoamerican terms.

First was the array of Quetzalcóatl: a serpent mask made of turquoise mosaic; a quetzal feather head fan; a plaited neck band of precious green stone beads, in the midst of which lay a golden disc; and a shield with bands of gold crossing each other, or with bands of gold crossing other bands of sea shells, with spread quetzal feathers about the lower edge and with a quetzal feather flag; and a mirror upon the small of the back, with

quetzal feathers, and this mirror for the small of the back was like a turquoise shield, of turquoise mosaic—encrusted with turquoise, glued with turquoise; and green stone neck bands, on which were golden shells; and then the turquoise spear thrower, which had on it only turquoise with a sort of serpent's head; it had the head of a serpent; and obsidian sandals.

The second gift which they went offering him was the array of Tezcatlipoca—the headpiece of feathers, with stars of gold; and his golden shell earplugs; and a necklace of sea shells; and the breast ornament decorated and fringed with small shells; and the sleeveless jacket painted with a design, with eyelets on its border, and fringed with feathers; and a mantle with blue knots, which was called tzitzilli, grasped by the corners in order to tie it across the back; also, over it, a mosaic mirror lying on the small of the back; and, as another thing, golden shells bound on the calves of the legs; and one more thing, white sandals.

Third was the adornment of the lord of Tlalocan: the headdress of quetzal and heron feathers, replete with quetzal feathers. It had quetzal feathers and was blue-green; blue-green was overspread. And over it gold interspersed with shells. And green stone were his serpent-shaped earplugs. There were his sleeveless jacket, with a design of green stone; his neck ornament, his plaited, green stone neck band with also a golden disc. Also he had a mirror at the small of his back, as hath been told; and likewise he had rattles and a cape with red rings on the border, which was tied on; and shells of gold for his ankles; and his serpent staff was made of turquoise.

Fourth, likewise the array of this same

Quetzalcóatl was yet another thing: the pointed ocelot skin cap, with pheasant feathers; a very large green stone at the top, which was fixed at the tip; and round, turquoise mosaic earplugs, from which were hanging curved sea shells fashioned of gold; and a plaited green stone neck band in the midst of which there was likewise a golden disc; and a cape with red border which was tied on; likewise, golden shells used upon his ankles; and a shield with a golden disc in the center, and spread quetzal feathers along its lower rim, and also with a quetzal feather banner. He had the curved staff of the wind god, hooked at the top, and white precious stone stars spread over it; and his foam sandals.

Behold, these were all the things called the array of the gods.[1]

On reaching Cortés's ship, the messengers were taken aboard, and they "adorned the Captain himself; they put on him the turquoise mosaic serpent mask" (pl. 58) and the other regalia of the god. But as the messengers immediately discovered and as Moctezuma was to learn soon enough, these Europeans were not beneficent gods. After asking the emissaries whether they had more gifts, Cortés "commanded that they be bound" and arranged for them to observe the firing of "the great lombard gun." They were awed by its destructive power, a power that was unfortunately as symbolic of the European sense of reality as the mask of the gods was of Moctezuma's.[2]

With biting irony, Sahagún's informants follow the description of the array of the gods with a description of the array of Cortés and his men:

All iron was their war array. They clothed themselves in iron. They covered their heads with iron. Iron were their swords. Iron were their crossbows. Iron were their shields. Iron were their lances. . . .

And they covered all parts of their bodies. Alone to be seen were their faces—very white. They had eyes like chalk; they had yellow hair, although the hair of some was black. Long were their beards, and also yellow; they were yellow-bearded.[3]

In the contrast between the regalia of the gods and that of the troops, we can discern the essential contrast between the European and the American conceptions of reality, a contrast clearly not lost on Sahagún and his informants.[4] While the peoples of Mesoamerica saw reality as the constant interpenetration of different planes of existence, planes anchored in the extremes of the unapproachable life-force, on the one hand, and the world of nature, on the other, Cortés and his men saw reality as essentially material, something to be conquered and exploited. The world of the spirit was, for them, a separate domain. In this fallen world, they had been given dominion. In the clash of these essentially different views of reality, the simplicity of the conception of the Conquistadores prevailed. They were not burdened with the complexity that came from attributing material events to spiritual causes. Octavio Paz has said of this unequal encounter that "for two thousand years the Mesoamerican culture lived and grew alone; their encounter with the Other came too late and under conditions of terrible inequality. For that they were destroyed."[5]

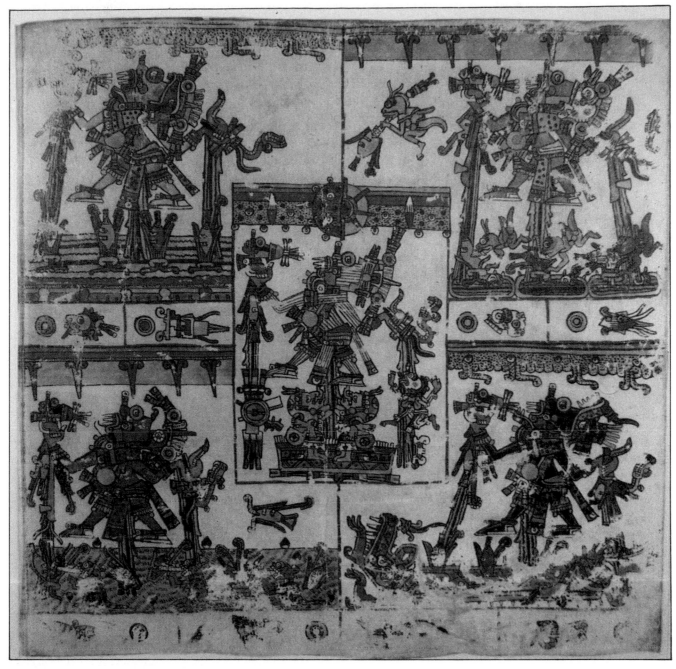

Cp. 1. Tlalocs, page 27 of the Codex Borgia (reproduced by permission of
Fondo de Cultura Económica, México).

a

b

Cp. 2. a. "Lightning Tlaloc," mural painting, Tetitla, Teotihuacán; b. Tlaloc, middle border of the Tlalocan mural, Tepantitla, Teotihuacán.

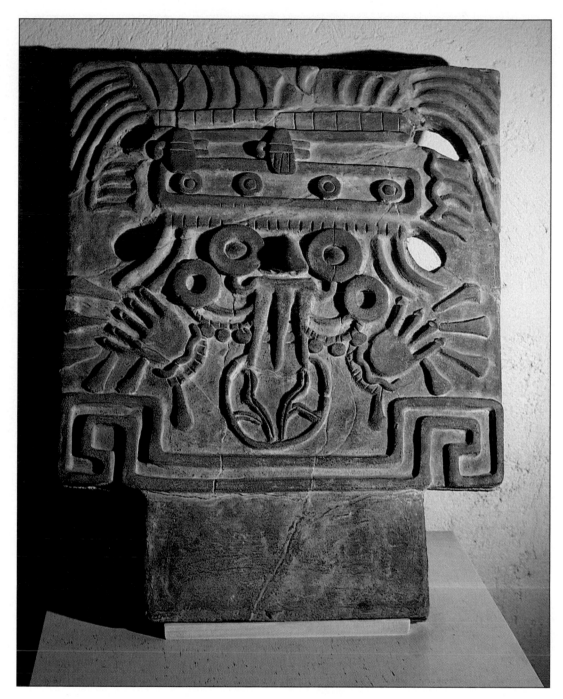

Cp. 3. Tlaloc, relief on a merlon, Teotihuacán (Museo de la Zona Arqueológica de Teotihuacán).

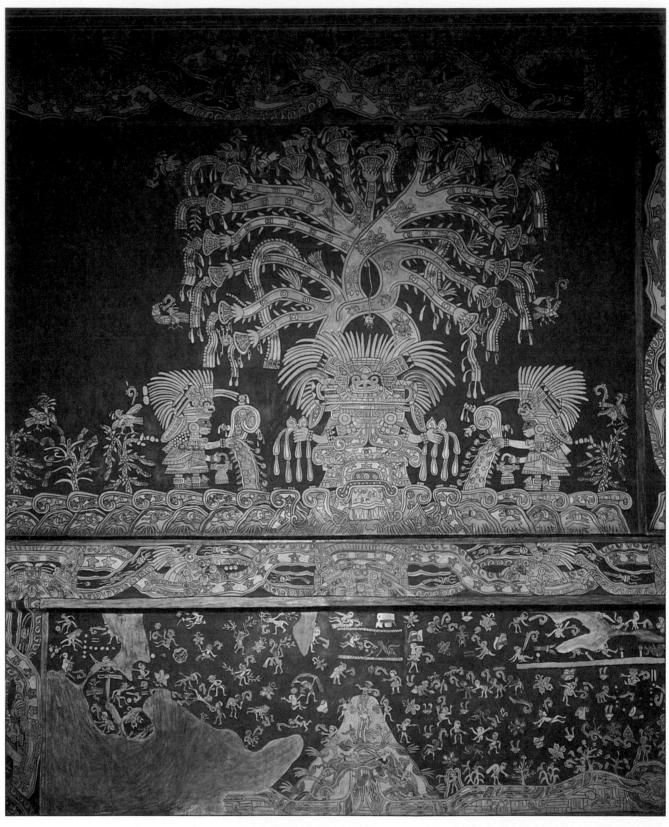

Cp. 4. Tlalocan mural, Tepantitla, Teotihuacán (reproduction in the Museo Nacional de Antropología, México).

a

b

Cp. 5. Abstract Tlaloc murals: a. Templo Mayor, Tenochtitlán; b. Street of the Dead, Teotihuacán.

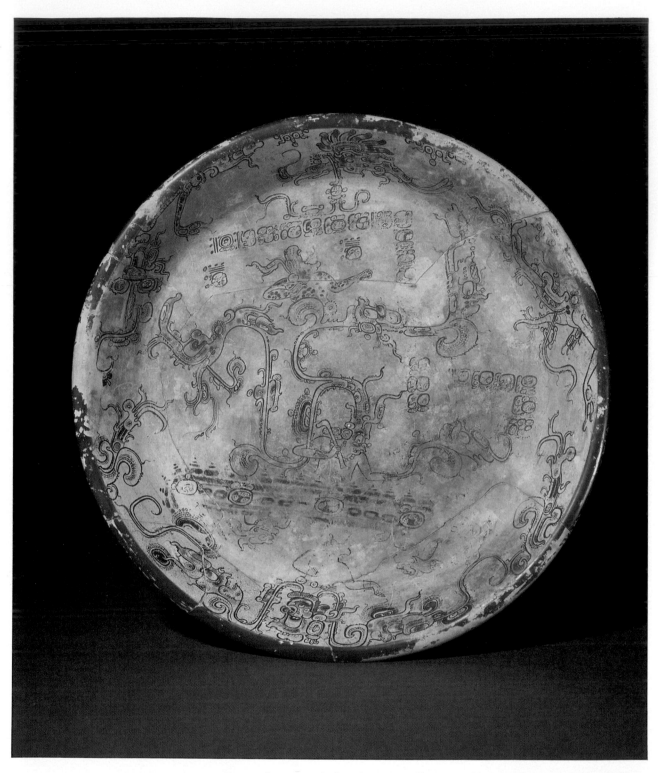

Cp. 6. Chac, tripod plate (private collection, photograph copyright Justin Kerr 1981, reproduced by permission).

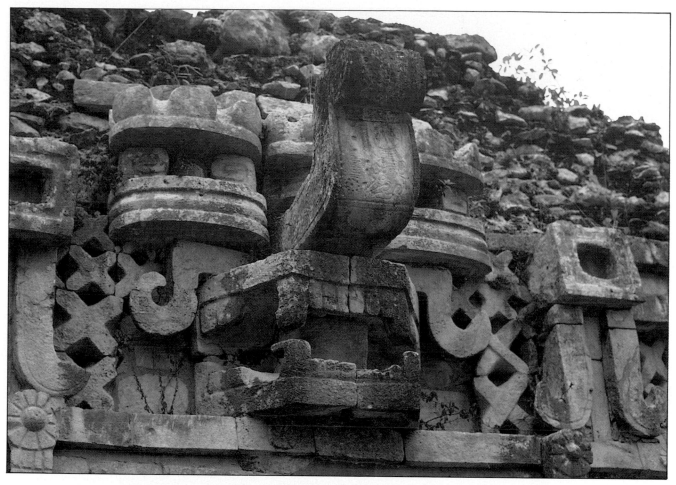

Cp. 7. Chac mask, carved stone mosaic, facade of the Palace, Labná, Yucatán.

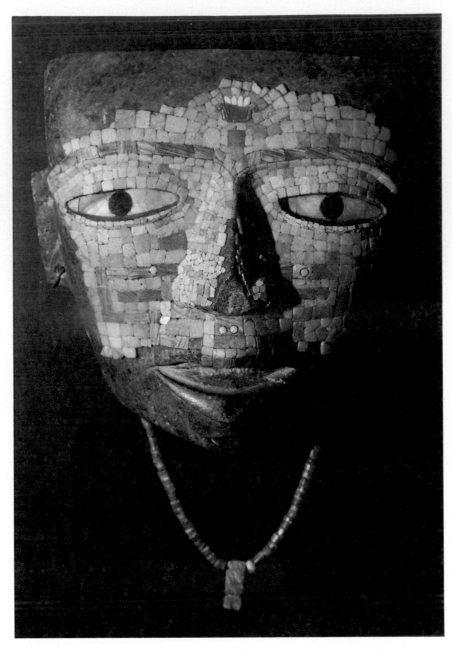

Cp. 8. Mosaic covered stone funerary mask, culture of Teotihuacán, Texmilincán, Guerrero (Museo Nacional de Antropología, México).

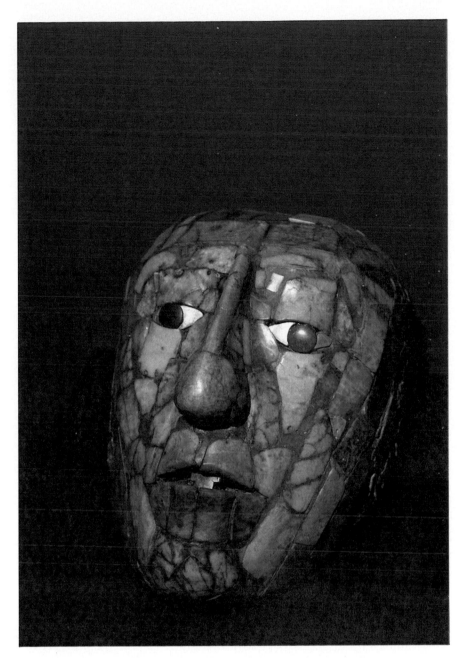

Cp. 9. Jade mosaic funerary mask of Pacal, Temple of Inscriptions, Palenque (Museo Nacional de Antropología, México).

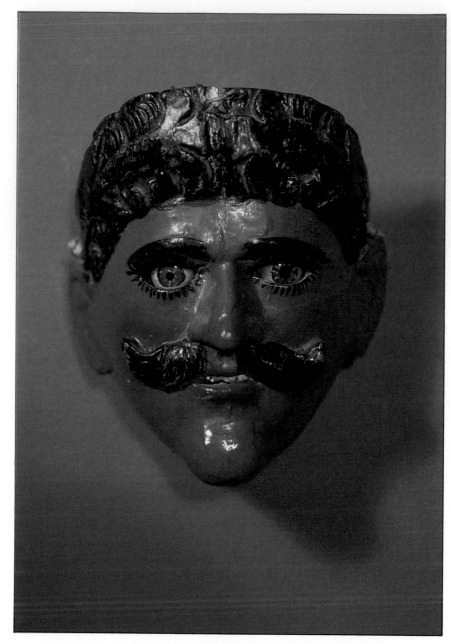

Cp. 10. Although this is the mask of an Indian in the Dance of the Conquest, the European features themselves suggest the syncretic nature of the drama. This mask is from the *Morería* of Pedro Antonio Tistoj M., San Cristóbal Totonicapán, Guatemala (collection of Peter and Roberta Markman).

Cp. 11. Mask of a Hermit in the Pastorela drama as performed in Ichan, Michoacan (collection of Peter and Roberta Markman).

Cp. 12. Mask of a *Tigre*, Zitlala, Guerrero (collection of Peter and Roberta Markman).

Cp. 13. (left) Rufino Tamayo, *Carnaval,* gouache on paper, 1941 (The Phillips Collection, Washington, D.C., reproduced by permission).

Cp. 14. (below) Rufino Tamayo, *Masque Rouge,* lithograph, 1973 (collection of Peter and Roberta Markman).

Cp. 15. Francisco Toledo, *Autoretratos-Mascaras*, gouache on paper, ca. 1965 (private collection, photograph courtesy Mary Anne Martin/Fine Art, New York).

Cp. 16. Francisco Toledo, *Autoretrato*, watercolor and gold leaf on paper, ca. 1975 (collection of Peter and Roberta Markman).

Part II

METAPHORIC REFLECTIONS OF THE COSMIC ORDER

4 The Shamanistic Inner Vision

The mask Moctezuma presented to Cortés had a long history and a number of levels of symbolic meaning. In fact, the beginning of its history and the source of its meanings must be sought in a time long before any actual masks appear in the archaeological record as the roots of the ritual and symbolic use of masks characteristic of Mesoamerican religion are deep in the shamanistic base from which that religion grew. Throughout the long history of its development, it continually drew sustenance from the basic conceptions brought across the Bering Straits land bridge as early as 40,000 years ago by the first discoverers, explorers, and settlers of the New World and bequeathed by those first Americans to all the generations who were to follow them in the development of what was to become the indigenous thought of the high cultures of Mesoamerica. All the subtlety, intricacy, complexity, and beauty of the thought and ritual of the highly developed religious institutions of Mesoamerica at the time of that second contact with the Old World, known as the Conquest, can be seen as developments from the shamanic base, developments from that original archaic religious system built on the individual shaman's ability to break through the normally impenetrable barriers that separate the planes of matter and spirit. His was an ecstatic personal experience with practical uses for his people, the hunting and gathering, nomadic peoples of the Early Paleolithic and later times. As magician, diviner, or curer, he was uniquely capable of bridging the gap between the mundane lives of the people of his community and the mysteries of the invisible world which could give those lives purpose, direction, and meaning and through which the ailments and problems of the individuals and the community could be dealt with. Of course, the highly developed religions of the later civilizations of Mesoamerica no longer depended upon the central figure of the shaman and the trance through which he was able to enter the world of the spirit, but the outlines of that shadowy figure can still be seen in the basic assumptions and many of the practices of the religions he founded.

The significance of shamanism to Mesoamerican spiritual thought has been recognized both by those who study Mesoamerica and those who study mythology and religion generally. Campbell, for example, among the latter group, has pointed out that "in any broad review of the entire range of transformations of the life-structuring mythologies of the Native Americas, one outstanding feature becomes immediately apparent: the force, throughout, of shamanic influences."[1] In this, he concurs with Eliade who, in his definitive study of shamanism, shows that "a certain form of shamanism spread through the two American continents with the first waves of immigrants."[2] Among Mesoamericanists, Furst, who claims that the shamanic world view forms the basis of "mankind's oldest religion, the ultimate foundation from which arose the religions of the world,"[3] notes that even the relatively late Aztec religion, which was certainly not dominated by the individual shaman and his trance, retained "powerful shamanistic elements"[4] that were derived from the fundamental shamanic assumptions underlying Mesoamerican religious thought and practice. A brief treatment of those assumptions will illuminate their shamanic origin and, interestingly, suggest an important reason for the widespread mask use we have traced in Mesoamerican religious symbolism and ritual.

Perhaps the most fundamental assumption shared by shamanism and Mesoamerican religion holds that all phenomena in the world of nature are animated by a spiritual essence, the common possession of which renders insignificant our usual

distinctions between man and animal and even the organic and the inorganic. In the shamanic world, everything is alive and all life is part of one mysterious unity by virtue of its derivation from the spiritual source of life—the life-force. Thus, each living being is in this sense merely a momentary manifestation of that eternal force, a mask, as it were, both covering and revealing the mysterious force of life itself. Furthermore, the commonality of the life-force makes possible within the shamanic context the primordial capability of magical transformation; man and animal can assume each other's outer form to become the alter ego, an ability central to the pan-Mesoamerican concept of the *nagual*, which is discussed below. Through this form of transformation, the shaman can explore the myriad dimensions of the material and psychological worlds; and through the concomitant liberation from the limitations of his own body, he can take the first step toward the exploration of the worlds of the spirit, the proper domain of his own spiritual essence. The ritual use of mask and costume clearly derives, at least in part, from that concept of magical transformation: through the mask, the ritual performer changes his physical form to enter the world of the spirit in a way analogous to the shaman's magical transformation.

A second assumption of shamanism that underlies Mesoamerican religion follows directly from this first one. In the shamanic universe, the soul, or individual spiritual essence, is separable from the body in certain states or under certain conditions; the spirit can become autonomous and function free of the body. Man is thus not necessarily limited to or by his physical existence; he is capable of moving equally well in each of the two equivalent worlds of which he is a part—the natural and the spiritual. This equivalence of the worlds of matter and spirit makes the common distinctions between dream and experience, this world and the afterworld, the sacred and the profane, as insignificant as those between man and animal because the shaman demonstrates that the only true reality is spirit, albeit spirit that may be temporarily garbed in the material trappings of the world of nature. Just as the spirit of the shaman can transform itself into other forms of natural life, so it can leave the physical body entirely and "travel" unfettered in the spiritual realm. It is there, of course, that the shaman finds what is needed to cure the ailments and solve the problems of his people, one of his primary functions in a world that believed the cause of everything in nature was to be found in the world of the spirit. Thus, the physical being of the shaman, and of living things generally, was a "mask" placed on the spiritual essence, a "mask" that could be removed and left behind in the shaman's ecstatic journeys to the world of the spirit. The actual masks and costumes worn by shamans suggested symbolically the separability of the worlds of matter and spirit, and precisely this symbolic meaning of mask and costume was to remain constant throughout the development of Mesoamerican spirituality.

This belief in the separability of matter and spirit concurs with a third basic assumption of shamanism and of Mesoamerican religion—that the universe is essentially magical rather than bound by what we would call the laws of cause and effect as they operate in nature. Since material realities were the results of spiritual causes, to change material reality, the spiritual causes had to be found and addressed through ritual and/or shamanic visionary activity. The magical universe consisted of two levels of spiritual reality, one above and one below the earthly plane, a shamanic conception that directly prefigures the structure of the cosmos as it was seen at every stage of the development of Mesoamerican spiritual thought. The three levels are connected by a central axis, often represented by a world tree, "soul ladder," or stairway that links the planes of spirit and matter and provides the pathway for the shaman's spiritual journeys. Again, shamanism posits a universe in which matter and spirit are separate yet joined, and that union both makes possible and is symbolized by the spiritual travel of the shaman when he takes off the "mask" of his physical being.

These assumptions are the core of shamanism. They suggest the fundamental spirituality of man and provide a conceptual base for the belief that through appropriate rituals performed by one who, by heredity, divine election, or the manifestation of a proclivity for the sacred, has acquired the ability to shed his physical being to become "pure" spirit, all boundaries can be crossed so that the zones of profane space and time can be transcended and the essential order of the cosmos revealed. The shaman is thus the mediator between the visible and the unseen worlds, the point of contact of natural and supernatural forces. Significant among the supernatural forces are the figures of his ancestors, the clear embodiment of death and the life after death. In thus linking the natural with the supernatural, the material with the immaterial, and life with death, the shaman establishes an inner metaphysical vision of the primordial wholeness of cosmic reality. He, himself, has left his body through a symbolic death, traversed the realms of both life and death, and returned to tell the tale. As he returns from his visionary experience, he again puts on the "mask" of the material world so as to communicate that experience and share his vision of the world of the spirit with his community.

Black Elk, the visionary Native American of comparatively recent times, beautifully suggests the essence of this shamanic vision characteristic of the indigenous cultures of the Americas.

I was standing on the highest mountain of them all, and round about beneath me was the

whole hoop of the world. And while I stood there I saw more than I can tell and I understood more than I saw; for I was seeing in a sacred manner the shapes of things in the spirit, and the shape of all shapes as they must live together like one being. And I saw that the sacred hoop of my people was one of many hoops that made one circle, wide as daylight and as starlight, and in the center grew one mighty flowering tree to shelter all the children of one mother and one father. And I saw that it was holy.[5]

That "sacred manner" of seeing which reveals the mysterious unity, the "one circle," at the heart of things is the ecstatic vision of the shaman, and it is as central to Mesoamerican thought and ritual throughout its development as it was to Black Elk's somewhat different vision of reality.[6] From that very sense of the spiritual unity of the cosmos, the cultures of Mesoamerica developed a religion that saw man's existence in essentially spiritual terms and that concentrated its ritual actions on symbolizing and breaking through the boundaries between the planes of matter and spirit through such means as the attainment of trancelike states induced by ritual privation, blood sacrifice, or the ingestion of hallucinogens; ritual human and animal sacrifice; and masked dance. As we have shown, even the sacred spaces in which these ritual activities took place were themselves symbolically "marked" by the use of masks to suggest the ultimately shamanistic idea of the separability of the worlds of spirit and matter. Underlying all these fundamental ritual practices we can see the vision so well described by Black Elk.

But it is not only in its shamanistic assumptions that we can find evidence of the shamanic base of Mesoamerican religion. Numerous clearly shamanic practices have been and continue to be integral parts of Mesoamerican religious activity. They can be seen in connection with funerary ritual, symbolic animal-human transformation, the attainment of trance states through the use of hallucinogens, and in the healing practices still associated with Mesoamerican spirituality. Evidence of all these practices can be found very early, but the earliest is, of course, fragmentary as a result of the destructiveness of man and nature through the course of the centuries and of the fact that archaeological research on Preceramic Mesoamerica is in its infancy. Significantly, however, MacNeish, one of the pioneers in that research, has found archaeological evidence to confirm that as early as the El Riego phase in the Tehuacán valley (ca. 6000 B.C.) there was "a complex burial ceremonialism that implied strong shamanistic leadership."[7] Since, as we have seen, the shaman is intimately involved with death in his movement between this world and the afterworld and since burials often preserve archaeological material, it is not surprising that

the early evidence of shamanic practices involves mortuary ceremonialism, the ritual involved with man's ultimate movement between the worlds of matter and spirit. That these very early shamanic burial customs persisted in central Mexico is indicated by the association between funerary ritual and male figurines dressed in shaggy costumes suggestive of the paraphernalia of the shaman as jaguar[8] found at Tlatilco as early as 1500 B.C. and as late as A.D. 750 on a grander scale at Teotihuacán. Soustelle discusses the examples from Tlatilco and concludes that

certain individuals wore garments, ornaments, masks that set them apart; no doubt these individuals were "shamans," awesome figures, respected and feared, intermediaries between the human world and the supernatural forces whose powers lay in a domain somewhere between magic and religion. Such magician-priests still exist today in Indian communities.[9]

Covarrubias also sees a funerary jaguar-shaman relationship in figurines from a Tlatilco burial. Each of the "shamans" is accompanied by a dwarf and each is wearing a small mask, some of the masks jaguarlike and others designed so that half portrays a contorted face with a hanging tongue and half is a human skull (pl. 52), together suggesting the duality of life and death,[10] one of the fundamental assumptions of shamanism. That this symbol of the equivalence of life and death, matter and spirit is found in the shape of a ritual mask worn by a shamanic ritual figure further strengthens the contention that the cultures of Mesoamerica from very early times consciously used the mask as a primary symbol for the idea that the material and spiritual worlds coexist in such a way that the material world acts as a covering for the world of the spirit, a covering that can be penetrated through the symbolic death of the shaman's ecstatic trance. We can also see in these early symbols and ceremonies associated with death the roots of the complex system of communicating with the world of the spirit through human and animal sacrifice which was characteristic of the cultures of Mesoamerica. That system of communication, already suggested by the sacrificial victims in the El Riego phase of the Tehuacán valley, was perhaps a logical development from the deathlike trance of the shaman which enabled him to enter the world of the spirit. In both cases, a form of death was seen as the necessary prerequisite for the spiritual journey.

Evidence of this transformation, through death, from matter to spirit is complemented in the archaeological record of early Mesoamerica by widespread indications of another sort of transformation. As we have demonstrated in the section "Merging with the Ritual Mask," such masks from the earliest times give evidence of the merging of human and animal features in the process of the

transformation of matter into spirit through art and ritual. Numerous figurines from such Preclassic sites in the Valley of Mexico as Tlatilco, Tlapacoya, and Las Bocas; a good deal of Olmec sculpture both from the heartland on the Gulf coast and other sites ranging from Chiapas to Puebla; and a number of examples of the early sculptural art of Monte Albán, all roughly contemporary, depict or suggest such transformations of man into animal, often a jaguar or bird. Both of these creatures are associated with the shaman and both, as we have seen, are potent factors in Mesoamerican spiritual symbolism. Such a transformation, of course, suggests the shaman's ability to transcend the material world and to transform himself into other natural forms. This assumption of the outer form of an animal alter ego was no doubt "the most striking manifestation of his power"[11] and was an integral part of his ability to enter the world of the spirit. Thus, the early masked rituals recorded by these ceramic and stone figures and those that followed them in the later cultures of Mesoamerica must often have effected a symbolic transformation of the essentially shamanic figure into his animal counterpart in the process of penetrating spiritual reality.

The jaguar, always important symbolically in Mesoamerica as we have seen in the context of rain, fertility, and rulership, is a key figure in these symbolic transformations, and linguistic studies showing that in some areas of the New World the words for *jaguar* and *shaman* are the same[12] offer further evidence of shamanic transformation. And, significantly, the Aztec name for the shamanic sorcerer-priest-curer, nahualli, was the same as the word that denoted the animal alter ego into which the sorcerer could transform himself. These two linguistic connections between priest and animal underscore Furst's claim that the jaguar's importance throughout Mesoamerican symbolism is connected with the fact that it is interchangeable with, or a kind of alter ego of, men who possess supernatural powers.[13] According to Eliade, the "mystical journeys [of the shaman] were undertaken by superhuman means and in regions inaccessible to mankind";[14] thus, the magical transformation of the shaman into a bird or an animal that could move with superhuman speed would symbolically supply the powers needed to make the journey into that other realm of being.

Recent research indicates that both of these forms of transformation—from matter to spirit through a symbolic death and from man to animal—were often accomplished through the ingestion of psychotropic substances by which the shaman attained the necessary mystical, ecstatic state that would enable him to transcend human time and space and gain insight into the divine order. That research provides evidence of the use of hallucinogens early in the development of Mesoamer-

ican religion. The abundant remains of *Bufo marinus* at San Lorenzo, for example, suggest that the Olmecs sought the hallucinogenic effects of eating these toads.[15] Coe and other students of the Classic period Maya have found extensive evidence on painted ceramics of the practice of ritual hallucinogenic enemas, a practice that seems to have roots in the Preclassic.[16] Furthermore, "the presence of mushroom stones and associated manos and metates in Middle and Late Preclassic caches and tombs indicates the existence of a widespread mushroom cult similar in concept, but not necessarily in performance, to that known [today] among the Mixtecs, Zapotecs, and Mixes of Oaxaca."[17]

This fragmentary evidence of the shamanic use of hallucinogens in pre-Columbian Mesoamerica takes on its proper significance when we examine the use of hallucinogens among the Aztecs. Because Aztec thought is far better documented than that of any other pre-Columbian civilization, the use of hallucinogens, like many other areas of spiritual thought and practice, can be better understood within Aztec culture than in the cultures of Classic and Preclassic Mesoamerica. The evidence of their extensive ritual use of hallucinogens to command visions of destiny and to experience the order to be found in the unseen world no doubt indicates that we would find the use of hallucinogens equally pervasive in earlier cultures were similarly extensive evidence available. The Aztecs considered psychotropic plants sacred and magical, serving shamans, and even ordinary people, as a bridge to the world beyond.[18] Providing the ability to enable man to communicate with the gods and thereby to increase his power of inner sight, such hallucinogens were important enough to be associated with the gods. Xochipilli, for example, was not only the god of flowers and spring, dance and rapture but patron deity of sacred hallucinogenic plants and the "flowery dream" they induced. He is often portrayed with "stylized depictions of the hallucinogenic mushroom" and "near realistic representations of *Rivea corymbosa*," the morning glory, called *ololiuhqui* by the Aztecs, whose seeds are hallucinogenic, as well as tobacco and other hallucinogens,[19] and in one of his most powerful representations he is depicted masked.

As such depictions indicate, many plants by which the shaman could induce his visions were included in the psychoactive pharmacopoeia discovered by the Spanish conquerors. In addition to sacred mushrooms, the morning glory, and a very potent species of tobacco called *piciétl*, there was peyote, a hallucinogen still widely used by the indigenous peoples of northern Mexico and the southwestern United States in ritual activity. Similarly, Durán tells of the Aztec use of *teotlacualli*, a divine brew made up of tobacco, crushed scorpions, live spiders, and centipedes which priests smeared on themselves and drank "to see visions."

METAPHORIC REFLECTIONS OF THE COSMIC ORDER

He reports that "men smeared with this pitch became wizards or demons, capable of seeing and speaking to the devil himself."[20] What seemed devilish to Durán, of course, was the plane of spiritual reality entered through the ecstatic trance of the shaman, the plane on which he could find spiritual knowledge.

The evidence of shamanic practices within Mesoamerican religion, then, clearly shows a shamanistic emphasis on transformation often accomplished through a hallucinogenic alteration of the mental state of the religious practitioner. As is the case with the traditional shaman of Siberia, in Mesoamerica these transformations often served the purpose of healing the physical and psychic ills of members of the community. A wealth of evidence, much too vast to cite here, points to this link between shamanism and Mesoamerican healing practices which existed from the earliest times and continues to the present day. Some representative examples, however, will suggest the nature of the connection. The Yucatec Maya *Ritual of the Bacabs*, which dates from pre-Columbian times, contains long incantations to be used by the healer in ridding the community of disease. Through this ritual, he could send the diseases inflicted by the underworld rulers on the race of men back through the entrance to a cave and thence to the underworld and the realm of death from which they came. And Landa, writing about the duties of Maya priests at the time of the Conquest, reports that they used knowledge drawn from the world of the spirit through shamanic means in the process of healing: "The chilánes were charged with giving to all those in the locality the oracles of the demon. . . . The sorcerers and physicians cured by means of bleeding at the part afflicted, casting lots for divination in their work, and other matters."[21] Vogt's research among the contemporary Maya in Zinacantan has uncovered ample evidence of the continuation into the present time of similar shamanic healing rituals exemplified by what he calls "rituals of affliction."

> *Many of these ceremonies are focused upon an individual "patient" regarded as "ill." But the illness is rarely defined as a physiological malfunctioning per se; rather, the physiological symptoms are viewed as surface manifestations of a deeper etiology; for example, "the ancestral gods have knocked out part of his soul because he was fighting with his relatives."*[22]

Through divination, the Zinacantecan shaman determines the state of the patient's animal alter ego in the realm of the spirit and proceeds ritually to restore the animal to its proper position, thus curing the patient. In much the same way as in pre-Columbian times, "the patient's relationship with his social world is reordered and restored to equilibrium by the procedures of the ritual."[23]

These shamanic healing practices were not limited to Maya Mesoamerica. In the Valley of Mexico, the Aztecs, too, placed great faith in the healing power of the sorcerer-priests who coexisted with the priests of the institutional religion of the temples. Generally referred to as shamans, these sorcerer-priests were the guardians of the physical and, to some extent, the psychic equilibrium of the community. According to Caso, each human imperfection was "transmuted [by the Aztecs] into a god capable of overcoming it."[24] In this way, the imperfections and ailments became spiritually accessible to the shaman. Whether through animal transformation, by the imitation of animal voices, or by chanting incantations using the *nahualtlatolli*, or "disguised words," the shaman could enter the place and "time where everything was possible to elicit the supernatural power of the gods and their primordial handiwork in the restoration of the patients' health and equilibrium."[25] This magical approach to healing is also evident in the belief that particular words could be pronounced by the shaman to control nature and cure the destructive imperfections plaguing a person or the whole community. These few representative indications of shamanic healing practices could be multiplied indefinitely, but they must serve here to indicate the widespread and long-lasting influence of shamanism on healing among the indigenous cultures of Mesoamerica.

Thus, the shamanic origin of Mesoamerican religion seems to be clearly indicated by many practices that derive from the fundamental assumptions of shamanism. More important than any of these particular forms of religious activity, however, is the fact that the way of seeing reality characteristic of Mesoamerican spirituality is the way of the shaman. In this connection, it is fascinating to note what seem to be indications of the shamanic origins of the gods of Mesoamerica, the metaphoric figures which inhabit and represent the spiritual realm, the true home of the spirit that animates man. In typical shamanic fashion, they are ranged on a number of levels of spiritual reality above and below the plane of earthly existence. Chief among the gods represented at the time of the Conquest in the Valley of Mexico, as we will show below, was Tezcatlipoca, whose cult at Texcoco "still retained echoes of an archaic, shamanic origin among the tribesmen of the north, embodied principally in a revered obsidian mirror, a magical artifact shamanistically used for divinatory scrying."[26] Nicholson sees in that mirror "Tezcatlipoca's ultimate origins," the source of "his role as archsorcerer, associated with darkness, the night, and the jaguar, the were-animal *par excellence* of the Mesoamerican sorcerer-transformer."[27] Seeing the mirror as central to Tezcatlipoca's identity and role suggests a relationship between that god and the iron-ore mirrors that dot the archaeo-

logical record as far back as the Olmecs.[28] Perhaps even that early, they were associated with a prototypical Tezcatlipoca and with the shamanic ritual connected with him. Nicholson suggests a similar background for Ehécatl-Quetzalcóatl, Tezcatlipoca's polar opposite and complement, who "appears to have functioned both as a patron of the regular priesthood and of those practitioners of various techniques which most anthropologists would classify as shamans."[29] These two important examples of the gods' origins in the shamanic past of Mesoamerican religion and myth suggest clearly the strength of the shaman's influence throughout the religion's long course of development and also provide a fascinating connection with the use of the mask as a metaphor within the Mesoamerican religious symbol system. Since the gods' origins were in the shamanic beginnings of Mesoamerican religion, their consistent depiction as masked human beings can be seen even more clearly as a metaphoric reference to their function in uniting the worlds of spirit and matter and in defining the spirit world through the symbolic features of the mask.

This influence also explains the pervasive symbolic and ritual use of masks in that religious development as the use of masks is a significant part of both the symbolism and ritual of shamanism. As Eliade points out, the mask of the shaman, the specialist of the sacred who has learned to move between the worlds of nature and spirit, "manifestly announces the incarnation of a mythical personage (ancestor, mythical animal, god). For its part, the costume transubstantiates the shaman, it transforms him, before all eyes, into a superhuman being."[30] In ritual, the mask provides the shaman with one of the important means of accomplishing his essential function—the movement into the realm of the spirit. In a similar way, shamanic songs or incantations suggested that same transformation, as did even "disguised words" or the imitation of animal voices, which served as a "sign that the shaman can move freely through the three cosmic zones: underworld, earth, sky."[31] The new, musiclike language of the liberated spirit of the shaman signified his movement away from the mundane world in his quest for sacred knowledge. These songs or chants are "a discipline of the interface between waking consciousness and night," the meeting point of the metaphoric equivalents of the worlds of nature and the spirit. Thus, the equation of masks with song by Lévi-Strauss, though not in connection with shamanism, suggests again the central symbolic function of the mask within the shamanic context. He explains that

within culture, singing or chanting differs from the spoken language as culture differs from nature; whether sung or not, the sacred discourse of myth stands in the same contrast to profane discourse. Again, singing and musical instru-ments are often compared to masks; they are the acoustic equivalents of what actual masks represent on the plastic level.[32]

Masks, then, are the visual equivalent of the song or chant of the shaman, and both mask and song are symbolic of the sacred discourse of myth created by the mind. All three—masks, song, and myth—are products of culture operating at its most profound level in a search for order in the invisible or spiritual world. Eliade's contention that the mask makes it possible for the shaman to transcend this life by enabling him "to become what he displays" and to exist as "the mythical ancestor portrayed by his mask"[33] suggests precisely the necessary immersion in the sacred order of the world of the spirit. Through the mask and the song, the shaman is transformed into something *other*, and with the vision of an animal, ancestor, or god symbolically acquired through this transformation, he is able to see into the mysteries of the spiritual realm. "He in a manner reestablishes the situation that existed *in illo tempore*, in mythical times, when the divorce between man and the animal world had not yet occurred,"[34] when the primordial order had not yet been hidden from man's view. Now outside of space and time, "he mystically unites himself with a sacred order of being, beyond the dimension of this or that person in this or that particular body."[35] He is, in effect, reborn with the divine ability to see, behind the mask that both covers and reveals the essence of the cosmos, the divine order that alone can resolve the seeming chaos of the world of man. Thus, the mask is surely a clear reflection of and the perfect metaphor for this shamanic world view, and Mesoamerican spirituality reveals its great debt to shamanism in its pervasive symbolic and ritual use of the mask.

Wherever we look in our study of Mesoamerican spirituality, we come face to face with its shamanic ancestor. Whether we are considering the use of divination to understand the "augural significance of dreams"[36] or noting that a burial ceremony provides a way of establishing contact with the ancestors who can show the way to the world of the spirit that they now inhabit; whether we find evidence of transformation into animals suggesting the transformative vision that provides the powers that are needed for the mystical journey or study healing accomplished by curers able to divine the cause of disease and find its cure in the spiritual realm; whether we find visionaries under the influence of hallucinogens predicting future events and establishing "auspicious times for the holy rites,"[37] we are consistently seeing practices whose roots are deep in the shamanic base of Mesoamerican religion. They all derive from the fundamental shamanic conception of an underlying cosmic order, an order of the spirit—the "sacred hoop" described by Black Elk.

It was precisely this shamanistic transcendence

of all mundane distinctions between the sacred and the profane, inner and outer, man and animal, dream and reality, that enabled Mesoamerican man to feel at one with a universe that included all the anxieties of life and death in its mysterious complexity and to be initiated "by shamans into a system of philosophical, spiritual, and sociological symbols that institutes a moral order by resolving ontological paradoxes and dissolving existential barriers, thus eliminating the most painful and unpleasant aspects of human life"[38] by putting them in their "proper" perspective. Perhaps the comfort of the shamanic world view through which "the Indians approached the phenomena of nature with a sense of participation"[39] gave Mesoamerican man his first impulse to search in all the other areas of the cosmos for similar manifestations of the same phenomenon. And in addition to providing the impulse, it seems clear that shamanism also provided the conceptual framework for the magnificent cosmological structure that resulted from Mesoamerican man's spiritual search. The shamanic vision can be found in every aspect of Mesoamerican spiritual thought making up that structure: in the underlying temporal order of the universe demonstrated in both the solar cycles and the cycles of generation from birth to death to regeneration; in the spatial order derived from the regular movements of the heavenly bodies; in the mathematically expressed abstractions of eternal cyclical order found in the calendrical system; and most of all, in the understanding of divinity as the fundamental life-force that is, at the same time, the source of all order. Ultimately, this vision reveals itself in the symbolic use of the mask as the most important metaphor for the essentially shamanic presentation of the vision of inner reality to the outer world.

5 The Temporal Order

THE SOLAR CYCLES

While the inner vision of the shaman surely showed the way to the essential truth for those who shaped the spiritual thought of pre-Columbian Mesoamerica through the centuries of its development, these speculative thinkers went far beyond their Siberian shamanic forebears in drawing out the mythic, philosophic, and theological implications of that vision. The shamanic world view posited a cosmos governed by an underlying spiritual order growing out of the mythical spiritual unity of all things which both caused and explained the myriad, seemingly disconnected "facts" of the material world, but the causes and explanations characteristic of the prototypical shamanism of the hunting and gathering peoples of Siberia were mystically simple and direct, those perceived by and applicable to the individual in a small group. The spiritual thought of Mesoamerica gradually evolved from that shamanic base into an intricate, subtle, and complex depiction of the revelation of the spiritual order of the cosmos in the world of man. Still apparent in the now centuries-old fragments of that highly developed thought is the sense of wonder with which those inquisitive minds responded to the indications of inherent orderliness which the shamanic vision allowed them to see in the seemingly chaotic world confronting them.

That wonder, as we shall see, is often expressed through the use of the mask as a metaphor for the way in which the harmonious vitality of the life-force underlies the chaotic life of the world of nature. The metaphor of the mask suggests that the natural world, the "mask" in this case, not only covers the animating force of the spirit but also expresses its "true face." Thus, the natural world was seen as symbolic, as pointing, in a way understood by the initiated, to the underlying harmony

of the spirit. Those who understood the symbols of the mask could "read" its meaning; the false face became the true face in much the same way the donning of the ritual mask allowed the wearer to express his "true" inner spirit. Although this underlying order was suggested by many kinds of natural "facts," nowhere was it clearer to the seers of Mesoamerica than in the regularity of the numerous cycles through which time seemed to move. Nothing drew their attention more powerfully than this cyclic time; its regularity must have seemed to them nothing less than the force of life itself, the spiritual essence of the cosmos at work. Through the understanding of those cycles, the Mesoamerican sages could figuratively remove the mask of nature, which in all other ways covered the workings of the spirit, and get at the thing itself.

The clearest, and no doubt the first recognized, evidence of this cyclic regularity was apparent in the movement of the sun. That the sun's movement should provide the key to unlock the mysteries of the cosmos makes sense in two quite different ways. First, the most apparent regularity in the external world of nature is provided by the sun's daily rising and setting around which human beings have always organized their lives as it bears an organic relationship to the rhythmic cycle of sleep and waking built into their own bodies. To this organic regularity, however, the shamanistic cultures of Mesoamerica added a second way of seeing the significance of that daily cycle. The endless alternation of day and night no doubt seemed the natural counterpart of and the perfect metaphor for the dualistic nature of the cosmos they envisioned. The presence of the sun during the day must have seemed naturally to represent the waking world of daily existence, sentient activity, logical thought, and physical life. The absence of the sun at night represented the complementary oppo-

site, sleep, which replaced the sentient activity of the daytime world with the fantastic imaginings of dreams, mental rather than physical activity, and the temporary and highly symbolic "death" of the waking person. The daily movement of the sun thus divided the natural world in the same way man felt himself to be divided: into matter and spirit, visible and invisible, living and dead. Tied to the sun's movements, man alternated between his waking, "real" self and his sleeping, dreaming, "spirit" self. This dichotomy within man's very nature, of course, is the same one expressed in the split masks, half-living and half-skeletal, found in Preclassic burials in the Valley of Mexico (pl. 52) which clearly image forth a shamanistic view of life and death as parts of an endless cycle, parts that exist in actuality or in potential at all times. Just as the ability of the shaman to enter the world of death at will suggests the unity of the two states, so the cyclic alternation symbolized by the sun's movement unified those opposed states. That cycle, then, could be seen as an expression of the mystic order of the spirit that alone could make comprehensible the seemingly anarchic diversity of earthly life.

In addition to this daily solar regularity, Mesoamerican thinkers early became aware of and fascinated by the other cycles of the sun. They charted the annual movement of sunrise and sunset along the horizon which resulted in the equinoxes and solstices and noted the regular coming and going of the two instances of the sun's zenith passage each year. The solar cycles were so basic to the concept of time throughout Mesoamerica that among the Maya, for example, the word for sun, kin, also means both day and time.[1] In fact, the day, the most obvious unit of time measured out by the sun, was the smallest unit of time measured in Mesoamerica and was the fundamental unit on which the Maya constructed all the other cycles of time with which they were concerned.[2] The Toltecs and other later groups in the Valley of Mexico saw the solar year as the basic unit, perhaps because their northern origins made them more concerned than the Maya with the annual cycle of seasonal change.[3] The significant fact, however, is that a unit derived from solar movement was used throughout Mesoamerica as the foundation of an elaborate calendrical system designated to chart and understand the force of the spirit as it worked in the natural world.

That such solar observation is of great antiquity in Mesoamerica and that its practice continued with the same intensity until the time of the Conquest (and, in fact, is still practiced by some contemporary Indian groups) can be seen in both the archaeological and written record that survived the Conquest. The great ceremonial centers constructed by the various cultures of Mesoamerica as focal points of the ritual through which they in-

teracted with the natural and supernatural forces of the cosmos were, from the earliest times, laid out on the basis of horizon sightings of solar positions and often contained structures that were designed or oriented to make precise solar and other astronomical observations for ritual purposes. In the Maya Petén, for example, the early pyramid Structure E-VII Sub at Uaxactún

> was the western point in group E from which sunrise was observed on the east, marked by three small temples. These temples were aligned on an eastern platform in a north-south line; their northern and southern locations were determined by sunrise at the summer and winter solstices, whereas the location of the central temple was set by sunrise at the equinoxes. . . . Thus Str. E-VII Sub was the viewing point in a solar . . . observatory.[4]

Built during the late Preclassic, this complex served as a model for "at least a dozen sites within a 100 kilometer radius of Uaxactún"[5] and indicates the early importance of solar observation among the Maya. In the Valley of Oaxaca, according to Anthony Aveni, the curiously shaped structure called Mound J built during Monte Albán I (ca. 250 B.C.) was probably used to sight the star Capella, which was used as an "announcer star" for the "imminent passage of the sun across the zenith." The passage could then be observed using a vertical shaft bored into a subterranean chamber aligned with Mound J.[6] Structures similarly suited to astronomical observation of significant moments in the various cycles of the sun are found throughout Mesoamerica. The best known is probably the Caracol at Chichén Itzá, and others have been found at such sites as Mayapán, Uxmal, Paalmul, and Puerto Rico.[7] Significantly, most of the structures probably related to solar observation are ornamented with huge stucco or mosaic masks that seem to denote the importance of the structures and to suggest their role in the solar observation that uncovered the spiritual order of the universe and in the ritual activity through which man harmonized his existence with that universal order.

Such structures were used in laying out the ceremonial centers of which they were a part, and the "cross petroglyphs" found at Teotihuacán evidently served the same purpose there. These markers consist of two concentric circles centered on a cross, the design indicated by a series of holes pecked into a stucco floor or rock. The first such petroglyph was found in a building next to the Pyramid of the Sun, and others were subsequently found at locations suggesting their use by the architects of Teotihuacán to determine the baselines of the grid pattern strictly adhered to throughout the centuries-long construction of the city. The location of the petroglyphs and the resulting location of the baselines indicate that the grid was oriented according to horizon sightings of celestial phenom-

ena related to solar cycles.[8] This solar connection can also be seen in the design of the petroglyph, a quartered circle, found in many contexts and variations throughout Mesoamerica, most of which refer to cycles of time, generally solar cycles.[9] These other symbolic uses of the design suggest that the cross petroglyphs of Teotihuacán were more than surveyor's base marks. They were, symbolically, the order of the city and the order of the cosmos, which it was intended to replicate. As we demonstrate below, they referred directly to the meeting place at Teotihuacán of the worlds of spirit and matter. Just as the rising and setting of the sun on the horizon symbolically denoted that meeting, the line of the cross petroglyph representing the sun's course was bisected by a line perpendicular to it, a line creating the universally symbolic cross designating the center of the universe.

That intersection of the central axis of the universe with the earthly plane marks the point at which the shamanic movement between the worlds of matter and spirit is possible. Hence, the cross petroglyph and the city itself must be seen as symbolic constructions placed on the earth so as to reveal the underlying spiritual order, an order seen most clearly in the essentially spiritual annual cycle of the sun from which the quartered circle was derived.[10] Seen in that way, the cross petroglyph and the city are "masks" placed on material reality, not to cover it but to reveal its spiritual essence—precisely, of course, the function of the shamanistically conceived ritual mask throughout Mesoamerican history. Similar petroglyphs used for the same purpose have been found at widely scattered sites from Zacatecas to Guatemala, most of which had been influenced by Teotihuacán,[11] suggesting the fundamental importance of that symbolic use of the solar cycles as the very fact of diffusion indicates the significance of the design to the people employing it. The structures of ceremonial centers throughout Mesoamerica, then, both in their siting and functions demonstrate the fundamental concern of the builders with the ways in which the regularity of solar movement betrayed the order inherent in the spiritual underpinnings of the natural world.

Further evidence of the concern of Mesoamerican thinkers with the regularities of the cycles of the sun can be seen in the calendrical systems that must have existed well before the Preclassic. The full extent of that calendrical system, one unsurpassed in intricacy and complexity, will be discussed below, but a significant part of the system was, as we would expect, a solar calendar. Made up of 360 days divided into eighteen "months" of twenty days with five "unlucky" days added to complete a 365-day cycle, it was called the *xíhuitl* in central Mexico and the *haab* by the Maya and provided one of the foundations of the larger calendrical systems. Evidence from Oaxaca suggests it

was already in use in the early Preclassic.[12] And we also have evidence of the early existence of one of these larger systems. Called the long count, it computed dates from a presumably mythical starting point corresponding to 3113 B.C. (according to the Goodman-Martinez-Thompson correlation), dates that were recorded on monuments by the Maya and before them by the Olmecs, the probable originators of the system.[13] A number of those dates suggest the antiquity of this elaborate system, among them the date on Stela 2 at Chiapa de Corzo which corresponds to 36 B.C., that of Stela C at Tres Zapotes corresponding to 31 B.C., and the date on the Tuxtla Statuette which corresponds to A.D. 162.[14] Obviously, the systematic solar observations on which the original solar calendar and its elaborate variations were founded must have begun in remote antiquity and been dutifully continued until the Conquest with the numerous dates and calculations of early times no doubt written on perishable materials such as wood, skin, and bark paper. Were these to have survived, they would have testified to the ancient and enduring Mesoamerican fascination with the connection between the regular movement of the sun and the orderly progression of time.

The written evidence that does survive in the codices, the screenfold painted books used for a variety of divinatory and pedagogical functions by the priests and shamans of the various pre-Columbian cultures, suggests in several ways the importance the recording of data related to the solar cycles had in the latter stages of pre-Columbian Mesoamerican development. Many of the Mexican codices contain solar calendars charting the movement of the year through the regular succession of the *veintena* festivals, the great ritual feasts that ordered the movement of time by denoting the end of each of the eighteen twenty-day periods of the solar year. Fittingly, then, the sun ordered the ritual life of the cultures of central Mexico, a ritual life designed to harmonize man's existence with the life-force symbolized by the sun. The few surviving codices of the Maya are astronomical in nature and offer a rather different sort of testimony to the importance of the sun and its cycles to Mesoamerican spiritual thought as they contain a great deal of astronomical information regarding the cycles of the moon and Venus as well as tables used to predict the possibility of eclipses, all of which were related to solar movement.

Thus, the written evidence of pre-Columbian thought coincides with the evidence from the archaeological record to indicate clearly that the various cycles of the sun were seen throughout Mesoamerica as embodying the spiritual order of the universe. They revealed a unity at the heart of all matter and the way in which the spiritual force emanating from that mystical unity operated in the world of nature. Rather than imagining a god

separate from his creation, the thinkers of Meso-america conceived of the divine as the life-force itself, constantly creating, ordering, and sustaining the world.

That force, embodied in and exemplified by the cycles of the sun, not only symbolized the workings of the spirit as it ordered the universe through the magic of time but was also the creator of life, a creation also linked metaphorically to the solar cycles. The sun, as a symbol of the mystical life-force, was seen as the source of all life, a cyclic source that made creation an ongoing process rather than a unique event.

> *Far from imagining a sure and stable world, far from believing that it had always existed or had been created once and for all until at last the time should come for it to end, . . . man [was seen] as placed, "descended" (the Aztec verb "temo" means both "to be born" and "to descend"), in a fragile universe subject to a cyclical state of flux, and each cycle [was seen] as crashing to an end in a dramatic upheaval.*[15]

This cyclic process of creation and destruction is recorded in the pan-Mesoamerican myth cycle of the Four (or Five) Suns which identifies each stage in the ongoing process of creation as a sun, one stage in a solar cycle. The basic myth is simple; in its Aztec version, the present age, that of man and historical time, is the Fifth Sun. The first of the four preceding periods, the First Sun, identified by the calendric name 4 Océlotl, or 4 Jaguar, saw the creation of a race of giants whose food was acorns. That age ended with their being devoured by jaguars, often a symbol of the night sky and thus the dark forces of the universe. The Second Sun, 4 Ehécatl, or 4 Wind, peopled by humans subsisting on piñon nuts, ended with a devastating hurricane that transformed the people who survived it into monkeys. This age was associated with Quetzalcóatl in his aspect of wind god, Ehécatl. The Third Sun, 4 Quiáhuitl, or 4 Rain, was naturally associated with Tlaloc and had a population of children whose food was a water plant. It was destroyed by a rain of fire from the sky and eruptions of volcanoes from within the earth with the surviving inhabitants changed into turkeys. The Fourth Sun, 4 Atl, or 4 Water, was populated by humans whose food was another wild water plant. It was destroyed by floods, as its association with Chalchiúhtlicue, the goddess of bodies of water, would suggest. The survivors of the destruction appropriately became fish. The present world age, the Fifth Sun, 4 Ollin, or 4 Motion, is destined to meet its end by earthquake.

This basic myth, so clear and direct on the surface, is fascinating in its subtle interweaving of the shamanistic idea of the life-force with the Meso-american conception of the solar cycles as representative of the inherent order of that essentially spiritual life-force. Both the daily and annual cycle of the sun are basic to the myth's conception of creation. The concept of five successive suns suggests the diurnal cycle of the sun with the awakening of life in the morning of each day and the "death" of life at day's end, a suggestion emphasized in the destruction of the First Sun by the jaguar, a symbol of the night. Just as awakening from sleep provides a model for creation, so the "awakening" of plant life in the spring provides another basic metaphor suggested by the care with which the myth specifies the sustenance provided for humanity in each of the world ages; it is always a plant that springs from the earth itself to provide nourishment. Thus, the earth functions as a repository of the life-force, which is "awakened" by the solar cycle in the spring in order to create the life that in turn sustains human life. The significance of the sun is underscored by the identification of corn in the present world age as the divine sustenance of humanity, suggesting at once the Indian's almost mystical reverence for that grain and the process of growing it, the reciprocal relationship between humanity, nature, and the gods, and the relationship between the life cycle of the individual plant and the sun, a connection that pervades the mystical attitude toward corn in the mythologies of Meso-amcrica. The myth of the Five Suns thus directly involves the cycles of the sun in the generation of life on the earthly plane by the life-force that lies at the heart of the universal order.

But the solar cycles are only part of a larger conception of creation. Life in the Fifth Sun is created by Quetzalcóatl from bones and ashes of the previous population which he was able to gather during a shamanlike journey to the underworld, the hidden world of the spirit entered only through a symbolic death to the world of nature. The shamanic nature of this creation is further suggested by the metaphoric reference to the belief that the life-force in the creatures of this earth resides in the bones, the "seeds" from which new life can grow. To create that life, Quetzalcóatl pierced his penis and mixed the blood resulting from that autosacrificial act with the pulverized bone and ash from the underworld. Symbolically, his creative act unites the shamanistic belief that the bones are the repository of the life-force with the Mesoamerican view that blood represents the essence of life, a view especially clear in this case since the blood is drawn from his penis, the source of semen, man's reproductive fluid. Creation is seen in a series of organic metaphors bringing together seeds and bones, the sun and birth, man and plants in a complex web of meaning suggesting the equivalence of all life in the world of the spirit, which underlies and sustains the world of nature. Life in this world, the myth suggests, must be understood in terms of that underlying spirit.

The evidence we have of Maya thought reveals a remarkably similar cyclic conception. In the

Popol Vuh, the mythic history of the Quiché Maya of highland Guatemala, the creation of life, or "the emergence of all the sky-earth," is described as

the fourfold siding, fourfold cornering,
measuring, fourfold staking,
halving the cord, stretching the cord
in the sky, on the earth,
the four sides, the four corners.

In other words, a quadripartite creation

by the Maker, Modeler,
mother-father of life, of humankind,
giver of breath, giver of heart,
bearer, upbringer in the light that lasts
of those born in the light;
worrier, knower of everything, whatever there is:
sky-earth, lake-sea.[16]

Attempting to create man, the gods three times formed creatures incapable of proper worship; only on the fourth try were they successful. First, birds and animals were created, but they could not speak to worship their creators "and so their flesh was brought low"; they were condemned thereafter to be killed for food. The second attempt resulted in men made from "earth and mud," but it was equally unsuccessful because they had misshapen, crumbling bodies; their speech was senseless so that they, too, were incapable of the worship required by their creators. After destroying these men, the gods next fashioned "manikins, wood-carvings, talking, speaking there on the face of the earth," but their speech was equally useless because "there was nothing in their hearts and nothing in their minds, no memory" of their creators. These manikins were destroyed by a flood and the combined efforts of the animals, plants, utensils, and natural objects they had ungratefully used. Those surviving the destruction became the present-day monkeys.[17]

Following this third unsuccessful creation, the *Popol Vuh* narrates the lengthy exploits of the Hero Twins Hunahpu and Xbalanque in the underworld, exploits comparable in mythic function to Quetzalcóatl's shamanic descent into the underworld in the cosmogony of central Mexico (significantly, one of the meanings of Quetzalcóatl is "Precious Twin"). Following those exploits, historical man, the Quiché, was created from the life-giving corn and thereby linked to the annual seasonal cycle. "They were good people, handsome," and "they gave thanks for having been made." But this time the gods had succeeded too well. These men were godlike: they could see and understand everything. In order to put them into their proper relationship to their makers, "they were blinded as the face of a mirror is breathed upon. Their eyes were weakened. . . . And such was the loss of the means of understanding, along with the means of knowing everything, by the four [original] humans."[18]

Although neither the account in the *Popol Vuh* nor the similar account in *The Annals of the Cakchiquels,* the neighbors and enemies of the Quiché Maya, suggests the eventual destruction of the present world age, there is a reference to such a destruction by Mercedarian friar Luis Carrillo de San Vicente, who said in 1563 that the Indians of highland Guatemala believed in the coming destruction of the Spaniards by the gods, after which "these gods must send another new sun which would give light to him who followed them, and the people would recover in their generation and would possess their land in peace and tranquility."[19] This belief indicates the close similarity between the cycles of the Maya cosmogony and those of central Mexico. Miguel León-Portilla points out that essential similarity when he writes that for the Maya, "*kin,* sun-day-time, is a primary reality, divine and limitless. *Kin* embraces all cycles and all the cosmic ages. . . . Because of this, texts such as the *Popol Vuh* speak of the 'suns' or ages, past and present."[20] Robert Bruce makes that idea even clearer. The *Popol Vuh,* he says, consists of "the same cycle running over and over," and that cycle is "the basic cycle, the solar cycle [that] pervades all Maya thought."[21] Thus, both the *Popol Vuh* and the Aztec myth depict a reality grounded in the spirit whose essential order is revealed by the cycles of the sun. It is no wonder that throughout Mesoamerica even today, Indians who think of themselves as Christians identify Christ, whose death allowed him to enter the world of the spirit, with the sun as the very epitome of the spirit as it moves in the world of nature.

The Mesoamerican fascination with the sun is further shown by the fact that insofar as the thinkers of Mesoamerica were interested in other celestial bodies, they were almost exclusively interested in those whose cyclic movements were apparently related to the sun. Thus, the two other bodies most often of concern were the moon and Venus. In view of the important role the moon plays in many mythologies, it perhaps seems strange that, as Beyer observed, the moon played a relatively "insignificant role in the mythological system encountered by the conquistadores."[22] Two myths from central Mexico at the time of the Conquest indicate clearly that whatever importance the moon had derived from its role in a predominantly solar drama.

The first of these myths depicts the creation of the current sun and moon shortly after the beginning of the present world age. In one of its versions, two gods—Nanahuatzin, poor and syphilitic, and Tecciztécatl, wealthy, handsome, and boastful—volunteer to throw themselves into a great fire in a sacred brazier which will purify and allow them to ascend as the sun and light the world. Tecciztécatl proves too cowardly to leap, but Nanahuatzin does and rises gloriously as the sun. Following Nanahuatzin's success, Tecciztécatl musters

his courage, immolates himself, and becomes the moon. True to his boastful nature, Tecciztécatl at first shines as brightly as the sun, but the remaining gods throw a rabbit in his face (what European culture sees as the image of an old man on the face of the moon was seen throughout Mesoamerica as a rabbit) to dim him to his present paleness.[23] In addition to the obvious oppositional relationship of the sun and moon—one the ruler of the day sky, the other of the night; one bright, the other pale; one retaining a consistent shape, the other changing—this myth suggests other oppositions that would have been of particular importance to the Aztecs, who saw themselves as the people of the sun, a warrior sun who symbolically led their nation. Nanahuatzin, ugly and disfigured on the surface, embodied the inner virtues they prized: courage, modesty, dedication; Tecciztécatl, superficially handsome and seemingly brave, was actually a cowardly braggart. The myth finds reality beneath the surface of appearances, and the fact that this truth is contained in a myth concerned with the creation of the sun and moon is amazingly appropriate as the sun and its various cyclic movements, including the cycle in which the moon participates, provided an understanding of and a metaphor for the underlying order of the cosmos for the Mesoamerican mind. As the myth suggests, the inner truth is most significant; one must look beneath the surface of reality in this more profound sense to understand the essential meaning of the world of appearances.

The second myth also delineates the basic opposition between the sun and moon within the cycle of day and night. Huitzilopochtli, the Aztec tutelary god, was said to have been conceived by Coatlicue, the earth goddess, when "a ball of fine feathers" fell on her. Her pregnancy was seen as shameful by her children, Coyolxauhqui and the four hundred (i.e., countless) gods of the south, and they resolved to kill her. Huitzilopochtli, still in her womb, vowed to protect his mother. As the four hundred, led by Coyolxauhqui, approached, Huitzilopochtli, born at that moment, struck her with his fire serpent and cut off her head. Her body "went rolling down the hill, it fell to pieces," and her destruction was followed by Huitzilopochtli's routing her four hundred followers and arraying himself in their ornaments.[24] As numerous commentators from Eduard Seler and Walter Krickeberg on have said, this myth clearly depicts the daily birth of the sun and the consequent "destruction" of the moon and stars as the sun replaces them in the sky. The dismemberment of Coyolxauhqui also suggests the moon's various phases as it waxes and wanes as well as its disappearance between cycles.

This myth also depicts the sun, with the virtues of the warrior, in opposition to the moon, this time female, which lacks them: Huitzilopochtli defends his mother, Coyolxauhqui betrays her; he stands alone bravely, she acts only with many followers. But here the implications go much deeper. Significantly, the moon is here depicted as female, and much of the myth's meaning turns on that opposition between male and female. For example, the myth portrays Huitzilopochtli's vowing to defend his mother as taking place while he is still in her womb, making clear that his birth from the female immediately precedes his destruction of his female sibling, an act in structural opposition to his birth: a female gives him birth; he takes a female life. But the Aztecs knew that with the coming of night he too would be destroyed, metaphorically, by being swallowed by the female earth. This further reversal (he destroys a female and is then destroyed by one) suggests the nature of the cycle in which the sun and the moon exist and also suggests the nature of cosmic reality, which both creates and destroys life, a cyclic reality also connected with the sun in the creation myth of the Five Suns.

The recent discovery of the monumental Coyolxauhqui stone (pl. 59) at the base of the pyramid of the Templo Mayor in Tenochtitlán confirms this thesis and suggests several other implications as well. The stone depicting the dismembered goddess was uncovered at the foot of the stairway leading up to the Temple of Huitzilopochtli atop the pyramid, a placement recalling the myth in which her body rolls down the hill and falls to pieces. When the sun is at its midday height, suggested by the temple at the top of the pyramid, the moon will be in the depths of the underworld, the land of the dead. But the Aztecs knew that just as the coming of the night would reverse those positions and states, so their own individual vitality, their nation's preeminent position in the Valley of Mexico, and the world age—the Fifth Sun—in which they lived would all eventually perish in the cyclic flux of the cosmos, only to be reborn, though perhaps in a different form. Thus, the killing of Coyolxauhqui paradoxically guarantees the rebirth of Huitzilopochtli and the continuation of the cosmic cycle of life, just as the sacrifice of captured warriors on the stone found by archaeologists still in place in the Temple of Huitzilopochtli and the rolling of their dead bodies down the pyramid to the stone of Coyolxauhqui at the base was seen by the Aztecs as vital to the continuation of their life and the life of the sun.

It is interesting that Huitzilopochtli's temple shared the top of the pyramid with the Temple of Tlaloc. Tlaloc, the god of rain, and the female Coyolxauhqui both have an association with fertility that opposes them to Huitzilopochtli, who is, after all, a male war god. But the myth suggests again the alternation that characterizes the daily cycle of the sun and the moon. Although associated in one sense with fertility, both Tlaloc and Coyolxauhqui also have a destructive aspect. Co-

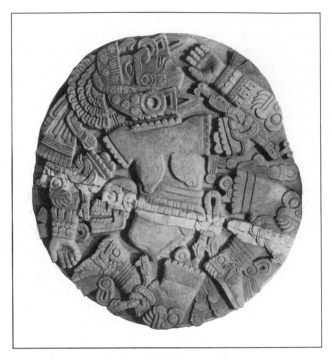

Pl. 59. Coyolxauhqui, Templo Mayor, Tenochtitlán (Museo del Templo Mayor, México).

yolxauhqui's role in the myth is destructive, not creative, and Tlaloc's rain could fall in the destructive torrents of a tropical storm. In both of these cases, Huitzilopochtli can be seen again in an opposing, but this time creative, role—that of the defender of his mother and as the life-giving sun. On a profound level, then, the myth of the destruction of the moon by the sun is clearly meant to delineate the cyclic alternation between life and death, creation and destruction which seemed to the Mesoamerican mind to characterize the rhythmic movement of the cosmic cycles for which the sun provided a metaphor. The two opposed forces become one within the cycle just as the feathered headdress of Coyolxauhqui on the monumental relief at the Templo Mayor (pl. 59) suggests her ultimate union with Huitzilopochtli, her brother, "the divine eagle of the sky." The feathers are "signs of the union consummated through sacrifice" and illuminate "the manifest duality that reveals the essential unity of the god and the victim,"[25] of the sun and the moon, of life and death—the unity originally perceived by the shamanic forebears of Mesoamerica and the same unity celebrated by the metaphoric use of the ritual mask to symbolize the union of matter and spirit.

Both of these myths depict the moon as subordinate to the sun, and in both myths, the underlying meaning reinforces that subordination. For the Aztecs, the moon was not important in itself but only as its opposition could be seen to clarify the sun's role and symbolic meaning. The situation among the Maya was much the same. In the *Popol Vuh*, at the end of the underworld adventures of the

Hero Twins Hunahpu and Xbalanque, "the two boys ascended . . . straight on into the sky, and the sun belongs to one and the moon to the other,"[26] a parallel to the Aztec myth of Nanahuatzin and Tecciztécatl at least in the fact that two male gods are transformed. But as in the Valley of Mexico, myths also exist among the Maya which depict the moon as female in relation to a male sun. According to Thompson, they are the norm and for contemporary Maya groups, at least, usually depict the sun and often a brother, Venus, hunting to provide food for the family. But the old woman at home, often their grandmother but always the moon, "gives all the meat they bring home to her lover. The children learn this, slay her lover, and trick the old woman into eating part of his body. She tries to kill the children, but they triumph . . . and kill her."[27] This generalized version has interesting structural similarities with the Huitzilopochtli-Coyolxauhqui myth, which, with its wide distribution with many variants among the contemporary Maya, indicate its pre-Columbian origin. Both myths depict the sun as a male child in the position of supporting the ideal of sexual virtue, both depict the moon as female and as betraying a parent or child, and both, of course, depict the destruction of the moon by the sun. The emphasis on sexuality in the Maya myth parallels the emphasis on birth in the Aztec version; both focus on generation and death, and, by implication, regeneration. Thus, it is fair to say that both call attention to the basic cyclic alternation between opposed states in the cosmos and to the unity underlying and governing the cycle.

The emphasis on the regularity of the solar and lunar cycles in the understanding of the cosmic unity would seem to indicate a need to deal with the phenomena of eclipses since they are clearly disruptions of those all-important cycles, and Mesoamerica did deal with them at some length. The suggestion in the Maya myth that the moon eats part of the body of her lover (alter ego of the sun?) is interesting in this context. A passage from the *Chilam Balam of Chumayel* describing the disastrous events of Katun 8 Ahau reads: "Then the face of the sun was eaten; then the face of the sun was darkened; then its face was extinguished,"[28] which is echoed by the Chorti Maya belief that an eclipse is caused by the god Ah Ciliz becoming angry and eating the sun.[29] Though these are post-Conquest beliefs, they reflect the pre-Columbian fascination with and fear of eclipses. Throughout pre-Columbian Mesoamerica, it was believed that both solar and lunar eclipses were disastrous portents signaling destruction, possibly even the end of the world, that is, the present world age or "Sun," just as the setting of the sun ended the day and the disappearance of the moon "destroyed" the night. The Maya Dresden Codex contains tables used to predict the dates of possible eclipses, tables that reflect the

working out by the Maya of the complex cycles that governed them. Given the cosmic importance Mesoamerica attributed to the cycles of the sun and, to a lesser extent, the moon, any interruption of them would seem to shake the very foundation of the universe. Interestingly, the Maya attempted to secure that foundation by finding a regularity in the occurrence of these seemingly unpredictable events, thereby including them within the cyclic nature of reality. Everything, they must have believed, when properly understood manifested the order derived from the spiritual unity underlying all reality.

The only other celestial body with which the peoples of Mesoamerica were greatly concerned was Venus. It is "the only one of the planets for which we can be absolutely sure the Maya made calculations"[30] and probably the only one that played a major role in central Mexican mythology. The reason for this, according to Aveni, is that "besides Mercury it is the only bright planet that appears closely attached to and obviously influenced physically by the sun."[31] This apparent "attachment" derives from the fact that its solar orbit lies between the earth's orbit and the sun. From the vantage point of the earth, Venus's movement can be divided into four distinct periods: (1) the period of inferior conjunction—an 8-day period when Venus is directly between the sun and the earth and thus invisible because of the sun's glare; (2) the period in which it is the morning star—a 263-day period during which the planet is most brilliant and rises before the sun in the eastern sky, at first only a moment before the sun, the annual moment of heliacal rising after inferior conjunction of utmost importance to Maya astronomers, and then for longer periods each day, the last and longest being about three hours; (3) the period of superior conjunction—a 50-day period during which the sun is between Venus and the earth; (4) the period in which it is the evening star—a 263-day period in which it is visible for a short time in the western sky after sunset, each day for a shorter period of time until inferior conjunction occurs and the cycle begins again. "The long-term motion of Venus can thus be described as an oscillation about the sun, the planet never straying far from its dazzling celestial superior."[32]

Not only was Venus tied visually to the sun but there were numerical relationships as well which fascinated the Mesoamericans. It was known throughout Mesoamerica that the synodic period described above took "584 days, the nearest whole number to its actual average value, 583.92 days and that $5 \times 584 = 8 \times 365$ so that 5 synodic periods of Venus exactly correspond to 8 solar years."[33] In addition, there were further numerical correspondences, which are discussed below in connection with the 260-day calendar. Suffice it to say that the apparently eccentric motion of Venus actually

meshed with the all-important solar cycles in a number of ways, suggesting again the basic order underlying the apparent randomness of the cosmos.

Among the Maya, "the main function of the study of Venus seems to have been to be able to predict the time of the feared heliacal rising after inferior conjunction," which could cause sickness, death, and destruction.[34] These dire predictions parallel those seen in the Codex Borgia of the Valley of Mexico,[35] and it seems likely that the Maya got these ideas from central Mexico[36] where the period of inferior conjunction was associated with Quetzalcóatl. Both mythologically and historically, in different contexts, his disappearance and reappearance under changed circumstances is central to his story. According to the *Anales de Quauhtitlán*,

at the time when the planet was visible in the sky (as evening star) Quetzalcóatl died. And when Quetzalcóatl was dead he was not seen for four days; they say that then he dwelt in the underworld, and for four more days he was bone (that is, he was emaciated, he was weak); not until eight days had passed did the great star appear; that is, as the morning star. They said that then Quetzalcóatl ascended the throne as god.[37]

Quetzalcoatl's rebirth in shamanic fashion—from the bone as seed—thus accords with the sacred heliacal rising of Venus after inferior conjunction, when its rising first heralds the rising of the sun in the east (the direction of regeneration) and his death with the disappearance of the western, evening star, itself a symbol of the death of the sun. Quetzalcóatl's very name, translated as "Precious Twin" as well as "Feathered Serpent," suggests this connection with the two aspects of Venus. According to Seler, the Codex Borgia includes "myths concerning the wanderings of the divinity [of the morning star] through the underworld kingdoms of night and darkness" during the period of inferior conjunction which are similar to the wanderings of the Hero Twins in the *Popol Vuh*,[38] wanderings that Coe sees as "an astral myth concerning the Morning and Evening Stars."[39] Thus, it is the period of inferior conjunction, when Venus seems to merge with the sun, and the following heliacal rising, when its rebirth heralds the rebirth of the sun, that fascinated Mesoamericans, a fascination clearly due to the interplay of Venus and the sun.

Surely, then, it is clear that when the seers of Mesoamerica looked to the heavens they saw a cosmic order revealed in the myriad, intricate cycles that meshed with the regular movement of the sun. This order became the basis of myths and rituals, the calendar that organized the ritual year, and the principle from which was derived the orientation of the great ceremonial centers in which those rituals took place. Everywhere one turns, one finds evidence in pre-Columbian Mesoamerica of the at-

tempt to replicate the order of the sun's cycles in man's earthly world and through that replication to understand the workings of the inner life of the cosmos, an understanding fundamental to Mesoamerican cosmology and cosmogony and an understanding for which the mask stood as metaphor.

GENERATION, DEATH, AND REGENERATION

The regular cycles of the sun not only revealed the cosmic order but suggested, just as surely, an orderliness in man's life and in the world he inhabited: implicit in the regularity of the solar cycle was the entire mystery of death and rebirth, the cycle of regeneration as it was manifested in the natural world. As Eliade puts it, "generation, death, and regeneration were understood as the three moments of one and the same mystery, and the entire spiritual effort of archaic man went to show that there must be no caesuras between these moments. . . . The movement, the regeneration continues perpetually."[40] And as Mesoamerican man looked at his world, the mystery of renewal was everywhere before him: the cycle of the sun as it moved from its zenith to the horizon and disappeared into the chaos of the night always to return from that chaos to be reborn; the changes in the moon as it gradually moved from its creation as the new moon to its growth as a full moon, diminishing to a final "death" before its reappearance once again as the new creation; the changes in the season from the periods of fullness to those of disintegration before a renewal of the cycle; the various stages in the process of the growth of his plants from the "dead seed" to the fully mature fruits; and even such a small thing as the life cycles of the snake and the butterfly with moments of "rebirth" punctuating the stages of development. Life could be counted on not to end; it was always in the process of transformation. And every stage of that process, including a symbolic, if not real, return to the "precosmogonic" chaos[41] through night and the dry season and even death, was an essential aspect of the mystery.

Through this process of regeneration manifested in the annual renewal of plant life, the gods provided sustenance for humanity, and ritual reciprocation was required. "Each stage of the farming round was a religious celebration"[42] of the divinely ordained mystery of "generation, death, and regeneration" in the sowing, nurturing, and reaping of the agricultural cycle. Thus, throughout Mesoamerica, ritual imitated nature and reflected the seasonal changes by "depicting the life cycle of domestic plants as well as their mythic prototype, the primordial course of events on the divine plane."[43] The rituals marked not only the transition from seed to maturity but, in their calendrical regularity, the very movement of time itself. Durán was aware of this ritual purpose as he lamented the destruction of the records that told of the calendar that

> taught the Indian nations the days on which they were to sow, reap, till the land, cultivate corn, weed, harvest, store, shell the ears of corn, sow beans and flaxseed. . . . I suspect that regarding these things the natives still follow the ancient laws and that they await the correct time according to the calendrical symbols.[44]

Corn, mankind's proper sustenance, was the focal point of this ritual cycle and was regarded as divine throughout Mesoamerica. Thompson points out that "in Mexican allegorical writing jade is the ear of corn before it ripens, and like the green corn, it is hidden within the rocks from which it is born and becomes divine. . . . The maize god always has long hair, perhaps derived from the beard of the maize in its husk."[45] Even today among the Lacandones, Bruce reports that the basic cycle of time is not related as much to the sun or to human life as it is to

> the corn, so inseparably linked with the life of the Mayas. The dry, apparently dead grains are buried in the spring. . . . The plants grow from tender, green youth to maturity and are then called to descend to their destiny in the shadows. The plants wither, they are "decapitated" or harvested, shelled, cooked, ground and eaten—though a few grains are saved. Fire (Venus, the Morning Star) clears the earth into which the seeds are cast and buried. Then the cycle begins anew.[46]

Applied metaphorically to man's life, the cyclical pattern of the corn promises the immortality of regeneration, a promise especially clear to the agricultural communities of pre-Columbian Mesoamerica as "the milpa cycle runs many times during the lifetime of a man, which has the same characteristics." The cycle of the corn teaches the same lesson as the cycle of the sun: all that is to come has already been; "more correctly, 'it simply is'"[47] in the vast cyclic drama of the cosmos.

The Aztec god Xipe Tótec, although clearly a complex and multivocal symbolic entity, embodies this concept; representing spring, the time of renewal, he is shown wearing the skin of a sacrificial victim as a garment (pl. 47). In the ritual dedicated to him and enacted at the time of the planting of the corn, a priest donned the skin of a victim, representing in this sense the dead covering of the earth in the dry season of winter before the new vegetation bursts forth in spring. As with the more usual ritual mask wearer, that priest represented the life-force existing eternally at the spiritual core of the cosmos and in his ritual emergence from the dead skin demonstrated graphically life's emergence from death in the cyclic round of cosmic

time. Thus, Xipe Tótec was the divine embodiment of life emerging from the dead land, of the new plant sprouting from the "dead" seed. It followed that "the land of the dead is the place where we all lose our outer skin or covering," a fundamental concept "contained in the phrase *Ximoan, Ximoayan,* which describes the process of removing the bark from trees and is thus closely related to the idea of the god who flays the dead man of his skin."[48] In the cyclical pattern, death is always a beginning, a rite of passage, a transition to a spiritual mode of being,[49] and an essential stage preceding regeneration in the transformational process. Thus, the development of the life-force within each human being paralleled the sacred movement of time. The rhythms of life on earth as manifested in the succession of the seasons, the annual cycles of plant regeneration, and the individual life that encompassed birth, growth, procreation, and death were intimately parallel to those of the heavens,[50] a parallelism that gave a divine aura to the human processes.

These fundamental ideas grew from the shamanic base of Mesoamerican religion with its emphasis on transformation, and that shamanic world view included the idea that "the essential life force characteristically resides in the bones. . . . [Consequently] humans and animals are reborn from their bones,"[51] which, like seeds, are the very source of life. Thus, Jill Furst contends that in the Mixtec Codex Vindobonensis, "some, if not all, skeletal figures . . . were deities with generative and life-sustaining functions," and her reading of the codex shows that skeletonization "symbolizes not death, but life-giving and life sustaining qualities."[52] This, of course, is the same metaphoric message carried by Xipe Tótec: death is properly seen as the precursor, or perhaps even the cause, of life. The striking visual image on Izapa Stela 50 (pl. 60) depicting what appears to be a small human figure attached to an umbilical cord emerging from the abdomen of a seated, masked skeletal figure puts this idea in its clearest symbolic form. There are, of course, many other manifestations of the belief that life is born from death. There is a scene in the Codex Borgia, for example, showing the copulation of the god and goddess of death, a depiction of "death in the act of giving life, . . . perfectly natural for a world that sees death as only another form of life."[53] And Francis Robicsek and Donald Hales identify many "resurrection events" on Maya funeral vessels; one shows "a young male rising from a skull, an event that can only mean emergence from death to life."[54] Still another connection between bones and rebirth can be seen in Ruz's suggestion that throughout the Maya lowlands, from the earliest times red pigment was used to cover bones and offerings because red, which "was associated with east where the sun is reborn every morning, may also have been a symbol of resurrec-

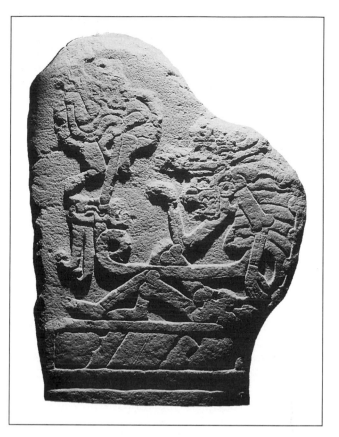

Pl. 60. Stela 50, Izapa (Museo Nacional de Antropología, México).

tion for men."[55] Ancestor worship shows yet another aspect of the concept. Among the Maya, as we have seen, dead members of the elite, especially rulers, "from whose race they sprang in the first place" were apotheosized as divinities.[56] And this belief was shared by those in central Mexico, as can be seen in a passage from the Codex Matritensis:

For this reason the ancient ones said,
he who has died, he becomes a god.
They said: "He became a god there,"
which means that he died.[57]

The life-force never dies; it moves in a cycle from ancestors to descendants, joining them in a spiritual pattern essentially the same as the one traced by the sun as it moves from its zenith to the underworld below and rises again as well as the one manifested in the "dead" seed sprouting new life.

These beliefs account for several of the burial practices found in pre-Columbian Mesoamerica. The fact that tombs were placed under and near temples, as at Monte Albán and throughout Maya Mesoamerica, suggests that when the hereditary elite died, they moved from earthly to spiritual leadership. Since "the ancestral dead were considered to be assimilated to the cosmos,"[58] they could function as intermediaries with the divine and thus maintain a connection with their living descendants.[59] So sure were the Maya that the dead person continued to live in altered form that not only food but "objects which belonged to him and which

characterized his office or rank and, sometimes, his sex and age" were buried with him. The jade bead characteristically found in the mouth of the deceased in Maya burials as well as those of the Zapotecs and Mixtecs "confirms the writings of the chroniclers of the Spanish Conquest when they refer to the belief of the Mayas and the Mexicans that jade was the currency to obtain foodstuffs and to facilitate one's entrance into the next world."[60] The tomb itself often "replicated the palace, so that the ruler could continue to enjoy those prerogatives which were his in life."[61] Others were buried in natural caves because, as we have seen, the cave was metaphorically the womb of the earth, the place of rebirth.[62] And the assumption that death precedes life is also to be found at the heart of the mythological tradition of Mesoamerica. The narratives of the Hero Twins of the *Popol Vuh* and those detailing the activities of Quetzalcóatl as the evening star place the return from death at the symbolic center of their tales. Clearly, the number of ways in which the belief in regeneration was expressed throughout Mesoamerica from the earliest times, ways to which we have only briefly alluded here, suggests the fundamental nature of that belief.

The Temple of Inscriptions at the Maya site of Palenque contains a stunning expression of the parallels we have been discussing as it brings together a number of sun-related cycles referring to regeneration on a number of metaphoric levels— the growth of corn, the transfiguration of ancestors, the movement of power from the dead ancestor to the living ruler, all of them affirmations of the belief that life will come from death. At Palenque, we can see the political implications of this world view: many of the monuments containing images related to cyclical regeneration are dedicated to the dynasty of which Pacal, ruler of Palenque from A.D. 615 to 683, was a member. The relief on the lid of the sarcophagus (pl. 10) in which he was buried in the tomb within the Temple of Inscriptions, for example, contains several images identifying him with the symbol of the setting sun, the Quadripartite Monster, with whom he is "metaphorically equivalent" at the time of his death. This equivalency inevitably suggests his rebirth with the rising sun as does the jade effigy of the sun god placed in his tomb.[63] Just above this scene is a youth in a reclining position whose body lies "upon various objects, two of which are symbols associated with death (the sea shell and a sign that looks like a percentage symbol), while the other two, on the contrary, suggest germination and life (a grain of corn and a flower or perhaps an ear of corn)."[64]

Thus, the earth not only takes life but generates it as well. According to Kubler, the corn symbolism is "metaphor or allegory for renewal in death, whereby the grown corn and the dead ruler are equated as temporal expressions promising spiritual continuity despite the death of the body," and he notes that Thompson also sees a metaphor of resurrection but sees the scene as "ritualistic," perhaps having "no reference to the buried chief."[65] And although Coe, Robertson, and Schele and Miller all see this plant as a world tree rather than corn, they too agree that the theme of the relief is resurrection.[66] Robertson, for example, sees the plant as the sacred ceiba tree reaching from a cave in the underworld through the middle world of the earth's surface to the heavens, a graphic image of transcendence,[67] while Ruz takes a more philosophical view of resurrection:

The youth resting on the head of the earth monster must at the same time be man fated to return one day to earth and the corn whose grain must be buried in order to germinate. The cruciform motif upon which the man fixes his gaze so fervently is the young corn which with the help of man and the elements rises out of the earth to serve once more as food for humanity. To the Maya, the idea of resurrection of corn would be associated with the resurrection of man himself and the frame of astronomical signs around the scene symbolizing the eternal skies would give cosmic significance to the perpetual cycle of birth, life, death, and rebirth of beings on the earth.[68]

He is convinced that the figure is not that of the buried ruler (he maintains that the Maya would have thought more symbolically) but probably represents either humanity or the corn, often symbolized by a young man.[69] Westheim adds the dimension of the sacrifice, noting that the seed must die so that the plant may sprout, thereby indicating that "constant renewal of the cosmos was possible only through human sacrifice, just as the continued existence of the human race was ensured only through the constant rebirth of the maize."[70] Although these major commentators on pre-Columbian Mesoamerican civilization offer different interpretations of the scene, the common denominator is the theme of the rising, falling, and regenerative pattern of the sun, here particularly applied to the regeneration of political power. Thus, even in the affairs of state, the principle of regeneration, intimately related to the cyclical movement of the sun through the heavens, is operative.

And other manifestations of the symbolism of regeneration can be seen in the tomb at Palenque. Both Franz Termer and Ruz have noted the unusual shape of the cavity that held the body, describing it "as a stylized representation of the womb. Burial in such a cavity would be a return to the mother by association of the concepts of mother and earth, sources of life."[71] The belief that the dead and the living communicate with each other is graphically represented by the hollow plas-

ter tube replicating the umbilical cord, which, in the form of a serpent, itself a symbol of regeneration, goes from the sarcophagus, following the stairway, up to the floor of the temple and thus provides a physical symbol of the spiritual link between the two realms. The red paint with which the crypt was covered, as we have seen, is a color associated with the east, the region from which the reborn sun appears after its return from the land of the dead, and here, as elsewhere among the Maya, is a symbol of regeneration and "an augury of immortality."[72] But perhaps the most fascinating suggestion of regeneration can be seen in the way the Maya

> manipulated architecture so that the movement of the universe confirmed the assertions of mythology. Just as the sun begins its movement northward following the winter solstice, the dead, after the defeat of death, will rise from Xibalbá to take up residence in the northern sky, around the fixed point of the North Star. Pacal, confident of defeating death, has made north his destination: His head was placed in the north end of the coffin, and the World Tree on the lid points north, although Pacal himself is depicted in his southward fall. Just as the sun returns from the underworld at dawn, and as it begins its northward journey after the solstice, Pacal has prefigured his return from the southbound journey to Xibalbá.[73]

John Henderson points out that those observing the actual movement of the sun at Palenque would have visual proof of the phenomenon.

> The sun itself appeared to confirm these symbolic associations. As the sun sets on the day of the winter solstice, when it is lowest and weakest, its last light shines through a notch in the ridge behind the Temple of Inscriptions, spotlighting the succession scenes in the Temple of the Cross. . . . Observers in the Palace saw the sun, sinking below the Temple of Inscriptions, follow an oblique path along the line of the stair to Pacal's tomb. Symbolically, the dying sun confirmed the succession of Chan Bahlum, then entered the underworld through Pacal's tomb. No more dramatic statement of the supernatural foundation of the authority of Palenque's ruling line is imaginable.[74]

Thus, both art and nature confirmed without question the Maya belief that life must follow death. The message was clear: "A king dies, but a god is born."[75] And as our discussion of the mask placed over the once-living face of Pacal as he was put in that sarcophagus made clear, the features of the dead man, through the metaphoric agency of the mask, became the eternal features of the deified ancestor. His inner reality had become "outer" in the most significant and final way.

The expression of the theme of resurrection in visual images is not limited to the Maya. One of the most important monumental sculptures of central Mexico, the Aztec Coatlicue (pl. 9), "says" the same thing. Although these two masterpieces were created centuries apart by different cultures, all of the imagery associated with Palenque's Temple of Inscriptions seems to be telescoped symbolically into this Aztec representation of the earth goddess which, according to Fernández,

> symbolizes the earth, but also the sun, moon, spring, rain, light, life, death, the necessity of human sacrifice, humanity, the gods, the heavens, and the supreme creator: the dual principle. Further it represents the stars, Venus and . . . Mictlantecutli, the Lord of the Night and the World of the Dead. His is the realm to which the sun retires to die in the evening and wage its battle with the stars to rise again the following day. Coatlicue, then, is a complete view of the cosmos carved in stone. . . . It makes one conscious of the mystery of life and death.[76]

The sculpture is a visual myth clearly related to the ritual involving the great mother goddess, a ritual in which a woman impersonating her was sacrificed to reenact her death, the propitiation of the earth, and her rebirth. This festival took place near the time of the harvest when the earth itself, having been renewed through death, would again provide the nourishment for life. Both Coatlicue and the earth granted everything with generous hands but demanded it back in repayment; and like the sun, they were both creator and destroyer. All of this is magnificently symbolized by the colossal sculpture of Coatlicue now in the National Museum of Anthropology in Mexico City: she wears a skirt of braided serpents and a necklace of alternating human hands and hearts with a human skull pendant. She is decapitated as were those sacrificed to her, and two streams of blood in the form of two serpents flow from her neck. Facing this figure, overpowering both in size and imagery, the observer must agree with Westheim that "there is no story; there is no action. [She stands] in majestic calm, immobile, impassive—a fact and a certainty."[77] And with Caso: "This figure does not represent a being but an idea."[78] She is a metaphoric image of the womb and the tomb of all life and simultaneously the embodiment of the cyclical pattern that unites them.

That certainty of death and regeneration, of the cyclical nature of the universe, was at the very core of the Mesoamerican world view. What Bruce says of the Maya is equally true of the other peoples of Mesoamerica: "The solar cycle pervades all Maya thought and cosmology. . . . It is the basic nature, not only of 'time,' but of Reality itself."[79] And that basic cycle provided Mesoamerica with a framework for thought; all the elemental processes of life

were cast in that mold—the stages in the growth of the corn from seed to harvest, the stages in the development of human life, the necessity of sacrifice to guarantee the continuation of life, and the ultimate unity of life and death manifested politically at Palenque, verbally in the experiences of the Hero Twins in the *Popol Vuh* and the tales of Quetzalcóatl, and visually in the sculptures of Coatlicue and Pacal's tomb.

But the awareness of this underlying unity did not negate the awe with which Mesoamerican man viewed the mystery of death. That mystery suggested the sacred nature of the cycle which transcended earthly matters and made man aware of his contingent nature. Joseph Campbell uses the metaphor of the mask to place the words of an Aztec poet in context: "Life is but a mask worn on the face of death. And is death, then, but another mask? 'How many can say,' asks the Aztec poet, 'that there is, or is not, a truth beyond?'

We merely dream, we only rise from a dream
It is all as a dream."[80]

Another poem from the same body of late Aztec poetry, however, using the metaphoric identification of flower and song with poetry itself, was able to lift the mask and find beneath it the assurance of "a truth beyond."

O friends, let us rejoice,
let us embrace one another.
We walk the flowering earth.
Nothing can bring an end here
to flowers and songs,
they are perpetuated in the house
of the Giver of Life.[81]

6 The Spatial Order

Not only were the cyclic processes of the cosmos seen by Mesoamerican man as underlying his own life and the life of his divinely ordained sustenance, corn, but the temporal order apparent in those processes was integrally related to the spatial order he perceived both in the world around him and in the hidden world of the spirit. That spatial order united matter and spirit just as the temporal order united man's life with the spiritual life of the cosmos, and both were linked to the cycles of the sun. And just as the temporal order was intimately related to, and perhaps derived from, the various solar cycles carefully observed and charted by Mesoamerican thinkers, the spatial order was directly related to the diurnal passage of the sun from sunrise on the eastern horizon to its highest point at midday, from there to sunset on the western horizon, and then to a point at the lowest depth of its passage through the underworld from which it returned to the eastern horizon to begin the cycle again. The daily path traced by the sun's passage can be visualized as either a circle or a square drawn on a plane perpendicular to the surface of the earth (fig. 3). Drawing two lines through the figure, one connecting East (the point of sunrise) and West (sunset) and the other connecting the zenith (high noon) and the nadir (midnight), locates the center, which is the point of the observer as well as the point—symbolically the world center—around which the sun revolves.

In addition to thus locating the mythic cosmic center, the two intersecting lines define two other mythologically crucial dimensions. The line connecting the highest and lowest points is a familiar feature in any shamanistic religion; it is the central axis of the universe which "is conceived as having these three levels—sky, earth, underworld—. . . three great cosmic regions which," according to Eliade, "can be successively traversed because they

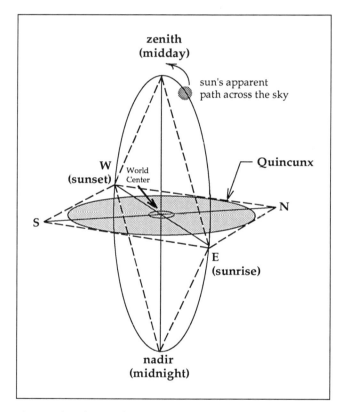

Fig. 3. The shape of Time and Space.

are linked together by this central axis." The symbolic location of this axis on the earthly plane, the center of the Mesoamerican figure we have been discussing, is therefore

> an "opening," a "hole"; it is through this hole
> that the gods descend to earth and the dead to
> the subterranean regions; it is through the
> same hole that the soul of the shaman in
> ecstasy can fly up or down in the course of his
> celestial or infernal journeys. . . . [It is thus]
> the site of a possible break-through in plane.[1]

It is a manifestation of the sacred, which is not of this earth. This shamanistic view of the importance of the center as a place of mediation between the planes of the sacred and secular accounts for the Mesoamerican attribution of sacredness to mountaintops and caves and for the practice of building pyramids topped with temples (architectural realizations of the basic figure we are discussing) and creating temples that are artificial caves. In these temples, symbolically located on the world axis and on planes above and below the earth, the priests could fulfill what was earlier the function of the shaman—the mediation between this world and the world of the spirit. Thus, it is no accident that the other line drawn through the figure derived from the sun's path, the line connecting East and West, effectively defines this world, the world of the earth's surface, man's world of life and eventual death which is bounded by the point at which the sun "dies" in the west and passes into the underworld, the necessary prelude to its rebirth at the opposing point on the eastern horizon. The cross created by the intersection of these two lines is the quincunx, a cross with arms of equal length whose central point joins the points of equal importance at the ends of each of the four arms. Ubiquitous in Mesoamerica, the five points of the quincunx symbolize the earth and the cosmos, life and motion, and the endless cyclic whirling of time.

If the quincunx thus derived from the solar course is rotated in a northerly direction on its east-west axis by 90 degrees so that it lies flat on the earth rather than being perpendicular to it, the terminal points of the quincunx become East, North, West, and South, and lines running from the center to each of those points divide the surface of the earth into four quadrants, thereby creating a very different symbolic definition of the same figure (fig. 3). There is a good deal of evidence to suggest that the Mesoamerican conception of the order of earthly space is based on exactly that mental "rotation" of the path marked out by the course of the sun[2] which resulted in a mental image of the earth as a plane, a landmass, either square, circular, or fourlobed, "resembling our four-leafed clover."[3] This landmass was metaphorically conceived as a crocodilian or toadlike monster floating in water which merged with the sky at the horizons to enclose the earth in an "envelope" of spirit represented by the water underneath and the sky above. The Maya visualized this concept as a house, "the roof and walls of which were formed by four giant iguanas, upright but with their heads downward, each with its own world direction and color."[4] This enclosing spirit was Itzamná, Iguana House, the ultimate spiritual essence.

The sacredness of the "enclosure" of the earth is also suggested by the fact that throughout Mesoamerica, each of the points marking the ends of the arms of the quincunx, that is, each of the cardi-

nal directions, had a series of sacred associations: with a certain color, a particular tree, a specific bird and animal, and a god functioning as a sky-bearer. In addition, this directional system had temporal implications as each cardinal point was associated with a season of the year and with specific time units—days, weeks, months, years, and even longer units—in each of the calendric systems making up the basic cycle of time. The whole system is incredibly intricate and complex, varying slightly in its details from area to area, but it surely indicates that the solar path Coggins calls "the shape of time," borrowing Kubler's metaphor,[5] must also be seen as the "shape" of both earthly and spiritual space. This multivocality of the symbolic quincunx suggests the essential point: throughout Mesoamerica, both space and time were seen as manifestations of a fundamental cosmic order underlying all reality, an order that expressed itself in space and time but was itself beyond space and time. And the center of the quincunx marked the center of the world, the navel of the universe, where man emerged from and therefore could return into the plane of the spiritual to experience that basic order directly.

Wherever the quincunx is found in Mesoamerica—in hieroglyphic writing, on sculpture, on the walls of temples, and, as we have seen, pecked into stucco floors and rocks—it always refers to this basic order of space and time. Of course, the figure carried various specific meanings at various times and places (fig. 4), but the ultimate referent is always the same. The Maya glyph for *Kin*, for example, which means "sun-day-time" and therefore indicates the "primary reality, divine and limitless,"[6] is such a figure, as is the *Kan* cross found at Monte Albán and seen by Caso as representing the solar year.[7] *Lamat*, the Maya glyph for Venus, is also a quincunx due, no doubt, to the Maya fascination with the sun-related cycles of that planet. The crossed band element, "which among the Maya appears in celestial bands, whatever its other meanings might be," has the same shape as well. It and the Kin sign and Lamat glyph were in use by the Olmecs as early as 900 B.C.,[8] suggesting the great antiquity of this symbolic association of the quincunx with time.

In addition, the glyph representing the completion of a *katun*, a cycle of twenty solar years, is "the most complicated of the Maya quadripartite glyphs" and is similar in form to the flower symbol found at Teotihuacán "which may also refer to calendric completion."[9] That these time-related figures have a spatial component is suggested by the various depictions of the ritual calendar found in such writings as the Mixtec Codex Fejérváry-Mayer, the Yucatec Maya Madrid Codex, and the *Book of Chilam Balam of Kaua*, also from the Yucatán and dating from about the time of the Conquest.[10] The Aztec calendar reproduced by Durán[11]

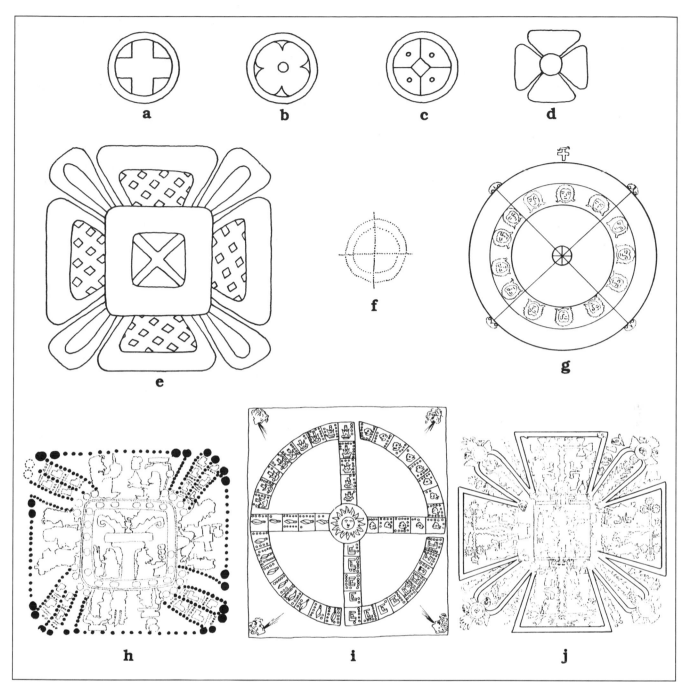

Fig. 4. The Quincunx Variously Applied: a. Monte Albán Kan cross; b. Maya Kin glyph; c. Maya Lamat glyph; d. Teotihuacán flower sign; e. Maya katun completion sign; f. Teotihuacán pecked cross; g. Maya calendar from the *Book of Chilam Balam of Kaua*; h. Maya calendar from the Madrid Codex; i. Aztec calendar from Durán; j. Mixtec calendar from the Codex Féjérvary-Mayer (a-e after Coggins 1980, figs. 2a-d; f after Aveni 1980, fig. 71a; g-j after Aveni 1980, fig. 57).

is a quincunx with the 52-year cycle "divided into four parts of thirteen years each, each part associated with a cardinal direction." The years progress in a counterclockwise, that is, sunwise, direction, and the figure is oriented, as always in Mesoamerica, with east, the place of birth or beginning, at the top. As if to indicate the many solar references in this graphic version of the calendar, the center of the circle contains a picture of the sun. This quincunx thus merges space and time and does it in portraying the 52-year cycle, the

most significant and widespread of the calendrical cycles of Mesoamerica.

So important was this symbol of the ultimate temporal and spatial order to the peoples of ancient Mesoamerica that they placed it on the very earth itself in the arrangement of their cities. At Teotihuacán, for example, a quincunx is formed by the intersection of the Street of the Dead with the main east-west avenue, an intersection intended to divide the city into the four-quadrant design rigidly adhered to during the centuries of its

growth. All the evidence suggests that this design was a conscious replication of the sacred figure. Millon believes, for example, that the Ciudadela, which is located at this intersection, the very center of the city, was the political and religious center of Teotihuacán,[12] so that just as the center point of the quincunx joins the east-west, earthly axis and the zenith-nadir, spiritual axis, the Ciudadela "joins" the secular and sacred functions of the urban center. The north-south line of the quincunx that formed the city was what we now call the Street of the Dead, and just as the north-south line corresponds to the zenith-nadir line of the sun-derived quincunx which connects the planes of the spiritual world with the material world, so at Teotihuacán the Street of the Dead was a Via Sacra lined with temples, fronting the all-important Pyramid of the Sun and ending in the courtyard of the Pyramid of the Moon. The street was intended to "overwhelm the viewer, to impress upon him the power and the glory of the gods of Teotihuacán and their earthly representatives."[13] This design was laid out using the cross petroglyphs (fig. 4) that are themselves the familiar quincunx.

These petroglyphs are found all over Mesoamerica at sites laid out according to the same directional orientation and general plan as Teotihuacán, which obviously functioned as a sacred model. The last to follow this model was Tenochtitlán where four avenues led from the gates of the ceremonial precinct in the center of the island city to the cardinal directions, thus marking out the quadrants. Each quadrant had its own ceremonial and political center,[14] indicating that the quadripartite division of the city had both sacred and secular significance and that the religious and political worlds were united in the symbolic form of the quincunx here as they were much earlier at Teotihuacán. Thus, "the structure of the universe was conceived as the model for social space at Tenochtitlán. . . . The circuits defining the boundaries of social space replicated the geometric structure that the universe was thought to have."[15] Throughout the development of Mesoamerican civilization, the "pervasive [worldwide] tendency to dramatize the cosmogony by constructing on earth a reduced version of the cosmos, usually in the form of a state capital,"[16] gave cities the sacred form of the quincunx, using them as "masks" to cover the randomly arranged natural features of the earth with an artificial symbolic construct revealing the underlying spiritual order of the cosmos.

The structures with especially sacred functions were often located in a sacred precinct at the center of the city which was, like the Ciudadela, symbolically "the center of the world, the point of intersection of all the world's paths, both terrestrial and celestial,"[17] the point at which the breakthrough in plane of which Eliade spoke was possible and therefore the location of the temple in which the priest or ruler could communicate with the world of the spirit. Typically, throughout Mesoamerica, more than anywhere else in the world, these temples were located atop pyramids that in their very structure replicated the sacred form of the universe. Viewed in profile, the pyramid emphasized three of the four points marking the sun's daily passage, the two horizon points and the zenith position symbolizing the heavens which was, appropriately, the location of the temple. One of the ways of visualizing the celestial world of the spirit throughout Mesoamerica confirms this identification of the pyramid with the path of the sun. The Maya, for example, believed the heavens

> rose in six steps from the eastern horizon to the zenith, following the sun god as he moved across the sky, and then descended in six more steps to the western horizon. Below the horizon, on into the underworld, there were four more steps down to the nadir, then four back up to the eastern horizon.

The profile of the pyramid on earth atop an imagined inverted pyramid underground creates again the sacred quincunx. In fact, Hammond continues, "the design of the twin-pyramid groups at Tikal may epitomize the solar cycle through day and night."[18] According to Krickeberg, the peoples of Postclassic central Mexico shared this association of the pyramidal shape with the "shape" of the sun's path.

> The sky was conceived of in the form of five or seven superimposed layers which decrease in length as they proceed upward. Depicted graphically in two dimensions, they form a stepped triangle with its apex at the top. The earth was similarly disposed in a series of five layers which two-dimensionally took the form of an inverted stepped triangle.[19]

This conception is also embodied in Aztec ritual and can be seen in at least two different festivals celebrated during the solar year. Twice during the year, on March 17 and December 2 of our calendar, the Aztec day 4 Motion occurred, and on those days, festivals were celebrated to honor the present world age, that of the Fifth Sun, whose name (i.e., birthdate) was 4 Motion. At these festivals, a captive was prepared for sacrifice, given numerous sacred objects, and ritually instructed to deliver them to "our god," the sun. After hearing the message he was to deliver, he began to ascend the pyramid, "little by little, pausing at each step . . . to illustrate the movement of the sun by going up little by little, imitating [the sun's] course here upon the earth." Reaching the top, he placed himself in the center of the Cuauhxicalli, in this case the monumental Stone of Tizoc, the top of which is covered with solar symbols, delivered his message, and was sacrificed. Durán says that "the hour had been cal-

culated so artfully that by the time the man had finished his ascent to the place of sacrifice it was high noon."[20]

In addition to marking the dates of the sun's birth with festivals and sacrifice, the Aztecs also celebrated the sun's zenith passage following the winter solstice with the Feast of Tóxcatl,[21] one of the veintena festivals marking the end of each of the eighteen months of the solar year, this particular one honoring Tezcatlipoca, the highest of the ritual gods, the one from whom the others derived and, in that sense at least, an equivalent of the sun. During this festival, a young impersonator of the god who "had been honored and revered as the god himself" for the past year was sacrificed at high noon (again, after a ritual ascent of the pyramid), his heart offered to the sun, and his body rolled down the steps of the pyramid.[22] As his body tumbled down the pyramid, the sun "fell" from the zenith position and began a new cycle, which would end a year later. A new impersonator of the god was selected at this time as well, one who would ascend to the zenith of the pyramid in a year's time to meet his death in another reenactment of the sacred annual cycle of the sun. As each of these men who impersonated the god and "became" the sun climbed the steps of the pyramid in the annual rite, the quincunx itself came to life in the ritual enacted on the pyramid's staircase.

Their ritual ascent indicates the tremendous symbolic importance of the steps leading to the top of the pyramid which is still felt by the present-day Tzotzil Maya for whom "the sacred mountains symbolize the sky, and to ascend one is tantamount to rising into the heavens. . . . [The mountains] are imagined as linked from top to bottom by a huge stairway, in many ways suggesting the ancient Maya pyramids."[23] Eliade suggests that "the act of climbing or ascending [universally] symbolizes *the way towards the absolute reality.*" A stairway, he says, "gives plastic expression to the break through the planes necessitated by the passage from one mode of being to another,"[24] from the natural world symbolized by the surface of the earth to the enveloping world of the spirit.

But the stairway suggests another way of seeing the pyramid as a quincunx since many Mesoamerican pyramids have square bases and stairways leading up each of the four sides. Such a pyramid seen from directly above as a two-dimensional figure would look exactly like the graphic depictions of calendars found in the codices. Seen in that way, the stairways would take on an even greater significance, becoming the arms of the quincunx and leading from the sacred cardinal points to the center, which symbolized the central axis of the cosmos. Thus, in climbing the stairway, the impersonator approached ever closer to the point of passage to another plane of reality. Not surprisingly, then, those stairways are often flanked with masks (pls.

20, 49) as if to emphasize their significance. The Preclassic Maya Structure E-VII Sub at Uaxactún provides an early example of this form, and the fact that it was probably the viewing point in a solar observatory designed to chart the annual cycles of the sun suggests that its design symbolized the cycles of time and space by taking the "shape" of those cycles.

Similarly square-based pyramids are found everywhere in Mesoamerica, and the form is often used for small platforms with four stairways located within the confines of the centrally located ceremonial precinct, examples of which are found at such widely scattered major sites as Teotihuacán, Monte Albán, Tula, Chichén Itzá, and Tenochtitlán and at numerous smaller sites. These platforms, often called dance platforms by archaeologists, were used for ritual activity, frequently calendric in nature, and thus the shape of the quincunx would seem again to fit the use of the structure. For these reasons, it seems at least possible that the basic pyramidal form, varied in countless ways throughout Mesoamerica but always associated with the sacred, was derived from the quincunx, a possibility suggested by their shared fundamental association with the underlying cosmic order from which grew space and time and which required ritual reenactment of its sacred processes.

The Pyramid of the Sun at Teotihuacán is a particularly significant example as it was "perhaps the greatest single construction project in Mesoamerican history"[25] and perhaps the most sacred. From the time of its building at about A.D. 100 until the Conquest, long after Teotihuacán had fallen and been abandoned, it served as the focal point of pilgrimages, its sacred quality undoubtedly connected, both as cause and effect, with Teotihuacán's dominance of much of Mesoamerica at the height of its power. For the later Aztecs, inheritors of the religious traditions of the Valley of Mexico, Teotihuacán was "the place where the gods were made," the site of their manifestation on the earthly plane. Perhaps their gods really were "made" there.

> At least four [mural] paintings at Teotihuacán seem to have elements of the Fifth Sun creation myth. If this belief was espoused at Teotihuacán and related to "the day that 'time began,'"[26] it could represent a crucial system of beliefs and rituals that transformed the city's shrines and temples into great pilgrimage centers. Teotihuacán's distinctive east of north orientation [which was the model for the orientation of ceremonial centers all over Mesoamerica][27] would have commemorated when *time began*, because Teotihuacán would have been where *time began.*[28]

Thus, the Pyramid of the Sun seems to have been connected throughout the history of the Valley of Mexico with the fundamental Mesoamerican sense

of the cosmic order as it manifests itself in space and time. Why this is so, why a pyramid of such magnitude was built where and when it was built, why it was built in one long burst of construction rather than being the result of successive rebuildings of an originally small structure as is more characteristic of Mesoamerica, and why it was oriented as it was are all questions that have been endlessly debated. While it is clear that there is no single answer that will fully resolve these questions, the discovery by Ernesto Taboada in 1971 of the entrance to a natural cave at the foot of the main stairway of the pyramid provides at least the framework for an answer, which connects caves and pyramids on the basis of their both being penetrations into the enveloping spiritual realm accessible only on the vertical cosmic axis.

As an understanding of the answer to those questions requires an understanding of the Mesoamerican symbolic conception of the cave, we will explain that conception briefly before returning to our consideration of the pyramid. Caves, like mountaintops, have always been venerated and used for ritual in Mesoamerica; archaeological evidence of such ritual activity goes back to the Preceramic period,[29] and both caves and mountains continue to be held sacred by Mesoamerican Indians thousands of years later.[30] It is undoubtedly this attribution of sacredness to those natural features which led to their use as models in the construction of artificial sacred spaces—the mountain became the pyramid; the cave became the temple—and they were perceived as sacred by a people whose shamanistic world view posited a "layered" reality because they are natural penetrations into the planes of the spirit providing a "god-given" means of communication between humanity and that world of the spirit. They are thus highly liminal places, to use the term Turner borrows from van Gennep's studies of rites of passage. He defines liminality as the state of being "betwixt and between the positions assigned and arrayed by law, custom, convention, and ceremonial. . . . Thus, liminality is frequently likened to being in the womb, . . . to darkness, . . . and to an eclipse of the sun or moon."[31] While Turner uses the term to describe a part of the ritual process, as we have in our discussion of masked ritual, it seems a particularly appropriate term to describe the Mesoamerican perception of the position of the mountaintop or cave "betwixt and between" the earth and the heavens or the earth and the underworld. The fact that the cave was and still is used for rites of passage in Mesoamerica[32] suggests a continued awareness of this liminality. Temples located at these liminal points were appropriate for the oracles who could penetrate into the "will" of the world of the spirit[33] and the priests who could mediate between the planes of matter and spirit; there the gods could be petitioned, and there they would respond.

This petitioning was often for the rain sent by the gods to ensure the survival of life on earth, and the same temples were used for sacrifices providing the gods the sacred fluid, blood, that sustained them. The mythic equation is clear; the gods gave the nourishing liquid they possessed in return for man's sacred fluid, which "nourished" them. These gifts were exchanged at the liminal locations always associated with rain in Mesoamerica: the mountain "penetrates into the sky whence came the winds, rains, storms, and lightning,"[34] while the cave often contains springs where water arises from within the earth, from the spiritual plane of the underworld, as a direct "communication" from the gods. Today's Maya, for example, still believe that mountains are actually hollow and filled with water that can be reached through caves[35] and that water from springs found deep in caves is "virgin," still close to the original source of all water and thus ritually pure.[36]

Such beliefs explain the ubiquitous association of caves with rain, lightning, and thunder throughout Mesoamerica.[37] The gods of rain—especially the Maya Chac and Tlaloc in central Mexico—are associated with caves, and Tlaloc's pervasive connection with the jaguar, a creature always related in the Mesoamerican mind to the earth, caves, and transformation, further strengthens the link between rain and caves and indicates again their fundamental sacredness. In addition, the sun in its night journey through the underworld was thought of as a jaguar,[38] thus providing yet another link with Tlaloc, whose name, according to Durán, meant Path under the Earth or Long Cave,[39] suggesting that solar night journey and further linking the god of rain to the cave, the symbolic source of all water.

The vital agricultural role of water was no doubt partially responsible for the Mesoamerican association of caves with fertility, but the identification of the cave as the womb of the female earth[40] suggests another reason for that belief. Not only does the seed sprout from the earth and grow with the aid of water into the corn that the gods have provided as man's sustenance but a widespread Mesoamerican origin myth held that man himself, in the beginning, emerged from the maternal earth. Its Aztec version at the time of the Conquest designated Chicomoztoc, Seven Caves, as the place of that emergence, while "the jaguar mouth from which the man with the 'baby' emerges" on the Olmec altar/thrones (pl. 12) was perhaps the earliest mythic "statement" of this belief. This metaphorical identification of the cave with the womb is but another way of describing the emergence of matter from spirit, of man from the gods. The cave becomes the liminal point of transformation where the planes of spirit and matter touch and a basic symbol of creation in the shamanistic, transformative sense understood throughout Mesoamerica. In fact, the transformation through fire by which the

sun and moon were created in the cosmogony of central Mexico has a variant that places the site of that transformative creation in a cave.[41]

Following this logic, then, the place of emergence becomes the place of return. In death, man is returned to the earth by burial, often in caves, signifying a return to the underworld, the world of spirit, from whence he came.[42] Often, this connection with death made the cave a focal point of the ritual associated with the veneration of the ancestors who provided a link between this world and the world of spirit,[43] suggesting again the cyclic nature of Mesoamerican thought, which constantly links birth and death. Just as birth provided a passage from that other plane of existence to this one, death completed the cycle by providing the passage back. As the cave served as an entrance to the world of the spirit through death, it was thought of as an entrance to the underworld in a more general sense. Among the Maya, caves were "pathways to Xibalbá,"[44] and the Nahua-speaking people of the Sierra de Puebla, the heirs of the traditions of the Aztecs, still believe that "the paradisiacal underworld . . . of Talocan as [the Aztec] Tlalocan is called in the Sierra de Puebla . . . is entered through places called encantas, caves, which are entries to the ideal world."[45]

That this symbolic linkage of places above and below the surface of the earth accounted in part for the layout of the ceremonial centers of Mesoamerica is evident in both the earliest and the latest of those sacred precincts. By 1000 B.C., that symbolic passage from mountaintop to cave, that is, from zenith to nadir, had already been recreated in the Olmec ceremonial center of La Venta. There were, of course, neither mountains nor caves on the island in the Gulf coast swamp on which this early ceremonial center was built, but its conical, probably fluted pyramid seems an obvious attempt to replicate the volcanic cones of the nearby Tuxtlas, which the Olmecs held sacred. After building the pyramid, "along the central line which forms the axis of La Venta the Olmecs made great offerings and left the famous mosaic floors representing jaguar faces. These mosaics were not left visible; they were covered [i.e., buried] immediately after they were laid down."[46] Numerous Olmec sculptures identify jaguar mouths with the openings of caves, a symbolic association that continued throughout Mesoamerican history, so it seems probable that these mosaics functioned symbolically as entrances to the underworld, and their placement on the central, north-south axis in literal and symbolic opposition to the pyramid suggests exactly the same zenith-nadir relationship as that of mountaintops and caves. And it is now clear, according to Johanna Broda, that the Aztec pyramid at Tenochtitlán known as the Templo Mayor was conceptually the same. "The temple itself was a sacred mountain covering the sacred waters like a cave."[47]

Returning now to our discussion of the Pyramid of the Sun at Teotihuacán, the sacredness of the cave in Mesoamerican thought lends substance to Millon's contention that the pyramid "must be where it is because the cave is there";[48] the pyramid was constructed to form the zenith that would complement the nadir of the cave and replicate on the earth the sacred cosmic axis.

The existence of the cave must have been known when the pyramid was built, inasmuch as the entrance to the 103 meter long tunnel coincides with the middle of the pyramid's original central stairway . . . and the tunnel itself ends in a series of chambers almost directly under the center of the pyramid.[49]

The location of the cave and the obvious desire to make the "entrances" and centers of cave and pyramid coincide seems to account for the location and orientation of the pyramid; the magnitude of the pyramid and its construction in one prolonged burst of sacred energy must have been a result of the belief that "the cave below it was the most sacred of sacred places. . . . The rituals performed in the cave must have celebrated a system of myth and belief of transcendent importance."[50]

Both the natural characteristics of the cave and the modifications the Teotihuacanos made to it give reason for this belief. The cave itself "is a natural formation, the result of a lava flow that occurred more than a million years ago. As it flowed into the Teotihuacán Valley, bubbles were formed, and when new lava flowed over them, the bubbles remained as subterranean caves."[51] The shape of the cave is that of a long tube culminating in a chamber considerably wider than the tubelike passage. The shape is suggestive of the womb and vagina and would surely have suggested the mythic cave of origin to the Teotihuacanos. The cave runs in an east-west direction, opening to the west, and as does the Pyramid of the Sun, the opening of the cave faces the setting sun directly on the ritually important days of zenith passage.[52] Thus, it is a long cave that naturally recreates the sun's path under the earth, and as Durán indicated, Tlaloc's name meant Path Under the Earth or Long Cave to the Aztecs who inherited the culture of Teotihuacán, and the rituals conducted in the cave (discussed below) suggest the significance of this connection.

All these natural characteristics of the cave must have given it the highest sacred character, and the modifications that were made enhanced these characteristics. The chamber at the end of the cave was given a four-lobed shape that looks very much like the shape of the calendars in the later codices as well as the caves of origin also depicted in those codices. This quincunxlike shape was oriented to the cardinal directions just as the city itself was divided into quadrants by the avenues running in the cardinal directions. The end

chamber must have "constituted the *sancta sanctorum*,"[53] and it was reshaped to give it the symbolic form of the cosmic cycles to the veneration of which it was no doubt dedicated. In addition to these alterations, the shaft of the cave was modified to give it "a more sinuous appearance than it originally had."[54] But perhaps the most significant alteration was the addition of a series of artificial drain channels to allow water to be made to flow from the end chamber to the mouth of the cave. Although it was once thought that the cave was originally the site of a natural spring, according to Millon, "we now know that water did not ever flow naturally in the cave" so that the symbolic connection between caves and the origin of water had to be made by man. As Millon concludes, "everything that was done to the cave and in the cave proclaims ritual,"[55] ritual based on man's symbolic recreation of the work of the gods which, according to Eliade, "is efficacious in the measure in which it reproduces the work of the gods, i.e., the cosmogony."[56]

Although we can never know the exact nature of the ritual carried out in that cave so long ago, the people of Teotihuacán have left us some tantalizing clues. The clearest of all is the water channel they constructed through which water, which had been carried into the cave, could have been made to flow out the mouth of the cave. Such a ritual would have been consistent with the pervasive Mesoamerican belief that caves penetrated symbolically to the original source of all water in being a reenactment of the original provision of water by the gods, a reenactment designed, of course, to assure the coming of the rains with the beginning of the rainy season. Such an interpretation of the physical facts of the cave accords amazingly well with the scenes depicted in the mural found at the Tepantitla apartment compound (colorplate 3) near the cave. As we have shown, the upper half of the mural depicts a deity or deity impersonator who unites the symbolic attributes of the gods of rain and fire to suggest the reciprocal relationship between man and the gods which ensures fertility and the continuation of life.

The upper painting abounds with allusions to water, an emphasis also found in the lower panel of the mural, which refers directly to the cave under the Pyramid of the Sun. In the center of a scene generally interpreted as Tlalocan, the paradise of the rain god, stands a pyramidal hill that contains the mouth of a cave from which emerges a stream of water that divides to flow in either direction along the base of the scene, nourishing the plants growing luxuriantly there. After thus fulfilling their function, the streams disappear into holes in the earth guarded or represented by toads. The

similarities between the painting and the actual pyramid and cave are too great to ignore. In both, the mouth of the cave is at the center of the base of the pyramidal structure; in both, water flows from the mouth of the cave and brings fertility and agricultural abundance to the land; both are sacred and fundamentally associated with ritual. Further support for this interpretation comes from the most recent excavations, which uncovered within the cave "offerings of fragments of iridescent shell surrounded by an enormous quantity of tiny fish bones," the remnants of ritually burned fish;[57] the association of aquatic creatures with water symbols is a common motif in the murals and relief sculpture at Teotihuacán and suggests the ritual use of the cave in calendrically determined rain petitioning ceremonies, and the ritual burning fits perfectly with the allusion to the god of fire in the mask of the figure in the upper mural. Were we to have been present in ancient Teotihuacán on the day of the ceremony at the beginning of the rainy season, we might well have seen a priest impersonating the deity in the mural's upper scene calling forth the waters from the *sancta sanctorum* inside the cave in a ritual reenactment of the original work of the gods in providing water to ensure the fertility on which life depended. Thus, the solar ceremonies connected with the ritual probably performed on the staircase and in the temple atop the Pyramid of the Sun symbolically merged with the fertility ceremonies associated with the cave in a vast cycle imitating and guaranteeing the continuance of the cosmic cycles of time and space of which earthly life was the product and on which it depended.

The building of the Pyramid of the Sun at Teotihuacán thus provides a significant example of the way the peoples of Mesoamerica combined their view of cosmic order, their art and architecture, and their ritual practice in the imposition of form on nature. Of course, they would have seen themselves as merely making apparent the implicit inner form rather than imposing one in their linking the center of the natural cave to the center of the man-made pyramid and using the resulting configuration as the center of ritual reenactment of the cosmogonic forces. The form they used was, for them, the basic form of the cosmos, a form that existed before space and time and from which space and time were derived. And that derivation of both space and time from a common source is no doubt the fundamental reason for their linkage in Mesoamerican thought. That they are both expressions of an underlying spiritual order is further suggested by their probable derivation from and constant association with the course of the sun, the ultimate symbol of spirit and the ultimate source of order.

7 The Mathematical Order

The peoples of Mesoamerica very early found clues to the mysteries of the cosmos in the order observable in the visible phenomena of the universe, clues that led them to an understanding of the cyclical movement of time, which they saw as a key to the basic rhythm of the universe. Such an insight was a natural result of the shamanic base of Mesoamerican thought which suggested that ultimate reality was to be found in the unseen world of the spirit. The material world "masked" that unseen world but in such a way the features of the mask—the phenomena of the natural world of time and space—revealed, when properly understood, the realities of the spirit. Thus, the spiritual essence of such observable phenomena as the cycles of the sun, the changes in the moon, and the movement of the stars and planets could be captured in abstract calendrical systems that charted the movement of essentially spiritual cyclical reality. These initially rudimentary systems grew in complexity as they were related mathematically to each other, and that growing complexity, in turn, fostered the profound pan-Mesoamerican effort to understand the relationship of every conceivable aspect of time to every other as those relationships manifested the ultimate reality of time—"something coming from the divinity and somehow part of its very being."[1]

According to a myth retold in the *Book of Chilam Balam of Chumayel*, the twenty days making up the *uinal*, the Maya name for the twenty-day unit of which the solar calendar was composed throughout Mesoamerica, were created and named by the gods even before heaven and earth came into being:

Every day is set in order
according to the count,

beginning in the east,
as it is arranged.[2]

Insight into the essence of the arrangement of the universe could therefore come through an understanding of "the count" and of the system by which it was "set in order" as the system according to which time moved must have preceded the existence of time itself and thus must be—or issue directly from—the ultimate creative power itself. No wonder, then, that "the counting and periodization of time, and the endowing of time with religious and ritual meaning, is [so fundamental as to be] a characteristic feature of pre-Columbian Mesoamerica,"[3] and no wonder that both the days and numbers that were the units of this counting and periodization were seen as sacred in themselves. The days were seen as living gods[4] closely linked to the fate of men and nations as were the numbers by which the days were designated.[5] The latter were, if anything, more sacred than the units of time because numbers could be manipulated mathematically, a process that must have seemed to the thinkers of early Mesoamerica to capture the essence of the workings of the divine system ordering the cosmos.

Given that attribution of supernatural status to the mathematical manipulation of the units of time and space comprising natural reality, it is not surprising that very early in its development, during the time of the Olmecs at the very latest, Mesoamerica saw the creation of a purely abstract calendar tied to no natural cycle, a calendar that, in the Mesoamerican mind, perhaps complemented the solar calendar in the same way that the realm of the spirit complemented the natural world. The calendar itself was essentially mathematical in its permutation of two different time sequences against

129

each other, one consisting of twenty named days, each symbolized by a day-sign, and the other of thirteen numbered days. The two sequences ran simultaneously so that any given day was designated by one of the twenty names and one of the thirteen numbers, making possible 260 different combinations within the sacred cycle. It thus took 260 days before the same combination of day-sign and number reappeared.

Why the 260-day period was selected is not known and will probably never be known for certain. That there is no obvious correspondence to any important observable cycle of time is suggested by the fact that no other civilization in the world used a 260-day cycle as the basis for a calendar.[6] There are, however, a variety of natural cycles that coincide fairly well with the calendar's 260-day period. Some of these are astronomical cycles. Aveni, for example, suggests that "the actual appearance interval of Venus as morning and evening star is close to 260 days (263 days on the average), Mars' synodic period is exactly three cycles of 260 days," and 260 is close to numbers used in predicting possible eclipses.[7] Biologically, the number is also close to the gestation period for humans, and Barbara Tedlock's research among the contemporary highland Maya suggests that possible base.[8]

None of these cycles, however, has gained acceptance as the foundation of the calendar. Henderson suggests the most widely held view: the 260-day period may simply be an artifact of the permutation of its two subcycles; thirteen and twenty are numbers of considerable ritual and symbolic importance throughout Mesoamerica. There is no compelling reason to suppose that 260 is significant in its own right.[9] Thus, the calendar may well have been essentially mathematical; given the astronomical, numerological, and biological coincidences, regardless of its origin, the number probably grew to be significant precisely because it reflected so many of nature's cycles.[10] These coincidences no doubt suggested to the Mesoamerican mind that a mathematical key to the various cycles that embodied the fundmental order of their world had been discovered, a key revealing the order of time itself and one that enabled man to give appropriate form to the essence of time, which was beyond visual reality. The elimination of the connection with visible phenomena characteristic of the solar calendar must have made this system seem a purer, more direct conceptualization of the sacred knowledge of ultimate reality, a means of lifting the mask covering the world of the spirit.

Modern scholarship has not discovered the original sacred calendar; we have only a series of variants presumably derived from an ancient prototype. These variants include the Aztec version known as the *tonalpohualli*, literally meaning "the count of day-signs," the Yucatec Maya version that is often referred to as the *tzolkin* by scholars although we do not know what the Maya called it, and the most ancient of them, the Zapotec variant known as the *piye*. In all of its local embodiments, however, it was a sacred calendar used for divination and prophecy and thus complemented the solar calendar used to regulate both the more mundane affairs of life and the grand ritual cycle that allowed earthly life to be led in harmony with the cosmic order.

While the origin of the 260-day sacred calendar remains obscure, its importance can be seen in its persistence. Although undoubtedly in use much earlier, it first appears archaeologically in Oaxaca during the sixth century before Christ where it is "still used today . . . after 2600 years have elapsed."[11] That its survival is due to its essentially religious nature is suggested by the fact that although the symbols for the day names varied somewhat throughout Mesoamerica, the 260-day calendar seems to have preserved its original sacred significance and divinatory importance in whatever variation it appeared.[12] Thus, both its nature and continuity suggest that "knowledge of time was the root of theological thought"[13] throughout Mesoamerica.

Satterthwaite's observation that the complexity of the Mesoamerican calendrical system "exceeds the needs of time measurement in affairs of daily life or the recording of history in the ordinary sense"[14] is clearly an understatement and suggests that the Mesoamerican concern with calendars ultimately had little to do with our concept of time measurement. Their fascination grew from the conviction that the various cycles of time revealed the inner workings of the essentially spiritual universe that shaped the world of nature. As Schele and Miller put it in their study of the Classic period Maya, "The Maya watched the heavens with committed concentration, not so that farmers knew when to plant (they already knew), but so as to detect the repetitive patterns against which history could take form."[15] Those patterns could be charted in the calendars and used to prophesy the future. And since, as we have seen among the Maya, the most important aspect of *kin* was its cyclic nature, the past also became a "clue to the present and both could be used to project the future," thereby "adding a divinatory or astrological quality to the Maya concept of time."[16] Past and future became one since "it is not memory that remembers the past, but the past that returns."[17] History was certain to repeat itself; knowing the past and understanding calendrical lore would allow man to divine the future.[18]

But the 260-day calendar was obviously too intricate for the common man to interpret with confidence; the sacred nature of the work required the efforts of those closer to the gods. It became the function of a special group of priests, the *tonalpouhqui* in central Mexico, for example, to interpret the signs of the tonalpohualli[19] as they were

found in the books containing the various specific versions, the *tonalámatl*. Schooled in the ancient myths and religious doctrine, such priests throughout Mesoamerica used their knowledge to calculate what was to come; "with mathematical precision they made adjustments to set their measures of time in accord with the changing reality of the universe."[20] They announced their prophecies at the festivals and other ceremonies and indicated which days were propitious for naming a child, celebrating a wedding, healing a patient, sowing and reaping, or even beginning a war. Society looked to them for direction, and they provided it by interpreting the sacred calendar.

Working with such a complex instrument was not an easy task. The priests were required to determine the augury of each of the 260 days of the sacred round since the essence of the day (kinh, among the Maya) was in itself the prophecy (also kinh).[21] "Once all the influences and interrelationships were fathomed . . . the key to the whole ordered scheme of existence" became apparent.[22] But that was easier said than done. As each of the 260 days was identified by a sign and a number, and each number from 1 to 13 was associated with a god, each day took on the sacred association of the number it bore.[23] In addition, each day-sign was also associated with a god so that the significance of the day was determined by the combination of the two. But the task was still more difficult, for

> *each of the 20 periods of 13 days ("weeks")*
> *. . . also had a patron god. Moreover, each 13-day cycle was accompanied by a sacred volatile. Again, each of the 13 volatiles had a patron god, because these flyers were theriomorphic aspects (theophanies) of the gods. Moreover, the 260-day cycle had a list of deities of the night, which were also patrons of 9 of the day periods.*[24]

Each of these symbolic entities had a prognosticatory value so that priestly divination necessarily involved not only the possession of a large body of knowledge but the ability to understand or intuit the significance of a given entity's symbolic influence on the others associated with a particular date. Thus, the 260-day sacred calender must have "followed an internal logic of allusion and connotations, which was ambiguously structured to allow for intuition in the divinatory horoscope arts, but which also reflected the mysteries of the gods' multiple identities and of astronomical configurations."[25] In short, the calendar was an interface between man's world and the underlying world of the spirit, and the calendar priests, working with what León-Portilla has justly called "a most unusual religio-mathematical vision of the universe, the fruit of highly refined and precise minds,"[26] were approaching as close as possible to divinity itself.

It is no wonder, then, that the complexity exceeded the needs of time measurement and the recording of history and no wonder that the priests became increasingly more powerful and important in the development of the culture.[27] Astronomy became astrology and was used to chart the course of the nation and to guide the lives of individuals. Scholars differ as to whether Mesoamerican man felt trapped by the signs, or was confident that he himself was capable of changing their portent, or felt optimistic that the cyclical and regenerative nature of the cosmos would eventually effect a movement paralleling the sun's journey away from the dark back into the light.[28] Whatever the case, however, each person knew that by virtue of having been born on a particular day of the calendar, he was linked to the supreme order of the cosmos. There is very early evidence on the Danzante sculptures of Monte Albán that people's names were taken from the day names of their birthdate in the sacred calendar,[29] thus indicating a relationship that continued throughout Mesoamerican history between one's very identity and the destiny determined by the augury of the day; "as the *Popol Vuh* economically expresses it: 'one's day, one's birth' was identical with his destiny."[30] Every aspect of life from the realm of the individual to the arena of nations, from the mundane to the sacred, from the specific to the archetypal was included in the complex structure of the calendrical system. In its entirety, it gave abstract form to Mesoamerican religious belief as well as the individual's fears and ideals. It united the past, present, and future and unified the "emotional vision of the religious cosmology"[31] with the mathematical genius of a people. It pulled all knowledge into a multifaceted view of the basic vision with each aspect of the cosmos in its ordered place. Whether it augured well or not in particular cases, its very existence provided reassurance that the universe was indeed in order.

The 260-day calendar reflects the Mesoamerican fascination with cycles as it is a created cycle rather than an observed one. Yet another indication of this fascination can be seen in the integration of individual cycles to form larger and larger, more and more intricate ones. The Maya codices reveal the significance of the 260-day sacred calendar in this effort; they embody one vast divinatory scheme and seek a single goal: to establish an order to human existence by bringing the naturally occurring astronomical cycles into accord with that 260-day calendar. This fundamental unit of time lies at the foundation of every almanac in the codices.[32]

The 260-day calendar itself is, of course, the result of two units of time, the 13- and 20-day periods, running concurrently, and in a similar permutation, the 260-day sacred calendar ran simultaneously with the 365-day solar year to create a 52-solar-year cycle at the completion of which the

beginning date of each calendar again fell on the same date. That mathematically derived 52-year cycle was of great importance throughout Mesoamerica. Called the Calendar Round by Maya scholars, it was of such significance to the Maya that they never indicated dates in heiroglyphic texts or historical documents by the solar year designation alone. Most often, the date was specified by its designation in the Calendar Round. The Aztecs, following the traditions of their predecessors in the Valley of Mexico, referred to the 52-year cycle as a bundle of years or, according to Durán, "a Perfect Circle of Years."[33] The perfection referred to, of course, is the perfection of the completed cycle, and this moment of completion was both a moment of renewal—the beginning of a new cycle—and a potential moment of disaster—the end of the old cycle—since the Aztecs believed that the continuance of the present world age was at that moment in jeopardy.

The importance of the 52-year cycle is nowhere seen more clearly than in the belief that the most important date of all, the end of the cycle of the Fifth Sun, could come only at the end of one of these Perfect Circles. According to Sahagún, the night preceding the inauguration of the new 52-year cycle was filled with anxiety as the priests appointed to that function watched the stars of the constellation Tianquiztli, which we call the Pleiades, for a sign indicating the continuation of the world. "When they saw that they had now passed the zenith, they knew that the movements of the heavens had not ceased and that the end of the world [i.e., the present world age] was not then."[34] Then the inhabitants of the Aztec nation could rekindle their fires, put out in ritual compliance with the end of the cycle, and breathe a collective sigh of relief with the knowledge that life would continue on its present course for another 52 years, a knowledge based on the perfection of the 52-year cycle, which merged the observable, natural cycle of the 365-day solar year with the abstract, spiritual cycle of the 260-day sacred calendar. That merging of the two orders had divinatory implications as well since each of the days of the solar calendar's months was identified with a different deity who influenced its meaning. Thus, each individual day of the 52-year cycle had a somewhat different meaning within the system of divination based on these calendrical cycles; a system aptly characterized as "an intricate mechanism in which each part can influence all the others."[35]

Mesoamerican observers were also aware of other cycles mathematically congruent with the 260-day cycle of the sacred calendar. Venus completed 65 of its cycles every 104 solar years, a doubling of the 52-year cycle called *huehueliztli,* an old age, by the Aztecs who regarded it as significant[36] because it merged again the 260-day cycle

with the cycles observable in the heavens. In the Maya codices, the same tendency can be seen:

In the lunar tables a count of 46 Tzolkins is necessary to create a re-entering moon-phase cycle which fits the possible occurrence of eclipses. The 1,820-day count in the Paris zodiacal table and the 780-day count of the Mars table were probably both chosen because they are exact multiples of the 260-day count.[37]

In addition to all of these cycles, the Maya created an even grander one by merging the solar year with the cycles of creation. Called the Long Count by Maya scholars, this cycle calculated time from a base point in the past which was the beginning of the present world age. According to the Goodman-Martinez-Thompson correlation, this date was August 12, 3113 B.C., from which point in time the present age would last a little over 5,000 years.[38] The Long Count used a number of units of increasing size based on the solar day and the solar year to make these calculations. The smallest unit was the day, and twenty days combined to form a uinal. Eighteen of these monthlike units formed a *tun* or year. Twenty tuns made up a katun, and twenty katuns a *baktun.* There is some disagreement about the existence of larger named units, but large periods of time were measured; periods of millions of years into the past and future were recorded on Classic period monuments. For us, however, the important point is that the Long Count was used "to record the number of days elapsed since the beginning of the current 'Great Cycle'"[39] and was, therefore, another indication of the penchant of Mesoamerican seers to build larger and more complex cycles by combining cycles they were already familiar with. Although the great length of the Long Count might lead us to see it as manifesting a linear concept of time rather than a cyclical one, we know that the Maya did not see it in that way.

In their inscriptions they made a concerted effort to underscore the essential symmetry of time by emphasizing cyclic repetition of time and event. The actions of contemporary kings were declared to be the same as those of their near and remote ancestors and the same as those of the gods tens of thousands—even millions—of years—in the past.[40]

Although the 260-day cycle is very important throughout Mesoamerica, it is interesting and perhaps significant that the two larger cycles we have discussed—the 52-year cycle and the Long Count—share only an association with the solar calendar. In that sense, at least, the sun can be seen again at the very center of Mesoamerican spiritual thought, with its basic cycles of the day and year lying at the heart of Mesoamerican cosmology.

In a fascinating way, this ancient cosmological system shares at least one fundamental assumption

with modern physics despite their totally different purposes. As Nobel Laureate Richard Feynman put it, mathematics provides physics with its only method of understanding the fundamental laws of the physical world. And mathematics similarly provided Mesoamerican spiritual thought with its primary method of comprehending the fundamental laws of the spiritual world. For this reason, "no other ancient culture was able to formulate, as they did, such a number of units of measurement and categories or so many mathematical relations for framing, with a tireless desire for exactitude, the cyclic reality of time."[41] The difference, of course, between our physics and their religion is that we want physical laws and they wanted spiritual ones. But to satisfy their desire, they devised what was the most advanced mathematics in the world at the time, one that used a notational system with place value and the concept of zero. Using only three symbols, this system could, and did, write numbers in the hundreds of millions. With it, the thinkers of Mesoamerica could chart and integrate the regular cycles of time in which their very existence was embedded and thus gain fundamental insight into the most sacred processes of the cosmos. What Giorgio de Santillana and Hertha von Dechend say of the ancient peoples of Europe and the Middle East seems even truer of their counterparts in Mesoamerica. Our forebears, they say, built

> time into a structure, cyclic time: *along with it came their creative idea of Number as the secret of things. . . . Cosmological Time, the "dance of stars" as Plato called it, was not a mere angular measure, an empty container, as it has now become, the container of so-called history; that is, of frightful and meaningless surprises that people have resigned themselves to calling the* fait accompli. *It was felt to be potent enough to control events inflexibly, as it molded them to its sequences in a cosmic manifold in which past and future called to each other, deep calling to deep. The awesome Measure repeated and echoed the structure in many ways, gave Time the scansion, the inexorable decisions through which an instant "fell due." Those interlocking Measures were endowed with such a transcendent dignity as to give a foundation to reality that all of modern Physics cannot achieve; for, unlike physics, they conveyed the first idea of "what it is to be," and what they focused on became by contrast almost a blend of past and future, so that Time tended to be essentially oracular.*[42]

It seems abundantly clear, then, that the peoples of Mesoamerica, in a manner similar to the archaic civilizations of Old Europe and the Middle East, perceived an inner, spiritual reality as metaphorically underlying and supporting the perceptible reality of the everyday world in which they found themselves. This underlying reality was most apparent to them in the regularity of the cycles to which everything in the natural, temporal world seemed to conform. The number and variety of the cycles for which we have evidence of their calculating is striking. In connection with the sun alone, they concerned themselves with the cycle of day and night, the annual cycle of the solstices and equinoxes which was the cycle of seasonal change, the regular occurrence of two zenith passages a year, and probably the regular cycle of dates of potential solar eclipse. They calculated the cycles of the moon as well, both the cycle of lunations and of dates of potential lunar eclipse. With its complex cycle of appearance and reappearance in a changed aspect, Venus fascinated them, and they calculated its periods as well as the moments of its clearest interaction with the sun. And there is evidence that they were interested in the cycles of Mars and perhaps Mercury and Jupiter as well. They also calculated the positions of certain stars in relation to the rising of the sun during the course of the solar year. And it was not only the cycles observable in the heavens which fascinated them. The well-known Mesoamerican obsession with death is, as we have seen, really an obsession with the cycle of life, death, and rebirth which they saw in the corn and in themselves as well as in the heavens. Literally everywhere they looked, both in the heavens and on earth, they saw reality in cyclical motion. In addition to these observable cycles that were charted and calculated and interpreted, the ancient thinkers of Mesoamerica created a cycle based on the permutation of two numerical sequences, thirteen and twenty, and combined their cycle with the cosmic cycles they had observed. With each cycle added to those already known, they must have felt they were coming closer and closer to the essence of divinity, the very principle of spiritual order underlying the universe.

Through the creation of their profound and complex calendrical system, the seers of pre-Columbian Mesoamerica were able to look behind the mask of nature to see the face of divinity itself; and through modern scholarship's study of the system they constructed from what they saw there, "if we look carefully, we can gain a tantalizing glimpse of the supreme mental genius of these people."[43] Hermann Hesse in his greatest novel, *Magister Ludi*, describes the Glass Bead Game, his metaphor for the supreme intellectual construct capable of revealing the spiritual unity of all experience:

> In the language, or at any rate in the spirit of the Glass Bead Game, everything actually was all-meaningful, . . . every symbol and combination of symbols led not hither and yon, not to single examples, experiments, and proofs, but into the center, the mystery and innermost heart of the world, into primal knowledge. . . .

[Each] was, if seen with a truly meditative mind, nothing but a direct route into the interior of the cosmic mystery, where in the alternation between inhaling and exhaling, between heaven and earth, between Yin and Yang, holiness is forever being created.[44]

One cannot help but believe that the shapers of the calendrical system of Mesoamerica would have seen in Hesse's metaphor the perfect description of their profound work.

8 The Life-Force
Source of All Order

All of the strands of Mesoamerican cosmological thought we have discussed have in common a constant attempt to penetrate beneath the surface of life and experience to an inner reality from which the visible world and its endless variety of shapes and forms emanate. Through their ecstatic shamanistic vision and their awareness of the regular, and hence prophetic, cycles of nature, Mesoamerican seers were able to lift the mask of the natural world and discern the features of that sanctified world. The complexity of the seemingly chaotic world the mask of nature presented as reality thus resolved itself into an orderly set of patterns governed by spiritual laws. Proof of the ultimate order of the cosmos came, for example, from their discovery that the annual cycle of the seasons, the organic cycle of plant growth, and the annual astronomical cycle of the sun really merged to form a single cycle governing agricultural activities and their accompanying ritual. Similarly, the solar year, the 260-day sacred year, and the Venus "year" merged to form another ritually significant cycle. Thus, ever-greater and more inclusive systems were formed, a process resulting finally in the metaphoric elaboration of an all-encompassing cosmic system that seemed to their minds capable of sustaining man's existence by generating the spiritual energy necessary to maintain the motion, or life, that characterized the cycles. Just as the heart's pumping of blood through the body symbolized life to the peoples of Mesoamerica, so the divine energy at the heart of this intricately cyclical cosmic system, an energy to which hearts and blood were sacrificed throughout Mesoamerican history, was seen as the vital force of the universe. And this vital force, to those profound thinkers, was the very essence of divinity—what we would call the godhead.

The history of Mesoamerican speculative thought, if it could ever be written, would chart the course of the development of this fundamental conception from its presumptive place of origin at La Venta 3,000 years ago to its final development at Tenochtitlán in the mid-fifteenth century, the time of the Conquest. By that time, this cosmological system had been fully developed by Mesoamerican philosophers and theologians from the assumptions implicit in the world view brought to this continent millennia earlier by its first inhabitants. But that history will never be written because the cultures of Mesoamerica preserved no detailed record of their speculative thought. Mesoamerica's Platos and Aristotles consigned their thought to an essentially oral tradition aided by various forms of glyphic writing,[1] a tradition destroyed by the Conquest. We are left with only tantalizing suggestions of the power and beauty of the fundamental conceptions that shaped it.

It is fascinating to observe Mesoamerican scholars grappling with the problem of defining those conceptions. From Seler's monumental studies at the turn of the century to the work of Beyer, Caso, León-Portilla, Hvidtfeldt, Nicholson, and Thompson to the more contemporary work of such scholars as Hunt, Flannery, Marcus, Pasztory, and Schele and Miller, a relatively consistent view of the basic tenets of Mesoamerican cosmological thought emerges, but that view is often couched in strikingly different terms. All of these scholars suggest the existence of something akin to a divine essence that provided the foundation for all reality and manifested itself in the vast number of so-called gods making up the Mesoamerican "pantheon." As Eva Hunt describes it, "Reality, nature, and experience were nothing but multiple manifestations of a single unity of being. God was *both* the one and the many. Thus the deities were but his multiple personifications, his partial unfold-

ings into perceptible experience."[2] She calls this system of beliefs pantheism as does Beyer in speaking of the god of fire,[3] but he also sees Tonacatecuhtli, the old creator god, as "a substitute for monotheism,"[4] whatever, precisely, that might mean. In speaking of the Maya, Thompson also uses the term *monotheism* but is similarly hesitant, saying that "there is some evidence for something approaching monotheism among the ruling class during the Classic period."[5] Caso, too, flirts with monotheism.

> The origin of all things was a single dual principle, masculine and feminine, that had created the gods, the world, and man. . . . If this is not a true monotheistic attitude because it still acknowledges the existence and worship of other gods, it does indicate that . . . the philosophical desire for unity had already appeared.[6]

Pasztory, however, in speaking of the same dual principle, contends that it "might seem in opposition to polytheistic belief, but such is not the case. Implicit in the view that all nature is animated spiritual power is the idea of unity within multiplicity."[7] Thus, pantheism, monotheism, and polytheism have all been used to designate the same set of beliefs; and Arild Hvidtfeldt borrows the term *mana* from Melanesia in his statement of an essentially similar view.[8]

We are fortunate that the use by scholars of such diverse terms, some of them contradictory, suggests a great deal more disagreement about Mesoamerican religion than actually exists. The problem of terminology arises at least in part from the attempt to use terms descriptive of European, Middle Eastern, and Far Eastern religious concepts for a unique religious structure that grew independently from those religions. Perhaps the best solution to this problem is simply to describe the features of Mesoamerican cosmological thought without characterizing those beliefs with a label. H. B. Nicholson, for example, simply notes that Aztec religious thinkers may have seen Ometeotl as a fundamental divinity of which "all the deities may have been considered merely aspects."[9] Irene Nicholson concurs, stating "that the many gods were only manifestations of one and the same all-powerful deity" and concluding that Aztec poetry contains "ample evidence to support this view."[10] Thus, León-Portilla's advice "to outline a specific interpretation of Nahuatl thought"[11] instead of using broad descriptive terms seems well founded and equally applicable to Mesoamerican thought as a whole.

At least two profound difficulties lie in the way of following this advice, however. First, of course, is the problem of reducing to a concept a culture's most fundamental notions about the ultimate ground of being, what India's Kena Upanishad describes, after all, as "what cannot be spoken with words, but that whereby words are spoken. . . . What cannot be thought with the mind, but that whereby the mind can think. . . . What cannot be seen with the eye, but that whereby the eye can see. . . . What cannot be heard with the ear, but that whereby the ear can hear."[12] By its very nature, the ground of being cannot be conceptualized by beings in time, neither those of pre-Columbian Mesoamerica nor those who study its thought. What mankind has always done is to create metaphors based on local experience to communicate the particular culture's limited perception of that reality. But as those who study literature and the arts know full well, a metaphor communicates in a way fundamentally different from the way of rational discourse in which speculative thought is generally embodied. The metaphor momentarily fuses two disparate areas of experience, in this case, allowing man's experience to provide the terms for a description of the ground of that experience.

These metaphoric descriptions, both visual and verbal, when taken together comprise a mythology, defined by Joseph Campbell as "an organization of symbolic images and narratives metaphoric of the possibilities of human experience and development in a given culture at a given time."[13] It is the task of the visionary creative mind, then, to draw those images from a mystical experience of the essence of divinity, an essence that can only be recreated through metaphor. As Campbell says, "As far as I know, in the myths themselves the origins of their symbols and cults have always been attributed to individual visionaries—dreamers, shamans, spiritual heroes, prophets, and divine incarnations."[14] The mythology comprised of those metaphoric images is capable of creating "an epiphany beyond words"[15] embodying the fundamental cosmological thought of a culture in its most basic form. The rational discourse of speculative thought attempts, however, to characterize the "meaning" of the metaphor in abstract terms, a profoundly difficult task.

Such a characterization is extremely difficult even when the area being studied is very fully known and the nuances of symbolic meaning are clear—our culture's attempt to reduce the central mystery of Christianity to concepts would provide an apt example of those difficulties—but that difficulty is multiplied when the area of study is little-known. That is precisely the second problem in conceptualizing the fundamental beliefs underlying Mesoamerican cosmological thought. We are studying, after all, the religion of a civilization that created the fabulously complex series of metaphors we have described to embody its essentially religious concepts of space and time, life and death, and the relationship between man and god but a civilization that did not record its speculative thought. We know that such thought existed, but we do not know the terms in which it was cast.

Consequently, we must describe it with terms derived from the descriptions of other systems of thought, leading to the bewildering array of terms. León-Portilla is clearly correct in calling for a "specific interpretation" of Mesoamerican thought.

The widespread agreement of Mesoamerican scholars suggests that such an interpretation must rest on the fundamental conception of the godhead as an incorporeal essence, simultaneously transcendent and immanent, giving rise to and sustaining all reality. Precisely such a conception is found at the heart of the best-documented cosmological thought in pre-Columbian Mesoamerica. Among the Nahua peoples of the Valley of Mexico at the time of the Conquest,

> perhaps evolving out of the sun and earth cults, the belief in an all-begetting Father and a universal Mother, as a supreme dual deity, came into being. Without losing his unity in that the ancient hymns always invoke him in the singular, this deity was known as Ometeotl, 'The Dual God,' He and She of our Flesh, Tonacatecuhtli and Tonacacíhuatl, who in a mysterious cosmic coition originated all that exists.[16]

The simultaneous unity and duality of Ometeotl is of the same order of mystery as the Christian Trinity; the difference between the two can be seen in the Mesoamerican use of the natural, sexual metaphor of the union of the two sexes in one creative being. Such a union suggests the basic nature of the duality at the heart of Mesoamerican thought; it is always the duality of the cyclical, regenerative forces of the natural world. Male and female are "opposed" forces merging to create life. That this metaphor suggested a continuous and therefore cyclic "act" of creation is perhaps most clearly seen in the words addressed by Aztec midwives to newborn children:

> Thy beloved father, the master, the lord of
> the near, of the nigh, the creator of men,
> the maker of men, hath sent thee; thou hast
> come to reach the earth.[17]

In a similar way, life itself is opposed to death, the two merging to form the cyclical reality of all existence for the peoples of Mesoamerica—the reality of human life, the life of the corn, the life of the sun, and the life of the cosmos. Thus, out of the unity of the divine essence, the "opposed" forces of male and female mysteriously emerge to create a world in their image, a creation metaphorically likened to birth through its use of the human process of reproduction as a paradigm but which is perhaps better described by León-Portilla and Hunt as "an unfolding," that is, a manifestation on other levels of reality of the multiplicity inherent in the essence of divinity, "the self-transformation of an originally undifferentiated, all-generating divine Substance."[18] This is a familiar mythological metaphor, but it takes on particular inflections in its American incarnations. As Campbell points out in a study of Navajo ritual, "in all mythology the several aspects of the divinity may separate into independent personages. Since the Navaho emphasis is upon the color-inflections of the four quarters, the divinities have a way of appearing suddenly fourfold, then suddenly singlefold again."[19]

That Navajo conception no doubt has roots in the high cultures of the Valley of Mexico before the Conquest since for the Aztecs, for example, the unfolding of the unitary divine essence into male and female entities who exist simultaneously with the unitary Ometeotl is followed by a further unfolding that brings into being Tezcatlipoca, Smoking Mirror, generally considered the most significant and most powerful of the gods. But just as Ometeotl, the ultimate ground of being, is at once unitary and dual, Tezcatlipoca is similarly mysteriously unitary, dual, and quadripartite. As half of a duality, Tezcatlipoca, Smoking Mirror, finds his opposite in Tezcatlanextia, Mirror Which Illumines. Tezcatlipoca is thus associated with the night with its obscured vision, while Tezcatlanextia is linked to the day illumined by the sun. The fact that "Tezcatlipoca and Tezcatlanextia (double mirror which envelops all things with darkness by night and illumines them by day) constituted a double title for Ometeotl in the remotest times of Nahuatl culture"[20] makes clear the nature of the process we have characterized as unfolding. Tezcatlipoca is both created by and identical to Ometeotl. He is a manifestation of the divine essence characterized as Ometeotl on another plane. Significantly perhaps, the Ometeotl duality uses the union of the male and female as its metaphor for creativity, while the Tezcatlipoca duality uses the union of day and night. These are, of course, the two clearest manifestations of cyclical rebirth in human life.

But Tezcatlipoca is, in addition, quadripartite—a quadripartite manifestation of the divine, each of whose four aspects is associated with a color, a cardinal direction, and a separate deity; he is defined, in short, by precisely the same four-part figure we have discussed earlier as the fundamental space-time paradigm. The symbolic meaning is clear: in that sense, at least, Tezcatlipoca *is* the created world. Each of the four separate deities may thus be seen as a manifestation of Tezcatlipoca, and as such, each shares with him the creativity characteristic of Ometeotl but on still another plane. These four deities are Quetzalcóatl, the white Tezcatlipoca who is associated with the west and who was widely seen as the creator of human life; Xipe Tótec, the red Tezcatlipoca associated with the east and the creative power that provided man's sustenance, the corn; Huitzilopochtli, the blue Tezcatlipoca, the warrior of the south who was responsible for the creation and maintenance of the Aztec

state; and the black Tezcatlipoca, the warrior of the north who is Tezcatlipoca himself who thus exists as the unitary being who unfolds into four, as one unit of a duality, and as one of the four divisions of Tezcatlipoca.

The quadripartite nature of Tezcatlipoca is also characterized by duality, opposing aspects merging to form a unity. As one of the four divisions of the unitary Tezcatlipoca, the black Tezcatlipoca is opposed in different ways to each of the others. In his role as the nocturnal sun of the underworld, the black Tezcatlipoca is opposed to Huitzilopochtli, who is associated with the blue sky of the daytime sun, and his similar opposition to Quetzalcóatl, the morning star, is recounted in one of the basic Nahua myths. As a warrior, Tezcatlipoca plays an opposed role to that of Xipe, the fertility god. But in each case, both he and the god to whom he is opposed are integral parts of the unitary Tezcatlipoca from whom they "unfolded." But there is still more oppositional structure here. The south-north, zenith-nadir vertical axis of the space-time paradigm is anchored by Huitzilopochtli and Tezcatlipoca—warrior gods concerned with the cosmic power underlying the course of the sun. It is to Huitzilopochtli in his temple at the zenith or "southernmost" point of the pyramid, after all, that hearts were offered to maintain the vitality of that same sun. The east-west, horizontal axis of the paradigm, the axis that defines the earthly state, is anchored by Quetzalcóatl and Xipe Tótec, both associated with the creation and maintenance of human life on the earthly plane. These oppositions that give "shape" to Tezcatlipoca's quadripartite nature therefore also suggest the cyclical merging of opposed forces which underlies all of Mesoamerican cosmological thought.

Further confirming the closeness of the black Tezcatlipoca to the essence of divinity is the fact that in each of these relationships of structural opposition, he is associated with night or death, both evocative to the Mesoamerican mind of the mystery enshrouding the essence of divinity. One of the names given the black Tezcatlipoca, Yohualli, means night, and when this aspect of the black Tezcatlipoca is opposed to the aspect of Quetzalcóatl referring to the wind, Ehécatl, the title Yohualli-Ehécatl, an appellation of the unitary Tezcatlipoca, is created, a title that is the equivalent of Tloque Nahuaque, another of Tezcatlipoca's "names," meaning "the one who is the very being of all things, preserving and sustaining them,"[21] that is, the designation of Ometeotl referring to him as the ultimate ground of being. The name Yohualli-Ehécatl, as Sahagún indicates, "symbolically means 'invisible' (like the night) and 'intangible' (like the wind)" and refers to the "invisible and impalpable reality" of the essence of divinity.[22]

The association of the black Tezcatlipoca with north reinforces this identification of Tezcatlipoca

with Ometeotl. As we have seen, north as a cardinal point was the equivalent in the Mesoamerican mind of the nadir position of the sun, which in turn symbolized the subterranean realm of the spirit. Ometeotl, the essence of divinity, was thought to be found in Omeyocán, the Place of Duality, the highest of the celestial levels and the spiritual counterpart of the sun's zenith position. Thus, "Ometeotl was merged with the sun god, Tonatiuh, the symbol of godhead *par excellence*,"[23] so that Tezcatlipoca can be seen as the complementary opposite and thus the fulfillment of Ometeotl. In a number of ways, then, it can be seen that the unitary Tezcatlipoca is actually a manifestation of the abstract Ometeotl, and in the same way the Black Tezcatlipoca is a manifestation of the unitary Tezcatlipoca. This majestic metaphor that depicts the divine essence manifesting itself through successive unfoldings into human reality defined, for the cultures of the Valley of Mexico, the relationship between man and god.

A part of that definition involves the demarcation of various levels of spiritual reality. Ometeotl was "the personification of godhead in the abstract."[24] No idols were made of his figure, and he was not the focus of ritual activity. Tezcatlipoca, while having many of the same functions as Ometeotl and even being designated by many of the same names, existed on a less abstract level and was thus more accessible to man. His image is often found in religious art, and he was impersonated in ritual and addressed in prayer. In the same way, the black Tezcatlipoca is a manifestation of the Tezcatlipoca essence on still another level. Each unfolding of the divine essence thus creates another level of spiritual being, and each succeeding level is somewhat more accessible through ritual. Thus, all of these so-called gods are ultimately manifestations of a single divine essence rather than having the wholly independent existence that the idea of a god often suggests. They are perhaps best thought of as serving specific ritual functions and allowing the definition of specific spiritual realities and are thus spiritual "facts" of a very different sort from the gods imagined by the Spaniards of the Conquest. To see them as their creators did, we must understand this Mesoamerican conception of the world of the spirit.

As one would expect, a fundamentally similar conception prevailed among the Maya. In the Yucatán and perhaps elsewhere, Hunab Ku was believed to be "the only live and true god. . . . He had no image because they said that being incorporeal, he could not be pictured."[25] Like Ometeotl, Hunab Ku created ritually accessible deities but was not himself the focus of ritual, and directly paralleling the conceptions of central Mexico, Hunab Ku gave rise to Itzamná, a quadripartite deity. This unfolding was sometimes seen as a birth, Itzamná being "worshipped as the son or solar manifestation of

the supreme and only god, Hunab Ku."[26] Itzamná, like Tezcatlipoca, was associated with colors and directions: the red Itzamná with the east, the white with the north, the black with the west, and the yellow with the south. In addition, Itzamná, as we have seen, literally means Iguana House, and the quadripartite deity was imagined as four iguanas standing upright at the cardinal points, each forming one of the walls of the "house" of the universe, with their heads together composing the roof. Thus, "Itzma Na, 'Iguana House,' is in effect the Maya universe"[27] in the same way that Tezcatlipoca was the four-part space-time paradigm. Seen in another way, Itzamná was a dual god representing the "opposed" realities of earth and sky; his earth aspect was Itzam Cab (the name Itzamná referred to the celestial aspect), paralleling again the central Mexican conception of Tezcatlipoca unfolding into aspects, one of which is Tezcatlipoca. According to Thompson, "the Itzam in their celestial aspect are senders of rain to earth, in their terrestrial aspect they are the soil in which all vegetation has its being, and now they receive that rain which formerly they dispensed from on high."[28] They are, then, the very process of life itself as well as the cosmos that encloses that life-force.

Clearly, then, the peoples of the two culture areas of Mesoamerica about which our knowledge is most complete, the Valley of Mexico and the Maya region, especially the Yucatán, held the same basic conception of godhead and its manifestation in the worlds of spirit and matter. Both conceived of a divine essence or spirit temporally and spatially coterminous with the universe, which was by its very nature the life-force itself as well as the motion that signified life. It is fascinating to note here that while the evidence of speculative thought among the Zapotecs of Oaxaca is exceedingly scanty, Joyce Marcus is able to contend, in the currently definitive work on the region, that while the Zapotecs were not monotheistic, "they did recognize a supreme being who was without beginning or end, 'who created everything but was not himself created,' but he was so infinite and incorporeal that no images were ever made of him."[29] This would accord with Boos's observation that certain symbols on Zapotec urns "implied the presence of a hidden, anonymous god, of whom the figure on the brazier or urn was a mere manifestation."[30]

Thus, it seems reasonable to assume that this conception of godhead was Pan-Mesoamerican, that were our knowledge of other areas, Veracruz, for example, more complete, we would find similar ideas of a divine essence manifesting itself through a process of unfolding into levels of reality that man could approach through ritual. And not only was this fundamental religious conception found throughout Mesoamerica, Joralemon also feels that at least a part of it can be traced back in time to the Olmecs. Itzamná, he holds, "is entirely homologous with the Olmec dragon." Both are associated with the heavens and rain as well as the earth and fertility; "both function as fire gods and both are closely related to kingship and royal lineage."[31] Furthermore, it would seem likely that if the Olmecs did in fact have a counterpart to Itzamná, they probably also conceived of a divine essence from which this deity unfolded, a conception that clearly seems to underlie Mesoamerican cosmological thought in every phase of its development and that may well have an Olmec origin as the hints of quadriplicity in Olmec masks suggest.

Understanding this basic principle of divinity unfolding itself into the world makes clear the reason for the existence of the seemingly innumerable gods of the Mesoamerican pantheon. Rather than being gods, each with an independent existence, related to each other in a pantheon as the Spanish believed since they applied to Mesoamerican religion a model derived from Greek and Roman religion (the form of paganism they already knew, or thought they knew), these "gods" were actually manifestations of the essence of divinity called into "existence" for specific ritual functions and fading back into the generalized world of the spirit at other times.[32] While there may have been "among the uneducated classes a tendency to exaggerate polytheism by conceiving of as gods what, to the priests, were only manifestations or attributes of one god,"[33] priestly thought saw mankind as immersed in a world of spirit that could take on a seemingly endless number of specific shapes and forms called gods. As Townsend says,

> There is a rainbow-like quality to these supposed gods of Mesoamerica; the closer one searches for a personal identity so vividly displayed by the anthropomorphic deities of the Mediterranean world, the more evanescent and immaterial they become, dissolved in mists of allusion and allegory with which Mexica poets and sculptors expressed their sense of the miraculous in the world about them.[34]

Many of these so-called gods, especially those that played a large part in the ritual life of the common man, were no doubt abstractions of natural forces;[35] often, in fact, "metaphoric cult names [that] were regarded by the Spanish as the specific names of gods and goddesses . . . do not seem to describe supernatural personages as much as they seem directly to describe natural phenomena, period, without the idea of an intermediary god or goddess."[36] These cult names designated "the very forces of nature with which peasants are so respectfully intimate"[37] but were also, as Beyer suggests, "religious and philosophical ideas of a much more highly advanced level" among the priestly class.[38] Thus, the "gods" described by the Spanish chroniclers were the multitudinous gods of the common man; the spiritual conceptions of the religious and

philosophical thinkers of Mesoamerica are hidden behind and within those chronicles of the popular religion; and it is the task of modern analysis of the myths and rituals of Mesoamerican spirituality to bring them forth.

But that can be done only through an understanding of the system in which these gods function, a system that the peoples of Mesoamerica believed to be driven by a dynamic, spiritual force operating in and on all aspects of the seen and unseen world.

> Since the divine reality was multiple, fluid, encompassing the whole, its aspects were changing images, dynamic, never frozen, but constantly being recreated, redefined. This fluidity was a culturally defined mystery of the nature of divinity itself. Therefore, it was expressed in the dynamic ever-changing aspects of the multiple "deities" that embodied it.[39]

This state of kaleidoscopic change was not as bewildering as it might seem, however, as it was governed by the constancy of the divine essence or spirit that manifested itself through each of the transformations composing that fluidity. This divine essence, as we have suggested earlier, was the life-force itself, that mysterious force which showed itself in every aspect of the cosmos. Everything, for the peoples of Mesoamerica, was charged with the vitality emanating from that life-force, and therefore everything could be seen as a manifestation, created through transformation, of it. Thus, the most profound mystery in Mesoamerican spiritual thought is the conception of that essence as simultaneously separate from the world and the most fundamental force in the world. In its existence in the world, it wore the "mask" of this world's beings, and it was only in that "masked" form that it could be approached.

9 Transformation
Manifesting the Life-Force

For the Mesoamerican seer, "cosmic creation is not something that happened only once: it has to happen constantly, over and over again. Every day is a day of creation"[1] because each day, each moment, in fact, the immanent life-force clothes itself anew in the finery of the gods and in the things of this world. It does so through the mystery of transformation and through that mystery is simultaneously the one and the many, the eternal and the temporal. In a very important sense, the entire effort of Mesoamerican spiritual thought is dedicated to the delineation through metaphor of the various specific processes of that mystery of transformation.

In the ninth chapter of the sixth book of the *General History of the Things of New Spain*, Sahagún's informants give us

> the words which the ruler spoke when he had been installed as ruler, to entreat Tezcatlipoca because of having installed him as ruler, and to ask his help and his revelation, that the ruler might fulfill his mission. Very many are his words of humility.
>
> "O master, O our lord, O lord of the near, of the nigh, O night, O wind, thou hast inclined thy heart. Perhaps thou hast mistaken me for another, I who am a commoner; I who am a laborer. In excrement, in filth hath my lifetime been. . . . Why? For what reason? It is perhaps my desert, my merit that thou takest me from the excrement, from the filth, that thou placest me on the reed mat, on the reed seat?
>
> "Who am I? Who do I think I am that thou movest me among, thou bringest me among, thou countest me with thy acquaintances, thy friends, thy chosen ones, those who have desert, those who have merit? Just so were they by nature; so were they born to rule; thou has opened their eyes, thou hast opened their ears.

> And thou hast taken possession of them, thou hast inspired them. Just so were they created, so were they sent here. They were born at a time, they were bathed at a time, their day-signs were such that they would become lords, would become rulers. It is said that they will become thy backrests, thy flutes. Thou wilt have them replace thee, thou wilt have them substitute for thee, thou wilt hide thyself in them; from within them thou wilt speak; they will pronounce for thee—those who will help, those who will place on the left, who will place in obsidian sandals, and who will pronounce for thy progenitor, the mother of the gods, the father of the gods, Ueuetéotl, who is set in the center of the hearth, in the turquoise enclosure, Xiuhtecutli, who batheth the people, washeth the people, and who determineth, who concedeth the destruction, the exaltation of the vassals, of the common folk."[2]

This remarkable ritual entreaty outlines one of those transformational processes, in this case involving rulership, through which Ometeotl, the divine essence, referred to here as "thy progenitor," that is, the creator of Tezcatlipoca, manifests itself in human life. That divine essence, seen here in two of its aspects, is the creative principle—"the mother of the gods, the father of the gods"—as well as the life-force itself represented as Ueuetéotl, the old god who is "life-giving warmth, the vivifying principle, . . . the sacred perpetual fire."[3] The outline of that transformational process is suggested in the newly installed ruler's depiction of himself as one of those who will "pronounce for thee," that is, Tezcatlipoca, and simultaneously "pronounce for thy progenitor," that is, Ometeotl. Significantly, it is Tezcatlipoca, the manifestation of the divine essence approachable through ritual, who is addressed, but it is also significant that the new ruler is not to be seen as a human being ad-

dressing a god from whom he is essentially separate. Rather, he is one of a line of rulers who, in some mysterious sense, shelters the god: "thou wilt hide thyself in them; from within them thou wilt speak." Thus "thy progenitor," who is located at "the center of the hearth, in the turquoise enclosure," a metaphoric reference to what is elsewhere referred to as "the navel of the earth," the symbolic center of the earth from which the primary axes of time and space radiate, manifests itself successively *and* simultaneously as the all-powerful Tezcatlipoca, as the earthly plane itself, and as the earthly ruler. It is important to note that the ritual entreaty takes care to indicate that this transformational process functions systematically. Rulers were not selected on the whim of a capricious god; rather, "their day-signs [in the tonalpohualli] were such that they would become lords, would become rulers." Thus the gods, the earthly realm in all of its spatial-temporal complexity, and the earthly ruler are all to be seen as systematic transformations of the essence of divinity.

Schele and Miller identify this same process in Maya ritual art depicting the bloodletting and vision quests of Maya nobles. "Images of these rites show humans wearing full-body costumes, including masks, to transform themselves symbolically into gods. These scenes do not appear to represent playacting but, rather, a true transformation into a divine being."[4] No matter that from the Maya point of view the transformation is reversed—the god is transformed into a human being. It is remarkably clear that the divine essence, constant and unchanging, enters the world of nature by transformation. Thus, paradoxically, the godhead is at once transcendent and immanent, continually "unfolding" and evolving, revealing itself successively to man in changing images he calls "gods" and rulers.

Such a use of the mask as a ritual agent of transformation is described clearly by a modern Hopi who has participated in the Hopi kachina ceremonies, which are now believed to have arisen as the result of diffusion from central Mexico in Toltec times.

> What happens to a man when he is a performer is that if he understands the essence of the kachina, when he dons the mask, he loses his identity and actually becomes what he is representing. . . . The spiritual fulfillment of a man depends on how he is able to project himself into the spiritual world as he performs. He really doesn't perform for the third parties who form the audience. Rather the audience becomes his personal self. He tries to express to himself his own conceptions about the spiritual ideals that he sees in the kachina. He is able to do so behind the mask because he has lost his personal identity.[5]

That simple last sentence expresses both the power and the essence of the Native American system of religious thought as it embodies the inherent potential of transformation. The power is also suggested by the remarkable ability of that system—whose roots we can dimly discern in the shamanism of the Preceramic period and whose fully elaborated, sophisticated body of thought we can perceive at the height of the development of the cultures of Mesoamerica—to survive in indigenous ritual and belief throughout the Americas. The Aztec ruler, the Maya noble, and the Hopi kachina dancer have all been transformed through ritual to another level of existence; they are functioning on a sacred, spiritual plane. They have "become" gods, or gods have "become" them. Our language has difficulty expressing the concept as it is clear that "becoming" in this sense has both diachronic and synchronic meanings; it means both changing from one state to another as well as functioning on one of several levels, all of which exist simultaneously.

It is in this latter sense that the Hopi loss of personal identity is primarily meant. "By donning the kachina mask, a Hopi gives life and action to the mask, thus making the kachina essence present in material form. . . . By wearing the kachina mask, the Hopi manifests the sacred. He becomes the sacred kachina, yet continues to be himself."[6] This is perhaps the most essential form of transformation—one that does not require abandoning one state for another but allows them all to exist simultaneously. Such a view sees life as a matter of the constant interpenetration of different planes of existence, a concept that is difficult for us to grasp because we tend to conceive of reality as linear and to think in that fashion. For us, one state of being gives way to another as on a journey one place after another is reached. Our conception of reality limits the idea of transformation to its simplest level, while the Mesoamerican conception expands the range of transformational possibilities tremendously. Soustelle puts it well:

> The world is a system of symbols—colors, time, the orientation of space, stars, gods, historical events—all having a certain interacting relationship. We are not faced with a long series of ratiocinations, but rather with a continuous and reciprocal complex of the various aspects of a whole.[7]

Thus, transformation is not only the essential process by which everything man perceives is revealed but also a basic characteristic of existence, and man is not only the recipient of life through the mystery of transformation but he must play his part in the transformational drama through ritual. It is no wonder, then, that the mask, a visual symbol of and an important agent in the transformative process as we have seen, became a central metaphor in Mesoamerican spiritual thought.

That the concept of transformation is basic to

Mesoamerican spiritual thought can be seen in those characteristics of that thought that we have thus far examined. First, the shamanistic inner vision from which that thought grows sees magical transformation as the method by which man can interact with the enveloping world of the spirit. By changing into an animal or by being catapulted through his trance into a level of consciousness, a mythical time or place, or a spiritual zone not accessible to the ordinary person, the shaman could transcend his human limitations and gain insight into the cosmic order. In the world of the shaman, the elements that constituted man, nature, and the spiritual world were readily interchangeable. This basic assumption with all its transformational implications was at the heart of Mesoamerican spiritual thought, in which, as Townsend puts it, "the boundaries between objective and perceptive become blurred, dream and reality are one, and everything is alive and intimately relatable."[8]

Second, the temporal order manifested in the solar cycles, the other astronomical cycles, and the cycles of generation, death, and regeneration seemed proof to the Mesoamerican mind that there is no death in the world, only transformation; there is no end to life, only changing forms, changing masks placed on the eternal and unchanging essence of life. The transformative process is conceptualized in Mesoamerican thought as the orderly movement of time through recurring cycles. Life, which is always in motion, is born from death and returns to death to complete the cycle. Great men, at death, are transformed into gods, their divine power taking on a different form; when the common man dies, he, like the corn that nourished him, returns his life-force to its source, which in turn creates new life.

Third, the spatial order derived from the regular movements of the heavenly bodies suggests a different kind of transformation—that of the macrocosmic order into a pattern for the microcosm seen in the replication on earth of the heavenly pattern in the siting and architecture of the great cities and ritual centers, from La Venta in 1200 B.C. to Tenochtitlán in A.D. 1400. In addition to reproducing the divine "shape" of space and time in their architecture, the creators of those heavenly patterns on earth were continually fascinated with the points of transition from the earthly plane to the realms of the spirit above and below that plane, liminal points locating in space what are essentially temporal experiences, such as death itself, which mark the precise moment of transformation. These places were to be found in nature in caves or on mountaintops, both of which were used as settings for the ritual that marked the transition between matter and spirit, between life and death. Thus, the physical features of the earth itself, features replicated in sacred architecture and marked

by masks, were seen as agents of transformation throughout Mesoamerica.

Fourth, the calendars of Mesoamerica embody in abstract form the whole process of transformation; they depict graphically the movement of time through the many phases of its process, each metaphorically expressed by the face of a god and the sign of the day. Through his understanding of that abstract movement, man could harmonize his existence with the underlying cosmic order through divination and ritual. The moments of transformation in man's microcosmic life—his own birth, initiation, and death; the corn's planting and harvesting; his ruler's ascension and death—could be given their proper place in the orderly, recurring transformative process of the cosmos through the calendars that give form to the Mesoamerican realization that the essence of time, change and transformation, could be mathematically charted and understood.

Fifth, all of these manifestations of the basic process of transformation, we have shown, had their source in a unitary divine essence that, through the transformative process of "unfolding," mysteriously became an elaborate system of "gods." These "god identities" were not always transformed temporally, that is, first one and then another in a diachronic process, but often exhibited a synchronic totality, being both states simultaneously. The Mesoamerican "god image" is thus essentially a set of symbols, each of which can exist simultaneously in many relationships, that "unfolds" as different and separate identities. The kaleidoscopic pantheon is the result of transformations of the divine essence, which "works" through the transformation of itself into the worlds of the gods and of space and time.

A fundamental premise of Mesoamerican spiritual thought, then, was the interchangeability through transformation of the inanimate, the human, and the divine as all were ultimately transformations of the same unchanging essence. Through these symbolic transformations, the very structure and order of the universe could be understood and human life could be harmonized with the sacred order. Since this transformative process is fundamental, it is not surprising that we find transformation rather than creation ex nihilo at the heart of the Mesoamerican mythological tradition. Just as the world of the spirit enters man's world through the various transformative processes we have cited above, so the original creation of matter from spirit was accomplished through transformation. In Aztec myth, for example, natural phenomena metaphorically come into being as a result of transformation: trees, flowers, and herbs from the hair of the Earth Monster; flowers and grass from her skin; wells, springs, and small caves from her eyes; rivers and large caves from her mouth; moun-

tain valleys from her nose; and mountains from her shoulders. And as we have seen, it is transformation rather than creation that is responsible for the birth of the sun as the result of the god Nanahuatzin leaping courageously into the great fire and becoming the sun. Man himself was created, according to one widely accepted mythological version, as the result of the transformation of the bones and ashes of earlier generations by Quetzalcóatl and his nahualli, or alter ego, who went into the underworld to collect them and then, by dripping over them blood ritually extracted from his penis, transformed them into the first male and female from whom all mankind was born.[9] The import of the myths is clear: through the process of transformation, the divine essence manifests *itself* as the created world, a world that seems material but is essentially spirit.

As it is with man's world, so it is with man himself. True to its shamanic base, Mesoamerican spiritual thought sees man as spirit temporarily and tenuously housed in a material body. "Soul loss" is a constant possibility, and curers from pre-Columbian times to the present have been called on to reunite body and spirit.[10] That spirit/matter dichotomy is represented metaphorically throughout the history of Mesoamerica and for most indigenous groups today by the belief that each person has a companion animal who somehow "shares" his soul. This animal is sometimes thought to be living in the temporal world but is more often thought to exist in the world of the spirit—often, significantly, inside mountains. Vogt vividly describes this concept in its present formulation in the Maya community of Zinacantan.

Rising up 9,200 feet to the east of the ceremonial center of Zinacantan is a majestic volcano called BANKILAL MUK'TA VIZ (Senior Large Mountain). Within this mountain a series of supernatural corrals house the approximately 11,400 wild animal companions of the Zinacantecos, one for each person. The corrals contain jaguars, coyotes, ocelots, and smaller animals such as opossums and squirrels. There is no abstract term in Tzotzil for these animals; CON is the general noun for "animal," and using the adjectival form one refers to "the animal of so-and-so" as "SCANUL---" when talking about one's animal companion. These animals are watered, fed, and cared for by the ancestral gods, under the general supervision of the Grand Alcalde, who is the divine counterpart of the highest ranking member of the religious hierarchy in Zinacantan. His home is located inside the mountain and his household cross is the shrine that Zinacantecos visit in the course of rituals on top of the mountain. A Zinacanteco and his animal companion are linked by a single innate soul. When the ancestors install a C'ULEL in the embryo of a Zina-canteco, they simultaneously install the same innate soul in the embryo of an animal. The moment the Zinacanteco is born, the animal is also born. Throughout their lives, whatever happens to either human or animal also happens to his alter ego. . . . It is usually during childhood or early adulthood that a person discovers what kind of animal companion he has. He receives this knowledge either in a dream, when his innate soul "sees" its companion, or from a shaman, when an illness is diagnosed.[11]

Clearly, the Zinacanteco sees himself as living simultaneously on the surface of the earth as a physical being and within the mountain as a spiritual being. The relative importance of the two forms of being can be gauged from his defining the significant problems that might beset him on the surface of the earth as soluble, in shamanic fashion, only within the mountain. What we would take to be physical, psychological, or social problems are seen in Zinacantan as *spiritual* problems. It is one's spirit-self—not his physical being—that must be healed. The lack of an abstract term in their language for these animal companions as a group seems to suggest that the identity of person and animal is so close that the animal companion cannot readily be thought of as an independent entity; it is a metaphor for the spirit and remains, among the Zinacantecos and other indigenous groups, transparent to transcendence. James Dow suggests the significance of this belief in his discussion of shamanic healing practices among the Otomí of the Sierra de Puebla.

These concepts [of the tonal and nagual] have a profundity that is not immediately apparent. They link man to nature and recognize that his fate is like that of other animals. They also proclaim that his fate depends on conflicts waged in a special mythic world, the world of the tonales and naguales. Where is this world? The Otomí talk about it being in the mountains, which are governed by an order of nature that is different from the order of humans.[12]

Although today's Zinacantecos and Otomís are nominally Christian, this metaphor for their spiritual selves, like many of their other beliefs and rites, obviously has a pre-Columbian origin. The original concept is best understood today as it existed among the Nahuatl-speaking peoples of the Valley of Mexico since that form was documented best by the Spanish conquerors. Called the nahualli in Nahuatl, the companion animal of pre-Columbian Mesoamerica had more clearly defined transformational qualities than exist today in communities such as Zinacantan, although other indigenous groups retain the idea of magical transformation. So much were those qualities a part of the original concept that, according to George Foster, *nahualli* "originally referred to the sor-

cerer in his transformation as his guardian animal, whereas the guardian animal itself was designated by the word *tonalli* or *tonal.*"[13] That potential of transformation from a person to his nagual or nahualli strongly suggests their interrelated destinies, but there is an even stronger implication of that interrelationship when the guardian animal is referred to as the tonal or tonalli since the latter term makes the obvious association with the 260-day calendar, the tonalpohualli, which, as we have shown, indicated a person's destiny by virtue of the signs and gods associated with his day of birth and with his name day. Thus, the idea of the companion animal was intimately associated with the divinatory calendar and its implicit assumption that a person's destiny was not to be found in this world but in an understanding of his spirit-self, represented metaphorically by the companion animal.

While the average person had one nagual, the early Spaniards reported that men with power often had several nagual forms and that such men were thought to be able to assume the physical form of a companion animal.[14] In such cases, the one being transformed and the image into which he was transformed were considered so much a part of each other that among the Aztecs the people capable of such transformation were themselves called *naguales.*[15] The sorcerer's knowledge of the world of the spirit thus was thought to enable him to transform his physical being into his spirit-self to bring the power of the world of the spirit, for good or ill,[16] into the physical world.

Brundage contends that *nahualli* is derived from *nahualtia,* meaning "to hide, covering one's self or putting on a mask."[17] Although other derivations have been suggested, the connection between the mask and the nagual is thought provoking. The relationship between the animal companion and the person is much the same as that between the wearer of the ritual mask and the mask itself. Both the mask and the physical body cover or "hide" the animating spirit represented by the ritual participant and the nagual, and both allow that underlying spirit to express itself in the world of space and time. This, of course, is the same metaphor (though not the same Nahuatl term) used for precisely the same conception in the newly installed ruler's ritual entreaty we quoted above. In each of these cases, the significant part of the human being is the spirit, while the temporal, physical being is merely the final transformation, a body that serves to shelter, for a time, the spirit within. It is fascinating to note that even the gods themselves had naguals, which indicates in still another way their kaleidoscopic nature. Rather than being tied to a single identity, they were capable of transforming themselves into their naguals to manifest other possibilities, and if Boos is correct in his assessment of the images on the urns of Monte Albán,

even the naguals of the gods themselves have naguals.[18] The transformative possibilities are endless.

Mesoamerican man found various means of moving from one plane of existence to another, of moving from the surface of life inward. As we suggested in our discussions of the calendar and the nagual, magic and divination were used to uncover a different kind of reality, one in which the spirit and the man, the magician and the disguise became strangely unified and, finally, interchangeable. As we have seen in the case of the shamanic trance, this unity was often achieved through some form of hallucinatory state induced by psychotropic substances; in this visionary state, the supernatural world could be entered. For the Maya, and probably for other cultures, bloodletting served a similar purpose in the transformational process; loss of blood produced visions that brought kings into direct contact with their ancestors and with the gods. The Hauberg Stela provides a fascinating example of this process in its depiction of the ritual bloodletting preceding by fifty-two days the accession of Bac-T'ul to the throne. The soon-to-be-installed ruler is not shown drawing his own blood but rather "in the midst of his vision, frozen between the natural and supernatural worlds,"[19] or, as we might put it, transformed from his physical being into spirit.

The act of blood sacrifice provides the most dramatic illustration of the use of ritual to incarnate the supernatural. A great deal has been written about sacrificial practices in pre-Columbian Mesoamerica, especially among the Aztecs, and it seems clear that the mythological equation represented by the sacrificial act is an integral part of the transformative relationship between matter and spirit. So fundamental is sacrifice to this conception that the extant creation myths for each of the cultures of pre-Columbian Mesoamerica all charge mankind with the ritual duty of sacrifice. As we have seen, Aztec myth depicts man's creation as the result of an autosacrificial act by Quetzalcóatl. That this idea is fundamental to the Aztec conception of Quetzalcóatl is demonstrated by his often being depicted in the codices holding a bone or a thorn used to draw blood, a clear reference to his sprinkling his own blood on the bones of past generations he had gathered in the underworld to transform them into the first man and woman, thereby creating mankind. The myth demonstrates the dependence of mankind on the sacrifice of the god for its existence and suggests the reciprocal human duty of sacrifice, a duty that is the reenactment of the gods' sacrifice in the creation of the sun: "This was the voluntary sacrifice of the assembled gods, to provide the freshly created sun with nourishment. In performing this self-immolation, the gods set an example for man to follow for all time."[20]

That the same reciprocal relationship was seen by the Maya is illustrated both in their buildings and in their myths. Speaking of Structure 22 at Copán, Schele and Miller point out that

> the facade of the structure once featured a great reptilian monster mouth at its entrance. The lords stepped onto his lower jaw and then passed through the mouth of a great Bicephalic Monster to enter the inner sanctum, a room probably designed for ritual bloodletting. While the nobility let blood in the inner sanctum, maize flourished on the exterior of the building, suggesting that the king's most potent substance, his blood, flowed to fertilize and regenerate nature itself.[21]

Thus, the king, or priest, entered symbolically into the world of the spirit to give his blood so that the gods would respond with man's sustenance. The same motif appears in the *Popol Vuh*, where the gods' intention is to create "a giver of praise, giver of respect, provider, nurturer." The import of this is made clear when man is finally created and begins to proliferate: "And this is our root, we who are the Quiché people. And there came to be a crowd of penitents and sacrificers,"[22] a "crowd" made up of the historic Quiché lineages, which are then enumerated.

The Mixtec creation myth, brief as it is, makes the ritual duty of sacrifice equally clear. In that account, two gods, male and female, who share the name 1-Deer and who "are said to have been the beginning of all the other gods . . . became visible" and created "two male children."[23] Among other things, these children pierced their ears and tongues "so that the drops of blood would come out," which they then offered as "a sacred and holy thing," doing so "in order to oblige" the gods who created them.[24] These actions are surely intended as a model for proper conduct for the human beings who were then "restored to life."[25] The various creation myths thus agreed that sacrifice of human blood was a ritual duty. Metaphorically, the sacrifice of life's blood, that is, returning life to its spiritual source, was necessary for the continuation of the endless cycle of transformations through which life was constantly created and maintained. Man, helpless without the gods, must sacrifice his blood in return for their continuing help "to make the rain fall, the corn grow, an illness to disappear."[26] There was no doubt that

> the machinery of the world, the movement of the sun, the succession of the seasons cannot continue and last unless they [the gods] are nourished on the vital energy contained in "the precious water," chalchiuatl; in other words, human blood. The reality we see and touch is merely a fragile veil that may be torn at any minute and reveal the monsters of dusk and decline.[27]

Reading any account of Mesoamerican ritual activity makes chillingly clear that the blood needed to maintain the universal system was provided. There seem to be endless numbers of sacrificial rituals running the gamut from symbolic bloodletting and animal sacrifice to autosacrifice to the ultimate sacrifice of human life itself. Autosacrifice, as depicted in the Aztec and Mixtec creation myths, was most common. Throughout Mesoamerica, the bleeding of ears, tongues, and genital organs by members of the priesthood was a daily ritual occurrence, sometimes reaching ghastly proportions. "In a certain Mixtec province," for example, "even the bleeding of the genital organ was practiced by passing cords as long as fifteen to twenty yards through it."[28]

One might say, however, that "if autosacrifice was the most common form of blood offering, human sacrifice was the most holy,"[29] for it involved the sacrifice of life to life. We see such sacrifice as the killing, or even slaughter, of human victims for the gods, but to understand human sacrifice in Mesoamerican terms, we must see it, for the moment at least, as they did, and their intent "was to sacrifice an image of the god to the god."[30] A vital part of the sacrificial ritual, therefore, involved a symbolic transformation of the sacrificial victim into the god, a transformation metaphorically possible because man was both spirit and matter and could, through ritual, "become" spirit. "Accordingly, not only was the correct godly attire important, but also the sex, age, physical condition, and proper emotional attitude of the deity impersonator. . . . All the sixteenth century reports make it clear that the victim *became* the god to whom he was sacrificed,"[31] costume and the physical body functioning as the ritual mask in making the inner reality outer, spiritualizing the physical. The actual sacrifice was the logical final step; the "mask" of the physical body was removed, leaving the spirit to travel to its proper home, the realm of the gods.

Aztec ritual life was "enormously complex. A prodigious amount of time, energy, and wealth was expended in ceremonial activities, . . . and some type of death sacrifice normally accompanied all important rituals." In the course of this ritual life, "human sacrifice was practiced on a scale not even approached by any other ritual system in the history of the world."[32] The ritual year was based primarily on the solar calendar with its eighteen "months" of twenty days, and each of these twenty-day periods was marked by an elaborate public ceremony generally celebrating the stage in the agricultural cycle which had been reached. Since each of these veintena ceremonies celebrated fertility, sacrifice played a key role, but the sacrifice was performed in accordance with the particular aspect of the agricultural cycle being cele-

brated. Durán presents a telling example in his description of the harvest festival of Ochpaniztli, which means "Sweeping of the Roads," a name symbolic of the clearing of the way for the passage of the gods associated with agricultural fertility. The festival celebrated both the earth's provision of man's sustenance and the return of the dead stalks to the earth so that the renewal of life in the spring might take place. For this festival, a woman was chosen to represent the earth-mother goddess Toci, Mother of the Gods, Heart of the Earth, and was transformed into that goddess not only by being "garbed exactly as the goddess" but also by being made godlike in other ways. After being "purified and washed," she was "given the name of the goddess Toci, . . . consecrated to avoid all sin or transgression, [and] locked up and kept carefully in a cage" for twenty days to ensure her abstention from all carnal sin. In addition, "she was made to dance and rejoice" so that "all could see her and worship her as a divinity"; she was encouraged to be joyful and happy in the manner of the gods. In fact, "the people held her to be the Mother of the Gods and revered her, respected and honored her as if she had been the goddess herself," as, ritually, she was.[33] The elaborate ritual preparation for the sacrificial ritual itself had symbolically transformed the woman from matter to spirit.

After her sacrificial death, the culmination of her transformation into the god, a further transformation took place. The skin was removed from her dead body "from the middle of the thigh upward as far as the elbows. A man appointed for this purpose was made to don the skin so as to represent the goddess again." Still later in the ceremony, he who was transformed into the goddess stripped himself and bestowed his goddess regalia on a straw figure, which resulted in the transformation of that figure into the goddess—a total of three incarnations of the goddess through transformation in a single festival. And each transformation of the goddess marked a stage in the all-important transformation of the ripened corn from the earth to man and back to the earth in the continuation of the cycle. Each of the celebrations involving human sacrifice similarly made clear the importance of transformation in its own particular way as each demonstrated a particular stage in the process of the transformation of energy from the heart of the cosmic realm into the natural world. Ritual provided the necessary catalyst for that transformation.

Nor are such examples confined to the Aztecs. Until recently, it was widely believed that the Maya were peace-loving philosophers and agriculturalists who did not practice human sacrifice. Recent scholarship has revised that view substantially, and nowhere is the revision more striking than in the current view of Maya ritual sacrifice. Coe provides a dramatic statement of the new perspective.

It is common among Maya archaeologists, not exactly the most imaginative of the anthropological profession, to think of their subject matter in terms of trade, agriculture, class structure, and all the other trappings of modern materialist-determinist scholarship. On the other side, the late Eric Thompson, who certainly did have imagination, conceived of his ancient Maya as though they were good High Church Angelicans attending Evensong at King's College. I doubt that either of these two schools of thought would feel at home among the real Maya as shown on a vase like Princeton 20: impersonators of bloodcurdling monsters from the depths of Xibalbá, poised in expectation of the human decapitation they are about to witness, on the verge of a dance to the music of throbbing drums, rattles, and turtle shell, and the doleful sound of wooden trumpets and conch shells. I have always thought that if I were a Mesoamerican captive destined for sacrifice, I would rather have been in the hands of the supposedly bloodthirsty Aztec than in the custody of the "peace-loving" Maya.[34]

And archaeologists have unearthed Classic period "decapitated burials"[35] and stelae depicting rulers wearing as trophies the heads struck off their captives in the sacrificial ritual Coe vividly recreates. The title of a recent work on the Classic period Maya, *The Blood of Kings,* illustrates this new view and details, among other things, the part that sacrifice played in ritual. "By the Early Classic period, the transformation of humans into kings had been formalized into a precise ritual consisting of several stages that seems to have been used at most sites."[36] Significantly, one stage of that ritual process through which a prince became a king and thus gained access to the realm of the spirit required the sacrifice of human blood, which, as among the Aztecs, was the most sacred of all sanctifications. Throughout Mesoamerica, blood was life, and it fueled the transformative processes of the cosmos. As the *Popol Vuh* puts it, man was created by the gods to be their provider and nourisher. By giving his blood in reciprocity for having been created through the gods' sacrifice, man ensured the continuation of life's endless series of cyclical transformations. Mysteriously, then, death itself was ultimately transformed by death; the one sacrificed did not die but merged with the source of all life.

While self-induced hallucinatory states and blood sacrifice served Mesoamerica as ritual means of transforming matter into spirit, perhaps the most obvious as well as the most profound means of such transformation was provided by the works of art expressing a spiritual reality created throughout the history of Mesoamerica. Such a work of art captures a natural image, not for its own sake but as an ex-

pression of a spiritual state. It reverses, in a sense, the creative process through which the natural object was created. Rather than transforming spirit into matter, the work of art uses matter to reveal spirit. Clearly, we cannot examine here all the art of Mesoamerica to demonstrate this transformative process, but perhaps an exploration of the use of a small but particularly fascinating set of images, one ripe with transformative implications, will illustrate the Mesoamerican use of art as a means of penetrating the wall between matter and spirit, between man and the gods.

Throughout the development of Mesoamerican art, the image of the butterfly recurs, albeit not with tremendous frequency, and often it is associated with fire. In Aztec art, for example, flames may be depicted in the shape of butterflies, a single image that links two natural forms of transformation. That simple Aztec image has roots deep in the history of Mesoamerican art, roots no doubt originating in the life cycle of the butterfly, as Janet Berlo points out in her study of Teotihuacán iconography.

> The butterfly is a natural choice for a transformational symbol. During its life it changes from caterpillar to pupa wrapped in hard chrysalis, to butterfly: a process of birth, apparent death, and resurrection as an elegant airborne creature. Fire, too, is a transforming process: fire feeds on natural materials, turning them to ash. In Mesoamerica's traditional system of slash and burn agriculture, fire transforms wild forest into workable milpa. Butterfly symbolism on incensarios relates directly to the fire offering within the censer. The burning of offerings is a concrete manifestation of natural powers of transformation, the butterfly symbolism a metaphorical one. To the Teotihuacano, the butterfly surely was an emblem of the soul as it was for the later Aztecs.[37]

The censers, usually displaying the mask of a human face recessed within a shrine, were ritual vessels of transformation related to "the god of fire [who] undoubtedly represents one of the oldest conceptions of Mesoamerican man. He was the god of the center position in relation to the four cardinal points of the compass, just as the *tlecuil*, or brazier for kindling fire, was the center of the indigenous home and temple."[38] All movement or change symbolically originates in the motionless center, just as fire itself causes the transformation of whatever it touches. Fire always had this symbolic meaning for Mesoamerican man, due, no doubt, to its association with the life-giving power of the sun. The Mixtec name for the fire serpent, for example, is *yavui*, meaning transformer or wizard, a definition "similar to the Aztec conception of this supernatural being," as Sahagún indicates that the xiuhcóatl, "a figure of a dragon, with fire

shooting from its mouth, was the insignia of Huitzilopochtli [always associated with the sun] and of the wizard, or transforming shaman."[39] And fire, of course, was the agent of transformation in the creation of the sun as the gods, in the Aztec myth, leaped into the transformative fire.

The butterfly, as Berlo suggests, is found in abundance on the ceramic incense burners of Teotihuacán because it has much in common with fire; they both manifest the ultimately shamanic idea that death is part of the process of transformation and thus the beginning of life. Seler explains that the butterfly,

> the fluttering one, was a symbol of fire and is therefore also a part of the symbol, which composed of the picture of water and of fire was for the Mexicans both a verbal and pictorial expression of war. As animal of the fire god the butterfly was also the symbol of the ancients, i.e., the dead ancestors, but not of the ordinary dead, who live beyond the great water, in Chicunauhmictlán, in the inmost depths of the earth, from where—once safely conveyed thence—they never return.[40]

In at least two ways, then, the image of the butterfly was associated with the ultimate transformation of death. It was connected with war and frequently used to symbolize the souls of dead warriors[41] whose spirits, like those of the dead ancestral kings, returned to earth transformed as butterflies and hummingbirds.[42] That the emphasis was clearly on transformation is also suggested by an interesting connection with the daily cycle of the sun. The spirits of the dead warriors are butterflies of the day charged with assisting the sun as it moves through the heavens, whereas the spirits of women who died in childbirth, also considered to be warriors, must assist the sun as it makes its nightly journey through the underworld. They are butterflies of the night associated with the moon.[43] Thus, the image of the butterfly, like most of the symbolic images in Mesoamerican art, has a range of transformational implications. This suggests that the highly metaphorical religious art of Mesoamerica is itself an instrument of transformation.

While many of the works of Mesoamerican art in museums and private collections are better considered examples of craft, the great works of that tradition, like those of all artistic traditions, were created by visionary artists able to capture the spiritual truth at the heart of their tradition in the malleable materials and fleeting images of the earthly world. Such an artist is characterized in an Aztec poem as a "stealer of songs" from the gods[44] and by Sahagún as one who "teaches the clay to lie" and thereby "creates life."[45] The truly creative artist, as James Joyce put it in his usual punning way, "creates life out of life" by embodying the spirit of life in the material of his art. Neither Joyce

nor Sahagún were speaking of art as a realistic re-production of the things of this earth but rather as the human alternative to the divine creative process. Even though Mesoamerican art is essentially religious and always aware that "the beautiful songs come from another world,"[46] its subject is frequently art itself, art as a metaphor for the cosmic creativity that shapes and maintains life.

> The artist: a Toltec, disciple, resourceful, diverse,
> restless.
> The true artist, capable, well trained, expert;
> he converses with his heart, finds things with his
> mind.
> The true artist draws from his heart; he works
> with delight;
> does things calmly, with feeling; works like a
> Toltec;
> invents things, works skillfully, creates; he ar-
> ranges things;
> adorns them; reconciles them.[47]

Like the life-force itself—the creator gods of the *Popol Vuh*, for example, who created man from corn—the artist creates by transforming reality. By shaping his materials and by manipulating the symbols of his society, he can provide the metaphors that reconcile the sacred with the profane by recreating in miniature the cosmic order. And the mystery at the heart of the cosmic creation can be understood through its metaphoric re-creation by the visionary artist in the images—visual, musical, and literary—in and through which myths exist and "delight." As Joseph Campbell puts it,

> It has always been the business of the great
> seers (known to India as "rishis," in biblical
> terms as "prophets," to primitive folk as "sha-
> mans," and in our own day [and, we might add,
> in Mesoamerica before the Conquest] as
> "poets" and "artists") to . . . recognize through
> the veil of nature, as viewed in the science of
> their times, the radiance, terrible yet gentle,
> of the dark, unspeakable light beyond, and
> through their words and images to reveal the
> sense of the vast silence that is the ground of us
> all and of all beings.[48]

The visionary artist metaphorically provides that "vast silence" a voice, a theme often found in Aztec poetry:

> The flowers sprout, they are fresh, they grow;
> they open their blossoms,
> and from within emerge the flowers of song;
> among men You scatter them, You send them.
> You are the singer![49]

As "flower and song" is the standard Aztec metaphor for poetry, it is strikingly clear that the poet here considers himself the vehicle for images and rhythms originating in the creative force at the heart of the cosmos. Through him, that cosmic force, the "You" of the poem, can "scatter" its

truths among men, can somehow transform its mysterious being into the beauty of life on the earthly plane. Another Aztec poem enunciates the theme clearly:

> With flowers you write,
> O Giver of Life;
> With songs You give color,
> with songs You shade
> those who must live on the earth.

> Later you will destroy eagles and ocelots;
> we live only in Your book of paintings,
> here, on the earth.

> With black ink You will blot out
> all that was friendship,
> brotherhood, nobility.

> You give shading
> to those who must live on the earth.
> We live only in Your book of paintings
> here on the earth.[50]

Using the metaphors of both poetry and painting, the poet suggests that the transformational relationship between temporal reality and the creator of that reality is the same as the relationship between the artist and his work. Life is to the creator what the poem is to the poet or the painting to the painter. Thus, through the poet's and painter's creations, we can see and understand more clearly the cosmic creation. But, of course, the ultimate creative force, the ground of our being, is finally beyond the comprehension of temporal beings. Its "black ink," a symbolic reference to Tezcatlipoca and to the writing that contains esoteric knowledge of the sacred mysteries as well as to its more obvious associations, will "blot out" our lives. Though everything on the earthly plane—eagles and ocelots, which is to say, bravery in war; friendship and brotherhood and nobility; and man himself—must perish, the life-force manifested in the things of the earth *and* in artistic creation will continue.

> My flowers will not come to an end,
> my songs will not come to an end,
> I, the singer, raise them up;
> they are scattered, they are bestowed.
> Even though flowers on earth
> may wither and yellow,
> they will be carried there,
> to the interior of the house
> of the bird with the golden feathers.[51]

Thus, the creative force can be embodied in artistic creation and take on the eternal life of its source, or as the poem elegantly puts it, "be carried there, to the interior of the house of the bird with the golden feathers." The creative impulse in mankind, expressed most clearly in artistic creation, is mysteriously part of the cosmic creative force, and that cosmic force expresses itself through the vi-

sionary artist. One is inevitably reminded here of another great American poet, Walt Whitman, who used a similar metaphor in *Leaves of Grass* to express the same enduring truth: "I permit to speak at every hazard, / Nature without check with original energy."[52] "Original energy," for Whitman, had its source in that cosmic creative force, and as that energy manifested itself in his poetry, the poetry, like that of the Aztec poet, was eternal.

I bequeath myself to the dirt to grow from the
 grass I love,
If you want me again look for me under your
 boot-soles.

You will hardly know who I am or what I mean,
But I shall be good health to you nevertheless,
And filter and fibre your blood.

Failing to fetch me at first keep encouraged,
Missing me one place search another,
I stop somewhere waiting for you.[53]

Whitman's buoyant optimism is not shared by his Aztec counterpart, but their sense of themselves as creative artists is remarkably similar and indicative of the many ways in which Mesoamerican thought is not as far removed from ours as we often think. Both see themselves as vehicles for the expression of an impulse mysteriously originating in the ground of being. In both cases, organic metaphors—flower and song, grass—are used to embody the creative process, and both therefore suggest that the entire process is a natural one: it is a matter of transforming energy from one level of nature—the ground of being, which is spirit—to another—the material world of space and time. For both of them, the artist served as the agent of that transformation.

Sahagún's description of the feather artist carries this theme a step further.

Amantécatl, the feather artist.
He is whole; he has a face and a heart.

The good feather artist is skillful,
is master of himself; it is his duty
to harmonize the desires of the people.[54]

The phrase "face and heart," often encountered in Nahuatl texts, carries a complex metaphoric meaning based on the conception of the beating heart (*yollotl*, derived from the same root as *ollin*, meaning movement) as the symbol of the dynamic center of the person, and the face (*ixe* or *ixtli*, not sim-

ply the physical face visible to others) as expressive of his being in the deepest sense. The physical face, therefore, had the metaphoric potential to signify one's true face by manifesting those characteristics that made him "whole," that is, unique and well integrated, as a result of the transformative process by which the outer appearance came to reflect the inner, spiritual being. When this integration had been achieved, a person was said to have a "deified heart" and to be "master of himself." It is no wonder, then, that an important goal of Aztec education was to teach a person to create such a "deified heart," thus enabling him to develop his innate spiritual potential by becoming "one who divines things with his heart,"[55] one who infuses ordinary experience with spiritual energy. Precisely, of course, the task of the artist.

It would follow that, as León-Portilla puts it, "if the good artist is master of himself and possesses a face and a heart, he will be able to achieve what is the proper end of art: 'to humanize the desires of the people,' that is, to help others to understand things human and divine, and to behave in a truly human way."[56] Behaving in such a way would be the result of understanding one's essentially spiritual nature and allowing that nature to express itself in the world of space and time, thereby transforming the material world into spirit. Thus, the Aztec poet, like his predecessors in the earlier cultures of Mesoamerica, was the messenger of the spirit, the transformer who had himself been transformed:

God has sent me as a messenger.
I am transformed into a poem.[57]

That transformation can stand as a symbol here for the entire effort of Mesoamerican spiritual thought—to embody in a system of metaphors the various ways in which the ground of all being manifested itself through transformation as the earth and the heavens and all they contained. This magnificent system of metaphors, far more complex than we have been able to suggest here, reveals clearly that for Mesoamerica all of reality—inner and outer, microcosmic and macrocosmic, natural and supernatural, earthly, subterranean, and celestial—formed one system, a system whose existence betrayed itself in the order that could be found behind the apparent chaos of the world of nature.

10 Coda II: The Mask as Metaphor

The system of metaphoric images that we find embodied in Mesoamerican art has as its function the revelation of inner truth through outward forms. Worldly images and materials are combined, often in distinctly unnatural ways, in each work of art as a way of allowing the underlying, otherwise unseen order of the universe to appear in this world. The relationship between physical and spiritual in that art is the same relationship defined for Aztec society by the concept of the deified heart according to which one could, and should, use his physical being to express his true, spiritual being. In that way, the material world could be transformed into spirit.

The raison d'être of the mask is, of course, to transform. It is a visual metaphor bringing together wearer and identity in an "instantaneous fusion of two separated realms of experience in one illuminating, iconic, encapsulating image."[1] In pre-Columbian Mesoamerica, and still today among indigenous groups, the image on the mask was chosen by the wearer or his society to replace the "image on the body" because it was spiritually significant. Such a use of metaphoric images, Jamake Highwater says, is "one of the central ways by which humankind ritualizes experience and gains personal and tribal access to the ineffable, . . . the unspeakable and ultimate substance of reality."[2] Thus, according to Campbell, masks "touch and exhilarate centers of life beyond the reach of vocabularies of reason and coercion"[3] and point "directly to a *relationship between two terms*, the one empirical, the other metaphysical; the latter being, absolutely and forever and from every conceivable human standpoint, unknowable."[4]

The mask, then, stands as a metaphoric recreation of what cannot otherwise be known and as such becomes the symbolic equivalent of the world of nature that "covers" the animating spirit just as the ritual mask covers the wearer who animates it. It is fascinating, and a testament to the fascination produced by the idea of the mask, that we find in one of the most significant passages in Herman Melville's *Moby Dick* a similar insight into the nature of the mask and its metaphoric role. Trying to explain the whale's responsibility for his rage and his unquenchable drive to get beyond the mask that the whale represents to him so as to confront the order of the universe that both lies beyond it and is given material form through it, Ahab says,

All visible objects, man, are but as pasteboard masks. But in each event—in the living act, the undoubted deed—there some unknown but still reasoning thing puts forth the mouldings of its features from behind the unreasoning mask. If man will strike, strike through the mask! How can the prisoner reach outside except by thrusting through the wall? To me, the white whale is that wall shoved near to me. Sometimes I think there's naught beyond. But 'tis enough. He tasks me; he heaps me; I see in him outrageous strength, with an inscrutable malice sinewing it. That inscrutable thing is chiefly what I hate; and be the white whale agent, or be the white whale principal, I will wreak that hate upon him.[5]

For Ahab, nature expresses spirit in much the same way it did for the cultures of Mesoamerica which used the mask as a central metaphor for the transformative relationship between matter and spirit. For them, the mask, as a symbolic covering of a spiritually important substance, served as a method of transforming the accidental to the essential, the ordinary to the extraordinary, the natural to the supernatural.

Schele and Miller in their recent study of the Maya recreate the thinking of a Maya lord, and in

that recreation suggest both the symbolic power and the metaphoric character of the mask for the peoples of Mesoamerica.

The style of this jade mask is clearly Olmec and would have been recognized as such by the Maya. It is possible that the identity of the portrait was still remembered in Maya times, but more likely the person portrayed was perceived to be from a legendary time. . . . A Maya lord, drawn perhaps to the immediacy and lifelike quality of the portrait, used this mask. Two glyphs, probably his own name, were carved on each flange, but only the left pair now survives. The way these two glyphs are drawn—backward so that they face toward the Olmec portrait—reveals the attitude of the Maya toward this object. By setting his name upon this heirloom, he claimed the Olmec portrait as his own, perhaps as a declaration of his identity with the kings of antiquity and as a means of controlling the sacred power stored in this extraordinary object.[6]

Indeed, he may have claimed the Olmec portrait as his own especially in the sense that it revealed his true, spiritual identity as man and ruler. By wearing this mask as a pectoral, that Maya lord was asserting his true identity. And just as that mask could reach across centuries of time to join Olmec and Maya, so the masks of Mesoamerica, properly regarded, can speak to us about the spiritual lives of their creators who used those masks as well as the concept of the mask to stand as a metaphor for their relationship to all they held most sacred.

Part III

THE METAPHOR OF THE MASK AFTER THE CONQUEST

11 Syncretism

The Structural Effect of the Conquest

It was almost to be expected that when the pre-Columbian world of Mesoamerica was confronted by the European world, when Moctezuma came face to face with Cortés, the mask would play a symbolic role in that confrontation of two worlds, each with its own spiritual assumptions. Confronted by the cross of Cortés, Moctezuma responded with the mask: different metaphors for different views of reality, each wonderfully expressive of a way of relating human life to the mystery of the eternal. These were such fundamentally different ways that the resulting conflict between the representatives of two of the world's great religions would never be fully resolved, for none of the possible resolutions could work. The fundamental differences made a full merger impossible; the realities of the Conquest dictated that the indigenous view could not prevail. But the eons-long, rich development of that indigenous view in the mythic vision and ritual practice of the peoples of Mesoamerica had entrenched it so firmly that it could never be destroyed by foreign invaders. The conquistadores prevailed physically, but the spiritual vision of the indigenous people remained intact. The result was the peculiar blending of Christian and indigenous symbols and ritual which continues to exist today among the Indian peoples of Mesoamerica.

When, thirty or so years after that meeting of Cortés and Moctezuma, the boy who was to grow up to be Fray Diego Durán came to Mexico City, he found himself in the midst of that unresolved conflict in "an unstable and motley [society]—two religions, two political systems, two races, two languages—in sum, two conflicting societies struggling to adapt to one another in a painful cultural, social, religious, and racial accommodation."[1] He was to spend his life in that struggle and in his darker moments came to doubt that

he and his fellow priests were making much progress toward ending the conflict through the meaningful conversion of the indigenous population. In 1579, he wrote, "These wretched Indians remain confused. . . . On one hand they believe in God, and on the other they worship idols. They practice their ancient superstitions and rites and mix one with the other."[2] As he realized, they were fitting Christian concepts into the structure of their own spiritual vision.

> *How ignorant we are of their ancient rites,*
> *while how well informed [the natives] are!*
> *They show off the god they are adoring right in*
> *front of us in the ancient manner. They chant*
> *the songs which the elders bequeathed to them*
> *especially for that purpose. . . . They sing these*
> *things when there is no one around who understands, but, as soon as a person appears who*
> *might understand, they change their tune and*
> *sing the song made up for Saint Francis with a*
> *hallelujah at the end, all to cover up their unrighteousness—interchanging religious themes*
> *with pagan gods.*[3]

He wrote that he was "extremely skeptical" that the indigenous religious calendar had been discarded in favor of the Catholic one and feared that he had "seen too much" to be optimistic about the possibility of true conversion.[4]

Those fears proved well founded. Four hundred years later, the "idolatry" he sought to stamp out still persists among indigenous groups, especially in the rural areas of Mexico and Guatemala serviced infrequently by visiting priests. Fairly near Mexico City in rural Tlaxcala, for example, an "extensive complex of basically pagan supernaturals, beliefs, and practices" still prevails,[5] and among the Maya of the Yucatán, the Chacs are still "the recipients of more prayers and offerings in a pagan context than any other supernatural being."[6] For

many Maya communities, in fact, the indigenous symbols of sun, moon, rain, and corn are still prominent.[7] An outsider visiting one of the Concheros dance troupes in central Mexico concluded that "they are carrying on the same practices that they had before the Conquest. They have not changed. . . . They are pagan, I tell you, purely pagan in their religion."[8] While his conclusion may exaggerate the "pagan" influence on today's belief structure and ritual activity generally and on the Conchero cult in particular, it is nevertheless quite true that pre-Conquest beliefs and practices persist, often within a fundamentally indigenous structure of belief.

> Four centuries later there still beats in the heart of every Mexican a little of that blood which once stirred emotions before the rising sun, incarnate in Huitzilopochtli, or danced in the gay fertility of the harvests beneath the blessed rain of a Tlaloc, who continues to produce the divine corn.[9]

And four centuries later, masked dancers continue to dance their obeisance to the eternal forces of the world of the spirit which create and nurture life in this world. For them, the mask serves the same metaphorical function that it did for their distant forebears thousands of years before in the village cultures that began the long development of that indigenous Mesoamerican spiritual tradition. But to understand fully the culminating episode of that tradition and its relationship to the metaphor of the mask, we must first come to terms with the impact of the Conquest on native religion. We must ask, with Gibson, "What, finally, did the church accomplish?"[10] The answer is far from simple and must necessarily be incomplete; one must ultimately be willing to accept a certain degree of ambivalence, for paradoxically, as Hunt suggests regarding Zinacantecan symbolic structures, the old beliefs "have both changed profoundly and remained much the same, depending on the perspective. The symbolic structure has not changed (the structure is still there) and paradoxically it has changed (it became buried)."[11] And further complexity arises from the fact that what the church was able to accomplish varied from region to region. The indigenous framework of Maya religion, for example, is today more obvious, closer to the surface than that of central Mexico, a difference resulting from the fact that "the Aztec abandoned pagan rites and fused their own religious beliefs with Catholicism, whereas the Maya retained paganism as the meaningful core of their religion, which became incremented with varying degrees of Catholicism."[12]

Thus, syncretism, which William Madsen, following H. G. Barnett,[13] defines as "a type of acceptance characterized by the conscious adaptation of an alien form or idea in terms of some indigenous counterpart,"[14] rather than the replacement of the indigenous religion by the Christianity of the conquerors provided the means by which the indigenous peoples of Mesoamerica were converted to Christianity, but even that end—which was not, of course, the goal the missionary priests sought—was difficult to achieve in spite of the many superficial factors that might have seemed to make it relatively easy to accomplish. Conversion was particularly difficult at first because the repressive tactics used by the conquerors produced profound resentment and bitterness; the church had destroyed their gods and so for at least ten years, "the dominant Aztec reaction to Christianity was rejection."[15] The response given by "some surviving Náhuatl wise men in 1524 to an attack by the first twelve missionary friars on the validity of Indian religion and tradition" captures, in both its words and tone, that bitter resentment:

It was the doctrine of the elders
that there is life because of the gods;
with their sacrifice, they gave us life.
In what manner? When? Where?
When there was still darkness.

It was their doctrine
that the gods provide our subsistence,
all that we eat and drink,
that which maintains life: corn, beans,
amaranth, sage.
To them do we pray
for water, for rain
which nourish things on earth.

.

For a long time has it been;
it was there at Tula,
it was there at Huapalcalco,
it was there at Xuchatlapan,
it was there at Tlamohuanchan,
it was there at Yohuallichan,
it was there at Teotihuacán.

Above the world
they had founded
their kingdom.
They gave the order, the power,
glory, fame.

And now, are we
to destroy
the ancient order of life?[16]

But punishment usually results in compliance, and because the friars meted out punishment for noncompliance and rewarded compliance, the behavior of the indigenous peoples gradually changed. But a "change of behavior does not [necessarily] involve acceptance of new values,"[17] and many of the conversions to the new religion were superficial.

That those superficial conversions took place is due in some measure to the numerous coincidences of belief and practice between the two religious systems. Durán, in fact, saw so many parallels that

he was convinced an evangelist had been there before the Spanish. But he was hardly pleased, as he also observed that "all of this was mixed with their idolatry, bloody and abominable, and it tarnished the good."[18] Some went even further.

> Fray Servando Teresa de Mier, a Dominican friar from northern Mexico, was to create a furor such as had never before shaken the religious life of New Spain with his memorable sermon of December 12, 1794. In the Shrine of Guadalupe he revealed to his astonished listeners that the Aztecs had actually been a Christian people, though their Christianity had been deformed. They had worshipped God the Father under the name of Tezcatlipoca, the Son as Huizilopochtli, and venerated the Virgin Mary as Coatlicue.[19]

The existence of such striking coincidences of belief and practice contributed greatly to the syncretic adaptation of Christian forms to indigenous beliefs by allowing the basically different underlying assumptions to dictate practice that seemed Christian but was motivated by essentially indigenous beliefs. Thus, one must proceed cautiously in attempting to determine what the church was finally able to accomplish.

A striking example of this coincidence is the resemblance between Ometeotl, the supreme and abstract creator god of the Aztecs of whom no idols existed and to whom no ritual was specifically dedicated, and the Christian conception of God the Father, the relatively remote creator aspect of the tripartite Christian godhead. Similarly, Quetzalcóatl, the white Tezcatlipoca who died, rose to the heavens, but would return, could be, and was, compared to Christ in addition to more commonly being likened to Saint Thomas and sometimes Saint James. Both Christ and Quetzalcóatl had been sacrificed, both were sonlike aspects of the creator god, both existed in opposition to a dark aspect of the creative force, and both were seen as particularly representative of mankind. Among today's highland Maya, the parallels are perceived differently; they often conceptualize the trinity as three symbolic beings. One of these incorporates the entire Christian pantheon of gods, including God the Father, Jesus, and the saints, angels, ghosts, and virgins; a second consists of the earthly world as a whole including mountains and volcanoes; and the third is comprised of the ancestral dead.[20]

Such comparisons, of course, attempted to paper over the fundamental structural differences between the two cosmological views and the profound differences in the purposes of ritual within the two systems. Christianity saw an unbridgeable gulf between man in this world and god in the heavens; through death, the individual might find a union with the godhead, but god was not present in this fallen world. That separation of man and god was alien to the indigenous spiritual vision that held that one need only don the mask in the proper ritual context to allow the omnipresent world of spirit to emerge into this world. This world, then, was not only not seen as fallen but as sanctified: it was the visual manifestation of the underlying world of the spirit. While Christian ritual was primarily dedicated to the salvation of the individual's soul, that is, the movement of one's spirit after death from this fallen state to union with god, such a concept was alien to indigenous thought since union with the godhead was achievable through ritual. Indigenous ritual focused rather on man's reciprocation for the creation and sustenance of life by the world of the spirit, a conception foreign to the Christianity of the conquerors. As Marilyn Ravicz says, "The pre-Hispanic Indian had seen his relationship to the divine as one of dependence but as collaborative; . . . they now had to see it as one of utter dependence upon a gracious two-edged Will of Love and Justice."[21]

But one aspect of the conquerors' religion was more easily assimilated than the others: the Virgin Mary, the symbolic giver and nourisher of life, was more similar to Coatlicue or Tonantzin, manifestations in indigenous thought of the nourishing earth that produced life, than was Christ to Quetzalcóatl or God the Father to Ometeotl. As is generally the case with Mediterranean Catholicism, in Mexico, even today, Mary is honored far more extensively than the Father and Son. She

> is believed to have appeared in person to an Aztec commoner, Juan Diego, ten years after the Conquest of Mexico by Cortes, and to have imprinted her image, that of a mestiza girl, on the rough cloak or tilma of maguey fibers which he was wearing. This miraculous painting is still the central focus of veneration for all Catholic Mexicans.[22]

As Alan Watts points out, in that manifestation as the Virgin of Guadalupe, her "icon stands before the worshippers in its own right, representing the Virgin alone without even the Christ Child in her arms."[23] She is the mother goddess. Thus, Madsen claims that the "most important stimulus for fusion [of the two religions] was the appearance of the dark-skinned Virgin of Guadalupe which enabled the Aztec to Indianize the white man's religion and make it their own."[24] And still today the Virgin of Guadalupe, whose cult began immediately after the Conquest, continues to be worshiped as Tonantzin in many areas.

The two deities share many characteristics. Mary was the virgin mother of Christ, while the Coatlicue manifestation of the earth goddess similarly gave birth to Huitzilopochtli after having been impregnated by an obsidian knife that fell from the sky. In consequence, both were mothers of gods and invoked as "our Holy mother." Not

coincidentally, Mary was associated with the temple originally dedicated to Tonantzin on the hill of Tepeyac where the Virgin of Guadalupe first appeared to Juan Diego. But these similarities cannot obscure some fundamental differences as "the nature and function of the Virgin of Guadalupe are entirely different from those of the pagan earth goddess. The Christian ideals of beauty, love, and mercy associated with the Virgin of Guadalupe were never attributed to the pagan deity"[25] whose dual nature as earth goddess made her both creator and destroyer of life in the cyclical flux of the cosmos. Thus, the similarities between them enhanced the syncretic process, while the differences assured Mary's taking on a symbolic meaning she had never had in Spanish Christianity.

The two religions also shared the use of the cross to symbolize the meeting of the world of the spirit and the natural world. As we have seen, the Mesoamerican cross is actually a quincunx (fig. 4), a cross in which the center is of the same importance as each of the arms, which, in turn, represent the four cardinal directions and the four "cardinal" points of the sun's diurnal course. For pre-Columbian Mesoamerica, the quincunx symbolized the spatial and temporal dimensions of the universe and located its symbolic center. Another cross, this one known as the foliated cross, was an important symbol to the Maya, as we have seen in our discussion of the symbolism of the lid of the sarcophagus of Pacal, ruler of Palenque, and the ceiba tree, as its equivalent, similarly marked the center point of the universe with its roots penetrating into the world of the spirit below and its branches reaching into the spiritual realm above. Significantly, Cortés "stamped the sign of the cross on the ceibas which he found along his route" in the Maya area and "suggested adorning the Christian cross with branches and flowers, therefore presenting to the Indians the precise image of the mythical foliated cross, symbol of life and center of the universe" they had always revered. In such ways "the syncretism of the Christian Holy Cross with the mythical tree of native theogony came into being." After identifying that tree as the symbol of "the support of the universe," Salmerón explains that

the Mexican of pre-Conquest times, like today's Indian, in order to find security and to bind himself to that which is sacred, constructed his home in the image and likeness of the universe as he conceived it: square in form and, at its summit, the reference to the tree which sustains it. When the evangelizer presented the Christian cross to the natives as the protector of man—In Hoc Signo Vinces—he was saying nothing strange: transposed, the cross was the same symbol that had protected these people since early times.[26]

The cross, then, was yet another indication that the symbols of the past continued to give meaning to the present, "ordering reality simultaneously in the shape of the root metaphors of the old quincunx and the new cross."[27]

Hunt sees that conflation of the two crosses and the idea of sacrifice for which both stood as central to an understanding of the syncretic merging of the two religions.

Why then did the Mesoamerican peoples not adopt the codes of Christianity clearly and purely or completely reject one symbol system or the other? This was not necessary. The marriage of the old and the new was an easy one to arrange. To be converted they had only to reject one single major ritual parameter, that is, to change from actual human sacrifice for the maintenance of the social-cosmic order to symbolic human sacrifice, in the most human figure of Christ on the cross. Obviously, the cross itself, so similar in design to the prehispanic quincunx, imbued both the old and the new iconographies with the same aura of received sacred truth.[28]

Although Hunt may oversimplify the essential problem, it is surely true that the Indians considered the crucifixion and violent martyrdom of Christ, as well as that of many saints, symbolic of human sacrifice but experienced no feeling of guilt, sadness, or repentance in connection with that sacrificial death. To the Indian, it, like pre-Columbian human sacrifice, was a reciprocal necessity in the cyclical flux constituting the eternal and universal order of things. Death was necessary so that rebirth might occur. Thus, the image of sacrifice might be the same, but the meaning of that image was profoundly different as the significance of the native symbol never changed.

Precisely that syncretic mode of apprehending spiritual reality can be seen in the Maya view of sacrifice, the supremely important ritual activity through which man offers his substance in reciprocation for the sustenance of his life by the world of the spirit. Interpreting the crucifixion as another version of human sacrifice, the Maya continue to "pray to the cross as a god of rain"[29] and thus unite the central symbol of Christianity with the central idea of indigenous Maya thought. Landa realized very early that the fusion of the idea of heart sacrifice with the Christian crucifixion was evidence of continued paganism among the Maya, but as Thompson points out, it was only through this connection that Catholicism could have had any meaning in the indigenous cultural context. What was "incipient nativism" to Landa[30] was "meaningful acculturation to the Indians."[31] And the rituals through which the now-symbolic sacrifice is rendered to the world of the spirit continue to be scheduled according to the indigenous calendar in many Maya communities. In the Chiapas villages of Chamula and Zinacantan, for example, the ancient solar calendar is still used both to regulate ag-

ricultural activity[32] and to determine the dates of religious festivals.[33] For the Maya, "the revelations of time are still tied to the destiny of man"[34] but now in a syncretic way.

Still another similarity between the religious practices of conquered and conqueror can be seen in the pre-Columbian personification of the gods in small idols similar in function to Spanish santos. Perhaps encouraged by this practice, a number of associations were made between the old gods and the Christian saints. Tlaloc, for example, was sometimes associated with Saint John the Baptist and Toci with Saint Anne. In fact, "there are saintly counterparts for nearly all the native deities, which are either mere additions to the native religions (existing only in name) or represent the beneficial aspect of the deities with whom they are paired."[35] Of all the coincidences we have enumerated, the association of idols and saints probably persisted longest and had the greatest impact on the syncretic process since in accepting the community of saints as "a pantheon of anthropomorphic deities,"[36] the Indians were able to see each of them as a particular manifestation of the undifferentiated world of the spirit, a particular manifestation that served a particular ritual purpose in much the same way the multitudinous "gods" of pre-Columbian spiritual thought had functioned in ritual. Before the Conquest, each village had its own patron deity whose idol was ritually adorned with robes and jewels and presented with offerings; after the Conquest, each adopted a Catholic patron saint whose image was similarly adorned.[37] Little changed except the image; the underlying structure remained intact. Religion continued to provide "an explanation of the ordering of the universe, a channel for dealing with the supernatural forces of nature."[38]

Specific examples of the connection between "pagan" idols and santos abound. Durán noted that even after fifty years of contact with Christianity, the Indians were hiding their idols in church structures. And the association of idols and saints was still so strong in the seventeenth century that the worship of Catholic saints was called idolatry by Jacinto de la Serna, "who observed that some Indians thought the saints were gods."[39] "In 1803 one entire town in the Valley of Mexico was found to be worshiping idols in secret caves."[40] And even as late as the 1940s, the churches were kept locked in some Mixe communities so that priests could not interfere with the townspeople placing idols on the altar alongside the saints; for the Mixe, the church was simply another shrine.[41] The santos were generally worshiped in ways very closely related to the earlier indigenous worship, and consequently the religious fiestas still held for Christian saints have many of the pre-Hispanic elements of those held earlier in honor of various "pagan" deities.[42]

The two religions were superficially similar not only in their symbols, however; remarkable coincidences in their ritual practices also encouraged syncretism. Both, for example, had rites of baptism, confession, and communion. As Coe notes,

The Spanish Fathers were quite astounded that the Maya had a baptismal rite. . . . [During the ceremony] the children and their fathers remained inside a cord held by four old and venerable men representing the Chacs or rain gods, while the priest performed various acts of purification and blessed the candidates with incense, tobacco, and holy water.[43]

Among the Aztecs after the Conquest, the baptized infant often received a Spanish first name in honor of a Catholic saint and an Aztec second name honoring an Aztec god, both selected according to the day on which the child was born; the Christian name was determined by consulting the Catholic calendar while the Aztec name came in traditional fashion from the tonalpohualli.[44]

In pre-Columbian Mesoamerica, ritual confession was related both to Tezcatlipoca, whose omnipresence enabled him to see all, and to Tlazolteotl, a manifestation of the female earth goddess known as the "filth eater" since the earth received everything. Confession could take place only once in a lifetime, and therefore the moment for it was carefully chosen. The penitent confessed his sins to a priest who was bound to secrecy; the confession was solely for the deity for whom the priest acted as agent. Then the priest, according to the severity of the sin, set a penance that, once accomplished, provided immunity from further temporal punishment. Durán explains that the confession was "not [always] oral as some have claimed,"[45] which he deduced from the fact that when he heard the Catholic confessions of Indians, they often brought pictures of their sins, evidently in the style of the codices. Although the modes of pre-Columbian confession varied somewhat from area to area— among the Zapotecs, for example, there were annual public confessions while the Maya might confess to family members in the absence of a priest[46]—the correspondence of all these practices to those of the Christian confessional was remarkable. It is little wonder that Durán was led to conclude that "in many cases the Christian religion and the heathen ways found a common ground."[47]

He was amazed as well by similarities in the rite of communion fundamental to both religions as each prescribed the ritual consumption of a sacrificed god. While "the Catholics drank wine and swallowed a wafer to symbolize their contact with the divine blood and body of Christ, the Mexica consumed images of the gods made of amaranth and liberally annointed with sacrificial blood."[48] The dough that formed those images was known by the Aztecs as "the flesh of god,"[49] a ritual substitute for the flesh of sacrificial victims who

had become gods but a substitute paralleling remarkably the Christian idea of transubstantiation. Other similarities in ritual practice existed as well: both religions accompanied ritual by the burning of incense in sacred places, and the priests who conducted that ritual in both cases "chanted, wore elaborate robes, made vows of celibacy, lived in communities . . . and wore their hair in a tonsure."[50] Pilgrimages to especially sacred places played a major part in both. In fact, pre-Conquest pilgrimage centers, such as the one at Chalma, soon became, and remain even today, Catholic pilgrimage centers. But while these similarities helped to make the superficial transition between the two religious systems relatively easy, beneath the surface they had the opposite effect. They allowed indigenous meanings to remain attached to apparently Christian ritual behavior. Coupled with the deep resentment generated by the displacement of indigenous priests and ritual practice, this retention of indigenous belief did much to counteract the superficial success of the syncretizing process.

In addition to the many coincidences that encouraged the syncretic process, the Spanish themselves helped to keep the native concepts and customs alive by consciously using those coincidences in belief and practice as a means of making the doctrine and practice of the church intelligible to the natives. We have already noted that Cortés, no doubt consciously, confounded the Christian and native crosses among the Maya by slashing crosses into sacred ceiba trees and by permitting Christian crosses to be adorned, a practice that continues today, thus contributing to their confusion in the indigenous mind with the foliated cross that symbolized the tree of life. Similarly, he allowed Aztec idols to remain in the temples side by side with the crosses he had erected. And this confusion of symbols occurred in the communication of doctrine as well. For example,

> in order to make the natives understand the meaning of the Christian heaven, the catechizer made use of the description of the Tonatiuh-Ichan (House of the Sun), the place where warriors killed in battle dwelled, or those who were sacrificed to the gods. These souls accompanied the sun . . . [and] returned to earth in the form of precious birds with red feathers, to suck nectar from the flowers.[51]

This same imagery can also be found in post-Conquest poems with angels taking the place of the warriors.[52]

The Catholic ceremonial calendar similarly encouraged the syncretic fusion of the two systems of ritual. As we have shown in Part II, the charting of the orderly movement of time was of great symbolic importance to the peoples of Mesoamerica. The calendar revealed the workings of the spirit, and the ceremonial cycle regulated by it was therefore ordained by the gods. Thus, it is not surprising, as Durán observed, that the particular day on which a Christian festival fell played a large part in determining the importance attached to it by the native populace and the enthusiasm with which it was celebrated. He noted that if the date had an important relationship to one of the indigenous gods, the feast was celebrated with much more joy, "feigning that the merriment is in honor of God—though the object is the [pagan] deity."[53] Even today, the pre-Columbian 260-day sacred calendar with named and numbered days persists in scattered places, especially among the Maya, and "time continues to be calculated and given meaning according to the ancient methods."[54] As will be seen in the discussion of the masked ritual involving the tigre and the pascola, such coincidences between Christian and indigenous ceremonial calendars are widespread even in areas where the indigenous calendar, as such, no longer exists. The tigres dance on days consecrated to the patron saints of the villages, but these days happen to fall at the proper time for rain-propitiating ritual. The Yaqui and Mayo celebrate the resurrection of Christ after the somber period of Lent, but their ritual makes clear that they are celebrating the rebirth of life in the agricultural cycle as well. Throughout Mesoamerica, the indigenous population continues to lavish its ritual attention on those Christian festivals that coincide with the important points of the indigenous ceremonial cycle.

The syncretic fusion of religious forms can also be seen in the continued use of indigenous sacred places as pilgrimage centers and places of worship. Cortés began this process when, during the Conquest, he decided that "in the place of that great Cue [pyramid] we should build a church to our patron and guide Señor Santiago" and built the cathedral dedicated to Saint James on the site of the Temple of Huitzilopochtli.[55] This construction at the Templo Mayor of Tenochtitlán which equated the Aztec god of war with the saint who was the patron of the Spanish forces was to be followed by many more churches throughout Mexico which would similarly relate an indigenous god to a Christian deity or saint. According to Rafael Carrillo Azpeitia,

> The conquerors used the pyramids as bases for their churches, thus taking advantage of the symbolism that represented the occupation and destruction of the temple of those people who had resisted the victors. Old places of worship were consecrated to the deities of the new religion. The cave of Oztoteotl was dedicated to the Holy Christ of Chalma; the church of Our Lady of Los Remedios was built on top of Mexico's most important ancient shrine, the pyramid of Quetzalcóatl in Cholula; in Tepeyac, at the northern edge of

*Mexico City, the basilica of the Virgin of
Guadalupe was constructed, on the site where
Tonantzin (Our Mother) had been adored.*

He goes on to relate this particular impetus toward
syncretism to the others we have discussed.

*In the same way that the ancient temples and
pyramids were used as bases for new sanc-
tuaries, the spiritual catechists used certain
customs and rites as a basis for the religious
conversion and the subjection of the Indians to
the power of the Crown. This syncretism is de-
fined clearly by Solórzano y Pereyra, when he
says about the Church: "Convinced that it
would not be easy to deprive the heathens of
their ancient customs immediately, and after
having considered well, [the Church] decided
to leave them their customs but call them by a
better name."* [56]

From our point of view in this study, there
was no more important custom "left" the indige-
nous peoples of Mesoamerica than the tradition of
masked dance.[57] Nowhere is the Spanish practice
of allowing native customs to remain while calling
them by "better names" clearer, and no set of cus-
toms shows more graphically the complexity of
the syncretic process. It can be said generally that
the interruption by the Conquest of the steady
development of Mesoamerican spiritual thought
and the ritual based on it led to the existence
in colonial and modern times of three types of
masked dance among the indigenous peoples of
Mesoamerica: those dances introduced by the friars
which have European forms and use European-style
masks, those that substantially retain indigenous
traditions and use masks derived from pre-Hispanic
sources, and those that demonstrate a thorough
fusion of the two traditions and a corresponding fu-
sion of mask styles.

These, of course, are "ideal" types; in fact, every
dance and folk drama contains both indigenous and
European elements. In even the most clearly in-
digenous of masked dances, such as the *Danzas del
Tigre*, which continue the association of the jag-
uar with rain and which will be discussed below,
there are European elements, and even the most
European of dance-dramas with the most Euro-
pean-appearing masks contain clearly indigenous
elements. And in some masked dances, such as
the Yaqui and Mayo pascolas, the indigenous and
Christian elements have become so interrelated
that they can no longer be separated. But it is sig-
nificant that all of these dances—from the Euro-
pean to the indigenous—are today performed by
Indian dancers in Indian villages. Where Indian and
Ladino communities coexist in rural villages, it
is the indigenous community that performs the
masked dance-drama, which is very often regarded
by the Ladinos with the scorn with which they
generally regard Indian customs. The millennia-old
Mesoamerican impulse to don the mask in ritual

is still carried on even by those ritual performers
who wear the most European of masks, masks that
are generally quite realistic depictions of human
features rather than the symbolic composite masks
of the pre-Columbian tradition. And those masked
dancers continue the ancient tradition even though
they may participate in the most European of ritual
forms.

The European forms are varied. Citing Ralph
Beals,[58] Gertrude Kurath points out that "influ-
ences from Spain were strongest in the sixteenth
century due to colonial policies," and these influ-
ences brought the folk dramas and dances as well
as the mask types then popular in Spain to the in-
digenous population of New Spain. Chief among
these were the *Moriscas, Pastorelas*, and *Diablos*.[59]
As part of their indoctrination into the new faith,
the indigenous population found themselves par-
ticipating in

*imaginary pastorals in which the forces of God
triumphed over those of the wicked one; . . .
supposedly historical representations in which
the Moorish world of the unfaithful fell, beaten
by the power of the champions of the faith;
dances in which the Christians or the con-
querors made the sign of the cross triumph
over the Mohammedan Moors or the infidelity
of the Indians.* [60]

Nothing in all of the syncretic adaptation of
Christian forms to indigenous realities is stranger
than the fact that even today masked Indians
throughout Mesoamerica, and beyond to the north
and south, are celebrating in dance the expulsion
of the Moors from medieval Spain. The reason for
this bizarre result of the syncretic process becomes
clear when one remembers that the Conquest of
the Americas took place shortly after the Recon-
quest of Spain in which the Moors were forced
back to North Africa. This new conquest seemed
an extension of the earlier one to the Spanish as
both pitted the spiritual and material force of Chris-
tendom against infidels. Throughout Spain, and ul-
timately throughout Europe, a dance-drama known
as *Morisma* reenacted the triumph of the Recon-
quest as costumed Spanish Christians engaged and
defeated the costumed forces of the Moors.[61] That
dance-drama came to the New World as an integral
part of the cultural equipment of the invaders and
was soon made relevant to the Conquest of the
Americas. No doubt performed in the Antilles be-
fore the Spanish even reached America, the first
recorded performance by Spaniards on this conti-
nent occurred in 1529, and the dance-drama was an
integral part of Spanish fiestas in New Spain from
that time on. Between 1600 and 1650, the dance
reached the pinnacle of its importance among the
Spanish colonists, but as it waned in importance
among them, as they gradually distanced them-
selves from the customs of the mother country, it
paradoxically grew in importance among the mes-

tizo and indigenous populations, although for different reasons.[62]

It had been introduced to the newly converted indigenous population by the missionary priests as a means of indoctrinating them with the Christian view of earthly life as a struggle between good and evil, and while the success of the priests in inculcating that view is debatable, their success in introducing the drama is still evident. By the twentieth century, it had become solely an indigenous institution and was no longer performed even by mestizo groups. In fact, according to Arturo Warman, its presence today can be considered diagnostic of the indigenous nature of the group performing it.[63] As the subject matter does not seem directly relevant to the realities of Mesoamerican Indian life, the reasons for the popularity of the dance are not entirely clear. While "the absolute Catholicism of these dances is an article of faith among the Indians," there are a number of suggestions that the enthusiastic adoption of the Moors and Christians was in some measure a result of its ability to encompass "vestiges of aboriginal ritual."[64] And that ability may come, in turn, from the pagan past of the Spanish dances themselves.

> Although Spanish history is the apparent source of the Moriscas, it seems probable that they actually represent religious acculturation in that more ancient pagan dances associated with spring fertility rites and other events received a new lease on life when they were transformed into festivals to celebrate Christian victory over the infidels.[65]

Thus, a level of metaphoric significance may have existed under the Christian veneer of the dance, making it easily assimilated by the tradition of Mesoamerican spiritual thought, which, after all, focused a great deal of attention on that annual moment of rebirth generated by the spiritual force that sustained life.

Whatever the reason for its successful implantation in the Americas, that success is undeniable and can perhaps best be measured by the number of variants of the original dance which presently exist,[66] variants that can be divided into two fundamental types. In the first, the struggle enacted by the masked and costumed participants still pits the Moors, often wearing dark masks (pl. 61), against the Christians, either unmasked or wearing light-colored masks, in a combat dance-drama filled with a bizarre mixture of historical references and anachronisms that lends importance and dignity to the mythic struggle being reenacted. A contemporary version performed in Tlaxcala, for example, has Christian characters with such names as Carlomagno, Oliveros, Roldán, Ricarte, and Guy de Borgoña confronting Moors called Almirante Balán, Fierabrás, Mahoma, and Lucafer as well as the devils Apolín and Zapolín.[67] In a variant popular in the Sierra de Puebla, the Christians are led

Pl. 61. Mask of a Moor, Dance of the Moors and Christians, Cuetzalan, Sierra de Puebla (collection of Peter and Roberta Markman).

by Santiago (Saint James), the patron of the Spanish forces during the Reconquest of their homeland and the Conquest of the New World, and the Moorish forces are often led by Rey Pilatos (King Pontius Pilate) and count among their soldiers a number of Pilatos. Essentially, the drama opposes the forces of good—Santiago and the Christians— to the forces of evil—Pontius Pilate, Mohammed, various specifically named devils, and the Moors. As we have seen, such an opposition of good and evil, symbolized here by the dark and light masks, is far more characteristically European and Christian than indigenous, so that, superficially at least, it seems clear that in theme as well as content, the dance of the Moors and Christians is a Spanish introduction.[68]

This makes the existence of the other fundamental variant of the dance even more difficult to explain, for in it, the Mesoamerican native population, usually identified in the dance as Aztecs, replaces the essentially evil Moors in the struggle with the Christians. Although this variant exists in a number of forms, they are generically known as Dances of the Conquest and exhibit "the core pattern" of the dance of the Moors and Christians.[69] That the Indians could have become involved with the expulsion of the Moors from Spain

seems strange, but it is even stranger that they could have been brought to define themselves as evil and to celebrate their own defeat.[70] The explanation of this phenomena most in accord with the ideas recorded by various ethnographers among the Indians themselves is that from their present position as Christians, they can regard the history of the "defeat" of their forebears as a victory for Christianity, which made possible their present status. Significantly, that interpretation portrays the drama as illustrative of the symbolic process of rebirth identified by Foster, although not in a fertility context.

Two variants of the Dance of the Conquest are particularly interesting from our point of view because they illustrate the vitality of the dance today as well as the differences in the processes of syncretism in the two major areas of Mesoamerica. In central Mexico, the Concheros, "a highly organized votive dance society," have as their primary activity the performance of a variant of this dance performed unmasked in fiestas from Taxco to Queretaro to which they make pilgrimages. Organized into "mesas" in military fashion, "they are like a religious army marching to fiestas to make a sacrifice, or an offering, of their dance,"[71] which they perform to the music of the *concha*, a lutelike instrument fashioned from the armadillo shells from which their name is derived. While the Concheros may accurately be described as "a nativistic complex for men and women of all ages in search of Indian tradition,"[72] it must be remembered that the native tradition, for them, is at least nominally Christian, and the Conquest provided the crucial, God-given opportunity for the conversion of the indigenous religion to Christianity. The Conquest, then, was a victory rather than a defeat.[73]

The case is somewhat different among the Maya, for the process of conversion in the Maya area was even less successful than in central Mexico. The Dance of the Conquest of Guatemala, when contrasted with the activities and beliefs of the Concheros, demonstrates some of those differences. Rather than being performed by a dance cult that makes pilgrimages to various fiestas, the Guatemalan dance is village based, being performed in villages by masked community members (colorplate 10) at the annual festival of the patron saint. While the dance-drama performed by the Concheros focuses its attention on the conversion of the indigenous population and the beneficent results that flowed from it, the Guatemalan dance-drama is seen by the peoples of the villages on one level as a form of historical instruction that emphasizes their glorious indigenous past.[74] On that level, the religious motivation is neither exclusive nor always even paramount but is, as Bode points out, somewhat subordinate to the role of the dance-drama in defining for the people what it is to be Maya.

The Conquista *is less than sacred and more than habit. The dancers do not fulfill esoteric vows. Nor do they sustain relatively heavy financial sacrifice, practice long hours, and recite perfectly in a high plaintive voice merely for tradition's sake. They are evoking a proud past and filling otherwise monotonous lives with the excitement and fellowship afforded in preparing for the dance: in practicing, in getting their costumes, in doing their* costumbres, *in performing for a people eager to have recounted again and again the story of Tecum.*[75]

And the story of Tecum is the story of their past glory, now to be experienced through the spectacle of the drama.

According to Tedlock, that drama, as it is performed in Momostenango today, "is strongly biased against the conquerors." The focus is on the three main indigenous characters, each of them identified by characteristic masks: the leaders Rey Quiché, Tecum Umam, and Rey Ajitz who is the red dwarf Tzitzimit.

Rey Quiché is terrified by the Spanish forces; he gladly receives baptism and thereby survives the Conquest. The brave Tecum Umam marches into battle against the Spanish; he refuses baptism and dies. The C'oxol or Tzitzimit correctly divines the defeat; he also refuses baptism, but instead of taking arms, he runs off to the woods to live . . . [where] according to Momostecan accounts, the C'oxol gave birth to Tecum's child. . . . The moral of the drama seems clear. The political leader accepted baptism, the military leader accepted death, and the customs survived the Conquest by going into the woods, where the lightning-striking hatchet of the Tzitzimit continues to awaken the blood of novice diviners and where the child of Tecum still lives.[76]

But there is another level of meaning here. Garrett Cook's research in Momostenango reveals a specifically religious dimension of this nativistic interpretation of the dance-drama. According to his informants, the characters of the dance are seen as *Mundos*, "anthropomorphic original beings" associated with the sacred earth,[77] or in our terms, manifestations of the world of the spirit existing momentarily for a specific ritual purpose and thus identical in that sense to the gods of pre-Columbian Mesoamerica. For the Quiché of Momostenango, then, the Dance of the Conquest is an integral part of an essentially indigenous ritual life required of them by their gods.

The Quiché are animists for whom the supernatural is immanent, not transcendent. They live in an inherited world which it is their job to maintain. The maintenance of the world and its complex institutions, which were created by the primeros, *the founders of civilization, is the primary religious duty.*[78]

In "the woods," away from the urban centers dominated by the new society, the Maya continue to live in the old ways, according to the old spiritual vision. Paradoxically, the Dance of the Conquest, introduced to replace that vision with the Christianity of the conquerors, has come to symbolize both the inner strength and the essential meaning of those old ways. Thus, defeat has been turned to victory in a very different way from that imagined by the Concheros of central Mexico. And this "victory" is celebrated in the old way—by masked dancers in a ritual performance.

In addition to the dance-dramas based on the struggle between Moors and Christians, the conquerors also introduced folk plays, often featuring masked characters, dramatizing the significant moments of the mythic narrative underlying the new religion. Passion Plays brought Christ's crucifixion to the Indians, while the Pastorelas, outgrowths of medieval European Miracle Plays, depicted Christ's miraculous birth. As Ravicz points out, the Pastorelas, still widely performed in both mestizo and Indian Mexico, were "one of the important ways in which the first missionaries used pre-existing religious patterns" in their proselytizing since in pre-Conquest ritual, "the role of the particular god whose ritual was being celebrated was literally enacted by a chosen member of the celebrants themselves."[79] She refers, of course, to masked impersonators of the gods, indicating the close relationship between pre- and post-Conquest masked ritual.

While the thematic centrality of the birth and crucifixion of Christ has obvious relevance to the pre-Columbian connection between sacrifice and rebirth, another motif commonly found in the Pastorelas seems more specifically Christian. That motif involves a struggle between the devils of the play who wear fantastic masks (pl. 62) derived from the European tradition but reminiscent of the composite masks of the pre-Hispanic Mesoamerican past and one or more hermits who, in stark contrast, wear simple, realistic masks (colorplate 11). The struggle may be for the soul of Bartolo, a foolish shepherd,[80] or may arise from the devil's attempt to disrupt the pilgrimage of the shepherds to Bethlehem, but whatever its specific cause, it presents, on a somewhat comic level, a struggle between good and evil. That struggle is also presented on a more serious level as the chief devil, generally Lucifer, attempts to disrupt the ceremonies surrounding the birth of the Christ child. His attempts are ultimately frustrated by the archangel Michael,[81] so that the dramatization of the struggle between good and evil, the struggle the immanent birth of Christ will ultimately resolve, is presented on each of the levels—comic, serious, and symbolic—of the play.

In a fascinating way, then, the Pastorelas couple the basic opposition of good and evil, an essentially

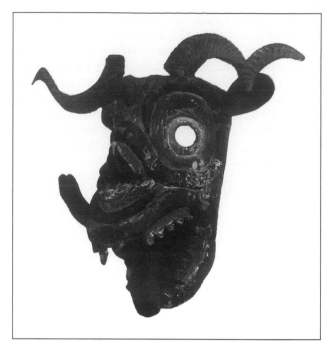

Pl. 62. Mask of a Devil, Pastorela, Michoacan (private collection).

Christian conception, with the most fundamental image of rebirth in Christian doctrine, the incarnation of Christ—the incarnation of spirit in matter, a conception with obvious and fundamental parallels in indigenous spiritual thought. It is not surprising, then, that of all the dance-dramas introduced by the Spanish, "those celebrating the Nativity are perhaps the most widely distributed."[82] The Christian emphasis on the opposition of good and evil in the context of the opposition of spirit to matter was introduced in part through such plays where the opposition is metaphorically defined by the contrast in masks. But it was understood in terms of the indigenous conception of rebirth, and thus the Pastorelas provide an excellent example of the syncretic process at work. As will be seen in the discussion of the *pascola*, that particular fusion of Christian and indigenous thought is at the heart of the system of religious thought created by the Yaqui and Mayo of northwest Mexico.

When the missionary friars taught the new religion by encouraging the converted "to honor Christian supernaturals with songs, dances, and folk dramas similar to those in Aztec worship,"[83] they not only allowed but encouraged the Indians to continue to perform, often in masks, what had been one of the most sacred forms of ritual behavior. Now, however, they were to "dance their way into Christendom."[84] By allowing those dances, including even the most indigenous, which were only slightly transformed by Christian themes, to be performed in the church courtyards on Catholic saints' days, the friars encouraged the continuation

of native forms of worship within a Christian context, a practice that is still alive. The results of that encouragement were both predictable and, evidently, apparent even to some of the friars, since in 1555, Indians were specifically forbidden "while dancing, to use banners or ancient masks 'that cause suspicion,' or to sing songs of their ancient rites or histories, unless said songs were first examined by religious persons, or persons who understood the Indian language well."[85]

Thus, the dances and folk dramas and their characteristic masks, along with the other factors we have enumerated (the coincidences between Spanish and indigenous symbols and ritual, the Spanish encouragement to retain some indigenous practices intact and others somewhat modified while "calling them by a better name," the mass conversions of the peasants "often with no more than a token understanding of the new divinities they were to worship,"[86] and the fact that "the confused natives, trying to understand [the Christian concepts], made their own selection of gods, rites, and ceremonies, according to the way these fitted into their version of the world"[87]) are sufficient to account for Charles Wisdom's conclusion that there appeared to be a

complete fusion [of indigenous and Christian religion] to the extent that the Indians themselves are unaware that any such historical process has taken place. An important point to make is that this has resulted in a new and distinct supernatural system, neither Maya, Mexican, nor Catholic, all the aspects of which are closely integrated to one another and to the remainder of the cultures of which they are a part.[88]

A small but amazingly instructive contemporary example of this fusion of the two traditions is provided by Martha Stone in her discussion of the Conchero dance cult. When she asked a "capitán" to explain the meaning of the twelve rays emanating from the Xuchil, the Conchero's version of the monstrance that in Catholic ritual holds the host, he replied that they symbolized "the twelve rays of the sun, or the twelve disciples of Christ, as you please." And the meaning of the mirror in the center? It represents "the all-seeing powers of Tezcat, a god of our ancestors [Tezcatlipoca was referred to as Smoking Mirror] or the all-seeing powers of the ánimas benditas, as you please."[89] His response carries in potential all the responses of all the practitioners of the folk religion of Mesoamerica, that spiritual structure bearing within its rich symbolism and ritual both of the traditions from which it was formed. Whether in terms of the fiestas and their rituals or the churches and their idols, there are still two cultures at work, and thus one can choose the name that pleases.

Seeing all of this fusion as a "hybrid" religion, Hunt asks,

How is it possible . . . that Indians so readily accepted the Christian religion but continued their old rituals, their attachment to ancient symbols, native gods, and autochthonous notions, for over five centuries? The answer is that this is a natural response for a culture with a pantheistic view of the sacredness of the universe. Because reality is one and many, the addition of new images such as the Christian saints or Jesus himself simply expands the repertoire of sacred "words" that can be fitted into the divine "sentence matrix," already defined as simultaneously complex, ultimately unknowable, ever-changing, and unitary.[90]

Her "pantheistic view" is what we have described as the shamanistic foundation of Mesoamerican spiritual thought. The development of syncretism has shown its durability, but it has also demonstrated something more surprising: that foundation was capable of supporting a new, syncretic system of spiritual thought, which can be characterized as the interplay between the indigenous foundation and the materials of the imported religion, an interplay that makes clear that the foundation determines to some extent the shape and appearance of the edifice raised on it. In that sense, it can be said that Mesoamerican spiritual art "still expresses the shamanic state of cosmic unity."[91] More specifically, Robert Redfield observes that the shamanic beliefs and practices that coexist with Christianity in many regions of highland Guatemala are still

essentially pagan. Practically all of these Highland villages maintain . . . shaman-priests who carry on rituals and recite prayers in which pagan deities as well as saints are addressed. These rites are sometimes performed in a Christian church and sometimes at shrines on the hilltops where the pagan gods dwell. Animal sacrifice is practiced; stone idols are still used in connection with religion and magic; not a few of the communities carry on their ritual and even their practical life according to a pagan calendar that has survived from the days before the Conquest.[92]

Mesoamerican Indians generally "view the universe as peopled by spiritual beings; many of the features of nature around them are spiritual and personal."[93] The underlying shamanistic structure of belief remains.

It is clear, then, that Christianity came to Mesoamerica in the form of syncretism rather than as the conversion from one faith to another, which Durán and his fellow missionary priests sought. The Christian forms of spiritual thought and ritual were adapted in terms of what the adapting culture saw as counterparts in their thought and ritual. The two religions became one only in this sense, but since that combination could not resolve the fundamental contradictions between

them, the indigenous structure of spiritual thought remained intact. Even the friars often realized that the two systems were fundamentally incompatible and used that argument as a means of bringing the Indians to accept the new faith and reject their own,[94] but this argument succeeded no better than their other efforts. The Indians, realizing the essential incompatibility of the two, retained the structure of the faith of their forefathers.

Fundamental to that spiritual vision was the idea that the creative force of the spirit entered the world of man through a process of "unfolding" whereby a continuum was constructed which ultimately connected that force to man. Moreover, indigenous spiritual belief saw all things as part of one essentially spiritual reality in which "the microcosm and the macrocosm are but different forms in which one and only one vital order is manifested."[95] Christianity could provide no parallel to this conception as it saw man and this world as "fallen," as essentially separate from god and the world of the spirit. For the conquering Christians, the world of man and man's physical being were essentially material and could be dealt with by material means; man's spirit was separate from this world and from his body. For the indigenous population of Mesoamerica, no such separation was possible; everything was essentially spirit. Christianity, moreover, proposed that good might ultimately exist without evil, pleasure without pain, and light without darkness, while indigenous spiritual thought, on the contrary, was dualistic in the sense that it conceived of unity as the joining of opposed qualities and was always aware of the simultaneous existence of both halves of those pairs of opposites. For this reason, it was not just difficult but almost impossible for Mesoamerican thinkers to comprehend the idea of a single, monolithic truth.

As we have seen, the result of the intersection of these two mythic systems is extremely complex, but it is perhaps fair to say that while the Conquest destroyed the theoretical superstructure of pre-Columbian religion (i.e., the philosophical and theological speculation of the priesthood), the myths and rituals and the underlying structure to which they gave essential form remained fixed in the minds and lives of the peasants. It was there that the formal and temporal order of the ritual life of the European conquerors merged into the indigenous structure, preserving intact the foundation of pre-Hispanic spiritual thought. The old religion was forced underground, but it remained alive in "a different intellectual context" from that of its earlier splendor.[96] As James Greenberg discovered, what survived was not merely the "bare bones" of that ancient body of belief. "It was only after extensive work that I realized that what I had perceived as 'bones' were the flesh and blood of Chatino belief and that 'Catholicism' had been completely reworked and resynthesized in terms of the pre-existing nexus of ritual and doctrine."[97]

Even as we write, the conflict continues. Today's *Los Angeles Times*, delivered to our doorstep this morning contains an article headlined: "400-Year Church Ties Cut by Ancient Mexican Tribe." The article recounts "the troubles between the Catholic Church and the Chamulas. . . . Chamula leaders charged that the Catholic bishop in San Cristobal connived to end traditional Mayan forms of worship." In response, they ousted the Catholic clergy from their churches and "called in a preacher from a solitary Christian sect in the faraway state capital" who would not "interfere with the ancient ceremonies."[98]

The vitality of indigenous religion, as exemplified by the Chamulas, corroborates Charles Gibson's answer to his question which we posed earlier: "What, finally, did the church accomplish?"

On the surface it achieved a radical transition from pagan to Christian life. Beneath the surface, in the private lives and covert attitudes and inner convictions of Indians, it touched, but did not remold native habits. Modern Indian society . . . abundantly and consistently demonstrates a pervasive supernaturalism of pagan origin, often in syncretic compromise with Christian doctrine. Although it cannot really be demonstrated, it may be assumed that the pagan components of modern Indian religions have survived in an unbroken tradition to the present day.[99]

Today, while many scholars predict the death of pagan beliefs and customs, the Concheros continue to dance and to pray, "May our ancient religion endure, as it has from the beginning, to the end of all things."[100] Their prayer is repeated—in a variety of words and ritual actions—by indigenous groups throughout Mesoamerica.

12 The Pre-Columbian Survivals
The Masks of the Tigre

O jaguar, most noble, slyest of all the beasts of ancient Mesoamerica, deified for thousands of years by the Olmecs and Zapotecs, by the peoples of Teotihuacán, Tula, and Mexico-Tenochtitlán: fight on wildly in the fray; die on a thousand times in our village fiestas.[1]

The jaguar—as a symbol of the earth, rain, and fertility—did not die with the Conquest but ironically continues to die every year in the festivals in and through which the indigenous folk religion of Mesoamerica exists. This annual death is, as it always has been, representative of the death that precedes rebirth in the eternal cycle of life and death. Thus, the jaguar mask central to the widespread Danza del Tigre in its many variations (to which Fernando Horcasitas refers) provides the best example of the survival of the mask and its underlying assumptions in indigenous ritual. What Gibson says of pre-Columbian survivals generally—that while a continuity of existence from pre-Columbian times is difficult to demonstrate, "it may be assumed that the pagan components of modern Indian religions have survived in an unbroken tradition to the present day"[2]—is specifically true of today's jaguar mask and its accompanying ritual; without exception, scholars accept Horcasitas's contention that "from all indications, *la Danza del Tigre* has pre-Hispanic roots."[3]

The earliest evidence we have for the existence of the mask and the dance, while colonial, strongly suggests their pre-Columbian origin. In 1631, the Inquisition prohibited the Danza del Tigre in Tamulte, Tabasco, since "it contained hidden idolatry offensive to our Religion." Specifically, dancers "disguised as *tigres*" fought, captured, and simulated the sacrifice of a dancer dressed as a warrior in "a cave called Cantepec"; the simulated sacrifice was followed by an actual sacrifice of hens.[4] On the basis of this and other evidence, Carlos Navarrete concludes that "popular 'animal dances' [often] concealed ancient pagan rites."[5] That those rites in this case are involved with the provision of water from the world of the spirit is demonstrated by the ritual's familiar combination of thematic motifs. The union of blood sacrifice, the cave, and a human being disguised as a jaguar (*tigre*, in the context of indigenous ritual, means, and is generally translated as, jaguar) in this ritual configuration recalls the pre-Columbian rain gods and their ritual propitiation at the time of the coming of the rains. The central position of the jaguar mask makes the connection clear; and that colonial mask was the forerunner of the numerous jaguar masks worn today, 350 years later, masks which are visually reminiscent of their pre-Columbian predecessors.

The modern mask, in most of its variations, generally displays the features of the pre-Columbian, jaguar-derived rain god masks—prominent fangs, a pug nose, round eyes with prominent eyebrows, and often a large, though not bifid, tongue dangling from its mouth. In many cases, the wearer looks out of the mask through the open mouth,[6] an unusual arrangement in modern masks but one reminiscent of pre-Columbian practice. Thus, both the earliest evidence of tigre mask ritual and the appearance of the masks themselves suggest a pre-Columbian origin.

Probably the most widespread and surely the best-documented ritual dance-drama is the *Danza de los Tecuanes* found primarily in the central Mexican states of Guerrero and Morelos.[7] It recounts "the hunting and killing of a *tecuani* or jaguar" who has devastated the local village. The version detailed by Horcasitas in 1979 begins with the wealthy landowner, Salvadortzin, and his assistant recruiting hunters, among them an archer, a tracker, and Juan Tirador, the marksman who will

finally shoot the jaguar. Once they are recruited, Salvadortzin gives them their charge:

> *Viejo Rastrero! Old Tracker! I want you to hunt and kill the tiger because the tiger's been doing a lot of damage. The tiger's ruined seven villages, the tiger's destroyed seven hamlets, the tiger's finished off all the good cows, the tiger's eaten up all the good donkeys, the tiger's eaten up all the good bulls, it's eaten up all the good goats, it's eaten up all the good sheep. It's even devoured all the good girls who go to the well for water, man! I'll pay you well to get the tiger, man!*[8]

In a similar speech delivered by Don Salvador to his mayordomo in the version of Texcaltitlán in the state of Mexico, the landowner says the tigre is consuming the yearling bulls, the calves, the lambs, the kids, the piglets, and the rabbits, to which the mayordomo responds, "We are going to die of hunger."[9] Thus, the wild animal, the jaguar, is destroying the domesticated animals that support human culture by providing food in an orderly and regular manner and is serving here the same structural function it had in pre-Columbian Meso-america from the time of the Olmecs; it is still generally symbolic of the untamed forces of nature that must be brought into harmony with the order underlying human society.

And it is through the accoutrements of human society that that order is achieved. Salvadortzin questions Juan Tirador, who will kill the jaguar, about his looks and then about his weapons:

> *"Juan Tirador, they tell me that you are brave. They tell me you are a good hunter. Is it true that you have a strong heart? Is it true that you have a big mustache? Is it true that you have a bushy beard? Is it true that you are handsome and have rosy cheeks?"* All this is in reference to Juan's wooden mask. *To each of these questions he answers "Yes, yes. True, true." "Is it true you have good weapons?" Juan Tirador then describes his hunting equipment, which is that of a small army: traps, cords, pistols, shotguns, munitions, rifles, muskets, bullets, cartridges, machetes, knives, daggers and so forth.*[10]

The answers seem deliberately designed to point up the difference between the "natural" mask and claws of the jaguar and the "civilized" mask and weapons of the hunter and thus reiterate the opposition of nature to culture suggested by the destruction of the domesticated animals by the wild jaguar. And this theme is found in other details of the dance-drama. Much is made, for example, of the wealth of the landowner and the paying of Juan Tirador, a motif emphasizing the social structure in opposition to the natural behavior of the jaguar: the hunter kills as a profession, the jaguar as an expression of his being. The emphasis on the dogs used by the tracker suggests the theme of domesti-

cation in another way: domesticated animals can be used to subdue wild animals as well as be destroyed by them. And the final skinning of the jaguar to make various items of clothing for the hunters and the dogs demonstrates that nature is not only potentially destructive but can also be useful to human society when brought under control. It is fair to say that the drama turns on the underlying opposition between nature and culture and in the killing of the jaguar, illustrates the necessity of "domesticating" wild nature.

The final speech of the variant enacted at Tlamacazapa, Guerrero is fascinating in this regard:

> *"But wait, Juan Tirador," shouts the Governor. "The jaguar is so big that I will give you a piece of skin for your coat, for your vest, for your belt, for your shirt, for your pants, for your leather jacket, for your chaps, for your trousers, for your leggings, for the case for your weapons. Even for the shoes of your puppies! Even for your mask, man!"*[11]

The dead jaguar (a human being wearing a mask) thus becomes a mask for the hunter in a startling switch ending the dance and making clear both the sophistication of this tradition of mask use and the awareness within the drama of the metaphoric nature of the mask, for the shoes for the puppies and the mask, the last of the items enumerated, are the only items not part of everyday life outside the drama; what was formerly wild can be used to support culture and in that use becomes a "mask" to cover the inherent "wildness" of all life. That this theme should exist in a dance-drama whose central character wears the mask of a tigre, or jaguar, indicates clearly that the symbolic merging of man and jaguar in the were-jaguar masks of pre-Columbian Mesoamerica continues, albeit in altered form, and that the were-jaguar still stands as a metaphor for the sustenance of man by the world of the spirit through the fertility of nature.

While the dance-drama of los Tecuanes lacks most of the earth and fertility symbolism associated with that pre-Columbian were-jaguar, a closely related variant in which essentially similar masks are employed retains that symbolism, as its name, *los Tlacololeros,* suggests. The name is derived from *tlacolotl,* Nahuatl for a plot of land,[12] and the dance "dramatizes the efforts of men to cultivate their fields and their struggle against the tiger that ambushes them and threatens to destroy their human labor."[13] The two dance-dramas seem to have divided the two forms of domestication characteristic of agricultural life—that of animals and the land—into two separate, but clearly related, dances that coexist in the state of Guerrero; perhaps the single colonial source of these modern variants[14] united the two forms of domestication.

While los Tecuanes is almost wholly involved with animals, los Tlacololeros deals with the agricultural cycle. As the drama begins, the jaguar

taunts the spectators while the ten or twelve tlacololeros, all similarly dressed and masked and each named after a particular plant, prepare a plot of land and plant a seed, after which they complain to the chief of the hunters of the jaguar who threatens their agricultural efforts. In response to these complaints, the chief uses a dog, *la Perra Maravilla*, to track the jaguar, and when he is brought to bay, often in a tree, the chief finally kills him. After the hunt, as in los Tecuanes, there is a good deal of discussion of the size of the jaguar. The tlacololeros then burn the plot of land in preparation for the next planting. While the land is burning, pairs of dancers whip each other, often violently, on their padded costumes, the sounds of the whips simulating the sound of the fire. Often a clownlike character carries a dessicated squirrel with which he torments the other characters and the audience.[15] Thus, all the elements of the cycle of life, especially as it applies to agriculture, are here, and the theme of life coming from death with its complementary notion of the necessity of the sacrifice of life is clearly evident. Often, though not always, los Talcololeros is presented as a part of rain-petitioning ceremonies,[16] providing yet another link to the agricultural cycle and to the were-jaguar mask of pre-Columbian Mesoamerica.

The tigre masks employed in the dances of Guerrero and Morelos range from carved and lacquered wood masks (pl. 63), often magnificent creations, to mask helmets made by covering a reed or wire frame with painted cloth (pl. 64).[17] Different as the masks are, however, their common origin can be seen in their remarkably similar, though differently interpreted, features. Always, for obvious reasons, the mouth is the focus of attention. Large and generally fanged, it often has a protrud-

Pl. 64. Masked *Tigre*, Dance of the Tecuanes, Texcaltitlán, State of Mexico (reproduced with the permission of FONADAN).

ing tongue and sometimes provides the opening through which the wearer sees. In such cases, the face of the wearer can be seen within the mask exactly as the opossum mask helmet from Monte Albán (pl. 34) symbolically revealed its wearer within. The nose of the tigre mask is generally a feline pug nose, and the eyes are often distinctly circular and goggle shaped, though not always. The masks generally bristle with clumps of hair, eyebrows, and mustaches of hog or boar hair and are usually painted yellow with black spots. The masks comprised of these features range from relatively realistic portrayals of the jaguar to highly stylized ones, but they all emphasize at least some of the features we have seen in the jaguar-derived pre-Columbian rain gods from the Olmec were-jaguar[18] to the Oaxacan Cocijo, the Tlaloc of central Mexico, and the Maya Chac.

Although there is some regional variation, masks essentially similar to these represent the jaguar in ritual throughout Mesoamerica, and other elements of los Tecuanes and los Tlacololeros consistently appear along with the familiar mask.

Pl. 63. Mask of a *Tigre*, Guerrero. The wearer of the mask may be seen through the mask's mouth.

First, the tigre seems always to be accompanied by boisterous, generally sexually based humor. At times, the jaguar interacts with the spectators, teasing and taunting them; at times, the performance includes a ritual clown, often carrying a stuffed animal, who engages in sexual foolery; and at other times, the various characters within the drama involve themselves in similar antics. Whatever form it takes, however, there is always humor. As Horcasitas puts it, "The dance is a comedy, yet it would show disrespect to omit it from the village fiesta. It is holy and funny. Religious feeling here is expressed in merriment, not in gloom."[19] That the dances are thought of as religious is indicated by their being preceded and concluded by specifically religious ritual and by their often being presented in the courtyard of the church. But the generally sexual nature of the humor is obviously related to the fertility theme of the ritual drama and is remarkably compatible with its basic nature/culture opposition as it suggests that human sexual proclivities must be controlled for culture to exist. In this connection, it is significant that male participants are generally required to observe a period of sexual abstinence that provides the opposite extreme from the wild sexuality of the humorous elements of the drama. The message is clear: normal human life within a culture is characterized by what the culture defines as normal sexual activity—neither the abstinence of the ritualist nor the wild abandon of the tigre and other characters.

Along with the humor that functions in the context of the nature-versus-culture oppositions, the tigre performances of modern Mesoamerica almost always involve a series of up/down oppositions. In the version just described, the jaguar climbs a tree where he is finally killed. Other versions are more spectacular; in a variant performed at Texcaltitlán, Guerrero, for example, the jaguar first climbs a tree in an attempt to escape the hunters and then climbs a rope extending from that tree to the top of the nearby church tower.[20] Conversely, the tigre is often involved with caves. These up/down and in/out oppositions seem clearly related to pre-Columbian pyramid/mountain and temple/cave ritual and assumptions, especially since the summits of mountains and the inner reaches of caves, as we have seen, were intimately associated in myth and ritual with the provision of rain by the gods. Significantly, the tigres are often involved with church towers, that is, contemporary, religiously defined "summits."

The tigre dances also share a fundamental involvement with violence. The central character, the jaguar, is violent in his destruction of other characters and is finally disposed of violently, and dramatic violence often occurs between the other characters. Moreover, the violence within the drama often provokes very real violence among the spectators. Because of the large amounts of alcohol consumed by festival participants and the emotions aroused by the dance-drama, real blood is often shed and, not infrequently, participants are killed. But this is expected and, in a strange way, seen as desirable. Véronique Flanet, in discussing the festivals in the Mixteca, says that a fiesta is not deemed successful if no one has been killed. She quotes typical remarks: "Last year's festival was much better; there were seven people killed," or "When no one is killed, there is nothing worth mentioning about a fiesta."[21] This emphasis on, and expectation of, bloodshed and violent death—both within the ritual performances and without—may seem barbaric to us and to the civil and ecclesiastical authorities of modern Mexico, but as an integral part of the ritual fertility festivities, it reflects the fundamental connection in the Mesoamerican mind between sacrifice and fertility. Seen in this way, it is in perfect accord with other modern practices and assumptions with the same pre-Columbian roots. One thinks, for example, of the *penitentes* throughout Mesoamerica and the bloody depictions of Christ in indigenous art.

While a number of other ritual dances involve tigre-masked characters, none demonstrates the characteristics connected to the pre-Columbian past more clearly than the combat of tigres enacted on May 2, *el día de la Santa Cruz*, at Zitlala, Guerrero. To call this a ritual combat between members of opposing barrios should not suggest that it is in any sense a mock combat; the fighters "trade blows until they are gravely wounded."[22] The practical function of the leather mask helmet (colorplate 12) is to protect the wearer's head from the blows delivered by his opponent's rope-covered cudgel, but the nature of the mask and cudgel indicates their pre-Hispanic origin and the pre-Columbian roots of the ritual. Formed of a single piece of heavy leather folded at the top with the sides laced together,[23] the mask helmet completely covers the wearer's head down to the nape of his neck. Protruding from the top, at the ends of the fold, are prominent ears, and a nose formed of a rolled piece of leather divides the front of the mask from the top to just above the mouth. On either side of the nose are the eyes made of mirrors or tin and outlined with remarkably gogglelike circles of leather. The lower part of the mask is dominated by the oval mouth that the wearer sees through which is also formed of leather and contains leather teeth and a prominently protruding tongue. The front of the mask bristles with clumps of inserted hog or boar hair, and the whole construction is painted either yellow or green and spotted with small black circles.[24] While its overall appearance is quite different from the masks used in los Tecuanes and los Tlacololeros, its individual features are remarkably similar, a fact suggesting a common source from which the varied masks evolved. The cudgel wielded by this masked combatant is a length of

stiffened rope wound at the end with more rope to form what has proved at times to be a lethal weapon, a weapon reminiscent of the pre-Columbian *macuahuitl* used by Aztec warriors.[25]

The description of the mask suggests its close relationship to the jaguar-derived, pre-Columbian rain gods, especially Tlaloc. Most reminiscent of the Aztec god, of course, are the goggle eyes, but the nose, too, is very close in appearance to the nose formed of twined serpents often seen on Aztec images of the god. The mouth looks like the Tlaloc mouth with the upper and lower lips meeting to form an oval, and the protruding tongue, while not bifid, suggests those commonly found on masks of the rain god. It is perhaps significant to an understanding of both the pre-Columbian masks and this one that the serpent-related characteristics of the rain god mask, possibly excepting the nose, added by the inheritors of the Olmec were-jaguar have disappeared.

And the substance of the ritual as well as the appearance of its participants has pre-Columbian roots. As both Cruz Suárez Jácome and Roberto Williams García point out, the combat is an integral part of the ritual activities of the second of May, activities whose primary purpose "is to entreat the *aires* to send beneficent rains and abundant harvests." These aires are, like the pre-Columbian rain gods, quadripartite in nature with directional, color, and bird symbolism. The ritual "should be interpreted as propitiating the *aires* in general, and in particular entreating the *aires* of the East to deliver the beneficent rains and discouraging the *aires* of the North from sending hail, frost, and destructive rain." Significantly, the ritual is performed at roughly the same time as the Aztec festival of *Huey Tozoztli* dedicated to Tlaloc and serving a similar purpose.[26]

An understanding of these similarities between the modern festival and its pre-Columbian forerunner allows the full import of the comments of participants in and viewers of the combat to emerge. José Colasillo, an elder of the village of Zitlala, said that the combatants must fight as "a sacrifice for rain." Another member of the community made the idea even more explicit: "If we do not do this, God will not see the necessity to send the sacred waters." And another said, "Without our tiger fights, the sun might not rise, and the rains might not come. We must sacrifice with all our hearts."[27] These words suggest the human reality of Suárez Jácome's contention that the combat, as a necessary sacrifice, gives the rain-petitioning ceremonies greater force.[28] Thus, the pre-Columbian formulation equating blood with rain as the basis of a reciprocal relationship requiring man's sacrifice in return for the "sacrifice" of the gods may still be found in Zitlala. Now, of course, the Zitlaleño would say "God" rather than "the gods," but the underlying spiritual assumptions remain.

As Juan Sánchez Andraka puts it, "the Aztec 'flowery war' persists"[29] and continues to provide the blood that nourishes the gods.

It is thus doubly fascinating that a portion of the rain-petitioning ritual of the second of May takes place in a cave on the Cerro Cruzco,[30] a mountain that rises above Zitlala. While that fact alone has pre-Columbian implications, this particular cave is the cave of Oxtotitlán containing the Olmec murals discussed above which has functioned as a fertility shrine at least since the time of the Olmecs a thousand years before the birth of the Christ, who gave his name to the religion now "accepted" by the people of the village. As the jaguar mask worn by the combatants makes abundantly clear, their Christianity rests on a pre-Columbian spiritual base.

But the situation is complex as these clearly pre-Columbian elements are embedded in a ritual with numerous Christian elements. In fact, May 2 is the Day of the Holy Cross, an entity that is even more important to the ritual than the tigres. "For the people of Zitlala, the cross is more than a symbol; it is a living entity, a feminine deity," and while the tigres figure importantly in the ritual, "their once-principal role has been subordinated to the cult of the cross."[31] The activities that culminate in the ritual on the Day of the Holy Cross begin in earnest on April 30 when three crosses, one for each of the barrios of Zitlala, are brought down to the river from the cave on the Cerro Cruzco. On the following day, they are "dressed" with special capes, in a manner reminiscent of pre-Conquest practice, prayed over, and decorated with offerings of candles, chickens, corn, copal, and garlands of flowers and bread. In this state, they are borne on special frames by unmarried young women on a circuitous route up from the river, through the village to the church. Along the way, the head of each household the crosses pass adds to the offerings. That night the crosses "rest" in the church while masked dances are performed outside. On the following day, the second of May, after the celebration of masses in the morning, the crosses are borne back to the river and carefully restored to their former place, now, however, without the offerings. At this point, the celebrants separate. Some carry the cross up a steep and rocky path on the Cerro Cruzco to the adoratorio while others participate in the combat of the tigres in the riverbed at the base of the mountain. Those who follow the cross engage in a complex set of activities, including the ritual sacrifice of chickens, on the mountain which results in a variety of foods to be given as offerings to the now newly "dressed" crosses.[32] Meanwhile, the tigres are rendering offerings of another sort.

The Christian elements of the festival are now more prominent than the indigenous elements, but the similarities between the two are far more fas-

cinating than their differences. Both are subordinated to the overall theme of sacrifice as an offering to the world of the spirit from whence comes life, and both involve the metaphor of the mask, a metaphor fundamental to the combat of the tigres. The combatants don the mask of the god, animate it with the force of their life, and then shed the symbol of that life-force, their blood, in voluntary combat. Thus, their blood becomes the "blood" of the gods, the rain, which enables man to live. But what is the "dressed" cross but precisely the same metaphor? By covering the cross with the things of this world, as the santos are often dressed in indigenous ritual imitative of the pre-Columbian dressing of the nude or nearly nude stone or ceramic figures we now see in museums, the cross itself becomes the inner life-force animating the clothing and giving vital force to the flowers and bread. It requires sustenance and provides sustenance. The treatment of the cross and its offerings reveals exactly the same reciprocal relationship between man and the world of the spirit as that revealed by the combat of the masked tigres.

These elements are evident in the events of the Day of the Holy Cross, but when that day is linked to its counterpart of September 10 when Zitlala celebrates the day of Saint Nicholas, they can be even better understood. Although that festival nominally celebrates the patron saint, it is actually a harvest festival.[33] The Indians of the region pay homage to the image of San Nicolás "according to the blessings received from him. When harvests have been plentiful, the shrine is visited by hundreds of the faithful."[34] Thus, the ritual of the Day of the Holy Cross in May seeks rain, fertility, and an abundant harvest, and the ritual of the Day of San Nicolás Tolentino in September gives thanks for their provision, if they have been provided. The activities surrounding that day of thanksgiving, while quite different from those of the earlier festival, are equally syncretic. And while the tigres play an important role, they do not engage in ritual combat, and the Aztec-derived cudgel with which they fight on the second of May is replaced by the teponaxtli, a cylindrically shaped pre-Columbian percussion instrument, which at least some of the villagers believe is "the voice of God, of the Celestial Jaguar, of the thunder and lightning."[35]

Sánchez Andraka describes an observer's experience of the eve of the festival vividly, if somewhat dramatically.

Fireworks shook the earth, all the bells were ringing, and the people filled the plaza and the atrium. The dance troupes began to arrive one by one. Los Moros. Los Moros Chinos. Los Diablos. Los Zopilotes. Los Vaqueros. Colacillo, the great healer of Zitlala, whose fame goes beyond the borders of the state, played the violin frenetically for Los Vaqueros. Colored lights shot into the sky and thousands of candles adorned the church. In the midst of all this, a strange sound could suddenly be heard, a sound of wood striking wood that silenced everyone and transported us to another epoch. The bells and the firecrackers ceased. Tap, tap, tap, tap. It was an imperious wooden voice that carried us beyond fear and the night. Tap, tap, tap, tap. It seemed to be the voice of a deity speaking to the people or invoking the heavenly bodies, the moon and the stars, which shone intensely this night. And then a long laugh and a yell. Everyone's eyes lifted to the church tower. Four shadows could be seen on the ledge of the first cornice. The tap tap *of the teponaxtli and the laugh and the yell had come from there. Héctor shined his flashlight on them and others followed suit. The one who carried the teponaxtli over his shoulder was dressed in red with a red mask and very long hair. Another, dressed similarly but with a black mask, reverently beat the teponaxtli and continued yelling and laughing, but it was a mysterious laugh. At their sides were the impressively masked* tigres—*one bright yellow, the other dark yellow. They leaped from the first cornice and climbed to the second. The* tap, tap, tap *grew in intensity and changed in tone. Below was a profound silence. When the masked figures reached the third cornice, they were 30 meters above the ground on a ledge a scant 20 centimeters wide. From this ledge they climbed to the small cupola topped with the cross, one of them carrying the teponaxtli, the other beating it, and the* tigres *giving three cat-like leaps. Now the yell and the laugh were very strong. They decorated the cross with garlands of zempazúchil and then began to descend, incessantly* tap, tap, tap*ping.[36]

At the base of the tower, the crowd awaited them, headed by a group of festively dressed young women holding garlands of flowers and bread to adorn the teponaxtli, which "moments before had been announcing the voice of the Celestial Jaguar from the cupola,"[37] when it appeared borne on the back of one of the tigres. When the other masked figures had descended, the four of them, bearing the now-decorated teponaxtli, led the crowd in a solemn procession toward the main altar of the church on which rested the gold monstrance containing the sacred host. On reaching the altar, the masked figures moved the monstrance to one side, depositing the flower- and bread-laden teponaxtli in the place of honor. Catholic hymns were sung and Catholic prayers said while the tigres executed silent, feline movements in honor of the enshrined teponaxtli. Following these acts of devotion, the tigres picked up the teponaxtli and led the crowd of worshipers, now a lengthy procession, through the streets of the village to the houses of the mayordomos and padrinos.[38] Such a description al-

lows us to feel as well as understand the syncretic unity of the experience woven, like the ritual on the Day of the Holy Cross, from strands of indigenous and Christian ritual. The indigenous symbols of mask and teponaxtli have merged with the Catholic symbols of cross and host to create a single, syncretic ritual experience for the participant.

There are obvious similarities between this activity on the eve of the harvest festival and the activities propitiating the aires at the beginning of the growing season. Both involve the masked tigres, a cross decorated with flowers and bread, and a procession through the town. In both cases, there is what clearly seems to be a conscious replacement of Christian symbols with pagan ones: in the harvest festival, the teponaxtli replaces the host in the central position on the altar as it has "replaced" the cross atop the tower; in the earlier ritual, the tigre combat "replaces," for some of the participants at least, the attendance on the cross as the culmination of the ritual activities. Thus, in both cases, a powerful indigenous symbol related to the jaguar is equated with Christian symbols, and in both, the ritual is fundamentally involved with bringing a religious symbol deemed to be a living thing down from a height to the temple, a practice with obvious overtones of pre-Columbian, pyramid-related ritual. These similarities show the depth and importance of the syncretic merging of the two traditions as the ritual redefines the most fundamental of symbols—the Christian cross and the indigenous mask—within the ritual context to accomplish that fusion.

But there are basic differences between the two ritual observances as well, the most important of which is the fact that the harvest festival does not involve the sacrifices that are the focal point of the earlier fertility ceremonies. In the latter, the tigres not only do not shed their blood in ritual combat, but as Sánchez Andraka states explicitly, the Zitlaleños believe that in the dangerous climb up the church tower, "no one has ever fallen."[39] And no chickens are sacrificed in connection with the offerings to the cross atop the cupola or to the teponaxtli. The reason for this difference seems obvious: this ritual activity is not done in reciprocation for the gods' sending of rain and thus does not require sacrifice. The difference points directly to the fundamental fertility symbolism of the two ritual situations and demonstrates that in the case of these two observances, at least, the merging of the two traditions leaves the fundamental purpose of the indigenous system intact since neither a Festival of the Holy Cross nor a Festival of the Patron Saint would normally be fertility related.

The two indigenous symbols central to the spiritual life of the people of Zitlala, the tigre mask and the teponaxtli, are both related to the jaguar: the mask images forth the jaguar's features, and the teponaxtli allows its voice to be heard. These in-

digenous symbolic forms manifest the sacred as they have always done for the peoples of Mesoamerica. They are animated by the force of the divine and are therefore seen as symbolically equivalent to the living cross, the other important spiritual symbol in Zitlala. Thus, the jaguar, through his mask, continues to provide a metaphor for the reciprocal relationship between man and the world of the spirit, a relationship through which the sustenance of man's life is provided by the force of the spirit. That this is true is indicated, in an interesting way, by Suárez Jácome. Enumerating the factors in the life of Zitlala which are changing these centuries-old customs and beliefs, she lists education, along with the influence of the priest, the civil authorities, and the economic system, as a factor. Now, she says, "it is believed by students that rain is a phenomenon of nature which is involved in a cycle independent of ritual, and the teachers (90% of whom are strangers to the community and to the culture) condemn the rites as barbaric."[40] These teachers, on behalf of "modern life," are attacking a set of assumptions wholly alien to their own culture and in so doing indicate clearly the nature of those assumptions. The jaguar's days are numbered, it would seem, at least in Zitlala.

The symbolic importance of the jaguar mask at Zitlala echoes what we have seen in the dance-dramas of los Tecuanes and los Tlacololeros. Superficially different from the activities of the tigres of Zitlala, beneath the surface they are the same—revealing metaphorically the reciprocal, sacrificial relationship with the world of the spirit through which man's life is sustained. While this jaguar symbolism is strongest in Guerrero and the closely related areas of Morelos and the state of Mexico where los Tecuanes, los Tlacololeros, and their variants flourish,[41] it can be found elsewhere as well, especially along the Pacific slope and in the neighboring highlands from central Mexico through Oaxaca and Chiapas to Guatemala. In the Mixteca along the Pacific coast of the state of Oaxaca, the area called the Costa Chica, carnival dances and antics are performed by a group of masked figures, *los Tejorones*, and among those dances is a tigre dance. Called in Mixtec *El Yaa kwiñe*, in its plot it is reminiscent of los Tecuanes,[42] although, due no doubt to the nature of carnival, the performers improvise a great deal.[43] Those improvisations, according to Flanet, usually have highly sexual, generally tabooed, implications that often provoke violence, leading, at times, to fights, serious injury, and even death. The tigre epitomizes the antisocial tendencies within the performance, representing the prohibited forces of violence and sexuality.[44]

Although the tigre plays only a part in the carnival activities of the masked Tejorones, its role defines the parameters of Mesoamerican carnival in

a significant way. According to Mikhail Bakhtin, in his penetrating analysis of the carnivalesque,

carnival is the festival of all-destroying and all-renewing time. . . . This is not an abstract meaning, but rather a living attitude toward the world, expressed in the experienced and play-acted concretely sensuous form of the ritual performance. . . . All carnivalistic symbols are of this nature: they always include within themselves the perspective of negation (death), or its opposite. Birth is fraught with death, and death with new birth.[45]

Such a formulation suggests the basis for an inclusion of the tigre and its sacrificial fertility symbolism within the pre-Lenten carnival festivities that are not generally thought of as agricultural festivals. Both agricultural fertility and the death and resurrection of Christ are potent examples of the principle of rebirth, of the eternal return of life after the death that necessarily precedes rebirth. We have seen the relationship of ritual violence to this symbolism in the paradigmatic case of the Zitlala tigres, which explains the violence, injury, and death, sometimes symbolic and sometimes very real, always associated with the masked tigres as the sacrifice of life to life so that life may continue in its eternal cyclical alternation with death. Blood must be shed in that process of renewal.

But the Mixtec carnival tigre seems not quite so directly related to fertility as his Nahuatl counterparts. The plot of the Costa Chica dance-drama is similar to los Tecuanes, the least obviously fertility-related tigre dance, and the actions of the Mixtec tigre in their extreme sexuality and violence seem more consistent with the inversion of values of carnival than with the dance-dramas associated with agricultural festivals. When he is not fighting his would-be killers or assaulting the cow or one of the other animal characters, he is preoccupied with sexual concerns, using "his principal attribute—his long tail—constantly: he masturbates with it, uses it sexually to violate the cow or one of the *tejorones* while the others assault him sexually, handling him now as a woman, now as a man and, with his complicity, imitating either homosexual or heterosexual coitus."[46] Such activities have obvious fertility implications, suggesting that in the Mixteca the tigre's role in essentially agricultural ritual has been modified to fit the carnival context. The tigre mask is surrounded by those of the tejorones and acts accordingly. J. C. Crocker points out the underlying general truth.

Clearly the complex meanings shown forth in any one mask are amplified, negated, and generally culturally debated through other masks, both those appearing simultaneously with it and those in other ceremonials. Furthermore, the mask's symbolisms are obviously enhanced by those meanings conveyed through other material objects used in the ceremony—

the songs, lyrics, dance movements, special foods and drinks and drugs consumed only or mainly on such celebratory occasions.[47]

And as Flanet points out, the dominant activities of the Tejorones parody the social order in a deliberate inversion of accepted values and modes of behavior. Forming what she calls a "counter-society," they mask themselves and dress in rags, insult and ridicule spectators, both male and female, and assault them with sexual gestures; they also attempt to provoke the indigenous authorities who are watching by parodying their actions and behavior and do the same with the mestizo authorities and important citizens.[48] In all these activities, but especially in their attitude toward the authorities, they exemplify the classic themes of European carnival. According to Bakhtin, "the primary carnival performance is the mock crowning and subsequent discrowning of the king of carnival" in a parody of normal life. And that "parody is the creation of a double which discrowns its counterpart." Essentially, this "is the very core of the carnivalistic attitude to the world—the pathos of vicissitude and change." But it "is an ambivalent ritual expressing the inevitability, and simultaneously the creativity of change and renewal."[49] Although the details of the performance of the Mixtec Tejorones differ from those of the much earlier European carnival that Bakhtin describes, their parody of authority has much the same purpose. But in the Mixtec case, both the sexual byplay and the violence allow us to see clearly that their social level of interpretation is complemented by another level—that of agricultural fertility where sexual union and sacrificial bloodshed produce rebirth in a different sense. In both cases, order is restored after the individual cycle ends. Thus, at the very basis of the symbolism of carnival is "the cognizance of a cyclical time which is recurrent [and] capable of regeneration."[50] On each of its metaphoric levels, carnival opposes the wildness inherent in nature to the order necessary for the existence of human society and shows that that order must constantly be reborn from the reinvigorating wildness within nature and within man. It seems fitting that "the *tigre* is central to the *Tejorones.*"[51]

The masked carnival dances of Juxtlahuaca in the Mixteca Baja provide a similar example of the tigre in a carnival context. In contrast to the highly structured and rather formal Festival of Santiago held on July 25, which is the only other festival involving masked dancers, "carnival performances . . . appear, seemingly spontaneously, on street corners, in the open plazas, and wandering from house to house." The tigre forms part of this festive spontaneity. As part of the Chilolos del Ardillo, there are two clowns. One, Mahoma del Ardillo (Mohammed of the Squirrel), "wears a hairy black-faced mask and carries a stuffed squirrel, . . . a gun and a hunting bag." The other, Tigre or Tecuani, "wears

a spotted jaguar suit and a dramatic feline mask." The two of them "enact a spoof of hunting with the *Tigre* as the ultimate victim." The strong sexual overtones associated with the Costa Chica tigre are present in the Juxtlahuaca carnival although associated not with these clowns but with the performance of the Macho who, in "courting" Beauty violates every sexual taboo by "yelling obscenities, speaking of sex quite explicitly, and . . . enacting numerous deeds." The implications of the sexual activity are complex since it is not lost on the spectators that the ostensibly female Beauty is actually a man wearing the mask of a woman.[52] Carnival at Juxtlahuaca thus contains the same elements found on the Costa Chica, although they appear in somewhat different form.

The carnivalesque actions of the Mixtec tigre barely mask his very real fertility connections. His sexual activity can be seen as metaphoric of the fertility his symbolic death will achieve, a view supported by the fact that similarly sexual activities, though not so extreme, are associated with the tigre dance-dramas of Guerrero and Morelos in which the tigre and other characters often tease the onlookers with comments relating to their sexual lives and capabilities. And according to Marion Oettinger, the festivities on the Day of the Holy Cross at Zitlala include a masked clown, not directly connected to the tigres, who teasingly menaces onlookers with "a large ceramic vessel in the shape of a penis. With this phallus, the clown moves about the crowd simulating sexual acts with men and women."[53] And the violence associated with the tigre, as we have seen in the case of Zitlala, must be seen as the blood sacrifice necessary for the propitiation of the forces that will ultimately send the rains and assure fertility. These motifs, so clearly related to fertility, are an integral part of the symbolic nature of the jaguar, accompanying that symbolic beast even in ritual, like that of carnival, not overtly related to agricultural concerns.

The tigre masks and tigre dances of the village festivals of Oaxaca are neither as numerous nor as significant as those of Guerrero and Morelos, and the farther one travels along the Pacific slope, as Horcasitas has noted,[54] the fewer tigre dances and masks one finds. The masks and characters that do exist among the Maya are usually involved in other dances, often revolving around the serpent or the hunting of a deer. That they have a long history is clear from the fact that the colonial dance with which we began our discussion was performed, and prohibited, in Tabasco. Mercedes Olivera B., after suggesting that such dances in Chiapas similarly have features of clearly pre-Hispanic origin related to "the earth, water, and fertility" and that they are related to los Tecuanes, notes that "other elements such as the deer and the serpent (*calalá*)" are involved in the dances.[55] She records descriptions of

three versions of *El Calalá*, each of which involves one or more tigres and are clearly fertility related since "the dance is dedicated to Tlaloc, god of rain."[56]

Similar uses of the tigre are to be found among the Guatemalan Maya. Horcasitas mentions various hunting dance-dramas involving the tigre,[57] and the description of one of them, a Deer Dance, by Thompson in 1927 reveals obvious similarities to los Tecuanes of central Mexico. Its pre-Columbian roots were suggested to him both by the appearance of the masks and by its being performed at roughly the same time of the year as similar pre-Hispanic dances.[58] David Vela categorizes such dances as "primitive forms of pre-Columbian dances" in contrast to the few dances such as the *Rabinal Achí* and the *Baile del Tun* which have survived virtually intact from pre-Columbian times,[59] and Lise Paret-Limardo de Vela also suggests a pre-Columbian source for the dance-drama on the basis of its dedication by the dancers to indigenous gods and its inclusion of a shaman who appeals to those gods for help for the hunters of the tigre.[60] But Gordon Frost, noting Paret-Limardo's assertions, illustrates a jaguar mask from San Marcos with two crosses painted in black, like the mask's spots, between the eyes and on the forehead.[61] Thus, the Guatemalan tigre seems also to continue his pre-Hispanic existence within a syncretic framework.

While all of these masked jaguar impersonators among the Maya play important roles in fertility-related ritual, the year-ending rituals of the Festival of San Sebastián enacted by the Tzotzil Maya of Zinacantan, Chiapas, provide an example of jaguar characters with clear fertility implications playing a role in a much larger drama. Vogt, who describes the events of the festival in great detail, suggests that their complexity, resulting from the multivocal nature of the festival, makes understanding their symbolism difficult.[62] While its ritual may not be primarily related to fertility, there is within it a fascinating constellation of symbols suggesting that on one of its many levels it not only has fertility implications but is probably still today a fertility ritual. This level, of course, can coexist with the others because it is "saying" essentially the same thing but applying the common theme to this particular area of human concern. We will focus our attention here on that level, pulling out of the complex ritual those elements that relate to fertility, elements strikingly similar both to those found in the festivals of Guerrero which we have discussed and, in their subordination to other themes, to the Mixtec carnival of Oaxaca.

The focus of the ritual is the annual "changing of the guard" of the town's cargoholders, a focus clearly indicated by the attire of those officials. While the newly installed cargoholders wear the regalia of their offices, the outgoing officials im-

personate what Vogt calls "mythological figures." Among them are jaguars "dressed in one-piece, jaguarlike costumes of orange-brown material painted with black circles and dots. Their hats are jaguar fur. They carry stuffed animals in addition to whips and sharply pointed sticks [and] . . . make a 'huh, huh, huh' sound."[63] Except for their lack of a mask, the similarity between these figures and the masked tigres of Guerrero is striking, and the stuffed animal is a common feature of the tigre dances we have discussed. Interestingly, these figures' identifying hats display masks as they were often displayed in the headdresses worn in pre-Columbian ritual, and the other characters display other variations typical of pre-Columbian mask use: the Plumed Serpents of the festival wear hats that are masks; the White Heads wear forehead decorations that are often described as masks; and the Blackmen wear cloth masks over their faces.[64]

Not only the appearance of the jaguars and their relationship to the metaphor of the mask but the extensive sexual humor of the festival, humor in which the jaguars are directly involved, recalls the central Mexican tigres generally and the Mixtec carnival specifically. In the most graphic of terms, for example, the jaguars accuse officials of neglecting their duties to engage in sexual activity and use their stuffed animals to represent the negligent officials' wives in similarly graphic parodic actions.

> Stuffed female squirrels [are] painted red on their undersides to emphasize their genitals and adorned with necklaces and ribbons around their necks. The men carry red-painted sticks carved in the form of bull penises, which, to the accompaniment of lewd joking, are inserted into the genitals of the squirrels. The squirrels symbolize the wives of those religious officials who failed to appear for this fiesta and complete their year of ceremonial duty.[65]

Sexuality is also emphasized in the jaguars' climbing and descending from the Jaguar Tree as their "genital areas are playfully poked with the heads of the stuffed animals."[66]

That ascent and descent of what is in this case an artificial tree, a branched pole set up for the festival, is another familiar element of tigre ritual, and in the festival of San Sebastián, it is clearly fertility related. After circling the tree three times and leaving their stuffed squirrels on the ground, "the two jaguars, followed [hunted?] by the Blackmen, climb to the tree's uppermost branches. Laughing and shouting, they spit and throw pieces of food at the crowd, supposedly 'feeding' the stuffed animals."[67] The fertility implications seem obvious as food and saliva "rain" down on the spectators from the jaguars. It would, in fact, be hard to imagine a more literal rendering of the "gods" sending rain and sustenance. That this takes place from the

Jaguar Tree, in which the tigre is killed in Guerrero, and that the jaguars are pursued up it by the Blackmen suggests sacrifice here, just as it does in Guerrero.

The significance of this episode is enhanced by its being one of two similarly structured episodes in the festival. The other takes place at Jaguar Rock, a large boulder.

> At the base of the boulder is a wooden cross, where the Lacandon, flanked by two jaguars, places four white candles and lights them. The others join the Lacandon and Jaguars to kneel, pray, and finally dance in front of the candles and cross. Then the Jaguars and Blackmen climb on top of the boulder and the Jaguars light three candles in front of a cross there. The Jaguars and Blackmen subsequently set fire to a heap of corn fodder and grass on top of the rock and shout for help as they toss the stuffed squirrels down to their fellows on the ground, who in turn toss them up again. . . . The grass fire on the boulder signifies the burning of the Jaguar's house and the death of the Jaguars; the two Jaguar characters descend from the rock with the Blackmen and crawl into a cave-like indentation at the base of the rock to lie still, pretending to be dead. As the Jaguars lie there, the Lacandon pokes or "shoots" at them with his bow and arrow and then turns to seize two Chamula boys from the onlooking crowd. He brings them near the prone Jaguars and "shoots" the boys with his bow and arrow. Symbolically, the Jaguars are revived by the transference of the souls of the Chamula boys to their animal bodies and they leap up, "alive" again, to drink rum, [and] dance awhile.[68]

All of the elements of fertility ritual are present, but in a configuration now emphasizing rebirth rather than the provision of sustenance; the key to the ritual's emphasis is the revival of the Jaguars, which is also, paradoxically, a rebirth of the boys who have been "shot," or sacrificed, so that the Jaguar, or "god," might live. Their souls do not die but live on in altered form. Since all this is clearly related to the burning of the grass and corn fodder, in a land of slash-and-burn farming, it is obvious that such burning, or "death," must precede the rebirth of the corn. And that burning is said to cause the destruction of the Jaguar and of his house, a ritual demonstration of the essential fact that while particular living things may die, the life-force does not; it can be counted on to revivify nature. That these Jaguars do not wear conventional masks but are involved with all the variations of mask use is fascinating since the ritual depends on the central metaphor, which has, at least since the time of the Olmecs, been symbolized by the mask. Here again we see the natural world as the equivalent of a mask, lifeless until it is animated by the

force of the spirit and projecting in its symbolic features the "face" of the world of the spirit.

It can also be seen that the events at Jaguar Tree and Jaguar Rock are related to essentially pre-Columbian metaphors in their employment of up/down oppositions. In both cases, the ritual emphasizes the tops of Tree and Rock. It is from the Treetop that sustenance flows, and it is atop the Rock that the death—or sacrifice—of the Jaguars takes place. Such activities correspond to pre-Columbian myth, in the connection of mountaintops with rain, and ritual practice, in the location of sacrifices in the temples atop pyramids. Furthermore, the episode at Jaguar Rock opposes the top of the Rock to the "cave": sacrifice takes place above and revivification below. These metaphorical uses of heights and caves did not end with the Conquest, nor are they presently to be found only in Zinacantan. In varied forms, they are central to the ritual associated with the mask of the tigre from Guerrero to Guatemala.

These similarities between the festival of San Sebastián and the tigre dances of central Mexico are rather general, but there is another similarity that is so specific as to be both amazing and quite difficult to explain. Central to both Zinacantan's Festival of San Sebastián and Zitlala's Festival of San Nicolás is a sacred teponaxtli. Zinacantan's is called the t'ent'en, and it normally "rests" in a small chapel. For the festival each year,

the drum is ritually washed in water containing leaves of sacred plants, . . . reglued, and decorated with bright new ribbons. The similarity between its treatment and that of saint images is striking. Like a saint it is referred to as "Our Holy Father T'ENT'EN"; . . . before its major ceremonial appearance, it is washed and "clothed." The drum is involved in only two rituals each year: the fiesta of San Sebastián and the rain-making ritual, for which shamans must make a long pilgrimage to the top of Junior Great Mountain south of Teopisca. Its appearance at any other fiesta is forbidden.[69]

While it is not suggested in the discussions of either Vogt or Victoria Bricker that the t'ent'en provides a voice for the gods as does the teponaxtli of Zitlala, Vogt does say it is believed "that the t'ent'en has a strong and powerful innate soul" and that it is "continuously played and carefully tended throughout the fiesta period."[70] This essential similarity suggests another. The employment of the t'ent'en indicates that, on one level at least, the Festival of San Sebastián is to be "paired with" Zinacantan's rain-making ritual in much the same way that Zitlala's harvest festival provides a complement to its rain-petitioning ritual, for the San Sebastián festival also completes the annual cycle and inaugurates the beginning of a new year.

That final similarity suggests that the Chiapas and Guerrero festivals have similar fundamental purposes. Vogt speculates as to the general meanings of this festival.

Why does the richest ritual segment of the annual ceremonial calendar occur in December and January? The period corresponds to the end of the maize cycle. . . . [In addition] the period of Christmas to San Sebastián—from the point of view of either the Catholic saints' calendar or the movements of the sun—is the time of transition from the old to the new year. . . . It is my thesis that the Zinacantecos are first unwiring, or unstructuring, the system of order and then rewiring, or restructuring, it, as the cargoholders who have spent a year in "sacred time" in office are definitively removed from their cargos and returned to normal time and everyday life.[71]

Thanks to Vogt's careful and lengthy observation of Zinacanteco customs and to his painstaking analysis of their ritual, we can begin to understand its almost incredible complexity and by extension, that of its counterparts throughout Mesoamerica. That complexity here, as in all the cases we have examined, makes sense within its cultural context only because it is organized around a fundamental theme relevant to many levels of experience. In this case, the theme of death and rebirth provides the organizing principle. We have the "deaths" of the calendar year, the cargoholders' year in office, the Catholic saints' calendar, and the agricultural cycle. But in each case, there is a rebirth. Thus, "fertility," the force that "causes" birth, is the driving force the festival celebrates; and the omnipresent sexual humor, some of it directly involving birth, refers quite directly to that force, while the up-down oppositions and the symbolic use of the cave are related to it in an equally clear, if somewhat more symbolic, fashion. As we would expect, the jaguars are right in the middle of these activities symbolizing fertility, and, more unexpectedly, the teponaxtli also plays a central part.

There are, then, a significant number of fundamental similarities between the ritual of the Festival of San Sebastián and the rain-related fertility ritual involving the tigre-masked dancers of central Mexico. Both Bricker and Vogt see this ritual as rain-related, but neither sees the Jaguars as important in that regard. On the basis of their understanding of pre-Columbian thought, both see the costumed figures identified as k'uk'ul conetik (literally, plumed serpents),[72] as central to the rituals' rain symbolism. Vogt associates them with Quetzalcóatl whom he sees as a "deity of new vegetation,"[73] and Bricker relates them to the Ehécatl aspect of Quetzalcóatl since Ehécatl symbolized for the pre-Columbian peoples of central Mexico the winds of the rain storm which sweep the roads clear for the coming of the rains. She identifies another group of characters in the festival, the White Heads, with Tlaloc on the basis of a tri-lobed

device worn on their foreheads which she sees as similar to tri-lobed designs associated with Tlaloc in the art of Teotihuacán and Tenochtitlán.[74] To us, of course, these seem roundabout ways of demonstrating the clearly pre-Hispanic roots of the fertility aspect of this ritual. The key is not really the plumed serpent but the jaguar, the source of attributes for the mask of the rain gods of Mesoamerica from time immemorial. That this is the real connection between this ritual and rain is demonstrated conclusively by the numerous similarities, some amazingly precise, between this ritual activity and the fertility ritual of central Mexico which revolves around the tigre-masked impersonator of the jaguar; the plumed serpent plays no role there.

The striking similarities between the jaguar-related fertility ritual of such widely distant villages is obviously the result of evolution from a common source rather than direct contact, but the clear differences indicate that that source lies relatively far in the past. How far is indicated by what is known of the history of Zinacantan and by the fact that the activities of the Jaguars here and the features of the Guerrero tigres whose activities are so similar point to a central Mexican source. Vogt believes that whatever central Mexican influence there was in pre-Conquest Maya Zinacantan came during the time of the Toltecs,[75] the time of the dispersion of central Mexican religious forms generally, and of Tlaloc-related symbols particularly, throughout Mesoamerica. Positing a Toltec-period beginning for the jaguar symbolism of the fertility ritual would certainly fit Bricker's identification of the Plumed Serpents here with Ehécatl as that aspect of Quetzalcóatl was often associated with Tlaloc in the context of the rain storm by the Aztecs, an association we can safely assume was part of their Toltec heritage. Only such a historical development, it would seem, could explain the numerous and remarkably precise similarities between Zinacanteco ritual and that of Zitlala and other distant communities.

One can only conclude from all of this evidence that the contemporary jaguar-masked or costumed impersonator has a long history, going back at least three thousand years to the Olmecs. In addition to tracing the development of the features of mask and costume, we can also ascertain that the symbolic meanings associated with that metaphoric disguise have remained constant. These contemporary "jaguars" are still involved with maintaining, through ritual sacrifice, the order that guarantees the coming of the rains at the proper times and in the proper amounts; they are still involved, at least in Zinacantan, with the symbolization of the divine basis of rulership; and they are still fundamentally involved with symbolizing the opposition between nature and culture and the necessity for man to resolve that opposition so as to create and maintain a culture within which fully human life can exist. Such realizations not only help us to understand the vital role the metaphor of the mask has played and continues to play in indigenous Mesoamerican thought but also enable us to see both the continuity of that thought and, equally important, its continuing complexity and sophistication.

While the mask of the jaguar provides the fullest, the most compelling, and the most fascinating evidence for the continuity of metaphorical mask use from pre-Columbian times to the present, it is far from being the only example. Two other types stand out although there are numerous specific masks with clear pre-Columbian roots. The masks and dance of *los Viejitos* as they exist throughout Tarascan Michoacán are widely recognized as having pre-Conquest roots in their symbolization of the relationship between age, or the end of the cycle of life, and the rebirth of youth.[76] And Tarascan ritual also involves *los Negritos*, black-masked figures whose history, while clearly pre-Hispanic in part, is more difficult to trace. Compounding the difficulty of understanding the Negrito mask is the fact that it is not one mask: there are black-masked figures throughout modern Mesoamerica, and the masks they wear are quite unlike each other. There are two Tarascan masks that differ in both appearance and function; the Tejorones of the Mixtec carnival wear small black masks with Negroid features displaying contrasting white areas of striking design, but there are also quite different Negrito masks in Oaxaca. Among the Totonacs in Veracruz there is still another variant, this one involved in an agricultural drama portraying the conflict between the black-masked Negro and his boss who wears an identical mask that is white. And there are a number of other variants as well as unmasked Negritos who wear elaborate costumes.[77] While some of them surely have pre-Columbian roots, others may not; their common color is not clearly illustrative of a common heritage.

What is abundantly clear is that the tradition of masked ritual, as well as particular masks, survived the Conquest and that the particular survivals carried within their symbolic features the same meanings they had embodied in pre-Columbian society. More important, the continuing tradition of mask use allowed the mask to retain its centrality as a metaphor for the most fundamental relationship between humanity and the world of the spirit that created and sustains human life.

13 The Syncretic Compromise
The Yaqui and Mayo Pascola

I was once told by an elderly pascola *that the patron of all* pascolas *was Jesus Christ, and that for this reason* pascolas *wore loincloths and went barechested just as He did at the crucifixion. . . . Another dancer stated that all* pascolas *were goats, and mentioned that the flaps on the back of the loincloths were the hair on the animals' flanks. In addition, some Yaquis believe that the original* pascola *came from the devil and was persuaded to remain in the service of God.*[1]

This statement indicates a significant difference between the pascola masks and dancers of the Yaqui and Mayo of northwest Mexico and the southwestern United States and the tigre masks and dancers of central and southern Mesoamerica in their relationship to pre-Hispanic forms and symbols. The roots of the tigre are clearly pre-Columbian, even though that mask and character may at times be found involved in syncretic ritual, but the pascola's heritage is not so easily determined, in part because of the problems involved in ascertaining the exact relationship between the cultures that lived on the fringes of Mesoamerican civilization and those of Mesoamerica proper. It is generally felt by Mesoamericanists, though it cannot be conclusively demonstrated, that the masked dance found in the southwestern United States and in northern Mexico, along with other ceremonial forms and paraphernalia, diffused from Mesoamerica proper accompanying trade, probably during or immediately after the period of Toltec hegemony.[2] But the precise source of the pascola's indigenous traits has been difficult to determine.

A greater source of difficulty arises from the degree to which both mask and ritual exhibit the effects of the syncretic fusion of Christian and indigenous traits. The distinctive mask bears both Christian and indigenous symbols, and the ritual in which the masked dancer is involved gives him a bewildering array of roles. He is, perhaps primarily, a ceremonial host whose function is to involve the audience and guide its experience of the sacred during the course of a particular type of indigenous ritual, but he is also a clown, deeply involved in the carnivalesque inversion of values which may very well have medieval Christian roots and all of the fertility implications we have seen in the Oaxacan tejorones. Third, he is an actor, taking part in "skits" with fertility-related themes which often involve the deer dancer, as well as playing a role in the monumental Christian drama of Lent. Finally, he is a dancer whose dances are a fundamental part of the indigenous ritual he hosts.

Perhaps these difficulties arising from the pascola's cloudy origins and numerous roles might be mitigated by understanding how the Yaqui and Mayo have been able to create a viable religion from the fundamentally opposed Christian and pre-Columbian traditions of spiritual thought and practice which constitute their heritage. As we shall see, that "new" syncretic religion has a number of fundamental features directly traceable to pre-Columbian antecedents, chief among them the use of the mask as a central metaphor for the relationship between spirit and matter, between man and the gods—or God. That pre-Columbian metaphor and the view of reality it communicates has survived intact in a new context that is nominally Christian, but a Christianity reworked to fit indigenous patterns of thought. Edward Spicer suggests the syncretic nature of that reworked Christianity in the conclusion to his argument that it is a "new religion." He says, "We may sum the matter up without going into the meaning deeply by pointing out merely that a *Pascola* dance is required at each of the important devotions on the Christian Calendar."[3]

It is clear to Spicer, and equally clear to us, that the masked pascola dancer of the Yaqui and Mayo[4] unites in his dedication, in his movements, and in his mask and costume the two traditions that have shaped the world view and ceremonial life of all of the indigenous peoples of modern Mesoamerica. Indeed, the pascola is the clearest example of the particular way in which the Yaquis and Mayos have fused the Christian and indigenous traditions in their ceremonial lives, an important fact because it is through those ceremonial lives that the Yaquis identify themselves as Yaquis and the Mayos as Mayos.[5] That sense of identity is often related specifically to the symbolic pascola. According to N. Ross Crumrine, for example, the Mayo believe that "the *paskolam* are the best of all Mayos because they are the most characteristically Mayo in their behavior and speech, always praying and giving *hinakabam* [ritual speech] in Mayo and participating in church processions."[6] Similarly, Spicer indicates that in the Arizona Yaqui village of Pascua in the 1930s the pascolas were seen by some as "the most distinctive of Yaqui institutions"; he quotes a *maestro* as saying, "Wherever you have *pascolas*, there you have Yaquis."[7] Their symbolic importance to the cultures in which they are found and the clear sense within those cultures that they demonstrate a syncretic fusion of Christian and native spiritual traditions makes them an excellent example for us of the way the tradition of Mesoamerican spiritual thought has fused with European Christianity in masked ritual—and a particularly fascinating one since they exemplify the continuing importance of the mask as a powerful central metaphor for the spiritual foundation of material life.

The pascola's syncretic nature can be seen in the way a Mayo or Yaqui becomes one who "dances *pascola*" (pl. 65) and wears the characteristic mask (pls. 66, 67). While "any adult male Yaqui [or Mayo] can become a *pascola*,"[8] often as the result of a youthful fascination leading to apprenticeship to a practicing pascola, such a prosaic description obscures another set of beliefs widely held by Yaquis and Mayos. Among the Mayo, although it is

> denied by individual practicing paskolam, the recruitment of paskolam is said to take place as a result of a supernatural experience in which a paskola visits a cave in the mountains and talks to an old man with a white beard. The paskola is sometimes said to sell his soul to the old man in exchange for the power to dance well. . . . Paskolam, when they die, are almost universally believed to go and live in the mountains or forest with this old man. The paskola, closely acquainted with the animals of the forest, may see the otherwise invisible huya ania (sacred forest) and such sacred animals as deer, pigs, and goats. The commander

Pl. 65. Mayo *Pascola* dancer, La Playa, Sinaloa (photograph taken with permission by James S. Griffith, reproduced with his permission).

> of the huya ania *may take the form of one of these animals who are his children.*[9]

The Yaqui have a similar belief:

> There is . . . a strong connection between the pascola arts and a mystic region called the yo ania, or the enchanted land. The yo ania is a region that lies within the hills and can be entered through caves. It is a dangerous place, and although pascola skills may be learned through contact with it, one does so at the risk of one's soul. Closely associated with the yo ania are several animals including a large goat and a snake. Both of these appear in the power dreams through which a boy can learn that he is to become a pascola.[10]

Thus, both Yaqui and Mayo believe, metaphorically at least, that the pascola dances as the result of a "calling" originating in a world of the spirit,

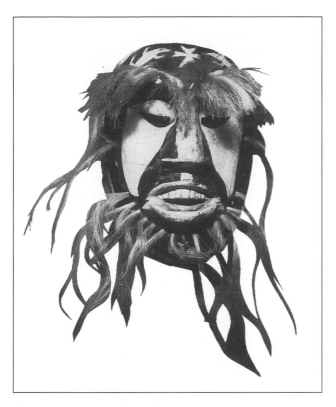

Pl. 66. Yaqui *Pascola* mask, Pimientos, Sonora (collection of Peter and Roberta Markman).

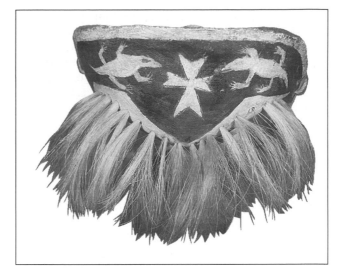

Pl. 67. Yaqui *Pascola* mask, Pimientos, Sonora, detail.

which, while quite different from that generally imagined by Christians, has a number of Christian overtones. Composed of several aspects, the spiritual realm of the Yaqui and Mayo has proved difficult for scholars to understand fully as it exists in an essentially oral tradition that has been in a state of flux for hundreds of years as a result of its gradual syncretic "accommodation" of, or to, Christian views.

The precise relationship between the concepts of the yo ania and the huya ania, for example, is not clear although we can discover a basic distinction. For both Yaqui and Mayo, the term *huya ania* refers to what we would call the natural environment surrounding areas of human habitation, but while we think of nature as material, "the spiritual conceptions of Yaquis regarding the *yo ania* and wisdom derivable by learning about it are not consistent with the purely material view of nature, rooted in medieval Christianity, taught in schools and underlying the Western conception." From the indigenous perspective, "incorporeality" rather than materiality is "the very essence of the *huya ania*." And that incorporeal essence, in Spicer's view, is the yo ania, a "power suffused through the *huya ania*."[11] Looked at in another way, the yo ania is the "rich poetic and spiritual and human dimension of the area surrounding the Yaqui villages."[12] Within this realm lies the source of the pascola's power to manifest the sacred, and as the quotations from Crumrine and Griffith and Molina cited

above both suggest, there is an ambivalence within Yaqui and Mayo thought as to whether the nature of that source and the spiritual power it can grant is good or evil.

That ambivalence probably results from the fusion of indigenous and Christian beliefs as it is likely that the initial impetus to link the spiritual power of the pascola to the devil came from the Jesuit priests who ministered to the Yaquis for 150 years after the Conquest. The Christian overtones are striking: the yo ania is imagined underground, presided over by a lord to whom one can sell his soul for earthly power,[13] and inhabited by animal spirits such as snakes and goats traditionally associated with the Christian devil. But these animal spirits are not necessarily evil; side by side with this Christian view that leagues the pascola with the devil, the Yaqui and Mayo have also retained what must surely be the pre-Hispanic idea of the yo ania.[14] Beals, in his early research among them, found that "the *pascola* dancer, in no sense and at no time appears to have any association with evil, even when masked, despite his connection with the woods."[15] The terms of that "connection" are clear: the power of the pascola "derives directly from the beings of the *huya ania*."[16] These beings appear in animal form to men in dreams or "in something more properly describable as a vision. . . . There was, for example, a conception of a mountain sheep who gave dance power to a human *Pascola*." But this was not a natural animal; "perhaps it was the essence of all mountain sheep."[17]

The denizens of the huya ania who confer power on the pascola are thus connected either with the devil or the essence, or life-force, of living things in the world of nature. While these two views— Christian and indigenous—are contradictory in moral terms, they are congruent in other, more important, ways. Both view the huya ania as the repository of essential power, and both see the

masked pascola as the agent through whom that power enters the human world. Fundamentally, this is the classic pre-Columbian view of spiritual reality described in Part II, despite its incorporation of Christian elements. Essential reality is still seen as spiritual and as "hidden" or "inner," and the unique mask of the pascola still functions, as masks always have in Mesoamerica, as a metaphor for the way in which that spirit can be brought into this world.

That the Yaqui and Mayo, as cultures and at times individually, can see this spiritual power that animates the pascola as both good and evil, that is, from both Christian and indigenous standpoints simultaneously, is not a measure of their ingenuity but an indication of the reformulation of the Christian hell and devil in indigenous terms. While Christianity defines the devil as the principle of evil, an abstract conception associated always with the separation of man and nature from God, the tendency among the indigenous peoples of Mesoamerica has been to associate the devil with powerful natural forces—sexuality and violence, primarily—that can disrupt the order on which human culture rests. The problem, then, is not to "overcome" the "evil" power of the devil but to harness it. The "devilish" forces must be harmonized with the demands of human culture through ritual; their destruction, if even conceivable, would be unthinkable as they are the very forces that, when controlled, sustain human life. The pascola, and other masked ritualists, are engaged in that dangerous but vital task of ritual control.

In this sense, these rituals and the masked ritualists who participate in them are really forces for "good," and it is fascinating that among the Yaqui of Arizona, for example, Spicer has identified a process, which he calls "sanctification," that is gradually reformulating the vital power of the huya ania in Christian terms—but as good rather than evil.[18] This process can be seen particularly clearly in the case of the pascola[19] due to "the irrelevance of the [pascola's fundamental] animal associations to the present ceremonial system."[20] By the 1930s, Spicer found "some association" between the pascola and Jesus,[21] an association referred to in the quotation with which we began this chapter. As he points out, a Yaqui "does not become a *pascola* as a result of a *manda*, or promise, to any deity, [and] thus there is no *patron* of the *pascolas*" such as exists for the other masked dancers, such as the *matachini* or *fariseos*, who participate in Yaqui and Mayo ritual. Nonetheless, individual Pascuans frequently said "that Jesus is the patron of the *pascolas*."[22] And this linkage of the pascolas to Jesus can also be found among the Mayo who, according to Crumrine, believe that pascolas were present at the birth of Christ,[23] a thinly veiled historical refer-

ence, perhaps, to the existence of the indigenous religion before the Conquest.

A further step in this process of sanctification may be seen in an aspect of the huya ania referred to in the songs that accompany the deer dancer, an aspect called the *sea ania*, or "flower world," which has come to be seen by some Yaquis as opposed to the yo ania. For them, "the *sea ania* has become aligned with Christ and Heaven, the *yo ania* has become associated with the Devil and Hell."[24] But this seems to be a recent development; earlier, Spicer found a different conception. In the deer songs, "one frequently mentioned, now mysterious, place . . . is called *seya wailo*, which is not translatable by 20th-century Yaquis, but which they generally agree probably has some reference to a place of flowers." In this connection, he notes that *seataka*, a term used to denote the huya ania-derived power of the deer and pascola dancers also refers to flowers. And, he continues,

> there is a further and curious meaning of flowers among Yaquis which appears, perhaps through recent reworking, to link all the important realms of meaning into a single one. Twentieth-century Yaquis sometimes give as the primary meaning of sewa, "grace of God." They hold that flowers are symbolic of grace, because when blood fell from Christ's wound to the ground, flowers grew on the spot.[25]

Thus, the pre-Columbian symbol par excellence of the life-force—blood—has come, among the Yaqui and Mayo, to be seen as equivalent to the symbol for the comparable Christian conception. God's grace, symbolized here by flowers, the mysterious force that enables human life to continue, is metaphorically nourished by the sacrificial blood of Christ, and the flower is the symbol of the sustaining quality of that sacrificial blood and provides the root metaphor for the domain of the world of the spirit to which the pascolas and other ritual dancers are being assimilated. Their dance is conceived as the necessary ritual action that enables "God's grace" to move from the world of the spirit to man's world; the fundamental pre-Hispanic relationship between man and the world of the spirit on which it depends has not changed but is now being given a Christian rationale.

Changes in Yaqui society have made this reformulation of the mythic relationship between the pascola and the now widely accepted Christian view of the world of the spirit necessary. As long as the indigenous conception of the huya ania retained a standing equal to the Christian conception of the world of the spirit, Yaqui and Mayo spiritual thought could accommodate an association of the pascolas with the devil as their simultaneous connection with the huya ania provided a sufficient basis for their profoundly sacred nature. As late as the 1950s there was still "unquestionably a certain

sacredness for some of the older men" attached to the deer and pascola ritual due to "their relation to the persistent, aboriginal non-Christian stream of tradition in Yaqui culture,"[26] a source of sacredness particularly clear in the still earlier ideas of a resident of Pascua:

The pascolas *and the deer-dancer have the power of all kinds of animals; they get this power, according to myth, from streams of water in the mountains or out in the country somewhere. Each* pascola *does not get it there now, but that is where it came from originally. . . . This is different from the* matachini *and* fariseos. *They are connected not with animals but with the Virgin and Jesus. . . . But, nevertheless, [the* pascolas] *. . . are part of "our religion," too.*[27]

Nothing could demonstrate the vital importance of the masked pascola to contemporary Yaqui and Mayo spiritual thought and ritual practice, that is, "our religion," more clearly than the fact that rather than being discarded as outmoded, the pascola ritual action is being given a new, "sanctified" mythic foundation and that still today pascola dancers "always play a significant role in processions and are felt to be an integral part of almost every religious ceremony in the Mayo valley."[28] But an understanding of the full significance of the pascola's ritual importance and his ability to link the indigenous and Christian strands from which Yaqui and Mayo religion are woven requires a recognition of two very different, and in some senses opposed, types of Yaqui and Mayo ritual, one rooted in the Christianity brought by the Conquest, the other growing from the indigenous past. The ritual most clearly Christian is centered on the church, which "in Yaqui [and Mayo] thought is the residence of Jesus and of Mary and of the saints" and the focal point of communitywide ritual. It is linked "through ceremonial labor" to "every household in the community," and these households replicate, in their physical plan and, more important, in their ritual functions, the structure and function of the church. That ceremonial life of the household takes place in the context of the *pahko* and contains a number of clearly indigenous elements.

While pahko is generally translated as "fiesta," Spicer feels it is more precisely defined as a "joint religious ceremony" uniting church and household,[29] a unity apparent in the physical structure housing the household ritual and in the ritual itself. To give a pahko, a household must construct a ramada, called the *pahko rama*, which is divided into two sections, one of which has a table that will serve temporarily as an altar to hold the santos brought from the church for the occasion while the other is prepared for the pascolas and the deer dancer, if there is to be one. Thus, half the pahko rama will be devoted to church-based ritual

brought to the household and the other half to the huya ania-related ritual of the pascolas. The pahko rama unites the indigenous with the Christian under a single roof but carefully distinguishes one from the other.

Similar care is taken in the ritual activity that begins with the formal procession of the "church group," perhaps including matachin dancers, from the church to the pahko rama. There they are ritually welcomed and directed to the "altar" on which they place the santos and which they arrange for their devotions during the night. These devotions will be performed simultaneously with the pascola activities taking place in the other section of the pahko rama. It is no doubt significant that the two types of ritual activities are not synchronized but proceed as if each were the only activity taking place. Again, the two strands of ritual are brought together but kept separate. In fact, "formal structuring is maintained during rests as well as when the ceremonial labor is being performed"; there is no mingling even then of church-related with huya ania-related ritualists. When the nightlong ritual activity has been completed, the church group formally takes its leave and marches "in formal procession back to the church" carrying the santos.[30]

The pahko's uniting of church and household while keeping the indigenous distinct from the Christian is significant to an understanding of the pascola because his primary ritual activity occurs in the indigenous ritual of the pahko, and it is on that base that his other ritual activities are built. The depth of the relationship between pascola and pahko becomes clear when one realizes that the term *pascola* is derived from *pahko'ola*, which literally means "old man of the pahko" and refers directly to what must be the aboriginal role of the pascola as the ceremonial host during the pahko who must ensure the meaningful involvement in the ritual activities of those attending. The crucial importance of this role is apparent in the almost mystic value attached in Yaqui thought to the participation of all community members, collectively known as the *pweplum*, "out to the last one," in all political, social, economic, and ceremonial matters. Similarly, the Mayo "argue that one must repeatedly see what is done in a given ceremony 'with his or her own eyes.'"[31]

In its aboriginal formulation, the function of the masked pascola must have been to bring his intensely personal experience of the world of the spirit to his community through ritual activity, which, though it might be seen as the individual activity of the ritualist by outside observers, was defined by the Yaqui and Mayo themselves as essentially communal. Even today it is felt that "the sacred chants and dances would have no significance if they were not attended to and witnessed to by the townsmen in general."[32] The pascola's ritual activity thus takes place at the conceptual

interface between man, as represented by the community of communicants, the pweplum, and the world of the spirit, which his visionary experience enables him to bring to the pahko. In the classic fashion of the shamanistic spiritual tradition of which he is a part, the pascola journeys to the world of the spirit in the service of his people, and as we have seen in our consideration of Meso-american ritual practice, that journey across the interface of matter and spirit is metaphorically represented by the mask, which allows inner spiritual reality to be made "outer" and thus available to the community; were that spiritual reality not so manifested, it would have no reason to exist. This shamanistic conception of the relationship between man and the world of the spirit is, perhaps, the reason that "the fundamental orientation of Catholic Christianity, namely, salvation of the individual soul and the objective of heaven had not been incorporated into the ceremonial system."[33] The masked pascola's concern is communal rather than individual, and in his role as ceremonial host and clown, he serves the most basic spiritual needs of the Yaqui and Mayo people, as they define them. Steven Lutes, an anthropologist who himself "danced pascola," explains the goal of this service.

The final personal goal at a fiesta is to emerge with a stronger heart and soul, something that happens during a special state of being, induced by all the forces of the fiesta taken together. Both the people and the community as a whole should go from the fiesta with renewed and bolstered power to lead their lives as their lives should be led.[34]

But the pascola not only serves as host and clown; he also dances. Through an examination of his function in that role, we can begin to understand the structure of pahko ritual and see how that structure is fundamentally involved in bringing the community into communion with the world of the spirit. The pascola's dances are a fundamental part of the complex structure through which the pahko achieves this essentially spiritual goal. Part of that structuring grows from the interplay between the deer dancer, when he is present, and the pascolas. While the ritual clowning of the pascolas with the audience provides one emotional level of the fiesta experience, the intensity and seriousness of the deer dancer, who does not even speak much less interact with the audience, "suggests the mysteries of a difficult and compelling discipline, as it somehow lifts viewers with dancer to a sense of repose through its very intensity of movement," a "sense of repose" that "transports" the audience "from the human world into the *yo ania.*"[35]

Larry Evers and Felipe Molina describe the complex interplay between pascola and deer dancer, between clowning and seriousness, between light-hearted banter and silent, sacred intensity as creating a "pace" for the pahko which is "oceanic, ebbing and cresting throughout the long night,"[36] but, as they realize, the pascola's ebb is no less necessary, and no less sacred in the totality of the pahko, than the deer dancer's crest. Thus, pascola and deer, while they may seem to be working at cross-purposes on different emotional levels, are integral parts of the pahko as a whole, united in the psychologically complex nightlong sequence of events that serves to manipulate the audience's experience of the sacred in order to renew in them their essentially spiritual power "to lead their lives as their lives should be led."

Even more fundamental to the achievement of that goal than the structuring provided by the contrast between deer and pascola is the sequential ordering of the stages of the pahko experience which suggests both the pahko's meaning and its purpose. It is divided "into three distinct phases: one from the opening until 'when the world turns' at midnight, one from midnight till dawn, and one from dawn until the close of the fiesta,"[37] and it is "the order of dancing and the kind of dancing . . . prescribed" for the pascolas[38] which most clearly marks that tripartite division, a division as clear to the audience's ears as its eyes since "the tonal classifications of Yaqui music fall into three separate melody types. Each is reserved for the appropriate period of the all-night ceremonies—evening, midnight, and dawn—and each accompanies particular dance patterns."[39]

In the beginning stage of the traditional pahko, prayers are offered by the pascolas first to the santos brought from the church and then to animals, and the pascolas' first movements are awkward as they move metaphorically from the enchanted world of the huya ania to the "strange" world of man. These actions mark the beginning of the penetration of the sacred world represented by the pascola into the everyday world of man and the Christian world of the church. By the time "the world turns" at midnight, the pahko rama has become that enchanted world. Then follows

a traditional sequence of Pascola *pieces which must be danced to after midnight. These are for the most part about or dedicated to various kinds of animals, and from them sometimes the* Pascolas *take their cues for variations in their dances. It is into a world not of the church-town, but of the* huya ania *that the* Pascolas *induct the townspeople who watch them.*[40]

Thus, the ritual experience, like the deer singers' songs, is

an expression of the equation upon which the aboriginal part of Yaqui religion is based. That equation links the gritty world of the pahko rama *with the ethereal flower world [the sea*

ania], a world seen with one unseen, a world that is very much here with one that is always over there.[41]

Again, we have the mask as a central symbolic device in ritual activity designed to "lift the mask" of the material world to allow an experience of the "hidden" world of the spirit. Under that mask, the individual Yaqui or Mayo sees what the peoples of Mesoamerica always saw—the essentially spiritual force that is constantly at work creating and sustaining life. In Mayo terms:

We have made a commitment or an obligation with the earth. We move above the land, we make earthen pots and plant the land. To Our Father (Itom Achai) we ask the favor, that we be able to easily till (break up) the land. Thus we eat from the body of the land. In exchange for this favor at the time of our death the earth will eat us. We have a commitment with the earth. We have an obligation to Itom Achai. We are baptized Christians and not animals. Thus we have this commitment to Itom Achai. When humans die the earth will eat us up, but God will restore us.[42]

Or as the Yaqui deer singer, Don Jesus, put it, "That is the way we people are; we are made to die."[43] But while individuals die, life is eternal. Contained metaphorically within the huya ania, that eternal life-force shows itself through the ritual events in the pahko rama. The ritual experience of that force enables those who participate to "secure their existence, enjoy themselves, and . . . see and feel the truth of their beliefs."[44]

That fundamental theme of rebirth can be seen in the pivoting of the pahko on the moment "when the world turns," the moment of midnight marking the death of one day (or "sun"), and the birth of the next as the sun passes the nadir in its nightly journey. Significantly, in the phase of the pahko beginning at midnight, various "skits" in which the pascolas dance as animals—denizens of the huya ania—take place. The most popular of these[45] involves the killing of the deer by the pascolas who impersonate either animals or hunters and dogs. In this skit, "the *pahkolam*'s burlesques and the deer singers' song sets come together to provide an expression of the very core of the ritual of the deer dance that is as powerful as any we know."[46] This power comes directly from the theme of rebirth, a theme connected here with the sea ania aspect of the huya ania.

The deer continues to speak [through the songs of the deer singers] as he is carried back to the kolensia, his favored haunt, and laid out there on a bier of branches gathered from each plant in the wilderness world [huya ania]. The transmogrification of the deer that occurs there as his physical body is divided is imaged in the final five songs of the set. A tree asks for the deer's tail:

Put a flower on me
 from flower-covered person's flower body
As his flesh is roasted, his hide tanned, and his innards thrown to glisten in the patio, no doubt awaiting the vultures who gathered to talk about him earlier, the deer speaks:
 I become enchanted

 I become flower.
This graphic sequence of images of death and rebirth indicates, in the words of Don Jesus [the deer singer], that "the deer's spirit stays in the wilderness."

The last song of the set describes the now-dead deer in contrast to a stick that is actually one of the pascolas, a creature of this world in the drama:

Over there, I, in the center
 of the flower-covered wilderness,
 there in the wilderness,
 one, good and beautiful, is standing.
But one stick,
 not good and beautiful,
 is standing.[47]

The death of the deer thus frees his essence, a metaphor for the life-force, to return to its source "over there" in the huya ania. More important, this ending separates spirit—the deer essence "over there" in the sea ania—from matter—the nonliving stick that is "here" in this world. The commentary of the song is direct and to the point: spirit is "good and beautiful" while matter unsupported by spirit is "not good and beautiful." Goodness and beauty are complementary inner qualities that, when present, can be expressed externally or can be worn as a mask to reveal the features of the spirit in the way that the deer dancer wears the deer head atop his own and the pascola wears the mask over his face. The return of the deer, through death, to the huya ania completes the cycle of the pahko when this skit is performed as the obligatory first deer song describes "*saila maso*, little brother deer, as a young deer, a fawn. During the night of the *pahko* he will grow up. In this song we talk about him coming out to walk around and to play in an enchanted opening in the flower world":

Over there, in the flower-covered
 enchanted opening
 as he is walking
 he went out.
Flower-covered fawn went out,
 enchanted, from each enchanted flower
 wilderness world,
 he went out.[48]

The striking similarities in language and imagery between the first and last songs are not coincidental. The singers and the audience know their import: the essence of the deer, for it is that which lives in the flower world, cannot die. It will return

to the "gritty world" of the pahko rama each time the performers and audience gather. And like the deer, life, sustained by spirit, can be counted on not to end.

That this image of rebirth is meant to conclude the pahko is clearly suggested by another skit performed in the latter stages of a pahko which enacts the coming of the rain. Like "the killing of the deer," this skit is often performed at a *lutupahko*, a pahko performed a year after the death of a family member to release "the family from mourning even as it releases the spirit of the departed from this world."[49] Significantly, "the coming of the rain" is performed only when "the killing of the deer" is not; clearly, they are seen as serving the same function and having the same theme since "water in any form is rare in the Sonoran desert, and it is rain that prompts the miracle of rebirth in this wilderness world."[50] Carleton Wilder suggests that "the direct causal relationship between rain and flowers is explicit in these songs. Flowers are a manifestation of rain."[51] But for the Yaqui, as we have seen, flowers are symbolically a manifestation also of Christ's blood spilled on Calvary. And underlying these two symbolic meanings, flowers symbolize the essence of the huya ania—what we have been calling the life-force. Thus, we have the basic Mesoamerican formulation again, this time in a rather different form. The sacrifice of blood is reciprocated by the coming of the rains. Man, or in this case a life form conceptualized as being in man's world for the moment (Christ or the deer), must be sacrificed so that life may continue. This is the "lesson" of the pahko experience. In the enchanted world beneath the mask of "natural" reality, a world that exists within the "gritty" world of nature, within the community as a whole, and within the microcosmic individual, the essence of spirit is always at work creating and sustaining life.

But the pweplum cannot remain in the enchanted realm of the pahko, and just as the pascola brings them into that communion with the realm of the spirit and guides their experience of it, so the pascola must return them to the everyday world. The second turning point, the one that occurs at dawn, begins this phase of the pahko with the ceremony finally coming to a close as

the senior Pascola *stands before the crowd and gives a sermon, an apology devoted largely to asking the pardon of God for any offenses that the* Pascolas *and their associates may have committed during the night. He says that they may have been irreverent in their jokes, obscene in their antics, careless of propriety in their reference to saints, even sacreligious regarding their own animal sources of power. . . . In this way the* Pascolas *express their courtesy and humility before God, but only after an active night of taking the crowd into their world*

of the huya ania *and its ways so different from those of the town.*[52]

Thus, the ritual of the pahko, by its very structure, allows the Yaqui and Mayo, "out to the last one," a very personal experience of the sacred, an experience through which the masked pascola, as host, enables each individual to lift the mask of the mundane world and see the enchanted, sacred world beneath "with his or her own eyes." Only one may wear the mask, but through the ritual experience all participate in its metaphoric implications.

Such a formulation of pahko ritual carries numerous Christian connotations, especially as it equates the deer killed by the pascolas with Christ, but it is important to qualify that equation. While "contemporary Yaquis often interpret the deer dancer as gathering the wilderness world into a symbol of earthly sacrifice and of spiritual life after death," it must be realized that "contemporary Yaqui culture brings the figure of the deer dancer together with the figure of Christ only implicitly and very tentatively."[53] Interestingly though, while the pascolas play only a relatively small role in church-related ritual and the deer dancer an even smaller one, the roles they do play in the most significant of those rituals are involved with the rebirth symbolized by the moment of Christ's death and resurrection and thus seem to grow directly out of the assumptions underlying pahko ritual. While the connection between their actions and the symbolism of Christ will no doubt remain implicit as the Christian and indigenous conceptions of rebirth are quite different, Yaqui and Mayo ritual does make that connection.

Significantly, the particular church-related ritual to which we refer is by far the most important of the year and is, in fact, "the most inclusive cooperative enterprise in which Yaquis engage as Yaquis."[54] It consumes Yaqui society for the forty days of Lent, reaching its climax in the dramatization of Christ's Passion. Although the lengthy ritual cycle is far too complex even to summarize here as it may contain over forty ceremonial events, each involving the interaction of a number of symbolic forces, it has been treated at length in both its Yaqui and Mayo incarnations by other scholars as has the remarkably similar Lenten drama enacted by the neighboring Coras.[55] In all of its variants, its focus is on the rebirth of life after death—the death of Christ, the "death" of his masked persecutors, and the "death" of the agricultural year—which is generated by the cyclical opposition of two forces. One must die for the other to be born. This festival, more than any other, demonstrates the truth of Spicer's contention that Yaqui religion has "a world view which includes a conception of interdependence between the natural world and the world of Christian belief."[56]

That such an interdependence is fundamental can be seen in the fact that while Yaqui church-related ritual seems to follow the normal Roman Catholic religious calendar and to include the usual ceremonial occasions, it is divided into two distinct segments in a seasonal way not associated with Catholicism. Winter and spring constitute one season, characteristically solemn in its ceremonial tone, while summer and fall comprise the other season, this one marked by a tone of gaiety and well-being.[57] These seasons, of course, are the divisions of the agricultural year: first the period of the planting, growth, and harvest of the crops, followed by the "dead," postharvest fallow time, leading to the sowing and germination of the new crop in June which ushers in the summer/fall season once again. The Easter ceremonial cycle falls roughly at the end of the fallow period and thus can be seen as heralding the beginning of the season of "birth," growth and eventual harvest, a view that fits nicely the drama of Christ's death and resurrection.

But the situation is somewhat more complex than that formulation would suggest. According to Spicer, the actual drama of the Lenten ceremonial is not centered on Christ's Passion but on "the obverse of the Passion, that is, the rise to power and ultimate destruction of the persecutors of Christ,"[58] a group known as the Infantry which includes the unmasked Soldiers of Rome and the masked *chapayekas* whom they command. As a group, they are opposed to the protectors of Christ, the Horsemen, who are aided in their holy cause by a number of other ceremonialists, chief among them the matachini, dancers who wear a symbolic flower headdress, and the Little Angels, a group of children. At a crucial point in the struggle, the forces of good are joined by pascolas and deer dancers.

The Soldiers of Rome and the chapayekas "are pursuing the most evil of purposes, [but] they are building their own doom, as everyone knows. In the unfolding of the story the steps which appear to lead to their complete triumph also lead to their destruction . . . and the restoration of the order and goodness which they have so fearfully threatened."[59] Thus, the Yaqui, and the neighboring Mayo and Cora whose versions are essentially the same, have transformed the linear progression of the traditional Christian story into a cyclical drama. Evil is neither destroyed by good nor does good transcend evil; rather, it is transformed into good by the cyclical movement of time. This transformation can be seen clearly in the case of the chapayekas, the masked persecutors of Christ. These ritual clowns, far more sinister and dangerous than the pascolas,[60] delight in the graphic inversion of accepted values. Their coalition with the Soldiers of Rome "will result in some stupendously evil deed." But under the mask of each of the chapa-

yekas, there is "the father of a family, a respected townsman. Moreover he is in some ways the most worthy of all men in the town because he has undertaken a very arduous task which works for the good of all."[61] Like Christ, he suffers for humanity, in this case the pweplum. Thus, in an exceedingly strange twist of meaning, these persecutors are themselves understood as undergoing a death and resurrection parallel to that of Christ, whom they kill. "Through [their] suffering and confession (death) comes purity and the resurrection, the return to life, of Holy Saturday and Easter Sunday."[62] The forty-day ceremonial period ends with the ritual rebaptism of the chapayekas and the burning of their masks. Evil has been converted into good by the transforming forces of water and fire. Since both persecutor and persecuted are involved in the same cyclical process, it is made clear that while all "evil" will become "good," that "good" must in turn become "evil" since everyone knows that the drama will be repeated the following year when the good townsmen must once again don the evil mask that will later be "converted into the intangible again by burning immediately after use."[63]

It is fascinating that these masks, like the masks of the pascola and the deer dancer, are clearly understood as having their source in the transcendent world of the spirit and are specifically returned to that world after their use in the time-honored Mesoamerican way of "spiritualizing" matter, in the case of the Yaqui and Mayo, by burning and in the case of the Cora, by floating down the river as the dancers wash away their emblematic body paint in what is both an actual and a ritual cleansing. The cyclical nature of the drama is clear, as is its relationship to the seasonal cycle. The Infantry epitomizes the sombreness of the winter/spring season as it symbolically kills the spirit of life, a spirit that is reborn in the risen Christ, the newly baptized chapayekas, and the soon-to-be-planted corn.

The pascola's role in this pivotal drama is small but significant. The climax of the forty-day ceremonial cycle comes not, as one would expect, with the crucifixion and resurrection of Christ but with the battle between the forces of evil and good for control of the church and town. In this symbolic battle, the Infantry—Soldiers of Rome and chapayekas—charges forward and is repulsed three times by the defenders, a significantly diverse group made up of the Little Angels, the children, coached by their godparents, who form the Angel Guard; the Horsemen who are the good soldiers; the Matachin Dancers "with their streaming red headdresses, called 'flowers'; and the *Pascola* and Deer Dancers beside whom is a high pile of flowers and new green leaves." When the attackers rush forward, the Little Angels emerge with their switches, the Horsemen with their weapons, "the *Matachin* Dancers dance, and the *Pascola* and Deer Dancers

reach deep into the piles beside them and throw handful after handful of flowers directly at the running attackers."

> In the third rush all is lost. The chapayekas have been weakened by the power of the pelting flowers and the Matachin "flower" headdresses; by the good soldiers, who remain firm in their formation; and above all by the earnest spirit of the Little Angels. The chapayekas cast off their masks, in which their evil power resides, and throw them at the feet of the pyre, where the effigy of Judas is set afire.[64]

"Evil" has been defeated and its symbolic essence returned to the world of the spirit. Its defeat has come through the agency of the angelic innocence of the children, surely symbolic of the Christian world of the spirit, and the flowery weapons of the Matachin, pascola, and deer dancers, just as surely symbolic of the huya ania. Thus, the rebirth of Christ, of his persecutors, of the people of the town, of the seasonal cycle, and of the Yaqui spirit has simultaneously been assured. Significantly, the only part played by the pascola in the entire Lenten ceremonial cycle is directly related to that moment of rebirth.

The role of the pascola in the Lenten drama is thus consistent with, and no doubt grows from, his much larger role in the indigenous pahko ritual. In both, he is directly involved in a dramatic realization of the conception of rebirth. In both, he is connected directly with the moment of transition between the "death" of one phase of a cycle and the "birth" of the next; in the case of the Lenten ritual, the cycle is annual, while in the ritual of the pahko, the daily cycle of the sun provides the metaphorical structure. In both, he is intimately associated with the flowers that symbolize the underlying life-force—whether of the huya ania or God's grace—that provides the motive power for the cyclical movement. The masked pascola dancer therefore unites the two strands of Yaqui religion at their most important point of contact, their symbolization of the movement of the underlying life-force into the world of man and nature. Nowhere is this syncretic role of the pascola made more graphically clear than in a picture that Spicer presents of two pascola dancers kneeling and praying before a pahko rama altar containing a crucifix and santos. In the picture, the crucifix appears directly between the two pascolas' masks, which are worn at this moment on the sides of their heads. Spicer writes, "Before the fiesta begins for which they are preparing, the pascolas will also offer prayers to the Horned Toad and other animals."[65]

The juxtaposition of mask to crucifix in the picture results from a curious part of pascola ritual practice, a part that demonstrates again the tendency to bring Christian and indigenous practices together but to keep them distinct. In the ritual of the pahko rama, itself uniting Christian and indigenous ritual while keeping their separate identities clear, the pascola's dances are of two kinds: one is "an intricate stepdance accenting and embellishing the rhythm" of the music played by a violinist and a harpist, while the other consists of "pawing foot motions, peering gestures with the masked face, and complex rattle play" to the music played by a musician called a tampaleo who simultaneously plays a flute and a drum. When dancing to the music of the harp and violin, the pascola wears his mask on the side or back of his head, but when he is accompanied by the tampaleo, he wears the mask over his face.[66] Although neither Yaquis nor Mayos can explain the reason for this differing use of the mask, scholars generally have seen it as the result of a distinction between the music and dance of European origin and that derived from the indigenous background. True to this distinction, the pascolas in Spicer's picture wear their masks on the sides of their heads while engaging in Christian devotions. When the spirit of the huya ania moves through them into the sacred space of the pahko rama, that spirit "speaks" through the mask, which the pascola then wears over his face. For the mask is the inner reality, the reality of the enchanted huya ania, which ritual allows to emerge into the mundane world of man's daily life.

That pascola mask, although found in varied forms,[67] is always recognizable. It is generally small, dark, and decorated with symbolic designs, either incised, inlaid, or painted on.[68] Its features may be those of a goat (pl. 68) or a human being (pl. 66), but it will always have flowing strands of goat hair or horsehair forming a beard and eyebrows. The hair is sometimes so full that it partially obscures the mask's features, but

> the hair and its motion are an important aspect of pascola mask aesthetics . . . [for] when a Mayo pascola shows his mask, he carefully unwraps the sashes that he uses to protect it, and smooths the hair out with his hands. Then, instead of sweeping the hair out of the way so that the visitor can appreciate the carved and painted wood, he holds the mask with the face slightly down, so that the hair falls freely. He then wags the mask back and forth, causing the long eyebrows to swing across the face. The value of a mask is seriously impaired when the hair is missing.[69]

As Lutes points out, all of the features of the mask are "symbolic elements,"[70] expressing in the small compass of the mask itself the meanings we have already seen in the ritual activities of those who wear the mask. Those symbolic features include references to animals, the clearest of which is to the goat as a number of pascola masks are made in the image of that animal, and it is even "said that all pascola masks represent goats."[71] Some believe that a pascola who wears such a goat

mask acquired his ability to dance directly from the huya ania,[72] perhaps through a dream in which a goat appeared as a representative of that enchanted world.[73] The importance of the goat symbolism to the pascola mask can be seen in the fact that although the chapayeka often wear masks with animal features, they never bear the features of a goat,[74] no doubt because of the goat's association with the pascola. The significance of the goat symbolism can also be seen in the fact that the goat-featured masks do not generally bear other symbolic designs that might compete for importance.

Such designs are found only on the masks that have human features, and they are images of other symbolic denizens of the huya ania. Mayo masks, for example, often have a zigzag design forming a border, a design that, according to Crumrine, represents a snake,[75] the serpent from the huya ania which may "appear in the power dreams through which a boy can learn that he is to become a *pascola*."[76] Lizards, considered "one of 'the little animals of the *pascola*,'"[77] are also frequently found decorating the masks (pl. 67), and it is no doubt through their association with the huya ania that they have come to represent "order and fecundity in nature"[78] and so to be an important symbolic feature of the mask of the pascola who is fundamentally involved with the ritual symbolism of rebirth. Along with snakes and lizards, the masks often contain stylized representations of flowers, which are, as we have seen, the most fundamental symbol within Yaqui and Mayo thought of the huya ania and of the life-force that metaphorically resides in that enchanted world.

These huya ania-related symbolic features sometimes appear, but sometimes they do not. The only symbolic design that must appear on a pascola mask, interestingly enough, is a cross (pl. 67). It is said by both Yaqui and Mayo to be necessary, along with whatever other decorations are found on the forehead of the mask, "to keep danger away from the *pascola* while he is dancing." For that reason, masks carved to be sold to outsiders often lack the forehead cross. That necessary symbolic feature of the mask illustrates clearly its fundamentally syncretic nature. While it is seen by both Yaqui and Mayo as a Christian cross, it is, at the same time, felt "to represent the four directions and also the sun."[79] In this connection, it is significant that the cross that appears on the masks is often a Greek Cross, or quincunx, which, as we have seen, has been the quintessential representation of the "shapes" of space and time in indigenous thought from the earliest times. This visual similarity is particularly important as there is a great deal in pascola ritual which is linked to these concepts of the quincunx.

The ritual of the pahko pivots on midnight, the nadir in the sun's journey and one of the four points of the sun's daily path which are represented

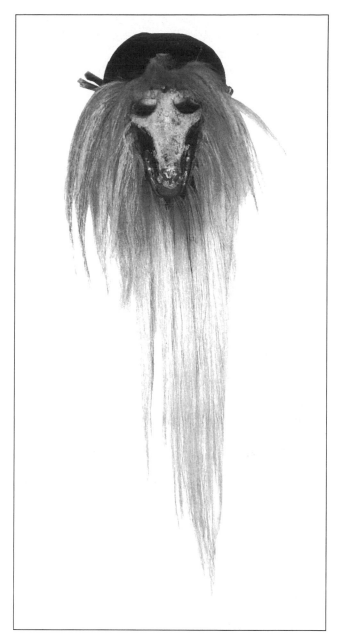

Pl. 68. Mayo *Pascola* mask, San Miguel, Sinaloa (collection of Peter and Roberta Markman).

by the ends of the arms of the quincunx. Significantly, that is the least likely of the four "cardinal" points marking the sun's diurnal course to occur to the nonindigenous mind, thereby suggesting the indigenous nature of this conception of the "shape" of time. Midnight and its opposite, high noon, represent the vertical axis of the quadripartite quincunx symbolizing that "shape," and as we have seen, it is that vertical axis that links the enveloping world of the spirit to man's world. The shamanistic "breakthrough" from the earthly plane to the upper or lower world of the spirit can come only on this vertical axis. Here it occurs at midnight.

And the directional implications of the quincunx are associated with the pascola ritual as well. These implications, and their syncretic formula-

tion, can be seen clearly in Molina's description of a part of the traditional opening ritual of the pahko among the Arizona Yaqui.

> When they had finished dancing to the tampaleo they started to bless the ground. They stood toward the East, home of the Texans, and they asked for help from santo mocho'okoli (holy horned toad). Each pahkola marked a cross on the ground with the bamboo reed with which the moro had led him into the ramada. Then they stood toward the North and said: "Bless the people to the North, the Navajos, and help me, my santo bobok (holy frog), because they are people like us," and they marked another cross on the ground. Still they stood towards the West and said: "Bless the Hua Yoemem (Papagos) and help me my santo wikui (holy lizard)" and they marked another cross on the ground. Finally they stood towards the South and said: "To the South, land of the Mexicans, bless them and help me my santo behori (holy tree lizard)" and they marked the last cross on the ground.[80]

The pre-Columbian assumptions implicit in this ritual action are striking. Most obvious is the association of the cardinal points with a particular "god," as we might call the denizens of the huya ania, and a particular people. That identification locates the Yaqui in general and this ritual action in particular in the center of the quincunx which is, of course, the symbolic center of the universe, the point metaphorically described in pre-Columbian spiritual thought as the navel of the universe. Like its timing, the metaphoric location of the ritual enables the participants and the community to accomplish the "breakthrough in plane" from man's middle world to the enveloping world of the spirit that has always been the focus of Mesoamerican ritual.

The syncretic nature of the cross, the ritual, and Yaqui and Mayo spiritual thought is emphasized by the fact that these crosses are inscribed on the ground just after the pascolas pray before a crucifix on the altar in the pahko rama. The cross, in both its incarnations, refers to the meeting point of spirit and matter just as it had in Mesoamerica from time immemorial. And the ritual activity, as always, is calculated to bring those two realms together. Thus, it is significant that the masked dancer is seen as protected by the cross from the harm that might befall him in his liminal movement from the plane of matter to that of spirit and even more significant that the cross he wears around his neck is not sufficient; he must have the cross inscribed on the mask itself. Implicit in this necessity is a recognition of the crucial role the mask plays in this meeting of matter and spirit. And also implicit is the metaphorical statement made by the mask of the pascola. It is the same statement made by every mask in the Mesoamerican tradition: essential reality is spiritual and inner, but through ritual, it can be made outer. The mask displays that reality and thus allows the enveloping world of the spirit to enter the world of man. And conversely, by wearing the mask, man enters the world of the spirit, in this case the enchanted world of the huya ania.

Lutes recounts and comments on the words of an elder pascola: "If you continue this road of the paskola, where our hearts speak directly with each other, you will understand more of the clown and find its secrets. My mask has its own demonio and I would not part with it for any other." And that demonio is "a spirit or efficacious power within the physical form."[81] Thus, it is apparent that the mask continues, even in syncretic ritual and thought, to function as a metaphor for the most basic of Mesoamerican culture's spiritual conceptions and that the members of that culture are profoundly aware of its metaphoric meaning.

This metaphoric meaning is the same for the Yaqui and Mayo as it was for their distant forebears at the beginnings of Mesoamerican civilization. As we have seen, the masked impersonators whose features were carved into and painted on rock by the Olmecs were allowing the sacred world of the spirit to move through them into man's world in the same way as the Yaqui and Mayo pascola. Contemporaneously with those Olmec ritualists, the masked dancers of the village cultures of Mesoamerica were engaged in their own simpler, but equally profound, ritual. It is certainly coincidental that the pottery replicas of those masked dancers of Tlatilco could be mistaken for Yaqui or Mayo pascolas—they were the same small masks (pl. 44) and the same cocoon rattles wrapped around their legs—since the separation in time and space between the culture of Tlatilco and the cultures of the Yaqui and Mayo would rule out any direct connection. But it is an intriguing coincidence because it is not only the outward form that coincides. As we have seen, those dancers, separated by almost three thousand years, are dancing to the same set of spiritual assumptions. Their masks cover and reveal the same enchanted world of the spirit.

14 Today's Masks

Our discussion of the syncretic nature of the Yaqui *pascola* mask properly brings to a close our consideration of the mask as metaphor in indigenous Mesoamerican spiritual thought and practice. It suggested metaphorically the nature of spiritual reality as an animating and sustaining force since the lifeless mask must be animated by the wearer in order to "live" in ritual, thus demonstrating the integral relationship of spirit and matter. Although the mask and the wearer might be discussed separately, they existed as one, just as the idea of a mask by its very nature compels one to think of the person under the mask, the existence of vivified material reality testified to the existence of spirit—the vivifying force. Without a face under it, a mask would be a meaningless conception, and without spirit, from the Mesoamerican point of view, the material world would be inconceivable. As we have seen, this fundamental metaphoric conception underlying mask use existed as early as the village cultures that preceded the growth of the high civilizations of pre-Columbian Mesoamerica and is still fundamental to modern indigenous groups, the distant heirs of those civilizations.

But what is to come? Eric Wolf, for one, sees a bleak future for the cultures of the indigenous peoples of Mesoamerica.

Until 900 B.C. . . . the community [i.e., what we have earlier called the village culture] was the autonomous unit of social life; and the growth of ties beyond its limits was still to come. And when we look at this unit in long-term perspective, we find that in Middle America it was never obliterated. The simple inventory of farm tools and kitchen equipment, the tasks of farming, the religious concepts geared to the cycle of planting and harvesting, the style of life centered upon the community of one's birth—these have remained basic and stable until today. Empires and conquests sweep over the land, cities arise, new gods announce salvation, but in the dusty streets of the little villages a humble kind of life persists, and rises to the surface again when the fury of the conquest is stilled, when the cities crumble into ashes, and when the new gods are cast into oblivion. In the rhythm of Middle American development we recognize phases of great metabolic construction, followed by catabolic processes which gnaw at the foundations of temples and citadels until they collapse of their own weight or vanish in a fury of burning and destruction. Yet until today the community of cultivators has retained its capacity to turn in upon itself and to maintain its integrity in the face of doubt and disaster—until today, and perhaps not much longer, because the modern world is engaged in severing once and for all the ties which bind people into local unity, in committing them to complete participation in the Great Society. This is a one-way street along which there is no return. The Middle American world has survived many destructions; our present cycle of time is now approaching its nadir.[1]

As with much else in the development of the spiritual core of Mesoamerican civilization, this fundamental change, which Wolf describes in terms of the "shape" of cyclical time basic to Mesoamerican thought, can be seen in the changing use of masks in the festivals in which the ritual defining that spiritual core is enacted, festivals for which Donald Thompson suggests an equally bleak future. "Perverted ceremonies, costumes, and dances will probably remain as an attraction for tourists to the economic advantage of the natives. It is a sad thought that a unique religion of four centuries'

growth may end as a tourist attraction."[2] As we have seen, that religion actually has far more than four centuries' growth, which makes such an ignominious end especially sad and an even greater loss to humanity.

Wolf and Thompson wrote these words thirty years ago, and the developments over those thirty years have borne out their truth. In most areas of Mesoamerica, the process of disintegration is well advanced. In an essay explaining the dangers to the indigenous way of life inherent in opening to further tourism the Sierra Norte de Puebla, an area whose relative inaccessibility has protected its indigenous way of life, Eduardo Merlo Juárez describes the situation in 1978 at the largest festival in the area, that of Cuetzalan which draws indigenous people from throughout the region. Traditionally, its focal point, indicative of its fundamentally religious but syncretic nature, is provided by dances; in fact, the festival begins with

> all the different dance groups dancing in front of or behind the priest with the Eucharist and others with the images of the patron saints [to whom the festival is dedicated] The priest is accompanied to the church, where the first mass is celebrated. . . . In front of the church the different dances are performed, but first the groups enter the church to dance inside for the saint.[3]

According to Merlo Juárez, this emphasis on the religious nature of the dances in particular and the festival in general is changing. In 1978, the high point of the festival came with the arrival of the regional officials, as those in charge were bent on impressing these secular authorities. The dancers, whose efforts were "merely" meant to please "the divine authorities," were interrupted so that the focus of attention might be on the more spectacular *Voladores*. Cameramen crowded around, obscuring the view of the seemingly unimportant local people in their festival garb, and "the crowning touch was supplied when a tiny, charming dancer barely five years old was brought to the place of honor." All the other activity ceased so that

> certain women, I believe they were "Miss Tourism" or "Miss Who-Knows-What," could pose for the press photographers at the side of this child, pretending to give him a kiss, but only placing their lips near the terrified face of the child who had no comprehension of what was going on. He understood even less the action of one of the retinue who offered him, in the view of all, a banknote of high denomination.[4]

This tawdry example makes strikingly clear that the indigenous people of Cuetzalan are well on their way to "complete participation in the Great Society," and that the commercialization of the masks and dances, and ultimately of the whole

proud tradition of indigenous Mesoamerican spirituality, is among the means by which that sad conversion is being accomplished. Material reality—in the form of cute children, sexually attractive young women, money, publicity, and political power—has become an end in itself and is to be celebrated through its own peculiar ritual. Earlier, in 1952, Redfield characterized this development precisely when he wrote that while it once was an

> intensely sacred act made by the village as a collectivity composed of familially defined component groups, with close relationship to the system of religious and moral understandings of the people, the festival has become, in the more urbanized communities, chiefly an opportunity for recreation for some and of financial profit for others, with little reference to moral and religious conceptions.[5]

Despite the changing nature of the Mesoamerican festival, masks continue to be produced. Some of them, like those of the tigres and the pascolas, continue to play their traditional roles in the festival enactment of ritual, a significant portion of which still serves the ancient ends of linking matter to spirit so that human life may be sustained. These masks testify to the continuing vitality of that spiritual tradition in its ability to incorporate elements of the "Great Society" without losing the focus of its own spiritual vision. As James Griffith and Felípe Molina point out, pascola masks "do not appear to have changed appreciably in the past hundred years,"[6] indicating that the strength and vitality of the tradition they represent enables them to encompass the new realities. Griffith, describing a pink pascola mask made especially for him, says that "in response to a question concerning the somewhat unusual color, the carver stated that it represented an 'americano pascola.'"[7] While designed for an "outsider," the mask shows both the careful craftsmanship of the masks meant for the pascola dancers themselves and an imaginative grasp of the essentials of the tradition represented by the mask in its ability to integrate an alien tradition into its features. In this and similar cases, the masks themselves indicate that the battle between the old and new traditions is at times still being won by the representatives of the ancient ways.

But not all masks produced for outsiders—and tremendous numbers of them are being made by the cottage industry turning out tourist goods in Mexico—are so profound, and not all of them record a victory for the old traditions. Throughout Mexico, wherever tourists might go, a different sort of mask is to be found. Some of them are modeled on masks that play a part in the festival dances we have described, while others result from the maker's ideas of what his potential buyers—urban Mexicans and U.S. tourists—might want.[8] Regarded in the light of indigenous ritual mask use, these are

often absurdities, brightly painted, leering, horned faces adorned with crawling insects, reptiles, or animals. In their garishness, they reveal far more about the taste and minds of the buyers of such monstrosities than about the sensibilities of their makers. To one familiar with the spiritual depth of the tradition of Mesoamerican mask use and with the unique beauty of many of the masks produced by that tradition, a walk through Mexico City's Sunday market at Lagunilla, for example, with its piles and piles of those masks meant for tourists, can be a truly depressing experience. These masks symbolize a victory for the new tradition.

The Yaqui "americano pascola" and Lagunilla's tasteless tourist masks provide examples of the two extremes of the impact of the traditions of the "Great Society" on the making of masks, but there are still other types of contemporary masks besides those that are still a vital part of a living tradition and those that pervert the beauties of that tradition in the service of a new, materialistic vision of reality. One of them demonstrates the difficulties one might encounter in attempting to classify contemporary masks as either traditional or commercial.[9] A recent discussion we had with Lino Mora, a young mask maker in the small town of Naolinco, Veracruz, illustrates the source of that difficulty. He talked about his masks and the variant of the Dance of the Moors and Christians in Naolinco in which they were worn and showed us a "report," prepared by students of the local primary school and illustrated with locally taken photographs, detailing the background and meaning of the dance. Unfortunately, the information had been taken from readily available sources and did not pertain to the local dance, but the photographs were particularly interesting as they showed townspeople dressed as dance characters wearing masks carved by Mora, masks that would generally have been identified by "experts" as designed for the tourist trade. This encounter made two things clear. First, the dance not only continues to exist in Naolinco but its continued existence is a source of pride and satisfaction to the community. Second, masks continue to play an important part in the dance, and the mask maker is seen as making a significant contribution to the community's ceremonial life.

But the masks themselves suggested that the tradition was in the process of fundamental change. Señor Mora had two finished masks for sale. One of them, a skull mask, had been used, while the other was a new mask, identical to those worn by the local dancers, which had been carved for a shopkeeper in Xalapa. After some discussion, it was agreed that we could buy both and that Señor Mora would carve another to be sold, presumably to a tourist, in the shop in Xalapa. We returned home with the mask, but along with it we brought a question. How can one distinguish between a mask meant for ritual use and one meant for sale to tourists? In the case of the work of Lino Mora, at least, they may well be the same mask. And that double market he serves suggests a crucial possibility in the development of the tradition: the features designed to please the tourist and collector might find their way into the dances. There is an interesting piece of evidence in this case that that has happened. When we arrived home with the mask that had been destined for the Xalapa shopkeeper, we discovered that it was remarkably similar thematically to a mask, also from Naolinco, that Covarrubias had acquired sometime before 1929 when it was published in *Mexican Folkways*.[10]

The similarity, however, served to emphasize some striking differences. Both our new mask (pl. 69) and Covarrubias's old one (pl. 70) have realistic human faces with prominent eyebrows, noses, and teeth, and in each case, the face is encircled by a snake, but all of the symbolic features of the new mask are more dramatic. Furthermore, unlike the features of the old mask, they are clearly designed to suggest a modern, Hollywood-style Satan. This identity, of course, coincides with the serpent whose head, in marked contrast to the one on the earlier mask, is carved and painted to suggest its similarity to the human face of the mask. Señor Mora identified the mask as that of a Moor, but those opponents of the Christians have clearly coalesced in his mind with Satan, the archenemy. And the source of his mental image of Satan could be guessed from the fact that immediately to the right of the masks displayed for sale sat a television set, and next to the masks on the wall were tacked a number of pictures clipped from popular magazines. Like the rest of us, Señor Mora is bombarded by the images generated by what Wolf calls the Great Society, and those images, as we would expect, emerge in his art, an art worn on the streets of Naolinco in the syncretic celebration of the festival of the town's patron saint.

What happens under these circumstances to the symbolic meanings communicated by the masks? It seems likely that these new images will ultimately convey a new symbolism in the same way that the masks used on All Hallows Eve in the United States and some areas of urban Mexico are a part of festivities that today have a vastly different meaning from the original religious celebrations. Halloween is now a recreational event for children, an event that uses masks but strips them of their meaning—and their power. The Naolinco Moor's mask resembles a Halloween Satan, a Satan whose menacing countenance is all in fun. Naolinco has not yet reached the stage of development of the cities of the United States or the large cities of Mexico, but one suspects that it is on its way, propelled by the potent symbolic images of the television screen and the magazine's glossy

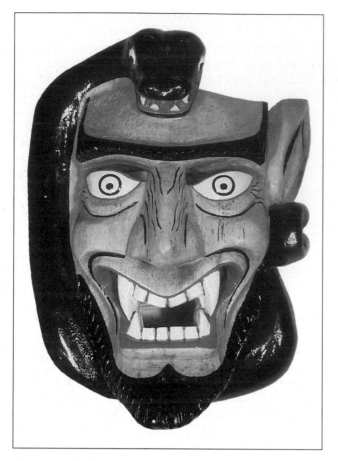

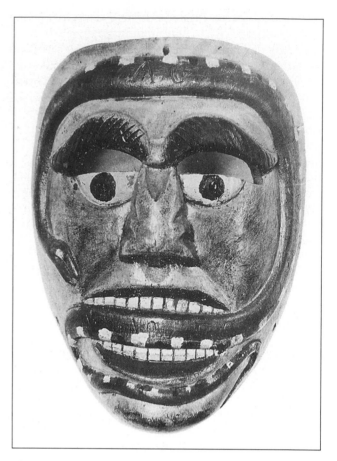

Pl. 69. Mask for a Moor carved by Lino Mora, Naolinco, Veracruz (collection of Peter and Roberta Markman).

Pl. 70. Mask from Naolinco, Veracruz, in the collection of Miguel Covarrubias.

pages, which are designed to sell not only the products but ultimately the value system of "the Great Society."

Those concerned with contemporary Mesoamerican masks and the tradition in which they function take various attitudes toward these changes. Some, such as Donald Thompson, see such changes as marking the end of the tradition, while others believe they are natural developments, that all traditions change and that such change is healthy. María Teresa Pomar, for example, suggests that all artists work within the ambit of their cultures and that "each object produced corresponds to an epoch" and necessarily and properly reflects the culture of that epoch despite the tendency of some, which she sees as regrettable, to see objects produced in the past as better than those of today.[11]

That tendency can be seen nowhere more clearly than in the attitudes of many collectors of and dealers in Mesoamerican masks. Among such people, the desirability of a particular mask is determined to a great extent by its age and whether or not it has been "danced." Ironically, and somewhat humorously, the collectors' passion for patina has spawned a whole new genre of masks. Primarily fabricated in the state of Guerrero, these masks are a late development of the commercialization of mask making. According to María Teresa Sepúl-

veda Herrera they are often consciously imitative of old masks and are generally very well carved and given an artificial patina to mislead collectors. There are several styles, some realistic, others fantastic, that have been developed by particular carvers and that have been imitated throughout the region.[12] One type, perhaps developed from the fantastic masks that Donald Cordry attributed to José Rodríguez,[13] a shadowy figure who may or may not have existed,[14] features bizarre combinations of animals, reptiles, and human faces in beautifully carved and painted masks.[15] Masks of another type are quite large and designed to cover the head of the wearer in the manner of a helmet (pl. 71). Often painstakingly carved, they represent characters from the Dance of the Moors and Christians, and although they have been made to appear old,[16] there is no record of any such masks ever having been used. Other large masks exist as well, all of them designed for the collectors' market: some are gigantic insects, reptiles, or animals incorporating a human face and supposedly used in harvest celebrations,[17] others are large human faces with flowing beards supposedly representing dwarves in rain-petitioning ceremonies,[18] and still others are stylized crocodiles and mermaids that are often accompanied by large representations of those creatures designed to be worn around the waist.[19] In still

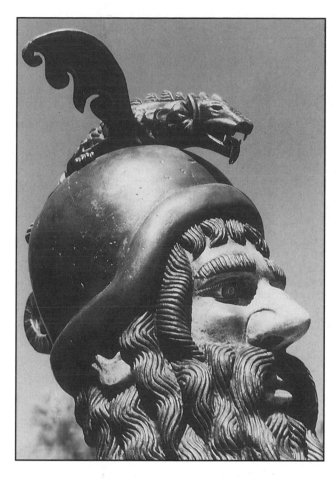

Pl. 71. Mask of Fierabraz, Iguala, Guerrero (collection of Peter and Roberta Markman).

another category of such *falsos*, as these masks designed for collectors are called by now-knowledgable collectors and dealers in Mexico, is what Cordry referred to as the *Barbones* masks,[20] which are beautifully carved of hard wood with particular attention paid to the carving of the luxuriant beards.[21] The carving of these masks represents a high point in the development of the carver's art, but none of them was ever intended for use. Like the others, these were meant for collectors in Mexico and the United States, and those same collectors comprise as well the only market ever intended for the copper and silver masks also made in Guerrero.[22]

There is no evidence that the collectors' market has had any appreciable effect on the tradition of mask use within Mesoamerica, but it has had a substantial impact on the scholarly and curatorial approach to Mesoamerican masks within the United States. Unfortunately, Cordry's *Mexican Masks*, the only major treatment of the subject in English, represents either an attempt to legitimize such frauds as those described above or a complete lack of awareness of their spurious nature since, as Janet Esser points out, the book treats these masks as genuine while failing to document the existence of the dances to which these masks are attributed, a documentation that would, of course, be impossible because the masks were not designed for

dancers but for collectors.[23] Even worse, as Esser also explains, this book, lavishly illustrated, published by a prestigious university press, and introduced by a well-known scholar, ultimately "addresses Mexican masks [both genuine and 'false'] as 'collectables.'"[24] A sad end, indeed, for a central metaphorical form of one of the world's great religious traditions. Just as the festival in which the mask has been used symbolically to reveal spiritual reality is succumbing to commercialization—the worship of the material as an end in itself—so the mask itself has become in such cases as these merely a "thing" to be "consumed" by the voracious new tradition.

But if we see this situation in Mesoamerican terms, in terms, that is, of the cyclical "shape" of time, as Wolf does, this nadir must presage rebirth just as midnight foretells dawn. But what will the dawn bring? The bleakness of Wolf's vision of the future for the "sons of the shaking earth" might well suggest William Butler Yeats's similar vision for a different people:

Turning and turning in the widening gyre
The falcon cannot hear the falconer;
Things fall apart; the centre cannot hold;
Mere anarchy is loosed upon the world,
The blood-dimmed tide is loosed, and
 everywhere
The ceremony of innocence is drowned;
The best lack all conviction, while the worst
Are full of passionate intensity.[25]

As Wolf puts it, "Our present cycle of time is now approaching its nadir." The "severing once and for all the ties which bind people into local unity, in committing them to complete participation in the Great Society," a society that defines reality as essentially material, has brought the indigenous peoples of Mesoamerica, along with the rest of humanity, to the point of seeing beneath a mask never before lifted. The breakdown of the "local" spiritual traditions, such as we find in Mesoamerica, requires either the birth of a new global tradition of some sort or the living of human life in the absence of any such tradition. In either case, we might feel with Yeats that "surely some revelation is at hand."

But what is that revelation? Joseph Campbell has addressed this question in more general terms than our concern with Mesoamerica, and his answer is instructive: "One cannot predict the next mythology any more than one can predict tonight's dream; for a mythology is not an ideology. It is not something projected from the brain, but something experienced from the heart, from recognitions of identities behind or within the appearances of nature," and it is the artist, he points out, "who brings the images of a mythology to manifestation." This insight is of crucial importance as "without images (whether mental or visual) there

is no mythology."[26] That function of the artist is precisely the transformative function attributed to the Mesoamerican artist. Thus, if Campbell and the Mesoamerican spiritual tradition are correct, while we cannot know the nature of the new dispensation, if there is to be one, we can know the source of the images through which it will be expressed: they must come from the creativity of the artist, who can transmute the essence of man's relationship to the wellsprings of his being into images painted on canvas, carved in stone or wood, cast in clay or metal, or described in words. Knowing what we know of Mesoamerican spiritual thought, we might well predict that the mask would figure prominently among the images embodying that new dispensation.

Interestingly, it is possible to see just such a development in the modern Mexican art through which its creators attempted to define a uniquely Mexican view of reality. If time and space in this study permitted us to outline the development of that modern art and to show its tendency to focus on the indigenous past in its attempt to create a truly Mexican art that could render the modern Mexican consciousness, we could trace that development from the nineteenth-century landscapes of José María Velasco which captured both the uniqueness and the spiritual quality of the Mexican setting to the landscapes of Dr. Atl in which that spirit appeared in images tempered by his fascination with both modern European art and Mexican popular art. We could then examine Diego Rivera's uses of indigenous images in the highly sophisticated art he developed, after returning to Mexico from four years spent as a cubist in Paris,[27] to place Mexico's heritage at the base of the Mexican revolution. In his art, especially the murals, as in the art of many of his contemporaries, the mask was a common feature, both because as an image it could convey the texture of indigenous life and because it fit Rivera's conception of a nation whose powerful native strength was contained under the "mask" of a decadent, Europeanized upper class. These political uses of the mask also appear in the powerful art of Rivera's contemporary, David Alfaro Siqueiros, and, to a somewhat lesser extent in the third of los Tres Grandes, José Clemente Orozco, as well as in the host of artists who followed in their footsteps.[28]

Such a discussion of the importance of the mask as an image in the art of the revolutionary period would lead to a consideration of the reaction against this nationalization and politicization of art by such sophisticated younger artists as José Luis Cuevas who also used masks and masklike images but used them to convey a conception of reality diametrically opposed to that of Rivera, Siqueiros, and Orozco. For Cuevas, the mask provided the perfect image for the peculiarly modern sense of the alienation of the individual in a world that forced that person constantly to "prepare a face to meet the faces that you meet," to mask the inner, spiritual self in order to live in a world that defined reality as material. Such an examination of the use of the mask by Cuevas, on the one hand, and by los Tres Grandes and their followers, on the other, would show the stark contrast between their bitterly opposed views of the proper aims and the proper means of art. Significantly, however, both used the mask in the service of rendering these two very different, widely held, but ultimately European (in the sense that we have used the term in this study) views of reality. In that sense, both use the image fundamental to indigenous art in an essentially nonindigenous way. Native Mesoamerican spiritual art, of course, has no monopoly on the use of the mask as a metaphor.

But more to the point of the concern of our study, there are two internationally acclaimed Mexican artists, one a contemporary of los Tres Grandes and the other a contemporary of Cuevas, who in themselves and in their art unite the indigenous with the European; Indian Mexico with modern Mexico. They are Rufino Tamayo and Francisco Toledo. Coincidentally, both were born of Zapotec parents in the state of Oaxaca and grew up surrounded by images generated by the indigenous culture. But both lived for a time in New York and Paris, and their temporary immersion there in the world of international art made it possible for each of them—in vastly different ways, as we shall see— to transmute their indigenous heritage into universal images capable of relating that heritage to the concerns of modern human beings, wherever they may have been born. For both, the mask is often central, but it is rarely an actual mask.

To understand the profoundly indigenous nature of their art in general and their metaphoric use of the mask in particular, however, it is necessary to understand their relationship to modernism in art. Paz puts it best in his discussion of Tamayo.

The modern aesthetic opened his eyes and made him see the modernity of pre-Hispanic sculpture. Then with the violence and simplicity of every creator, he took possession of these forms and transformed them. Using them as a starting point he painted new and original forms. Popular art had already fertilized his imagination and had prepared him to accept and assimilate the art of ancient Mexico. However, without the modern aesthetic, that initial impulse would have been dissipated or would have degenerated into mere folklore and decoration.[29]

That aesthetic allows Tamayo, and Toledo, to do what every great modern artist who would use his art to communicate his conception of the human condition must do—to "make it new," to express the oldest and most profound of human truths in the newest of forms so that the rest of us may see

them as our own. The past must be transformed through the artist's images.

Juan García Ponce suggests this in his consideration of Tamayo's relationship to that past.

When most Mexican artists were attempting a return to the past, imitating its forms in a sterile attempt to revive them without really believing in the things that made these art forms possible, Tamayo definitely made a break with the past. Instead of cultivating it, he let it act upon him, not as a living presence, but rather as a memory. Thus, instead of representing those myths as dead matter of which only the external image remains without any true communication with reality, Tamayo tried to reinvent them, to give them new life, to re-create them. . . . In using daily life as his theme, he searches for what is sacred within this life, . . . making our immediate reality become a mythical reality and causing it to leave its own time.[30]

Although Toledo's art is vastly different in appearance from Tamayo's, the two painters' works share this impulse to reinvent the formal and mythic truths of their common past. Joanne Kuebler points out that it is in precisely this way that the older artist has influenced the younger: "Tamayo's influence on Toledo is strong; both artists address the existential dilemma of modern man through a reinterpretation of pre-Columbian mythology."[31] And it must have been in this sense that Tamayo meant his comment regarding the "two or three" young Mexican artists he regards highly: "The future of painting in my country is in their hands. . . . The best of them is Francisco Toledo."[32]

Tamayo's definitive connection to his pre-Hispanic past was formed early. Brought up in Oaxaca until the death of his parents when he was twelve, he was surrounded by the popular art of Indian Mexico. At twelve, he went to live with an aunt in Mexico City who made her living selling fruit, gradually became involved with art training, and finally as a young man was employed by the government to copy works of popular and pre-Columbian art in the National Museum of Anthropology to make them more readily available to artists involved in the government-sponsored mural painting program. According to Emily Genauer, Tamayo absorbed the pre-Columbian influence "emotionally, spiritually, intellectually, technically, simultaneously, and almost, he says, subconsciously."[33] A strange background for the man who was to become "Mexico's first artist unequivocally dedicated to the tenets of Modernism,"[34] but it was only part of that background.

Chafing at the limitations of Mexican art schools and Mexican life, Tamayo and his young wife fled to New York. Olga Tamayo recalled in 1965, "Thirty-two years ago . . . we went to New York moneyless, on the bus. The trip took seven days. When we arrived, Rufino took me right from the bus station to Fifty-seventh Street, which has the best galleries, the best art." And Tamayo himself recalled the impulse that brought him there: "I wanted to be in New York, a modern city in a modern age, a modern concept."[35] There he absorbed the art of that "modern concept," the art of Cezanne, Rouault, Matisse, Brancusi, Braque, but most of all Picasso. And from that art, he wrenched the means of expressing his vision. He no more imitated those artists, however, than he copied the forms of his native pre-Columbian or popular art. Rather, he combined these impulses in the formulation of what Paz has called his own "personal and spontaneous answer to the reality of our era." Through them he has "rediscovered the old formula of consecration"[36] and through that formula seeks to consecrate the forces at work in "a modern city in a modern age."

That old formula continues to prescribe the use of the mask. It often plays a vital metaphoric role in the large body of work Tamayo has created, a corpus that is itself an essentially metaphoric expression of the pre-Columbian, indigenous theme in modern images. "All of Tamayo's work seems to be a vast metaphor. Still-lives, birds, dogs, men and women, space itself are only allusions, transfigurations or incarnations of the dual cosmic principle which the sun and moon symbolize."[37] Or to put it another way, "that web of pictorial sensations which is a Tamayo painting is at the same time a metaphor. What does the metaphor say? The world exists, life is life, death is death: all is. . . . The world exists through the imagination that reveals it to us as it transfigures it."[38] Tamayo's is thus the unique vision of the artist, a vision resulting from his dual heritage that enables him to see beneath the mask with which our culture covers reality and to reformulate the essential stuff of that reality into a new vision, a new mask, expressive of the ancient truths in modern terms. In the service of that expression, he uses both images of actual masks and "composed" faces, often in the mode of Picasso, whose features form "masks."

Even in his early work, the faces are often masklike, and in some of the paintings of this period, masks are used in the service of symbolizing a larger vision. Two of these paintings, one from 1936 (pl. 72) and one from 1941 (colorplate 13), are illustrative. Both are entitled *Carnaval*, and in both, carnival masks like those that form a part of Tamayo's personal collection of popular art help to communicate their themes, themes that are, however, diametrically opposed. This is particularly significant as the fundamental opposition enunciated here was to provide one of the strongest currents of meaning, often defined through the images of masks, running through all the work of Tamayo's long career. The earlier of these two

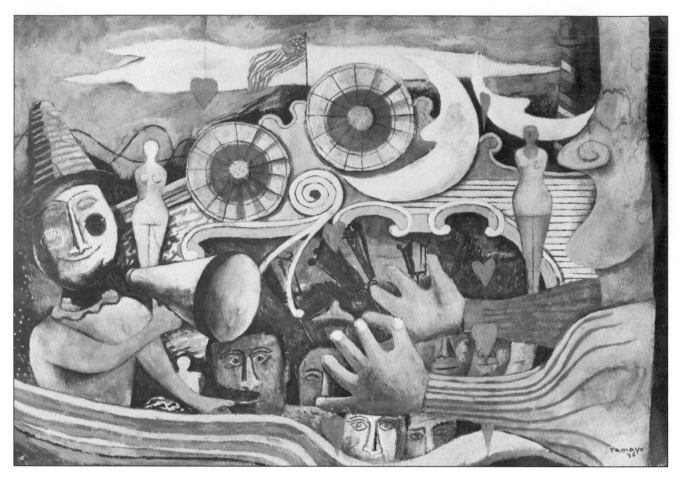

Pl. 72. Rufino Tamayo, *Carnaval*, gouache on paper, 1936 (Harry A. Franklin Gallery; reproduced with the permission of Rufino Tamayo and the Harry A. Franklin Gallery, Beverly Hills, California).

paintings presents a collage of images with a mask-faced barker on the left and a series of mask-faces receding into the background in the lower portion of the painting. The barker's mask, in a motif derived from indigenous masks, has a dark circle on one cheek and a light one on the other, representing in this case sun and moon, a reference repeated in the crescent moon's opposition to one of the ferris wheel circles, which suggest in turn the endless whirling of time. But the moon also finds a visual reference in the face on the right of the painting, while the ferris wheel echoes visually the barker's face on the left. A U.S. flag surmounts the carnival, and Valentine's Day hearts dangle in front of it, but beneath the glittery facade we see the darkness into which the mask-faces recede. Thus, the painting has reference after reference to "the dual cosmic principle which the sun and the moon symbolize," a principle manifesting itself in sun and moon, light and dark, male and female, human and mechanical, and ultimately, cultural and natural oppositions existing within the images of the painting. The surface of life, with all its frenzied activity, masks the eternal rhythms of the universe, and in this painting the Picassoesque representational techniques are used to reveal that ancient truth. In the revelation, however, we might sense a dis-

turbing suggestion that all is not well under the frenzied mask of modern civilization with its nationalism and ersatz hearts. The riotous life of Carnival, as we know, precedes the "death" of Lent in the annual cycle.

The *Carnaval* of 1941 represents that same fundamental opposition in the service of a diametrically opposed theme, and it too revolves around the mask. This painting depicts a man and a woman apparently readying themselves to attend the festivities. The nude woman is tying the string that secures a mask over her face while her dressed and masked companion waits behind her. The striations on one side of her mask suggest a reference to Picasso's *Les Demoiselles d'Avignon*, a reference echoing those in other paintings of the period such as *Mujer con Piña*, also of 1941. But the painting in general looks very little like the work of Picasso because the forms of the figures are derived not from European models but from the west Mexican, pre-Hispanic ceramic figures found in the shaft tombs of Colima, Nayarit, and Jalisco (the male figure's hat is reminiscent of the single horn-like appendage often found on these figures) and from the figures of popular art, a dual source of the images that dominate Tamayo's numerous paintings of couples in this period. Though not overtly

sexual in any way, the painting in its emphasis on the nude female body, earthy in color, clearly suggests the fertility that springs from both the female and the earth. Further, its portrayal of a couple suggests as well all of the fertility implications of the union of male and female opposites. That fertility creates the flowers, symbolic of life, that twine above the couple's heads, and it is, of course, a fertility that exists eternally beneath the mask of our daily existence. Although the essence of woman depicted here may put on the mask of this or that particular identity, this or that individual woman living in the world, that essence is itself representative of the source of life which generates the cyclical flux of the universe. This theme, expressed so clearly here, is one to which Tamayo would return again and again. Carnival, as the earlier painting suggests, may precede the death symbolized in Lent and the Crucifixion, but both precede the cyclical rebirth of life. In this painting, then, we can see specifically what Paz says generally about Tamayo's work: "The relationship between Tamayo and popular art must . . . be sought on the deepest level; not only in the forms but in the beliefs that animate them."[39]

From this base, Tamayo's work evolved in the late 1940s and 1950s into paintings communicating a genuine "sense of terror"[40] at the loss of life's essential meaning in the frenzy of modern civilization, which he saw as haunted by "the specter of technology."[41] The frenzy suggested in the 1936 Carnaval became an obsession, and he "sought metaphors for the great anxieties of the age and, above all, for the dehumanization of man by technology."[42] The paintings of this period contain human figures very different from those of the earlier period. More stylized, more geometric, the paintings' figures seem less concerned with communicating the texture of life than the earlier ones and more devoted to revealing the tortured inner reality of alienated modern man. The titles, given here in their English translations, are instructive: The Cry (with its dual reference to Mexican history in its title El Grito and to Munch's painting, The Scream), The Tormented, Cosmic Terror, Man Pouring Out His Heart (referring both to the need for modern man to express his feelings and to pre-Columbian heart sacrifice), The Burning Man (suggesting Orozco's work). Such examples as these make clear Tamayo's preoccupation with the "cosmic terror" that grows from man's alienation from sustaining values and traditions. In these paintings, the mask often served as a vehicle for the expression of Tamayo's feelings. As Shifra Goldman points out, a number of these paintings "may have their sources in the grotesque masks of Mexican popular art or in the ubiquitous calavera,"[43] but these faces also owe a good deal to analytical cubism in their taking apart of normal human features

in order to display them differently and more thematically as a "mask" revealing the essential truth.

Once that tormented feeling had been fully expressed, Tamayo seemed to become more open to the expression of the counterpart he had already explored in such paintings as the 1941 Carnaval. In the 1960s, his art

> ceased to give us the "frisson," the "scream in nature." . . . Instead his art has become purified, more serene, more positive. If his figures are afraid, they have also found a philosophy with which to combat their fears and this is a gain in depth, in profundity. Again, his early influences—popular arts, ancient arts, Cezanne, Picasso, even Dubuffet—have mellowed, entering deeply into him to re-emerge completely his own.[44]

That profundity expresses itself in two distinct ways, both frequently using the mask. On the one hand, there are the paintings portraying mechanical figures with geometric mask-faces reminiscent of gas masks or the constructed faces one might imagine on robots. A painting from 1970 entitled Dos Hombres en el Espacio provides an apt example. These two "men" in space are machines; their "faces" contain features that represent eyes and noses, but they are not human faces. Their "bodies" are reminiscent of airplanes, and their interaction suggests an encounter between warplanes although the beautiful arrangement of the lush colors on the picture-plane belies the violence such an encounter would suggest. What we have is the serenity of a mechanical universe—clean and beautiful but not human. Here technology has triumphed, has absorbed or devoured and so replaced human beings. Such a painting as this surely grows from his stated concern with the disturbing realities of modern life.

> "We are in a dangerous situation, and the danger is that man may be absorbed and destroyed by what he has created." The technology which has guided man to the moon, he says, could also be pushing him over the edge of our value system into a situation where reason, sensibility, and feeling all are sacrificed, and man becomes a kind of apparatus directed by electronics.[45]

The frenzy of Carnival has given way to the serenity of death. The "faces" here lack mouths, perhaps because they have no inner reality to express.

These figures, probably male, are diametrically and dramatically opposed to other archetypal figures in the paintings of this later period. The best example and perhaps the ultimate source of these images can be seen in a painting of 1964 which portrays Tamayo's wife. Entitled simply Retrato de Olga (pl. 73), it depicts her body encased in a shawl whose folds suggest pre-Columbian sculpture. Rising above the shawl her head is elegantly coiffed,

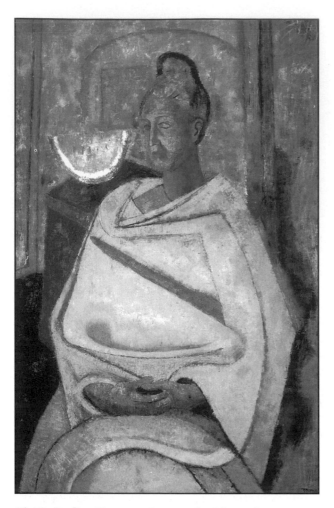

Pl. 73. Rufino Tamayo, *Retrato de Olga*, oil on canvas, 1964 (Tamayo Museum, México; photograph by Jesus Sanchez Uribe, reproduced with the permission of Rufino Tamayo and the Tamayo Museum).

the only identifiable object in the painting, an object that seems distinctly out of place in such a portrait. Second, Tamayo's composition places the watermelon directly next to Olga's face, suggesting an equivalence of the two. When one realizes that Tamayo painted watermelons, sometimes alone and sometimes as parts of larger scenes, from the beginning of his career, one begins to suspect that they represent something more than a pleasing shape and color. They, like the other fruit he painted, are a symbolic reminder of the indigenous world of his youth, of the markets of Oaxaca, central to the life of the Indian, as well as a reminder of his aunt, his surrogate mother, who sold fruit so that they might live.[46] And here we have the watermelon, symbol of the earth's fertility that sustains human life, equated with the woman, symbol of the fecundity of human life. Significantly, this woman is a very real human being in contrast to the starkly impersonal forms of the men in space.

The symbolic equation of the watermelon and human fertility is most precisely and symbolically displayed in two lithographs of the 1970s, and in both, the mask is a central feature. In the first of them, entitled *Masque Rouge* (colorplate 14), the watermelon has become a mask, and the female figure is depicted in the act of placing that mask over her face. Although far less realistic than the *Carnaval* of 1941 (colorplate 13), the image here is almost exactly equivalent to the female image in that painting. In both, the woman is shown covering her face with a red mask. In both, her nude body is earthy in texture and color. In both, her breasts are visually emphasized by being outlined in the red of the mask. In both, the fullness of her hips is emphasized by being contrasted to the straight lines of the doorway in which she stands. Both masks are smiling. This image, no less than the earlier one, is a visual representation of fertility, the force that creates and sustains life. Not directly sexual, it nonetheless evokes the duality of life which finds its unity in the sexual act that recreates life. The exuberance of the growth of the watermelon, symbolic of summer and the period of growth, is matched by the exuberance of the female body. And both exist in the greatest possible opposition to the machinelike men in space who may be able to destroy life but who can never create it. This essential woman wears the mask of nature as an emblem since her fecundity is the vital force that animates it.

Another lithograph of this same period, *Tête* (pl. 74), suggests, however, that this vital force need not be associated only with the female. This round, masklike head, reminiscent in its shape and texture, but not its color, of pre-Columbian sculpture, has cheeks and chin indicated by semicircular zones of color. That these should be "read" as references to the watermelon is suggested by that shape as well as their color and the black, seedlike marks

with the suggestion of flowers in her hair, and her face is at once both realistic and elegantly Mayan with its long, regal nose terminating at the top in raised eyebrows. The red of her mouth provides a focal point for the red of the flowers in her hair, of her dress under the shawl, and of the rear plane of color, a red that seems in deliberate contrast to the pink of the slice of watermelon resting on a table behind her. The only other visible physical feature of the woman is her hands; these are not the dainty, patrician hands of the Mayan ruler, however, but the strong, capable hands of a peasant woman, hands whose strength may well come from Picasso but whose power reflects the strength of the archetypical Mexican woman.

While it would be absurd to say that the most important feature of the painting is the watermelon, one who would understand Tamayo's art and its relationship to the long tradition of Mesoamerican spirituality should pay attention to that slice of fruit. The painting itself indicates its significance in at least two ways. First, the watermelon inevitably calls attention to itself by being

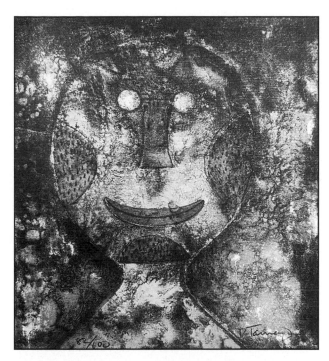

Pl. 74. Rufino Tamayo, *Tête*, lithograph, 1975 (collection of Peter and Roberta Markman, reproduced with the permission of Rufino Tamayo).

within them. The mouth and nose are the same color, but the eyes are not. Gray-blue, they suggest the sky and reveal the possibility that we may be looking at a mask. If so, the mask betrays no sexual identity and would seem to be representative of humanity in general rather than the female, thus suggesting, through its watermelon associations, that human beings are the expression of the vital force of the universe and that through their fertility that force can enter the world. Read in that way, the symbolic simplicity of this lithographic image contains all we have said in this study concerning the metaphor of the mask in Mesoamerican spiritual thought and indicates the profound truth of Ponce's characterization of Tamayo's art.

> *Almost from the first Tamayo's art seems to be dedicated to the revelation of the other side of reality, the side which does not remain on the surface of appearances, but that rather penetrates them, conceiving the world as a living and open mystery which the artist has to capture and communicate to us through the effectiveness of his own peculiar language. . . . His painting destroys yet continues art and the mythical magic thought of Mexico in an ambivalent and vital manner. His purpose of reaching the transcendental, the origin and external source from which the essence of reality emanates, gives his art a religious character.*[47]

It is vitally important to note that that religious character is intensely modern. Although it is built on ancient beliefs and finds expression in forms derived in part from ancient models, Tamayo has

crafted an art for today's humanity. Its fears—of violence, of technology, of isolation and loneliness—are the fears of today's human beings, and as Tamayo's international acceptance testifies, its faith in the persistence of the life-force speaks to a common recognition of that force. Though built from Mexican materials, his is an art for all of humanity; he communicates the Mesoamerican spiritual vision to today's world and with it a "sense of release, almost of joy"[48] in the contemplation of the spiritual potential within humanity.

The success of the much younger Francisco Toledo in communicating the essence of that spiritual vision further testifies to its universality and vitality, especially since his art is vastly different in appearance and subject from that of the older artist. While Tamayo celebrates fertility and the vitality of life in paintings never referring directly to sexuality, variations on the theme of the sexual act involving all sorts of creatures as participants are a constant preoccupation of Toledo's art. But

> *it would be too simple to explain Toledo's painting as only the depiction of sexual acts linking humans to animals and vice versa. The sacralization of coitus in the inscription of an immense and definitive sexual act within the work implies a motive beyond the sexual act itself and places it within the category of ritual.*[49]

Thus, the images through which Toledo celebrates fertility differ radically from those employed by Tamayo in that same celebration, but they have similar sources. Like Tamayo, Toledo was born of Zapotec parents in Oaxaca, but unlike the older artist, he grew up in Juchitan, close to rural Oaxaca, rather than in Mexico City. His sexual images reflect that background, redolent as they are of the images and folktales of rural life. His is not the often cold beauty of the archaeological museum but the teeming vitality of everyday indigenous life.

Through that vitality, however, he reached the same wellspring of indigenous belief that Tamayo found in the museum, and for that reason his is also an art of transformation. In fact, as Evodio Escalante observes, his art *is* transformation. "Toledo is not a painter, a sketcher, a ceramicist or a sculptor, he probably isn't even an artist—in the usual sense of the word. He is a universe of shapes and traditions that are incessantly being transformed, and that also transform everything within their reach."[50] Thus, Toledo's work embodies the idea most fundamental to pre-Columbian spiritual thought, the idea for which the mask has always served that body of thought as a central metaphor. It is the conception that the vital force manifests itself in the world of nature through transformation. To enter this world, that force must don the "mask" of a living being, and, conversely, only in the life of that being can the essential force be seen

by man. Toledo's often masklike images are created to make the life-force visible; they manifest the spirit in the world of nature.

Many of them combine masked or composite faces with the sexual activity always symbolic of creation. The 1974 etching *Botellas* (pl. 75), for example, depicts a strangely masked figure entering the picture plane headfirst from above. On the figures's back is a toad, a significant fact as the masked figure is observing a series of similar toads mounted on each other and/or emerging from the mouths of larger toads. But the picture is entitled *Bottles*, thus calling attention both to the central image depicting the smallest of the toads inserting the neck of a bottle into the mouth of a funnel which is itself inserted into the mouth of another bottle and to the background of the etching which is formed of rows of similar bottles. What Toledo has given us is a complex visual metaphor for the cyclical nature of life as small toads emerge from larger toads and one bottle fills another. That human beings participate in this cycle as well is symbolically suggested by the toadskin mask worn by the central figure, a female figure clearly suggesting fertility. The toads mount each other, the phallic bottle is inserted into the vaginal funnel, and the strange, tubular devices on the toadskin mask may well be phallic. Although not obviously sexual, the images here express as clearly as Whitman's poetry the sexual underpinnings of the cycle of life:

Urge and urge and urge,
Always the procreant urge of the world.
Out of the dimness opposite equals advance,
 always substance and increase, always sex,
Always a knit of identity, always distinction,
 always a breed of life.[51]

Toledo's graphic images seem dedicated to depicting this "knit of identity" revealing the "procreant urge" that unites all life and from which life springs.

Another etching, also from 1974, contains the image of a mask in a different context. Part of a suite of etchings inspired by the Aztec folk beliefs recorded by Sahagún shortly after the Conquest, this etching represents "Witches and Sorcerers" (pl. 76) and relates to the belief in the nagual, or animal companion, which is discussed in Part II of this study. Toledo presents a text to accompany the image:

OF SORCERERS AND SWINDLERS
Witches and Sorcerers
 The naualli is properly called a witch who frightens men at night and sucks the breath from children. He who has studied this craft well understands everything related to sorcery and is smart and shrewd in using it without causing harm.
 He who is wicked or mischievous in this

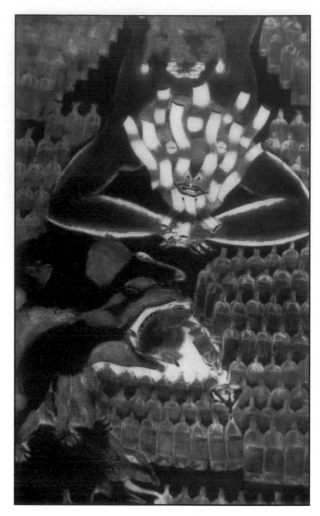

Pl. 75. Francisco Toledo, *Botellas*, etching, ca. 1975 (collection of Peter and Roberta Markman; reproduced with the permission of Francisco Toledo).

craft harms people's bodies with these spells, drives them mad, and smothers them. He is an imposter or enchanter.[52]
As is the case with all of the images in this suite, the relationship of Toledo's illustration of this text to the text itself is far from clear. What he gives us is a mask-face composed of geometric, shell, or bonelike parts. Although the specific organic source of those parts is not obvious, they suggest the segmented face formed by an insect's exoskeleton or the "segments" of a tortoise shell. Skeletal forms surround the mask-face, and tubular elements similar to those on the mask in *Botellas* form a beard or bib beneath it. The face is an artificial combination of natural forms and in that sense perhaps symbolic of human identity, of the power each individual derives from the commonly held life-force but necessarily expresses in his or her own way, for good or ill. Since Sahagún's sorcerer makes use of his animal companion as the source of his good or evil power, his human form can thus be seen as a mask covering the vital force symbolized by the animal companion. Or conversely,

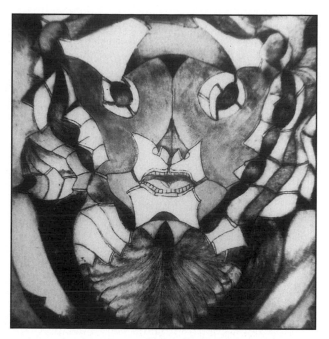

Pl. 76. Francisco Toledo, *Brujos y Hechiceros*, etching, 1974 (collection of Peter and Roberta Markman; reproduced with the permission of Francisco Toledo).

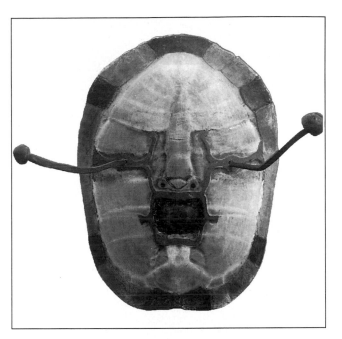

Pl. 77. Francisco Toledo, incised turtle shell (private collection; reproduced with the permission of the owner and Francisco Toledo).

the human being, in order to use that power, "becomes" the nagual, that is, puts the inner reality over his normal outer reality in the manner of a mask. The etching, however, depicts neither the human face of the sorcerer nor the animal identity. What Toledo presents instead is an almost abstract mask, perhaps to suggest the metaphorical essence of the nagual as the mask always did in Mesoamerican spiritual thought and to focus the viewer's attention on the transformation that lies at the heart of the idea of nagualism.

In its appearance and theme, this etching is reminiscent of two other kinds of masklike works Toledo created during the same period. Well known for working in all the possible media available to the artist, Toledo at times stretches those boundaries as he did in the construction of a series of masklike sculptures fashioned from whole turtle shells (pl. 77). Fixing a shell in a vertical position, he incised, painted, carved, and affixed things to its surface to render it masklike in its frontal appearance although it could never function as a mask since it was always the complete shell, both top and bottom. This suggests at least part of its symbolic significance as the turtle in indigenous folklore as well as in Toledo's paintings, drawings, and graphic works is a sexual symbol, due most obviously to the similarity in shape and movement in and out of the shell of the turtle's head to the male penis. Thus, the mask is again related to sexuality, on the one hand, and identity, on the other, for there is no more obvious symbol in nature of the opposition of inner to outer than the turtle, whose life is more clearly "inner" than that of any other

creature. In this sense, too, the transformation of the turtle shell into a mask makes symbolic sense. The "mask" Toledo has fashioned on the turtle's shell makes visible the inner reality of a human being, a reality as "inner" and as vital as the turtle's. And that inner reality is just as fertile because, as we have seen again and again in our examination of Mesoamerican spiritual thought, it is essentially the life-force.

The etched mask of the sorcerer, however, is related not only to the turtle/mask but also to another, more fundamental, series of works that approach the theme in a somewhat different way. These are portraits, and Toledo has produced them in great numbers. Two portraits of a Mexico City art dealer, Armando Colina, are typical and indicate clearly Toledo's approach to portraiture. One of them provides a case in point (pl. 78); in it, the human facial features are exaggerated beyond recognition to reveal an animallike inner reality clearly related to the concept of the nagual—the animal companion symbolic of one's inner reality—which fascinates Toledo. He has given the world an inner portrait of Armando Colina, two of them, in fact, since there is another, quite different portrait, suggesting the complex, multifaceted nature of man's reality. While these physical features link the man to other forms of life, the composition of the painting also relates the subject to the world in which it exists. "The flattened, masklike face exists in a complex relationship to the surrounding areas. Striations define the forehead and mouth and extend to the adjacent areas, unifying figure and background space."[53] Thus, the figure exists in and is part of a context, and the nagual-

Pl. 78. Francisco Toledo, *Retrato de Armando Colina*, oil on canvas, 1966 (Galeria Arvil, México; photograph courtesy of Galeria Arvil; reproduced with the permission of Francisco Toledo).

mask suggests that that context is spiritual as well as material. To understand Armando Colina, Toledo's insight shows us, one must understand those contexts.

The great majority of Toledo's portraits, however, are not of others but of Francisco Toledo himself. He did a substantial number of these self-portraits in the mid-1960s and another series late in the 1970s. They are revealing works, as any self-portrait must be, but what they reveal is not what one might expect. In them, Toledo's face generally becomes a mask composed of seemingly organic elements often visually similar to those that comprise the sorcerer's mask. And in the construction of those masklike composed faces, he uses, as did his pre-Hispanic forebears, the metaphor of the nagual to conceptualize the natural, inner reality that is his identity. As a modern man, however, he knows that this identity is not unitary but multiple: he cannot paint a single portrait of Armando Colina, and since his knowledge of himself is much more extensive, there must be a multitude of self-portraits.

A fascinating drawing, or series of drawings, from 1965 makes clear Toledo's vision. Eight separate drawings originally designed and displayed

mounted edge-to-edge and called collectively *Self Portrait-Masks* (colorplate 15), this composition is uniquely important to understanding Toledo's conception of the portrait, a conception that is both embodied in these drawings and stated in a text intended to be displayed with the visual images. The text is written in Zapotec, however, and mounted vertically rather than horizontally, perhaps to assure that the conception is not too easily grasped. Translated, it reads:

> These are my portraits. I have the face of a dog, face of a cat, face of a pig, face of a coyote, face of an owl, face of an insect, face of a turtle, face of a monkey. An old man. They are all like masks. Although they do not look like it, they are my portraits.

Toledo, himself the old man (though he was in his twenties at the time), knows that looks deceive, that his true reality is inner and that if he is to be understood, he must project that inner reality. This, of course, is the logic of the mask, and true to that logic, Toledo constructs a mask that *is* his portrait.

Or, at any rate, one of his portraits. The unification of the eight drawings into one makes graphically clear his awareness that the complexity of the inner reality of human beings can never be captured in a single image, and the animal masks presented here suggest why. The vital force within Francisco Toledo—or any human being—contains the macrocosm. All life metaphorically exists within the single human being, and thus an understanding of life, both the life of the man and life itself, must be sought within. When Toledo draws the essence of himself, he simultaneously creates the essential cat, pig, coyote, and so forth. He expresses himself in their forms, and they live within his form. We have again, in a very different form, the "knit of identity" expressed in his sexual works, but here it is expressed through the metaphor of the mask. To understand the workings of the life-force, Toledo seems to be saying in the two sorts of works, one may look within or without, at the inner life of man or the teeming life of the natural world; both views present the same reality.

Thus, as did Tamayo, Toledo provides a fresh image to embody the age-old conception, and like Tamayo's, his is derived from indigenous sources but tempered by the fruits of his contact with European art. The individual portrait-masks that make up this work often suggest the drawings of Paul Klee—in their whimsicality, their line, their use of animal images, and their symbolism—rather than Picasso, but as with Tamayo, the lessons of European art have been completely internalized. One would never mistake these drawings for the work of Klee. And the fact that they are masks and that there are faces within the faces that compose the masks as well as the organic vitality of the forms within those faces demonstrate their derivation

from Toledo's indigenous roots rather than his European experiences.

These portrait-masks, typical of his work in the 1960s, give way in the 1970s to a different sort of portrait-mask. Often more painted than drawn, more controlled, cleaner and more elegant, these later self-portraits both continue and modify the basic theme. One of them, *Autoretrato* of 1975 (colorplate 16), a watercolor incorporating gold leaf, illustrates this new tendency clearly. Its composition is complex although seemingly simple. The background against which the human figure appears is composed of rectangular forms of varying dimensions and colors, in one of which a bird almost startlingly appears. On this ground, the human figure is placed in such a way that the torso divides the picture plane diagonally, itself filling the lower right-hand portion while the head occupies the upper left-hand segment. The result of all of this compositional sleight of hand is to focus the viewer's attention on the figure's head, which seems almost to project from the picture plane. And that head is striking. Its face, like a normal human face, is symmetrical with a clearly recognizable chin, lips, nose, eyes, and ears. But the face is not really human. It has more in common with the mask of the sorcerer we have examined than with the actual face Francisco Toledo daily presents to the world. Like that sorcerer's face, it is segmented, a segmentation made obvious by the gold leaf, but even more clearly than in the case of the earlier etching, this face is a mask. A careful examination reveals that there may well be a greenish-brown face beneath the beautiful blue, rose, and gold mask, a face that is hinted at under the deeply cleft chin of the mask, in the ears protruding beyond the sides of the mask, and in the forehead appearing above the eyebrows and beneath the organic forms surmounting the face of the mask.

There is a somber quality, a serenity, in this mask-face which is quite different from Toledo's earlier mask-faces, but the vitality of those earlier animal-related masks is here as well. It can be seen most obviously in the bird, strikingly depicted on an almost white ground in contrast to the rest of the painting. The bird's face confronts the viewer from the same angle, in relation to its body, as does the man's face, suggesting, as does the composition of the painting itself, that the bird is to be seen as

the nagual, the alter ego of the man. Significantly, the bird suggests the perky, feisty birds of the barnyard rather than the somber composed man of the painting. And the mask worn by that man also has clearly animalistic overtones in the strange forms that compose the hair or hat or headdress. Unlike the bird, their precise identity is not clear. Toad-like in one way, in another they resemble slugs and can even be seen as phallic, but whatever their identity, they surely suggest the organic life in which the identity of the man here portrayed is rooted. However sophisticated his identity may become, that identity, like Toledo's art, has its origin in the vital force that for him is most clearly apparent in the rural Oaxaca of his youth. It is his great strength as an artist that all of his images, kaleidoscopic and forever changing and developing as they are, grow from that perception of the vital force. As Teresa del Conde puts it, his art reveals "an interminable chain of iconographic associations that refer to rural culture."[54] But as this painting makes clear, his art is rooted in that source because *he* is rooted there. This masked face is, after all, a self-portrait, and it demonstrates more clearly than words could the fact that for Toledo, his artistic development cannot be separated from his self-development. He is his art, and his art reveals him in the most essential way. True to his heritage in these images, he uses the mask as a central means of his continuing exploration of the essentially spiritual vital force as it manifests itself, in and through him, in the world of nature.

Thus, the mask reveals the inner man, or if one takes into account the whole series of self-portraits, the inner men—the series of inner realities that make up the individual known to the world as Francisco Toledo. Emblemlike, these masks make the inner reality outer and thus fulfill precisely the same symbolic function that the mask has always served in Mesoamerica. It is a testament to its essential nature that it can serve to define the inner realities of twentieth-century human beings as effectively as it did the inner reality of the human beings living in the village cultures of Mesoamerica 3,000 years ago. Much has changed, but the mask remains and serves, as it always has, not to conceal but to reveal the inner vision of that variant of human culture which developed in Mesoamerica.

Notes

PROLOGUE

1. Mann 1957, 12–13.
2. Jacobsen 1976, 4–5.
3. Campbell 1986, 69.
4. Most recent scholarship, unlike that of the past, considers pre-Columbian Mesoamerica a single civilization made up of closely related cultures sharing a body of basic beliefs and a single mythological tradition. As Schele and Miller put it, "the societies identified as Mesoamerican share . . . the sense of a common cultural origin—in much the same sense that most Europeans think of themselves as the natural inheritors of Greek and Roman civilization" (1986, 9). And Hammond, discussing the specifically religious art of the Maya, cites "the existence of an overall Mesoamerican religious *oikumene* within which the Maya, Aztec, and even Olmec gods and cults were regional variants" (1982, 273).
5. Paz 1978, 18.
6. Tennyson, "Ulysses," lines 19–20.
7. Gingerich (1987, 102) makes a fascinating point regarding our understanding of the thought of the ancient cultures we study: "I take it as axiomatic that we—Western, neo-Platonic, Judeo-Christian rationalists—cannot simply by an act of will and intention 'open our minds' to the *weltanschauung* of the Nahua traditions, or of any genuinely indigenous American tradition. . . . I also, however, assume that communication, understanding, valid hermeneutical activity are possible, once we have found within ourselves and our own traditions the sets of terms or instrumentalities needed to enact the self-revelation which are the preconditions for discovering vital correspondences between our own history, our own ontology, and those of the Nahuas." For Gingerich, "Heidegger serves as such an instrumentality." Similarly, we have found in the work of a number of nineteenth- and twentieth-century artists ways of approaching reality that are remarkably similar to those of the cultures we study. Since their mode of artistic expression is somewhat more accessible to "Western" minds, we occasionally referred to their works. Clearly, we do not believe that Hermann Hesse or Walt Whitman, for example, were any more directly influenced by Mesoamerican thought than Heidegger.
8. Ruz Lhuillier 1973, 202.
9. Grieder 1982, 6.
10. V. Turner 1974, 25.
11. Westheim 1965, 44–45.

1. THE MASK AS THE GOD

1. Watts 1963, 7.
2. Leach 1979, 158.
3. León-Portilla 1980, 182, 186.
4. Durán 1971, 72–73.
5. Seler n.d.*a*, 42.
6. Townsend 1979, 36.
7. Sahagún 1950–1978, bk. 3:3–4.
8. Durán 1971, 73.
9. Townsend 1979, 36.
10. Caso 1958, 91.
11. See Alexander 1964, 61.
12. H. Nicholson 1971*a*, 426.
13. Durán 1971, 70–72.
14. Soustelle 1961, 97.
15. Lévi-Strauss 1966, 54.
16. Durán 1971, 73.
17. For these variations, see Sahagún 1950–1978, bk. 3, pl. 3; Codex Borbonicus 34; and Codex Magliabechiano 43.
18. Westheim 1965, 96.
19. Sahagún 1950–1978, bk. 1:3.
20. H. Nicholson 1971*a*, 426.
21. Caso 1958, 33, 39.
22. Matos Moctezuma 1987, 189.
23. Pasztory 1987, 460.
24. Lévi-Strauss 1966, 95.
25. Watts 1960, 7.
26. Lévi-Strauss 1966, 131.
27. See Kubler 1970 and 1973*b*; and see H. Nicholson

1976b for a particularly good response to Kubler's objections.

28. Even Kubler would seem to agree; see Kubler 1967, 9.

29. There may well be far earlier prototypes. Gimbutas's study of myths and cult images in Old Europe from 6500 to 3500 B.C. reveals very similar mask symbolism, and she says, for example, that "supernatural powers . . . were given form as masks, hybrid figures and animals, producing a symbolic, conceptual art not given to physical naturalism. The primary purpose was to transform and spiritualize the body and to surpass the elementary and corporeal" (1982, 38). The striking similarities between these conceptions and those of Mesoamerica suggest a prototype in the shamanic tradition from which they both spring.

30. M. Covarrubias 1957, 60.

31. Ibid., 58.

32. Bernal 1969a, 66.

33. Joralemon 1976, 33.

34. de la Fuente 1981, 89.

35. Pohorilenko 1977, 14.

36. A great deal of that art and the art of subsequent cultures is dynastic, but even the portrayals of rulers are essentially religious, as we will argue below, since they are identified with supernatural powers through mask and costume. These depictions make clear the religious nature of what we, but not the Olmecs, would call secular power.

37. Many scholars (e.g., Grove 1984) see them as portraits.

38. It has become popular among scholars to attribute to the Olmecs a myth that explains the were-jaguar as the issue of the sexual union of a male jaguar and a human female, a view often supported by interpreting three quite fragmentary and, in their present damaged state, quite enigmatic Olmec sculptures as depicting that copulation. As we argue below, these sculptures are more plausibly interpreted in other ways, and, whatever their interpretation, there is no warrant in later Mesoamerican thought for a theory that sees human-animal sexual union as creating the gods. The evidence of Olmec art points, rather, to the "unfolding" process we will delineate in the second section. Not only would that theory explain the large number of "gods" but it also easily accommodates the constant suggestion of quadriplicity in Olmec art as well as the gradual progression from "monstrous" conceptions to human ones noted by Bernal. Modern scholars would perhaps be well advised to study existing myths, both visual and verbal, rather than trying to create them.

39. See Schele and Miller 1986, 69, for the Maya practice.

40. de la Fuente 1981, 94.

41. Soustelle 1984, 151.

42. This uncertainty can be seen even in the identification of the gods depicted on the major monuments of Tenochtitlán. The central face on the so-called Calendar Stone, for example, was long thought to be that of Tonatiuh, the sun, but it has recently been argued that it is Tlaltecuhtli, the earth monster (Townsend 1979, 63–70; Pasztory 1983, 170) or Yohualtecuhtli, the night sun (Klein 1976, 184–185). Similarly, the monumental Coatlicue, it is now argued, may represent the tzitzimime (Pasztory 1983, 160) or Tlaltecuhtli (Broda 1987a, 243).

43. As we will explain below, several scholars would disagree: Bernal (1969a) sees the were-jaguar as associated with fertility rather than rain, Peter Furst (1981) and Kennedy (1982) see were-toads rather than were-jaguars, Stucker and others (1980) see were-crocodilians, and Luckert (1976) sees were-snakes.

44. Joralemon 1976, 45, fig. 13e.

45. This is a chancy procedure as we possess only a small fragment of the total number of Olmec works, and other combinations are always possible. In addition, a number of pieces we do have come from pot-hunters rather than controlled excavations, and their authenticity is often open to doubt.

46. L. Parsons 1980, 47.

47. One explanation of the meaning of the cleft arises from the possibility of real babies having really cleft heads—the medical term is Spina bifida (see, e.g., Coe 1965c, 752)—and another from the real appearance of a cleft—actually a furrow—on the head of actual jaguars (see, e.g., Bernal 1969a, 72). Unfortunately, this sort of "explanation" ignores the clearly symbolic nature of this category of Olmec art. Even if the Olmecs did copy "real" life, we would still have to discover why those particular aspects of reality were chosen to be copied; there is a significant difference between the source of an idea and its meaning. In this instance, the proposed sources of the symbolic detail do not suggest a meaning that helps us to understand the symbolic meaning of the figures on which it appears.

48. P. Furst 1981, 151, 156.

49. Grove argues that they are much later (1984, 167).

50. Gay 1972, 29; and see our discussion below of Cleft in the Popol Vuh.

51. It is fascinating in this connection that the recently discovered Naj Tunich cave in Guatemala contains both child burials and the most graphic representation of sexual intercourse yet discovered in Maya art.

52. These various interpretations are offered in P. Furst 1981; Kennedy 1982; Stucker and others 1980; Grove 1984, 126; and Luckert 1976.

53. See Clewlow 1974, 102.

54. Grove 1984, 50.

55. Vogt 1969, 387.

56. Gay 1972, 73–82.

57. Grove 1984, 116.

58. Diehl 1981a, 73–74.

59. Coe 1973, 9.

60. Rue 1968, 159.

61. Ibid., 167.

62. Ibid., 159.

63. Seler n.d.a, 6.

64. Rue 1968, 164–165.

65. M. Covarrubias 1944, 26.

66. Vivó Escoto 1964, 193–195.

67. Ibid., 213.

68. Rue 1968, 164.

69. Sahagún 1950–1978, bk. 2: 2, 44.

70. J. E. S. Thompson 1970, 181.

71. Bernal 1969a, 100–101; and see M. Robertson 1983, 18, for an indication of the divinity of dwarves at Palenque.
72. Clewlow 1970, Pl. I.
73. Joralemon 1976, fig. 9gl.
74. The sarcophagus has been destroyed (Kubler 1984, 120), and the drawings of it which exist vary widely in their depiction of symbolic details. We use the drawing of Miguel Covarrubias (1957, 70), as does Kubler, since it seems likely to be most authoritative and since he does not "fill in" details where the erosion of the monument effaced the original relief carving.
75. See Coe and Diehl 1980a, 363.
76. The attitudes of scholars toward this relationship changes with the times, perhaps indicating that our own preoccupations indicate what part of the Mesoamerican elephant we will "see"—today's emphasis (see, e.g., Pasztory 1983; Schele and Miller 1986; Flannery and Marcus 1983a) is on secular power, while yesterday's (Eric Thompson's studies of the Maya are a good example of the type) emphasized spiritual power. What tomorrow will bring is difficult to predict, but the lesson seems clear. If we are to see the Mesoamerican conception whole, we must realize that for Mesoamerica, power was both spiritual and profane; the one complemented the other as the world of the spirit complemented the world of nature. Each would have been literally inconceivable to the Mesoamerican mind without the other. H. B. Nicholson discusses the current underestimation of the importance of religious matters in pre-Columbian Mesoamerica nicely (1976c).
77. Sahagún 1950–1978, bk. 6:48; the words are those of Sahagún's informants and thus refer to the Aztec practice, but the concept of the ruler being responsible for the welfare of the ruled is Pan-Mesoamerican.
78. D. Tedlock 1985, 84.
79. Ibid., 163–164.
80. Edmonson 1971, 146.
81. D. Tedlock 1985, 165–167.
82. Geertz 1983, 124.
83. Grove 1984, 158.
84. Grove and Gillespie 1984, 29–33.
85. The theme of domination is probably also depicted on the monuments supposedly depicting jaguar-human copulation—Rio Chiquito Monument I, Laguna de los Cerros Monolito 20, and Potrero Nuevo Monument 3. For the most compelling argument for seeing these monuments as depicting domination, see Drucker 1981, 45. Davis 1978 makes a similar case.
86. See, e.g., Grove 1981, 66.
87. Coe and Diehl 1980a, 392.
88. Ibid., 392.
89. M. Covarrubias 1957, 83.
90. Soustelle 1984, 81.
91. M. Covarrubias 1957, 83.
92. Coe 1977, 80.
93. For a detailed consideration of the connection between the trade routes and the development of the rain god throughout Mesoamerican history, see García-Barcena 1972.
94. Pires-Ferreira and Flannery 1976, 286.
95. Grove 1984, 162–163.
96. See, for example, Wilkerson 1981 on the northern Gulf coast, Paradis 1981 and Griffin 1981 on Guerrero, and Flannery 1976b and Flannery and Marcus 1983a on Oaxaca. But Lowe 1981 hints that San Isidro, Chiapas, may be an Olmec site outside the heartland.
97. Drucker 1981, 46.
98. Drennan 1983b, 49.
99. Grove 1984, 160.
100. Paradis 1981, 201.
101. Coe 1965b, 122.
102. Drennan 1976, 358.
103. Flannery and Marcus 1983d, 74.
104. Marcus 1983b, 144.
105. Boos 1966, 17.
106. See, e.g., Marcus 1983b and Sharp 1981, 10.
107. Drennan and Flannery 1983, 70.
108. Paddock 1983a, 98.
109. Miguel Covarrubias, from whose collection the urn came, described it as "a typical rain-god vase with an 'Olmec' jaguar-god mask in front with a bifurcated tongue that probably represents lightning" (1957, 145). Caso and Bernal (1952, 365) also identify the feline features of the early Cocijo representations as Olmec.
110. It has been argued that the snake symbolism was there from the beginning. The very fact that all of the Classic period rain gods include snake symbolism is itself powerful evidence for such an Olmec prototype. Except for the dubious case of the La Venta sarcophagus, however, we find no clear evidence of the Olmec inclusion of the snake in the symbolic structure of the rain god.
111. Leigh 1970, 257.
112. Caso and Bernal 1952, fig. 27. Leigh 1970 gives a full account of this matter.
113. Seler n.d.a, 73.
114. See, e.g., Seler 1963, 1:259.
115. Zimmer 1962, 75. Interestingly, Zimmer discusses here the coupling of eagle and serpent in Indian thought; a similar coupling played a large role in Mesoamerican mythological thought.
116. Sahagún 1950–1978, bk. 2:213.
117. Pasztory 1983, 234.
118. M. Robertson 1983, 17–18.
119. Ibid., 35.
120. V. Turner 1979, 237. Considerations of liminality play a large role in our discussion of Mesoamerican spiritual thought in the second section of this study as well as in our consideration of the role of the mask in ritual below.
121. See, e.g., Leach 1979, 157.
122. Seler n.d.a, 73.
123. Ruz Lhuillier 1970, 27.
124. Marcus 1983b, 146.
125. See Flannery 1983a, 132, and Kubler 1984, 165.
126. M. Covarrubias 1957, 150–151.
127. See Paddock 1970b, 127, and 1983b, 172–174, as well as Caso and Bernal 1965, 884, for a detailed consideration of this influence.
128. Marcus, Flannery, and Spores 1983, 38.
129. Flannery 1983a, 134.
130. Marcus 1983a, 91.

131. See, e.g., Caso and Bernal 1952, figs. 54 and 55.
132. von Winning 1976, 145–151.
133. H. Nicholson 1976b, 168.
134. von Winning 1976, 143.
135. Masks of Tlaloc or related masks are found on Maya stelae, Monte Albán urns, and reliefs at El Tajín. This is not to say that Tlaloc was central to the thought or symbolism of those areas, but it is a significant indication of the symbolic importance at Teotihuacán of that mask that the widespread influence of Teotihuacán in Classic period Mesoamerica is often indicated by its presence.
136. Davies 1977, 58.
137. Ibid., 97.
138. Who the original builders of Teotihuacán were is still unclear, although scholars generally feel, on the basis of very little evidence, that they were the peoples, probably Nahua, of the early village cultures of the area.
139. Piña-Chan 1971, 167.
140. Bernal 1969a, 137.
141. Grove 1972, 57.
142. Although the Oxtotitlán mask is close in its resemblance, it may be contemporary with Teotihuacán; see Pasztory 1976, 131n. Grove seems to have changed his mind about the identity of the Chalcatzingo face, now seeing it as a ruler rather than a representation of Tlaloc (1984, 122), and it is illustrative of the difficulties in interpreting Preclassic art that Brundage sees the same face as "Tlaloc's prototype, if not the fully formed god himself" (1982, 149).
143. See M. Covarrubias 1957, 60; and see Pasztory 1974, 15, on the symbolic use of "goggle" eyes on non-Tlaloc images.
144. von Winning 1976, 150.
145. Pasztory 1974, 4.
146. Kubler 1967, 9.
147. Pasztory 1974, 6.
148. The Ozymandian implications of the remnants of the destruction of that magnificent city were clearly not lost on the Aztecs.
149. Millon 1981, 213.
150. Séjourné 1976, 98.
151. Kubler 1967, 5–6.
152. Séjourné, in what has proven to be a highly controversial reading of the art of Teotihuacán (Donald Robertson calls her work "somewhat unorthodox" [1963, 118, n. 23] and Kubler sees it as a search for a "magic key" to an understanding of that art [1967, 3]), a significant proportion of which she excavated, interprets an image from a mural at Tetitla which depicts a ritual performer wearing a buccal mask from whose hands flow streams of water filled with small images of objects as "a deity creating the world of forms, which are seen pouring from his hands" (1976, 176). Although we would interpret this particular image differently, Séjourné's interpretation captures the essential spiritual conception underlying the art of Teotihuacán.
153. See Pasztory 1976, 133.
154. Pasztory 1974, 9.
155. Seler 1963, 1:257–258.
156. It might be objected that this is not necessarily an Aztec conception as we are not certain of the provenience of the Codex Borgia, but it contains images identical to those in Aztec art and has long been used by scholars to interpret that art.
157. Séjourné 1966, 278.
158. Pasztory 1974, 7.
159. Although it differs from the Olmec and Zapotec and Maya systems iconographically and in its emphasis on painting rather than stone or ceramic sculpture and relief carving, the art of Teotihuacán depicts a symbolic system of spiritual thought identical in structure to those other Mesoamerican systems—a fact that implies a common Olmec source and ongoing communication on a profound level with the cultures of Monte Albán and the Maya. A great deal of evidence of that communication has been dealt with in recent years, including the existence of a Zapotec barrio at Teotihuacán, a significant amount of Teotihuacán symbolism, presumably related to the visits of Teotihuacán dignitaries, at Monte Albán and among the Maya, a virtual replica on a smaller scale of Teotihuacán at Kaminaljuyú, and a long list of similarities in the symbolic vocabularies of the three cultures.
160. Although we agree with Pasztory's identification of the essential Tlaloc mask, we differ profoundly from her in her division of the Tlalocs at Teotihuacán into two rigid categories. She designates the Codex Borgia type as Tlaloc A and on the basis of a single image, sees it as iconographically related, through Izapan art, to the crocodile. The image she sees as the only other Tlaloc, her Tlaloc B, has a bifurcated tongue and is derived from the Olmec were-jaguar (1974, 7–10). As our analysis indicates, we see a shading of one Tlaloc into another rather than a clear separation of two (or more) types. As we will demonstrate, there are images that blend her two types as well as images that fit neither category but that are Tlalocs. It must be remembered that we have but a tiny fraction of the number of Tlaloc images that must have existed, which should argue caution in building rigid structures.
161. Pasztory 1974, fig. 5
162. Séjourné 1969, 114–115, 267.
163. Kubler 1967, fig. 1; Coe 1977, fig. 26.
164. Pasztory 1976, fig. 79; Séjourné 1969, 270.
165. Sheppard 1972, pl. 241; Kubler 1967, fig. 41.
166. Acosta 1964, fig. 58; and see Séjourné 1969, 194.
167. Clearly, our choice of a particular image of the Teotihuacán Tlaloc as a "central image" is just that—our choice. One could probably make a case for other Tlaloc images, but what is important is the underlying principle of theme and variation which allows such a central image to be transformed into the various aspects of the god.
168. Pasztory 1974, 20.
169. Kubler 1967, fig. 32.
170. Kubler 1973a, fig. 7.
171. In view of the connection between the later Codex Borgia and the Teotihuacán Tlaloc, it is worth noting that Seler sees the serpent as related to sacrificial blood in the codices generally and in the Borgia particularly (1963, 1:27).
172. Kubler 1967, fig. 16.
173. Pasztory 1976, 62.
174. The identification of the painting as Tlalocan was

first made by Caso in 1942 and has since been generally accepted although some see it differently. See Pasztory 1976, 104.

175. We should make clear that our analysis is based on the reconstruction of the paintings by Villagra. There is some controversy concerning the accuracy of his reconstruction of the uppermost portion of the paintings. See Pasztory 1976, 65–66.

176. Originally identified as Tlaloc by Caso (1942), this figure has since been variously identified by later scholars as, for example, a female "cult image compounding the attributes of water, air, earth, and fire" (Kubler 1967, 10) and a fertility deity "but *not* Tlaloc" (Pasztory 1974, 11).

177. Séjourné 1976, 104.

178. Acosta 1964, figs. 108, 109.

179. Millon 1981, 234.

180. Séjourné 1976, 99. As Séjourné acknowledges, it is generally felt that "water and fire together, *atl-tlachinolli*, was the Mexican symbolical expression for war" (Seler 1898a, 44). Her argument (1976, 99–111), central to the thesis of her book *Burning Water*, that the symbol must be interpreted in a far more fundamental manner is persuasive in this case, at least, in light of the complete lack of reference to war in the mural.

181. Caso 1958, 38.

182. Séjourné 1976, 104; and see Berlo 1982, 99.

183. H. Nicholson 1971b, 97–98.

184. Ibid., 100.

185. Although their analyses differ from ours, a number of scholars have suggested the ultimate unity of these two seemingly different masks. Piña-Chan, for example, sees the bird-serpent as the "animal vehicle" or announcer of Tlaloc (1977, 24–26); Séjourné feels that together they symbolize "the vital impulse arising from the unification of opposing elements. . . . Like Quetzalcóatl, Tlaloc is the bearer of the luminous seed which converts matter—in this case the earth—into creative energy" (1976, 87); and Jiménez Moreno sees them as the Plumed Serpent, "the genuine symbol of rain," and Xiuhcóatl, "emblem of drought." Together they "represent the succession of the wet and dry seasons" (1966, 59). Coe follows this interpretation, seeing them as "sculptured Feathered Serpents [that] alternate with heads of the Fire Serpent" (1977, 92). Interestingly, Hultkranz makes precisely this point regarding the Maya: "closely related to the rain god was the wind god (God K), also depicted with some of the serpent's symbols. It is possible that he did not exist separately but only as a manifestation of the rain god" (1979, 226).

186. H. Nicholson 1971b, 98.

187. Kubler 1984, 476, n. 24.

188. Acosta 1978, 23.

189. Séjourné 1976, 102.

190. Millon 1976, 236–239.

191. Jiménez Moreno 1966, 50.

192. D. Carrasco 1982, 122.

193. Kubler 1984, 476, n. 55.

194. Seler 1963, 1:257–258.

195. Kubler, 1984, 55.

196. Piña-Chan 1977, 27.

197. Stierlin 1982, 53.

198. Jiménez Moreno 1966, 41.

199. Millon 1976, 241.

200. Diehl 1976, 260.

201. McVicker 1985, 82.

202. Kubler 1984, 68.

203. H. Nicholson 1971b, 104.

204. Kubler 1984, 73.

205. Piña-Chan argues that despite the central Tlaloc image, the stela, like the other two, depicts Quetzalcóatl "who here takes on a new form as the Lord of Time" (1977, 35). We would argue that the overall theme of the three stelae relates to sacrifice as the necessary reciprocal activity of man in the maintenance of life through fertility (Tlaloc as rain god and Quetzalcóatl as wind god) and divine order (the numerous calendrical references).

206. H. Nicholson 1982, 242; Kubler 1984, 74.

207. See McVicker 1985, 90.

208. McVicker 1985, 92–94.

209. Pasztory, for example, argues that "the Mixteca-Puebla style originated in the city-states of the Oaxaca and Puebla areas. A major center was the city of Cholula" (1983, 46). While this seems to be the generally agreed upon position, the development of the style is not at all fully understood. See H. Nicholson 1982 for a discussion of the complexities of that development.

210. H. Nicholson 1971b, 119.

211. Spores 1983a, 342.

212. See J. Furst 1978, introduction, for an example of the argument.

213. Smith 1983, 239.

214. Paddock 1970a, figs. 118, 241–243, 292.

215. M. Covarrubias 1957, 301–304.

216. H. Nicholson 1982, 241.

217. Diehl 1983, 50.

218. Davies 1977 and H. Nicholson 1976d do admirable jobs of distinguishing myth from history and explaining the implications of the symbolism of Quetzalcóatl at Tula.

219. Pasztory 1983, 222.

220. Diehl 1983, 92.

221. Ibid., pl. 13.

222. Piña-Chan 1977, fig. 51.

223. Davies 1977, 63.

224. Matos Moctezuma 1987, 206.

225. Ibid., 191.

226. Pasztory 1987, 459–460.

227. León-Portilla 1980, 208–209.

228. H. Nicholson 1973, 72.

229. Heyden 1987, 110.

230. González González 1987, fig. 7.

231. Bonifaz Nuño 1981, pl. 81.

232. Seler 1963, 1:86–87.

233. A number of effigy urns carved from *tezontle* stone were found at the first excavation level associated with the skeletal remains of sacrificed children (Román Berrelleza 1987, figs. 3–5). These share the features of the stone urn found in Offering 17 rather than the features of the ceramic urns, perhaps indicating a significant symbolic association.

234. Pasztory 1983, 222.

235. Seler 1963, 1:258.

236. H. Nicholson 1987, 465.

237. Pasztory 1983, 292.

238. Ibid., 175, pl. 141; López Austin 1987, figs. 2, 3.
239. López Austin 1987, 262, figs. 3, 4.
240. Arguing that every different combination of symbols represents a distinct god in "Mesoamerican polytheism," López Austin (1987) concludes this is Cuecuex, an aspect of "the god of fire and of the dead," whose name means "Restless, Nervous, Agitated, Shameless and Full of Unfulfilled Desires." Such an analysis, we feel, misreads the nature of the Mesoamerican symbol system.
241. Bernal 1969a, 101.
242. Broda 1987a, 232.
243. J. E. S. Thompson 1970, 269.
244. Henderson 1981, 112–113.
245. Hammond 1982, 118–122.
246. Coe 1980, 47. The Olmec-Izapa-Maya transmission of the rain god is not yet fully understood. According to Hammond, "the Olmec cultural tradition dominated the region west of Tehuantepec, penetrating into the central basin of Mexico and spreading its influence east along the Pacific coast of the Maya area" (1982, 118–119), and Miles (1965b, 254–255) relates the transitional nature of some Izapan-style sculpture to the reliefs at Chalcatzingo which we have discussed. Quirarte suggests that the combination of a variety of Izapan symbolic motifs "produced the Mayan long-lipped rain deity" (1973, 33), but he later cautions that "the relationship of Izapan units of meaning to those found in the Maya area has barely been scratched" (1976, 84). And it must be noted that Izapan art is not universally seen as involved with the transition from Olmec to Maya. Soustelle, for example, says flatly that "Izapa cannot be regarded, stylistically, as being an intermediary form between Olmec and Maya sculpture" (1984, 139).
247. Benson 1981b, fig. 6.
248. Bernal 1969a, 59.
249. Joralemon 1976, 47–52.
250. Coe 1980, 55.
251. Ibid., 52.
252. Joralemon discusses the elongation of noses and lips on these masks (1974, 63).
253. Schele and Miller 1986, 84.
254. Coggins 1979, 40.
255. Schele and Miller 1986, 70–71.
256. Ibid., 76–77, pl. 2.
257. Ibid., 215. As we indicate in our discussion of this remarkable X-ray image in our consideration of the ritual mask, other scholars have identified the mask worn by Bird Jaguar with other deities.
258. Ibid., 70.
259. Hammond 1982, fig. 10.5.
260. Schele and Miller 1986, 274.
261. Robicsek and Hales 1981, 154.
262. Schele and Miller 1986, 302–305.
263. Ibid., 312.
264. Ibid., 312.
265. Henderson 1981, 57.
266. Coggins 1979, 38, fig. 3-1. There is some disagreement as to the precise identity of this mask. Pasztory contends that it is "not the peaceful rain god Tlaloc but the emblem of a war deity" (1974, 14). Except for its non-Tlaloc mouth, however, the mask is very much that of Teotihuacán's rain god.
267. Coggins 1979, 44–45.
268. Coggins 1980, 735.
269. Schele and Miller 1986, 213.
270. Sharp 1981, 12.
271. Ibid., 15–16.
272. J. E. S. Thompson 1972a, 27, 94.
273. J. E. S. Thompson 1970, 196.
274. Hammond 1982, 279.
275. Clancy et al. 1985, 210.
276. Coe 1973, 9; and see H. Nicholson 1973, 164–165.
277. Jacobsen 1976, 19.
278. Séjourné 1976, 130–131.
279. Campbell 1986, 44.

2. THE MASK IN RITUAL
Metaphor in Motion

1. V. Turner 1974, 259.
2. Ibid., 253.
3. Flannery 1976b, 329.
4. Flannery 1976a, 337.
5. van Gennep 1960, 21.
6. V. Turner 1974, 232.
7. Ibid., 242–243.
8. Shaffer 1974, 95.
9. Campbell 1986, 121.
10. Geertz 1979, 86.
11. Gill 1976, 51–52.
12. Sekaquaptewa 1976, 38.
13. Gill 1976, 53, 54–55.
14. Sekaquaptewa 1976, 36.
15. V. Turner 1974, 25.
16. Doty 1986, 86.
17. Scholars agree that the mask depicts a god but do not agree on the identity of the god. J. E. S. Thompson (1973, 68) sees it as "the God K aspect of Itzam Na" and sees the mask with the cutaway human face under it as "yet another way of proclaiming the divine right of kings"; Schele and Miller (1986, 215) identify it as Chac-Xib-Chac, the red, eastern aspect of the quadripartite Chac often associated with sacrifice and rulers; while Kubler (1969, 45) argues that it is "a sun-mask, equivalent to the kin sign," a view with which Paul (1976, 122) concurs. It is significant that each of these identifications relates the mask to rulership, and thus there is more agreement among these scholars than is immediately apparent.
18. Sahagún 1950–1978, bk. 6:42.
19. Schele and Miller 1986, 215.
20. Ibid., 44.
21. Ibid., 66.
22. Ibid., 66.
23. See e.g., Coe 1978, 130, pl. 20; Schele and Miller 1986, 227, pl. 92a; and Paul 1976, 126.
24. Grove 1970, 8, 31.
25. Soustelle 1984, 96; Grove 1970, 9, 10, 11, 31.
26. Although the Teotihuacán mask is probably most akin to a quetzal and the feathered horns of this mask suggest an owl (see Grove 1970, 9–11), the significant fact is that both are composite masks clearly designed to make a symbolic statement related to the provision by the gods of water rather than to depict realistically any particular avian species.

27. Schele and Miller 1986, 78, 87.

28. See Caso and Bernal 1952, fig. 421.

29. The existence of an iconographically identical seated figure, also Zapotec (L. Parsons 1980, fig. 226), suggests the symbolic importance of the figure, and another illustrated by Boos (1966, figs. 272–274) indicates the fundamentally human identity of the figure even more clearly by delineating the human hands and feet beneath those of the animal, a jaguar in this case.

30. Durán captures this conception in his description of the Aztec ritual culminating in the sacrifice of an impersonator of Tezcatlipoca when he observes that the impersonator wore "the complete attire and insignia of the deity ... and went about honored and revered as the god himself" (1971, 126). And Hvidtfeldt, in his discussion of the representation of Tezcatlipoca in ritual, takes that statement a step further. "It is the 'image' itself," he says, "that constitutes the 'god'" (1958, 98, 140). In his discussion of Hvidtfeldt's analysis, Townsend agrees that the terms "impersonator" or "substitute" used to translate the Nahuatl term *teixiptla* designating the masked ritual performers depicted in Mesoamerican art are only approximately suggestive of the close relationship between the essence of the divine spirit and the symbolic representation of it through the mask (1979, 28).

31. Easby and Scott 1970, 80.

32. Coe, for example, says that this image "is none other than the feathered serpent" (1973, 9), while Bernal, exemplifying the alternative position, says, "as I cannot distinguish feathers anywhere on this sculpture, I agree with Drucker (1952, 223) when he states that 'the feathered serpent never appears'" (1969a, 61–62). Soustelle quotes Drucker, Heizer, and Squier (1959, 199) in taking a middle position: the serpent's "head, with its gaping jaws, its eye surmounted by an elongated protuberance, like a crest, prefigures that of all the countless serpents of the pre-Columbian art of Mesoamerica. Ought we to interpret this latter feature as a plume and confer on this animal the honor of being the oldest 'Plumed Serpent' in Mexico? Let us merely say that it is 'beyond a doubt one of the meanest-looking reptiles in Mesoamerican art'" (1984, 47).

33. Milbrath 1979, 35.

34. Bernal 1969b, IV; Stierlin 1982, 78.

35. See, e.g., Pasztory 1983, pls. 142, 196, 207, 260, colorplate 45.

36. See Pasztory's discussion (1976, 118–119) and D. Carrasco (1982, 125), who identifies the headdress as a representation of Quetzalcóatl. It is important to note, however, that Séjourné sees the motif of "sowing" depicted here and elsewhere in Teotihuacán art as having a meaning that extends well beyond its obvious fertility connotations. She argues that the object-filled streams flowing from the hands "irresistibly invoke the idea of Creation: they must in fact represent the act of sowing, but a sowing in which the seeds are the whole universe of humanity. So in these scenes the gods are caught in the act of giving breath to the world of forms, of transforming their hidden reality into visible phenomena" (1976, 178). We see no necessary connection tradition between her views and the narrower interpretations of such scholars as Pasztory, Carrasco, and Kubler. Significantly, her broader views fit well into the understanding of Mesoamerican spirituality, which we will develop in Part II.

37. D. Carrasco 1982, 125.

38. M. Covarrubias 1957, 150–151.

39. Kubler 1984, 165.

40. Caso and Bernal 1952, fig. 341.

41. Boos 1966, fig. 75.

42. Proskouriakoff 1950, 50.

43. Schele and Miller 1986, 66–68.

44. Ruz Lhuillier 1970, 97.

45. Stierlin 1981, 140.

46. Schele and Miller 1986, 46, 177.

47. Grove 1970, fig. 19, pp. 21–22.

48. Caso and Bernal 1952, 365–366.

49. Séjourné 1976, 178.

50. Bernal 1965, 798.

51. Coe 1978, 78, 106.

52. H. Nicholson 1973, 84–86.

53. Hvidtfeldt 1958, 125.

54. Coe 1973, 5.

55. Caso and Bernal 1952, 250.

56. H. Nicholson 1972, 214–215.

57. Seler 1963, 1:127–135.

58. H. Nicholson 1972, 217.

59. Séjourné 1976, 148–155.

60. Sahagún 1950–1978, bk. 2:46–54.

61. Paz 1987, 6.

62. D. Carrasco 1982, 70.

63. Paz 1987, 6.

64. Schele and Miller 1986, 123.

65. Millon 1976, 240.

66. Schele and Miller 1986, 103.

67. Ibid., 122.

68. Eliade 1961, 40.

69. Ibid., 39.

70. Heyden 1975, 134.

71. Ibid., 134.

72. Ibid., 134.

73. Heyden 1976.

74. Grove 1970, 31–32.

75. Mendoza 1977, 73.

76. Grove 1984, 50.

77. Hammond 1982, 286.

78. Schele and Miller 1986, 302.

79. Hammond 1982, 255.

80. Eliade 1963, 100–101; and see Eliade 1959, 12, 15, and Huxley 1974, 170–171, for a discussion of the general concept. It is interesting in this connection that according to Eric Thompson, in the Guatemalan highlands, mountains were personified and considered deities (1966, 225).

81. Eliade 1963, 18.

82. One inevitably thinks here of the long, sinuous, dark passage through the shaft of the real cave under Teotihuacán's Pyramid of the Sun which must be traversed to reach the "center," the *sancta sanctorum.*

83. Eliade 1961, 51.

84. Ibid., 49.

85. Hammond 1982, 124.

86. Coe 1980, 106.

87. Kubler 1984, 241.

88. Ruz Lhuillier 1970, 89.
89. Stierlin 1981, 134.
90. Mendoza 1977, 69–72.
91. Townsend 1982, 124.
92. Mendoza 1977, 65–66.
93. Townsend 1982, 130–137.
94. Stierlin 1982, 208.
95. Pasztory 1983, 138.
96. Freidel et al. 1982, 21.
97. Hammond 1982, 253. Reactions to the facade vary. Proskouriakoff described it as "an indiscriminate piling-up of ornament" whose "artistic effect is disappointing" (1963, 67), and Coe calls it a "rather hideous palace" (1980, 106). However, Gendrop feels that the architect "made fascinating, what could have been monotonous" (1982, fascículo 9:163), and Stierlin calls it "visually, one of the most fascinating in all Maya architecture" (1981, 156).
98. Stierlin 1981, 158.
99. See León-Portilla 1980, 176–177.
100. Ibid., 181.
101. See J. Furst 1982.
102. León-Portilla 1980, 182.
103. Kerényi 1960, 153.
104. Eliade 1976, 38.
105. Pasztory 1983, 277.
106. Tonkin 1979, 242.
107. MacNeish 1964, 425.
108. Hammond 1982, 115.
109. Aveleyra Arroyo de Anda 1964, 396.
110. Ruz Lhuillier 1965, 453.
111. Their striking realism has led Joralemon (in a personal communication with Gillett Griffin) to identify them as historical figures (Griffin 1981, 221).
112. Medellín Zenil 1971, 47.
113. Furst and Furst 1980, 22.
114. Coe 1965b, 54.
115. Henderson 1981, 125.
116. Kidder et al. 1977, 100.
117. Lowe 1981, 252.
118. Coe 1975c, 194–195; 1978, 13–14.
119. See Paul 1976, 122.
120. Ruz Lhuillier 1973, 152, 153.
121. Ibid., 205.
122. Ruz Lhuillier 1970, 116.
123. Ibid., 282–285.
124. M. Robertson 1983, 56–57.
125. See, e.g., Coe 1980, 58, fig. 31; Adams 1977, 119; J. E. S. Thompson 1965a, 338, and 1966, 56.
126. Clancy et al. 1985, 105.
127. Ruz Lhuillier 1973, 105.
128. Landa 1978, 56–57. See also Krickeberg et al. 1968, 75.
129. Séjourné 1966b, 293.
130. Krickeberg et al. 1968, 17.
131. M.Covarrubias 1957, 134.
132. Ibid., 134.
133. Stierlin 1982, 51.
134. Westheim 1965, 142.
135. Kubler 1984, 62.
136. Westheim 1965, 143–145.
137. Stierlin 1982, 53.
138. Caso 1965b, 902.
139. M. Covarrubias 1957, 151.

140. Ibid., 151.
141. Paddock 1970a, fig. 151.
142. Flannery 1983a, 134.
143. Caso 1970; although hesitant to concur in Caso's specific identification, Flannery also sees this as a royal burial (1983b, 291–292).
144. Moser 1975, 36.
145. Ibid., 32.
146. Moser 1983, 270–272.
147. Klein 1987, 343. See also Umberger 1987, 431.
148. Westheim 1965, 96–97.
149. Townsend 1979, 32–33.
150. León-Portilla 1980, 187.
151. Pasztory 1983, 254.
152. Pasztory (1982) questions the authenticity of three of the best known of these stone masks, the two in the British Museum and one owned by the Musée de l'Homme, on the basis of the aberrant iconographic features of the figures carved on the inside surface of the masks. She also claims that a number of existing obsidian masks are falsifications since, as Ekholm has indicated, "the Aztecs did not make large carvings out of obsidian" (see Pasztory 1983, 250).
153. Pasztory 1983, pl. 292.
154. Ibid., 277.
155. H. Nicholson 1982.
156. Berdan 1987, 164.
157. Carmichael 1970, 12.
158. Stierlin reproduces an excellent illustration of a Mixtec skull discovered in Tomb 7 at Monte Albán (1982, fig. 99), and Bonifaz Nuño illustrates a similar skull from Offering 11 at Tenochtitlán's Templo Mayor (1981, pl. 71). Other offerings at the Templo Mayor have yielded similar skulls (Boone 1987b, 45, 52, 53).

3. CODA I: THE MASK AS METAPHOR

1. Sahagún 1950–1978, bk. 12:11–13.
2. Ibid., 15–16. Highwater, in fascinating juxtaposition, presents five versions of this event by "several different writers from highly different cultures," including Sahagún's informant's Náhuatl account and both English and Spanish translations of it as well as Bernal Díaz's account and Prescott's. As he demonstrates, the accounts vary according to the writer's preconceptions. "We do not really comprehend what happened," he says, "unless we are in possession of the various responses to the same event" (1981, 114–117).
3. Sahagún 1950–1978, bk. 12:19.
4. According to López Austin, this account is essentially native: "The Náhuatl style is unmistakable: the characteristic connectives of uninterrupted narrative abound, particularly those formed with the word auh and a verb in the preterit perfect which refers to the last thing mentioned in the previous paragraph" (1974, 148).
5. Paz 1987, 7.

4. THE SHAMANISTIC INNER VISION

1. Campbell 1983, 253.
2. Eliade 1964a, 333.

3. P. Furst 1977, 21.
4. P. Furst 1976a, 151.
5. Neihardt 1959, 36.
6. That there is no simple cause and effect connection between the visions of Mesoamerican seers and Black Elk is clear, but while the views of the relatively contemporary Native American have a different derivation from those of ancient Mesoamerica, the fact remains that they are quite similar, indicating, perhaps, that such a view of the relationship of man and god is one of humanity's few basic formulations of that relationship and is, in that sense, universal.
7. MacNeish 1981, 34.
8. Kurath and Martí 1964, 6.
9. Soustelle 1984, 145.
10. M. Covarrubias 1957, 26–27.
11. H. Nicholson 1971a, 439.
12. P. Furst 1977, 16.
13. P. Furst 1968, 148.
14. Eliade 1964a, 174.
15. Kennedy 1982.
16. Coe 1982, 11.
17. Borhegyi 1965, 18.
18. P. Furst 1976b, 15.
19. Ibid., 73–74.
20. Durán 1971, 115–116.
21. Landa 1978, 47.
22. Vogt 1976, 61.
23. Ibid., 61.
24. Caso 1958, 3.
25. P. Furst 1976b, 23.
26. Townsend 1979, 35.
27. H. Nicholson 1971a, 412.
28. Coe and Diehl 1980a, 394.
29. H. Nicholson 1971a, 439.
30. Eliade 1964a, 99.
31. Ibid., 99; Caso 1958, 84.
32. Lévi-Strauss 1969, 28.
33. Eliade 1964a, 179.
34. Ibid., 94.
35. S. Larsen 1976, 62.
36. H. Nicholson 1971a, 440.
37. Hultkranz 1979, 233.
38. Halifax 1979, 34.
39. Townsend 1979, 9.

5. THE TEMPORAL ORDER

1. León-Portilla 1973, 54; Aveni 1980, 135.
2. Satterthwaite 1965, 605.
3. Brotherston 1978, 123.
4. Coggins 1980, 732.
5. Aveni 1980, 280.
6. Ibid., 257.
7. Ibid., 267–277.
8. Ibid., 222–226.
9. Coggins 1980, 727–729.
10. See Zolbrod 1987, 30–38, for a different argument, one that derives the figure from the imagery in creation myths.
11. Aveni 1980, 226–228.
12. Caso 1971, 333.
13. Caso 1965a, 932; Coe 1980, 37; Bernal 1969a, 92–96.

14. Muser 1978.
15. Soustelle 1971, x.
16. D. Tedlock 1985, 72.
17. Ibid., 79–86.
18. Ibid., 165–167.
19. J. E. S. Thompson 1970, 335.
20. León-Portilla 1973, 54.
21. Bruce 1975, 99–101.
22. Beyer 1965a, 275.
23. Caso 1958, 17–18; H. Nicholson 1971a, 401.
24. León-Portilla 1969, 42–48; H. Nicholson 1971a, 431.
25. Bonifaz Nuño 1981, 43.
26. D. Tedlock 1985, 159–160.
27. J. E. S. Thompson 1970, 355.
28. Roys 1967, 76–77.
29. J. E. S. Thompson 1970, 322.
30. Coe 1980, 160.
31. Aveni 1980, 184.
32. Ibid., 85–86.
33. Coe 1975b, 19.
34. Aveni 1980, 186; Hammond 1982, 292.
35. J. E. S. Thompson 1972a, 70–71.
36. Ibid., 65.
37. Seler 1904, 364–365.
38. Seler 1898a, 37.
39. Coe 1975a, 90.
40. Eliade 1964b, 35.
41. See ibid., 33.
42. J. E. S. Thompson 1966, 234.
43. Hultkrantz 1979, 275; and see details of Aztec rites, 273ff.
44. Durán 1971, 396–398.
45. J. E. S. Thompson 1966, 237.
46. Bruce 1975, 101.
47. Ibid., 102–103.
48. I. Nicholson 1965, 49.
49. See Eliade 1964b, 32.
50. D. Carrasco 1982, 70.
51. P. Furst 1976a, 152.
52. J. Furst 1982, 207, 221.
53. Westheim 1965, 25.
54. Robicsek and Hales 1981, 149.
55. Ruz Lhuillier 1965, 459.
56. See Coe 1975a, 103–104.
57. León-Portilla 1980, 187.
58. Townsend 1979, 33.
59. See Hammond 1982, 286.
60. Ruz Lhuillier 1965, 459.
61. Coe 1975a, 88.
62. P. Furst 1973, 128; he contends that this practice continues today among the Huichol (131).
63. See Schele and Miller 1986, 286–289. Henderson 1981, 181, suggests that the "reliefs in the Temple of the Cross, the monument celebrating the succession of Chan Bahlum [his son, Serpent Jaguar], reaffirm this association." He also points out that in the sanctuary within the Temple of the Cross, Pacal is shown holding the sun god's head.
64. Ruz Lhuillier 1970, 117.
65. Kubler 1969, 27.
66. See Coe 1975a, 102.
67. M. Robertson 1983, fig. 145.
68. Ruz Lhuillier 1970, 118.
69. Ibid., 117.
70. Westheim 1972, 17.

71. Ruz Lhuillier 1970, 114–115.
72. Ibid., 114.
73. Schele and Miller 1986, 269.
74. Henderson 1981, 181.
75. M. Robertson 1983, 56.
76. Fernández 1969, 44–45.
77. Westheim 1965, 229.
78. Caso 1958, 54.
79. Bruce 1975, 101.
80. Campbell 1974, 160.
81. León-Portilla 1980, 267.

6. THE SPATIAL ORDER

1. Eliade 1964a, 259.
2. Hunt says that "the cardinal directions were markers not simply of space, but also of time" and goes on to discuss that idea at some length (1977, 177–180). Coggins makes essentially the same point (1980, 731), and see Klein 1976, 168.
3. Coe 1975b, 6.
4. J. E. S. Thompson 1970, 214.
5. Coggins 1980, 727.
6. León-Portilla 1973, 54.
7. See Coggins 1980, 728.
8. Coe 1976, 111.
9. Coggins 1980, 728.
10. Aveni 1980, 154–156.
11. Durán 1971, 359.
12. Millon 1976, 237.
13. Ibid., 226.
14. Calnek 1976, 296.
15. Townsend, 1979, 48.
16. D. Carrasco 1982, 70, places Wheatley's idea in the Mesoamerican context.
17. D. Carrasco 1982, 71.
18. Hammond 1982, 285–286.
19. Klein 1973, 80.
20. Durán 1971, 188–190.
21. Hultkranz 1979, 276–277.
22. Durán 1971, 106–107, 126–127.
23. Holland 1964, 17.
24. Eliade 1976, 50–51.
25. von Winning 1976, 149.
26. Malmstrom 1978, 114.
27. See Aveni 1980, 311–315.
28. Millon 1981, 230.
29. Flannery, Marcus, and Kowalewski 1981, 89.
30. See, for example, the discussions of V. Turner (1974, 223), Spores (1967, 23, 96), and Redfield and Tax (1968, 36).
31. V. Turner 1969, 95.
32. Heyden 1976.
33. Heyden 1975, 134.
34. Ruz Lhuillier 1970, 23.
35. Pasztory 1976, 167.
36. J. E. S. Thompson 1970, 184.
37. See Grove 1970, 31; Klein 1973, 73; Gossen 1979, 118; and Heyden 1975, 141, for discussions of this association.
38. Coe 1975a, 93; León-Portilla 1973, 82.
39. Durán 1971, 154.
40. Hunt 1977, 107–108; Heyden 1975, 134.
41. Heyden 1975, 134.

42. Miles 1965a, 285; Heyden 1975, 135.
43. See, in this connection, Miles 1965a, 279; Borhegyi 1965, 54; and Townsend 1982, 136.
44. Hammond 1982, 286.
45. Knab 1976, 127.
46. Bernal 1969a, 39.
47. Broda 1987b, 94.
48. Millon 1981, 231.
49. Heyden 1975, 131.
50. Millon 1981, 235.
51. Heyden 1975, 131.
52. Stierlin 1982, 50.
53. Heyden 1975, 131.
54. Millon 1981, 231.
55. Ibid., 234.
56. Eliade 1976, 21.
57. Millon 1981, 234.

7. THE MATHEMATICAL ORDER

1. León-Portilla 1973, 28.
2. León-Portilla 1980, 233–236.
3. Willey, Eckholm, and Millon 1964, 460.
4. J. E. S. Thompson 1966, 14; although Thompson's view of the Maya as time worshipers has given way to a more balanced view of Maya civilization, we must not go to the other extreme. The fact remains that the Maya were concerned to a degree surely approaching obsession with the regularity of the movement of time, an essentially religious concern for them, as for all archaic civilizations, rather than historical, as it is for us.
5. Aveni 1980, 138.
6. Ibid., 148.
7. Ibid., 150.
8. B. Tedlock 1982, 93; and see P. Furst 1986, for a presentation of his own and Schultze Jena's arguments for this position.
9. Henderson 1981, 75.
10. Aveni 1980, 151.
11. Caso 1965a, 946; and see Marcus 1976, 137; and B. Tedlock 1982 for its contemporary use in divination by the highland Maya.
12. See Caso 1971, 340, and 1965a, 944–945, for a thorough study of some of the basic differences among the various versions, the latter particularly concerned with a comparison between Mexican and Zapotec and Southern Zapotec; J. E. S. Thompson 1972b, 21, notes "the common ancestry" despite specific differences of the various versions of the 260-day almanacs.
13. León-Portilla 1973, 110.
14. Satterthwaite 1965, 605.
15. Schele and Miller 1986, 320.
16. Henderson 1981, 74.
17. Paz 1974, 10.
18. J. E. S. Thompson 1972a, 7.
19. H. Nicholson 1971a, 439.
20. León-Portilla, 1973, 109.
21. Bruce 1975, 99.
22. J. E. S. Thompson 1972a, 112.
23. Hammond 1982, 285.
24. Hunt 1977, 187.
25. Ibid., 191.

26. León-Portilla 1973, 107.
27. Flannery, Marcus, and Kowalewski discuss the extent to which the full-time priests took religion out of the hands of the commoners (1981, 80).
28. Soustelle (1961, 112) and J. E. S. Thompson (1972a, 113), for example, state the case for seeing Mesoamerican thought as absolutely fatalistic; León-Portilla (1973, 119–120) and Bruce (1975, 27), for example, suggest the existence of a system of thought that was what León-Portilla calls "far from what is normally understood as absolute fatalism."
29. Caso 1965a, 940.
30. Edmonson 1971, xv.
31. I. Nicholson 1965, 58.
32. Aveni 1980, 202.
33. Durán 1971, 389.
34. See Aveni 1980, 33.
35. Henderson 1981, 75.
36. Soustelle 1982a, 116–117.
37. Aveni 1980, 203.
38. Ibid., 143.
39. Henderson 1981, 78.
40. Schele and Miller 1986, 320.
41. León-Portilla 1973, 13.
42. de Santillana and von Dechend 1977, 332–333.
43. Aveni 1980, 203.
44. Hesse 1970, 104–105.

8. THE LIFE-FORCE
Source of All Order

1. See León-Portilla 1963, for a thorough discussion of the Aztec *Tlamatini* and *Calmécac* as an essentially oral means of preserving and transmitting that speculative thought.
2. Hunt 1977, 55.
3. Beyer 1965b, 399.
4. Ibid., 398.
5. J. E. S. Thompson 1970, 200.
6. Caso 1958, 8.
7. Pasztory 1983, 64.
8. Hvidtfeldt 1958, 84.
9. H. Nicholson 1971a, 411.
10. I. Nicholson 1965, 60–61.
11. León-Portilla 1963, 96.
12. Sproul 1979, 8, 187–188.
13. Campbell, personal communication.
14. Campbell 1969a, 75.
15. Campbell 1986, 21.
16. León-Portilla 1980, 28.
17. Sahagún 1950–1978, bk. 6:167–168.
18. Zimmer (1962, 25) makes this statement regarding Hindu thought but expresses the Mesoamerican conception marvelously well.
19. Campbell 1969b, 42n.
20. León-Portilla 1963, 87.
21. Ibid., 93.
22. Ibid., 92.
23. H. Nicholson 1971a, 424.
24. Ibid., 411.
25. J. E. S. Thompson 1970, 203.
26. León-Portilla 1973, 26.
27. J. E. S. Thompson 1970, 212–218.
28. Ibid., 216.

29. Marcus 1983d, 345.
30. Boos 1966, 18.
31. Joralemon 1976, 61.
32. See our analysis in chapter 1 of the god depicted on the Tlalocan mural at Tepantitla for an example of precisely such a god. Tlaloc, in contrast, is an example of a god with a far more permanent and fixed identity.
33. Caso 1958, 7.
34. Townsend 1979, 30.
35. See H. B. Nicholson 1971a, 408, and Ruz Lhuillier 1970, 120, for examples of such gods.
36. Townsend 1979, 28.
37. Paddock 1970b, 153.
38. See León-Portilla 1963, 89.
39. Hunt 1977, 55–56.

9. TRANSFORMATION
Manifesting the Life-Force

1. Westheim 1965, 31.
2. Sahagún 1950–1978, 41–42.
3. H. Nicholson 1971a, 413.
4. Schele and Miller 1986, 44.
5. Sekaquaptewa 1976, 39.
6. Gill 1976, 55.
7. León-Portilla 1963, 217.
8. Townsend 1979, 70.
9. H. Nicholson 1971a, 400.
10. See, e.g., H. Nicholson 1971a, 441, and Vogt 1976, 18.
11. Vogt 1976, 19.
12. Dow 1986, 62.
13. Foster 1944.
14. Miles 1965a, 284.
15. Seler 1888, 146; and see H. Nicholson 1971a, 439.
16. Colby 1976, 76; and see H. Nicholson 1971a, 439.
17. Brundage 1982, 133.
18. Boos 1966, 17.
19. Schele and Miller 1986, 179.
20. H. Nicholson 1971a, 402.
21. Schele and Miller 1986, 144.
22. D. Tedlock 1985, 79, 167.
23. León-Portilla 1980, 145–146.
24. J. Furst 1978, 66.
25. León-Portilla 1980, 147.
26. Caso 1958, 96.
27. Soustelle 1971, 179.
28. Durán 1971, 263.
29. Anawalt 1982a, 44.
30. Anawalt 1982b, 52.
31. Anawalt 1982a, 44.
32. H. Nicholson 1971a, 431–432.
33. Durán 1971, 229–237, pl. 124; Durán's account can be profitably compared with the more detailed and complex account in Sahagún 1950–1978, bk. 2:110–116.
34. Coe 1978, 13.
35. Anawalt 1982a, 43.
36. Schele and Miller 1986, 109.
37. Berlo 1982, 99.
38. Caso 1958, 38.
39. J. Furst 1978, 61.
40. Seler n.d.a, 82.

41. Berlo 1982, 97.
42. Seler n.d.c, 45; see also León-Portilla 1963, 126.
43. See Seler n.d.a, 83–87, for numerous examples of the many variations and frequent occurrences of the symbol.
44. León-Portilla 1980, 205–206.
45. León-Portilla 1963, 173.
46. I. Nicholson 1965, 100.
47. León-Portilla 1969, 174.
48. Campbell 1983, 10.
49. León-Portilla 1963, 77.
50. León-Portilla 1980, 244.
51. Ibid., 243.
52. Whitman 1959, 25.
53. Ibid., 68.
54. León-Portilla 1980, 210.
55. I. Nicholson 1965, 99, 155.
56. León-Portilla 1980, 210n.
57. León-Portilla 1969, 80.

10. CODA II: THE MASK AS METAPHOR

1. See V. Turner 1974, 25.
2. Highwater 1981, 58.
3. Campbell 1968b, 4.
4. Campbell 1969a, 70.
5. Melville 1950, 161.
6. Schele and Miller 1986, 107.

11. SYNCRETISM
The Structural Effect of the Conquest

1. Horcasitas and Heyden 1971, 11.
2. Durán 1971, 152—153.
3. Ibid., 207–208.
4. Ibid., 387.
5. Nutini 1976, 34.
6. J. E. S. Thompson 1970, 251.
7. Villa Rojas 1973, 115.
8. Stone 1975, 27.
9. I. Nicholson (1965, 113) translates this passage from Angel María Garibay's *Historia de la Literatura Náhuatl*, 1:149.
10. Gibson 1964, 134.
11. Hunt 1977, 247–248.
12. Madsen 1967, 370.
13. Barnett 1953, 49, 54.
14. Madsen 1967, 369.
15. Ibid., 372.
16. León-Portilla 1963, 62–65.
17. Madsen 1967, 372–374.
18. Durán 1971, 184–185.
19. Horcasitas 1979, 98.
20. B. Tedlock 1982, 41–43; 1983, 241. Cook (1986, 140–141) presents an alternative view of the interpretation of the trinity in Momostenango.
21. Ravicz 1970, 42.
22. V. Turner 1974, 189. Horcasitas tells the story of Juan Diego's vision of the Virgin of Guadalupe in detail (1979, 88–90).
23. Watts 1960, 110.
24. Madsen 1967, 389.
25. Ibid., 378.
26. Salmerón 1971, 2:371, 377–378.
27. Hunt 1977, 280.
28. Ibid., 275–276.
29. Madsen 1967, 384.
30. D. Thompson 1960, 15.
31. Bricker 1981, 179.
32. Aveni 1980, 44.
33. Hunt 1977, 248.
34. Villa Rojas 1973, 159.
35. Wisdom 1968, 123.
36. Gibson 1964, 100.
37. Madsen 1967, 378.
38. Ibid., 390.
39. Ibid., 380.
40. Gibson 1964, 101.
41. Beals 1945b, 64.
42. Kandt 1972a, 104.
43. Coe 1980, 146.
44. Madsen 1957, 136.
45. See Soustelle 1961, 199–200; and see Durán 1971, 246–247, and Madsen 1967, 378–379, for descriptions of the rite among the Aztecs and Landa 1978, 45–46, for an account of the roughly similar practices among the Yucatec Maya.
46. Wolf 1959, 171.
47. Durán 1971, 247.
48. Wolf 1959, 171.
49. Durán 1971, 203–204, 245.
50. Horcasitas and Heyden 1971, 27.
51. Carrillo Azpeitia 1971, 1:34–35.
52. See our discussion below of the Yaqui Lenten ritual for the link between the Little Angels and warriors, and see Pickands (1986, 118n.) for the fascinating suggestion that the Magi may be seen as warriors, at least by the Yucatec Maya.
53. Durán 1971, 71, 196.
54. B. Tedlock 1982, 174–175.
55. Díaz del Castillo 1956, 222.
56. Carrillo Azpeitia 1971, 34.
57. Ravicz (1970, 20–25) presents a clear summary of the little specific information that remains regarding the pre-Columbian tradition of drama and dance-drama, both masked and unmasked.
58. Beals 1968.
59. Kurath 1967, 189.
60. Salmerón 1971, 2:373.
61. For discussions of the Spanish dance in the light of the New World variants, see Foster 1960, 221–225; Kurath 1949, 1956, 1958, and 1968; and Warman 1985, 15–54.
62. Warman (1985) presents the history of the complex development of the dance in Mexico in great detail, and our brief summary follows his account.
63. Warman 1985, 135.
64. Kurath 1949, 99–100.
65. Foster 1960, 221–222.
66. Warman lists, categorizes, and discusses the variant types (1985, 111–135), and Mompradé and Gutiérrez (1976, 124–194) provide a similar discussion. Numerous ethnographic studies and popular accounts, in addition to those cited elsewhere in this discussion, of contemporary variants exist. For versions performed in the predominantly Nahua area of Guerrero, Morelos, Tlaxcala, and Puebla, see, for example, González 1925 and 1928; Toor

1930, 86–88, and 1947, 346–352; Spratling 1932, 70–71; Domínguez 1962b, 33–36, and 1962d, 88; Téllez Girón 1962a, 355–360, 1962b, 417–421; Fergusson 1942, 69–84; Altamirano 1984b; Basauri 1940, 3:213; Amezquita Borja 1943; Friedlander 1975, 109–114; Gillmor 1983, 103–105; Heller 1983, 2; Horcasitas 1979, 127–130; Jäcklein 1974; Kandt 1972a, 106; Nutini and Isaac 1974; Sepúlveda Herrera 1982, 131–132, 143–144.

Ichon (1973, 394–408) discusses the dance among the Totonacs of Veracruz, while the dance in Oaxaca is described in Starr 1896, 166–167, and 1908, 30–31; Basauri 1940, 2:324, 400, 561; and Brown 1978, 16–19. Variants of the dance in Guatemala, especially the Dance of the Conquest, are discussed in Bode 1961, 213–216 (which also presents a text of the dance); LaFarge 1931; Redfield 1962; Reina 1972; Borhegyi 1955; McArthur 1972, 494–496; Lújan Muñoz 1965, 1967, 1971, 1982, and n.d. The variants of the dance, especially the Tastoanes, performed in Jalisco are described in Starr 1896 and 1902; Altamirano 1984a; Robe 1954; FONADAN n.d., 43–66; Gillmor 1983, 106–107; and McAllister 1984, 55–58. The variants of Michoacán are discussed by Beals 1946, 144; Foster 1948, 208; Zantwijk 1967; and P. Carrasco 1970. Kurath (1949, 90–94) discusses the *Matachines* of northwest Mexico and the southwestern United States in the context of the Moors and Christians tradition.

67. Sevilla, Rodríguez, and Camara 1985, 213.
68. The extent to which a present version of the dance-drama reflects indigenous as opposed to Christian views is interestingly debated by Zantwijk (1967) and P. Carrasco (1970).
69. Gillmor 1983, 103.
70. There are variants, especially among those called Tastoanes, in which Santiago is killed by the indigenous forces who thus triumph. The fertility implications of these, however, are particularly strong so that even in this case the theme of rebirth seems clearer than any political implications. See Gillmor 1983, 106–109, for a description of one such dance.
71. Stone 1975, 7.
72. Kurath 1967, 177.
73. Stone 1975 provides the most complete discussion of the Concheros. See also Vásquez Santana and Dávila Garibi 1931a, 43–45; Domínguez 1962b; Fernández and Mendoza 1941; Altamirano 1984c; Kurath 1946; Toor 1947, 323–330; and Guerrero 1947.
74. LaFarge 1931, 109.
75. Bode 1961, 238.
76. B. Tedlock 1982, 149–150; and see Cook 1986, 143–144, for an interesting discussion of Tzitzimit.
77. Cook 1986, 141.
78. Ibid., 139.
79. Ravicz 1970, 4–9.
80. Esser 1981a., n.p.
81. Barker 1953, 4.
82. Barker 1953, 3. For other accounts of the Pastorelas, see Mendoza and Mendoza 1952, which presents a complete text as does Barker; Starr 1896, 167–168; Cole 1907; Vásquez Santana and Dávila Garibi 1931a, 41–55, 69–71; Domínguez 1962b, 34–38,

and 1962d, 88; Michel 1932; Toor 1932; Beals 1946, 148–149; Gillmor 1957; Robb 1957; Robe 1954, 1957; Campa 1960; Ravicz 1970; Ichon 1973, 422–430; Esser 1984a, 209–222. Mompradé and Gutiérrez (1976, 195–204) discuss related dances and Foster (1960, 168–170) discusses the drama in Spain in connection with the New World versions.
83. Madsen 1957, 134.
84. H. Larsen 1937a, 179.
85. Stone 1975, 196–197.
86. Wolf 1959, 173.
87. Salmerón 1971, 2:373.
88. Wisdom 1968, 120.
89. Stone 1975, 161.
90. Hunt 1977, 56.
91. Jonaitis 1981, 50. Madsen (1955, 48) questions the existence of shamanism in Mexico—and properly so since he refers specifically to Siberian shamanism rather than the set of shamanistic assumptions we have defined above. Vogt and Vogt (1979, 283–285) point out the existence of shamanic relationships in Zinacantan where animal spirits still act as mediators between culture and nature, and there is no clearer exposition of the fundamentally shamanistic nature of the spiritual assumptions of a particular Mesoamerican community than Vogt's *Tortillas for the Gods* (1976).
92. Redfield 1962, 203.
93. Redfield and Tax 1968, 38.
94. Madsen 1967, 374.
95. Salmerón 1971, 2:369.
96. Proskouriakoff 1950, 182.
97. Greenberg 1981, 82.
98. *Los Angeles Times*, July 5, 1987, 1:1, 12–13.
99. Gibson 1964, 134.
100. Stone 1975, 150.

12. THE PRE-COLUMBIAN SURVIVALS
The Masks of the Tigre

1. Horcasitas 1971a, 2:583.
2. Gibson 1964, 134.
3. Horcasitas 1980, 251. Among those who affirm its pre-Columbian origins are Guerrero (1984a, 116), who discusses the dance in general; Sepúlveda Herrera (1982, 51), who is concerned with the masks used in the state of Guerrero; Suárez Jácome (1978, 5) and Williams García (n.d.), who deal with the *pelea del tigres* of Zitlala, Guerrero; McArthur (1972, 519–520), J. E. S. Thompson (1927, 103), and Olivera B. (1974, 77, 96), who deal with Maya tiger masks and dances; Stresser-Péan (1948, 337–338), who deals with a manifestation in the Huasteca; and Esser (1981a) and Pérez Rodríguez (1981, 35), who see connections between contemporary jaguar symbolism and the jaguar symbolism of pre-Columbian Mesoamerica which we have discussed at length above. Warman and Warman (1971, 750–752) believe that while the dance is colonial, the jaguar-masked central figure is "of American origin"; and FONADAN (1975, 19) indicates that the *Danza del Tecuan* of Texcaltitlán, Guerrero, has pre-Hispanic elements, "the most important of which is the *tigre o jaguar*" in a colonial context.

4. Navarrete 1971*b*, 374–375; Cordry presents an English translation of the edict by Marilyn Olen (1980, 181).
5. Navarrete 1971*a*, 2:742.
6. Cordry 1980, fig. 176.
7. Horcasitas 1980, 14:239; 15:313, 317.
8. This English translation is given in Horcasitas 1979, 125–126. In his Spanish translation of the Nahuatl text of the dance-drama (1980, 14:277), the speech is given by Salvador's assistant, Mayeso. In addition to this complete text of los Tecuanes, another is available in FONADAN 1975.
9. FONADAN 1975, 128–129.
10. Horcasitas 1979, 126; and see 1980, 14:271.
11. Horcasitas 1971*b*, 583.
12. The Indians among whom Guerrero did research defined *Tlacolol* as the act of preparing the earth for planting (1984*b*, 125).
13. Warman and Warman 1971, 751–752.
14. Ibid., 750; Horcasitas 1979, 14:245.
15. This summary combines data from Guerrero 1984*b*, 125–126; Warman and Warman 1971, 751–752; and Sepúlveda Herrera 1982, 53.
16. See Méndez and Yampolsky 1971, 2:737, n. 524, and Sepúlveda Herrera 1973, 19.
17. The masks worn by impersonators of the tigre in the dances of los Tecuanes and los Tlacololeros are similar. For particularly good illustrations of traditional masks, see Centro 1981, pl. 33; Cordry 1980, pls. 176, 297; Esser 1981*a*, pl. 122; Kurath 1967, figs. 23–25; Mompradé and Gutiérrez 1976, Pl. IV; Oettinger 1986, 15; Sepúlveda Herrera 1982, pls. 5–20; Sociedad de Arte Moderno 1945, pls. 22, 23; Speer and Parker 1985, pl. 92; and Toor 1930, 90. Good illustrations of the dances themselves are to be found in Fernández n.d., pls. 64, 65; FONADAN 1975; FONAPAS-INI n.d., Encuentro XLV; Gyles and Sayer 1980, 35; Kurath and Martí 1964, pl. 108; Méndez and Yampolsky 1971, pls. 523, 524, 528–530; Mompradé and Gutiérrez 1976, pls. 121, 122, 124; Oettinger 1986, 15; Santiago E. 1978, 63; and Toneyama 1974, pl. 54. Useful descriptions of the dances are available. In addition to the ones we have cited in our discussion, Luis Covarrubias describes a dance in Chichihualco, Guerrero (n.d., VIII); Gyles and Sayer describe one in Totoltepec, Guerrero (1980, 34–36); Luna and Romandia describe the version of Huitzuco, Guerrero (1978, 93–94); Spratling gives a generalized description (1932, 76–80); Toor describes one in Taxco (1930, 88–90); and Horcasitas lists other descriptions (1980, 14:240–242).
18. While a number of writers have commented on the remarkable similarities between some tigre masks and the Olmec were-jaguar and noted as well the fact that the modern masks are found in an area associated much earlier with the Olmecs (see, e.g., M. Covarrubias 1957, 60; Williams García n.d., 29; Gyles and Sayer 1980, 33–34; Luna and Romandia 1978, 90–92), it seems highly improbable that there is the direct connection some of them suggest. But such similarities are perhaps not merely coincidental. As we have shown above, the features of that Olmec man-jaguar metamorphosed into those of the later pre-Columbian rain gods, one of which—Tlaloc—was no doubt central to the agricultural ritual of the pre-Columbian peoples of what is now the state of Guerrero (but the ethnohistory of Guerrero is complex and not particularly well understood; see Harvey 1971 for an assessment). And Tlaloc carried within him the symbolic features of that were-jaguar which may well have reemerged in the evolution of the jaguar mask.
19. Horcasitas 1979, 127.
20. FONADAN 1975, 142.
21. Flanet 1977, 169.
22. Sánchez Andraka 1983, 53.
23. Cordry's illustration of a mask maker, Juan Godinillo of Zitlala, in the process of making one of these masks clearly shows its basic construction (1980, pl. 184).
24. For good illustrations of these masks and dancers in addition to those provided in the articles we cite in the course of our discussion of the ritual, see Centro 1981, pl. 39; Cordry 1980, pl. 55; Grau 1978, [60–61]; Luna and Romandia 1978, 95; Mexican Fine Arts Center 1984, pl. 12; and Speer and Parker 1985, pl. 95.
25. Williams García n.d., 22.
26. Suárez Jácome 1978, 4–6.
27. McDowell 1980, 743–749.
28. Suárez Jácome 1978, 5, 11–12.
29. Sánchez Andraka 1983, [174].
30. Williams García n.d., 22.
31. Ibid., 1.
32. Suárez Jácome 1978, 7–9.
33. According to Madsen (1969, 634), this is typical: "A significant feature of the Náhuatl annual cycle is the correlation between the village fiestas and the growing season."
34. Santiago E. 1978, 64–65.
35. Sánchez Andraka 1983, 82.
36. Ibid., 79–80.
37. Ibid., [157].
38. Ibid., 80.
39. Ibid., [156].
40. Suárez Jácome 1978, 12.
41. See Horcasitas 1980, 14:245–250, for an exhaustive list of those variants and the communities in which they are performed.
42. See Stanford 1962, 189–190, for a detailed description of the dance-drama.
43. Stanford 1962, 190.
44. Flanet 1977, 172. She includes illustrations of the tigre-masked character in action (192*b*, 192*c*). For depictions of the mask itself, see Brown 1978, 38; Mexican Fine Arts Center 1984, pls. 9, 15; Smithsonian Institution 1978, cover; and Speer and Parker 1985, pl. 96. Méndez and Yampolsky 1971, 2: pls. 526, 538, depict masked dancers.
45. Bakhtin 1973, 102.
46. Flanet 1977, 172.,
47. Crocker 1982, 83.
48. Flanet 1977, 170–173.
49. Bakhtin 1973, 102–105.
50. Mesnil 1987, 189.
51. Flanet 1977, 171.
52. Brown 1984, 65–67.
53. Oettinger 1986, 17.
54. Horcasitas 1980, 14:250–251.
55. Olivera B. 1974, 77.

56. Ibid., 96. See pp. 93–95 for other tigres. See Morris on the Suchiapa tigre mask and costume (1979, 2: 262); and Méndez and Yampolsky 1971, 2:pls. 531–537, for illustrations.
57. Horcasitas 1980, 14:251.
58. J. E. S. Thompson 1927, 103; LaFarge 1931, 100, describes similar masks used in a similar performance at San Marcos.
59. Vela 1972, 520.
60. Paret-Limardo de Vela 1963, 13–15.
61. Frost 1976, pl. 9.
62. Vogt 1976, 174.
63. Ibid., 162. Bricker (1981, 143) suggests a possible historic basis for these figures.
64. Bricker 1981, 139, figs. 21, 26.
65. Vogt 1976, 10.
66. Ibid., 172.
67. Ibid., 172.
68. Bricker 1973, 55.
69. Vogt 1976, 164–165.
70. Ibid., 165; see Bricker 1981, 147–148.
71. Vogt 1976, 176–177.
72. Ibid., 162.
73. Ibid., 175–176.
74. Bricker 1981, 139–147.
75. Vogt 1969, 15–16.
76. For the pre-Conquest nature of the mask and dance and its local variants, see Esser 1984a, 57–121; and see L. Covarrubias n.d., III; Esser 1981a, n.p.; Esser 1982, 115–123; and Warman and Warman 1971, 2: 754–755. Additional illustrations of Viejito dances and masks may be found in Cordry 1980, pl. 311; Esser 1984b, 40; Fernández n.d., pl. 18; Luna and Romandia 1978, 80–84; Méndez and Yampolsky 1971, 2: pls. 401, 402; Mexican Fine Arts Center 1984, 24; Mompradé and Gutiérrez 1976, pls. 114, 115, 117, 119, 120; and Speer and Parker 1985, pls. 141, 142.
77. Esser treats the Negrito most comprehensively (1984a, 123–178), concluding that they reflect the convergence of the pre-Columbian tradition, which associated black "with the extraordinary: with godhead, power and lavish display of riches," with the colonial, in which "black Africans were experienced by the Indians as having control over people and goods" (1981a, n.p.). Miller, Varner, and Brown discuss the pre-Columbian and colonial sources of *Negrito* masks (1975, 46–47) as do Warman and Warman (1971, 747–748). Beals discusses the Negritos of Cherán (1946, 144–147).

For illustrations of Tarascan Negrito masks and dancers, see Bahm 1982, 31; Brown 1978, 20; Cordry 1980, pl. 86; Esser 1981a, fig. 8, pl. 62; Esser 1984a, figs. 36–40; Fernández n.d., pl. 22; Luna and Romandia 1978, 44; Méndez and Yampolsky 1971, 2:pls. 563, 565; Mompradé and Gutiérrez, pls. 165, 171, 173; Oettinger n.d., 7; and Speer and Parker 1985, pl. 33.

In addition to the sources cited in our discussion of the Mixtec carnival, illustrations of Tejorones masks and dancers may be found in Centro 1981, pl. 11; Cordry 1980, pl. 59; Esser 1981a, pl. 56; Mexican Fine Arts Center 1984, 5; Pérez Rodríguez 1981, 159; and Speer and Parker 1985, 11, pl. 139. Illustrations and discussion of the tusked Negrito mask are avail-able in Beals 1945b, 68–83; Brown 1978, 19–20; Cordry 1980, pl. 45; Esser 1981a, fig. 9; Fernández n.d., pl. 81; FONAPAS-INI n.d., Encuentro XXVIII; Méndez and Yampolsky 1971, 2: pl. 578; Nahmad 1981, 64–65; Weitlaner and Olivera de Vásquez 1969, pl. 95.

On Veracruz Negrito masks and dances, see Centro 1981, pls. 18, 19; Esser 1981a, fig. 10; Heller 1983, 2–3; Ichon 1973, 413–421; Kelley and Palerm 1952, 210, 222; Luna and Romandia 1978, 63; Starr 1908, 287; and Warman and Warman 1971, 747. For Negritos of Guerrero and the state of Mexico, see Cordry 1980, pl. 99; Luna and Romandia 1978, 97; and Mompradé and Gutiérrez 1976, pls. XVII, 128–131. For the unmasked Negritos of the Sierra de Puebla, see Fernández n.d., pl. 55; Horcasitas 1979, 130; Kandt 1972a, 51, 56–59, 105; Méndez and Yampolsky 1971, 2: pls. 575–576; Mompradé and Gutiérrez 1976, pl. 177; and Téllez Girón 1962b, 381–383.

13. THE SYNCRETIC COMPROMISE
The Yaqui and Mayo Pascola

1. Griffith 1982, 55.
2. See, e.g., Kelly 1944 and Kelley 1966.
3. See Spicer 1980, 69–70, for a fascinating argument that the Yaquis have created what is, in fact, a new religion.
4. While it is true that there are significant differences between contemporary Yaqui and Mayo cultures, their ceremonial practices are quite similar, reflecting, no doubt, their common origin. For a full treatment of these similarities and differences, see Spicer 1969b.
5. Spicer 1969b, 841, 843.
6. Crumrine 1977, 98; various scholars use various spellings of the Yaqui term. While we have elected to use *pascola*, the spelling most commonly used, we retain other scholars' spellings, *paskola* and *pahkola*, in quotations from their work. Similarly, we retain the indigenous plural form, used here by Crumrine, in quotations.
7. Spicer 1984, 173, 199.
8. Lutes 1983, 86.
9. Crumrine 1977, 98; his italics.
10. Griffith and Molina 1980, 29.
11. Spicer 1980, 328, 68.
12. Evers and Molina 1987, 44.
13. That this is the devil is often made explicit. Crumrine (1977, 60), for example, indicates that the Mayo of Sonora believe that particularly talented pascolas have sold their souls to the devil, and Spicer (1984, 196) found the same connection among the Arizona Yaqui in Pascua. Molina tells a story he heard from his grandfather in which the first pascola is the devil's son (Griffith and Molina 1980, 32–33).
14. Spicer (1980, 326) explains the situation clearly: "The *yo ania* was steadily revalued against the sacred written words. . . . A mythology of the evil origins of the *Pascolas* and the *Chapayekas* at some point became a part of Yaqui thought, but this idea competed with the idea of beneficent origin."
15. Beals 1945a, 205.
16. Spicer 1980, 88.

17. Ibid., 66–68.
18. Spicer 1984, 299–308.
19. Ibid., 173.
20. Ibid., 306.
21. Ibid., 299.
22. Ibid., 175.
23. Crumrine 1977, 86.
24. Evers and Molina 1987, 62.
25. Spicer 1980, 88.
26. Spicer 1954, 184.
27. Spicer 1984, 198.
28. Crumrine 1977, 26.
29. Spicer 1980, 88–89.
30. Ibid., 90–92.
31. Crumrine 1977, 80.
32. Spicer 1980, 92.
33. Spicer 1969b, 842.
34. Lutes 1983, 86.
35. Spicer 1980, 105.
36. Evers and Molina 1987, 73.
37. Griffith and Molina 1980, 14.
38. Crumrine 1977, 33.
39. Sands 1980, 152.
40. Spicer 1980, 102–103.
41. Evers and Molina 1987, 138.
42. Crumrine 1983b, 255.
43. Evers and Molina 1987, 16.
44. Lutes 1983, 86.
45. Griffith and Molina 1980, 18.
46. Evers and Molina 1987, 137.
47. Ibid., 154, 173.
48. Ibid., 88–89.
49. Ibid., 154.
50. Ibid., 174.
51. Wilder 1963, 201.
52. Spicer 1980, 94.
53. Evers and Molina 1987, 129.
54. Spicer 1980, 71.
55. Spicer's account of the Yaqui drama is the most extensive and his analysis the most penetrating (1980, 70–88). The personal experiences of Rosalio Moises as a Yaqui chapayeka are recounted in Moises, Kelley, and Holden 1971; Domínguez (1962f, 1:121–136) gives an account of a particular Yaqui ceremony. Crumrine discusses the Mayo festival at length in a number of places; see, for example, 1969; 1974; 1977, 85–96; 1983b. Beristáin Márquez et al. (n.d.) deals at length with the Mayo Easter ceremonies while Gyles and Sayer (1980, 177–190) give an account of a particular Mayo ceremony. See also Altman 1946, 1947a, 1947b; Barker 1957; Montell 1938; and Robb 1961. There are a number of lengthy accounts and analyses of the Cora ceremony. The earliest account is that of Preuss 1912. For other descriptions of the ceremony, see Castillo Romero 1979, 219–242; González Ramos 1972; Luna and Romandia 1978, 108–127; Téllez Girón 1964a, 96–106, and 1964b, 158–168. Analyses of the Cora ceremony and relevant aspects of Cora culture are to be found in Grimes and Hinton 1969; Hinton 1970 and 1971; and Weigand 1985. A lengthy and very useful description and analysis is provided by Benítez (1984, 3:484–523) and a shorter analysis may be found in Anguiano Fernández 1972. Espejel 1978, pls. 296–317, provides excellent pictures of masked Cora ritualists as do Benítez and Luna and Romandia in the sources we have cited above. Additional pictures of Cora masks and ritualists may be found in *Artes de México* (1969, 9–14); Cordry 1980, pl. 172; and Sodi M. 1975, pls. 261, 274, 286. Additional pictures of Yaqui and Mayo masks may be found in Cordry 1980, pls. 71, 75–77; Méndez and Yampolsky 1971, 2: pls. 338–342; and Sodi M. 1975, pls. 271–272.
56. Spicer 1980, 60.
57. Ibid., 60–61.
58. Ibid., 70.
59. Ibid., 76.
60. See Spicer 1980, 106, for a discussion of the contrasts between the clowning of the pascolas and the chapayekas.
61. Spicer 1980, 78, 81.
62. Crumrine 1969, 8.
63. Spicer 1980, 68.
64. Ibid., 81.
65. Ibid., 58.
66. Griffith and Molina 1980, 14.
67. See Griffith and Molina 1980, 26, for a clear statement of the differences between Yaqui and Mayo masks and the regional variations within the masks of each culture.
68. According to Lutes (1983, 85) the typical colors of the mask are symbolic. Red is associated with the devil and with "mirth and joy. . . . White is linked with feelings of purity and tranquility, balanced activity, and spiritual grace. . . . [And] black has to do with death, gloom, and sorrow."
69. Griffith and Molina 1980, 30.
70. Lutes 1983, 84.
71. Griffith and Molina 1980, 29.
72. Spicer 1980, 102.
73. Fontana, Faubert, and Burns 1977, 20.
74. Spicer 1980, 112.
75. Crumrine 1977, 97.
76. Griffith and Molina 1980, 29.
77. Fontana, Faubert, and Burns 1977, 20.
78. Lutes 1983, 85.
79. Griffith and Molina 1980, 30.
80. Ibid., 41.
81. Lutes 1983, 89–90.

14. TODAY'S MASKS

1. Wolf 1959, 67–68.
2. D. Thompson 1960, 32.
3. Kandt 1972a, 104.
4. Merlo Juárez 1979, 42–43.
5. Redfield 1962, 250–251.
6. Griffith and Molina 1980, 22.
7. Ibid., 27.
8. Sepúlveda Herrera (1982, 215–216) discusses the development of these masks. Their manufacture originated in San Francisco Ozumatlán, Guerrero, and the surrounding area, and their commercial acceptance, especially by governmental agencies charged with fostering popular art, led to the spread of the industry to other woodworking areas of Guerrero. See also Ogazón 1981, 77; Speer and Parker 1985, 11–13; and Pomar 1982, 22. For illustrations, see, for

example, Speer and Parker 1985, pls. 18, 55–58, 65, 68–71, 107, 115, 117; Griffith 1982, pls. 4, 7, 10, 16, 32; and Mexican Fine Arts Center 1984, pls. 25, 91, 103–128.

9. For a sense of the great difficulties in making such determinations, see Speer and Parker's account of the problems they encountered when "experts" could not agree as to the ritual nature of masks they were prepared to mount in an extensive exhibit. They conclude that "it has become evident to the researchers of this exhibition that vast research still needs to be done on Mexican masks, particularly the contemporary phenomenon of market-induced production" (1985, 14–15).

10. *Mexican Folkways* 5:125. It was displayed in the landmark exhibition of Mexican masks mounted by the Sociedad de Arte Moderno in 1945 (Sociedad de Arte Moderno 1945, 73), and it is also depicted in the catalog of the recent Homage to Miguel Covarrubias (García-Noriega y Nieto 1987, 187).

11. Pomar 1982, 28–29.

12. Sepúlveda Herrera 1982, 216.

13. Cordry 1980, 105–107.

14. See Esser 1981b, 87, and Sepúlveda Herrera 1982, 216.

15. For illustrations of such masks, see, for example, Cordry 1980, pls. 15, 17, 18, 23–25, 37–38, 67–68, 105, 116–117, 120–121, 150, 181, 189, 206, 219, 225–232, 242, 248, 258, 269, 313; Speer and Parker 1985, pl. 124; Pérez Rodríguez 1981, 81, 91; Mexican Fine Arts Center 1984, 91–95; and Griffith 1982, pls. 2, 12, 18, 22, 23, 25.

16. For illustrations, see Cordry 1980, pl. 138; Pérez Rodríguez 1981, 67–69, 72–73, 93; Mexican Fine Arts Center 1984, pl. 200; and Griffith 1982, pl. 30.

17. See Cordry 1980, 204–205, and for illustrations, see Cordry 1980, pls. 252–256; Mexican Fine Arts Center 1984, pls. 74–76; and Griffith 1982, pl. 34.

18. Cordry 1980, 138–139. For illustrations of these, see Cordry 1980, pl. 188; Mexican Fine Arts Center 1984, pl. 173; and Griffith 1982, pl. 11.

19. For illustrations, see Cordry 1980, pls. 187, 198, 199, 214, 241, 247, 263, 302, 303; Speer and Parker 1985, pls. 125, 129–132; Mexican Fine Arts Center 1984, pls. 50–51, 86–87; Pérez Rodríguez 1981, 87; Griffith 1982, pls. 14, 28.

20. Cordry 1980, 27.

21. For illustrations, see Cordry 1980, pls. 16, 32; Speer and Parker 1985, pls. 44–47; Pérez Rodríguez 1981, 66, 71, 77, 80, 82, 85–86, 91, 99; Mexican Fine Arts Center 1984, 159, 176–180, 188–197; and Griffith 1982, pl. 26.

22. For illustrations, see Cordry 1980, pls. 20–21, 154; Mexican Fine Arts Center 1984, pl. 178; and Griffith 1982, pls. 5–6.

23. Sepúlveda Herrera 1982, 215–217.

24. Esser 1981b, 87.

25. Yeats, "The Second Coming," lines 1–8.

26. Campbell 1986, 17, 19.

27. This period of Rivera's work, 1913–1917, has been documented in a recent exhibition. The catalog essay by Ramón Favela concludes that "for Rivera, Cubism became an acutely individualized and personalized state of mind that led him on a road to monumental self-discovery from which he later never veered. . . . It was in Cubism . . . that Rivera had discovered the road back to his birthplace, Anáhuac" (1984, 152).

28. Numerous studies of los Tres Grandes and the other artists of this period exist. Two concise, penetrating analyses are to be found in Paz 1959, 25–27, and Tibol 1974.

29. Paz 1979a, 20.

30. Ponce 1967, [36].

31. Kuebler 1987, 142.

32. Bermudez 1974, 34.

33. Genauer 1979, 42.

34. Sturges 1987, 94.

35. Capa 1966, 147.

36. Paz 1959, 34–35.

37. Ibid., 31.

38. Paz 1979a, 23.

39. Ibid., 17.

40. Goldman 1977, 18.

41. Genauer 1979, 40.

42. Sturges 1987, 97.

43. Goldman 1977, 18.

44. Joysmith 1967, 43.

45. Genauer 1974, 21.

46. But Tamayo's complexity is also suggested by the fact, fascinating to note, that a similar slice of watermelon appears in the center of the lower portion of one of Picasso's most powerful explorations of the symbolic dimensions of the female form, *Les Demoiselles d' Avignon*.

47. Ponce 1967, [34–35].

48. Genauer 1974, 76.

49. Traba 1976, 52.

50. Escalante 1980, 62.

51. Whitman, "Song of Myself," 4.

52. Toledo 1974.

53. Kuebler 1987, 144.

54. Conde 1985, 57.

Bibliography

This is a reference bibliography consisting primarily of works cited in the study. Given the scope of the topic, it can be comprehensive only with respect to colonial and modern mask use. In that area, we include all of the relevant ethnographic studies and all of the important exhibition catalogs.

Unless otherwise noted, all English translations of material originally in other languages are our own. The following abbreviations appear in the bibliography:

AA *American Antiquity.*
HMAI *Handbook of Middle American Indians.* Austin: University of Texas Press.
INAH Instituto Nacional de Antropología e Historia.
INI Instituto Nacional Indigenista.
UNAM Universidad Nacional Autónoma de México.

ACOSTA, JORGE R.
 1964 *El Palacio de Quetzalpapálotl.* Memorias del INAH, no. 10. México: INAH.
 1978 *Teotihuacán: Official Guide.* México: INAH.
ACUÑA, RENÉ
 1965 "Ystoria de Moros de Dabid y Amon." *La Palabra y el Hombre* 36: 689–745.
 1975 *Introducción al Estudio del Rabinal Achí.* Centro de Estudios Maya, cuaderno 12. México: UNAM, Instituto de Investigaciones Filológias.
ADAMS, RICHARD E. W.
 1977 *Prehistoric Mesoamerica.* Boston: Little, Brown and Co.
ADÁN, ELFEGO
 1910 "Las Danzas de Coatetelco." *Anales del Museo Nacional de Arqueologica, Historia y Etnografía de México* 3a: 177.
ALEXANDER, HARTLEY BURR
 1964 *Latin American Mythology.* Vol. 11, *The Mythology of All Races.* Louis H. Gray, ed. New York: Cooper Square Publishers. Orig. pub. 1920.

ALTAMIRANO, LEÓN
 1984a "Danza de los Tastoanes." In Altamirano et al. 1984, 95–99. Orig. pub. 1945.
 1984b "Danza de los Concheros." In Altamirano et al. 1984, 107–112. Orig. pub. 1945.
 1984c "Danza de los Moros." In Altamirano et al. 1984, 113–114. Orig. pub. 1945.
ALTAMIRANO, LEÓN, et al.
 1984 *Trajes y Danzas de México.* México: Joaquín Porrúa. Orig. pub. 1945.
ALTMAN, GEORGE J.
 1946 "The Yaqui Easter Play at Guadalupe, Arizona, Part 1." *The Masterkey* 20:181–189.
 1947a "The Yaqui Easter Play at Guadalupe, Arizona, Part 2." *The Masterkey* 21:19–23.
 1947b "The Yaqui Easter Play at Guadalupe, Arizona, Part 3." *The Masterkey* 21:67–72.
AMEZQUITA BORJA, FRANCISCO
 1943 *Música y Danza de la Sierra Norte de Puebla.* México: n.p.
ANAWALT, PATRICIA R.
 1982a "Understanding Aztec Human Sacrifice." *Archaeology* 36:38–45.
 1982b "Analysis of the Aztec Quechquemitl: An Exercise in Inference." In Boone 1982a, 37–72.
ANGUIANO FERNÁNDEZ, MARINA
 1972 "Semana Santa entre los Coras de Jesús María." In Litvak King and Castillo Tejero 1972, 559–565.
ARTES DE MÉXICO
 1969 *Artes de México: Mitos, Ritos y Hechicerias* 124.
AVELEYRA ARROYO DE ANDA, LUIS
 1964 "The Primitive Hunters." *HMAI* 1:384–412.
AVENI, ANTHONY F.
 1975 ed. *Archaeoastronomy in Pre-Columbian America.* Austin: University of Texas Press.
 1980 *Skywatchers of Ancient Mexico.* Austin: University of Texas Press.
BAHM, LINDA, ed.
 1982 *Fiestas of San Juan Nuevo: Ceremonial Art*

from Michoacán, Mexico [Catalog of an Exhibition at the Maxwell Museum of Anthropology, November 15, 1981–September 19, 1982]. Albuquerque: University of New Mexico.

BAKHTIN, MIKHAIL
1968 *Rabelais and His World.* Helene Iswolsky, trans. Cambridge: MIT Press.
1973 *Problems of Dostoevsky's Poetics.* R. W. Rotsel, trans. N.p.: Ardis.

BARKER, GEORGE C.
1953 ed. and trans. *The Shepherd's Play of the Prodigal Son.* University of California, Folklore Studies: 2. Berkeley and Los Angeles: University of California Press.
1957 "The Yaqui Easter Ceremony at Hermosillo." *Western Folklore* 16:256–262.

BARNETT, H. G.
1953 *Innovation: The Basis of Cultural Change.* New York: McGraw Hill.

BASAURI, CARLOS
1940 *La Población Indígena de México: Etnografía.* 3 vols. México: Secretaria de Educación Pública.

BEALS, RALPH L.
1943 *The Aboriginal Culture of the Cahita Indians.* Ibero-Americana 19. Berkeley: University of California Press.
1945a *The Contemporary Culture of the Cahita Indians.* Smithsonian Institution, Bureau of American Ethnology Bulletin no. 142. Washington, D.C.
1945b *Ethnology of the Western Mixe.* University of California Publications in American Archaeology and Ethnology no. 42. Berkeley: University of California Press.
1946 *Cherán: A Sierra Tarascan Village.* Smithsonian Institution, Institute of Social Anthropology, pub. 2. Washington, D.C.
1968 "Notes on Acculturation." In Tax 1968. Orig. pub. 1952.

BENÍTEZ, FERNANDO
1984 Los Indios de México. 5 vols. 4th ed. México: Biblioteca ERA. Orig. pub. 1970.

BENSON, ELIZABETH P.
1968 ed. *Dumbarton Oaks Conference on the Olmec.* Washington, D.C.: Dumbarton Oaks Research Library and Collections.
1970– ed. *The Cult of the Feline.* Washington, D.C.:
1972 Dumbarton Oaks Research Library and Collections.
1975 ed. *Death and the Afterlife in Pre-Columbian America.* Washington, D.C.: Dumbarton Oaks Research Library and Collections.
1981a ed. *The Olmec and Their Neighbors.* Washington, D.C.: Dumbarton Oaks Research Library and Collections.
1981b "Some Olmec Objects in the Robert Woods Bliss Collection at Dumbarton Oaks." In Benson 1981a, 95–108.

BERDAN, FRANCES F.
1987 "The Economics of Aztec Luxury Trade and Tribute." In Boone 1987a, 161–184.

BERISTAIN MÁRQUEZ, EVELIA, et al.
n.d. *Ceremonial de Pascua entre los Indígenas Mayos.* México: FONADAN.

BERLO, JANET C.
1982 "Artistic Specialization at Teotihuacán: The Ceramic Incense Burner." In Alana Cordy-Collins, ed., *Pre-Columbian Art History: Selected Readings.* Palo Alto, Calif.: Peek Publications. 83–100.

BERMÚDEZ, JOSÉ
1974 "A Word with Tamayo." *Americas.* 33–38.

BERNAL, IGNACIO
1965 "Archaeological Synthesis of Oaxaca." *HMAI* 3:788–813.
1969a *The Olmec World.* Doris Heyden and Fernando Horcasitas, trans. Berkeley and Los Angeles: University of California Press.
1969b *Cien Obras Maestras del Museo Nacional de Antropología.* México: José Bolea Editor.

BEST MAUGARD, ADOLFO
1929 "Masks." *Mexican Folkways* 5:122–126.

BEYER, HERMANN
1965a "La Astronomía de los Antiguos Mexicanos." *Mito y Simbología del México Antiguo.* Carmen Cook de Leonard, trans. *El México Antiguo* 10:266–284. Orig. pub. 1910.
1965b "El Idolo Azteca de Alejandro de Humboldt." *Mito y Simbología del México Antiguo.* See Beyer 1965a, 390–401. Orig. pub. 1910.

BODE, BARBARA
1961 *The Dance of the Conquest of Guatemala.* Middle American Research Institute, pub. 27: 203–298. New Orleans: Tulane University.

BONIFAZ NUÑO, RUBÉN
1981 *The Art in the Great Temple, México-Tenochtitlán.* W. Yeomans, trans. México: INAH.

BOONE, ELIZABETH HILL
1982a ed. *The Art and Iconography of Late Post-Classic Central Mexico.* Washington, D.C.: Dumbarton Oaks Research Library and Collections.
1982b ed. *Falsifications and Misreconstructions of Pre-Columbian Art.* Washington, D.C.: Dumbarton Oaks Research Library and Collections.
1987a ed. *The Aztec Templo Mayor.* Washington, D.C.: Dumbarton Oaks Research Library and Collections.
1987b "Templo Mayor Research, 1521–1978." In Boone 1987a, 5–70.

BOOS, FRANK H.
1966 *The Ceramic Sculptures of Ancient Oaxaca.* South Brunswick, N.J.: A. S. Barnes and Co.

BORGES, JORGE LUIS
1984 *Manual de Zoológica Fantástica.* Francisco Toledo, illus. México: Fondo de Cultura Económica. Orig pub. 1957.

BORHEGYI, STEPHAN F. DE
1955 "Pottery Mask Tradition in Mesoamerica." *Southwestern Journal of Anthropology* 11: 205–213.
1965 "Archaeological Synthesis of the Guatemala Highlands." *HMAI* 2:3–58.

BRICKER, VICTORIA R.
1973 *Ritual Humor in Highland Chiapas.* Austin: University of Texas Press.
1981 *The Indian Christ, The Indian King.* Austin: University of Texas Press.

BRODA, JOHANNA

1987a "The Provenience of the Offerings: Tribute and *Cosmovisión*," In Boone 1987a, 211–256.

1987b "Templo Mayor as Ritual Space." In Johanna Broda, Davíd Carrasco, and Eduardo Matos Moctezuma, *The Great Temple of Tenochtitlán: Center and Periphery in the Aztec World.* Berkeley, Los Angeles, London: University of California Press. 61–123.

BROTHERSTON, GORDON

1978 *Image of the New World: The American Continent Portrayed in Native Texts.* London: Thames and Hudson.

BROWN, BETTY ANN

1978 *Máscaras: Dance Masks of Mexico and Guatemala* [Catalog of an Exhibition at the Ewing Museum of Nations, April 21, 1978–December 16, 1978]. Bloomington: University Museums, Illinois State University.

1984 "Mixtec Masking Traditions in Oaxaca." In Ramsey 1984, 59–68.

BRUCE, ROBERT D.

1967 "Jerarquía Maya entre los Dioses Lacandones." *Anales del INAH* 18:93–108.

1975 *Dream Symbolism and Interpretation.* Vol. 1, *Lacandon Dream Symbolism.* México: Ediciones Euroamericanas.

1982 "Introduction." In Victor Perera and Robert D. Bruce, *The Last Lords of Palenque: The Lacandon Mayas of the Mexican Rain Forest.* Boston: Little, Brown and Co. 2–34.

BRUNDAGE, BURR CARTWRIGHT

1982 *The Phoenix of the Western World: Quetzalcóatl and the Sky Religion.* Norman: University of Oklahoma Press.

BUNZEL, RUTH

1952 *Chichicastenango: A Guatemalan Village.* Publications of the American Ethnological Society no. 12. Locust Valley, N.Y.: J. S. Augustin.

BURLAND, C. A.

1968 *The Gods of Mexico.* New York: Capricorn Books.

CALNEK, EDWARD E.

1976 "The Internal Structure of Tenochtitlán." In Wolf 1976, 287–302.

CAMPA, ARTHUR L.

1960 "El Origen y la Naturaleza del Drama Folklórico." *Folklore Américas* 20:13–47.

CAMPBELL, JOSEPH

1959 *The Masks of God: Primitive Mythology.* New York: Viking Press.

1964 ed. *Man and Transformation: Vol. 5, Papers from the Eranos Yearbooks.* Princeton: Princeton University Press.

1968a "The Historical Development of Mythology." In Henry A. Murray, ed., *Myth and Mythmaking.* Boston: Beacon Press. 19–45. Orig. pub. 1959.

1968b *The Masks of God: Creative Mythology.* New York: Viking Press.

1969a *The Flight of the Wild Gander: Explorations in the Mythological Dimension.* New York: Viking Press.

1969b *Where the Two Came to Their Father.* Prince-ton: Princeton University Press. Orig. pub. 1943.

1974 *The Mythic Image.* Princeton: Princeton University Press.

1983 *The Way of the Animal Powers.* Vol. 1, *Historical Atlas of World Mythology.* New York: Alfred van der Marck Editions.

1986 *The Inner Reaches of Outer Space: Metaphor as Myth and as Religion.* New York: Alfred van der Marck Editions.

CAMPOBELLO, NELLIE, and GLORIA CAMPOBELLO

1940 *Ritmos Indígenas de México.* México: Oficina Editora Popular.

CAPA, CORNELL

1966 "Profile: Rufino Tamayo." In Thomas M. Messer and Cornell Capa, *The Emergent Decade: Latin American Painters and Painting in the 1960's* [Prepared under the auspices of Cornell University and the Solomon R. Guggenheim Museum]. 146–153.

CAPPS, WALTER H., ed.

1976 *Seeing with a Native Eye: Essays on Native American Religion.* New York: Harper and Row.

CARDOZA Y ARAGÓN, LUIS

1978 *Günther Gerzo, Carlos Mérida, Rufino Tamayo* [Catalog of an Exhibition at the Palacio de Bellas Artes, México, 1978]. México: Instituto Nacional de Bellas Artes.

CARMICHAEL, ELIZABETH

1970 *Turquoise Mosaics from Mexico.* London: Trustees of the British Museum.

CARRASCO, DAVÍD

1982 *Quetzalcóatl and the Irony of Empire: Myths and Prophecies in the Aztec Tradition.* Chicago: University of Chicago Press.

CARRASCO, PEDRO

1970 "Tarascan Folk Religion, Christian or Pagan?" In Goldschmidt and Hoijer 1970, 3–15.

CARRILLO AZPEITIA, RAFAEL

1971 "Introduction." In Méndez and Yampolsky 1971, 1:9–88.

CASO, ALFONSO

1929 "The Use of Masks among the Ancient Mexicans." *Mexican Folkways* 5:111–113.

1934 "Máscaras Mexicanas." *MAPA*, November: 39–40, 53.

1942 "El Paraíso Terrenal en Teotihuacán." *Cuadernos Americanos* 6:127–136.

1958 *The Aztecs: People of the Sun.* Lowell Dunham, trans. Norman: University of Oklahoma Press.

1965a "Zapotec Writing and Calendar." *HMAI* 3: 931–947.

1965b "Lapidary Work, Goldwork, and Copperwork from Oaxaca." *HMAI* 3:896–930.

1965c "Mixtec Writing and Calendar." *HMAI* 3:948–961.

1970 "The Lords of Yanhuitlan." In Paddock 1970a, 313–335.

1971 "Calendrical Systems of Central Mexico." *HMAI* 10:333–348.

CASO, ALFONSO, and IGNACIO BERNAL

1952 *Urnas de Oaxaca.* Memorias del INAH, no. 2. México: INAH.

1965 "Ceramics of Oaxaca." *HMAI* 3:871–895.

CASTILLO ROMERO, PEDRO
1979 *Calendario Folklórico de la Fiestas en Nayarit.* N.p.: Editorial del Magisterio "Benito Juárez."

CASTRO RUIZ, MIGUEL
1950 "Las Máscaras de Michoacán." *Mundo Hispánico* 3, 23:28–32.

Centro de Investigación y Servicios Museológicos (cited as "Centro" in notes)
1981 *Máscaras* [Catalog of an Exhibition at the Museo Universitario de Ciencias y Arte]. México: UNAM.

CHRISTENSEN, BODIL
1937 "The Acatlaxqui Dance of Mexico." *Ethnos* 2: 133–136.

CLANCY, FLORA S., et al.
1985 *Maya: Treasures of an Ancient Civilization.* New York: Harry N. Abrams, Inc., and the Albuquerque Museum.

CLEWLOW, CARL WILLIAM, JR.
1970 "A Comparison of Two Unusual Olmec Monuments." Contributions of the University of California Archaeological Research Facility, no. 8. Berkeley: University of California Department of Anthropology. 35–40.
1974 *A Stylistic and Chronological Study of Olmec Monumental Sculpture.* Contributions of the University of California Archaeological Research Facility, no. 19. Berkeley: University of California Department of Anthropology.

CODEX BORBONICUS
1979 México: Siglo Veintiuno. Facsimile.

CODEX BORGIA
1963 México: Fondo de Cultura Económica. Facsimile.

CODEX DRESDEN
1972 In J. E. S. Thompson 1972*a*.

CODEX MAGLIABECHIANO
1983 Berkeley, Los Angeles, London: University of California Press. Facsimile.

COE, MICHAEL D.
1965*a* "Archaeological Synthesis of Southern Veracruz and Tabasco." *HMAI* 3:679–715.
1965*b* *The Jaguar's Children: Pre-Classic Central Mexico.* New York: Museum of Primitive Art.
1965*c* "The Olmec Style and its Distributions." *HMAI* 3:739–775.
1973 "The Iconology of Olmec Art." In Metropolitan Museum of Art 1973, 1–12.
1975*a* "Death and the Ancient Maya." In Benson 1975, 87–105.
1975*b* "Native Astronomy in Mesoamerica." In Aveni 1975, 3–32.
1975*c* "Death and the Afterlife in Pre-Columbian America: Closing Remarks." In Benson 1975, 191–196.
1976 "Early Steps in the Evolution of Maya Writing." In H. Nicholson 1976*a*, 107–121.
1977 *Mexico.* Rev. ed. New York: Praeger Publishers.
1978 *Lords of the Underworld: Masterpieces of Classic Maya Ceramics* [Catalog of an Exhibition at the Art Museum, Princeton University,

March 4–June 8, 1978]. Princeton: Princeton University Press.
1980 *The Maya.* Rev. ed. London: Thames and Hudson.
1982 *Old Gods and Young Heroes: The Pearlman Collection of Maya Ceramics* [Catalog of an Exhibition at the Israel Museum, Spring 1982]. Jerusalem: American Friends of the Israel Museum.

COE, MICHAEL D., and RICHARD A. DIEHL
1980*a* *The Archaeology of San Lorenzo Teotihuacán.* Vol. 1, *In the Land of the Olmec.* Austin: University of Texas Press.
1980*b* *The People of the River.* Vol. 2, *In the Land of the Olmec.* Austin: University of Texas Press.

COGGINS, CLEMENCY C.
1979 "A New Order and the Rule of the Calendar: Some Characteristics of the Middle Classic Period at Tikal." In Hammond and Willey 1979, 38–50.
1980 "The Shape of Time: Some Political Implications of a Four-Part Figure." *AA* 45:727–739.

COLBY, BENJAMIN N.
1976 "The Anomalous Ixil: Bypassed by the Post-Classic?" *AA* 41:74–77.

COLE, M. R.
1907 *Los Pastores: A Mexican Play of the Nativity.* Memoirs of the American Folklore Society, vol. 9. Boston: Houghton, Mifflin.

COOK, GARRETT
1986 "Quichean Folk Theology and Southern Maya Supernaturalism." In Gossen 1986, 139–153.

CORDRY, DONALD B.
1973 *Mexican Masks* [Catalog of an Exhibition Organized by the Amon Carter Museum, January 1974–March 1975]. Fort Worth.
1980 *Mexican Masks.* Austin: University of Texas Press.

CORDRY, DONALD B., and DOROTHY M. CORDRY
1940 *Costumes and Textiles of the Aztec Indians of the Cuetzalan Region, Puebla, Mexico.* Southwest Museum Papers, no. 14. Los Angeles.

CORNEJO FRANCO, JOSÉ
1943 "La Danza de la Conquista en Juchitlan, Jalisco." *Anuario de la Sociedad Folklórica de México* 4:155–186.

CORREA, GUSTAVO
1958 *Texto de un Baile de Diablos.* Middle American Research Institute, pub. 27:97–104. New Orleans: Tulane University.

COSS, JULIO ANTONIO
N.d. *Fiestas Tradicionales del Istmo de Tehuantepec.* México: FONADAN.

COVARRUBIAS, LUIS
N.d. *Mexican Native Dances.* México: Eugenio Fischgrund.

COVARRUBIAS, MIGUEL
1929 "Notes on Mexican Masks." William Spratling, trans. *Mexican Folkways* 5:114–117.
1944 "La Venta: Colossal Heads and Jaguar Gods." *DYN* 6:24–33.
1945 "Exposición de Máscaras Mexicanas." *Intercambio*, March: 24–25, 44–48, 50, 52.

1946 "El Arte 'Olmeca' o de La Venta." *Cuadernos Americanos* 28:153–179.

1947 *Mexico South: The Isthmus of Tehuantepec.* New York: Alfred A. Knopf.

1957 *Indian Art of Mexico and Central America.* New York: Alfred A. Knopf.

CROCKER, J. C.

1982 "Ceremonial Masks." In V. Turner 1982, 77–88.

CRUMRINE, N. ROSS

1969 "Căpakoba, The Mayo Easter Ceremonial Impersonator: Explanations of Ritual Clowning." *Journal for the Scientific Study of Religion* 8:1–22.

1974 "Anomalous Figures and Liminal Roles: A Reconsideration of the Mayo Indian Căpakoba, Northwest Mexico." *Anthropos* 69:858–873.

1977 *The Mayo Indians of Sonora: A People Who Refuse to Die.* Tucson: University of Arizona Press.

1979 ed. *Ritual Symbolism and Ceremonialism in the Americas: Studies in Symbolic Anthropology.* Greeley, Colo.

1983a "Mask Use and Meaning in Easter Ceremonialism: The Mayo Parisero." In Crumrine and Halpin 1983, 92–100.

1983b "Symbolic Structure and Ritual Symbolism in Northwest and West Mexico." In Kendall, Hawkins, and Bossen 1983, 247–266.

CRUMRINE, N. ROSS, and MARJORIE HALPIN, eds.

1983 *The Power of Symbols: Masks and Masquerade in the Americas.* Vancouver: University of British Columbia Press.

DAVIES, NIGEL

1977 *The Toltecs until the Fall of Tula.* Norman: University of Oklahoma Press.

DAVIS, WHITNEY

1978 "So-Called Jaguar-Human Copulation Scenes in Olmec Art." *AA* 43:453–457.

DAY, HOLLIDAY T., and HOLLISTER STURGES

1987 *Art of the Fantastic: Latin America, 1920–1987* [Catalog of an Exhibition at the Indianapolis Museum of Art, June 28, 1987–September 13, 1987]. Indianapolis: Indianapolis Museum of Art.

DE LA FUENTE, BEATRIZ

1972 "La Escultura Olmeca como Expresión Religiosa." In Litvak King and Castillo Tejero 1972, 79–84.

1981 "Toward a Conception of Monumental Olmec Art." In Benson 1981a, 83–94.

1982 ed. *Historia del Arte Mexicano: Arte Prehispánico.* México: Salvat Mexicana de Ediciones y Consejo Nacional de Fomento Educativo.

DEL CONDE, TERESA

1985 "Mexico: The New Generations." Rilda L. Baker, trans. In *Mexico: The New Generations* [Catalog of an Exhibition at the San Antonio Museum of Art, September 27–November 17, 1985]. Nancy L. Kelker, ed. San Antonio. 16–21.

DE SANTILLANA, GIORGIO, and HERTHA VON DECHEND

1977 *Hamlet's Mill: An Essay in Myth and the Frame of Time.* Boston: David R. Godine.

D'HARNONCOURT, RENÉ

1929 "Masks at Ten Cents." *Mexican Folkways* 5:118–121.

DÍAZ DEL CASTILLO, BERNAL

1956 *The Discovery and Conquest of Mexico, 1517–1521.* Genaro García, ed. A. P. Maudslay, trans. N.p.: Farrar, Strauss and Cudahy.

DIEHL, RICHARD A.

1976 "Pre-Hispanic Relations between the Basin of Mexico and North and West Mexico." In Wolf 1976, 249–286.

1981a "Olmec Architecture: A Comparison of San Lorenzo and La Venta." In Benson 1981a, 65–82.

1981b "Tula." *HMAI.* Supplement 1:277–295.

1983 *Tula: The Toltec Capital of Ancient Mexico.* London: Thames and Hudson.

DOCKSTADER, FREDERICK J.

N.d. *Mexican Masks.* Exhibit Leaflet No. 7, Museum of the American Indian. New York.

DOMÍNGUEZ, FRANCISCO

1962a "Investigación en Jilotepec, Méx., Febrero de 1931." In Samper 1962–1964, 1:11–22.

1962b "Investigación en Chalma, Méx., Febrero y Mayo de 1931." In Samper 1962–1964, 1:23–64.

1962c "Musica Yaqui Recogida en la Ciudad de México, en 1931." In Samper 1962–1964, 1:65–84.

1962d "Investigación en Tepoztlán, Mor., Febrero de 1933." In Samper 1962–1964, 1:85–98.

1962e "Investigación en Huixquilucán, Méx., Marzo de 1933." In Samper 1962–1964, 1:99–112.

1962f "Investigación en las Regiones de los Yaquis, Seris y Mayos, Estado de Sonora, Abril y Mayo de 1933." In Samper 1962–1964, 1:113–226.

1962g "Investigación en San Juan de los Lagos, Jal., Febrero de 1934." In Samper 1962–1964, 1:227–258.

1962h "Investigación en San Pedro Tlachichilco, Hgo., Julio de 1934." In Samper 1962–1964, 1:319–334.

1962i "Investigación en Tepoztlán, Mor., Septiembre de 1937." In Samper 1962–1964, 1:335–350.

DOTY, WILLIAM G.

1986 *Mythography: The Study of Myths and Rituals.* University: University of Alabama Press.

DOW, JAMES W.

1974 *Santos y Supervivencias: Funciones de la Religión en una Comunidad Otomí, México.* Antonieta S. M. de Hope, trans. México: INI.

1986 *The Shaman's Touch: Otomí Indian Symbolic Healing.* Salt Lake City: University of Utah Press.

DRENNAN, ROBERT D.

1976 "Religion and Social Evolution in Formative Mesoamerica." In Flannery 1976b, 345–368.

1983a "Ritual and Ceremonial Development at the Hunter-Gatherer Level." In Flannery and Marcus 1983a, 30–32.

1983b "Ritual and Ceremonial Development at the Early Village Level." In Flannery and Marcus 1983a, 46–50.

DRENNAN, ROBERT D., and KENT V. FLANNERY
1983 "The Growth of Site Hierarchies in the Valley of Oaxaca, Part II." In Flannery and Marcus 1983a, 65–71.

DRUCKER, PHILIP
1952 La Venta, Tabasco: A Study of Olmec Ceramics and Art. Smithsonian Institution, Bureau of American Ethnology Bulletin no. 153. Washington, D.C.
1981 "On the Nature of Olmec Polity." In Benson 1981a, 29–48.

DRUCKER, PHILIP, ROBERT F. HEIZER, and ROBERT J. SQUIER
1959 Excavations at La Venta, Tabasco, 1955. Smithsonian Institution, Bureau of American Ethnology Bulletin no. 170. Washington, D.C.

DURÁN, DIEGO
1964 The Aztecs: The History of the Indies of New Spain. Doris Heyden and Fernando Horcasitas, trans. New York: Orion Press.
1971 Book of the Gods and Rites and The Ancient Calendar. Fernando Horcasitas and Doris Heyden, trans. and eds. Norman: University of Oklahoma Press.

EASBY, ELIZABETH K., and JOHN F. SCOTT
1970 Before Cortés: Sculpture of Middle America. New York: Metropolitan Museum of Art.

EDMONSON, MUNRO S.
1971 The Book of Counsel: The Popol Vuh of the Quiché Maya of Guatemala. Middle American Research Institute, pub. 35. New Orleans: Tulane University.
1974 ed. Sixteenth-Century Mexico: The Work of Sahagún. Albuquerque: University of New Mexico Press.

ELIADE, MIRCEA
1957 The Sacred and the Profane: The Nature of Religion. Willard R. Trask, trans. New York: Harper and Row.
1959 Cosmos and History: The Myth of the Eternal Return. Willard R. Trask, trans. New York: Harper and Row.
1961 Images and Symbols: Studies in Religious Symbolism. Philip Mairet, trans. Kansas City: Sheed Andrews and McMeel, Inc.
1963 Patterns in Comparative Religion. Rosemary Sheed, trans. Cleveland: World Publishing Co.
1964a Shamanism: Archaic Techniques of Ecstasy. Willard R. Trask, trans. Princeton: Princeton University Press.
1964b "Mystery and Spiritual Regeneration in Extra-European Religions." In Campbell 1964, 3–36.
1975 Myths, Rites, Symbols: A Mircea Eliade Reader. 2 vols. Wendell C. Beane and William G. Doty, eds. New York: Harper and Row.
1976 Occultism, Witchcraft, and Cultural Fashions: Essays in Comparative Religions. Chicago: University of Chicago Press.

ENGLEKIRK, JOHN E.
1957 "El Teatro Folklórico Hispánoamericano." Folklore Américas 17:1–33.

ESCALANTE, EVODIO
1980 Review of Francisco Toledo exhibition, Museo de Arte Moderno, México. Artes Visuales 25:59, 62.

ESPEJEL, CARLOS
1978 Mexican Folk Crafts. Barcelona: Editorial Blume.

ESPEJO, A.
1955 "La Danza 'Los Tecuanes' en Acatlan." Anuario de la Sociedad Folklórica de México 9: 117–128.

ESSER, JANET B.
1976 "The Hortelanos: A Buffoon's Dance of Uruapan, Michoacán." Actas del XLI Congreso Internacional de Americanistas 3:224–229.
1979a "Masks of Women from Michoacán." The Masterkey 53:94–101.
1979b "Hortelanos: An Investigation into a Masking Tradition in a Changing Society." The Fabrics of Culture. 267–294.
1981a Faces of Fiesta: Mexican Masks in Context [Catalog of an Exhibition at the University Gallery, San Diego State University and the Galería de la Ciudad de Mexicali, October 24–December 14, 1981]. San Diego: San Diego State University.
1981b Review of Donald Cordry, Mexican Masks (1980). African Arts 14:86–87.
1982 "Fools, Drunks, and Chichimecs: Ugly Masks of the Tarascans of Michoacán." Continuity and Change in Latin America: Proceedings of the Pacific Coast Council of Latin American Studies 9:114–128.
1984a Máscaras Ceremoniales de los Tarascos de la Sierra de Michoacán. Martha Hernández Laris, trans. México: INI.
1984b "The Functions of Folk Art in Michoacán." In Ramsey 1984, 40–50.

EVERS, LARRY, and FELIPE S. MOLINA
1987 Yaqui Deer Songs—Maso Bwikam: A Native American Poetry. Tucson: Sun Tracks and University of Arizona Press.

FACIO, SARA, MARÍA CRISTINA ORIVE, and MIGUEL ANGEL ASTURIAS
1980 Actos de Fe en Guatemala. Buenos Aires: La Azotea Editorial Fotográfica de América Latin.

FALASSI, ALESSANDRO, ed.
1987 Time out of Time: Essays on the Festival. Albuquerque: University of New Mexico Press.

FAVELA, RAMÓN
1984 "Diego Rivera: The Cubist Years, 1913–1917." in Diego Rivera: The Cubist Years [Catalog of an Exhibition Organized by the Phoenix Art Museum, March 10, 1984–February 11, 1985]. James K. Ballinger, org. Phoenix. 1–168.

FERGUSSON, ERNA
1942 Fiesta in Mexico. New York: Alfred A. Knopf.

FERNÁNDEZ, JUSTINO
1959 Coatlicue: Estética del Arte Indígena Antiguo. 2d ed. México: Instituto de Investigaciones Estéticas, UNAM.
1969 A Guide to Mexican Art. Joshua C. Taylor, trans. Chicago: University of Chicago Press.
N.d. Mexican Folklore: 100 Photographs by Luis Marquez. México: Eugenio Fischgrund.

FERNÁNDEZ, JUSTINO, and VICENTE T. MENDOZA
1941 Danza de los Concheros en San Miguel Allende. México: Fondo de Cultura Económica.

FLANET, VÉRONIQUE
1977 *Viviré, Si Dios Quiere: Un Estudio de la Violencia en la Mixteca de la Costa.* Tununa Mercado, trans. México: INI.

FLANNERY, KENT V.
1976a "Contextual Analysis of Ritual Paraphernalia from Formative Oaxaca." In Flannery 1976b, 333–345.

1976b ed. *The Early Mesoamerican Village.* New York: Academic Press.

1983a "The Legacy of the Early Urban Period: An Ethnohistoric Approach to Monte Albán's Temples, Residences, and Royal Tombs." In Flannery and Marcus 1983a, 132–136.

1983b "Major Monte Albán V Sites: Zaachila, Xoxocotlán, Cuilapan, Yagul, and Abasolo." In Flannery and Marcus 1983a, 290–295.

FLANNERY, KENT V., and JOYCE MARCUS
1976 "Evolution of the Public Building in Formative Oaxaca." In Charles B. Cleland, ed. *Cultural Change and Continuity: Essays in Honor of James Bennett Griffin.* New York: Academic Press. 205–221.

1983a eds. *The Cloud People: Divergent Evolution of the Zapotec and Mixtec Civilizations.* New York: Academic Press.

1983b "The Earliest Public Buildings, Tombs, and Monuments of Monte Albán, with Notes on the Internal Chronology of Period I." In Flannery and Marcus 1983a, 87–91.

1983c "Monte Albán and Teotihuacán: Editor's Introduction." In Flannery and Marcus 1983a, 161–166.

1983d "The Rosario Phase and the Origins of Monte Albán I." In Flannery and Marcus 1983a, 74–77.

FLANNERY, KENT V., JOYCE MARCUS, and STEPHEN A. KOWALEWSKI
1981 "The Preceramic and Formative of the Valley of Oaxaca." *HMAI.* Supplement 1:48–93.

FONADAN
1975 *La Danza del Tecuan.* México: FONADAN.
N.d. *Danzas Fundamentales de Jalisco, Memorias del Dr. Francisco Sánchez Flores.* México: FONADAN.

FONAPAS-INI
N.d. *50 Encuentros de Música y Danza Indígena.* N.p.

FONTANA, BERNARD L., EDMOND J. B. FAUBERT, and BARNEY T. BURNS
1977 *The Other Southwest: Indian Arts and Crafts of Northwestern Mexico* [Prepared in Coordination with an Exhibition by the Heard Museum, May 20–August 27, 1977]. Phoenix.

FOSTER, GEORGE M.
1944 "Nagualism in Mexico and Guatemala." *Acta Americana* 2:85–103.

1948 *Empire's Children: The People of Tzintzuntzan.* Smithsonian Institution, Institute of Social Anthropology Publication 6. Washington, D. C.

1960 *Culture and Conquest: America's Spanish Heritage.* Viking Fund Publications in Anthropology, no. 27. Chicago: Quadrangle Books.

FREIDEL, DAVID, et al.
1982 "The Maya City of Cerros." *Archaeology* 35:12–21.

FRIEDLANDER, JUDITH
1975 *Being Indian in Hueyapan: A Study of Forced Identity in Modern Mexico.* New York: St. Martin's Press.

FRIGERIO, COCOA
1982 "Mexican Masks." *Domus* 625:57–59.

FROST, GORDON
1976 *Guatemalan Mask Imagery.* Los Angeles: Southwest Museum.

FURST, JILL LESLIE
1978 *Codex Vindobonensis Mexicanus I: A Commentary.* Institute for Mesoamerican Studies, pub. 4. Albany: State University of New York at Albany.

1982 "Skeletonization in Mixtec Art: A Re-evaluation." In Boone 1982a, 207–225.

FURST, JILL LESLIE, and PETER T. FURST
1980 *Pre-Columbian Art of Mexico.* New York: Abbeville Press.

FURST, PETER T.
1965 "West Mexican Tomb Sculpture as Evidence for Shamanism in Prehispanic Mexico." *Antropologica* 15:29–80.

1968 "The Olmec Were-Jaguar Motif in the Light of Ethnographic Reality." In Benson 1968, 143–178.

1973 "West Mexican Art: Secular or Sacred?" In Metropolitan Museum of Art 1973, 98–133.

1976a "Shamanistic Survivals in Mesoamerican Religion." *Actas del XLI Congreso Internacional de Americanistas* 3:149–157.

1976b *Hallucinogens and Culture.* San Francisco: Chandler and Sharp.

1977 "The Roots and Continuities of Shamanism." In Anne T. Brodsky, Rose Danesewich, and Nick Johnson, eds. *Stones, Bones and Skin: Ritual and Shamanic Art.* Toronto: Society for Art Publications. 1–28.

1980 "Donald Cordry (1907–1978): Foreword." In Cordry 1980, ix–xx.

1981 "Jaguar Baby or Toad Mother: A New Look at an Old Problem in Olmec Iconography." In Benson 1981a, 149–162.

1986 "Human Biology and the Origin of the 260-Day Sacred Almanac: The Contribution of Leonhard Schultze Jena (1872–1955)." In Gossen 1986, 69–76.

GALLOP, RODNEY
1938 "Masks of Indian Mexico." *Apollo* 28 (164):57–60.

GARCÍA-BARCENA, JOAQUÍN
1972 "Origen y Desarrollo de Algunos Aspectos de las Representaciones de los Dioses Mesoamericanos de la Lluvia y su Relación con las Rutas de Intercambio Prehispánicas." In Litvak King and Castillo Tejero 1972, 151–160.

GARCÍA-NORIEGA Y NIETO, LUCÍA, ed.
1987 *Miguel Covarrubias: Homenaje.* México: Centro Cultural Arte Contemporáneo y Editorial MOP.

GAY, CARLO T. E.
 1972 *Chalcacingo*. Portland, Ore.: International Scholarly Book Services.
GEERTZ, CLIFFORD
 1979 "Religion as a Cultural System." In Lessa and Vogt 1979, 78–89. Orig. pub. 1965.
 1983 *Local Knowledge: Further Essays in Interpretive Anthropology*. New York: Basic Books.
GENAUER, EMILY
 1974 *Rufino Tamayo*. New York: Harry N. Abrams.
 1979 "Rufino Tamayo." *Horizon* 22:38–47.
GENDROP, PAUL
 1982 "Arquitectura Maya." In de la Fuente 1982, fascículo 6–9:112–177.
GENIN, ALEXIS M. A.
 1920 "Notes on Dances, Music, and Songs of the Ancient and Modern Mexicans." *Annual Report of the Board of Regents of the Smithsonian Institution for the Year Ending June 30, 1920*. Washington, D.C. 657–677.
GIBSON, CHARLES
 1964 *The Aztecs under Spanish Rule: A History of the Valley of Mexico, 1519–1810*. Palo Alto: Stanford University Press.
GILL, SAM D.
 1976 "The Shadow of a Vision Yonder." In Capps 1976, 44–58.
GILLMOR, FRANCES
 1942 "Spanish Texts of Three Dance Dramas from Mexican Villages." *University of Arizona Bulletin* 13, 4; *Humanities Bulletin*, no. 4. Tucson.
 1943a "The Dance Dramas of Mexican Villages." *University of Arizona Bulletin* 14, 2; *Humanities Bulletin*, no. 5. Tucson.
 1943b *Three Dances from Mexican Villages*. Tucson: University of Arizona Press.
 1957 "*Los Pastores* Number: Folk Plays of Hispanic America—Foreword." *Western Folklore* 16:229–231.
 1983 "Symbolic Representation in Mexican Combat Plays." In Crumrine and Halpin 1983, 102–110.
GIMBUTAS, MARIJA
 1974 "The Mask in Old Europe from 6500 to 3500 B.C." *Archaeology* 27:262–269.
 1982 *The Goddesses and Gods of Old Europe: 6500–3500 B.C. Myths and Cult Images*. Berkeley, Los Angeles, London: University of California Press.
GINGERICH, WILLARD
 1987 "Heidegger and the Aztecs: The Poetics of Knowing in Pre-Hispanic Náhuatl Poetry." In Swann and Krupat 1987, 85–112.
GLOTZ, SAMUEL, ed.
 1975 *Le Masque dans la Tradition Européenne* [Catalog of an Exhibition at the Musée International du Carnaval et du Masque, June 13–October 6, 1975]. Binche, Belgium.
GOLDMAN, SHIFRA M.
 1977 *Contemporary Mexican Painting in a Time of Change*. Austin: University of Texas Press.
GOLDSCHMIDT, WALTER, and HARRY HOIJER, eds.
 1970 *The Social Anthropology of Latin America: Essays in Honor of Ralph Leon Beals*. Los Angeles: Latin American Center, University of California, Los Angeles.
GOLDWATER, ROBERT
 1947 *Rufino Tamayo*. New York: Quadrangle Press.
GONZÁLEZ, CARLOS
 1925 "The Dance of the Sonajas or of the Señor." *Mexican Folkways* 1:13–15.
 1928 "The Dance of the Moors." *Mexican Folkways* 4:31–36.
GONZÁLEZ GONZÁLEZ, CARLOS JAVIER
 1987 "Mezcala Style Anthropomorphic Artifacts in the Templo Mayor." In Boone 1987a, 145–160.
GONZÁLEZ RAMOS, GILDARDO
 1972 *Los Coras*. México: INI.
GOSSEN, GARY H.
 1974 *Chamulas in the World of the Sun: Time and Space in a Maya Oral Tradition*. Cambridge: Harvard University Press.
 1979 "Temporal and Spatial Equivalents in Chamula Ritual Symbolism." In Lessa and Vogt 1979, 116–129.
 1986 ed. *Symbol and Meaning Beyond the Closed Community: Essays in Mesoamerican Ideas*. Studies on Culture and Society, vol. 1. Albany: Institute for Mesoamerican Studies, University at Albany, State University of New York.
GRAU, J.
 1978 *Acapulco, Guerrero State, and Its Coastline*. México: Editorial Grijalbo.
GREENBERG, JAMES B.
 1981 *Santiago's Sword: Chatino Peasant Religion and Economics*. Berkeley, Los Angeles, London: University of California Press.
GREIDER, TERENCE
 1982 *The Origins of Pre-Columbian Art*. Austin: University of Texas Press.
GRIFFIN, GILLETT C.
 1981 "Olmec Forms and Materials Found in Central Guerrero." In Benson 1981a, 209–222.
GRIFFITH, JAMES S.
 1967a *Legacy of Conquest: The Arts of Northwest Mexico*. Colorado Springs: Taylor Museum of the Colorado Springs Fine Arts Center.
 1967b "Mochicahui Judio Masks: A Type of Mayo Fariseo Mask from Northern Sinaloa, Mexico." *The Kiva* 32:143–149.
 1972 "Cahitan Pascola Masks." *The Kiva* 37:185–198.
 1982 *Mexican Masks from the Cordry Collection*. Tucson: Arizona State Museum, University of Arizona.
GRIFFITH, JAMES S., and FELIPE S. MOLINA
 1980 *Old Men of the Fiesta: An Introduction to the Pascola Arts* [Prepared in Coordination with an Exhibition by the Heard Museum, April 12–August15, 1980]. Phoenix.
GRIMES, JOSEPH E., and THOMAS B. HINTON
 1969 "The Huichol and Cora." *HMAI* 8:792–813.
GROVE, DAVID C.
 1970 *The Olmec Paintings of Oxtotitlán Cave, Guerrero, Mexico*. Studies in Pre-Columbian Art and Archaeology, no. 6. Washington, D.C.: Dumbarton Oaks.

1972 "Preclassic Beliefs in Mexico's Altiplano Central." In Litvak King and Castillo Tejero 1972, 55–59.

1973 "Olmec Altars and Myths." *Archaeology* 26: 128–135.

1981 "Olmec Monuments: Mutilation as a Clue to Meaning." In Benson 1981a, 49–68.

1984 *Chalcatzingo: Excavations on the Olmec Frontier.* London: Thames and Hudson.

GROVE, DAVID C., and SUSAN D. GILLESPIE
1984 "Chalcatzingo's Portrait Figurines and the Cult of the Ruler." *Archaeology* 37:27–33.

GUDEMAN, STEPHEN
1976 "Saints, Symbols, and Ceremonies." *American Ethnologist* 709–729.

GUERRERO, RAÚL G.
1947 "Danzas Mexicanas." *Anales del INAH* 2: 259–278.

1984a "Danza del Tigre." In Altamirano et al. 1984, 116–119. Orig. pub. 1945.

1984b "Danza de los Tlacololeros." In Altamirano et al. 1984, 125–126. Orig. pub. 1945.

GUTIÉRREZ SOLANA, NELLY
1982 "Escultura Huasteca: Periodo Clásico y Posclásico." In de la Fuente 1982, fascículo 16–17:116–121.

GUZMAN ANLEU, MARIO A.
1965 "Danzas de Guatemala." *Folklore de Guatemala* 1:17–30.

GYLES, ANNA BENSON, and CHLOE SAYER
1980 *Of Gods and Men: The Heritage of Ancient Mexico.* New York: Harper and Row.

HALIFAX, JOAN
1979 *Shamanic Voices: A Survey of Visionary Narratives.* New York: E. P. Dutton.

HALPIN, MARJORIE
1979 "Confronting Looking-Glass Men: A Preliminary Examination of the Mask." In Crumrine 1979, 41–61.

1983 "The Mask of Tradition." In Crumrine and Halpin 1983, 219–226.

HAMMOND, NORMAN
1982 *Ancient Maya Civilization.* New Brunswick: Rutgers University Press.

HAMMOND, NORMAN, and GORDON R. WILLEY, eds.
1979 *Maya Archaeology and Ethnohistory.* Austin: University of Texas Press.

HANDELMAN, DON
1981 "The Ritual Clown: Attributes and Affinities." *Anthropos* 76:321–370.

HARVEY, H. R.
1971 "Ethnohistory of Guerrero." *HMAI* 11:603–618.

HELLER, LISA LETHIN
1983 "Dance Dramas of the Mexican Highlands." *A Report from the San Francisco Crafts and Folk Art Museum.* Fall: 1–4.

HENDERSON, JOHN S.
1981 *The World of the Ancient Maya.* Ithaca: Cornell University Press.

HERNÁNDEZ, JOANNE F.
1981 "Mexican Indian Dance Masks." *African Arts* 14, 3:81–82.

HESSE, HERMANN
1970 *Magister Ludi* (The Glass Bead Game). Richard and Clara Winston, trans. New York: Bantam Books.

HEYDEN, DORIS
1975 "An Interpretation of the Cave Underneath the Pyramid of the Sun in Teotihuacán, Mexico." *AA* 40:131–147.

1976 "Los Ritos de Paso en las Cuevas." *Boletín INAH* 19:17–26.

1987 "Symbolism of Ceramics from the Templo Mayor." In Boone 1987a, 109–130.

HIGHWATER, JAMAKE
1981 *The Primal Mind: Vision and Reality in Indian America.* New York: Harper and Row.

HINTON, THOMAS B.
1970 "Indian Acculturation in Nayarit: The Cora Response to Mestoization." In Goldschmidt and Hoijer 1970, 16–35.

1971 "An Analysis of Religious Syncretism among the Cora of Nayarit." *Verhandlung des XXXVIII Internationalen Amerikanistenkongresses* 3:275–280.

HOLLAND, WILLIAM R.
1964 "Contemporary Tzotzil Cosmological Concepts as a Basis for Interpreting Prehistoric Maya Civilization." *XXXV Congreso Internacional de Americanistas, Actas y Memorias* 2:13–22.

HORCASITAS, FERNANDO
1971a "Feats of Gods and Heroes." In Méndez and Yampolsky 1971, 2:453–480.

1971b "The Noble *Tigre* Continues to Die." In Méndez and Yampolsky 1971, 2:583–614.

1979 *The Aztecs Then and Now.* México: Editorial Minutiae Mexicana.

1980 "La Danza de los Tecuanes." Estudios de Cultura Náhuatl 14:239–286, 15:313–317.

HORCASITAS, FERNANDO, and DORIS HEYDEN
1971 "Fray Diego Durán: His Life and Works." In Durán 1971, 3–47.

HULTKRANZ, AKE
1979 *The Religions of the American Indians.* Monica Setterwall, trans. Berkeley, Los Angeles, London: University of California Press.

HUNT, EVA
1977 *The Transformation of the Hummingbird: Cultural Roots of a Zinacantecan Mythical Poem.* Ithaca: Cornell University Press.

HUXLEY, FRANCIS
1974 *The Way of the Sacred.* London: Aldus Books.

HVIDTFELDT, ARILD
1958 *Teotl and Ixiptlatli: Some Central Conceptions in Ancient Mexican Religion.* Niels Haislund, trans. Copenhagen: Munksgaard.

ICHON, ALAIN
1973 *La Religión de los Totonacas de la Sierra.* José Arenas, trans. México: INI.

INGHAM, JOHN M.
1986 *Mary, Michael, and Lucifer: Folk Catholicism in Central Mexico.* Austin: University of Texas Press.

INSTITUTO GUERRERENSE DE LA CULTURA
1987 *Calendario de Fiestas del Estado de Guerrero.* Chilpancingo, Guerrero.

ISLAS GARCÍA, LUIS
1950 "Trayectoria de las Máscaras Mexicanas." *Mundo Hispánico* 3, 23:28–32.

JÄCKLEIN, KLAUS
1974 *Un Pueblo Popolaca*. María Martínez Peñalosa, trans. México: INI.

JACOBSEN, THORKILD
1976 *The Treasures of Darkness: A History of Mesopotamian Religion*. New Haven: Yale University Press.

JIMÉNEZ, GUILLERMO
1941 "The Dance in Mexico." *Bulletin of the Pan-American Union* 65:317–324.

JIMÉNEZ MORENO, WIGBERTO
1945 "Introducción." *Guia Arqueológica de Tula*. México: INAH.
1966 "Mesoamerica before the Toltecs." Maudie Bullington and Charles R. Wicke, trans. In Paddock 1970a, 3–82.
1979 "De Tezcatlipoca a Huitzilopochtli." *Actes du XLIIe Congrès International des Américanistes* 6:27–34.

JONAITIS, ALDONA
1981 "Transformation and Dualism." *Latin American Literature and Arts Review* 28:49–52.

JONES, GRANT D., ed.
1977 *Anthropology and History in Yucatán*. Austin: University of Texas Press.

JORALEMON, PETER D.
1971 *A Study of Olmec Iconography*. Studies in Pre-Columbian Art and Archaeology, no. 7. Washington, D.C.: Dumbarton Oaks.
1974 "Ritual Blood-Sacrifice among the Ancient Maya." In M. Robertson 1974, 2:59–76.
1976 "The Olmec Dragon: A Study in Pre-Columbian Iconography." In H. Nicholson 1976a, 27–72.

JOYSMITH, TOBY
1967 "Two Magic Worlds of Rufino Tamayo." *Artist's Proof: The Annual of Contemporary Prints*. 7:40–43. Orig. pub. 1966.

KANDT, VERA B.
1972a "Fiesta in Cuetzalan." *Artes de México: La Sierra de Puebla* 155:49–74, 104–107.
1972b "Handicrafts and Costumes of the Cuetzalan Region in the Sierra de Puebla." *Artes de México: La Sierra de Puebla*. 155:75–95, 107–112.

KEARNEY, MICHAEL
1972 *The Winds of Ixtepeji: World View and Society in a Zapotec Town*. New York: Holt, Rinehart and Winston.

KELLEY, J. CHARLES
1966 "Mesoamerica and the Southwestern United States." *HMAI* 4:95–110.

KELLY, ISABEL
1944 "West Mexico and the Hohokam." *El Norte de México y el Sur de los Estados Unidos*. México: Sociedad Mexicana de Antropología. 206–222.
1953 "The Modern Totonac." In Ignacio Bernal and E. Davalos Hurtado, eds. *Huastecos, Totonacos, y Sus Vecinos*. México: Sociedad Mexicana de Antropología. 175–186.

KELLY, ISABEL, and ANGEL PALERM
1952 *The Tajín Totonac: Part 1: History, Subsistence, Shelter, and Technology*. Smithsonian Institution, Institute of Social Anthropology, pub. 13. Washington, D.C.

KELLY, MICHAEL, and MICHAEL CALDERWOOD
1979 *Mexican Dance: The Kelly Calderwood Collection* [Catalog of an Exhibition at the Brighton Museum, September 25–October 28, 1979]. Brighton, England.

KENDALL, CARL, JOHN HAWKINS, and LAUREL BOSSEN, eds.
1983 *Heritage of Conquest: Thirty Years Later*. Albuquerque: University of New Mexico Press.

KENNEDY, ALISON B.
1982 "*Ecce Bufo*: The Toad in Nature and in Olmec Iconography." *Current Anthropology* 23:273–290.

KERÉNYI, C.
1960 "Man and Mask." *Spiritual Disciplines: Papers from the Eranos Yearbooks*. Joseph Campbell, ed. Princeton: Princeton University Press. 151–167. Orig. pub. 1948.

KIDDER, ALFRED V., et al.
1977 *Excavations at Kaminaljuyú, Guatemala*. University Park: University of Pennsylvania Press. Orig. pub. 1946.

KLEIN, CECILIA F.
1973 "Post Classic Mexican Death Imagery as a Sign of Cyclic Completion." In Benson 1975, 69–86.
1976 "The Identity of the Central Deity on the Aztec Calendar Stone." *Art Bulletin* 58:1–12.
1987 "The Ideology of Autosacrifice at the Templo Mayor." In Boone 1987a, 293–370.

KNAB, TIM
1976 "Talocan Talmanic: Supernatural Beings of the Sierra de Puebla." *Actes du XLIIe Congrès International des Américanistes* 6:127–136.
1986 "Metaphors, Concepts, and Coherence in Aztec." In Gossen 1986, 45–56.

KRICKEBERG, WALTER, et al.
1968 *Pre-Columbian American Religions*. Stanley Davis, trans. London: Weidenfeld and Nicolson.

KUBLER, GEORGE
1967 *The Iconography of the Art of Teotihuacán*. Studies in Pre-Columbian Art and Archaeology, no. 4. Washington, D.C.: Dumbarton Oaks.
1969 *Studies in Classic Maya Iconography*. Memoirs of the Connecticut Academy of Arts and Sciences, vol. 18. New Haven.
1970 "Period, Style and Meaning in Ancient American Art." *New Literary History* 1:127–144.
1973a "Iconographic Aspects of Architectural Profiles at Teotihuacán and in Mesoamerica." In Metropolitan Museum of Art 1973, 24–39.
1973b "Science and Humanism among Americanists." In Metropolitan Museum of Art 1973, 163–167.
1984 *The Art and Architecture of Ancient America: The Mexican, Maya, and Andean Peoples*. 3d ed. Harmondsworth: Penguin Books.

KUEBLER, JOANNE
1987 "Francisco Toledo." In Day and Sturges 1987, 142–145.
KURATH, GERTRUDE P.
1946 "Los Concheros." *Journal of American Folklore* 59:387–399.
1947 "Los Arrieros of Acopilco, Mexico." *Western Folklore* 6:232–236.
1949 "Mexican Moriscas: A Problem in Dance Acculturation." *Journal of American Folklore* 62:87–106.
1956 "Dance Relatives of Mid-Europe and Middle America." *Journal of American Folklore* 69: 286–298.
1958 "La Transculturación en la Danza Hispano-Americano." *Folklore Américas* 18:17–25.
1967 "Drama, Dance, and Music." *HMAI* 6:158–190.
1968 "Dance Acculturation." In Tax 1968, 233–242. Orig. pub. 1952.
KURATH, GERTRUDE P., and SAMUEL MARTÍ
1964 *Dances of Anáhuac: The Choreography and Music of Precortesian Dances.* Viking Fund Publications in Anthropology, no. 38. New York: Wenner-Gren Foundation for Anthropological Research.
LaFARGE, OLIVER
1931 *The Year Bearer's People.* Middle American Research Institute, pub. 3. New Orleans: Tulane University.
1977 "Maya Ethnology: The Sequence of Cultures." In Clarence L. Hay et al., eds. *The Maya and Their Neighbors.* New York: Dover Publications. 281–291. Orig. pub. 1940.
LANDA, DIEGO DE
1978 *Yucatan Before and After the Conquest.* William Gates, trans. New York: Dover Publications. Orig. *Relación de las Cosas de Yucatán,* 1566.
LARSEN, HELGA
1937a "Notes on the Volador and Its Associated Ceremonies and Superstitions." *Ethnos* 2: 179–183.
1937b "The Mexican Indian Flying Pole Dance." *National Geographic* 71:387–400.
LARSEN, STEPHEN
1976 *The Shaman's Doorway.* New York: Harper and Row.
LEACH, EDMUND R.
1979 "Anthropological Aspects of Language: Animal Categories and Verbal Abuse." In Lessa and Vogt 1979, 153–166. Orig. pub. 1964.
LEIGH, HOWARD
1970 "The Evolution of Zapotec Glyph C." In Paddock 1970a, 256–269.
LEÓN-PORTILLA, MIGUEL
1963 *Aztec Thought and Culture: A Study of the Ancient Nahuatl Mind.* Jack E. Davis, trans. Norman: University of Oklahoma Press.
1969 *Pre-Columbian Literatures of Mexico.* Grace Lobanov and Miguel León-Portilla, trans. Norman: University of Oklahoma Press.
1973 *Time and Reality in the Thought of the Maya.* Charles L. Boilés and Fernando Horcasitas, trans. Boston: Beacon Press.

1980 ed. *Native Mesoamerican Spirituality.* New York: Paulist Press.
LESSA, WILLIAM, and EVON Z. VOGT, eds.
1979 *Reader in Comparative Religion.* 4th ed. New York: Harper and Row.
LÉVI-STRAUSS, CLAUDE
1966 *The Savage Mind.* Chicago: University of Chicago Press. Orig. pub. in French, 1962.
1969 *The Raw and the Cooked: Introduction to a Science of Mythology: I.* John Weightman and Doreen Weightman, trans. New York: Harper and Row.
1982 *The Way of the Masks.* Sylvia Modelski, trans. Seattle: University of Washington Press.
LINNÉ, S.
1952 "Archaeological Problems in Guerrero, Mexico." *Ethnos* 17:142–148.
LITVAK KING, JAIME, and NOEMÍ CASTILLO TEJERO, eds.
1972 *Religión en Mesoamérica: XII Mesa Redonda.* México: Sociedad Mexicana de Antropología.
LÓPEZ AUSTIN, ALFREDO
1974 "The Research Method of Fray Bernardino de Sahagún; The Questionnaires." In Edmonson 1974, 111–150.
1987 "The Masked God of Fire." In Boone 1987a, 257–292.
LOTHROP, SAMUEL K.
1927 "A Note on Indian Ceremonies in Guatemala." *Indian Notes* 4, 1.
1929 "Further Notes on Indian Ceremonies in Guatemala." *Indian Notes* 6, 1.
LOWE, GARETH W.
1981 "Olmec Horizons Defined in Mound 20, San Isidro, Chiapas." In Benson 1981a, 231–255.
LUCERO-WHITE, AURORA, ed.
1944 *Coloquios de los Pastores.* Santa Fe: Santa Fe Press.
LUCKERT, KARL W.
1976 *Olmec Religion: A Key to Middle America and Beyond.* Norman: University of Oklahoma Press.
LÚJAN MUÑOZ, LUIS
1965 *Máscaras Guatemaltecas.* Guatemala: Instituto Geográfico Nacional.
1967 *Notas sobre el Uso de Máscaras en Guatemala.* Guatemala: Tipografía Nacional.
1971 "Notas sobre el Uso de Mascaras en Guatemala." *Guatemala Indígena* 6.
1982 *Semana Santa Tradicional en Guatemala.* Guatemala: Serviprensa Centroamericana.
N.d. *Máscaras de Guatemala.* Guatemala: Programa Permanente de Cultura de la Organización Paiz.
LUMHOLTZ, KARL
1971 *New Trails in Mexico.* Glorieta, N.M.: Rio Grande Press. Orig. pub. 1912.
1973 *Unknown Mexico.* 2 vols. Glorieta, N.M.: Rio Grande Press. Orig. pub. 1902.
LUNA PARRA DE GARCÍA SAINZ,
GEORGINA, and GRACIELA ROMANDIA DE CANTÜ
(cited as Luna and Romandia in notes)
1978 *En el Mundo de la Máscara.* México: Fomento Cultural Banamex.
LUTES, STEVEN V.
1983 "The Mask and Magic of the Yaqui Paskola

Clowns." In Crumrine and Halpin 1983, 81–92.

McAfee, Byron
 1952 "Danza de la Gran Conquista." *Tlalocan* 3: 246–273.

McAllister, Linda
 1984 "Prehispanic Ideas in the Sculpture of Santa Cruz, Jalisco." In Ramsay 1984, 51–58.

McArthur, Harry S.
 1962 "Orígenes y Motivos del Baile del *Tz'unum.*" *Folklore de Guatemala* 2:139–156.
 1972 "Los Bailes de Aguacatán y el Culto a los Muertos." *América indígena* 32:490–513.

McDowell, Bart
 1980 "The Aztecs." *National Geographic* 158:704–751.

MacNeish, Richard S.
 1964 "The Food-Gathering and Incipient Agriculture Stage of Prehistoric Middle America." *HMAI* 1:413–426.
 1972 ed. *The Prehistory of the Tehuacán Valley.* Austin: University of Texas Press.
 1981 "Tehuacán's Accomplishments." *HMAI.* Supplement 1.

McVicker, Donald
 1985 "The 'Mayanized' Mexicans." *AA* 50:82–101.

Madsen, William
 1955 "Shamanism in Mexico." *Southwestern Journal of Anthropology* 11:48–57.
 1957 "Christo-Paganism: A Study of Mexican Religious Syncretism." *Nativism and Syncretism.* Middle American Research Institute, pub. 19:105–180. New Orleans: Tulane University.
 1967 "Religious Syncretism." *HMAI* 6:369–391.
 1969 "The Nahua." *HMAI* 8:602–637.

Malmstrom, V.
 1978 "A Reconsideration of the Chronology of Mesoamerican Calendrical Systems." *Journal for the History of Astronomy* 9:105–116.

Mann, Thomas
 1957 *Confessions of Felix Krull, Confidence Man.* Denver Lindley, trans. New York: New American Library.

Marcus, Joyce
 1976 "The Iconography of Militarism at Monte Albán and Neighboring Sites in the Valley of Oaxaca." In H. Nicholson 1976a, 123–140.
 1983a "The First Appearance of Zapotec Writing and Calendrics." In Flannery and Marcus 1983a, 91–96.
 1983b "Rethinking the Zapotec Urn." In Flannery and Marcus 1983a, 144–148.
 1983c "Teotihuacán Visitors on Monte Albán Monuments and Murals." In Flannery and Marcus 1983a, 175–181.
 1983d "Zapotec Religion." In Flannery and Marcus 1983a, 345–351.

Marcus, Joyce, Kent V. Flannery, and Ronald Spores
 1983 "The Cultural Legacy of the Oaxacan Preceramic." In Flannery and Marcus 1983a, 36–39.

Matos Moctezuma, Eduardo
 1987 "Symbolism of the Templo Mayor." In Boone 1987a, 185–210.

Medellín Zenil, Alfonso
 1971 *Monolitos Olmecas y Otros en el Museo de la Universidad de Veracruz.* Carolyn B. Czitrom, trans. Corpus Antiquitatum Americanensium, vol. 5, México: INAH.
 1983 *Obras Maestras del Museo de Xalapa.* México: Studio Beatriz Trueblood.

Melville, Herman
 1950 *Moby Dick.* New York: Holt, Rinehart and Winston.

Méndez, Leopoldo, and Marianne Yampolsky, eds.
 1971 *The Ephemeral and the Eternal of Mexican Folk Art.* 2 vols. México: Fondo Editorial de la Plástica Mexicana.

Mendoza, Ruben G.
 1977 "World View and the Monolithic Temples of Malinalco, Mexico: Iconography and Analogy in Pre-Columbian Architecture." *Actes du XLIIe Congres International des Américanistes.* 63–80.

Mendoza, Vicente T.
 1942 "Versos de la Gran Conquista." *Anuario de la Sociedad Folklórica de México* 1:123–125.

Mendoza, Vicente T., and Virginia R. R. de Mendoza
 1952 *Folklore de San Pedro Gorda, Zacatecas.* México: Instituto Nacional de Bellas Artes y Secretaria de Educación Pública.

Merlo Juárez, Eduardo
 1979 "El Indígena y el Turismo en la Sierra Norte de Puebla." *Tercera Mesa Redonda sobre Problemas Antropologicos de la Sierra Norte del Estado de Puebla.* Cuetzalan, Puebla: Dirección del Centro de Estudios de la Sierra Norte del Estado de Puebla. 35–46.

Mesnil, Marianne
 1987 "Place and Time in the Carnivalesque Festival." Fae Korsmo, trans. In Falassi 1987, 186–196.

Metropolitan Museum of Art
 1973 *The Iconography of Middle American Sculpture.* New York: Metropolitan Museum of Art.

Mexican Fine Arts Center
 1984 *Celebración de Máscaras: Mexican Masks from Chicago Collections* [Catalog of an Exhibition Sponsored by the Mexican Fine Arts Center and the School of the Art Institute of Chicago Gallery, Chicago, October 5–27, 1984]. Chicago.

Michel, Concha
 1932 "Pastorela or Coloquio." *Mexican Folkways* 7:5–31.

Milbrath, Susan
 1979 *A Study of Olmec Sculptural Chronology.* Studies in Pre-Columbian Art and Archaeology, no. 23. Washington, D.C.: Dumbarton Oaks.

Miles, S. W.
 1965a "Summary of Pre-Conquest Ethnology of the Guatemala-Chiapas Highlands and Pacific Slopes." *HMAI* 2:276–287.
 1965b "Sculpture of the Guatemala-Chiapas Highlands and Pacific Slopes, and Associated Hieroglyphs." *HMAI* 2:237–275.

MILLER, VIRGINIA E., DUDLEY M. VARNER, and BETTY A. BROWN
 1975 "The Tusked Negrito Mask of Oaxaca." *The Masterkey* 49:44–50.

MILLON, RENÉ
 1976 "Social Relations in Ancient Teotihuacán." In Wolf 1976, 205–248.
 1981 "Teotihuacán: City, State, and Civilization." *HMAI* Supplement 1:198–243.

MILNE, JEAN
 1975 *Fiesta Time in Latin America.* Los Angeles: Ward Ritchie Press.

MOISES, ROSALIO, JANE H. KELLEY, and WILLIAM C. HOLDEN
 1971 *A Yaqui Life: The Personal Chronicle of a Yaqui Indian.* Lincoln: University of Nebraska Press.

MOMPRADÉ, ELECTRA L., and TONATIÚH GUTIÉRREZ
 1976 *Danzas y Bailes Populares.* Vol. 6, *Historia General del Arte Mexicano.* México: Editorial Hermes.

MONTELL, GOSTA
 1938 "Yaqui Dances." *Ethnos* 3:145–166.

MONTENEGRO, ROBERTO
 1926 *Máscaras Mexicanas.* México: Publicaciones de la Secretaria de Educación.
 1929 "The Carnival in Zaachila, Oaxaca." *Mexican Folkways* 5:28–30.
 1953 "Máscaras." *Yan* 1:4–5.

MORLEY, SYLVANUS G.
 1956 *The Ancient Maya.* 3d ed. Rev. by George W. Brainerd. Palo Alto: Stanford University Press.

MORRIS, WALTER F., JR.
 1979 *A Catalog of Textiles and Folkart of Chiapas, Mexico.* 2 vols. San Cristobal de las Casas, Chiapas: Publicaciones Pokok de la Cooperativa de Artesanías Indígenas.
 N.d. *Máscaras de Chiapas.* San Cristobal de las Casas, Chiapas: Instituto de la Artesanía Chiapaneca.

MOSER, CHRISTOPHER L.
 1975 "Cueva de Ejutla: Una Cueva Funeraria Pósclasica?" *Boletín del INAH* 14:25–37.
 1983 "A Postclassic Burial Cave in the Southern Cañada." In Flannery and Marcus 1983a, 270–272.

MOYA RUBIO, VÍCTOR JOSÉ
 1974 *Máscaras Mexicanas de la Collecion del Ing. Víctor José Moya* [Catalog of an Exhibition at the Museo Nacional de Antropología]. México: Dirección de Museos del INAH.
 1978 *Máscaras: La Otra Cara de México.* México: UNAM.

MULRYAN, LENORE H.
 1982 *Mexican Figural Ceramists and Their Work.* Monograph Series, no. 16. Los Angeles: Museum of Cultural History, University of California, Los Angeles.

MUSEO NACIONAL DE LA MÁSCARA
 N.d. *Catalogo.* San Luis Potosi.

MUSER, CURT, comp.
 1978 *Facts and Artifacts of Ancient Middle America.* New York: E. P. Dutton.

NAHMAD, SALOMÓN
 1981 *Los Pueblos de la Bruma y el Sol.* México: INI.

NAPIER, DAVID
 1987 "Festival Masks: A Typology." In Falassi 1987, 212–219.

NAVARRETE, CARLOS
 1971a "Masks." In Méndez and Yampolsky 1971, 2:742–743.
 1971b "Prohibición de la Danza del Tigre en Tamulte, Tabasco, en 1631." *Tlalocan* 4:374–376.

NEIHARDT, JOHN G., ed.
 1959 *Black Elk Speaks: Being the Life Story of a Holy Man of the Oglala Sioux.* New York: Washington Square Press.

NICHOLSON, HENRY B.
 1971a "Religion in Pre-Hispanic Central Mexico." *HMAI* 10:395–446.
 1971b "Major Sculpture in Pre-Hispanic Central Mexico." *HMAI* 10:92–134.
 1972 "The Cult of Xipe Tótec in Mesoamerica." In Litvak King and Castillo Tejero 1972, 213–218c.
 1973 "The Late Prehispanic Central Mexican (Aztec) Iconographic System." In Metropolitan Museum of Art 1973, 72–97.
 1976a ed. *Origins of Religious Art and Iconography in Preclassic Mesoamerica.* UCLA Latin American Studies Series, vol. 31. Los Angeles: UCLA Latin American Center Publications and Ethnic Arts Council of Los Angeles.
 1976b "Preclassic Mesoamerican Iconography from the Perspective of the Postclassic: Problems in Interpretational Analysis." In H. Nicholson 1976a, 157–175.
 1976c "Introduction." In H. Nicholson 1976a, 1–6.
 1976d "Ehécatl Quetzalcóatl vs. Topiltzin Quetzalcóatl of Tollan: A Problem in Mesoamerican Religion and History." *Actes du XLIIe Congrès International des Américanistes* 6:35–47.
 1982 "The Mixteca-Puebla Concept Revisited." In Boone 1982a, 227–249.
 1987 "Symposium on the Aztec Templo Mayor: Discussion." In Boone 1987a, 463–484.

NICHOLSON, IRENE
 1965 *Firefly in the Night.* London: Faber and Faber.

NUTINI, HUGO G.
 1976 "An Outline of Tlaxcaltecan Culture, History, Ethnology, and Demography." In M. H. Crawford, ed. *The Tlaxcaltecans: Prehistory, Demography, Morphology, and Genetics.* University of Kansas Publications in Anthropology, no. 7. Lawrence: University of Kansas Press. 24–34.

NUTINI, HUGO G., and BARRY L. ISAAC
 1974 *Los Pueblos de Habla Náhuatl de la Region de Tlaxcala y Puebla.* Antonieta S. M. de Hope, trans. México: INI.

OETTINGER, MARION
 1986 "Máscaras: The Other Face of Mexico." *San Antonio Museum Association Quarterly,* Autumn:12–19.
 N.d. *Con Cariño: Mexican Folk Art from the Collection of the San Antonio Museum Association.* San Antonio: San Antonio Museum of Art.

OGAZÓN, ESTELA
1981 "Masks of Mexico." In Centro 1981, 76–77.

OLIVERA B., MERCEDES
1974 Catalogo Nacional de Danzas: Vol. I, Danzas y Fiestas de Chiapas. México: FONADAN.

PADDOCK, JOHN
1970a ed. Ancient Oaxaca. Palo Alto: Stanford University Press.
1970b "Oaxaca in Ancient Mesoamerica." In Paddock 1970a, 83–242.
1983a "Yagul during Monte Albán I." In Flannery and Marcus 1983a, 98–99.
1983b "The Oaxaca Barrio at Teotihuacán." In Flannery and Marcus 1983a, 170–175.

PAINTER, MURIEL T., and E. B. SAYLES
1962 Faith, Flowers, and Fiestas: The Yaqui Indian Year. Tucson: University of Arizona Press.

PARADIS, LOUISE I.
1981 "Guerrero and the Olmec." In Benson 1981a, 195–208.

PARET-LIMARDO DE VELA, LISE
1963 La Danza del Venado en Guatemala. Guatemala: Centro Editorial José de Pineda Ibarra.

PARSONS, JEFFREY R.
1976 "Settlement and Population History of the Basin of Mexico." In Wolf 1976, 69–100.

PARSONS, LEE A.
1980 Pre-Columbian Art: The Morton D. May and the St. Louis Art Museum Collections. New York: Harper and Row.

PASZTORY, ESTHER
1974 The Iconography of the Teotihuacán Tlaloc. Studies in Pre-Columbian Art and Archaeology, no. 15. Washington, D.C.: Dumbarton Oaks.
1976 The Murals of Tepantitla, Teotihuacán. New York: Garden Publishing.
1982 "Three Aztec Masks of the God Xipe Tótec." In Boone 1982b, 77–106.
1983 Aztec Art. New York: Harry N. Abrams.
1987 "Texts, Archaeology, Art, and History in the Templo Mayor: Reflections." In Boone 1987a, 451–462.

PAUL, ANNE
1976 "History on a Maya Vase?" Archaeology 118–126.

PAZ, OCTAVIO
1959 Tamayo en la Pintura Mexicana. Sita Garst, trans. México: UNAM.
1961 The Labyrinth of Solitude: Life and Thought in Mexico. Lysander Kemp, trans. New York: Grove Press.
1974 Conjunctions and Disjunctions. New York: Viking Press.
1978 "The Art of Mexico." Americas, September: 13–22.
1979a "An Art of Transfigurations." Rachel Phillips, trans. In Rufino Tamayo: Myth and Magic [Catalog of an Exhibition at the Guggenheim Museum]. New York: Solomon R. Guggenheim Foundation. 9–23.
1979b "Reflections: Mexico and the United States." Rachel Phillips, trans. The New Yorker, 17 September:136–154.
1987 "Food of the Gods," a review of Schele and Miller, The Blood of Kings. Eliot Weinberger, trans. The New York Review of Books 34:3–7.

PÉREZ RODRÍGUEZ, BERNARDO
1981 "Maschere del Messico." Maschere del Messico. Annunziata Augieri Raimondi, trans. N.p.: Edizioni di Comunita. 35–197.

PICKANDS, MARTIN
1986 "The Hero Myth in Maya Folklore." In Gossen 1986, 101–123.

PIÑA-CHAN, ROMAN
1971 "Preclassic or Formative Pottery and Minor Arts of the Valley of Mexico." HMAI 10:157–178.
1977 Quetzalcóatl: Serpiente Emplumada. México: Fondo de Cultura Económica.

PIRES-FERREIRA, JANE W., and KENT V. FLANNERY
1976 "Ethnographic Models for Formative Exchange." In Flannery 1976b, 286–292.

POHORILENKO, ANOTOLE
1977 "On the Question of Olmec Deities." Journal of New World Archaeology 2:1–16.

POMAR, MARÍA TERESA
1982 Danza-Máscara y Rito-Ceremonia. México: Fondo Nacional para el Fomento de las Artesanías.

PONCE, JUAN GARCÍA
1967 Tamayo. Emma Gutiérrez Suárez, trans. México: Galería del Arte Misrachi.

PREUSS, KONRAD T.
1912 Die Nayarit-Expedition: Textaufnahmen und Beobachtungen unter Mexicanischen Indianern. Vol. I: Die Religion der Cora Indianer. Leipzig: B. G. Teubner.

PROSKOURIAKOFF, TATIANA
1950 A Study of Classic Maya Sculpture. Carnegie Institution, pub. 593. Washington, D.C.
1963 An Album of Maya Architecture. Norman: University of Oklahoma Press. Orig. pub. 1946.

QUIRARTE, JACINTO
1973 Izapan-Style Art: A Study of Its Form and Meaning. Studies in Pre-Columbian Art and Architecture, no. 10. Washington, D.C.: Dumbarton Oaks.
1976 "The Relationship of Izapan-Style Art to Olmec and Maya Art: A Review." In H. Nicholson 1976a, 73–86.

RAMIREZ TOVAR, DELFIN
1929 "The Carnival in Huixquilucán." Mexican Folkways 5:35–49.

RAMSEY, JAMES R., ed.
1984 Arte Vivo: Living Traditions in Mexican Folk Art. Memphis: Memphis State University Gallery.

RAVICZ, MARILYN EKDAHL
1970 Early Colonial Religious Drama in Mexico: From Tzompantli to Golgotha. Washington, D.C.: Catholic University of America Press.

RAVICZ, ROBERT, and A. KIMBALL ROMNEY
1969 "The Mixtec." HMAI 7:367–399.

REDFIELD, ROBERT
1929 "The Carnival in Tepoztlán, Morelos." Mexican Folkways 5:30–34.
1962 Human Nature and the Study of Society: The Papers of Robert Redfield. Margaret P.

Redfield, ed. Chicago: University of Chicago Press.

REDFIELD, ROBERT, and SOL TAX
1968 "General Characteristics of Present-Day Mesoamerican Indian Society." In Tax 1968, 31–42. Orig. pub. 1952.

REINA, RUBÉN E.
1972 "Chinautla, a Guatemalan Indian Community." *Community Culture and National Change*. Middle American Research Institute, pub. 24:55–130. New Orleans: Tulane University.

REINA, RUBÉN E., and NORMAN B. SCHWARTZ
1974 "The Structural Context of Religious Conversion in Petén, Guatemala: Status, Community, and Multicommunity." *American Ethnologist* 1:157–191.

REYES GARCÍA, LUIS
1966 "Texto de una Danza." *La Palabra y el Hombre*, Enero-Marzo:37.

REYNOLDS, DOROTHY
1956 "Guatemalan Dances at Colorful Highland Festivals." *Americas* 8:31–35.

REYNOSO, LOUISA
1980 "Mexico through Masks." *Americas* 32:37–44.

RICARD, ROBERT
1932 "Contribution à l'etude des Fêtes de 'Moros y Cristianos' au Mexique." *Journal de la Societe des Américanistes* 24:51–84.

ROBB, J. D.
1957 "The Music of *Los Pastores*." *Western Folklore* 16:263–280.
1961 "The Matachines Dance: A Ritual Folk Dance." *Western Folklore* 20:87–101.

ROBE, STANLEY L.
1954 *Coloquios de Pastores from Jalisco, Mexico*. University of California Folklore Studies, no. 4. Berkeley: University of California Press.
1957 "The Relationship of *Los Pastores* to Other Spanish-American Folk Drama." *Western Folklore* 16:281–289.
1966 "Distribución Geográfico del Carnaval Americano." *XXXVI Congreso Internacional de Americanistas* 2:429–438.

ROBERTSON, DONALD
1963 *Pre-Columbian Architecture*. New York: George Braziller.

ROBERTSON, MERLE GREENE
1974 ed. *Primera Mesa Redonda de Palenque*. Pebble Beach, Calif.: Robert Louis Stevenson School.
1983 *The Temple of Inscriptions*. Vol. 1, *The Sculpture of Palenque*. Princeton: Princeton University Press.

ROBICSEK, FRANCIS, and DONALD M. HALES
1981 *The Maya Book of the Dead: The Ceramic Codex*. Charlottesville: University of Virginia Art Museum.

ROMÁN BERRELLEZA, JUAN ALBERTO
1987 "Offering 48 of the Templo Mayor: A Case of Child Sacrifice." In Boone 1987a, 131–143.

ROMANDIA DE CANTÚ, GRACIELA
1979 *El Magico Mundo de las Máscaras* [Catalog of an Exhibition of the Collection of Rafael Coronel, March 1979] Monterrey, México: Promoción de las Artes.

ROYS, RALPH L.
1967 *The Book of Chilam Balam of Chumayel*. Norman: University of Oklahoma Press.

RUE, LEONARD L., III
1968 *Sportsman's Guide to Game Animals: A Field Book of North American Species*. New York: Harper and Row.

RUIZ DE ALARCÓN, HERNANDO
1982 *The Treatise on Superstitions: Aztec Sorcerers in Seventeenth-Century Mexico*. Michael D. Coe and Gordon Whittaker, trans. Institute for Mesoamerican Studies, pub. 7. Albany: State University of New York at Albany.

RUZ LHUILLIER, ALBERTO
1965 "Tombs and Funerary Practices in the Maya Lowlands." *HMAI* 2:441–461.
1970 *The Civilization of the Ancient Maya*. Serie Historia XXIV. México: INAH. Orig. pub. 1957.
1973 *El Templo de las Inscripciones, Palenque*. México: INAH.

SAHAGÚN, BERNARDINO DE
1950– *General History of the Things of New Spain:*
1978 *Florentine Codex*. 13 vols. Charles E. Dibble and Arthur J. V. Anderson, trans. Santa Fe: School of American Research and University of Utah.

SALMERÓN, FRANCISCO
1971 "The Roots of Mexico's Ceremonial Life." In Méndez and Yampolsky 1971, 2:367–381.

SAMPER, BALTASAR, ed.
1962– *Investigación Folklórica en México* 2 vols.
1964 México: Instituto Nacional de Bellas Artes.

SÁNCHEZ ANDRAKA, JUAN
1983 *Zitlala, por el Mágico Mundo Indigena Guerrerense, Tomo I*. Guerrero: Fondo de Apoyo Editorial del Gobierno del Estado de Guerrero.

SANDI, LUIS, and FRANCISCO DOMÍNGUEZ
1962 "Investigación en el Estado de Chiapas, Abril de 1934." In Samper 1962–1964, 1:259–318.

SANDS, KATHLEEN M.
1980 "Background and Interpretations." In Savala 1980, 143–218.

SANTIAGO E., FEDERICO
1978 *Fiestas in Mexico*. México: Ediciones Lara.

SATTERTHWAITE, LINTON
1965 "Calendrics of the Maya Lowlands." *HMAI* 3:603–631.

SAVALA, REFUGIO
1980 *The Autobiography of a Yaqui Poet*. Kathleen M. Sands, ed. Tucson: University of Arizona Press.

SAVILLE, MARSHALL H.
1922 "Turquoise Mosaic Art in Ancient Mexico." *Contributions to the Museum of the American Indian, Heye Foundation*. 6.
1925 *The Wood Carver's Art in Ancient America*. Vol. 9, Contributions from the Museum of the American Indian, Heye Foundation. New York.

SCHELE, LINDA, and MARY ELLEN MILLER
1986 *The Blood of Kings: Dynasty and Ritual in*

Maya Art. New York: George Braziller, Inc., in association with the Kimbell Art Museum, Fort Worth.

SÉJOURNÉ, LAURETTE
 1966a *Arquitectura y Pintura en Teotihuacán.* México: Siglo Veintiuno Editores.
 1966b *El Lenguaje de las Formas en Teotihuacán.* México.
 1969 *Teotihuacán: Métropole de L'Amérique.* Paris: Francois Maspero.
 1976 *Burning Water: Thought and Religion in Ancient Mexico.* Berkeley: Shambhala. Orig. pub. 1956.

SEKAQUAPTEWA, EMORY
 1976 "Hopi Indian Ceremonies." In Capps 1976, 35–43.

SELER, EDUARD
 1888 "The Day Signs of the Aztec and Maya Manuscripts and Their Divinities." In Seler n.d.*d*, 1:96–158. Orig. pub. 1888.
 1898a "Codex Borgia." In Seler n.d.*d*, 1:25–46. Orig. pub. in *Globus*, 1898. 74:297–302, 315–319.
 1898b "The Tonalamatl of the Ancient Mexicans." In Seler n.d.*d*, 1:10–22. Orig. pub. 1898.
 1904 "Venus Period in the Picture Writings of the Borgian Codex Group." C. P. Bowditch, trans. *Bureau of American Ethnology Bulletin* 28: 355–391.
 1963 *Comentarios al Códice Borgia.* 2 vols. Mariana Frenk, trans. México: Fondo de Cultura Económica. Orig. pub. 1904.
 N.d.*a* "The Animal Pictures of the Mexican and Maya Manuscripts." In Seler n.d.*d*, 4.
 N.d.*b* "Mixed Forms of Mexican Divinities." In Seler n.d.*d*, 3:58–60.
 N.d.*c* "The Wooden Drum of Malinalco and the Atl-Tlachinolli Sign." In Seler n.d.*d*, 3:1–48.
 N.d.*d* *Collected Works of Eduard Seler.* C. P. Bowditch, trans. N.p.

SELVAS, EDUARDO J.
 1954 "Máscaras y Danzas Indígenas de Chiapas." *Revista Ateneo* 5:15–33.

SEPÚLVEDA HERRERA, MARÍA TERESA
 1973 "Peticion de Lluvias en Ostotempa." *Boletín INAH* 4:9–20.
 1982 *Catalogo de Máscaras del Estado Guerrero de las Colleciones del Museo Nacional del Antropología, México, D.F.* México: INAH.

SEVILLA, AMPARO, HILDA RODRÍGUEZ, and ELIZABETH CAMARA
 1985 *Danzas y Bailes Tradicionales del Estado de Tlaxcala.* Tlahuapan, Puebla: Premiá Editora de Libros.

SHAFFER, PETER
 1974 *Equus.* New York: Avon Books.

SHARP, ROSEMARY
 1981 *Chacs and Chiefs: The Iconography of Mosaic Stone Sculpture in Pre-Conquest Yucatán, Mexico.* Studies in Pre-Columbian Art and Architecture, no. 24. Washington, D.C.: Dumbarton Oaks.

SHEPPARD, LANCELOT C., trans.
 1972 *Prehispanic Mexican Art.* New York: A Giniger Book published in association with G. P. Putnam's Sons.

SMITH, MARY ELIZABETH
 1983 "The Mixtec Writing System." In Flannery and Marcus 1983a, 238–245.

SMITHSONIAN INSTITUTION
 1978 *Mexican Masks* [Catalog of an Exhibition at the Renwick Gallery of the National Collection of Fine Arts, September 29, 1978– February 19, 1979]. Washington, D.C.: Smithsonian Institution.

SOCIEDAD DE ARTE MODERNO
 1945 *Máscaras Mexicanas.* México.

SODI M., DEMETRIO
 1975 "Máscaras." In Xavier Moyssén, ed. *Arte Popular Mexicano.* México: Editorial Herrera. 209–240.

SOLORZANO, ARMANDO, and RAÚL G. GUERRERO
 1941 "Ensayo para un Estudio sobre la 'Danza de los Concheros de la Gran Tenochtitlán.'" *Boletín Latino-Americano de Música* 5:449–476.

SOUSTELLE, JACQUES
 1961 *The Daily Life of the Aztecs on the Eve of the Spanish Conquest.* Patrick O'Brian, trans. New York: Macmillan.
 1967 *Arts of Ancient Mexico.* New York: Viking Press.
 1971 *The Four Suns.* E. Ross, trans. New York: Grossman.
 1982a "El Pensamiento Cosmológico de los Antiguos Mexicanos." Juan José Utrilla, trans. In Soustelle 1982b, 93–175. Orig. pub. 1940.
 1982b *El Universo de los Aztecas.* México: Fondo de Cultura Económica.
 1984 *The Olmecs: The Oldest Civilization in Mexico.* Helen R. Lane, trans. Garden City: Doubleday and Co.

SPEER, LON A., and JANE PARKER, eds.
 1985 *Changing Faces: Mexican Masks in Transition* [Catalog of an Exhibition at the McAllen International Museum, April 3–May 26, 1985]. McAllen, Texas.

SPICER, EDWARD H.
 1954 *Potam: A Yaqui Village in Sonora.* American Anthropological Association Memoir 77. Menasha, Wisconsin.
 1965 "La Danza Yaqui del Venado en la Cultura Mexicana." *America Indigena* 25:117–139.
 1969a "Northwest Mexico: Introduction." *HMAI* 8: 777–791.
 1969b "The Yaqui and Mayo." *HMAI* 8:830–845.
 1980 *The Yaquis: A Cultural History.* Tucson: University of Arizona Press.
 1984 *Pascua: A Yaqui Village in Arizona.* Tucson: University of Arizona Press. Orig. pub. 1940.

SPORES, RONALD
 1967 *The Mixtec Kings and Their People.* Norman: University of Oklahoma Press.
 1983a "Mixtec Religion." In Flannery and Marcus 1983a, 342–345.
 1983b "The Origin and Evolution of the Mixtec System of Social Stratification." In Flannery and Marcus 1983a, 227–238.

SPRATLING, WILLIAM
 1932 *Little Mexico.* New York: Jonathan Cape and Harrison Smith.

SPROUL, BARBARA C.
1979 *Primal Myths: Creating the World.* San Francisco: Harper and Row.

STANFORD, THOMAS
1962 "Datos sobre la Música y Danzas de Jamiltepec, Oaxaca." *Anales del INAH* 15:187–200.

STARR, FREDERICK
1896 "Popular Celebrations in Mexico." *Journal of American Folklore* 161–169.
1899 *Catalogue of a Collection of Objects Illustrating the Folklore of Mexico.* Publications of the Folklore Society, no. 43. N.p.
1902 "The Tastoanes." *Journal of American Folklore.* 73–83.
1908 *In Indian Mexico.* Chicago: Forbes and Co.

STEVENS, MICHAEL
1976 *Mexican Festival and Ceremonial Masks.* [An Exhibition of Masks from the Víctor José Moya Collection at the Lowie Museum of Anthropology and the California Academy of Sciences]. Berkeley: University of California.

STIERLIN, HENRI
1981 *Art of the Maya from the Olmecs to the Toltec-Maya.* New York: Rizzoli International Publications.
1982 *Art of the Aztecs and Its Origins.* New York: Rizzoli International Publications.

STONE, MARTHA
1975 *At the Sign of Midnight: The Concheros Dance Cult of Mexico.* Tucson: University of Arizona Press.

STRESSER-PÉAN, GUY
1948 "Danse des Aigles et Danse des Jaguars chez les Indiens Huasteques de la Région de Tantoyuca." *Actes du XXVIIIe Congrès International des Américanistes.* 335–339.

STUCKER, TERRY, et al.
1980 "Crocodilians and Olmecs: Further Interpretations in Formative Period Iconography." *AA* 45:740–758.

STURGES, HOLLISTER
1987 "Rufino Tamayo." In Day and Sturges 1987, 94–102.

SUÁREZ JÁCOME, CRUZ
1978 "Petición de Lluvia en Zitlala, Guerrero." *Antropología e Historia* 3, 22:3–13.

SWANN, BRIAN, and ARNOLD KRUPAT, eds.
1987 *Recovering the Word: Essays on Native American Literature.* Berkeley, Los Angeles, London: University of California Press.

TAMAYO, RUFINO
1968 "A Commentary by the Artist." *Tamayo.* Phoenix: Phoenix Art Museum. 1–7.

TAX, SOL, ed.
1968 *Heritage of Conquest.* New York: Cooper Square Publishers. Orig. pub. 1952.

TEDLOCK, BARBARA
1982 *Time and the Highland Maya.* Albuquerque: University of New Mexico Press.
1983 "A Phenomenological Approach to Religious Change in Highland Guatemala." In Kendall, Hawkins, and Bossen 1983, 235–246.

TEDLOCK, DENNIS, trans.
1985 *Popol Vuh: The Mayan Book of the Dawn of Life.* New York: Simon and Schuster.

TÉLLEZ GIRÓN, ROBERTO
1962a "Investigación en los Distritos de Teziutlán, Tlatlauquitepec, y Zacapoaxtla, Pue., y Jalacingo, Ver., Junio y Julio de 1938." In Samper 1962–1964, 1:351–404.
1962b "Investigación en los Distritos de Teziutlán, Tlatlauquitepec, y Zacapoaxtla y Municipio de Huitzilan, Pue., y Distrito de Jalacingo, Ver., Agosto y Septiembre de 1938." In Samper 1962–1964, 1:405–486.
1962c "Investigación en Huitzilan, Pue., Diciembre de 1938." In Samper 1962–1964, 1:487–622.
1964a "Investigación en San Pedro Ixcatán." In Samper 1962–1964, 2:23–106.
1964b "Investigación en La Mesa del Nayar y Jesús María." In Samper 1962–1964, 2:107–168.

TERMER, FRANZ
1930 "Los Bailes de Culebra entre los Indios Quichés en Guatemala." *Proceedings of the 23d International Congress of Americanists.* 661–667.

THOMPSON, DONALD E.
1960 "Maya Paganism and Christianity: A History of the Fusion of Two Religions." *Nativism and Syncretism.* Middle American Research Institute, pub. 19:1–36. New Orleans: Tulane University.

THOMPSON, J. ERIC S.
1927 *A Correlation of the Mayan and European Calendars.* Field Museum of Natural History, pub. 241. Chicago.
1965a "Archaeological Synthesis of the Southern Maya Lowlands." *HMAI* 2:331–359.
1965b "A Copper Ornament and a Stone Mask from Middle America." *AA* 30:343–345.
1966 *The Rise and Fall of Maya Civilization.* 2d ed. Norman: University of Oklahoma Press.
1970 *Maya History and Religion.* Norman: University of Oklahoma Press.
1972a *A Commentary on the Dresden Codex.* Philadelphia: American Philosophical Society.
1972b *Maya Hieroglyphs without Tears.* London: Trustees of the British Museum.
1973 "Maya Rulers of the Classic Period and the Divine Right of Kings." In Metropolitan Museum of Art 1973, 52–71.

TIBOL, RAQUEL
1974 *Orozco, Rivera, Siqueiros, Tamayo.* México: Fondo de Cultura Económica.

TOLEDO, FRANCISCO
1974 *Sahagún.* [A suite of eight etchings with accompanying texts.] México: Galería Arvil.

TONEYAMA, KAJIN
1974 *The Popular Arts of Mexico.* Richard L. Gage, trans. New York and Tokyo: Weatherhill/Heibonsha.

TONKIN, ELIZABETH
1979 "Masks and Powers." *Man* 14:237–248.

TOOKER, ELISABETH
1983 "The Many Faces of Masks and Masking: Discussion." In Crumrine and Halpin 1983, 12–18.

TOOR, FRANCES
1929a "Carnivals at the Villages." *Mexican Folkways* 5:10–27.

1929b "The Present Day Use of Masks." *Mexican Folkways* 5:127–131.

1930 "Fiesta de la Sta. Vera Cruz in Taxco." *Mexican Folkways* 6:84–94.

1932 "A Note on Pastorelas or Coloquios." *Mexican Folkways* 7:4.

1939 *Mexican Popular Arts.* México: Frances Toor Studios.

1947 *A Treasury of Mexican Folkways.* New York: Crown Publishers.

TORO, ALFONSO

1925 "The Indian Dances of the Moors and Christians." *Mexican Folkways* 1:8–10.

TOWNSEND, RICHARD F.

1979 *State and Cosmos in the Art of Tenochtitlan.* Studies in Pre-Columbian Art and Architecture, no. 20. Washington, D.C.: Dumbarton Oaks.

1982 "Malinalco and the Lords of Tenochtitlán." In Boone 1982a, 111–140.

TRABA, MARTA

1976 *Los Signos de Vida: José Luis Cuevas y Francisco Toledo.* México: Fondo de Cultura Económica.

TURNER, PAUL

1972 *The Highland Chontal.* New York: Holt, Rinehart and Winston.

TURNER, VICTOR

1969 *The Ritual Process: Structure and Anti-Structure.* Ithaca: Cornell University Press.

1974 *Dramas, Fields, and Metaphors: Symbolic Action in Human Society.* Ithaca: Cornell University Press.

1979 "Betwixt and Between: The Liminal Period in *Rites de Passage.*" In Lessa and Vogt 1979, 234–243. Orig. pub. 1964.

1982 ed. *Celebration: Studies in Festivity and Ritual.* Washington, D.C.: Smithsonian Institution Press.

1987 "Carnival, Ritual, and Play in Rio de Janeiro." In Falassi 1987, 74–91.

UMBERGER, EMILY

1987 "Events Commemorated by Date Plaques at the Templo Mayor: Further Thoughts on the Solar Metaphor." In Boone 1987a, 411–449.

UTZINGER, RUDOLF

1921 *Indianer-Kunst.* Munich: O. C. Recht-Verlag.

VAN GENNEP, ARNOLD

1960 *The Rites of Passage.* Monika B. Vizedom and Gabrielle L. Caffee, trans. Chicago: University of Chicago Press.

VARNER, DUDLEY M., VIRGINIA E. MILLER, and BETTY A. BROWN

1975 "Masked Stilt Dancers of Oaxaca." *The Masterkey* 49:110–113.

VÁZQUEZ SANTANA, HIGINIO, and J. IGNACIO DÁVILA GARIBI

1931a *Bilingual Calendar of Typical Festivals of Mexico for 1931.* México: N.p.

1931b *El Carnaval.* México: Talleres Gráficos de la Nación.

1940 *Fiestas y Costumbres Mexicanas.* México: Editorial Botas.

VELA, DAVID

1972 "Danzas y Primeras Manifestaciones Dramáticas del Indígena Mayaquiché." *América Indígena* 32:515–521.

VELAZQUEZ G., PABLO

1948 "Pastorela de Viejitos." *Tlalocan* 2:321–367.

VILLA ROJAS, ALFONSO

1973 "The Concept of Space and Time among the Contemporary Maya." Appendix to León-Portilla 1973, 113–159.

VILLAGRA CALETI, AGUSTÍN

1971 "Mural Painting in Central Mexico." *HMAI* 10:135–156.

VIVÓ ESCOTO, JORGE A.

1964 "Weather and Climate of Mexico and Central America." *HMAI* 1:187–215.

VOGT, EVON Z.

1969 *Zinacantan: A Maya Community in the Highlands of Chiapas.* Cambridge: Belknap Press.

1976 *Tortillas for the Gods: A Symbolic Analysis of Zinacanteco Rituals.* Cambridge: Harvard University Press.

VOGT, EVON Z., and CATHERINE C. VOGT

1979 "Lévi-Strauss among the Maya." In Lessa and Vogt 1979, 276–285. Orig. pub. 1970.

VON WINNING, HASSO

1976 "Late and Terminal Preclassic: The Emergence of Teotihuacán." In H. Nicholson 1976a, 141–156.

WAGLEY, CHARLES

1941 *The Social and Religious Life of a Guatemalan Village.* Memoirs of the American Anthropological Association, no. 71. Menosha, Wisconsin.

WARMAN, ARTURO

1985 *La Danza de Moros y Cristianos.* 2d ed. México: INAH. Orig. pub. 1972.

WARMAN, ARTURO, and IRENE WARMAN

1971 "Dances." In Méndez and Yampolsky 1971, 2:743–756.

WATTS, ALAN W.

1960 *Myth and Ritual in Christianity.* New York: Grove Press.

1963 *The Two Hands of God: The Myths of Polarity.* New York: Collier Books.

WEIGAND, PHIL C.

1985 "Considerations on the Archaeology and Ethnohistory of the Mexicaneros, Tequales, Coras, Huicholes, and Caxcanes of Nayarit, Jalisco, and Zacatecas." In William J. Folan, ed. *Contributions to the Archaeology and Ethnohistory of Greater Mesoamerica.* Carbondale: Southern Illinois University Press. 126–187.

WEITLANER, ROBERTO J.

1948 "Danza del Marques." *Tlalocan* 2:379–383.

WEITLANER, ROBERTO J., and MERCEDES OLIVERA DE VÁSQUEZ

1969 *Los Grupos Indígenas del Norte de Oaxaca.* México: INAH.

WESTHEIM, PAUL

1965 *The Art of Ancient Mexico.* Ursula Bernard, trans. Garden City, N.Y.: Anchor Books.

1972 "Artistic Creation in Ancient Mexico." In Sheppard, trans., 1972, 11–82.

WHITMAN, WALT

1959 *Complete Poetry and Selected Prose.* James E. Miller, Jr., ed. Boston: Houghton Mifflin.

WILDER, CARLETON S.
1963 *The Yaqui Deer Dance: A Study in Cultural Change.* Smithsonian Institution, Bureau of American Ethnology, bull. 186. Washington, D.C.

WILKERSON, S. JEFFREY K.
1981 "The Northern Olmec and Pre-Olmec Frontier on the Gulf Coast." In Benson 1981*a*, 181–194.

WILLEY, GORDON R., GORDON F. ECKHOLM, and RENÉ F. MILLON
1964 "The Patterns of Farming Life and Civilization." *HMAI* 1:446–498.

WILLIAMS GARCÍA, ROBERTO
N.d. *Fiestas de la Santa Cruz en Zitlala.* México: FONADAN.

WISDOM, CHARLES
1968 "The Supernatural World and Curing." In Tax 1968, 119–141. Orig. pub. 1952.

WOLF, ERIC R.
1959 *Sons of the Shaking Earth.* Chicago: University of Chicago Press.
1976 ed. *The Valley of Mexico: Studies in Pre-Hispanic Ecology and Society.* Albuquerque: University of New Mexico Press.

ZANTWIJK, R. A. M. VAN
1967 *Servants of the Saints: The Social and Cultural Identity of a Tarascan Community in Mexico.* Assen, Netherlands.

ZIMMER, HEINRICH
1962 *Myths and Symbols in Indian Art and Civilization.* Joseph Campbell, ed. New York: Harper and Row. Orig. pub. 1946.

ZOLBROD, PAUL G.
1987 "When Artifacts Speak, What Can They Tell Us?" In Swann and Krupat 1987, 13–40.

Index

Mediation/mediators: ancestors as, 102, 117, 127; caves as, 122; gods as, 4, 6, 7, 11, 66, 90, 117; mask as, 4, 12, 63; between matter and spirit, xvii–xviii, 3–4, 6, 12, 17, 19, 68, 88, 102, 106; mountains as, 122; priests as, 66, 122; shaman as, 4, 102, 122; taboos on, 4; were-jaguar as, 17, 19
Melville, Herman, 151
Mendieta, Fr. Gerónimo de, 95
Mendoza, Ruben G., 83
Mercury, 133
Merlo Juárez, Eduardo, 192
Merlons, 38–39, 41, 48
Mesoamerica, as single culture, 9, 207 n. 4
Metaphor: defined, 69; function of, 136; mask as, xi, xiv, xvii–xix, 3, 35, 37, 40, 55, 56, 60, 63, 66, 69, 70, 84, 97–98, 103, 107, 120, 142, 179, 190
Mictlan, 88
Mictlantecutli, 119
Midnight, in ritual, 184, 185, 189
Miles, S. W., 212 n. 246
Miller, Mary Ellen, 59, 70, 75, 118, 130, 142, 146, 147, 151–152, 207 n. 4, 212 n. 17
Millon, René, 42, 45, 83, 124, 127, 128
Mirror, of Tezcatlipoca, 64, 105–106, 137, 165
Mixcoatl, 4
Mixe, 159
Mixtec, 47; afterlife, 94; burial practices, 94–95, 118; carnivals, 174–175, 176, 178; codex, 49; creation myth, 146; fire serpent, 148; funerary masks, 90, 93, 94–95, 96; gods, 5, 28, 49, 53, 146; sites, 94–95 (see also Oaxaca); tigre dance, 174–175
Mixteca-Puebla: codices, 59; style, 49, 211 n. 209
Moctezuma, 96(pl), 97–98, 155, 214 n. 2
Molina, Felípe, 181, 184, 190, 192
Momostenango, 163
Monotheism, 136
Monsters, 84, 85–86, 118, 143–144
Monte Albán, 83, 117; Cocijo at, 29; Danzante sculpture at, 131; funerary offering of, 93–94; funerary urns at, 28–29, 32–33, 74–75, 80, 93, 145; god-impersonator at, 71; observatory at, 109; quincunx at, 122; rain god mask at, 28; serpent mask at, 78–79; Xipe Tótec at, 80
Moon: Aztecs on, 112–114; butterfly associated with, 148; cycles of, 110, 114–115, 116, 132, 133; eclipses disrupt, 114–115; god of, 112–113, 114; Mayas on, 110, 114, 132, 156; night equated with, 113; rabbit in, 113; and sun, as duality, 112–115; sun destroys, 113, 114
Moors, 161–163; masks of, 193–194
Mora, Lino, 193
Morelos, 167–168, 169, 173, 175. See also Chalcatzingo
Morisca, 161–163
Mosaic, 127; masks, 5, 80, 89, 90, 91, 92, 94–95, 96
Moser, Christopher, 94–95
Motolinía, Fr. Toribio de, 95
Mountain: artificial, 84, 122, 126, 127; cave in, 127, 171; as center, 83, 84; climbing of, 125; as deity, 213 n. 80; as entrance to heavens, 84; lightning from, 126; as liminal, 20, 126, 127, 143, 144; as mediator, 122; rain associated with, 126; rituals on, 126, 143, 176, 177; on Tlalocan mural, 40,

41, 42; as transformation agent/site, 126, 143
Mouth: cave associated with, 15, 16–17, 24, 83–84, 127; Chac's, 58, 59, 60, 61, 63; Cocijo's, 28, 29, 63; drains associated with, 16–17; emergence from, 48, 50, 70–77, 126; expresses/reveals, 38, 63, 82; handlebar-mustache, 37, 38, 39, 41, 43, 52–53, 55, 61, 63; jade in, 118; jaguar's, 15, 16–17, 48, 50, 51(pl), 55, 57, 83–84, 127, 167, 169, 170; as liminal point, 17; mask-wearer looks through, 167, 169, 171; as mediator, 17, 19; Olmec, 13, 15–16, 17, 18, 19, 29, 34, 36, 56, 57, 63, 127, 169; rain god's, 13, 14, 15, 19; scroll element/ spiral near, 16, 23, 59, 78; serpent's, 15, 41, 44, 72–73, 76–77; temple doors as, 84; Tlaloc's, 34, 36, 37, 38, 39, 41, 43, 44, 48, 52–53, 55, 57, 61, 63, 169, 171; toad's, 15; toothless, 13, 18–19; water-lily in, 36, 37–38, 48; were-jaguar's, 15–16, 17, 18, 19, 26, 28, 29, 36, 56, 57, 63, 169
Murals. See Oxtotitlán cave; Tlalocan mural
Mushrooms, hallucinogenic, 104
Myth, xi, xii, 6–7, 8, 136, 195–196; metaphorical, xiv–xv; transformation as basis of, 143–144. See also Creation/creation myth

Nagual/nahualli, 5, 55, 102, 104, 105, 144–145, 202–203, 204
Nahua people (Nahuatl-speaking people), 127, 137, 144–145, 146
Naj Tunich cave, 208 n. 51
Name, 159
Nanahuatzin, 112, 113, 114, 144
Nature, 18, 101–102; v. culture, 22–23, 168, 178; mask of, 3, 31, 135, 151; Mayo/Yaqui on, 180, 181
Navajo, 137
Navarrete, Carlos, 167
los Negritos, 178
Nicholson, Henry B., 43, 44, 49, 52, 54, 80, 81, 105, 106, 136
Nicholson, Irene, 136
Night: /day duality, 108–109; jaguar associated with, 86, 111, 126; moon as, 113; Tezcatlipoca associated with, 137, 138
North, 83, 122, 138, 139
Nose: jaguar's, 44, 167, 169, 171; rain god's, 13, 15, 50, 58, 59, 60, 61, 62, 63, 171
Novalis (Friedrich von Hardenberg), xv
Ñuiñe tradition, 47
Numbers, as sacred, 85, 129

Oaxaca: astronomy in, 109; calendars of, 33, 110, 130; carnivals in, 173, 174, 175; composite masks/beings in, 27, 28, 29; face painting in, 79–80; funerary masks in, 89–90, 93–94, 95, 96; funerary urns in, 28–30, 31–33; gods of (see Cocijo); Olmec influence in, 27, 28, 29, 32; people of (see Mixtecs; Zapotecs); sites in (see individual sites by name); tigre dance in, 173, 175
Obsidian, 105–106, 214 n. 152
Océlotl, 111. See also Jaguar
Ochpaniztli, festival of, 147
Oettinger, Marion, 175
Olivera B., Mercedes, 175
Olmec: astronomy, 109; biologically impossible creatures, 9–12, 13 (see also Were-jaguar); bird, 71; buccal masks, 78; calendar, 110; caves, 15,

16, 24 (see also Oxtotitlán cave); on children, 18, 24, 26; cleft imagery of, 13, 14, 15, 19, 26, 30; creator god, 12; crocodilian, 17; cross, 14, 15–16, 24, 26; dragon, 13, 139; face painting, 79; on fertility, 13, 14, 15, 19; funerary masks, 89, 92; hallucinogens, 104; influence, xv, 9, 10, 11, 26–27, 28, 29, 32, 34, 36, 37, 56, 57, 58–59, 60–61, 63, 90, 139, 169, 210 n. 159, 212 n. 246; jade mask, 152; jaguar, 9, 10, 11, 15, 17–18, 23–24, 28, 46, 71, 126, 127; mediation beliefs, 12, 17, 19; mosaics, 127; mountains, 20, 127; mouth/nose imagery, 13, 15–16, 17, 18, 19, 29, 34, 36, 56, 57, 63, 127, 169; origin myth, 126; quincunx, 122; rain god, 9, 13–26, 28, 29, 30, 34, 36, 57, 63, 169, 208 n. 43; rulers/rulership, 21, 22, 23–24, 24–26, 27, 28, 57, 71, 139; scarification, 79; serpent, 17; sites (see individual sites by name); trade, 26–27, 34, 60; village cultures fused with, xiii, 26, 27–28, 34, 90; on volcanoes, 127; water images, 16, 17, 19, 21; were-jaguar, xii, 8–26, 28, 34, 36, 56, 57, 63, 169, 208 n. 38; Xipe Tótec prototype, 80; x-ray technique, 70–71
Ometeotl: aspects/manifestations of, 4, 5, 6, 136, 137, 138; Christian God compared to, 157; as creator, 4, 136, 141; duality of, 137, 141; as godhead, 138
Omeyocán, 138
Opossum mask, 71, 72(pl), 78
Oral tradition, 135
Order, 102–103, 106; calendar expresses, 129, 131, 143; Chac associated with, 61; cycles express, xii, xiii, 108, 115–116, 119, 121, 143; devil disrupts, 182; life-force as source of, xiii, 135–140; mathematical, 129–134; reality displayed by, xi, xvii; ritual restores, 18, 182; spatial, xii, 121–128, 143; sun as source of, 121, 128; temporal, xii, 108–120, 121, 143
Origin: cave as place of, 15, 83, 84, 126, 127; myth, 83, 126
Orozco, José Clemente, 196
Otomí people, 144
Outer, xv, 3, 37. See also Inner
Ovid, 67, 69
Oxtotitlán cave, 12, 24, 34, 57, 70–71, 78, 171
Oztoteotl, 160

Pacal: funerary mask of, 90, 91, 119; regeneration associated with, 31, 91, 118–119; serpent and, 31; tomb of, 19, 20(pl), 31, 91, 92, 118–119, 158
Paddock, John, 29
Paganism. See Religion
Pahko ritual, 184–186, 190; community participates in, 183–184, 186; as identity ritual, 186; midnight in, 184, 185, 189; phases of, 184–186; pascola's role in, 183, 184–186, 188; for rain, 186; rama in, 183; for regeneration, 185–186
Palenque, 59, 60; Pacal's tomb at, 19, 20(pl), 31, 91, 92, 118–119, 158; Temple of the Cross at, 119; Temple of Inscriptions at, 91, 118, 119
Pantheism, 135–136, 165
Paradis, Louise, 27
Paret-Limardo de Vela, Lise, 175
Partial masks, 78
Pascola/pascola dance, 179–190; animals in, 180, 181, 183, 184, 185, 189;

Designer: Linda M. Robertson
Compositor: Prestige Typography
Text: 10/12 Trump Medieval
 Roman
Display: Trump Medieval